TEXTILES IN PERSPECTIVE

BETTY F. SMITH / IRA BLOCK
University of Maryland

TEXTILES

IN
PERSPECTIVE

PRENTICE-HALL, INC., Englewood Cliffs, N.J. 07632

Library of Congress Cataloging in Publication Data

SMITH, BETTY F.
 Textiles in perspective.

 Includes index.
 1. Textile industry. 2. Textile fabrics.
3. Textile fibers. I. Block, Ira (date). II. Title.
TS1445.S64 677 81-19976
ISBN 0-13-912808-5 AACR2

Editorial development, design,
and production supervision: Hilda Tauber
Interior design assistance: Lee Cohen
Cover design: Maureen Olsen
Manufacturing buyer: Harry P. Baisley

TEXTILES IN PERSPECTIVE
by Betty F. Smith and Ira Block
© 1982 by Prentice-Hall, Inc. Englewood Cliffs, N.J. 07632

10 9 8 7 6 5 4 3 2 1

ISBN 0-13-912808-5

PRENTICE-HALL INTERNATIONAL, INC., *London*
PRENTICE-HALL OF AUSTRALIA PTY. Limited, *Sydney*
PRENTICE-HALL OF CANADA, LTD., *Toronto*
PRENTICE-HALL OF INDIA PRIVATE LIMITED, *New Delhi*
PRENTICE-HALL OF JAPAN, INC., *Tokyo*
PRENTICE-HALL OF SOUTHEAST ASIA PTE. LTD., *Singapore*
WHITEHALL BOOKS LIMITED, *Wellington, New Zealand*

contents

Preface *vii*

PERSPECTIVES ON TEXTILES *1*

1 Historical Backgound *3*

2 Consumer Decision Making *17*

3 Chemistry Basics for Understanding Textiles *31*

II FIBERS: STRUCTURE, PROPERTIES, AND IDENTIFICATION *61*

4 Introduction to Textile Fibers *63*

5 Natural Fibers *70*

6 Man-made Cellulosic Fibers *107*

7 Man-made Petroleum-based Fibers *119*

8 Other Man-made Fibers *157*

9 Fiber Identification Methods *172*

v

III YARNS: CONSTRUCTION AND PERFORMANCE *179*

 10 Simple Yarns *181*

 11 Complex Yarns *194*

IV FABRICS: CONSTRUCTION AND PROPERTIES *205*

 12 Woven Cloths *207*

 13 Knit Cloths *228*

 14 Pile, Nonwoven, and Specialty Fabrics *247*

V FINISHING AND COLORING OF FABRICS *269*

 15 General Finishes *271*

 16 Functional Finishes *290*

 17 Design: Color and Pattern *329*

VI MANUFACTURING METHODS, STANDARDS AND TESTING *357*

 18 Manufacturing Methods *359*

 19 Standards and Testing *393*

 Glossary *415*

 Bibliography *424*

 Index *427*

preface

Since clothing and home furnishings make up a major porton of the family budget, a knowledge of textiles is as appropriate for consumers who wish to purchase wisely as it is for those whose career interests lie in textiles and related areas. Interior designers, retail merchandisers, manufacturers and marketers of textile fibers, fabrics, and finished goods must all be familiar with the manufacturing methods, construction, and finishing techniques which affect the performance of textile products. The textile scientist specializes in the development and improvement of fibers; the textile engineer is engrossed by the techniques of fabric manufacture and the workings of weaving and knitting machines; the textile designer addresses the arts of dyeing and printing; while the consumer—searching for the right dress, shirt, towel, or curtain—is likely to be indifferent to these other concerns. Yet, what everyone involved in the manufacture, sale, and use of textile products is concerned with is *performance*.

Textiles in Perspective focuses on the factors which affect the performance of textiles, and shows how the separate subsystems—fibers, yarns, construction, and finishes—interact to provide goods that satisfy the user's performance requirements in the five criteria of *appearance, comfort, maintenance, durability*, and *cost*. In Part I, we begin with a brief history, map the flow of goods from raw materials to consumer, and introduce the concept of *selection criteria*. We show how the five criteria are important to the consumer making a purchase decision and how these criteria are sensitive to fibers, yarn, construction, and finishes.

We believe that a knowledge of the chemistry of fibers, dyes, and finishes has now become too important to be given the superficial treatment that has prevailed in the past. Realizing that many students have had little or no chemistry, we devote a chapter to basic concepts and to the specifics necessary for understanding textiles. Throughout the book we explain more fully than is usual in beginning texts *why* and *how* performance properties vary with changes in physical and chemical structure. Technical discussion that may be too detailed for the beginner is set off in smaller type for future reference at the reader's discretion.

Part II is devoted to the study of fibers. Each segment follows the same format: historical background, macroscopic and microscopic properties, and a discussion of how the fiber's properties affect Appearance, Comfort, Maintenance, Durability, and Cost. Uses for each fiber are discussed, and tables of properties are given.

In Part III we examine the construction and performance of yarns, both simple and complex, and show how yarn properties can affect the selection criteria.

Part IV covers fabrics—their construction and properties—providing more information than previously available in introductory texts. For each woven construction we discuss in detail the differences in Appearance, Comfort, Maintenance, Durability, and Cost brought about by the difference in construction. We provide tables enabling the student to compare the performance of various cloths. The same is done for knit constructions. After this, we show how different combinations of yarn and cloth construction can provide fabrics with different properties.

In Part V we take up the finishing and coloring of fabrics. General and functional finishes are considered separately. General finishes are discussed in their usual order of application so that the reader may see how each contributes to the overall performance of the finished goods. Functional finishes are grouped according to the purposes intended, e.g., finishes which improve the ease of maintenance of fabrics, so that the reader can appreciate the different ways in which a desired goal can be achieved.

Color is approached as a psychological, physiological, physical, and chemical phenomenon. A brief description of how color is generated, why we see color, and what it means to us, is followed by a description of dyes, dyeing processes, and printing techniques. The fastness of the different dye classes is considered, as well as their applicability to different fibers.

Manufacturing methods are considered in a separate chapter, since we believe that most readers will be less interested in how fabrics are made than in how they perform. We have, however, attempted to cover the manufacturing of fibers, yarns, and cloth in enough detail to satisfy those readers who have more than the usual interest in the technical aspects of the industry.

The last chapter discusses standards, both voluntary and mandatory, and testing. We describe the various product standards mandated by law or regulation, discuss the consensus standards groups, and consider the ways in which they affect the freedom of the market.

Summaries, review questions, and student projects are provided wherever they best reinforce the text. A glossary of terms and a selected bibliography are also included for reference.

For illustrative materials we wish to thank the American Association of Textile Chemists and Colorists, the American Society of Testing Materials, the American National Standards Institute, and the American Apparel Manufacturer's Association, as well as the companies and institutes that have graciously provided help: American Dornier Machinery, Barber-Colman Company, Celanese Corporation, Chima, Inc., Ciba-Geigy Corporation, Dow Badische Co., Fi-Tech, Inc., Gaston County Dyeing Machine Co., ITT Rayonier Inc., Johns-Manville Corporation, The Maytag Company, Monsanto Textiles Co., Morrison Machine Co., North American Rockwell, B. F. Perkins, Platt Saco Lowell, Saurer Corporation, Shirley Institute (Manchester), Springs Mills, Inc., Sulzer Bros., Inc., Textile Physics Laboratory of the University of Leeds, 3M Company, The Wool Bureau.

We wish to acknowledge the invaluable suggestions from our colleagues and students and the excellent contributions of our editor, Hilda Tauber, in creating this book.

BETTY F. SMITH

IRA BLOCK

I

1 Historical Background

2 Consumer Decision Making

3 Chemistry Basics for Understanding Textiles

PERSPECTIVES ON TEXTILES

PART I PROVIDES a three-tiered foundation for the study of textiles. In Chapter 1 we survey the major historical developments from the dawn of civilization to the modern era, to see how the industry came into being and where it stands today. Chapter 2 examines the criteria for evaluating textiles and shows how they relate to consumer purchase decisions. This section forms the conceptual basis of the entire text. In Chapter 3 we introduce the third essential component—chemistry—and review the information that is basic to a real understanding of the hows and whys of textile performance.

1

historical background

The fabrication of textile products is one of our oldest arts. It is, in fact, one of the bases of civilization. A study of the growth and development of the textile industry is also a study of the growth and development of humankind. For textile production is not just machines and factories; it is an expression of the artistry of the designer, the imagination of the scientist, the adventuring spirit of the entrepreneur, and the dignity of the craftsman. All of these have created and powered the slow upward climb of civilization which we call progress.

This chapter is a review of the development of textile manufacturing from the crafts of the prehistoric era to the highly automated industry of today. To help keep these developments in perspective, refer to Table 1.1, which is divided into the four main branches of the textile industry: *fibers*, *yarns*, *fabrics*, and *finishes*.

BEGINNINGS IN ANTIQUITY

Long before people became farmers, they were shepherds. Goats and sheep provided the milk, meat, skins, and wool that fed and clothed the nomadic tribes. These animals were invaluable to the early peoples. It wasn't necessary to slaughter flocks to obtain their wool or hair; sheep could be sheared each season and would regrow their fleece. Moreover, the animals were self-propagating, so that with care the supply of food and fiber was constantly replenished.

3

TABLE 1.1 Milestones in the Development of the Textile Industry

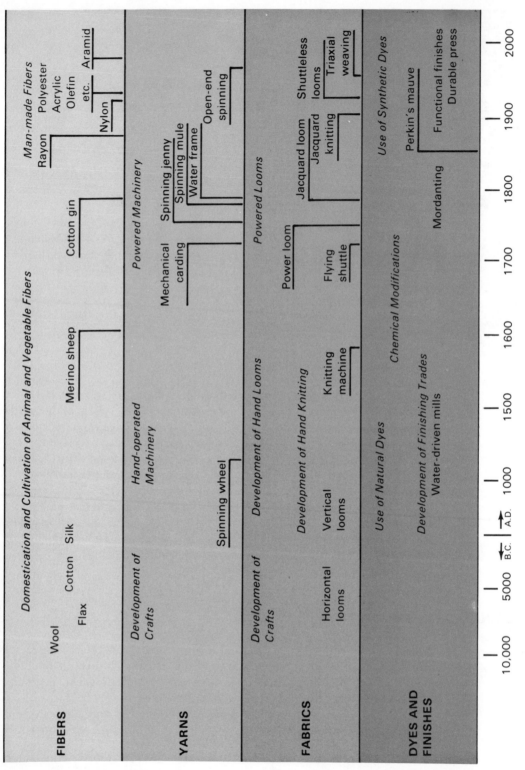

Another important factor in this early culture was the ease with which wool could be spun into yarn using only simple instruments. The early spindles were easily carried, and women spun bundles of fiber into yarn as they followed the herds. The yarn was then woven into cloth on simple looms and used to make clothing, tents, rugs, sacks, etc. Because of their flocks, the early tribes were almost self-sufficient.

With the development of agriculture, the nomadic tribes began to settle in one place and become farmers. The shift from the ways of the wanderer to those of the farmer meant that more time could be spent improving tools and implements. As farms became more productive and the quantity of food increased, it was no longer necessary for people to produce all the goods they needed. New skills were developed and old skills improved. Those with more skill in a particular craft began to trade their products for food and other items. Gradually separation of functions occurred, and people became carpenters, leather workers, bakers, weavers, and so on. The tools for making cloth became more complex since they no longer had to be light enough to carry. Looms capable of greater output were built. Spinning techniques were improved. The family could produce more fiber and cloth.

Spinning and Weaving Using only rudimentary tools, the early craftsmen could produce fabrics as fine as any we know today. Remains have been found of cloth woven on hand looms from hand-spun yarn that compares favorably with modern worsted fabrics. It was the skill and patience of the worker, not the tools, that determined the quality of the goods. By 6000 B.C. the arts of weaving and dyeing had developed into crafts from which a livelihood could be earned.

By 5000 B.C., villages and cities had evolved. Money was being coined and was replacing barter as a means of exchange. Since the manufacture of cloth was now a full-time occupation, people's natural inventiveness could be directed to making improvements in production processes. By about 3000 B.C., the Egyptians were producing sails for boats, bags for olive presses, and cloth for other industrial uses.

There was little change in the art over the next fifteen centuries until the development of the vertical loom, about 1500 B.C. With this type of loom the weaver could work from a more comfortable sitting position, which improved the rate of production. Although we lack direct evidence, the spinning of yarn appears also to have improved; at this time the Egyptians were weaving cloth with as many as 55 yarns per cm (138 per in) in the warp direction.

During the period in which western Mediterranean civilizations were improving woven fabrics, the nomads of Central Asia developed techniques for making felt, a nonwoven material, from wool. About 900 B.C., the Danes developed knit fabrics, but since there was little contact between Denmark and the "civilized" world until about A.D. 900, this invention had no impact on the development of the textile industry.

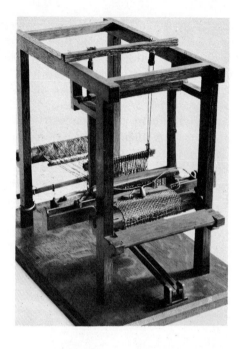

Figure 1.1 Model of a hand loom.
(*Smithsonian Institution*)

About 200 B.C., the Chinese invented the draw loom and the pedal loom. These represented a major advance in the development of the weaver's craft into an industry, since they left the operator's hands free to insert the yarn. These innovations significantly improved the production rates as compared with the simpler looms.

By the first century A.D., all of the important parts of the loom had been put together. Cloth was now manufactured on a loom which had harnesses and heddles to control the movement of the warp yarns, a shuttle to carry the fill yarns, a reed to compact the woven cloth, and a take-up roll upon which to wrap the cloth (Fig. 1.1).

Finishing and Dyeing As necessary as spinning and weaving are to the manufacture of cloth, they do not comprise the entire process. Fabric direct from the loom is skewed, irregular, and coarse. The finishing processes, which align the warp and filling and also clean, compact, and soften the cloth, greatly enhance its value. By the first century the finishing of fabric had been practiced for about 800 years. These were manual operations in which the craftsman "fulled" (softened and compacted) the fabric by treading upon it in a water-filled basin, and then straightened it by stretching it on a wooden frame. Finishers imparted a softer "hand" (the feel of cloth when held) and a more comfortable texture by brushing the surface with a coarse comb to raise the nap. These practices continued essentially unchanged for the next millennium.

But cloth is more than just a utilitarian material; it is also an artistic medium. From almost the very beginning of civilization, cloth has been

decorated and adorned. As early as 6000 B.C., geometric designs were woven into wall hangings and rugs. From that early date to the present, artists have been delighting the eye with the designs they have created in fabrics.

Two thousand years ago dyes were prepared from natural materials and usually applied to the entire piece of cloth. This "piece-dyeing" method of color application did not allow much in the way of artistic invention. Dyeing the yarns *before* weaving opened up many possibilities. This technique was used to create the beautiful silks from the Far East and the subtle and complex patterns of Persian carpets (Fig. 1.2).

For the next 500 years or so, technology remained at this level. The techniques of spinning, weaving, finishing, and dyeing spread throughout the Roman Empire. Cotton from the East and linen from Egypt were added to wool to increase the stock of available fibers. Silk manufacture, however, remained a secret known only in the Orient. Following the dissolution of the Roman Empire in the West, the textile industry slid back in the general decline that affected all commerce and trade. At the same time, in the Byzantine Empire in the East, the craft stagnated under the despotic government in Constantinople. It was not until the late Middle Ages that the industry again began to move forward.

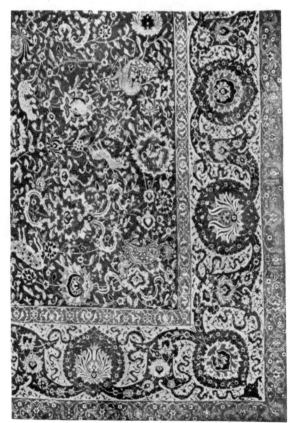

Figure 1.2 Corner of a very large, 16th century Persian rug; warp and woof of silk, half-knots of wool. (*New York Public Library*)

After the fall of Rome, many Mediterranean cities shrank to villages. The Western world became an agricultural society in which crafts were confined to the home or to a single worker in a village. Some of the arts were forgotten, and most of the artistry disappeared. Yet even during this period of stagnation there were advances. By the year 1000, cloth manufacture had become an industry again; by 1100 a weavers' guild had been established in England. Textile production again began to make great strides.

Perhaps the most important invention of this period was the spinning wheel (Fig. 1.3). Although the date of its introduction is not known, there is evidence of its use in 1298. The development of the spinning wheel was hampered by the opposition of the guilds, but by the fifteenth century automatic twisting and winding devices had been incorporated into it. By 1550 the treadle-operated spinning wheel, so popular with collectors, was fully developed and in widespread use.

The eleventh and twelfth centuries were a time of mechanical invention. Agriculture, mining, pottery, and metalworking, as well as textile manufacture, were improved by the development of machines to replace human labor. In the late 1100s fulling mills were introduced, freeing people from one of the most tedious tasks in the making of cloth. With increased mechanization production rates improved and labor costs were lowered.

By the late sixteenth century, textile manufacture had developed the characteristics of an industry. Division of labor, which separated the workers into skilled crafts, had given rise to spinsters, weavers, fullers, and dyers.

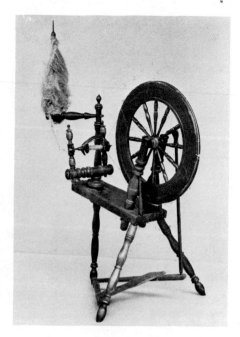

Figure 1.3 Spinning wheel, 18th century. (*The Metropolitan Museum of Art*)

Ancillary crafts, such as reed makers and loom makers, were dependent upon the textile manufacturers as an outlet for their products. Farmers could depend upon customers for their wool and flax as well as for the plants from which dyestuffs were extracted. The textile industry produced the cloth and cordage upon which other industries depended. Thus, economic factors spurred the industry to improve its techniques and its products. Spinsters looked for better ways to make yarn, dyers improvd their dyestuffs and dyeing techniques, weavers added more harnesses to their looms to create fancier patterns.

Knitting In 1589 William Lee invented the stocking frame. Although knitting had been known in Denmark as far back as the Bronze Age, it had not gained a foothold in the West because of the isolation of the Northern peoples. Hand knitting was either learned or invented in Europe in about 1400. Hand-knit hose and stockings were prized for their comfort (the cloth stretched with the body) and for their esthetic value. The demand was great enough to support a guild of hosiers in England as early as 1450. The rate for hand knitting was three to four stockings per week. With Lee's new device, a pair of stockings could be knit in a single day. The acceptance of the stocking frame, and its development into a knitting loom over the next half-century, introduced a new variety of cloth to Europe.

MAJOR INVENTIONS

As if resting for its next step up the ladder, the industry produced no major new developments until the 1730s, when John Kay invented the *flying shuttle* and John Paul the *mechanical carder*. Within the next fifty years, James Hargreaves produced the *spinning jenny*, Richard Arkwright the *water frame*, and Samuel Crompton the *spinning mule*. These five inventions had a dramatic effect on the productivity of the textile industry, and on the subsequent cost of fabrics.

Flying Shuttle Hand weaving, even with the draw loom, was a rather slow process. Because the shuttle was passed from one hand to the other as the fill was laid in place, the weaver was restricted to producing fabrics no wider than an armslength. Wider fabrics required two weavers. The flying shuttle, which was catapulted across the width of the fabric, allowed a single weaver to produce fabrics as wide as two weavers had done, and at a greater speed.

Mechanical Carder Carding is an operation by which a random mat of fibers is aligned and smoothed into a soft, straight bundle called a sliver. The carded fibers can be easily spun, while uncarded fibers will tangle and knot. Carding had been performed by drawing the fibers through hand-held combs to create the sliver. Paul's invention allowed a greater amount of sliver

Figure 1.4 Spinning jenny, invented by James Hargreave in 1770. (*Smithsonian Institution*)

to be produced by a single worker. This greater productive capacity was needed if the new looms equipped with Kay's flying shuttle were to operate at their greatest efficiency.

Spinning Jenny and Water Frame Hargreave's spinning jenny ("jenny" and "gin" are corruptions of the word "engine") multiplied the spinster's productivity by allowing a number of bobbins of yard to be spun simultaneously (Fig. 1.4). Arkwright incorporated a mechanical drive so that a spinning engine could be powered by water or draft animals.

Spinning Mule Crompton's mule was the culmination of the prior spinning improvements. Drawing on the ideas of Hargreaves and Arkwright, Crompton developed an automatic device that drew and spun fibers into yarn. Crompton's system, although greatly modified and powered by electricity, is still in use today.

Powered Looms The inventions of Paul and Crompton allowed yarn to be spun faster than it could be woven or knit. This bottleneck was broken in 1785 when Cartwright introduced the power loom. Yet it was not for another two decades that capital became sufficiently plentiful and the power loom was improved enough to support widespread use of the new technology.

One other invention that was to make its mark on the industry appeared at the end of the 1700s. This was Joseph-Marie Jacquard's modification of the loom. The Jacquard loom is arranged so that each of the warp yarns can be individually controlled. This allows the operator to produce a fabric containing any desired pattern. Interestingly enough, Jacquard's control system is very similar to a modern computer punchcard.

These inventions, though they stand out as milestones in the progression of the industry, were not in themselves sufficient to create the modern industry. Such developments as the replacement of wooden slivers by brass wires in the reed, or better ways of pressing cloth, along with a host of other small inventions, improvements, and modifications, also contributed in paving the road to progress. By the time the power loom was generally accepted, finishers were operating fulling mills, hot presses, and gigging and napping machines.

THE INDUSTRIAL REVOLUTION

By the mid-eighteenth century, the stage was set for the conversion of textile manufacture from a collection of small shops to a true industry. Almost all the steps of cloth manufacture and finishing had been mechanized, and the idea of using water and steam power to make the machines run had been added. All that was needed was a change in the workplace. The introduction of the factory to the textile industry marks one of the beginning steps of the Industrial Revolution.

The Rise of Factories As long as the machinery for producing and finishing yarn and fabric was hand-operated, there was no advantage to creating a common workplace for cloth manufacture. However, with the introduction of power machinery it became more economical to build a factory containing a number of spinning jennies and looms and to bring the workers to the factory. In this way, available capital could be used to increase worker productivity and yield more goods at lower prices. The factory system caused a fundamental change in living patterns as well. The workers could no longer live on the farm. The had to be housed near the factory where they worked. Tradesmen and other service workers settled near the factory to supply the employees. A town was born. The factory changed the modern nation from an agricultural, rural society to an urban one.

During this process of development the textile industry fostered other crafts and trades. The manufacturers of power looms and jennies employed metalworkers and carpenters. Millwrights and masons were needed to build factories and homes. Workers used their wages to purchase dishes, shoes, bathtubs, and other wares. The demand for new items encouraged industrialists to invest in factories to produce consumer goods. The mass production of everyday materials became the accepted method, and the industrial society began to grow and prosper.

THE DEVELOPMENT OF DYESTUFFS

The major problem associated with coloring fabrics in antiquity had been the impermanence of the dyestuffs available. The search for more permanent colors led to improvements in dyes and dyeing techniques. It was found, for example, that treating sunflower petals with ammonia gave a better dye than the expensive saffron yellow. In the early seventeenth century Cornelius Drebbel found a way to fix dyes to fabrics. In the search for a brighter red dye, the Spanish had brought cochineal back from the New World. This product of a South American insect provided a very bright scarlet which, unfortunately, faded quickly. Drebbel found that adding tin chloride to the dye bath fixed the dye to the fiber so that it would not fade quickly. This process of using salts to fix dyes, called *mordanting*, is still used today.

Perkin's Mauve In 1856 William Henry Perkin, while experimenting with coal tar to synthesize quinine, produced a black goo which upon purification yielded a dark blue powder. Perkin dipped a piece of silk into a water solution of the blue powder and came up with a brilliant deep-violet cloth. In partnership with his father and elder brother, Perkin set up the first synthetic dye plant. Their efforts were so successful that other scientists began to experiment with coal and petroleum. Over the next century a host of other dyes were developed, until today dyes are numbered in the thousands.

While the chemists worked in their laboratories, businessmen were using their discoveries to create wealth. In the late 1800s thousands of acres of farmland were devoted to raising madder, indigo, and other plants from which dyes were manufactured. Two generations later, these fields had been converted to other crops, and dyestuffs were being produced by the millions of pounds in chemical plants. The experience and technology developed in these early facilities provided the basis for other chemical processes and products, such as petroleum distillation and synthetic rubber, which form part of the foundation of our modern society.

NEW WORLD CONTRIBUTIONS

So far we have been discussing European progress. Except for cochineal, the red dye which the Spanish discovered in South America, the New World has not been mentioned. Until the nineteenth century the Americas were solely a source of raw materials. Wool and cotton were shipped to England and other European countries in exchange for finished goods. The investment capital and the skilled craftsmen needed to establish industries remained in short supply until long after the American Revolution. However, it was just this lack of capital and skilled labor that made the colonists prolific innovators of labor-saving devices. The cotton gin, invented in 1793, is a prime example.

Cotton Gin In order to make yarn from cotton, the fibers must be separated from the seeds. This is a tedious and time-consuming task if done by hand. Many attempts had been made to design a machine that would separate the seeds from the fibers. Eli Whitney's saw-gin was the first successful unit (Fig. 1.5). The hand labor it saved was utilized in expanding the acreage devoted to the cultivation of cotton. Thus, the fiber became available in larger amounts and at lower cost.

Textile Mills At about the same time that Whitney's machine was providing the key to American cotton growing, Samuel Slater was laying the foundation of American yarn production and John Schofield took the first step in forming the American weaving industry. In partnership with Moses Brown and William Almy, Slater built a spinning mill in Pawtucket, Rhode Island. That same year the Schofield brothers built the first power-operated

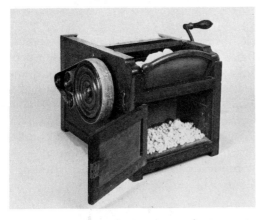

Figure 1.5 Original model of Eli Whitney's cotton gin, 1793. (*Smithsonian Institution*)

textile mill, in Montville, Connecticut, where they began the production of woolen and worsted fabrics.

By the middle 1800s spinning and weaving mills had sprung up throughout the United States and Europe. Millions of acres of land were devoted to raising cotton or sheep. A synthetic dye industry had been created to satisfy the desire for bright colors and fancy patterns. Cloth finishing had developed into an art as advanced as that of the spinner and weaver. But one bottleneck still remained. Garments were still cut and sewn by hand. Only the wealthy could afford the professional services of a tailor or seamstress; ordinary people had to make their own clothing. The invention of the sewing machine brought about a major change.

Sewing Machine Elias Howe and Isaac Singer independently invented sewing machines. Because Singer's machine was more suited to the manufacture of garments, he is usually credited as the founder of the garment industry. Heretofore, seamstresses and tailors had laboriously hand-sewn garments at top speeds of about 50 stitches per minute. Now they could machine-sew at 300 stitches per minute. Furthermore, a worker could be trained to perform a single operation on a garment faster and better than a worker who had to produce an entire garment alone. Thus assembly-line production was as important to garment manufacture as it would be to the manufacture of automobiles forty years later. Soon almost everyone could afford ready-made clothing.

By the end of the nineteenth century the world had changed radically. A relatively small number of skilled craftsmen had been replaced by a large number of semi-skilled machine operators, and the total productive capacity of the new workers was far greater. Consumer goods were less expensive and they were available in a wider variety than ever before. Workers had moved from the country to the city, where they had more opportunities to broaden their horizons and advance their material welfare. The old stratified society was yielding to the desire of the masses for a more comfortable and more fulfilling life.

13

MAN-MADE FIBERS

The first successful man-made fiber was *rayon*, developed in France during the late 1880s by Count Hillaire de Chardonnet. Following the successful introduction of rayon, developments in the textile industry were oriented more toward chemistry than toward mechanical devices. By the late 1930s the first totally synthetic fiber, *nylon*, was commercialized. The development of other synthetic fibers following World War II brought an increased sophistication and technical expertise to the industry. This has led to the technological innovations of the 1960s and 70s: new knitting techniques, high-speed looms, new spinning methods, and innovations in dyeing and printing. These developments will be discussed in detail in later chapters.

THE MODERN INDUSTRY

A few figures will convey the size and importance of this industry. In 1980 over 60 billion pounds of textile fiber were utilized in the world market. Of this amount cotton accounted for 47 percent, cellulosic man-made fibers 12 percent, and non-cellulosic man-made fibers 36 percent. Of the 22 billion pounds of non-cellulosic man-made fibers, polyester accounted for 47 percent, nylon 31 percent, and acrylic 20 percent. In the United States, the textile and related industries (exclusive of retailing) employed over 900,000 men and women and generated approximately $60 billion in sales. Fiber consumption in the United States was about 60 pounds per capita.

Figure 1.6 charts the components of the modern textile industry, from producers of raw materials to consumers of finished products. Related industries are shown with dashed lines. At the beginning of this stream are the FIBER PRODUCERS, perhaps the most diverse group in the production chain. On the natural fiber side we include the farmers and herdsmen who supply cotton, flax, wool, etc. and the small factories that harvest silk from caterpillar cocoons. On the other side we group the huge plants that produce man-made fibers. The fiber is generally sent to YARN MANUFACTURERS for processing into yarn. The very long fibers, known as FILAMENT (natural silk or man-made fibers), may go directly from the producer to the fabric manufacturer or to the THROWSTER for conversion into yarn. The short fibers, known as STAPLE (cotton, wool, cut man-made filament, etc.), are sent to SPINSTERS, who convert them into yarn suitable for weaving or knitting.

The yarn manufacturers supply a variety of plain and fancy yarns in an assortment of fibers to the FABRIC MANUFACTURERS, who produce an almost endless variety of fabrics for household, commercial, and industrial uses. Except where the fabric manufacturer is large enough to perform the converting and finishing operations, the cloth goes to the CONVERTER, whose job is to dye or print the cloth, and to finish it so that it will be acceptable to the PRODUCT MANUFACTURER, or to the consumer. Most of the cloth produced goes to commercial firms, although a significant fraction is absorbed by the home

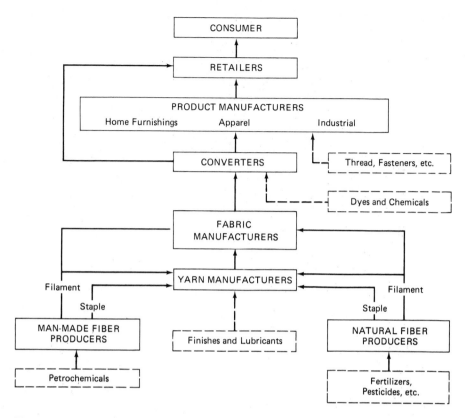

Figure 1.6 Components of the textile industry.

sewing market. The commercial firms may be garment manufacturers, upholstered furniture manufacturers, or industrial producers (those who make such products as conveyor belts and filter cloths). Consumer goods are delivered to retailers for direct sale to the user.

Retailers do more than just display goods for sale. They are also the communication link between consumers and manufacturers. Changes in fashion, economic conditions, and lifestyle are conveyed to the retailer through changes in inventory. For example, if green sweaters become an important fashion item, the retailer will know this by an increase in demand and a decrease in the inventory of green sweaters. This demand will be transmitted back to the sweater manufacturers in the form of more orders for green sweaters. These orders in turn will generate orders for green yarn, and so on down the line. When the fashion demand changes, the retailers will know it: they will have a large stock of green sweaters that they can't sell. Therefore, because the success of their enterprises depends upon their being attuned to the wants and needs of their customers, retailers often play the role of *purchasing agents* for the consumer.

Factors The textile and related industries are highly competitive. With the exception of synthetic fiber production, where a high capital investment forces the producer to be large, the industries are composed of many small firms. In fact, this is one of the few modern industries that conform to the free-market ideal of the capitalist system. Because most of the units within the industry are small, the textile industry relies perhaps more than any other on FACTORS. A factor is an organization that accepts a manufacturer's accounts receivable (the money owed to the manufacturer) in exchange for a percentage of the total amount. The factor pays the manufacturer immediately and accepts the risk of collecting the outstanding debts. Since factors are large companies with the resources needed to investigate the credit standing of all of their client's customers, they can protect the small manufacturer from default by other companies. In this way factors help to stabilize the industry.

In this chapter we have discussed the development of the textile industry and its structure in order to provide the reader with an understanding of how textile materials are made. In Chapter 2 we shall consider how the consumer decides what goods to purchase.

2

consumer decision making

In any modern department store the consumer is faced with row upon row, rack upon rack, and shelf upon shelf of merchandise. The variety of products is such that many people simply purchase the prettiest or the cheapest item without further consideration. These consumers should not be surprised if the seams open, the colors run, or the garments shrink. Although the phrase *caveat emptor*—let the buyer beware—is less applicable today than it once was, it is still necessary for purchasers to understand what they are buying and what they may expect from the products they buy.

Textiles are one of the basic components of our civilization. Fabrics and fibers are found everywhere—in our clothes; on our floors, chairs, and beds; and in our cars, trains, boats, and planes. Much of the food we eat, the air we breathe, and the necessities and luxury items we buy require textile products in their processing or delivery. It would be impossible to describe all these materials in one text. We shall, therefore, concentrate on apparel products, with occasional examples of other consumer goods, to illustrate the concepts that are applicable to a wide variety of textile materials.

PRODUCT END USE AND PERFORMANCE

In fabric selection the end use, or ultimate purpose, is a primary consideration. We know intuitively that a fabric used for a robe will not function well as a carpet. Let us see why.

17

First, where will the fabric be used? The carpet will lie on a floor; the robe will be worn by a person. We may expect that the comfort requirements will differ. The robe should be soft and smooth so as not to irritate the wearer's skin; the carpet can be much coarser. The robe must be flexible and adjust easily to body movement. The carpet must be rigid yet provide a springy feel when stepped upon. The robe is not meant to be stepped on. Both fabrics must provide thermal insulation, but the amount of heat transfer the two fabrics must resist differs. The robe should keep the wearer warm when room temperatures are low; the carpet should provide insulation between a cold floor and bare feet. Neither material should build up a high static charge, because electric shock or static cling can be quite uncomfortable.

Second, how will the fabric be maintained? It is not practical to put the carpet into the washing machine. Most likely it will be cleaned and renewed in place. To withstand the action of vacuum cleaners and shampooers, carpet yarns and fibers must not tear or pull out, and the rug must maintain its shape during cleaning because wrinkles cannot be ironed out. The robe, on the other hand, which is often machine laundered, must be made of a fabric that can withstand the abrasive action of a washing machine and perhaps a dryer. If the fabric wrinkles during laundering, it can be ironed.

Carpets and robes become soiled in different ways. The carpet is subject to many kinds of dirt tracked onto its surface and ground into the pile by people walking on it. The robe will become dirty by contact with body oils and perspiration. Thus, the type of dirt and the degree of soiling are different for each product.

The factors related to fabric durability are also different. A carpet is subject to a high degree of abrasion from shoes and other objects rubbing against it, but a robe must ordinarily withstand much less abrasion. It should, however, be able to resist tensile stress of the wearer's movements, to which a carpet is not subject. Resistance to sunlight, insects, and fungus are much more important in a carpet than they are in a robe.

It is apparent that the requirements for carpeting and robes are quite different. The image we have when we say a carpet is comfortable or durable is not the same as when we think of a robe. In order to provide for these different needs, we use different yarns and fabric constructions. The carpet is made from a pile fabric composed of heavy yarns that may weigh 1.3 kg/m^2 (40 oz/yd^2). The pile yarns are closely spaced to provide a springy surface that will resist crushing, surface abrasion, and penetration of dirt particles. The robe is produced from a light-weight fabric of perhaps 150 g/m^2 (4.5 oz/yd^2), and is composed of fine yarns that cannot stand up to the punishment a carpet must take. The robe, softer than the carpet and more comfortable against the skin, will have yarns that are finer and not as strong as those in a carpet.

Because the requisites for these two end uses are so different, the tests to which we subject the fabrics are different. We shall discuss test methods in a later section. For now, it is sufficient to note that the fabrics are expected to have different performance characteristics, and that the means for evaluating these performance characteristics must be suited to the end-use requirements.

Another point to bear in mind is that there are tradeoffs involved in making choices. It is rare to find a fabric that will satisfy all the user's requirements. Usually we choose a fabric because its strong points offset its weak points. For example, an upholstery fabric may be more expensive than we anticipated, but because the color or pattern is just right, or because of outstanding maintenance features, we are willing to pay the higher price. In another case, a fabric that does not meet all our performance requirements might be accepted because of its very low price.

In sum, the end use of a fabric determines the performance requirements and the choice of fabric.

SELECTION CRITERIA

Basic to any purchase decision is the identification of a NEED for a product. For instance, we may decide that we need a pair of slacks. The next step is a determination of the relative importance of the SELECTION CRITERIA. For textile products these selection criteria are APPEARANCE, COMFORT, ease of MAINTENANCE, DURABILITY, and COST. For each type of item we purchase we give different weights to the selection criteria.

Appearance

For some items of apparel, appearance may be the overriding criterion, while for other purchases it may have a reduced importance. Party or evening wear, no matter how durable, comfortable, or inexpensive, must look right in order to serve its purpose. On the other hand, a pair of jeans that are comfortable, easy to care for, and inexpensive may fulfill our requirements regardless of appearance.

Comfort

The importance of comfort varies with the purpose of the apparel. Coronation robes are not very comfortable, but since they are meant for show and are not worn very often, the wearer usually bears the discomfort. It would, however, be very difficult to sell anyone an uncomfortable pair of pajamas.

Maintenance

Ease of maintenance can be a major factor in a purchase decision. A carpet that shows every speck of dirt and lint will require frequent vacuuming and cleaning. A garment that wrinkles easily will need ironing after every wash. The time and effort to keep such items presentable must be supplied by the owner, because servants are uncommon in our modern society. This means that time spent cleaning and ironing is taken away from more useful or enjoyable pursuits. Since the premium on leisure time is high, any product that requires a high degree of maintenance will have to make up for it with outstanding qualities in other categories.

Maintenance of some garments may not require a lot of time and effort, but can still be costly. These garments may require professional cleaning. This does not mean that fabrics that must be dry-cleaned are inferior to those that can be laundered; often the reverse is true. But just as those materials that soil easily must perform better in other respects, those that require the extra expense of professional care should compensate for this in other ways.

Durability

The requirement that goods be durable tends to fluctuate with economic factors. When times are good and everyone has lots of money, the durability of a textile product is relatively unimportant. Under these conditions, children's clothes, for example, may be bought for fashion, comfort, and ease of maintenance, in that order. However, when economic conditions are less favorable and it is necessary to save money, children's clothes may have to be handed down from child to child. Then durability becomes important, and people are willing to trade effort on maintenance for lower expenditures for clothes. For other products, such as carpets, fashions change very slowly. These items are meant to last for many years, so that durability is a prime factor irrespective of economic conditions.

Cost

The cost of a consumer product must be related to its other characteristics before meaningful comparisons can be made. In purchasing a sofa, for example, we may find a particular model that costs $399 upholstered with one grade of fabric and $499 in a better fabric. The choice between the higher- or lower-priced sofa is dependent upon the purchaser's requirements for comfort, maintenance, and durability, assuming that both fabrics satisfy the appearance requirements. If the sofa is only intended for use over about three or four years before replacement, the cheaper item may be selected. If, however, the sofa must last for many years, the extra cost of the higher-priced item may be returned over a long period of time in reduced maintenance and replacement costs. Cost decisions are also dependent upon a consumer's present economic situation. If you don't have the money, you can't buy the higher-priced item, and your selection criteria weighting factors must be revised to make cost a major factor in your purchase decision.

MODEL FOR DECISION MAKING

To illustrate the use of the *selection criteria* in a purchase decision, let us suppose that we are to purchase two pairs of slacks, one for general use (office wear, occasional evenings out, etc.), the other for a party aboard the presidential yacht. Obviously we would not expect the same pair of slacks to be suitable for both uses.

Table 2.1 sets up possible WEIGHTING FACTORS of the selection criteria for these two needs, on a scale of 0 to 10. A value of 0 means that a particular

TABLE 2.1 Weighting of Selection Criteria for Two Garments

Selection Criteria	Weighting Factors	
	General Use	Party Wear
Appearance	5	10
Comfort	8	4
Ease of Maintenance	7	3
Durability	5	3
Cost	5	4

criterion is totally unimportant, 5 means moderate importance, and 10 means very important. (It is possible, though not usual, for more than one criterion to be given a ranking of 10.) As ranked here, the requirements for general-purpose slacks are fairly even, with some bias toward *comfort* and *ease of maintenance*, while those for party wear are heavily weighted in favor of *appearance* at the expense of the other criteria.

Generally, in making a purchase decision we limit the selection to two or more items that can be used for the same purpose. That is, our choice would be between different pairs of slacks that could be used for party wear, or different pairs of slacks suited for general use. Let us consider in detail the selection of a pair of slacks for general use. The selection criteria have been weighted in Table 2.1.

Performance Evaluation

Armed with a firm notion of the requirements that we expect the slacks to meet, we enter the marketplace, where we find two pairs of slacks that appear to suit our needs. It is now necessary to evaluate the expected performance of these garments. We are attempting to judge on the basis of PERFORMANCE CHARACTERISTICS how well each of the garments will meet the selection criteria.

(It should be noted that the quality of workmanship must also be evaluated as well as the material from which the slacks are made. However, construction techniques are beyond the scope of this text, and the reader should consult a reference dealing with the subject for further information.)

The factors that affect the performance characteristics and whether they are determined mainly by fabric construction, yarn type, or fiber type are listed in Table 2.2. Bear in mind that the performance of textiles is sensitive to all the above parameters, as well as to the finishes applied to the cloth.

APPEARANCE The appearance of a cloth is a function of the interplay of light and shadow on its surface. The highlights and shading are a consequence of the way light is transmitted through the cloth, scattered among its yarns, and reflected from its surface. Whether the cloth drapes in loose, soft folds or is firm and crisp will also affect its appearance. The cloth may have an overall pattern, such as the sawtooth of a herringbone twill,

TABLE 2.2 Factors Affecting Performance Characteristics

Performance Characteristics	Affected Mainly By		
	Fabric Construction	Yarn Type	Fiber Type
Appearance			
Light Transmission	X		
Light Reflection		X	X
Surface Texture	X	X	
Drape	X		
Pattern	X		
Color	—	—	—
Comfort			
Air Permeability	X		
Moisture Permeability	X		
Moisture Absorption			X
Wind Resistance	X	X	X
Hand	X	X	X
Stretch and Recovery	X	X	
Thermal Insulation	X	X	X
Electrical Properties			X
Maintenance			
Soil Resistance	X	X	
Soil Removal	X	X	X
Stain Resistance		X	X
Stain Removal			X
Wrinkle Resistance	X	X	X
Wrinkle Recovery and Removal	X	X	X
Shrink Resistance	X	X	X
Durability			
Tensile Strength	X	X	X
Tear Strength	X	X	X
Burst Strength (knits)	X	X	X
Abrasion Resistance	X	X	X
Dimensional Stability	X		X
Pilling Resistance		X	X
Snagging Resistance	X	X	
Run Resistance (knits)	X		
Resilience		X	X
Cost	X	X	X

woven or knitted into it. Its surface may appear smooth, as in a satin, or rough and pebbled, as in some twills. The color of a fabric is, of course, determined by the dyes applied to it and is independent of its construction, yarns, or fibers.

COMFORT The comfort of a fabric is determined by how well it permits air and water vapor to pass through (*permeability*), its feel against the skin (*hand*), its ability to stretch with the movements of the wearer and to return to its original shape after stretching (*stretch and recovery*), and its thermal and electrical properties.

Human beings are most comfortable when their skin is about 33° C (93° F)

and almost dry. Fabrics that help to maintain these conditions will be considered comfortable, while those that promote deviations in temperature or humidity will be uncomfortable. In warm weather, cloths that allow a free flow of air (high air permeability and low wind resistance) and rapid transmission of moisture (high moisture permeability and good wicking) will be most comfortable. In cold weather, comfortable garments should hold body heat; thus, high wind resistance and low air permeability are required.

The hand of a fabric is a complex combination of stiffness, texture, resilience, moisture absorption, and thermal properties. A large vocabulary has been compiled in an attempt to describe this elusive phenomenon. Terms such as furry, warm, cool, slick, fuzzy, dry, smooth, and rough are often used. The evaluation of hand is entirely subjective. What may be appealing to some may be annoying to others.

Cloth that stretches readily provides freedom of motion and is usually more comfortable than one with little stretch. However, proper garment design, in which fullness is provided where it is needed, will generally compensate for lack of stretch. If a garment stretches out of shape during use because of poor stretch recovery, it will become uncomfortable. In general, cloths with low stretch properties have better stretch recovery than cloths that stretch easily.

Thermal and electrical properties affect warmth and static buildup. In general, good insulating capacity is good for cold-weather use, while a low level of insulation is favored in hot weather. Fibers that are poor conductors may develop a static charge that can cause garments to cling to the wearer or even produce a detectable shock when used in carpets.

MAINTENANCE The ease of maintenance of a fabric is dependent upon several factors: How resistant is it to soiling and staining, and how readily can dirt and stains be removed? (Note: The *Stain Removal Guide* on pp. 24–27 is a handy reference for washable items.) What is its wrinkle resistance and ease of wrinkle removal? And finally, how well does it withstand shrinkage?

Smooth surfaces resist soiling better than textured ones, so smooth fibers, high-twist yarns, and closely constructed fabrics with little surface texture are the most soil-resistant. Fabrics that are easily soiled are often (though not always) the most easily cleaned. Stain resistance and ease of stain removal are almost entirely fiber properties, although very open yarns and pile fabrics with a high-surface area may have low stain resistance. Wrinkle resistance is best in flexible, pliable fabrics. Stiff fibers, highly twisted yarns, and close constructions that do not allow freedom of movement generally have low wrinkle resistance. It should be noted, however, that some fibers, such as nylon and polyester, are very wrinkle-resistant and dominate the performance of cloth made from them. The shrink resistance of a cloth determines how it may be cleaned (machine laundering, hand laundering, dry-cleaning) and is dominated by the fiber properties. Some fibers, such as cotton and wool, shrink readily while others, such as polyester and nylon, have very high resistance to shrinking. Loose, open yarns and open fabric constructions promote shrinkage.

STAIN REMOVAL GUIDE

This chart applies only to washable items. It does not apply to garments which should be drycleaned. Some stains are not easily seen when the fabric is wet. Air dry the articles to be certain the stain has been removed. Machine drying might make the stain more difficult to remove. Prewash products may be more convenient to use in treating stains than the process of rubbing detergent into the dampened stain.

STAIN	Bleachable Fabrics: White and colorfast* cotton, linen, polyester, acrylic, triacetate, nylon, rayon, permanent press. REMOVAL PROCEDURE	Non-Bleachable Fabrics: Wool, Silk, Spandex, non-colorfast items, some flame retardant finishes (check labels). REMOVAL PROCEDURE
Alcoholic Beverages	Sponge stain promptly with cold water or soak in cold water for 30 minutes or longer. Rub detergent into any remaining stain while still wet. Launder in hot water using chlorine bleach.	Sponge stain promptly with cold water or soak in cold water for 30 minutes or longer. Sponge with vinegar. Rinse. If stain remains, rub detergent into stain. Rinse. Launder.
Blood	Soak in cold water 30 minutes or longer. Rub detergent into any remaining stain. Rinse. If stain persists, put a few drops of ammonia on the stain and repeat detergent treatment. Rinse. If stain still persists, launder in hot water using chlorine bleach.	Same method, but if colorfastness is questionable, use hydrogen peroxide instead of ammonia. Launder in warm water. Omit chlorine bleach.
Candle Wax	Rub with ice cube and carefully scrape off excess wax with a dull knife. Place between several layers of facial tissue or paper towels and press with a warm iron. To remove remaining stain, sponge with safe cleaning fluid. If colored stain remains, launder in hot water using chlorine bleach. Launder again if necessary.	Same method. Launder in warm water. Omit chlorine bleach.
Carbon Paper	Rub detergent into dampened strain; rinse well. If stain is not removed, put a few drops of ammonia on the stain and repeat treatment with detergent; rinse well. Repeat if necessary.	Same method, but if colorfastness is questionable, use hydrogen peroxide instead of ammonia.
Catsup	Scrape off excess with a dull knife. Soak in cold water 30 minutes. Rub detergent into stain while still wet and launder in hot water using chlorine bleach.	Same method. Launder in warm water. Omit chlorine bleach.
Chewing Gum, Adhesive Tape	Rub stained area with ice. Remove excess gummy matter carefully with a dull knife. Sponge with a safe cleaning fluid. Rinse and launder.	Same method.
Chocolate and Cocoa	Soak in cold water. Rub detergent into stain while still wet, then rinse thoroughly. Dry. If a greasy stain remains, sponge with a safe cleaning fluid. Rinse. Launder in hot water using chlorine bleach. If stain remains, repeat treatment with cleaning fluid.	Same method. Launder in warm water. Omit chlorine bleach.
Coffee, Tea	Soak in cold water. Rub detergent into stain while still wet. Rinse and dry. If grease stain remains from cream, sponge with safe cleaning fluid. Launder in hot water using chlorine bleach.	Same method. Launder in warm water. Omit chlorine bleach.
Cosmetics (Eye shadow, lipstick, liquid make-up, mascara, powder, rouge)	Rub detergent into dampened stain until outline of stain is gone, then rinse well. Launder in hot water using chlorine bleach.	Same method. Launder in warm water. Omit chlorine bleach.

Stain		
Crayon	Rub soap (Instant Fels, Ivory Snow, Lux Flakes) into dampened stain, working until outline of stain is removed. Launder in hot water using chlorine bleach. Repeat process if necessary. For stains throughout load of clothes, wash items in hot water using laundry soap and 1 cup baking soda. If colored stain remains, launder with a detergent and chlorine bleach.	Same method. Launder in warm water using plenty of detergent. Omit chlorine bleach. If colored stain remains, soak in an enzyme presoak or an oxygen bleach using hottest water safe for fabric; then launder.
Deodorants and Antiperspirants	Rub detergent into dampened stain. Launder in hot water using chlorine bleach. Antiperspirants that contain such substances as aluminum chloride are acidic and may change the color of some dyes. Color may or may not be restored by sponging with ammonia. Rinse thoroughly.	Rub detergent into dampened stain. Launder in warm water. Antiperspirants that contain such substances as aluminum chloride are acidic and may change the color of some dyes. (If ammonia treatment is required, dilute with an equal amount of water for use on wool, mohair, or silk.) Rinse thoroughly.
Dye (Transferred from a non-colorfast article)	May be impossible to remove. Bleach immediately using chlorine bleach. Repeat as often as necessary. Or use a commercial color remover.	Use a commercial color remover.
Egg, Meat Juice, and Gravy	If dried, scrape off as much as possible with a dull knife. Soak in cold water. Rub detergent into stain while still wet. Launder in hot water using chlorine bleach.	Same method. Launder in warm water. Omit chlorine bleach.
Fabric Softener	Rub the dampened stain with bar soap (such as Ivory or Lux) and relaunder in the usual manner.	Same method.
Fingernail Polish	Sponge white cotton fabric with nail polish remover; other fabrics with amyl acetate (banana oil). Launder. Repeat if necessary.	Same method.
Formula	Soak in cold water, then launder in hot water using chlorine bleach. If stain persists, soak in an enzyme presoak.	Soak in warm water using an enxyme presoak. Launder in warm water using plenty of detergent.
Fruit Juices	Soak in cold water. Launder in hot water using chlorine bleach.	Soak in cold water. If stain remains, rub detergent into stain while still wet. Launder in warm water.
Grass	Rub detergent into dampened stain. Launder in hot water using chlorine bleach. If stain remains, sponge with alcohol. Rinse thoroughly.	Same method. Launder in warm water. Omit chlorine bleach. If colorfastness is questionable or fabric is acetate, dilute alcohol with two parts water.
Grease and Oil (Car grease, butter, shortening, oily medicines or vitamins)	Rub detergent into dampened stain. Launder in hot water using chlorine bleach and plenty of detergent. If stain persists, sponge thoroughly with safe cleaning fluid. Rinse.	Rub detergent into dampened stain. Launder in warm water using plenty of detergent. If stain persists, sponge thoroughly with safe cleaning fluid. Rinse.
Ink (Ballpoint)	Sponge stain with rubbing alcohol, or spray with hair spray until wet looking. Rub detergent into stained area. Launder. Repeat if necessary.	Same method.
Ink (India)	May be impossible to remove. Run cold water through stain until no more color is being removed. Rub detergent into stain, rinse. Repeat if necessary. Soak in warm sudsy water containing one to four tablespoons of ammonia to a quart of water. Rinse thoroughly. Launder in hot water using chlorine bleach.	Same method. Launder in warm water. Omit chlorine bleach.

STAIN REMOVAL GUIDE (Continued)

STAIN	Bleachable Fabrics: White and colorfast* cotton, linen, polyester, acrylic, triacetate, nylon, rayon, permanent press.	Non-Bleachable Fabrics: Wool, Silk, Spandex, non-colorfast items, some flame retardant finishes (check labels).
	REMOVAL PROCEDURE	*REMOVAL PROCEDURE*
Ink (Felt Tip)	Rub liquid household cleaner such as 409 or Mr. Clean into stain. Rinse. Repeat as many times as necessary to remove stain. Launder. Some may be impossible to remove.	Same method.
Iodine	Make a solution of sodium thiosulfate crystals (available at drugstore). Use solution to sponge stain. Rinse and launder.	Same method.
Mayonnaise, Salad Dressing	Rub detergent into dampened stain. Rinse and let dry. If greasy stain remains, sponge with safe cleaning fluid. Rinse. Launder in hot water with chlorine bleach.	Same method. Launder in warm water. Omit chlorine bleach.
Mildew	Rub detergent into dampened stain. Launder in hot water using chlorine bleach. If stain remains, sponge with hydrogen peroxide. Rinse and launder.	Same method. Launder in warm water. Omit chlorine bleach.
Milk, Cream, Ice Cream	Soak in cold water. Launder in hot water using chlorine bleach. If grease stain remains, sponge with safe cleaning fluid. Rinse.	Soak in cold water. Rub detergent into stain. Launder. If grease stain remains, sponge with safe cleaning fluid. Rinse.
Mustard	Rub detergent into dampened stain. Rinse. Soak in hot detergent water for several hours. If stain remains, launder in hot water using chlorine bleach.	Same method. Launder in warm water. Omit chlorine bleach.
Paint and Varnish	Treat stains quickly before paint dries. If a solvent is recommended as a thinner, sponge it onto stain. Turpentine or trichloroethane can be used. While stain is still wet with solvent, work detergent into stain and soak in hot water. Then launder. Repeat procedure if stain remains after laundering. Stain may be impossible to remove.	Same method.
Perfume	Same as alcoholic beverages.	Same as alcoholic beverages.
Perspiration	Rub detergent into dampened stain. Launder in hot water using chlorine bleach. If fabric has discolored, try to restore it by treating fresh stains with ammonia or old stains with vinegar. Rinse. Launder.	Same method. Launder in warm water. Omit chlorine bleach.
Ring around the collar	Apply liquid laundry detergent or a paste of granular detergent and water on the stain. Let it set for 30 minutes. A prewash product especially designed for this purpose may be used. Follow manufacturer's directions. Launder.	Same method.

Stain		
Rust	Launder in hot water with detergent and RoVer Rust Remover (available from Maytag dealers). Follow manufacturer's instructions.	Same method. If colorfastness is questionable, test a concealed area first.
Scorch	Launder in hot water using chlorine bleach or RoVer Rust Remover (see Rust). Severe scorching cannot be removed; fabric has been damaged.	Cover stains with cloth dampened with hydrogen peroxide. Cover with a dry cloth and press with an iron as hot as is safe for fabric. Rinse thoroughly. Rub detergent into stained area while still wet. Launder. Repeat if necessary.
Shoe Polish (Wax)	Scrape off as much as possible with a dull knife. Rub detergent into dampened stain. Launder in hot water using chlorine bleach. If stain persists, sponge with rubbing alcohol. Rinse. Launder.	Scrape off as much as possible with a dull knife. Rub detergent into dampened stain. Launder in warm water. If stain persists, sponge with one part alcohol and two parts water. Rinse. Launder.
Soft Drinks	Sponge stain immediately with cold water. Launder in hot water with chlorine bleach. Some drink stains are invisible after they dry, but turn yellow with aging or heating. This yellow stain may be impossible to remove.	Same method. Launder in warm water. Omit chlorine bleach.
Tar and Asphalt	Act quickly before stain is dry. Pour trichloroethane through cloth. Repeat. Stain may be impossible to remove. Rinse and launder.	Same method.
Urine	Soak in cold water. Rub detergent into stain. Launder in hot water using chlorine bleach. If the color of the fabric has been altered by stain, sponge with ammonia; rinse thoroughly. If stain persists, sponging with vinegar may help.	Same method. Launder in warm water. Omit chlorine bleach. If ammonia treatment is necessary, dilute ammonia with an equal part of water for use on wool, mohair, or silk.
Wine	Same treatment as for alcoholic beverages. Wait 15 minutes and rinse. Repeat if necessary.	Same treatment as for alcoholic beverages.
Yellowing (White Cottons and Linens)	Fill washer with very hot water. Add at least twice as much detergent as normal. Place articles in washer and agitate for four minutes on regular cycle. Stop washer and add one cup of chlorine bleach to the bleach dispenser or dilute in one quart of water and pour around agitator. Restart washer at once. Agitate four minutes. Stop washer and allow articles to soak 15 minutes. Restart washer and set ten minute wash time; allow washer to complete normal cycle. Repeat entire procedure two or more consecutive times until whiteness is restored.	
Yellowing (White Nylon)	Soak 15 to 30 minutes in solution of 1/8 cup of chlorine bleach and one teaspoon of vinegar thoroughly mixed with one gallon of warm water. Rinse. Repeat if necessary.	

*To test for colorfastness: Mix 1 tablespoon of bleach with 1/4 cup water. Apply one drop of this solution to an inconspicuous portion of the item, such as an inside seam. Make sure the solution penetrates the fabric and let stand for one minute. Then blot dry with a paper towel. If there is no color change, then the article can be safely bleached. (Courtesy of The Maytag Company, Newton, Iowa 50208)

DURABILITY Durability is a measure of how readily a cloth can be pulled apart (*tensile strength*), ripped apart (*tear strength*), or rubbed away (*abrasion resistance*). In knit cloth the *burst strength* is measured, because tear and tensile tests do not work well for knits. Strength and abrasion resistance are so strongly affected by fabric construction, yarn type, and fiber type that it is not possible to say which predominates. Dimensional stability is important because products that shrink or stretch out of shape will not fit properly, and so will not be used. Pills, snags, and runs can make a cloth appear unsightly, and so shorten its lifetime. Resilience is particularly important for pile fabrics; fibers that are not resilient will crush down and lose the favorable properties of the pile construction.

COST The cost of a textile product is dependent upon all the factors involved in its production, distribution, and sale. No one factor is dominant.

Measurability of Performance

How well textile materials satisfy the requirements for appearance and cost are subjective evaluations that each consumer must make. We cannot measure the esthetic performance of a textile material. Although we can measure such factors as the amount of light reflected from the surface of a fabric, such a measurement simply describes the behavior of the material; it cannot tell us if an increase in light reflection results in an improvement in appearance. Cost must be evaluated in terms of the circumstances of each individual. The price of an item is descriptive; it does not tell us if the item is affordable or even if it is reasonably priced with respect to other items of its type.

In contrast, many of the factors that affect comfort, maintenance, and durability can be measured by tests that correlate reasonably well with performance in actual use. We know, for example, that an increase in abrasion resistance leads to an increase in durability. We can demonstrate that improved soil resistance enhances the ease of maintenance and that moisture permeability is related to comfort.

Although many of the performance factors can be measured by standardized tests, it is not always necessary to have exact measurements to make a purchase decision. Consumers can develop a general feeling for the expected performance of various fabrics through their own experience. For example, most of us know that an all-cotton fabric that has not been given a durable press finish will require some ironing, that knit woolens usually need to be washed by hand, and so forth. In addition, consumer guides prepared by extension services and trade associations can provide the information necessary for proper evaluation of fabric and garment performance.

Let us reconsider the two pairs of general-purpose slacks. For the purposes of this discussion, it is not necessary to completely describe the items.

TABLE 2.3 Selecting the Best Garment

Performance Characteristics (P)	Garment A		Garment B	
Appearance		7		4
Comfort		6		5
Maintenance		4		8
Durability		4		7
Cost		5		6
Selection (S) × Performance (P)*				
	5 × 7 =	35	5 × 4 =	20
	8 × 6 =	48	8 × 5 =	40
	7 × 4 =	28	7 × 8 =	56
	5 × 4 =	20	5 × 7 =	35
	5 × 5 =	25	5 × 6 =	30
		156		181

*The various values of the performance characteristics have been assumed for this example. The weighting factors for the selection criteria are taken from Table 2.1.

Assume, on the basis of our own experience and other available information, that we can evaluate the two pairs of slacks in question. First, we rate the expected performance of each of the garments on a scale of 0 to 10 just as we did the selection criteria. Thus a rating of 5 is average, while a rating of 10 is outstanding. Second, we multiply the values for performance by the weighting factors for the selection criteria. Finally, we sum the products. The method is shown in Table 2.3.

Our example shows that garment A rates well in *appearance* and about average in the other performance characteristic. Garment B does well in *maintenance* and *durability* and average in the other factors. Multiplying the values for the performance of each garment by the weighting factors for the selection criteria (which are biased toward *comfort* and *maintenance*) and adding the products, we find that garment B suits our needs better than does garment A. (Note: differences of less than 10 percent should not be taken as signifying a real difference between items. In that case, the products are probably equivalent.)

This exercise may seem, at first, to be more complex than the ordinary consumer would be able to handle, but consider how often you have seen a person at a sales counter or clothes rack feeling the fabric, checking the hang tags or labels, and trying on the garments. Each of these acts is an attempt to determine the expected performance characteristics, to integrate these values with the rankings of the selection criteria, and to determine the desirability of the garment. This process may take as little as a few seconds or as long as a few hours. Those shoppers who are aware of the process and knowledgeable enough to gauge the performance characteristics accurately will make the wisest choices.

SUMMARY

We have established the important principle of evaluating the performance characteristics of fabrics in terms of their end-use requirements. This means that for a given situation, fabric selection must take into account one's priorities among the selection criteria. Is appearance more important than durability? Is comfort more important than ease of maintenance? And so on. In actuality, not one but several fabrics will usually be suited to a particular end use. This is because of the great number of combinations of fibers, yarns, and fabric constructions from which the modern consumer may choose. In the chapters that follow, we will investigate each of these components in detail, and show how they contribute to fabric performance. With a complete understanding of the factors that determine the properties of textile products, consumers can make the wisest choices from among the available alternatives.

REVIEW QUESTIONS

1. List the performance factors that affect each of the selection criteria. Show how they are used in a purchase decision. Which of the factors are affected mainly by fiber properties? Which by yarn properties? Which by fabric construction?
2. Describe the role of the converter in the textile production chain. Why would small manufacturers contract out their finishing business? Why would large manufacturers do their own finishing?
3. List the end-use requirements for a blouse or shirt for summer wear. How do they differ from the requirements for the same garment for winter wear?
4. Consider the factors that affect the performance of fabrics under each of the selection criteria. Are any of these antagonistic? That is, does an improvement in one property lead to a decrease in another property? Discuss why it is not possible to produce a fabric that is perfect for all applications.

ACTIVITIES

1. The handcrafts of spinning, knitting, and weaving are still practiced. Arrange to see a demonstration by a working craftsman. Observe the techniques used, the rate of production, and the quality of product.
2. Your local library may be able to supply you with information on the arts of spinning, weaving, and knitting. Research a particular area, such as the development of the hand loom or the spinning wheel, and report on the different designs.
3. Natural dyestuffs may be extracted from fruits, vegetables, nuts, and berries. Your local library may have information on how to make and use natural dyes. Try dyeing cloths made from natural and synthetic fibers with these dyes. Report on the results.
4. The weighting factors for the different selection criteria are affected by age, income, and marital status of the individual. Question about twenty people who differ in these parameters regarding their weighting factors for different products, such as jackets, trousers or slacks, blouses or shirts, home furnishings, etc. Report your findings on this survey.

3

chemistry basics for understanding textiles

It is impossible to develop a knowledge of textile materials without some acquaintance with chemistry. Fibers are chemical entities whose unique structures determine their use in textiles. Finishes and dyes are chemicals applied to textile materials in order to enhance their useful and esthetic qualities. This chapter provides information that will enable the reader with no chemistry background to understand those aspects of fibers, dyes, and finishes that cannot be explained without some reference to chemical structure. We discuss the basic concepts of the atom, explain how atoms bond together to form molecules, and consider how the active groups on molecules can react to form complex materials such as textile fibers or chemical substances that may be used to finish or dye textiles.

THE STRUCTURE OF ATOMS

The concept that all the material in the universe is built up of basic units that cannot be made simpler is an ancient one. Plato and Aristotle, in about 350 B.C., considered all nature to be composed of four substances: Air, Earth, Fire, and Water. They believed that these elements were indivisible—that is, they could not be reduced. Other philosophers, notably Democritus (460–370 B.C.), believed that the elements could be reduced to still smaller particles called *atomos*. Over the next 2000 years, philosophers pondered the composition of matter without reaching any satisfactory conclusions as to its makeup.

A major step forward was the publication of John Dalton's theories of matter in the early nineteenth century. At that time, many of the chemical elements had been discovered. Dalton proposed that (1) each ELEMENT is made up of small identical particles, called ATOMS; (2) the atoms of each element are different from those of other elements; and (3) COMPOUNDS are formed when the atoms of different elements combine. Dalton's theories were so successful in explaining the known chemical phenomena that succeeding research dealt with the structure of atoms rather than merely their existence.

By 1909, scientists had come to accept that atoms consisted of two kinds of material—one with a positive charge (+) and one with a negative charge (−). It was believed that the attraction between the two unlike charges held the atom, and matter itself, together. In 1911, Ernest Rutherford explained that the atom consisted of a small, dense NUCLEUS containing the positive charge surrounded by a cloud of negative charge. Niels Bohr refined this idea in 1914 and gave us the contemporary concept of the atom.

In Bohr's model, the atom consists of a tiny, dense nucleus containing PROTONS, which have a positive charge (+) and a mass of 1, and NEUTRONS, which also have a mass of 1 but no charge. The nucleus is surrounded by ELECTRONS, which have almost no mass and a negative charge (−). The number of electrons in an atom is equal to the number of protons it contains, so that an atom is electrically neutral, with no net charge. The electrons circle the nucleus in defined orbits, much as the planets circle the sun.

The properties of an atom are defined by the number of its neutrons and protons, and the arrangement of its electrons. The ATOMIC NUMBER of an atom is the number of protons it contains. The ATOMIC WEIGHT of an atom is approximately the number of neutrons and protons in the nucleus. The elements are usually arranged in the form of a PERIODIC TABLE in order of their atomic numbers (Fig. 3.1). The periodic table was originally proposed by Dmitri Mendeleev in 1869. His arrangement of the known elements was so successful that he was able to predict the existence and properties of an element that had not yet been discovered. This element, germanium, was finally isolated in 1886 and found to have the properties that Mendeleev had predicted.

Upon examining the periodic table, we see that all the elements in a given column have similar chemical properties. For example, the elements in column 7A, the halogens, are all very reactive nonmetals. Gilbert N. Lewis and Irving Langmuir theorized that the repetition of the chemical properties must be due to a repetition of the electronic structure of the elements in a given column. Noting that the noble (inert) gases helium (He), neon (Ne), argon (Ar), krypton (Kr), xenon (Xe), and radon (Rn) do not readily react with other elements, they reasoned that their electrons must exist in a very stable condition.

Lewis and Langmuir proposed that the atoms must have their electrons arranged in shells and that the orbits of the electrons are confined within the shells. Based on the atomic numbers of the noble gases, they concluded that the complete shells would have contained 2, 8, 8, 18, and 32 electrons, respectively, depending upon their distances from the nucleus. Thus, the first

Active metals

Nonmetals

Transition metals

1A	2A	3B	4B	5B	6B	7B	8B	8B	8B	1B	2B	3A	4A	5A	6A	7A	8A
1 H 1.00797																	2 He 4.0026
3 Li 6.941	4 Be 9.0122											5 B 10.811	6 C 12.01115	7 N 14.0067	8 O 15.9994	9 F 18.9984	10 Ne 20.179
11 Na 22.9898	12 Mg 24.305											13 Al 26.9815	14 Si 28.086	15 P 30.9738	16 S 32.064	17 Cl 35.453	18 Ar 39.948
19 K 39.098	20 Ca 40.08	21 Sc 44.956	22 Ti 47.90	23 V 50.942	24 Cr 51.996	25 Mn 54.9380	26 Fe 55.847	27 Co 58.9332	28 Ni 58.70	29 Cu 63.54	30 Zn 65.38	31 Ga 69.72	32 Ge 72.59	33 As 74.9216	34 Se 78.96	35 Br 79.904	36 Kr 83.80
37 Rb 85.47	38 Sr 87.62	39 Y 88.905	40 Zr 91.22	41 Nb 92.906	42 Mo 95.94	43 Tc (99)	44 Ru 101.07	45 Rh 102.905	46 Pd 106.4	47 Ag 107.868	48 Cd 112.41	49 In 114.82	50 Sn 118.69	51 Sb 121.75	52 Te 127.60	53 I 126.9045	54 Xe 131.30
55 Cs 132.905	56 Ba 137.33	57 *La 138.91	72 Hf 178.49	73 Ta 180.948	74 W 183.85	75 Re 186.2	76 Os 190.2	77 Ir 192.2	78 Pt 195.09	79 Au 196.967	80 Hg 200.59	81 Tl 204.37	82 Pb 207.19	83 Bi 208.980	84 Po (210)	85 At (210)	86 Rn (222)
87 Fr (223)	88 Ra 226.0254	89 †Ac (227)	104 Rf (257)	105 Ha (260)													

*Lanthanide series

58 Ce 140.12	59 Pr 140.907	60 Nd 144.24	61 Pm (147)	62 Sm 150.35	63 Eu 151.96	64 Gd 157.25	65 Tb 158.925	66 Dy 162.50	67 Ho 164.930	68 Er 167.26	69 Tm 168.934	70 Yb 173.04	71 Lu 174.97

†Actinide series

90 Th 232.038	91 Pa 231.0359	92 U 238.03	93 Np 237.0482	94 Pu (242)	95 Am (243)	96 Cm (247)	97 Bk (247)	98 Cf (249)	99 Es (254)	100 Fm (253)	101 Md (256)	102 No (253)	103 Lr (257)

Figure 3.1 Periodic table of the elements. The number beneath the symbol is the atomic weight of the element; numbers in parentheses are approximate values for radioactive elements. (T. L. Brown and H. E. LeMay, Jr., *Chemistry: The Central Science*, 2nd ed. ©1981. Reprinted by permission of Prentice-Hall, Inc., Englewood Cliffs, N.J.)

1st shell: 2 electrons

2nd shell: 8 electrons

3rd shell: 8 electrons

Nucleus
18 protons
22 neutrons

Figure 3.2 The argon atom consists of a small, dense nucleus surrounded by 18 electrons arranged in shells of 2, 8, and 8. The depth of color in each shell is proportional to the electron density.

shell, which is very close to the nucleus, can contain only two electrons; the sixth shell, which contains up to 32 electrons, is very far from the nucleus. The Lewis-Langmuir structure of argon is illustrated in Fig. 3.2.

According to the Lewis-Langmuir model, an atom is most stable when its outer shell contains the same number of electrons as the nearest noble gas. Thus those atoms, such as the halogens, in which the outer shell is almost filled, will readily accept an electron from an atom of another element, while those atoms, such as the alkalies (column 1A), in which the outer shell contains only one electron, will readily give up that electron to an atom of another element. It is to be expected that the formation of a compound from an alkali metal and a halogen would occur by a vigorous spontaneous reaction, since the metal would readily give up its electron and the halogen would readily accept an electron in order to achieve the noble gas configuration. Furthermore, such compounds should be very stable. The reaction between sodium (Na) and chlorine (Cl) to form sodium chloride (NaCl), common salt, illustrates the validity of this atomic model. The two elements react explosively to form an extremely stable compound. Work since the time Lewis and Langmuir proposed their model has shown that the electronic structure of the atom and the mechanism of compound formation is not as simple as they conceived, but their model is sufficient for our purposes.

BONDING AND MOLECULAR STRUCTURE

Ionic and Covalent Bonding

There are two types of bonding of importance to the study of textiles: ionic and covalent. IONIC BONDING comes about when an atom of one element transfers one or more of its electrons to one or more atoms of another element. The atom that gives up electrons is called the donor. The atom that picks up electrons is called the acceptor. The donor becomes positively charged because it now has more protons than electrons. The acceptor becomes negatively charged because it has more electrons than protons. A charged atom is called an ION. The compounds formed from the ionic bonding of atoms are called salts, and are generally the subject of inorganic chemistry, although some organic compounds do form salts. Ionic compounds are held together by the mutual attraction of the positive and negative ions.

COVALENT BONDS are formed when two or more atoms *share their outer electrons.* Electron sharing between atoms comes about when less energy is required for an electron to circle two nucleii than to be transferred from one atom to another. The mechanics of the formation of covalent bonds is extremely complex and beyond the scope of this textbook. It is sufficient for our purposes to note that covalent bonds are formed by the outer (valence) electrons of atoms. The most important examples of covalent bonding are the formation of compounds containing carbon.

Other Forces of Attraction

HYDROGEN BONDING occurs when molecules having hydrogen (H) bound to oxygen (O), nitrogen (N), or flourine (F) approach other molecules containing O, N, or F. When hydrogen is bonded to these atoms to form the

—OH, \diagdownNH, or HF bond, its single electron is attracted to the other atom.

This leaves the nucleus of the H atom, a single proton, slightly uncovered, while the other atom has a slight excess of electrons. Thus, the combinations

of —OH, \diagdownNH, and HF are slightly positive at the H end owing to a dearth of

electrons, and slightly negative at the other end owing to an excess of negative charge. This situation is illustrated in Fig. 3.3 for water.

When these hydrogen-containing molecules approach other molecules that have a slight excess of negative charge (usually those containing O, N, or F), the proton of the H atom will be attracted toward the other molecule. At some point there will be an equal attraction between the proton and each of the two negative charges; the pair of molecules will be held together by this attraction (Fig. 3.4). Although the hydrogen bond is very weak compared to covalent or ionic bonds, many H bonds acting together are powerful enough to affect the physical properties of many chemical compounds. Most notably, the high boiling point of water and the helical structure of keratin in wool are due to hydrogen bonding.

Figure 3.3 Charge distribution in the water molecule. The oxygen atom is slightly negative due to a greater affinity for electrons.

Figure 3.4 Hydrogen bonding (– – –) between water molecules causes them to cluster together.

VAN DER WAALS (London) forces are extremely weak attractive forces which function only when molecules come very close to each other. In any neutral molecule the sum of the positive charges (protons) is equal to the sum of the negative charges (electrons). However, since the electrons are constantly in motion, the negative charges are not always exactly balanced by the positive charges. This situation gives rise to a slight transient polarization of the molecule in which one portion is slightly positive and the other is slightly negative. If a second molecule with the proper orientation and charge distribution approaches the first very closely, the slight charge differences will cause the two molecules to adhere as the unlike charges attract each other. As with the hydrogen bond, Van der Waals forces can affect the physical properties of materials by the action of numerous small attractions. The strength of the attraction increases with the number of atoms in a molecule.

BUILDING MOLECULES FROM ATOMS

Carbon is interesting in that it has four electrons in its outer shell. Thus, it is difficult for it to fill its outer shell by accepting four more electrons or to divest itself of its outer shell by giving up four electrons. As it turns out, sharing electrons with other atoms is easier than either of these alternatives. Fig. 3.5 illustrates the formation of the simple methane molecule by covalent bonding between one carbon (C) and four hydrogen (H) atoms. Each of the hydrogen atoms fills its first shell by sharing one of the outer carbon electrons, while the carbon atom fills the second shell by sharing four electrons with the hydrogen atoms. In this way, all the atoms attain their most stable structures. Although the first-shell electrons of the carbon atom stay in orbit about the carbon nucleus, the outer electrons orbit all five nuclei. Note that two electrons are required to bond each pair of atoms.

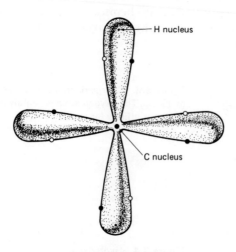

H nucleus

C nucleus

● = electron from H atom
○ = electron from C atom

Figure 3.5 Covalent bonding in methane. Each C atom shares electrons with four H atoms. The shaded volumes are the orbits of the outer electrons.

The arrangment of atoms and electrons in organic compounds are illustrated through *Lewis structures*, in which the covalent bonds are shown by pairs of dots representing two electrons, or by a line representing a single bond. The Lewis structure of methane is illustrated in Fig. 3.6. Note that the electrons that are not part of the valence shell are not shown. It often occurs that it is only necessary to understand a few of the many atoms and electrons making up an organic molecule in order to understand the properties of the molecule. In such cases the bonds between the other atoms are not shown at all.

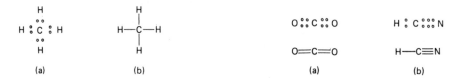

Figure 3.6 The Lewis structure of methane. Electron pairs are shown in (a) and a single line representing a bond in (b).

Figure 3.7 The Lewis structures of (a) carbon dioxide (CO_2) and (b) hydrogen cyanide (HCN).

Carbon atoms are capable of forming bonds in which more than one pair of electrons are shared. For example, in carbon dioxide one carbon atom shares two electrons with each of two oxygen atoms. In hydrogen cyanide, a carbon atom shares one pair of electrons with a hydrogen atom and three pairs of electrons with a nitrogen atom. The Lewis structures are shown in Fig. 3.7. Multiple bonds are shown by multiple pairs of dots or by multiple lines.

Simple Organic Compounds

The hundreds of thousands of organic compounds are built up of simple chains of carbon atoms to which hydrogen atoms, other elements, or other molecules are bonded. Those compounds, which consist of only carbon and hydrogen atoms, are called HYDROCARBONS. Other families of compounds may be formed by replacing an H atom with other atoms or groups of atoms. Alcohols, aldehydes, amines, and acids, for example, are created when one of

the H atoms on a hydrocarbon is replaced by an —OH, $\begin{array}{c}\diagdown\\\diagup\end{array}$C=O, —NH₂ or

—COOH, respectively. The molecules that replace the H atoms are known as FUNCTIONAL GROUPS. Specific examples of functional groups that are important in this discussion are shown in Table 3.1.

When a hydrogen atom is replaced by a functional group, the entire character of the compound is changed. For example, the common dry-cleaning fluid perchloroethylene is simply ethylene that has had all of its H atoms replaced by chlorine atoms, as shown in Fig. 3.8a. Likewise, if one of the hydrogen atoms of ethane is replaced by an —OH molecule (hydroxyl group), the resulting compound (see Fig. 3.8b) is ethanol (ethyl alcohol), the active ingredient in beer, wine, and whiskey. Ethane is a gas that boils at

TABLE 3.1 Basic Functional Groups

Group	Structure	Example	
Acid	$\overset{\displaystyle O}{\overset{\|}{-C}}-OH$	$H_3C-\overset{\displaystyle O}{\overset{\|}{C}}-OH$	Acetic acid
Alcohol	$-OH$	H_3C-CH_2-OH	Ethanol (Ethyl alcohol)
Aldehyde	$\overset{\displaystyle O}{\overset{\|}{-C}}-H$	$H_3C-\overset{\displaystyle O}{\overset{\|}{C}}-H$	Acetaldehyde
Amide	$-\overset{\displaystyle O}{\overset{\|}{C}}-\overset{\displaystyle H}{\overset{\|}{N}}-$	$H-\overset{\displaystyle O}{\overset{\|}{C}}-\overset{\displaystyle H}{\overset{\|}{N}}\overset{\displaystyle CH_3}{\underset{\displaystyle CH_3}{}}$	N,N-dimethyl formamide
Amine	$-N\overset{\displaystyle H}{\underset{\displaystyle H}{}}$	$H_3C-N\overset{\displaystyle H}{\underset{\displaystyle H}{}}$	Methyl amine
Ester	$\overset{\displaystyle O}{\overset{\|}{-C}}-O-$	$H_3C-\overset{\displaystyle O}{\overset{\|}{C}}-O-C_2H_5$	Ethyl acetate
Ether	$>C-O-C<$	$C_2H_5-O-CH_3$	Ethylmethyl ether
Ketone	$>C=O$	$H_3C-\overset{\displaystyle O}{\overset{\|}{C}}-CH_3$	Acetone
Methylol	$-CH_2OH$		
N-methylol	$>N-CH_2OH$		
Sulfhydril	$-SH$		

$-88°$ C, while ethanol is a liquid that boils at $+78°$ C. Furthermore, the biological effects of the two chemicals are dramatically different.

It should be noted that ethane, a simple hydrocarbon, is relatively inert. The addition of a functional group to form ethanol causes dramatic changes in the chemical properties of the compound. The chemical reactivity of organic compounds is due, in large part, to the presence of functional groups.

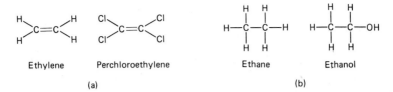

Ethylene Perchloroethylene Ethane Ethanol

 (a) (b)

Figure 3.8 Replacing hydrogen atoms by functional groups changes the nature of the compound. In (a) ethylene gas becomes liquid perchloroethylene. In (b) a similar change occurs when ethane becomes ethanol.

Chemical reactions between different functional groups can lead to the formation of new organic compounds. Esters, for example, are formed by the reaction between an alcohol and an acid, as follows:

$$\underset{\text{alcohol}}{R-OH} + \underset{\text{acid}}{HO-\overset{\overset{\textstyle O}{\|}}{C}-R'} \longrightarrow \underset{\text{ester}}{R-O-\overset{\overset{\textstyle O}{\|}}{C}-R'} + \underset{\text{water}}{H_2O}$$

where R and R' are any chemical species.

In this section we shall discuss the chemical compounds that are of importance to the study of textile materials. These compounds may consist of straight-chain molecules (Tables 3.2 and 3.3), ring compounds (Tables 3.2, 3.3 and 3.4), compounds formed from the substitution of functional groups for H atoms (Tables 3.4 and 3.5), or compounds formed from the reactions between functional groups. The molecules may contain single, double, or triple bonds. It is apparent that some orderly system of nomenclature is needed if we are to be able to discuss the chemistry of these compounds.

Nomenclature

The most widely accepted system of nomenclature is that of the International Union of Pure and Applied Chemistry (IUPAC) adopted in 1949. However, many of the chemicals used in large volume were discovered and named decades before the IUPAC system was developed and are still called by their common names.

Alkanes The *alkanes* are the simplest of the organic compounds. They contain only carbon and hydrogen in a straight-chain configuration, and all the bonds are single covalent bonds. These compounds have the general formula $C_n H_{(2n+2)}$, where n is the number of carbon atoms in the molecule. Because they contain only single bonds, they are called *saturated hydrocarbons*. Some of the simple alkanes are shown in Table 3.2. Their names are derived by the addition of the suffix *ane* to the Greek or Latin prefix

TABLE 3.2 Simple Alkanes (C_nH_{2n+2})

Number of Carbon Atoms	Name	Structure	Formula
1	methane		CH_4
2	ethane		C_2H_6
3	propane		C_3H_8
4	butane		C_4H_{10}
6	hexane		C_6H_{14}

Cyclic Alkanes (C_nH_{2n})

4	cyclobutane		C_4H_8
5	cyclopentane		C_5H_{10}
6	cyclohexane		C_6H_{12}

for the number of carbon atoms. Thus, an alkane containing five carbon atoms is called *pentane*.

Saturated hydrocarbons may also exist in ring structures. In these cases the general formula is $C_n H_{2n}$, and the compound is named like the straight-chain compound, except that the prefix *cyclo* is added. Thus a saturated ring compound containing six carbon atoms is called *cyclohexane*. It is shown in Table 3.2.

Alkenes Another family of hydrocarbons is the *alkenes*. They are characterized by double bonds between carbon atoms and have the general formula $C_n H_{2n}$ if they form straight chains and $C_n H_{(2n-2)}$ if they form ring compounds. Because they have double bonds, they are called *unsaturated hydrocarbons*. The alkenes are named in the same manner as the alkanes, except that the suffix *ene* is added. Thus, a hydrocarbon containing four carbon atoms with one double bond is called *butene*. Note that there are two straight-chain structures for butene (Table 3.3). Alkenes containing two double bonds are called *dienes* (Table 3.3).

Aromatics A very important class of compounds containing multiple double bonds are the *aromatic hydrocarbons*. The parent compound of this class of materials is benzene, the structure of which was deducted by Kekulé in 1865. Its structure is shown in Table 3.4. Many important industrial chemicals, plastics, and dyes are prepared from benzene derivatives. Some of these are shown in Table 3.4.

WRITING CHEMICAL REACTIONS

The chemical behavior of molecules and atoms is expressed in the form of an equation which indicates the materials that are reacting (the reactants) and the materials formed from the reaction (the products). Other symbols may be used to indicate the conditions under which the reaction occurs. In general, the form of the equation is as follows:

$$A + B \longrightarrow C + D$$

in which A and B are the reactants and C and D are the products. If the reaction takes place only under certain conditions, such as high pressure or temperature or in the presence of a catalyst, the conditions are indicated above or below the arrow. For example,

$$A + B \xrightarrow[\text{[O]}]{\text{cat}} C + D$$

indicates that A will react with B to form C and D in the presence of a catalyst and oxygen.

TABLE 3.3 Simple Alkenes (C_nH_{2n})

Number of Carbon Atoms	Name	Structure	Formula
2	ethylene (ethene)		C_2H_4
3	propylene (propene)		C_3H_6
4	1-butene		C_4H_8
	2-butene		

<div align="center">Simple Dienes</div>

4	1,3-butadiene		

<div align="center">Cyclic Alkenes and Dienes</div>

6	cyclohexene		C_6H_{10}
6	1,4-cyclohexadiene		C_6H_8
6	1,3-cyclohexadiene		C_6H_8

TABLE 3.4 Aromatic Compounds

Name	Structure		Formula
benzene	(structure)	or (structure)	C_6H_6
*ortho*xylene	(structure)	or (structure)	C_8H_{10}
*meta*xylene	(structure)	or (structure)	C_8H_{10}
*para*xylene	(structure)	or (structure)	C_8H_{10}
styrene (a monomer)	(structure)	or (structure)	C_8H_8
alizarin (a dye)	(structure)	or (structure)	$C_{14}H_8O_4$

In many organic reactions, the products are not inert but will react with each other to re-form the reactants. In such situations, a condition of *equilibrium* between the reactants and products is reached. At equilibrium, the formation of one molecule of product is accompanied by the dissolution of another molecule of product into a molecule of reactant. Thus, when equilibrium has been reached, the amounts of reactants and products remain the same. Reactions that readily attain equilibrium are called *reversible reactions* and are written as follows:

$$A + B \rightleftharpoons C + D$$

in which the two arrows indicate that the reaction proceeds in both the forward and the reverse directions.

COMPOUNDS CONTAINING FUNCTIONAL GROUPS

Alcohols

Alcohols containing one hydroxyl (—OH) group are named after the parent hydrocarbon, with the suffix *ol*. For example, methanol (methyl alcohol) is CH_3OH, while CH_3CH_2OH is ethanol (ethyl alcohol). Three types of simple alcohols may be formed by replacing one H atom by an —OH group. They are called *primary*, *secondary*, and *tertiary* alcohols. The structures are illustrated in Table 3.5. If two hydrogen atoms are replaced by hydroxyl groups, the product is called a *diol* or *glycol*. The common antifreeze agent ethylene glycol (1,2-ethanediol) is simply ethane that has had one H atom on each of the carbon atoms replaced by a hydroxyl group.

TABLE 3.5 Configurations of the Alcohols

Type	Structure	Name								
Primary	$\begin{array}{cccc} H & H & H & H \\	&	&	&	\\ H-C-&C-&C-&C-OH \\	&	&	&	\\ H & H & H & H \end{array}$	*n*-butanol
Secondary	$\begin{array}{cccc} H & H & H & H \\	&	&	&	\\ H-C-&C-&C-&C-H \\	&	&	&	\\ H & & H & H \\ & OH & & \end{array}$	*s*-butanol
Tertiary	$\begin{array}{c} CH_3 \\	\\ H_3C-C-OH \\	\\ CH_3 \end{array}$	*t*-butanol						

Alcohols may be formed by the addition of water to an alkene in the presence of a catalyst:

$$\underset{\text{ethylene}}{H_2C=CH_2} + \underset{\text{water}}{HOH} \xrightarrow{\text{cat}} \underset{\text{ethanol}}{H-\overset{H}{\underset{H}{C}}-\overset{H}{\underset{H}{C}}-OH}$$

Alcohols may be dehydrated by the action of sulfuric acid to form alkenes:

$$\underset{\text{ethanol}}{H-\overset{H}{\underset{H}{C}}-\overset{H}{\underset{H}{C}}-OH} \xrightarrow{\text{acid}} \underset{\text{ethylene}}{H_2C=CH_2} + \underset{\text{water}}{H_2O}$$

Primary alcohols may be oxidized to form aldehydes or acids:

$$\underset{\text{methanol}}{H-\overset{H}{\underset{H}{C}}-OH} \xrightarrow[\text{[O]}]{\text{cat}} \underset{\text{formaldehyde}}{H-\overset{O}{C}-H} + \underset{\text{water}}{H_2O} \xrightarrow[\text{[O]}]{\text{cat}} \underset{\text{formic acid}}{H-\overset{O}{C}-OH}$$

Secondary alcohols may be oxidized to form ketones:

$$\underset{\substack{\text{isopropyl} \\ \text{alcohol}}}{H_3C-\overset{OH}{\underset{H}{C}}-CH_3} \xrightarrow[\text{[O]}]{\text{cat}} \underset{\text{acetone}}{H_3C-\overset{O}{C}-CH_3} + \underset{\text{water}}{H_2O}$$

Alcohols may react with organic acids to form esters:

$$\underset{\text{ethanol}}{H_3C-CH_2-OH} + \underset{\text{acetic acid}}{HO-\overset{O}{C}-CH_3} \longrightarrow \underset{\text{ethyl acetate}}{H_3C-CH_2O-\overset{O}{C}-CH_3} + \underset{\text{water}}{H_2O}$$

Aldehydes and Ketones

Aldehydes (R—CHO) and ketones (RR'CO) may be produced by the oxidation of alcohols. Aldehydes and ketones are similar in their chemistry, but aldehydes are generally more reactive. Aldehydes may be oxidized to form acids. Ketones, however, are difficult to oxidize and usually decompose in the presence of strong oxidizing agents.

The simplest aldehyde is formaldehyde. It is formed from the oxidation of methanol by air in the presence of a catalyst, as shown above. Formaldehyde reacts with urea, phenol, and other compounds to produce thermosetting resins, which are of major importance to the textile industry, especially in durable-press finishing. The chemistry of durable-press finishes is discussed in Chapter 16.

Carboxylic Acids

Acids (RCOOH) may be formed from the oxidation of alcohols or the oxidation of aldehydes:

$$H_3C-CH_2-OH \xrightarrow[[O]]{cat.} H_3C-\overset{\overset{\displaystyle O}{\|}}{C}-OH + H_2O$$

$$\text{ethanol} \qquad\qquad \text{acetic acid} \quad \text{water}$$

The hydrogen atom attached to the —COOH group is acidic in nature and easily removed, so that acids may react with alcohols to form esters (see above) and with amines to form amides:

$$H_3C-\overset{\overset{\displaystyle O}{\|}}{C}-OH + H-\overset{\overset{\displaystyle H}{|}}{N}-CH_3 \longrightarrow H_3C-\overset{\overset{\displaystyle O}{\|}}{C}-\overset{\overset{\displaystyle H}{|}}{N}-CH_3 + H_2O$$

$$\text{acetic acid} \qquad \text{methyl amine} \qquad \text{N-methyl acetamide} \quad \text{water}$$

Acids may react with strong bases to form salts:

$$H_3C-\overset{\overset{\displaystyle O}{\|}}{C}-OH + NaOH \longrightarrow H_3C-\overset{\overset{\displaystyle O}{\|}}{C}-O^-\ ^+Na + H_2O$$

$$\text{acetic acid} \quad\ \text{sodium} \qquad\quad \text{sodium acetate} \qquad \text{water}$$
$$\text{hydroxide}$$

Esters

Esters (RCOOR′) are formed by the reaction of an acid with an alcohol, as shown above. Esters can be *saponified* by a strong base to form the alcohol and the salt of the acid from which the ester was derived:

$$H_3C-\overset{\overset{\displaystyle O}{\|}}{C}-O-CH_3 + NaOH \longrightarrow H_3C-\overset{\overset{\displaystyle O}{\|}}{C}-O^-\ ^+Na + H_3C-OH$$

$$\text{methyl acetate} \qquad \text{sodium} \qquad\qquad \text{sodium acetate} \qquad \text{methanol}$$
$$\text{hydroxide}$$

Amines and Amides

The amines $(R_1R_2R_3 - N)$ and amides $(R_1CONR_2R_3)$ may be considered as derivatives of ammonia (NH_3) in which one or more of the hydrogen atoms have been replaced. Like alcohols, amines may be primary, secondary, or tertiary, depending upon whether one, two, or all three hydrogen atoms have been replaced.

Simple amines are prepared industrially by the reaction between ammonia and an alcohol in the presence of a catalyst:

$$NH_3 \xrightarrow[CH_3OH]{cat} CH_3-NH_2 \xrightarrow[CH_3OH]{cat} H_3C-\overset{\overset{\displaystyle H}{|}}{N}-CH_3 \xrightarrow[CH_3OH]{cat} H_3C-\overset{\overset{\displaystyle CH_3}{|}}{N}-CH_3$$

$$\text{primary} \qquad\qquad \text{secondary} \qquad\qquad \text{tertiary}$$
$$\text{amine} \qquad\qquad\quad \text{amine} \qquad\qquad\quad \text{amine}$$

Amines may also be formed from the reaction of ammonia with an alkyl halide:

$$NH_3 \xrightarrow{CH_3Cl} \underset{\substack{\text{primary} \\ \text{amine}}}{CH_3-NH_2} \xrightarrow{CH_3Cl} \underset{\substack{\text{secondary} \\ \text{amine}}}{H_3C-\overset{\overset{\displaystyle H}{|}}{N}-CH_3} \xrightarrow{CH_3Cl} \underset{\substack{\text{tertiary} \\ \text{amine}}}{H_3C-\overset{\overset{\displaystyle CH_3}{|}}{N}-CH_3}$$

$$\left[H_3C-\overset{\overset{\displaystyle CH_3}{|}}{\underset{\underset{\displaystyle CH_3}{|}}{N}}-CH_3 \right]^{+} Cl^{-} \xleftarrow{CH_3Cl}$$

quaternary ammonium salt

The quaternary ammonium salts are important components of detergents, fabric softeners, and other textile finishes. Their uses are discussed in Chapter 16.

Like the alcohols, amines may react with carboxylic acids. The products of the reaction are called *amides*:

$$\underset{\substack{\text{formic acid}}}{H-\overset{\overset{\displaystyle O}{\|}}{C}-OH} + \underset{\substack{\text{dimethyl amine}}}{H-N\overset{\diagup CH_3}{\diagdown CH_3}} \longrightarrow \underset{\substack{\text{N,N-dimethyl} \\ \text{formamide}}}{H-\overset{\overset{\displaystyle O}{\|}}{C}-N\overset{\diagup CH_3}{\diagdown CH_3}} + \underset{\substack{\text{water}}}{H_2O}$$

N,N-Dimethyl formamide is important as a solvent in the production and identification of textile fibers.

POLYMERS

The molecules under discussion to this point have all been in the molecular weight range of about 20 to 200. Many of the properties of these molecules, such as melting point, boiling point, solubility, and density, can be explained by differences in their molecular weights. The effect of molecular weight on two of these properties—melting point and boiling point—is illustrated in Table 3.6 for the alkanes. From data such as these, scientists had come to expect that the chemical strucutre of materials could be deduced, in part, from the physical properties. For example, ammonia (NH_3), which melts at $-78°$ C and boils at $-33°$ C, should be a very small molecule if its properties are to be consistent with those of the compounds in Table 3.6. The molecular weight of ammonia is 17. Certain anomalies, such as the very high boiling point of water, $100°$ C, can be explained by hydrogen bonding, by which a number of small molecules become associated and behave as a large molecule would behave.

From about 1900 through the 1920s, scientists found that many of the properties of naturally occurring materials such as wool, starch, cellulose, and gums required that they have molecular weights in the many hundreds of thousands. Because analytical techniques of the time did not permit chemists to accurately determine the structure of these materials, some scientists

TABLE 3.6 Effect of Molecular Weight on the Physical Properties of the Alkanes

Formula	Name	DP	Molecular Weight	Melting Point (°C)	Boiling Point (°C)	Physical State
$H(CH_2)H$	methane	1	16	−184	−162	gas
$H(CH_2)_2H$	ethane	2	30	−172	− 88	
$H(CH_2)_4H$	butane	4	58	−135	−0.5	
$H(CH_2)_6H$	hexane	6	86	− 94	68	liquid
$H(CH_2)_8H$	octane	8	114	− 56	125	
$H(CH_2)_{10}H$	decane	10	142	− 31	174	
$H(CH_2)_{20}H$	eicosane	20	282	38	205	grease
$H(CH_2)_{30}H$	triacontane	30	422	66	235	soft wax
$H(CH_2)_{35}H$	pentatria-contane	35	632	75	331	hard wax
$H(CH_2)_{4000}H$	polyethylene	4000	56,000	142	decomposes	crystalline solid

explained these phenomena on the basis of the association of many small molecules, as in water. Others believed that these materials were actually very large molecules, which they named *macromolecules*. By the 1930s, sufficient evidence was available for chemists to recognize that these materials were indeed very large molecules.

Those macromolecules which are of importance in the study of textile materials may be visualized as long chains composed of many small molecules linked together by covalent bonds. Such macromolecules are called POLYMERS, from the Greek *polys* = many and *meros* = parts. An idealized polymer is illustrated in Fig. 3.9. Many of the properties of polymers derive from the fact that they are so large. As illustrated in Table 3.6 for a series of alkanes, which are all chains of $—CH_2—$ molecules differing only in molecular weight, increasing molecular weight causes a change in the physical state of the material. The solubility is also affected. The alkanes up to pentatriacontane (35 C atoms) are soluble in ether, but polyethylene is not.

Figure 3.9 An idealized polymer modeled as a chain of many identical links. The molecule tends to curl rather than stretch out.

Polymerization

Polymers used in fibers are either of the *condensation* type or of the *addition* type. The naturally occurring fibers, such as cotton and wool, are condensation-type polymers. These particular molecules cannot yet be synthesized in the laboratory. The synthetic fibers which can be synthesized in the laboratory from small molecules may be of either type. Polyester and nylon fibers are produced from condensation polymers. Acrylic and olefins are examples of addition polymers.

Condensation Polymerization When a compound contains more than one functional group, it may react with more than one other molecule. Thus a diacid (one containing two —COOH groups) can react with two alcohols. If the alcohol also contains two functional groups (diol), the ester formed from the reaction of the diol and the diacid will be capable of further reaction:

$$HO-\overset{\overset{O}{\|}}{C}-R-\overset{\overset{O}{\|}}{C}-OH + HO-R'-OH \longrightarrow HO-\overset{\overset{O}{\|}}{C}-R-\overset{\overset{O}{\|}}{C}-O-R'-OH + H_2O \qquad (1)$$

(where R and R′ are any organic compound)

In Equation 1, the reaction of a diacid with a diol has produced an ester with an acid group at one end and a hydroxyl group at the other. Each of these groups is capable of further reaction.

$$HO-\overset{\overset{O}{\|}}{C}-R-\overset{\overset{O}{\|}}{C}-O-R'-OH + HO-\overset{\overset{O}{\|}}{C}-R-\overset{\overset{O}{\|}}{C}-O-R'-OH \longrightarrow \qquad (2)$$

$$HO-\overset{\overset{O}{\|}}{C}-R-\overset{\overset{O}{\|}}{C}-O-R'-O-\overset{\overset{O}{\|}}{C}-R-\overset{\overset{O}{\|}}{C}-O-R'-OH + H_2O$$

In Equation 2, reaction of a pair of esters has produced a diester that is capable of further reaction. This mechanism is used in the production of PET [poly(ethylene terephthalate)] polyester according to the following sequence:

$$HO-\overset{\overset{O}{\|}}{C}-\bigcirc-\overset{\overset{O}{\|}}{C}-OH + HO-\overset{\overset{H}{|}}{\underset{H}{C}}-\overset{\overset{H}{|}}{\underset{H}{C}}-OH \longrightarrow$$

terephthalic
acid ethylene
glycol

$$HO-\overset{\overset{O}{\|}}{C}-\bigcirc-\overset{\overset{O}{\|}}{C}-O-\overset{\overset{H}{|}}{\underset{H}{C}}-\overset{\overset{H}{|}}{\underset{H}{C}}-OH + H_2O$$

hydroxyethyl
terephthalate

49

If we denote the acid end of the molecule by A and the alcohol end by B, we may illustrate the formation of a polyester as follows:

$$A[\]B + A[\]B \longrightarrow A[\]-[\]B$$
$$A[\]-[\]B + A[\]-[\]B \longrightarrow A[\]-[\]-[\]-[\]B$$
$$A[\]-[\]-[\]-[\]B + A[\]-[\]-[\]-[\]B \longrightarrow$$
$$A[\]-[\]-[\]-[\]-[\]-[\]-[\]-[\]B$$
$$A[\]_8 B + A[\]_8 B \longrightarrow A[\]_{16} B$$

until

$$A[\]_n B + A[\]_n B \longrightarrow A[\]_{2n} B$$

The reaction will continue with 4, 8, 16, 32, 64 . . . units of hydroxyethyl terephthalate being incorporated into the growing chain. The reaction is terminated by the addition of a stopping agent, a monofunctional material that reacts with the growing chain but has no other functional group with which to continue the reaction. In this example, methanol would act as a stopping agent:

$$\text{HO}-[\text{POLYESTER}]-\overset{\overset{\text{O}}{\|}}{\text{C}}-\text{OH} + \text{HO}-\text{CH}_3 \longrightarrow$$

$$\text{HO}-[\text{POLYESTER}]-\overset{\overset{\text{O}}{\|}}{\text{C}}-\text{O}-\text{CH}_3 + \text{H}_2\text{O}$$

The polymerization process ceases when all the polyester chains are terminated by alcohol or ester groups.

The structure of a polymer is illustrated by writing the repeat unit enclosed in brackets with a subscript indicating the number of units in the chain. Thus,

$$\text{HO}-\left[\overset{\overset{\text{O}}{\|}}{\text{C}}-\text{R}-\overset{\overset{\text{O}}{\|}}{\text{C}}-\text{O}-\text{R}'-\text{O}\right]_n \text{H}$$

indicates a polyester that is n units long.

The above reaction is called a STEPWISE POLYCONDENSATION REACTION. It is stepwise because the polymer "grows" step by step as each ester is added to the chain. It is a condensation reaction because small molecules, such as water, are formed and removed from the reaction medium. A similar process is used in the manufacture of nylon, except that the esterification reaction is replaced by an amidation (formation of an amide) reaction.

To prepare nylon 6,6 a diacid is made to react with a diamine to form a water-soluble salt:

$$\text{HO}-\overset{\overset{\text{O}}{\|}}{\text{C}}-(\text{CH}_2)_4-\overset{\overset{\text{O}}{\|}}{\text{C}}-\text{OH} + \text{H}_2\text{N}-(\text{CH}_2)_6-\text{NH}_2 \longrightarrow$$

adipic acid hexamethylene diamine

$$\text{HO}-\overset{\overset{\text{O}}{\|}}{\text{C}}-(\text{CH}_2)_4-\overset{\overset{\text{O}}{\|}}{\text{C}}-\text{O}^- \ \ \text{H}_3^+\text{N}-(\text{CH}_2)_6-\text{NH}_2$$

nylon salt

The salt solution is heated and a stepwise polycondensation occurs:

$$HO-\underset{\parallel O}{C}-(CH_2)_4-\underset{\parallel O}{C}-O^-\quad H_3^+N-(CH_2)_6-NH_2\quad\longrightarrow$$

<div align="center">nylon salt</div>

$$HO-\underset{\parallel O}{C}-(CH_2)_4-\underset{\underset{O}{\parallel}}{C}-\underset{\underset{H}{\mid}}{N}-(CH_2)_6-NH_2\quad\longrightarrow\quad polymer + H_2O$$

<div align="center">amide</div>

The polymerization proceeds in a manner similar to that for the polyester. The structure of the resulting polymer is written as follows:

$$H\left[\underset{\underset{H}{\mid}}{N}-(CH_2)_6-\underset{\underset{H}{\mid}}{N}-\underset{\overset{O}{\parallel}}{C}-(CH_2)_4-\underset{\overset{O}{\parallel}}{C}\right]_n OH$$

Addition Polymerization In this type of polymerization, the chains are formed by the addition of single monomer units to the growing macromolecule. Addition polymerization may be illustrated by the free radical polymerization of a family of compounds of the form $H_2C{=}CHR$ known as *vinyl monomers*. The initiator is a molecule that has one unpaired electron in its outer shell that it is seeking to fill. The process proceeds as follows:

$$I\cdot + \underset{\substack{\text{vinyl}\\\text{monomer}}}{\overset{\substack{H\qquad H}}{\underset{H\qquad R}{C{=}C}}} \longrightarrow \underset{\text{propagating radical}}{I-\overset{\substack{H\ H}}{\underset{\substack{H\ R}}{C-C}}\cdot} \qquad \text{Initiation}\quad(i)$$

<div align="center">initiator vinyl
monomer propagating
radical</div>

$$\underset{\substack{\text{propagating}\\\text{radical}}}{I-\overset{H\ H}{\underset{H\ R}{C-C}}\cdot}+\underset{\text{monomer}}{\overset{H\qquad H}{\underset{H\qquad R}{C{=}C}}}\longrightarrow\underset{\substack{\text{"growing}\\\text{chain"}}}{I-\overset{H\ H\ H\ H}{\underset{H\ R\ H\ R}{C-C-C-C}}\cdot}\qquad\text{Propagation}\quad(ii)$$

$$I\left[\overset{H\ H}{\underset{H\ R}{C-C}}\right]_m\overset{H\ H}{\underset{H\ R}{C-C}}\cdot+\cdot\overset{H\ H}{\underset{R\ H}{C-C}}\left[\overset{H\ H}{\underset{R\ H}{C-C}}\right]_n I\longrightarrow I\left[\overset{H\ H}{\underset{H\ R}{C-C}}\right]_{m+n+2}I\qquad\text{Termination}\quad(iii)$$

In step i, the initiator attacks the monomer, opens the double bond and attaches to a carbon atom. This is known as the initiation step. The product is a propagating radical in which the second carbon atom is left with an unpaired electron. It will attack another monomer molecule, open its double bond, attach it to the growing polymer chain, and transfer the unpaired

TABLE 3.7 Common Vinyl Monomers and Their Polymers

Monomer	*Polymer*
ethylene	polyethylene (olefin)
propylene	polypropylene (olefin)
acrylonitrile	polyacrylonitrile (acrylic)
vinyl chloride	poly(vinyl chloride) (vinyon)
vinylidene chloride	poly(vinylidene chloride) (saran)
vinylidene dinitrile	poly(vinylidene dinitrile) (nytrile)
vinyl acetate	poly(vinyl acetate)

TABLE 3.7 (cont.)

Monomer	Polymer

No monomer; prepared from poly(vinyl acetate)

$$\left[\begin{matrix} H & H \\ | & | \\ -C-C- \\ | & | \\ H & OH \end{matrix}\right]$$

poly(vinyl alcohol)
(vinal)

$$\begin{matrix} H & & H \\ & C=C & \\ H & & \bigcirc \end{matrix}$$

styrene

$$\left[\begin{matrix} H & H \\ | & | \\ -C-C- \\ | & | \\ H & \bigcirc \end{matrix}\right]$$

polystyrene
(a plastic)

$$\begin{matrix} & & CH_3 & & \\ H & & | & & H \\ & C=C-C=C & \\ H & & | & & H \\ & & H & & \end{matrix}$$

isoprene

$$\left[\begin{matrix} H & CH_3 & & H \\ | & | & & | \\ -C-C=C-C- \\ | & & & | \\ H & & H & H \end{matrix}\right]$$

poly(isoprene)
(rubber)

electron forward. This is the propagation step, ii. The termination step, iii, results in the elimination of the unpaired electron. It usually occurs by the recombination of two growing chains. The final product is a polymer molecule, the length of which is the sum of the two growing chains. Note that no small molecules are formed in an addition polymerization.

Polymers made from vinyl monomers are an important part of the fiber and plastics industries. Some of the more common polymers are shown in Table 3.7.

Degree of Polymerization (DP) and Molecular Weight

The molecular weight of a molecule is the sum of the weights of all the atoms which make up that molecule. Thus, the molecular weight of adipic acid $[HOOC(CH_2)_4COOH]$ is 146; that of hexamethylene diamine $[H_2N(CH_2)_6NH_2]$ is 116. The amide formed from the reaction of these materials has a molecular weight of 244. However the POLYAMIDE, nylon 6,6, has a molecular weight of about 50,000. This means that, *on the average*, about 200 amides are linked together to form the polyamide. The *number of repeat units*, in this case amides, that make up a polymer molecule, is known as the DEGREE OF POLYMERIZATION (DP). Thus, the DP of the nylon 6,6 in this example is 205. The DP of various polymers is shown in Table 3.8.

TABLE 3.8 Molecular Weight and Degree of Polymerization of Several Fibers

Fiber	DP	Molecular Weight
Cotton	3000–10,000	480,000–1,600,000
Rayon	400–600	130,000–195,000
Nylon	200–350	50,000–75,000
Polyester	250–400	50,000–80,000
Acrylic	1500–3000	80,000–160,000
Olefin	3000–4000	120,000–160,000

Synthetic condensation polymers have a DP in the region of 200 to 600, addition polymers are somewhat higher, and natural fibers, such as cotton, have DPs in the 3,000 to 10,000 range. The molecular weight of a given synthetic polymer is not limited to the range shown in Table 3.10, however. The physical and mechanical properties of fibers made from these polymers are affected by the molecular weight, so that the polymer is tailored to fit the required end use. For example, too high a molecular weight will reduce solubility or raise melting temperature and make the material too difficult to process, while too low a molecular weight will reduce strength and resiliency and make the fiber unsuited for use. Thus, commercially available polymers usually fall within the ranges given.

The degree of polymerization of a given polymer molecule within a fiber is determined by random events. Some molecules are terminated early, and so have a low DP; others are terminated late, and have a high DP. The random character of the polymerization process leads to a distribution of molecular weights. Typical distributions are shown in Fig. 3.10. Lower molecular weight leads to decreased melting temperature and higher flexibility, while high molecular weight lends strength and stiffness. In order to produce a fiber with the best performance properties, manufacturers attempt to maintain the molecular weight distribution over a particular range, and the average molecular weight (\overline{M}) at a given value.

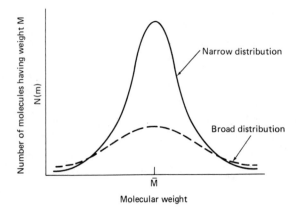

Figure 3.10 Molecular weight distribution having the same average value (\overline{M}). The narrow distribution is typical of catalyzed addition polymers; the broad distribution is found in many condensation polymers.

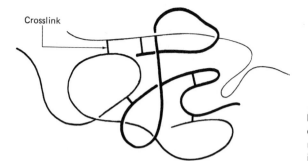

Crosslink

Figure 3.11 Intra- and intermolecular crossbinding within and among three polymer molecules. The three chains have been joined into one large macromolecule.

Crosslinking

It often becomes necessary to prepare polymers with very high molecular weights in order to obtain a high level of chemical resistance, thermal resistance, or very high strength properties. For example, durable-press and some flame-retardant finishes rely upon extremely high-molecular-weight polymers for their durability. However, very high DP polymers are difficult to process since they are generally insoluble and infusible (won't melt).

Processing problems may be overcome by joining lower molecular weight polymers with a CROSSLINKING AGENT. This method is used when cotton is crosslinked with formaldehyde for durable press, and in the polymerization of melamine-urea-formaldehyde binders for flame retardants. An idealized structure of a crosslinked polymer is shown in Fig 3.11. Note that since all the polymer chains are bound together through crosslinks, the result is a single huge molecule with a DP of many millions.

Copolymers

Sometimes it is not possible to achieve the proper balance of physical, mechanical, and chemical properties in a polymer made from a single monomer. It is relatively easy to effect changes in these properties by preparing polymers from two or more monomers. The resultant molecule is termed a *copolymer*. The modacrylics provide an example of this technique in which two vinyl monomers are reacted with each other to form a copolymer. Depending upon the chemical properties of the monomers, copolymers may be (a) *alternating*, (b) *block*, or (c) *random*. A special type of block copolymer, known as a *graft* copolymer, is often used to form crosslinked networks. These four arrangements (Fig. 3.12) lead to different properties.

FIBER MORPHOLOGY (MICROSTRUCTURE)

Many of the physical properties of fibers such as tenacity, resilience, and moisture regain are dependent not only on the types of molecules of which the fiber is composed but on the manner in which the molecules are arranged within the fiber. At the molecular level, the major structural features are the

55

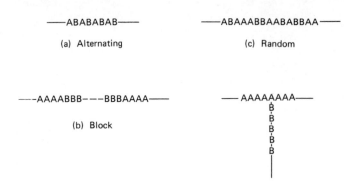

—ABABABAB——

(a) Alternating

——-AAAABBB———BBBAAAA——

(b) Block

——ABAAABBAABABBAA——

(c) Random

—— AAAAAAAA——
B
B
B
B
B
|

(d) Graft

Figure 3.12 The four types of copolymers.

ordered (crystalline) and disordered (amorphous) regions of the fiber. With the exceptions of asbestos, which is totally crystalline, and glass, which is totally amorphous, all fibers contain both crystalline and amorphous material.

Amorphous and Crystalline Regions

The amorphous regions of the fiber consist of polymer molecules that are randomly curled and intertwined. The crystalline regions of the fiber are composed of polymer molecules that are extended and packed together. The two conformations are shown in Fig. 3.13. The amorphous material is easily deformed, and the ease with which a fiber may be stretched or flexed is dependent upon the ability of the molecules within the amorphous regions to move in response to outside forces. If external stress is not too great, the molecules can return to their curled original positions upon being released, thus providing stretch recovery and wrinkle recovery to textile materials. The crystalline material, in comparison, is very strong and rigid, and the ability of a fiber to withstand tensile, crushing, and bending forces is due to the difficulty of forcing molecules within crystals out of their positions. A high level of crystallinity will yield a strong, inflexible fiber with little stretch. In addition, highly crystalline fibers are more resistant to penetration by foreign

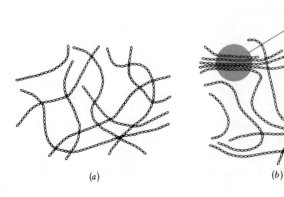

Crystallites

(a) (b)

Figure 3.13 Amorphous (a) and crystalline (b) regions within a polymeric fiber. (T. L. Brown and H. E. LeMay, Jr., *Chemistry: The Central Science*, 2nd ed. ©1981, p. 334. Reprinted by permission of Prentice-Hall, Inc., Englewood Cliffs, N.J.)

matter that can cause stains than are more amorphous fibers. (It should be noted that glass fibers are an exception to the above statements.)

The maximum level of crystallinity that is achievable in a fiber is dependent upon the chemical nature of the polymer from which the fiber is made and the rate at which the fiber was produced. In general, a high degree of attraction between polymer molecules and slow rates of fiber formation favor the growth of crystals. Thus acrylic, the molecules of which repel each other, has a low level of crystallinity, even if spun slowly. On the other hand, nylon 6,6 that has a high degree of attraction between molecules has a high percentage of crystals. Cotton is highly crystalline because of the slow rate of fiber formation during growth, while rayon (also made from cellulose) has a much lower crystal content because of the relatively rapid rate of formation of fiber during spinning.

The mere presence of crystals in a fiber is not sufficient to develop the fiber's full capabilities. It is also necessary that the crystals be oriented with respect to the fiber axis. This condition is achieved by drawing (stretching while heated) man made fibers after extrusion from the spinneret. During the months that it takes for a natural fiber to grow, the crystals align themselves to achieve the most stable orientation.

Drawing a fiber increases the degree of order to successive levels (Fig. 3.14). In Zone A, immediately upon extrusion, the fiber is still in a liquid state and consists of completely disordered polymer molecules, either in solution or in a melt. If the chemistry of the fiber permits, crystals are formed as the fiber solidifies, Zone B. The crystals are few in number and face in any direction. The fiber is partially crystalline and the crystals are unoriented. In Zone C the fiber is partially drawn. There is an increase in the number of crystals and most of them point in the direction of the fiber axis. In Zone D, the fiber is fully drawn. It now has a high concentration of crystals and they are oriented in the direction of the fiber axis.

Figure 3.14 The degrees of order in a typical drawn fiber.

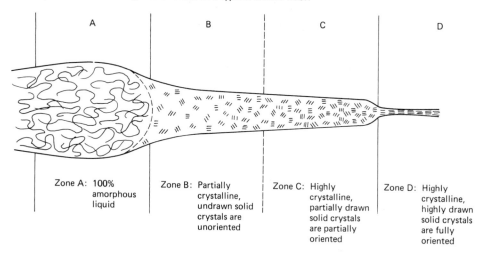

Zone A: 100% amorphous liquid

Zone B: Partially crystalline, undrawn solid crystals are unoriented

Zone C: Highly crystalline, partially drawn solid crystals are partially oriented

Zone D: Highly crystalline, highly drawn solid crystals are fully oriented

If the fiber were composed solely of a mass of perfect crystals, it would not hold together since, though each crystal is very strong, the forces binding crystals are very weak. The residual amorphous material in the fiber acts as the binder that holds the crystals, and thus the fiber, together. The structure of the crystals and the way they are bound is dependent upon the rate of formation of the fiber. Fibers, such as cotton, that are produced slowly tend to form *fringed micelles* (Fig. 3.15a). In the fringed micelle, long molecules fold back and forth upon themselves somewhat like the folds of an accordion, so that a single macromolecule may traverse the crystal many times. The micelles are held together by *tie molecules* which pass from one micelle to another. There is little amorphous material between crystals, and this amorphous material consists of elongated molecules. A fiber having this morphology would be expected to have little stretch and to be rather rigid.

Fibers, such as nylon 6,6, that are capable of crystallizing but are spun relatively rapidly, tend to produce *fringed fibrils* (Fig. 3.15b). In the fringed fibril, many molecules are packed together to form a crystal. Each macromolecule passes once through the crystal and goes on to another crystal. The amorphous material between crystals is relatively plentiful and the molecules have a more random arrangement. It is also more abundant in the ends of polymer chains that were not long enough to extend to the next crystal. A fiber having this morphology would be less rigid and have a greater degree of stretch than one composed of fringed micelles.

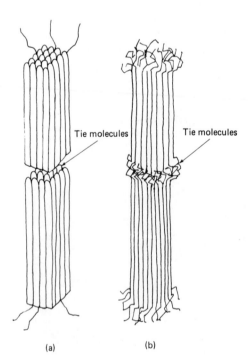

Tie molecules

Tie molecules

(a)

(b)

Figure 3.15 Models of crystals in fibers: (a) fringed micelle; (b) fringed fibril.

Glass Transitions and Melting

If a glass rod is held over the flame of a Bunsen burner or a glass blower's torch, after some period of heating the glass rod becomes soft and pliable. At this stage, while still maintaining the form of a rod, it can be bent and shaped. Continued heating will cause the glass to melt, no longer maintaining any structural shape. The temperature at which a material becomes pliable is called the *glass transition temperature*, T_g. The temperature at which a material becomes molten (liquifies) is called the *melting temperature*, T_m. Both transitions are important in the determination of fiber properties.

At the glass transition temperature, the molecules in the amorphous regions of the fiber become capable of *segmental motion*. This means that they are able to twist, bend, curl and uncurl, or stretch without affecting the structural form of the fiber. We take advantage of this phenomenon in the texturing and heat setting of fibers when we raise them to some temperature above their T_g and either crimp or stretch them to suit their end-use requirement. Upon cooling, the fibers will maintain their form unless heated above their T_g and deformed. The glass transition temperature of most textile fibers is in the range 50 to 80° C, so that texturing or heat setting is usually done at temperatures from 80 to 100° C. This is sufficient to prevent the fiber from reaching the processing temperature during home laundering.

As the temperature of a fiber is raised above the T_g, the molecules become capable of greater intensity of motion until they are able to pull free from the crystals into which they are bound. The temperature at which the crystals lose their structure is the melting temperature, T_m. Processing of polymers into fibers is done at temperatures above T_m in the melt spinning process. The melting temperature of most man made fibers ranges from 140 to 270° C.

SUMMARY

The major structural features of atoms are the protons and neutrons forming the nucleus and the electron cloud surrounding the nucleus. The protons have a mass of 1 and a positive charge (+); the neutrons have a mass of 1 and no charge, and the electrons have almost no mass and a negative charge (−). The electrons are contained in shells which may have up to 2, 8, 8, 18, or 32 electrons, depending upon their distance from the nucleus, and travel in orbits about the nucleus.

The atomic weight of an atom is the sum of its neutrons and protons.

Molecules are formed when atoms join together. Atoms may be joined by covalent or ionic bonds. Hydrogen bonding is a weak attraction between certain molecules which may affect the properties of materials in which it exists.

The molecular weight of a compound is the sum of the atomic weights of its atoms.

Hydrocarbons are molecules consisting solely of chains of carbon atoms with hydrogen atoms pendent from the chain. Alkanes contain only single bonds. Alkenes have double bonds.

The hydrogen atoms on hydrocarbons may be replaced by other atoms or molecules. When these substitutes are molecules that are capable of further reaction they are called functional groups. The functional groups determine, to a great extent, the chemistry of the compound.

Polymers are very large molecules (macromolecules) composed of repeat units of a single monomer. They may consist of addition polymers or condensation polymers. The degree of polymerization is the number of repeat units in a chain.

Copolymers are prepared from two or more monomers.

The glass transition temperature, T_g, is the temperature at which the molecules in the amorphous regions become capable of motion. The melting temperature, T_m, is the temperature at which the cyrstals no longer maintain their integrity.

II

4 Introduction to Textile Fibers

5 Natural Fibers

6 Man-made Cellulosic Fibers

7 Man-made Petroleum-based Fibers

8 Other Man-made Fibers

9 Fiber Identification Methods

FIBERS: Structure, Properties, and Identification

THE NEXT SIX CHAPTERS will examine the structure of textile fibers in relation to their properties and end uses. In Chapter 4 we discuss the historical background, the requirements of textile fibers, and their physical and chemical properties. We also look at a system of fiber classification.

Chapter 5 describes the major natural fibers: cotton, linen, jute, wool, silk, and asbestos. Chapters 6, 7, and 8 examine the man-made fibers, organized by origin into three groups: cellulosic (rayon, acetate, etc.), petroleum-based (nylon, polyester, etc.), and mineral-based (glass) fibers. Chapter 9 explains several methods that consumers can use for identifying the fiber content of cloth.

4

introduction to textile fibers

HISTORICAL BACKGROUND

Throughout most of human history, people have had to make do with what nature provided. Where textiles were concerned, this meant the common fibers COTTON, LINEN, and WOOL, and the not-so-common SILK. Near the end of the nineteenth century, however, things changed dramatically when the first man-made fiber, RAYON, began to be produced in commercial quantities. By the 1930s ACETATE and GLASS fibers had joined rayon to provide consumers with a wider range of choice in wearing apparel and home furnishings. The market expansion stimulated by the new fibers led manufacturers to develop still other, improved, fibers. In 1939, NYLON, the first totally synthetic fiber, was introduced. In many ways it was superior to the finest natural fibers; moreoever, nylon was priced at a level that people of moderate income could afford.

Following World War II, there was an unprecedented influx of new fibers: POLYESTER and ACRYLIC made their appearance in the 1950s; MODACRYLIC, SPANDEX, and OLEFIN were introduced in the 1960s; and ARAMID and NOVOLOID came in the 1970s. Four generations ago there were only four fibers; today the Federal Trade Commission recognizes nineteen. Since the pioneering work of the early 1890s, consumption of man-made fibers has grown to approximately 9 billion pounds a year in the United States and 14 billion pounds a year worldwide. During this same period, the use of natural fibers declined from 100 percent to only about one-third of the total U.S. fiber consumption.

Initially, the new fibers were chosen for their esthetic qualities and low cost. Artificial silk, for example, could be made into cloth that had the shine of real silk at a much lower price. As the industry progressed and products improved, the demand for the new fibers came to be based more on performance. Fibers have their greatest impact on textile performance in the areas of Comfort, Maintenance and Durability, although their Appearance and Cost are also significant. Because fiber content can play such an important role in determining fabric properties, the Congress, in 1960, passed the Textile Fiber Products Identification Act, requiring manufacturers to label the fiber content of their goods. To insure that consumers are not misled by the use of various brands and trademarks, the Act also provides for the assignment of GENERIC classifications. That is, "polyester" is defined as a type of fiber, composed of specific chemical compounds. Fiber manufacturers who wish to term their products "polyester" must abide by these specifications. Because of this Act, the consumer can be reasonably certain that all polyester products, whether branded Dacron, Encron, Kodel, etc., will provide a similar level of performance. *Note that labeling assures similarity, not equivalence.*

Other legislation that affects the labeling of fibers are the Wool Products Labeling Act and the Fur Products Labeling Act. These are meant to insure that the consumer is provided with an honest statement of the fiber content of wool and fur materials. This Act provides protection from fraudulent practices, such as substituting rabbit for mink or reused wool for virgin wool.

It would be impossible, as well as fruitless, to attempt to include in a single textbook a discussion of all the modifications of the generic fiber types and all the trade names under which they are sold. For example, a recent guide to the man-made fibers produced in the U.S. lists more than 250 trademarks. Instead, it is our purpose to provide our readers with sufficient knowledge of the basic fiber types to allow them to ask intelligent questions about specific fibers. This fundamental knowledge should provide a basis for analysis and assessment of textile materials in particular end uses.

REQUIREMENTS OF TEXTILE FIBERS

Textile fibers are slender, threadlike materials in which the length is at least 100 times the diameter. STAPLE fibers have lengths less than a meter (yard), while FILAMENT fibers are hundreds of meters long. Typical lengths for staple fibers are 25 mm (1 in) for cotton, 120 mm (5 in) for wool, and 50 cm (20 in) for linen. Fibers range from about 7 to 25 microns ($^1/_{10,000}$ cm) in diameter.

In order to be useful in the manufacture of textiles, a fiber must be strong and flexible. In addition, staple fibers must possess sufficient surface friction to adhere well to other fibers. This last property is known as *spinning quality*. Because fibers are long and slender, they are flexible and may be twisted together without breaking. The smaller the diameter, the more flexible the fiber, and the more pliable will be goods made from this fiber. This quality is referred to as the *fineness*. Fine fibers are soft and flexible. Coarse fibers are stiff.

The flexibility of fibers may be illustrated by the following example. A common iron nail has a length/diameter ratio (L/D) of about 24. It is rigid, and if bent will not straighten out. Iron wire, suitable for hanging pictures, cut to the same length as the nail, has an L/D of about 150. It may be coiled and looped, but if it is bent around a small radius it will/kink. Twisting two such wires together is difficult. An iron filament, drawn out to the fineness of a textile fiber, with an L/D of 900, is very flexible, will not kink readily, and may be spun into iron thread.

The strength of a fiber is measured by its tenacity, defined as the breaking strength in grams per denier. Tenacity ranges from about 1 for weak fibers such as wool and acetate to about 10 for strong fibers such as glass and aramid.

The stretchability and elasticity of fibers are also important factors in their conversion to yarn and ultimate end use. The stretch is measured by extending a fiber in an appropriate device and measuring its elongation at the break point. Rigid fibers such as linen or glass will stretch less than 1 percent, while fibers with high elongation, e.g. wool, may extend up to 35 percent before breaking. Elastomers, a special class of fibers, may elongate to 500 percent of their original length before breaking.

Elasticity is a measure of how well a fiber will recover from stretching. It is expressed as the recovery after stretching to 2 percent elongation. Fibers with high recovery can be stretched and released many times while retaining their original dimensions. Fibers with low recovery will stretch out of shape over time.

The specific gravity of a fiber is defined as its density with respect to water. Thus, a specific gravity of 1.5 means that the fiber is 1.5 times as heavy as an equal volume of water. Fibers of high density provide less yarn per pound and make heavier cloth than the same volume of fibers of low density.

PHYSICAL AND CHEMICAL PROPERTIES

The performance of a textile fiber is dependent upon its physical and chemical properties. The physical structure that is visible to the naked eye or to a low-powered microscope is the MACROSTRUCTURE (macro = large). The macro properties include length, cross-section, surface appearance, color and light reflection. More sophisticated techniques are required to explore the MICROSTRUCTURE (micro = tiny). The micro properties are determined by the type of molecules and the way they are arranged within the fiber. The microstructure affects such physical properties as strength, elasticity, and moisture absorption, as well as chemical properties such as sunlight resistance, dye fixation, and resistance to molds and fungi.

Macrostructure

The macrostructure of the natural fibers is essentially fixed, although breeding can modify them to some extent. The long, fine wools of some present-day sheep provide an example of how the macrostructure of natural

fibers can be modified. Modern wool is much finer and softer than the wool known to ancient people. The macrostructure of the man-made fibers is more easily varied, although chemical structure does put limits on the range of variation. It is possible to change the diameter, cross-section, and color of the man-made fibers by changing the manner in which they are produced.

Microstructure

The study of fiber microstructure is concerned with those features of the molecular structure which are too small to be seen and thus must be studied by instrumental methods. It is concerned with the type and size of molecules in the fiber and the ways in which the molecules are arranged. Many fiber properties, such as moisture regain, density, and tenacity, are directly related to the chemical structure; other properties, such as abrasion resistance and resilience, may be more sensitive to the extent to which the molecules may form crystals.

HOW FIBER PROPERTIES AFFECT PRODUCT PERFORMANCE

APPEARANCE Fashion will require that a material have particular esthetic qualities. The fiber can influence product esthetics by the way in which it reflects light; it may be bright if it has a smooth surface, or dull if it has a grainy surface. If the fiber is transparent, it may be very shiny, while the addition of delustrants will diffuse the reflected light and cause a more muted luster.

The type of cross-section a fiber has will affect the way in which light is reflected from the surface (Fig. 4.1). A fiber with a round cross-section will reflect light in one direction, causing a shiny surface. A lobed cross-sectional fiber tends to scatter the light that strikes the sides of the lobes, creating a more diffuse glow, while the light that strikes the tips of the lobes is not scattered and creates a bright spot on the surface; such a fiber will produce a fabric that sparkles. An irregular cross-section will scatter light in all directions, resulting in a dull appearance with few highlights.

The fineness of the fiber will affect fabric drape, the finer fibers making a more pliable cloth which flatters the wearer. The color of the fabric is dependent upon the fiber and the degree to which it accepts dyes.

Figure 4.1 Light reflection is affected by a fiber's cross-section: (a) round is shiny; (b) lobed is more diffuse with highlights; (c) irregular is dullest.

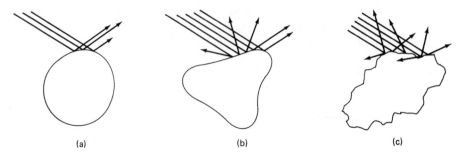

(a) (b) (c)

COMFORT Comfort is dependent upon the thermal conductivity, moisture absorption, surface friction, and stretch of the fiber. Fibers with high thermal conductivity will transfer heat readily so that garments made from these fibers will feel cool in summer. High moisture absorption will permit a rapid evaporation of moisture from the body and thus be more comfortable. Fibers with a moderate degree of surface friction will feel crisp; those with too low a level of friction will feel slick. If the surface friction is too high, the garment may feel rough. Stretching of the fiber will ensure that the garment provides the proper freedom of motion to the wearer.

MAINTENANCE Ease of maintenance is strongly dependent upon fiber properties. The fiber determines whether a garment should be laundered or dry-cleaned, whether it will wrinkle and require ironing. Fiber type also determines the types of soaps and bleaches needed to remove dirt, and whether or not the garment stains readily.

DURABILITY Durability of a garment depends upon the strength, abrasion resistance, dimensional stability, and spinning quality of the fiber. In general, the stronger the fiber the stronger the fabric made from the yarn. However, strength is also dependent upon yarn and fabric construction. Abrasion resistance of a cloth is very strongly dependent upon the abrasion resistance of the fiber, as is resistance to sunlight and heat.

COST The price of fibers, naturally, influences the cost of yarns and fabrics made from them. The factors that influence the cost of the natural and man-made fibers have traditionally been independent. The natural fibers, which are grown, were more labor-intensive than man-made fibers; a larger fraction of the cost of production went into wages. This meant that natural fibers were inexpensive where labor was cheap and expensive where labor was costly. Man-made fibers are capital-intensive. The major factor in their cost is the purchase of manufacturing plants and machinery. Man-made fiber producers can afford more expensive labor because the productivity of labor is high.

As farm labor became more scarce, however, and farms became more mechanized, the production of the natural fibers became more capital-intensive. Also, farms became more dependent upon manufactured chemicals to provide fertilizer to grow cotton or food for sheep. Petroleum was required to power farm machinery. The production of natural fibers has become dependent upon the same factors that influence the price of man-made fibers. These factors are the price of petroleum, which is used both as an energy source and as a raw material for fertilizer and fibers; the price of machinery, which is based on the cost of raw materials, energy, and skilled labor; and the cost of skilled labor.

Production of natural fibers in many nations may now be considered capital-intensive. The major difference is that man-made fibers are produced in large plants specifically designed for the purpose, staffed by skilled labor and trained professionals, while farming is a less specialized endeavor. In addition, natural fibers, being staple, require more processing to be turned into yarn than do man-made filament fibers. These factors have led to a turnabout in the

relationship between the price of natural and man-made fibers. Cotton yarn is now more expensive than nylon or polyester yarn. Wool has joined silk as a luxury fiber.

Safety is a performance property that has recently become important to consumers and manufacturers. It has been recognized that textile materials, particularly in apparel or home furnishings, can be a potential fire hazard. Congress has recognized the requirement to protect the consumer in legislation regulating the flammability of textile products. (This legislation is discussed in more detail in Chapter 19.) The flammability of materials is almost entirely dependent upon fiber properties. These are, in turn, determined by the microstructure of the fibers.

FIBER CLASSIFICATION

Until close to the turn of the century, fibers could be classified as animal, mineral, or vegetable. The major animal fiber was wool. Silk and a variety of exotic hairs and furs were used in luxury materials. The only mineral fiber was asbestos, the use of which was confined to high-temperature industrial products. The vegetable fibers of greatest importance were cotton and linen, although jute and hemp were used for sacks, nets, and other commercial products.

Today the classification must be broadened to encompass both natural and man-made fibers. Besides the distinction as to their *derivation* (natural or man-made), fibers are classified according to their *origin* (protein, cellulosic, petroleum, etc.), *generic type* (animal hair, bast, acrylic), and by *fiber name* (wool, linen) or *brand name* (Orlon). Table 4.1 illustrates one scheme whereby the recognized generic fiber types may be catalogued. (Brand names are, of course, too numerous to include.)

TABLE 4.1 Classification of Textile Fibers by Origin and Generic Type

NATURAL FIBERS			MAN-MADE FIBERS				
Cellulosic	*Protein*	*Mineral*	*Cellulosic*	*Rubber*	*Petroleum*	*Mineral*	*Protein*
Seed hair (cotton)	Animal hair (wool)	Asbestos	Rayon Acetate Triacetate	Rubber (natural)	Nylon Polyester Acrylic Modacrylic Olefin Spandex Aramid Novoloid Rubber (synthetic) Saran Vinyon Anidex* Nytril* Vinal*	Glass Metallic	Azlon*
Bast (flax) (jute)	(cashmere) Fur (angora)						
Leaf (sisal)	Secretions (silk)						
Husk (coconut)							

*Not presently manufactured in the U.S.A.

SUMMARY

Fibers may be classified by their derivation, origin, generic type, and name. The useful fibers are characterized by a high length-to-diameter ratio, spinning quality, fineness, strength, and flexibility. The macrostructure will affect light reflection, hand, and drape as well as comfort and ease of maintenance. The microstructure determines strength, elasticity and elongation, moisture absorption, ease of maintenance, and dyeability.

Natural fibers tend to have high moisture absorption, good sunlight resistance, a dry, crisp hand, and good dyeability. Man-made fibers tend to have lower moisture absorption and a slick, cool hand, but may be textured to provide improved comfort properties. The major advantages of man-made fibers are higher strength, lower cost, and improved ease of maintenance.

Fiber properties are usually the dominant factors affecting Comfort, Maintenance, and Durability, and have some effect upon Appearance and Cost.

REVIEW QUESTIONS

1. Identify the following fibers in terms of derivation, origin, and generic type: cotton, wool, acetate, spandex, nylon, acrylic, triacetate, polyester, silk.

2. Which man-made fibers might you expect to have properties similar to which natural fibers?

3. Why is the large length-to-diameter ratio of fibers important?

4. How do fiber properties affect the appearance of a fabric?

5. Why is the information on the label required by the Textile Fiber Products Identification Act important to the consumer?

6. How is the information on the label required under the Textile Fiber Products Identification Act used by the consumer?

7. Which fiber properties affect fabric comfort?

8. Can the same textile fiber be both very durable and very comfortable? Explain.

9. In which ways would you expect two fibers with the same microstructure but different macrostructures to differ in their properties?

5

natural fibers

Natural fibers have been used to make textiles since prehistoric times. They are still used today because, in many cases, artificial fibers cannot match either their performance or their low cost. In this chapter we shall discuss the three broad classes of natural fibers: *cellulosic*, *protein*, and *mineral*.

CELLULOSIC FIBERS

Cellulose is a high-molecular-weight polymer composed of carbon, hydrogen, and oxygen atoms. It is the major component of most plant cells, and therefore one of the most widely distributed organic materials. Cellulosic fibers, which account for more than half of the total consumption of textile fibers, may be produced from seed hairs, plant stems, leaves, or bark. In general, cellulosics provide excellent comfort properties, a high level of durability, and a strong affinity for dyes at low cost.

Cotton, linen, and jute are the three important cellulosic fibers that we will examine.

COTTON

Cotton is the world's most widely used fiber. Its popularity stems from both its relative ease of production and its applicability to a wide variety of textile products. The price of cotton yarn, however, is strongly dependent upon the

cost of labor, so that in the industrialized nations, where labor is expensive, cotton yarns may be relatively high priced.

It is likely that cotton was first commercialized as a textile fiber before 3000 B.C. in the Indus Valley, now modern Pakistan. It was known to the West as early as about 500 B.C. and was described by the Greeks as "the wool that grows on trees." There is some evidence that cotton has been cultivated in the New World for some 2,500 years.

Until relatively recent times, however, cotton was not as widely used as wool and linen. This was because it was easier to spin wool or flax into yarn because of their greater length. In addition, cotton fibers have to be separated from the seeds to which they cling. This procedure was very tedious and time-consuming when done by hand. Early machinery could be used on only the longest staple cotton, so labor costs tended to be very high.

The invention of the saw-type cotton gin by Eli Whitney made possible the exploitation of the shorter staple cotton which thrived in the Carolinas and Virginia. The dramatic increase in productivity, coupled with the low cost of slave labor in the southern United States, gave cotton a continually expanding portion of the world textile market. Increasing mechanization of fiber and yarn production helped keep the cost of cotton goods low in the century following the Civil War. The exportation of textile machinery to less developed nations such as Egypt and India enlarged the production base of the fiber, so that by 1950 cotton accounted for approximately 70 percent of world fiber production.

The seemingly limitless supply of low-cost petroleum available from the Middle East enabled man-made fibers to compete vigorously with cotton for the mass markets of the United States and Europe. At the same time, labor costs of cotton production rose, so that by 1979 cotton was supplying only 30 percent of U.S. fiber and 47 percent of world production. However, with petroleum prices rising since 1973, cotton has been able to maintain its position in the world market.

Fiber Production and Yarn Manufacture

Cotton cultivation requires warm climates with a high level of moisture or irrigation. The growing season is from six to seven months long. During this period the seeds sprout and grow, producing a white blossom in about 100 days. The blossom produces a seed pod which matures during the next two months. When the pod (boll) bursts, the cotton fibers are ready for picking.

The bolls are removed by mechanical pickers or strippers. The picker plucks the fibers from the boll, while the stripper removes the entire pod. The choice of machinery depends upon the type of cotton and the yield. Following picking, the cotton is ginned. The fiber is separated from the seeds and from most of the bits of twigs, leaves, pods, and dirt that have been captured with it during picking. The fibers are packed into 500-pound bales. The seeds are used for cattle feed and to make cottonseed oil.

Before yarn manufacture, cotton is graded, sorted, and blended to insure uniform yarn quality. Cotton is graded on the basis of its color, staple length,

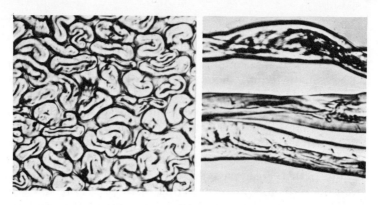

Figure 5.1 Photomicrographs of cotton fiber showing twisted ribbonlike structure and kidney-shaped cross-section. (*AATCC and ASTM*)

fineness, and freedom from foreign matter. The crop is rated on a seven-step scale from *good–middling* (best) to *good–ordinary* (poorest). Good–middling is the whitest, longest, finest, cleanest, and most lustrous of the lot. It requires the least amount of effort to produce high-quality cotton goods. Good–ordinary may be yellowish or gray, contain many bits of twigs and other trash, and is made up of the shortest, coarsest, dullest fibers. The blended fibers are spun into yarn by ring spinning or open-end methods.

Fiber Composition

MACROSTRUCTURE The cotton fiber may be from 0.3 to 5.5 cm ($\frac{1}{8}$ to $2\frac{1}{4}$ in) long. Under the microscope it appears as a ribbonlike structure that is twisted at irregular intervals along its length (Fig. 5.1). The twists, called "convolutions," increase the fiber-to-fiber friction necessary to secure a strong spun yarn. The fiber ranges in color from a yellowish to pure white, and may be very lustrous. However, most cotton is dull.

A cross-sectional view (Fig. 5.2a) reveals that the fiber is kidney-shaped with a central hollow core known as the LUMEN. The lumen provides a channel for nutrients while the plant is growing. A more detailed illustration of the cross-section is shown in Fig. 5.2b. The fiber is found to consist of an outer shell, or cuticle, which surrounds the primary wall. The primary wall, in turn, covers the secondary wall surrounding the lumen. The cuticle is a thin, hard shell which protects the fiber from bruising and damage during growth. In use as a textile fiber, the cuticle provides abrasion resistance to cotton. The primary wall is composed of a lattice network of thin cells known as FIBRILS (short fibers). The fibrils support the cuticle, and with it, stiffen and strengthen the fiber. The secondary wall is the flesh of the fiber. It is also composed of fibrils, though they are not packed as tightly as in the primary wall. The secondary wall provides flexibility. In addition, a small amount of slippage between the layers of the primary and secondary walls provides elasticity.

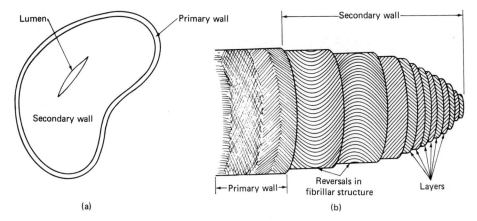

Figure 5.2 Schematic of cotton: (a) cross-section showing primary and secondary walls and lumen; (b) layered fibrillar structure of the walls.

MICROSTRUCTURE The cotton fiber is almost 100 percent CELLULOSE, a molecule composed of carbon, hydrogen, and oxygen atoms. It is a high-molecular-weight polymer, the basic unit of which is CELLOBIOSE, the repeat unit of cellulose (Fig. 5.3).

> The cellobiose repeat unit is composed of two beta-glucose monomer units linked by an oxygen atom. Thus, cellulose is a polysaccharide. Cellulose differs from other polysaccharides, such as starch, in the manner in which the glucose units are linked. In starch, the glucose units are joined by an oxygen atom that is not in the same plane as the rings. This prevents the molecules from packing together in an ordered arrangement. Cellulose, on the other hand, is a linear chain in which the oxygen links are in the same plane as the glucose rings. This structure allows the long molecules to pack together in neat, parallel rows within the fibrils of the fiber. Because cellulose can form well-ordered structures, it is insoluble in water. Starch, which cannot form well-ordered structures, is soluble in water.

The regions in which the cellulose chains are neatly packed are mostly crystalline. Thus, they are strong and rigid. Between 85 and 95 percent of the cotton fiber is composed of these ordered regions, so that the fiber is strong and relatively stiff. The manner in which the cellulose chains are arranged within the ordered regions of the cotton fiber are much like the fringed micelle model illustrated in Fig. 3.15a (see p. 58).

Figure 5.3 Cellobiose—the repeat unit of cellulose.

73

Figure 5.4 Simplified schematic of hydrogen bonding between cellulose chains.

HYDROGEN BONDING

Protruding from the ring formed by one oxygen and five carbon atoms are three *hydroxyl* (−OH) groups. These groups are POLAR. That is, the electrons surrounding the atoms are not evenly distributed. These groups may be likened to small magnets in which the H atom is a North pole and the O atom is a South pole. The H atoms of the hydroxyl groups are attracted to many of the O atoms of the cellulose in a manner similar to the way in which the North pole of a magnet is attracted to the South pole of another magnet. This attraction is called HYDROGEN BONDING. Hydrogen bonding within the ordered regions of the fibrils draws the molecules closer to each other and increases the strength of the fiber. Hydrogen bonding in cellulose is extremely complex. Fig. 5.4 is a stylized representation of this phenomenon, in which the attraction between −O− atoms and −OH groups is readily apparent.

Hydrogen bonding also plays an important role in moisture absorption. The reason that cotton ranks among the most absorbent fibers is that the oxygen atom in water (H_2O or $H—O—H$) acts as a South pole which is attracted to the North poles of the hydroxyl groups in the cellulose. The ability to absorb moisture is one of the main factors contributing to the comfort of cotton.

Fiber Properties

The important physical and chemical properties of cotton are listed in Table 5.1.

APPEARANCE Cotton, except for the longest, finest fibers, is a dull fiber with low luster. It is often bleached to improve its whiteness and light reflection.

COMFORT A relatively high level of moisture absorption and good wicking properties help make cotton one of the more comfortable fibers.

TABLE 5.1 Properties of Cotton

Molecular Structure	Cellulose.
Macroscopic Features	
Length:	0.3 to 5.5 cm.
Cross-section:	Kidney-shaped.
Color:	Generally white, may be cream-colored or brown.
Light reflection:	Low luster, dull appearance.
Physical Properties	
Tenacity (g/den):	3.0 to 5.0 (dry), 3.6 to 6.0 (wet).
Stretch and elasticity:	3 to 7% elongation at break. At 2% elongation recovery is 70%.
Resiliency:	Low.
Abrasion resistance:	Fair to good.
Dimensional stability:	Fabrics may shrink during laundering.
Moisture regain:	8.5%.
Specific gravity:	1.54.
Chemical Properties	
Effects of bleaches:	Highly resistant to all bleaches.
Acids and alkalies:	Highly resistant to alkalies. Strong acids and hot dilute acids will cause disintegration.
Organic solvents:	Resistant to most organic solvents.
Sunlight and heat:	Withstands high temperatures well. Prolonged exposure to light will cause yellowing due to oxidation.
Resistance to stains:	Poor resistance to water-born stains.
Dyeability:	Good affinity for dyes. Dyed with direct, vat, and basic dyes. Vat dyeing produces excellent wash and lightfastness.
Biological Properties	
Effects of fungi and molds:	Highly susceptible to attack by mildew. Mildew will promote odor and discoloration and result in rotting and degradation.
Effects of insects:	Starched cottons are attacked by silverfish.
Flammability Behavior	Burns rapidly. Smoldering red afterglow.
Electrical and Thermal Conductivity	Good heat conductor.

Because of the hydroxyl groups in the cellulose, cotton has a high attraction for water. As water enters the fiber, cotton swells and its cross-section becomes more rounded. The high affinity for moisture and the ability to swell when wet allows cotton to absorb about one-fourth of its weight in water. This means that in hot weather perspiration from the body will be absorbed in cotton fabrics, transported along the yarns to the outer surface of the cloth and evaporated into the air. Thus, the body will be aided in maintaining its temperature.

MAINTENANCE Unfortunately, the hydrophilic nature of cotton makes it susceptible to water-borne stains. Water-soluble colorants such as those in coffee or grape juice will penetrate the fiber along with the water; when the water evaporates, the colorant is trapped in the fiber. Perhaps the major disadvantage to cotton goods is their tendency to wrinkle and the difficulty of removing wrinkles. The rigidity of cotton fibers reduces the ability of yarns to resist wrinkling. When the yarns are distorted, the fibers are bent to a new

configuration. The hydrogen bonds which hold the cellulose chains together are ruptured and the molecules slide in order to minimize the stress within the fiber. The hydrogen bonds re-form in the new positions, so that when the crushing force is removed the fibers stay in the new positions. It is the rupture and re-formation of the hydrogen bonds that helps to maintain wrinkles, so that cotton goods must be ironed.

DURABILITY Cotton is a moderately strong fiber with good abrasion resistance and good dimensional stability. It is resistant to the acids, alkalies, and organic solvents normally available to consumers. But since it is a natural material, it is subject to attack by insects, molds, and fungus. Most prominent is the tendency of cotton to mildew if allowed to remain damp.

Cotton resists sunlight and heat well, although direct exposure to constant strong sunlight will cause yellowing and eventual degradation of the fiber. Yellowing may also occur when cotton goods are dried in gas dryers. The color change is the result of a chemical reaction between cellulose and oxygen or nitrogen oxides in the hot air in the dryer. Cottons will retain their whiteness longer when line-dried or dried in an electric dryer.

Of major interest is the fact that cotton yarn is stronger when wet than when dry. This property is a consequence of the macro- and microstructural features of the fiber. As water is absorbed, the fiber swells and its cross-section becomes more rounded. Usually the absorption of such a large amount of foreign material would cause a high degree of internal stress and lead to weakening of the fiber. In cotton, however, the absorption of water causes a decrease in the internal stresses. From Fig. 5.2(b) we see that the cellulose fibrils form spirals in reverse directions within the secondary wall. These reversals are regions of high-stress concentration. As the fiber swells, the angle of reversal is reduced and the stress is reduced. Thus, with less internal stresses to overcome, the swollen fiber becomes stronger. At the same time, the swollen fibers within the yarns press upon each other more strongly. The increased friction strengthens the yarns. In addition, the absorbed water acts as an internal lubricant which imparts a higher level of flexibility to the fibers. This accounts for the fact that cotton garments are more easily ironed when damp. Cotton fabrics are susceptible to shrinkage upon laundering.

Uses

Perhaps more than any other fiber, cotton satisfies the requirements of apparel, home furnishings, recreational, and industrial uses. It provides fabrics that are strong, lightweight, pliable, easily dyed, and readily laundered. In apparel, cotton provides garments that are comfortable, readily dyed in bright, long-lasting colors, and easy to care for. The major drawbacks are a propensity for cotton yarns to shrink and for cotton cloth to wrinkle. Shrinkage may be controlled by the application of shrink-resistant finishes. Durable-press properties may be imparted by chemical treatment or by blending cotton with more wrinkle-resistant fibers, such as polyester.

In home furnishings, cotton serves in durable, general-service fabrics. Although they may lack the formal appearance of materials made from other fibers, cotton goods provide a comfortable, homey environment. Cotton

fabrics have been the mainstay of bed linens and towels for decades, because they are comfortable, durable, and moisture-absorbent. Polyester/cotton blends provide the modern consumer with no-iron sheets and pillowcases that retain a crisp, fresh feel.

For recreational use, cotton has traditionally been used for tenting and camping gear, boat sails, deck and tennis shoes, and sportswear. Cotton is particularly well-suited for tents. A tent fabric must be able to "breathe," so that the occupants are not smothered in their own carbon dioxide. Furthermore, exchange of air with the outside atmosphere reduces the humidity within the tent and keeps it from becoming stuffy. Fabrics woven from cotton can be open enough to provide good air permeability for comfort. Tents should also shed water; when wet by rain, cotton yarns swell, reducing the interstices between the yarns and resisting the penetration of water. Today, however, heavy canvas gear is being supplanted by lighter-weight nylon in tenting and backpacking equipment.

Cotton cord, twine, and ropes are used in industry to bind, hold, and lash all kinds of things, from bales to boats. Cotton yarns are used to reinforce belts on drive motors, as cargo nets, and in work clothing.

LINEN

Linen has been used for millennia as a textile material. Linen fabrics dating to as early as 4500 B.C. have been uncovered in Egyptian archaeological sites. Until silk was introduced to the West, in about A.D. 500, linen was the choice of the wealthy, because it produced fabrics that were lighter, more comfortable, and more flattering than those made from cotton or wool. In the ancient world, as today, linen was relatively expensive.

Fiber Production and Yarn Manufacture

Linen is a bast fiber obtained from the stem of the FLAX PLANT, which grows best in regions of abundant rainfall. When the immature plants have grown to a height of about 1 m (3 ft), they are pulled up by the roots. After removal of the seed pods, the stalks are bundled and allowed to rot in tanks of water or in streams, from a few days up to three weeks. This process, known as *retting*, loosens the linen fibers from the woody core. The retted and dried stalks are passed through fluted rollers which break the woody material into splinters called *shive*. These are pulled away from the fibers by being beaten with wooden or metal blades in an operation known as *scutching*. This is followed by a combing process called *hackling*, whereby the bundles of linen fibers are passed through combs to separate the short fibers, *tow*, from the long fibers, *line*. Linen is spun into yarn while it is wet to prevent breaking and splintering of the fibers.

Linen is not produced in abundance because the flax plant is limited to areas of high rainfall, farming is not readily mechanized, and fiber processing requires a good deal of hand labor. Linen has many fine qualities, which,

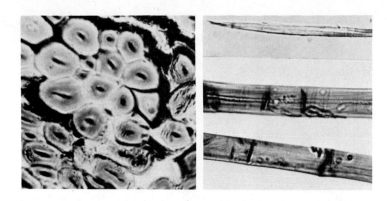

Figure 5.5 Photomicrographs of linen fibers showing the nodes in the longitudinal view and the irregular cross-section. (*AATCC and ASTM*)

despite its high cost of production, allow it to compete with other fibers. Today, linen is considered a luxury fiber, and its production rate is relatively low. Ireland, Belgium, and the Soviet Union are the major sources of linen and linen goods.

Fiber Composition

MACROSTRUCTURE Under the microscope, commercial linen is found to consist of bundles of individual fibers held together by natural cements (Fig. 5.5). The fiber bundles range in length from about 4 cm (2 in) for *tow*, to 1 m (3 ft) for *line*. The mean diameter of an individual fiber is abut 20 μ (0.0008 in). The fibers are composed of single cells, about 3 cm (1½ in) long, joined end to end. The surface of the fiber is smooth, with protuberances, called *nodes*, irregularly spaced along the length.

A cross-sectional view reveals that the individual fibers are polygonal in shape, with a thick, fleshy wall surrounding a central hollow core, or lumen. However, the lumen in mature fibers is not as pronounced as in cotton. A fiber bundle is illustrated in Fig. 5.6. The fiber ranges in color from creamy white to yellowish brown to gray. Residual wax from the flax stem helps to give linen its lustrous appearance.

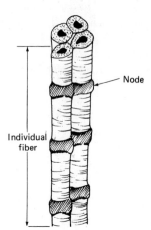

Figure 5.6 Individual fibers in the flax stem.

MICROSTRUCTURE Linen is about 70 percent cellulose, so that its molecular structure is very similar to cotton.

However, the fibrils forming the cells of the fiber do not exhibit the reversals of direction that are prominent in cotton. In addition, the spiral angle of the fibrils, as they coil about to form the interior of the cell, is less than in cotton. Not having reversals within the cell means that linen does not have the high internal stress that cotton has. Thus, the fiber may be expected to have a high tenacity. Because the spiral angle is lower, the fibrils are straighter and more difficult to extend. This means that linen will be more rigid and have lower elongation than cotton.

Fiber Properties

The important physical and chemical properties of linen are listed in Table 5.2.

TABLE 5.2 Properties of Linen

Molecular Structure	Cellulose.
Macroscopic Features	
Length:	30 to 100 cm.
Cross-section:	Oval or polygonal.
Color:	May vary from light ivory to dark tan or gray.
Light reflection:	Good luster, almost silky in appearance.
Physical Properties	
Tenacity (g/den):	5.5 to 6.5.
Stretch and elasticity:	2.7 to 3.3% elongation at break. At 2% elongation recovery is 65%.
Resiliency:	Poor resiliency, creases and wrinkles badly.
Abrasion resistance:	Fair to good.
Dimensional stability:	Fibers will not stretch or shrink, but fabrics are subject to relaxation during laundering.
Moisture regain:	10 to 12% at 65% relative humidity.
Specific gravity:	1.50.
Chemical Properties	
Effects of bleaches:	Unaffected by common household bleaches.
Acids and alkalies:	Easily damaged by hot dilute or cold concentrated acids. Highly resistant to all alkalies.
Organic solvents:	Resistant to organic solvents.
Sunlight and heat:	Extended exposure to sunlight weakens fibers. Scorches at high temperatures.
Resistance to stains:	Is not as harmed by water-borne stains as cotton and will give up stains more readily.
Dyeability:	Linen does not have a good affinity for dyes. It is dyed with direct and vat dyes.
Biological Properties	
Effects of fungi and molds:	Very vulnerable to damage by mildew.
Effects of insects:	Not damaged by insects.
Flammability Behavior	Burns rapidly. Smoldering red afterglow.
Electrical and Thermal Conductivity	Good electrical and heat conductivity.

APPEARANCE The smooth surface and residual waxes in the fiber make linen relatively bright.

COMFORT Linen has a relatively high moisture regain, which helps linen fabrics feel comfortable. In addition, the smooth yarns obtained from the long fibers do not retain heat easily, so that linen garments feel cool in warm weather. Linen has a smooth hand as a consequence of the long fiber length and the wax that is retained in the fiber bundles.

MAINTENANCE These same factors increase the soiling resistance of linen goods. Dirt cannot adhere readily to the surface, so that linen cloth maintains a clean appearance longer than cloth made from shorter staple fibers.

Linen is a strong, rigid fiber with little stretch and low elasticity. The stiffness of the fiber makes all but the finest yarns rather inflexible. Thus, linen cloth tends to wrinkle. It resists dilute acids and alkalies, and is not affected by dry-cleaning solvents. Extended exposure to sunlight causes a decrease in strength, but this decrease is less than for cotton.

DURABILITY Linen yarns are stronger than equivalent cotton yarns because the fibers are stronger and longer than cotton. The higher tenacity of linen is a result of decreased internal stress and the greater length of the fibers. The latter factor means that each fiber has more surface in contact with other fibers in the yarn. The increased friction between fibers enables the yarns to withstand a greater tensile force. Abrasion resistance is aided by the small amount of wax retained in the fiber. Like cotton, linen is stronger wet than dry.

If stored at high humidity, linen will mildew, although not as readily as cotton. It has greater resistance to insect attack than cotton because of the wax in the fiber.

Uses

Because of its high production cost and the fact that it wrinkles easily, linen does not enjoy the widespread popularity it once had. However, because linen fabrics are strong, lightweight, drape well, feel cool, and resist soiling, they are suited for higher-quality summer apparel.

Linen is often finished by a process known as *beetling*, which flattens the cloth and gives it a high luster. Beetled linen, providing an elegant and attractive appearance, is well suited for table linens. Linen towels are used to dry glasswear and optical equipment because they absorb moisture readily and do not leave lint. Linen sewing threads are used for shoes and boots because of their high strength and their ability to swell when wet. The latter property prevents water from penetrating through the needle holes in the leather.

Jute is grown in India, Bangladesh, and China. It is by far the most important bast fiber, second only to cotton in worldwide production. Known in the Orient since Biblical times, jute was introduced to Europe during the late eighteenth century. During the nineteenth century jute was used as a replacement for linen and cotton, when supplies of those fibers were difficult to obtain. Jute has traditionally been a very inexpensive fiber. It is used mainly for ropes, sacks, and nets. Higher-quality bleached jute burlap has sometimes been used as a fashion fabric in apparel and wall coverings. However, because it is brittle, scratchy, and has low durability, the fiber is generally limited to commercial items.

Fiber Production and Yarn Manufacture

Jute plants are cultivated in warm, humid climates. Seeds are planted densely to avoid formation of leaves, which would make securing the fiber from the plant more difficult. The stalks are harvested when they are about 3 to 4 m (10 to 13 ft) high and 1 to 2 cm ($\frac{1}{2}$ to $\frac{3}{4}$ in) in diameter. They are then retted, much like linen, until the fibers can be pulled from the stem. The fibers are washed, dried, baled, and shipped to spinning mills. Unlike linen, which has its own natural lubricants, jute must be oiled during processing. The residue of these oils imparts a brownish color to the fiber.

Fiber Composition

MACROSTRUCTURE Like linen, jute fiber consists of strands of individual fibers held in bundles by natural cements. The strands are usually $1\frac{1}{2}$ to 2 m (5 to $6\frac{1}{2}$ ft) long. Individual fibers (Fig. 5.7) are often five- or six-sided polygons with a central oval lumen. The lumen varies in size along the length of the fiber, so sometimes the fiber appears fleshy with a small lumen, while

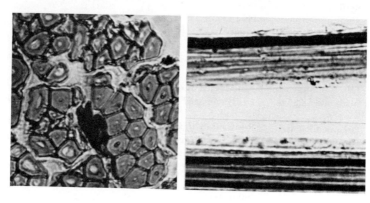

Figure 5.7 Photomicrographs of jute fibers showing longitudinal striations and the irregular cross-section. (*AATCC and ASTM*)

other sections may show a large lumen surrounded by very thin walls. The fiber diameter is approximately 20 μ (0.0008 in). Each fiber is composed of a chain of cells, about 0.1 to 0.5 cm (0.06 to 0.2 in) in length. Usually the surface is coarse, although the finest jute may be as soft and smooth as good linen.

MICROSTRUCTURE Jute is composed of 65 percent cellulose and 35 percent natural waxes, oils, and cements. The fiber is weaker than linen or cotton. In addition, the sunlight resistance of the minor constituents is relatively low, so that the fiber discolors upon exposure to sunlight. These materials also reduce the fading resistance of dyed jute and dull the colors obtainable.

Fiber Properties

The important physical and chemical properties of jute are listed in Table 5.3.

Jute is a stiff fiber with very low elongation. It is not as strong as linen or cotton, but this deficiency may be overcome by the use of heavier yarns. It is hydrophilic, but its wet strength is less than when it is dry. The fiber has a moderate luster but only poor to fair abrasion resistance. Broken individual

TABLE 5.3 Properties of Jute

Molecular Structure	Cellulose.
Macroscopic Features	
Length:	1½ to 2 m.
Cross-section:	Polygonal with a central lumen.
Color:	Yellow to brown to grey. May be bleached to white.
Light reflection:	Dull.
Physical Properties	
Tenacity (g/den):	1 to 4.
Stretch and elasticity:	2% elongation at break. Very low elasticity.
Resiliency:	Poor.
Abrasion resistance:	Poor to fair.
Dimensional stability:	Good.
Moisture regain:	13.8%.
Specific gravity:	1.5.
Chemical Properties	
Effects of bleaches:	Not affected by oxidizing or reducing bleaches.
Acids and alkalies:	Easily damaged by hot dilute or cold concentrated acids. Resistant to alkalies.
Organic solvents:	Resistant to organic solvents.
Sunlight and heat:	Poor sunlight resistance. Scorches at high temperatures.
Resistance to stains:	Poor resistance to water-borne stains.
Dyeability:	Easily dyed, but light- and washfastness are poor.
Biological Properties	Scoured jute has good to excellent resistance to micro-organisms and insects.
Flammability Behavior	Burns rapidly. Smoldering red afterglow.
Electrical and Thermal Conductivity	Moderate conductor of electricity and heat.

fibers cause the yarns to be somewhat hairy. If kept dry, clean, and away from direct sunlight, jute will last indefinitely. It resists attack by micro-organisms and pests because of the protective layers of noncellulosic materials.

Uses

Jute's major advantage is its rigidity. Sacks and ropes made from jute yarns will resist stretching. This assures that bindings will remain tight, and that cargoes will not shift during transportation. In consumer use, jute has been the material of choice for primary and secondary backings for carpets. The strength and dimensional stability of the backing prevent the carpeting from stretching in use.

Another obvious advantage is low cost. However, political instability coupled with variable weather conditions has caused the world price of jute to fluctuate over the past decade. The unstable pricing has made manufacturers cautious in their use of jute; and other materials, particularly polypropylene, have made major inroads on the use of jute in carpets and bindings.

OTHER CELLULOSIC FIBERS

Cotton, linen, and jute have been discussed to illustrate the properties of seed hair and bast fibers, as well as the properties of natural fibers with high and low cellulose contents. There are many more cellulosic materials that are useful as textile fibers. Most of these, such as hemp, kenaf, ramie, and nettle, are bast fibers. Sisal, henequen, and abaca are obtained from large, fleshy plant leaves. In general, these fibers are used to manufacture rope, nets, and sails, although on occasion they are used for decorative apparel. Some of the less widely used cellulosic fibers are discussed below.

Abaca

Abaca produces the highest-quality cordage fiber. It is particularly prized for marine uses—e.g., for ships' ropes and hawsers. The fiber is essentially a product of the Philippines, although other Pacific countries produce small amounts. The fiber is extracted from the leaves of the *Musa textilis*, of the same family of plants from which we obtain bananas. The plant consists of a thin stem, about 5 cm (2 in) in diameter, surrounded by a sheath of from twelve to twenty-five leaves. The leaves grow from the base of the stem and reach a height of 5 to 7 m (16 to 23 ft). At maturity, the leaf sheath forms a stalk about 15 cm (6 in) in diameter around the stem.

The stalks are cut when the plant is about two years old, and the leaves are stripped from the stem. The fibers found in the outer portion are stripped from the rest of the leaf. This mat of fibers, known as a *tuxy*, is broken up and the pulp removed by a decorticating machine. The resultant fiber is washed and dried before being spun. Approximately 200 kg (440 lb) of leaves are processed to obtain 1 kg (2.2 lb) of fiber.

Like the bast fibers, abaca consists of bundles of individual fibers formed into strands. These fiber strands average 3 m (10 ft) in length, although many are as long as 5 m (16 ft). Unlike the bast fibers, abaca is flexible, and has moderate elasticity as well as high strength. It is unusually resistant to rotting by seawater and degradation by sunlight.

Hemp

Indigenous to Eastern Asia, this bast fiber has been used for a variety of textiles for centuries. It was introduced to the Mediterranean during the early Modern Era as a replacement for linen. It achieved some commercial importance in the United States in the late eighteenth century and again during World War II when jute was in short supply.

Hemp is harvested and processed in much the same way as linen. It is coarser than linen, darker in color, and not as strong. Carefully selected and processed hemp can be used to produce fabrics that rival the finer linens. Hemp is used almost exculsively for cord and rope, sacks, and similar commercial products.

Henequen

Also called Cuban sisal, henequen is grown in Mexico and Cuba. The fiber is taken from a plant similar to *Agave sisalana*, and is much like sisal in its properties. The strands of henequen fiber are longer and finer than sisal, and yarns made from them are stronger and more durable. The fiber is used for twine, mats, and canvaslike materials.

Kapok

A seed-hair fiber, similar in appearance to cotton, kapok is very light and buoyant. The fibers are too rigid to be successfully spun into yarn, but make excellent stuffing for upholstery and life vests. Kapok fiber will support over thirty times its weight when submerged in water. In addition, it absorbs moisture slowly, so that it does not become waterlogged and will not sink for many days. Once the material of choice for life vests, kapok has been replaced by the inflatable life jacket. It is, however, often used as a filling for sleeping bags because it does not mat readily, resists moisture and mildew, and provides a warm filling.

Kenaf

Also known as Guinea hemp, kenaf is a bast fiber similar to jute. It has been used in India, Asia, and Africa for thousands of years, but became of interest in Europe and the United States when World War II limited supplies of jute. It grows well in hot, damp climates, reaching heights well over 3 m (10 ft). Though harvested and processed much like jute, it is weaker and less uniform. The fibers are paler, and do not resist sunlight as well. Kenaf finds its major uses in canvas, sacks, rope, and twine. The higher grades are used as a substitute for jute in carpet backing.

Nettle

Nettle has been widely used in Scandinavian countries for the manufacture of sails and other canvaslike materials. The long, creamy white fibers are removed from the plant stalk by retting and boiling. The fibers are hackled before spinning. The best-quality yarns are soft and have a pleasant hand; they are sometimes used in apparel and home furnishings. The bulk of the production goes into industrial uses.

Ramie

This bast fiber, also known as China grass, comes from the family of nettles. Originally cultivated in China and subtropical Asian countries, ramie came into widespread use in Europe and the Mediterranean countries during the Middle Ages. During the nineteenth century efforts were made to commercialize ramie on the scale of flax. It was felt that this fiber, which is almost as strong as linen, has good dyeing qualities and a pleasing luster, could be used to replace linen in apparel and upholstery uses. However, the difficulty of removing the fiber from the plant stem, and the necessity for removing the natural gums and cements that adhere to the fiber, made production costs too high.

Ramie is a lustrous white fiber that dyes well, has good moisture absorption, and dries quickly. The fibers are somewhat stiff and coarse, and the yarns are rather hairy, strong, and inelastic. Ramie is generally employed for industrial products, although it is occasionally found in upholstery and other home-furnishing fabrics.

Sisal

Sisal, a leaf fiber, was widely used by the ancient peoples of Mexico and Central America. It is a stiff, lustrous, yellowish-white fiber with good moisture absorption and a high affinity for dyestuffs. It is inferior to linen and cotton for use in apparel, but makes long-lasting, attractive mats and rugs. Its major end use is in ropes and cordage.

Sisal is obtained from the broad, fleshy leaves of the *Agave sisalana* plant. At about four to eight years of age, the plant produces as many as 200 leaves measuring 1 to $1\frac{1}{2}$ m (3 to $4\frac{1}{2}$ ft) in length. The leaves are harvested and scraped so that the flesh can be removed from the fiber. After being washed, the fibers are sun-dried to bleach the fiber. The sisal is then spun into yarn.

REVIEW QUESTIONS

1. Sketch the cross-section of the cotton fiber and label its parts.
2. Sketch the cross-section of the linen fiber and label its parts.
3. Why is linen more lustrous than cotton?
4. Explain why cellulose fibers have poor wrinkle resistance and wrinkle recovery.
5. Explain why cellulose fibers have a relatively high moisture regain.
6. What factors work against the use of jute in wearing apparel?

7. Why are linen fabrics so much more expensive than cotton fabrics?
8. What properties of jute make it useful for sacks and bags?
9. Cotton fibers stretch more than linen fibers. Explain why.

PROTEIN FIBERS

The natural protein fibers are derived from the coats of animals or from animal secretions. Wool, hair, and fur fibers form the first class, and silk is the product of the second. The fibrous cover of many mammals is composed of an outer layer of long, coarse fibers called hair and an undercoat of softer fibers, called wool. In the textile trade, the term "wool" is used only for the fibers derived from sheep; all other wools bear the name of the animal from which they are obtained—e.g., cashmere wool, vicuña wool. Hair and wool fibers range from 5 to 30 cm (2 to 12 in) in length.

The coat of some animals is fur rather than hair. While hair grows continuously, fur is shed in the summer and grows again during the winter. Hair is longer, generally softer than fur, and easier to spin into yarn. Most fur-bearing animals are raised for their pelts, the fur-covered hides, which are converted by furriers into garments. However, some animals, such as the Angora rabbit, are raised for their long, fine, soft fur fibers. Chemically and physically, fur is similar to hair. However, hair makes a stronger, more durable cloth and is easier to obtain than fur. In addition, only a small fraction of a pelt is suitable for spinning into yarn. For these reasons, fur is used almost exclusively for decoration. Fur is supplied to the textile industry as the byproduct of the furrier and hatmaker trades.

We are, perhaps, fortunate that protein filament fiber was discovered before the inception of regulatory agencies and the definition of fiber types. A product composed of "100 percent proteinaceous larval secretion" doesn't have the consumer appeal of "pure silk." Silk is chemically similar to animal hair and fur, but its physical characteristics are completely different. The physical differences are a consequence of the roles that nature intended for the different fibers. Hair and fur protect the animal from rain and cold; silk provides a cocoon into which moth larvae retreat during their change into the adult form. The different functions call for differences in surface texture, strength, elongation and elasticity, and thermal properties. These differences will be examined in the following sections.

WOOL

The important hair fibers are obtained from the sheep, goat, and camel families. By far, the most important of these is wool. Once the major textile fiber, the production of wool today is but a small fraction of what it once was. The need for its warmth has decreased as average world temperatures have risen, the climate has become dryer and more moderate, and central heating has become more widespread. In addition, rising labor costs have given a better competitive position to man-made fibers. Despite these reversals, wool is still one of the most useful textile fibers. Its durability and warmth remain

standards against which man-made fibers are appraised. Despite its high cost, the combination of Appearance, Comfort, and Durability make wool highly prized in home furnishings as well as apparel uses.

The use of wool has a long history. Early nomadic peoples raised sheep for their meat and hair. The wool of these early animals was merely a light down layer over the skin. Over the centuries, people learned the rudiments of breeding, so that the downy layer became longer and more easily spun into yarn. At the same time, the yield of wool increased. The Old Testament offers evidence that the production of wool was an important and thriving industry in the Middle East about 3,000 years ago. The Phoenician traders carried cargoes of woolen cloth to Spain and Northern Europe before the Roman Empire had formed. Interestingly enough, the return cargoes carried, along with iron and tin, wool.

Domesticated sheep were introduced into Britain at the time of the Celtic invasions in the sixth and seventh centuries B.C. By the time of the Roman invasion in 55 B.C., the Britons had developed a flourishing trade in wool and wool goods. The upheavals that followed the progress of the Roman armies greatly reduced the quantity of wool available in the Mediterranean area, so that the Romans received much of their wool from Britain. The invasion by the Saxons in the fourth and fifth centuries destroyed the herds and the workshops and reduced wool production to the level of home consumption.

The migrations from Central Asia through Europe and the Mediterranean led to the scattering of sheep throughout Europe. In the mountains and plains of Spain, shepherds found pasture and climate that allowed their herds to flourish. Selective breeding led to the development of the hardy merino breed. By 1700 Spain was producing the world's finest wool from some ten million merino sheep.

England, however, had not completely lost its capacity to produce wool. Fresh stocks were brought over by William the Conqueror during the Norman Invasion. By the twelfth century, the English had built up a woolen trade that rivaled the Spanish in quantity, though not in quality. Breeding stock smuggled out of Spain enabled the English to improve their herds. By 1800 England had a sheep population of 13,000,000.

The first colonists to settle North America brought in sheep of unimproved English and Dutch varieties whose wool was inferior to that imported from England. Bounties were offered to anyone who could introduce a full-blooded merino into the Colonies. It seems that the first pair of merinos arrived in 1793, but their owner, unaware of their value, ate them! In 1809 the American consul to Portugal seized the opportunity afforded by political unrest in Spain to ship some 4,000 merinos to the United States. These sheep, combined with other stocks brought from Europe, formed the foundation of the wool industry in the United States.

In 1942 U.S. production exceeded 200,000,000 kg (440,000,000 lb) of wool. Since the end of World War II, changes in consumer demands, rising labor costs, and competition from other fibers have caused a decline in wool production. In 1981, wool accounted for only about 1 percent of world fiber consumption.

Fiber Production and Yarn Manufacture

Sheep thrive and produce the best wool in temperate regions that provide good pasture. Although a significant number are raised on flatlands, from time immemorial sheep have been herded to mountain ranges for summer pasture and returned to sheltered valleys for the winter. The lambs are born in November, and the migration to summer pasture beings in April. Shearing begins in the spring and continues through the summer. The finest fiber, lamb's wool, it taken from sheep about eight months old. Hog wool is a coarser, stronger, longer fiber produced by older sheep. The wool of very old sheep is usually of inferior quality.

After shearing, the fleece is sorted and graded. There are thirteen grades of wools, which can be grouped as fine, medium, coarse, and carpet quality. The quality of the wool is based on its fineness or diameter, and length. The long, fine fibers, or *tops*, which may be 15 to 20 cm (6 to 8 in) long, are used for the finest worsted yarns. The shorter fibers, 6 cm (2.5 in) or less, are used in woolens. Usually, the best wool comes from the shoulders of the animal, with the sides and back yielding the next best grades. The wool from the head, legs, and belly is often coarse, short, and matted, yielding a low-grade product.

After sorting, wool is baled and shipped to the yarn manufacturer. Here it is again sorted, scoured, and dried. Since wool is a natural product, its quality varies from year to year. To insure product uniformity, wool from different bales is blended. Often the manufacturer will keep an inventory from two or three years' wool crops to assure the yarn quality. Blended wools are spun into yarns or used for making felt.

Fiber Composition

MACROSTRUCTURE The wool fiber grows from an opening in the sheep's skin, called a *follicle*, in the same way that human hair grows from the skin. Within the follicle, the root of the fiber is a living organism. Outside the skin, the fiber is dead. To the naked eye, wool appears as a curled, crimped rod. However, under the microscope a very complex internal and external structure is seen. A longitudinal view of a wool fiber is shown in Fig. 5.8. The fiber is covered by a scaly layer known as the CUTICLE. The scales of the cuticle are coated with an extremely thin, waxy film known as the *epicuticle*. This layer is the only part of the fiber that is not a protein material. It is water-repellent, but is pierced by thousands of submicroscopic pores which allow water vapor to pass through.

The irregular plates, known as *epithelial scales*, overlap each other from tip to root of the fiber, much like roof shingles. In the fine wools, the scales may wrap completely around the fiber; in the coarser fibers, the scales are too small to do this. They overlap both horizontally and vertically, like armor plate. The cuticle is itself composed of an outer layer, the *exocuticle*, and an inner layer, the *endocuticle*. The layering of the cuticle permits a stronger, more flexible material than if the cuticle were solid.

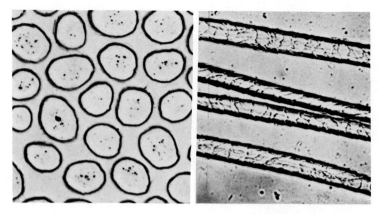

Figure 5.8 Photomicrographs of wool fibers showing the scaly cuticle and the nearly round cross-section. (*AATCC and ASTM*)

Within the cuticle, the CORTICAL LAYER makes up over 90 percent of the weight of the wool. The cortex is composed of spindle-shaped cells measuring about $100\,\mu$ (0.004 in) in length and $2\,\mu$ in diameter. The cortical cells are made up of millions of *fibrils* (small fibers). The fibrils contain microfibrils, which join the fibrils within the cortical cells. The microfibrils also maintain the bonds between the cortical cells within the fiber.

The overall structure is shown in Fig. 5.9. All the cortical cells are not alike. It has been shown that there are two types, designated by the prefixes *para* and *ortho*, which differ in their structure. Figure 5.10 shows a cross-section of wool fiber that has been treated to show the two types of cells. Because the wool fiber is formed in two dissimilar sections, the two sides respond differently to changes in temperature and humidity. This differential response to environmental conditions helps give wool its crimped, curled structure.

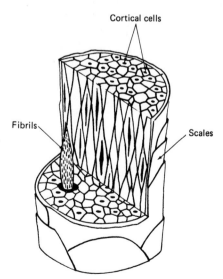

Cortical cells

Fibrils

Scales

Figure 5.9 Schematic of wool. The cuticle surrounds an inner structure, the cortex, made up of millions of small spindles (cortical cells) which are composed of even smaller structures called fibrils. (*The Wool Bureau, Inc.*)

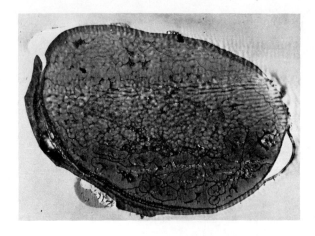

Figure 5.10 Cross-section of a wool fiber showing the cuticle and the two types of cortical cells. (*Textile Physics Laboratory, University of Leeds, England*)

At the center of the wool fiber is the MEDULLA. In immature fibers, this is a prominent, hollow central core. In the mature fiber, the medulla may be invisible. Unlike the lumen in cotton, the medulla in wool does not serve to nourish the fiber. It provides internal air spaces that make the fiber lighter and a better thermal insulator. Fibers with a large medulla are straight, coarse, and difficult to spin.

MICROSTRUCTURE Wool is a PROTEIN; a high-molecular-weight, naturally occurring organic compound composed of carbon, hydrogen, oxygen, nitrogen, and sulfur. Proteins are an essential constituent of the tissues of all animal life. The atoms join together to form *amino acids*, eighteen of which have been found in wool, which are linked together in a polymer known as a *polypeptide*. The structure of a polypeptide, or protein, is shown in Fig. 5.11. The —R groups are constituents of the various amino acids, and the —CONH— groups are peptide linkages. The components of the wool fiber (cuticle, paracortex, and orthocortex) are made up of the protein KERATIN. The arrangement of amino acids in the keratin molecule, and the manner in which these molecules arrange themselves within the cells, determine the properties of the different components.

(a)

(b)

Figure 5.11 (a) Two amino acids join to form a peptide. (b) The repeat unit of a polypeptide.

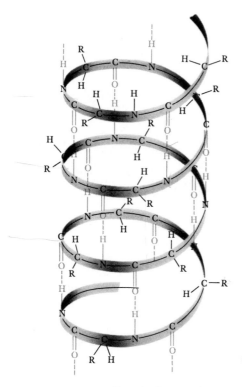

Figure 5.12 The preferred configuration of the keratin molecule is the helix. (T. L. Brown and H. E. LeMay, Jr., *Chemistry: The Central Science*, 2nd ed. ©1981, p. 778. Reprinted by permission of Prentice-Hall, Inc., Englewood Cliffs, N.J.)

Keratin does not have an extended structure, but is shaped like a spring, or helix, as illustrated in Fig. 5.12. This is the relaxed form of the molecule, and is known as α-keratin. When stretched, the molecules extend to form β-keratin. When tension on the fiber is removed, the molecules return to the α form, and the fiber returns to its original shape and dimensions.

It is the ability of the molecules to return to the coiled configuration so readily that gives wool its very high elasticity. This ability is due in great part to the crosslinks, which bind several keratin molecules into a bundle. These crosslinks are formed through the —R groups which project form the keratin helix.

The crosslinks in wool also play an important role in determining the strength of the fiber. They bind the wool molecules so that when tension is applied to the fiber the microfibrils are not easily broken. The greater strength of the microfibrils means that the fibrils, and hence the cortical cells, will be able to withstand greater stress than if the crosslinks were absent. The tenacity of the fiber is also improved by the presence of the peptide links, as hydrogen bonding between the oxygen and hydrogen atoms of alternate curls of the helix strengthen the structure. Thus, a greater force is required to stretch the molecules. In addition, when the molecules have been extended into the β configuration, hydrogen bonding between the protein chains helps to strengthen the microfibrils. It should be noted, however, that wool is a weak fiber.

Fiber Properties

The important physical and chemical properties of wool are listed in Table 5.4.

TABLE 5.4 Properties of Wool

Molecular Structure	Helical protein (keratin).
Macroscopic Features	2 to 50 cm.
Length:	Most fibers are between 2 and 20 cm.
Cross-section:	Elliptical.
Color:	Most wool is white; however, it may be found in gray, brown, and black.
Light reflection:	Luster is highest in low-grade wool.
Physical Properties	
Tenacity (g/den):	1 to 2.
Stretch and elasticity:	35% elongation at break. 100% recovery at 2% elongation.
Resiliency:	Exceptionally good.
Abrasion resistance:	Good.
Dimensional stability:	Poor; undergoes felting when wet.
Moisture regain:	13.6 to 16.0%.
Specific gravity:	1.30 to 1.32.
Chemical Properties	
Effects of bleaches:	Wool will turn yellow and dissolve in sodium hypochlorite. Damaged by most oxidizing bleaches; less damaged by reducing bleaches.
Acids and alkalies:	Destroyed by concentrated solutions of nitric and sulfuric acids. Rapidly destroyed by strong alkalies.
Organic solvents:	Highly resistant to organic solvents.
Sunlight and heat:	Prolonged exposure to light will cause photo chemical oxidation and fabric deterioration. Becomes harsh at 100°C if in dry air.
Resistance to stains:	Resistant to oil-borne stains. Easily stained by water-borne stains.
Dyeability:	High affinity for dyes; fabrics dye well and evenly. Acid and base dyes are used, and in some cases direct dyes may be used.
Biological Properties	
Effects of fungi and molds:	Will mildew if exposed to damp conditions for prolonged periods.
Effects of insects:	Easily damaged by carpet beetles and the larvae of clothes moths.
Flammability Behavior	Burns slowly with slight sputtering; self-extinguishing.
Electrical and Thermal Conductivity	Wool is a good insulator. Poor conductor of electricity.

APPEARANCE Since wool is a natural fiber, its properties vary from breed to breed and even from sheep to sheep. The quality of wool is dependent upon the fiber diameter, its length, the amount of impurities contained in the fleece, the scale structure, color, and the part of the fleece from which it is derived. The finest wools are thin, long, white, and have a definite crimp; the poorest are coarse and straight and may be brown or black.

COMFORT Wool stretches well. It may be extended to over 30 percent of its original length without breaking or permanent deformation. It is also very elastic. Elasticity is a measure of the fiber's ability to return to its original dimensions after stretching. Wool has 99 percent recovery from 2 percent stretch. It will immediately recover 63 percent of the extended length after being stretched 20 percent. If allowed to relax, wool will recover completely. This combination of a high level of elongation and excellent elastic recovery means that wool yarns will permit garments to give with the motion of the body. Furthermore, wool is very resilient. When crushed, wool fibers spring

back to their original shape; this means that wool garments will resist wrinkling. Wool carpets will usually not show footprints, and will resist being matted by heavy furniture.

Wool is uniquely suited for garments used in cold, damp climates. The high level of crimp and the loose structure of wool yarns allow a good deal of air to be trapped within the fabric; the trapped air acts as an insulator. When wool absorbs moisture it gives off heat, so that wool apparel helps stave off the cold, clammy feeling that accompanies damp weather. Upon drying, wool absorbs heat from the body as the absorbed moisture slowly evaporates. This cooling effect helps to prevent overheating when a person enters a warm room from the cold outdoors.

MAINTENANCE Wet wool, when subject to mechanical action, will compact into a tangled mass of fibers that is not easily pulled apart. This process, known as FELTING, is not fully understood. It appears to be related to the shape of the fiber, its crimp, and the scaly surface. Wool fibers will readily slide together but resist sliding apart. This tendency to felt is put to use in the *fulling* of wool (Chapter 15), whereby the wool cloth is made softer and more compact. It can be a disadvantage, however, since it means that wool garments must be handled carefully in cleaning. When subject to the tumbling action of a washing machine, wool garments will shrink as the fibers of the cloth slide together and entangle themselves. Wool is also subject to relaxation shrinkage.

DURABILITY Wool is a relatively weak fiber, but wool yarns are strong because wool's natural crimp, combined with the high friction provided by the scales on its surface, allows the fibers to cling tenaciously to one another. In addition, the fibers are relatively long. This means that each individual fiber will be in contact with many other fibers along its length. These factors make it possible to spin relatively strong yarns from a weak fiber. WORSTED yarns—those made from the longest and finest fibers—rival some man-made filaments in strength and durability. Wool cloth is very durable. Because of its high elasticity, normal stretching and relaxation of the cloth during wear does not weaken the fibers. Furthermore, wool's felting tendency makes the cloth more compact and more resistant to abrasion as it is used. Thus, wool fabrics maintain their durability as they age. Finally, the natural resilience and crimp of the fibers provide a high degree of bulk which hides thin spots, so that wool cloth does not show wear readily.

Wool does not deteriorate if stored in dry, dark places. Dampness, however, allows micro-organisms to flourish. Wool also provides a highly nutritious diet for a variety of grubs. beetles, and moth larvae, so wool fabrics must be protected by insect repellents or insecticides during storage. Sunlight destroys wool more rapidly than cotton. The fiber becomes discolored and weak. Wool is attacked by acids and alkalies and should be laundered in very weak alkalies such as borax, rather than the stronger soaps and detergents used for other fibers. Chlorine bleach will cause the fiber to weaken; peroxide bleaches are recommended.

Wool ranks among the least flammable of textile fibers. Dry wool will burn slowly, with a sputtering, smoky flame. When the relative humidity rises above 20 percent, wool absorbs enough moisture to be able to self-extinguish when the flame source is removed.

Uses

Wherever comfort, esthetics, and durability are the major criteria, wool is a suitable material. In apparel, wool is found in socks, for its abrasion resistance and ability to absorb moisture; in outerwear, for its warmth and durability; and in men's and women's suits for its wrinkle resistance, comfort, and durability. In home furnishings, wool provides the standard by which other carpet fibers are measured. Its resiliency, durability, hand, and dyeability are unsurpassed. Wool and wool blends provide long life, excellent comfort properties, and excellent esthetics to upholstery. Although central heating has greatly reduced their use in the U.S., wool blankets are still prized in many parts of the world.

Two examples will illustrate the versatility of wool for apparel. The Scottish climate is cold and damp. Wool trousers, flannel shirts, and sweaters protect the wearer against the cold by providing a bulky cloth which traps air and maintains body temperature. The ability of wool to warm as it absorbs moisture protects against chill. The compact wool cloth resists penetration by wind and water.

During the day, the Arabian desert is hot and dry. Direct exposure to the sun can literally bake a person to death. Wool garments block the fierce heat of the sun's rays and protect the skin from painful sunburn. The insulating layer of trapped air within the wool cloth helps to keep body temperatures at tolerable levels. Since wool is capable of absorbing a great deal of water, the body is surrounded by a region of high humidity which prevents rapid loss of body moisture to the atmosphere. Furthermore, the slow evaporation of water from the cloth helps to cool the body. At night, woolen garments protect against the cold.

The demand for wool products has always tempted unscrupulous manufacturers to adulterate or otherwise diminish the quality of wool goods. Laws meant to protect the consumer by regulating the manufacture of wool yarns and cloth have been necessary since the early Middle Ages. In 1939, the U.S. Congress passed the Wool Products Labeling Act in order to protect consumers against abuses. The Act (discussed in detail in Chapter 19) requires the labeling of products containing wool to indicate the fiber content and the source of the wool.

SPECIALTY HAIR FIBERS

Hair and wool fibers from animals other than sheep are usually referred to as specialty hair fibers. These products of the goat and camel families are by no means inferior to wool, nor are they limited in their uses. The term "specialty" arose because of their scarcity.

Cashmere

The fine down (wool) that grows under the coarse outer hair of the Kashmir goat is known as cashmere. China, Tibet, and India produce most of the commercial fiber. The down is combed from the animal in the spring and summer, and yields are estimated to be about 250 g ($\frac{1}{2}$ lb) per animal. Such a small yield can only be justified by a superior quality of fiber.

Cashmere wool fibers are between 2 and 10 cm (1 to 4 in) long, may be white, pale brown, or gray, and are somewhat finer than sheep's wool. The tenacity, stretch, and elasticity are essentially the same as for ordinary wool, but because of its smaller diameter, cashmere is much softer. Used exclusively in apparel, this luxury fiber makes fabrics that are soft, warm, and lustrous, and have excellent drape.

Mohair

While the sheep has been bred to maximize wool production, the Angora goat has been bred for its long, lustrous hair, called mohair. Before the Industrial Revolution, mohair was almost exclusively obtained from Turkey. However, introduction of the Angora goat into Texas and California near the end of the nineteenth century led to a thriving industry. Today the United States is the major producer and user of mohair.

Mohair is very similar in physical and chemical structure to wool. Fibers range from 10 to 30 cm (4 to 12 in) in length, are covered by scales, and possess a natural crimp. The scales on mohair are flatter than those on wool, so that the fiber has a smoother hand. In addition, mohair is finer than most wools, and more tightly curled. It is equivalent to wool in strength, elasticity, and dyeability.

Mohair is exceptionally resistant to abrasion and is very durable. Its tight curl provides interesting esthetics in complex fabric constructions. The major uses include sweaters, suits, and upholstery. It is often blended with wool.

Camel Hair

The family *Camelidae*, along with goats, is the other major source of specialty hair fiber. This small family of animals has two branches, the Old World camel and the llama. The camel branch is composed of the dromedary (one-humped) and the bactrian (two-humped), while the llama branch comprises the alpaca, guanaco, haurizo, llama, misti, and vicuña. Of these, the bactrian camel, alpaca, and vicuña are the most important to the textile industry.

The bactrian camel of Central Asia is the major source of camel hair. The hair that is used in textiles is the fine undercoat of the camel, which is shed during the spring and summer. It ranges in color from pale reddish-brown to dark brown and black. The fibers, about the same diameter as wool, range in length from 2 to 12 cm (1 to 5 in), and are covered with scales. The camel-hair scales are not as well defined as those of wool, so the fibers do not felt as readily. Its major use is in men's outerwear, particularly overcoats.

Garments of camel hair are warm, durable, relatively lightweight, and comfortable.

Alpaca

In the high Andean Mountain regions of northern South America, the Indian tribes have made use of the llama family as beasts of burden for centuries. The alpaca, however, has been bred mainly for its fleece. These small animals, which stand about 1 meter (3 ft) high, produce a beautiful, fine, strong, and durable fiber.

Alpaca wool is sheared from the animal every other year, to yield 2 to 3 kg (4 to 7 lb) of fiber. The fibers may be from 20 to 30 cm (8 to 12 in) long, and range in color from black through gray and brown to white. Cloth prepared from alpaca is soft, warm, glossy in appearance, and yields interesting color variations without the use of dyestuffs. It is often found in suits, dresses, upholstery, and garment linings.

Vicuña

The finest, softest, and rarest of the wool fibers is that obtained from the vicuña. This mammal, about the size of a very large dog, roams the Peruvian mountains at elevations of 4,000 meters or more. Attempts to domesticate the vicuña have so far proved economically unsuccessful, and the animal is hunted under government license. One animal yields about ½ kg (1 lb) of fleece.

Vicuña wool is about half the diameter of sheep's wool. It is extremely soft, yet stronger than other wools and hair of equal fineness. It ranges in color from pale cinnamon to pure white. The scales of the fiber are very fine, giving a smooth hand to the yarn, and reducing its propensity to felt. Vicuña ranks among the most luxurious and expensive fibers. Used chiefly in suits and overcoats, vicuña garments are noted for warmth, softness, and light weight. The cloth is relatively weak, however, and must be handled carefully.

FUR FIBERS

The use of the hair covering of fur-bearing animals for manufacture of yarns has been known from antiquity. Today, however, the expense of removing the small amount of useable hair has made widespread use of animal fur in the textile trade uneconomical. The major exception is the Angora rabbit.

The pelt of fur-bearing mammals is composed of an outer layer of long, stiff "guard hairs" and an inner layer of soft, short fur fibers. In the Angora rabbit the fur fibers are longer than those of other animals, often reaching 7 to 8 cm (3 in). The major sources of Angora fur are France and Belgium. The rabbits are sheared three to four times a year for their soft, glossy, white, silky fiber. These fibers are often blended with wool in knitted goods such as sweaters, gloves, and hats; the blend yields a yarn that is softer and smoother than wool, yet stronger and more durable than fur alone.

The ancient Chinese emperors reserved for themselves a cloth so fine, so supple, so beautifully colored, and so comfortable that they were envied by all who had knowledge of the material. This cloth was made from silk. From its discovery, in about 2650 B.C., until today, silk has been known as the "queen of the fibers." It offers strength and durability in sheer, lightweight fabrics; excellent draping characteristics that flatter the wearer; a soft, luxurious hand; and a high level of moisture absorption for comfort. In addition, silk may be dyed with brilliant, long-lasting colors, and has an inherent elegant sheen.

For millennia, the Chinese maintained a monopoly of silk production. During this time, they developed many of the techniques of weaving and embroidery that made silk garments as much works of art as clothing. Silk cloth became an important item of commerce in the ancient world, often selling for more than its weight in silver. In the early centuries of the Modern Era, *sericulture*—the process of producing silk—spread to Korea and Japan. Slowly, the knowledge spread throughout Asia and into the Mediterranean. In the sixth century, the Emperor Justinian established a silk manufactory in the palace at Constantinople, in the hopes of sharing in the profits of the silk trade. The Moors brought the techniques to Spain and Sicily in the eighth century, and from there it spread to France and Italy. By the late 1800s, the production of silk had been attempted in all the nations of Europe and America; and in all these countries it failed.

Until the early years of the twentieth century, silk cloth was the material most desired for apparel and home furnishings. Its appearance, durability, and comfort suited it to elegant and comfortable underwear as well as suits, dresses, shirts, and blouses. Silk velvets and other heavy silk fabrics were used for the highest-quality draperies and upholstery. Ancient silk tapestries and carpets still exhibit their exquisite colors and designs. Silk was also used as an article of industrial significance. The early experimenters in electricity used silk cloth for insulation. Silk cords were stronger and more durable than those of similar size made from other materials. Until World War II, parachutes were made from silk, since it was so light and strong.

Fiber Production and Yarn Manufacture

Silk production requires the careful breeding and nurturing of the *Bombyx mori* species of moth. The intensive labor requirements of sericulture, combined with the agriculture and harvesting of the mulberry leaves upon which the moth larvae feed, limit silk production to warm, temperate regions in which cheap labor is available. Japan and China are the world's major sources of silk, although minor quantities come from India, Italy, and Korea.

Sericulture consists of four separate processes:

1. Harvesting mulberry leaves to feed the silkworms
2. Production of eggs from which the silkworms are grown
3. Raising the silkworms and harvesting the cocoons
4. Reeling the filaments to form silk strands, and twisting the strands into yarn

The particular species of mulberry tree, the conditions under which it is grown, and the quality of the leaves affect the growth and development of the silkworm into an adult moth. If the leaves are not of the best quality, development of the adult moth is stunted, and she will produce only a few eggs of inferior quality. The quality of silk also depends upon diet. The best mulberry trees are found in Japan and China; consequently, Chinese and Japanese silk is, generally, the best quality.

Various strains of Asian and European moths have been bred, much like sheep, to produce high-quality silk. After emerging from the cocoon, these flightless creatures mate. The males die, and the females produce between 350 and 400 eggs before death. During the laying period, the females do not eat. The eggs are laid on sheets of paper or in small conical cups. Adult moths, and their eggs, are isolated from one another to prevent the spread of disease.

The eggs are kept refrigerated until the leaves begin to appear on the mulberry trees. They are then incubated; tiny caterpillars appear in a few days and begin to feed on the mulberry leaves supplied them. During the next thirty days the worms eat and grow, shedding their skins (moulting) four times. After the final moult, the silkworm consumes over twenty times its weight in ten days. Finally, it attaches itself to a convenient stick or piece of straw and commences to spin its silk cocoon.

The silk is produced in two glands within the body of the worm. It is carried by ducts to an exit tube in the head, where the two streams of liquid emerge. The liquid silk is composed of a protein called *fibroin*, which hardens upon contact with the air. Two other glands, one on each side of the exit tube, secrete a second protein known as *sericin*, which bonds the silk strands together. Over a period of three days, the silkworm encases itself in a silk cocoon.

Inside the cocoon the larva begins the change into a chrysalis, from which it will become a moth. Ordinarily, the chrysalis escapes from the cocoon by exuding a fluid which destroys the fiber. To prevent this from happening, the cocoons are refrigerated until they are harvested. From 30 g (1 oz) of eggs, which yield over 36,000 silkworms, the producer acquires 65 kg (145 lb) of cocoons. Only 5 kg (11 lb) of raw silk is obtained from these cocoons. To produce this silk, the worms have eaten over 1000 kg (2,200 lb) of mulberry leaves!

To obtain silk, workers stifle the larvae and boil the cocoons in a carefully controlled bath to loosen the sericin coating. The end of the filament is brushed off the cocoon and, along with ends from one or two other cocoons, unwound. This process is known as *reeling*. The filaments are usually twisted to form a silk yarn of about 6 to 8 denier. The raw silk may now be used as is. However, it is generally *thrown*, or twisted, with two or three other yarns to form a heavier cord. This cord is what is used in cloth manufacture.

The sericin coating is generally removed after the yarn has been woven or knitted into cloth by a process known as DEGUMMING, in which the natural cement is removed in hot, soapy water. Degummed, or soft, silks are softer and more lustrous than hard silk, which still retains its sericin coat.

Fiber Composition

MACROSTRUCTURE Unlike wool, silk has never been a living material, therefore it does not have the complex internal structure of wool. Under the microscope, raw silk is found to consist of a pair of fine filaments bonded by sericin gum. The *bave*, as the dual strand is called, is elliptical in cross-section. A longitudinal view reveals a rough, cracked surface containing many striations. The roughness is in the sericin layer. When degummed, the individual strands, or *brins*, are revealed as triangles with rounded points. The brin, shown in Fig. 5.13, is translucent, smooth, and lustrous.

Cultivated silks are fine white strands measuring about 500 meters (1,600 ft) in length and 10 micron (0.0004 in) in width. Tussah silks, obtained from *Antheraea mylitta* or *Antheraea pernyi* (two other species of silkworm), are darker in color, less regular in cross-section, and not as smooth as the cultivated silks. Tussah silk, and the product of other types of silk-spinning caterpillars, are known as *wild silks*.

MICROSTRUCTURE Like wool, silk is a protein. The particular protein structure is called FIBROIN and is similar to the β form of wool. Cultivated silk appears as a homogeneous solid bar of fibroin. Wild silks have a striated appearance, indicating that they contain layers of fibroin. Acid treatment of wild silks shows that they are composed of fibrils. It is generally accepted that cultivated silks are also composed of fibrils that are finer and more evenly fused.

X-ray analysis of silk shows that it has a high degree of crystallinity. These crystals are formed by extended protein chains stacked in neat, ordered regions. Hydrogen bonding between the peptide links helps to increase the strength. The ends of the molecules extend out of the crystals, or fibrils, into disordered regions. These amorphous regions are weaker but more elastic than the fibrils. The combination of rigid, strong crystals and elastic amorphous regions provides a fiber that is both strong and elastic.

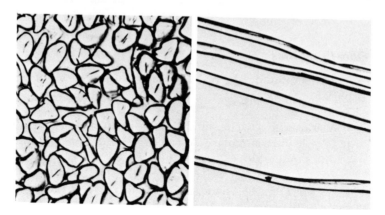

Figure 5.13 Photomicrographs of silk fibers showing the straight, smooth surface and the triangular cross-section. (*AATCC and ASTM*)

TABLE 5.5 Properties of Silk

Molecular Structure	Extended protein (fibroin).
Macroscopic Features	
Length:	400 to 700 m.
Cross-section:	Triangular cross-section with no specific markings.
Light reflection:	Excellent light reflectance due to triangular cross-section.
Physical Properties	
Tenacity (g/den):	2.4 to 5.1.
Stretch and elasticity:	15% elongation at break. 90% recovery at 2% elongation.
Resilience:	Moderate.
Abrasion resistance:	Good abrasion resistance.
Dimensional stability:	Good resistance to stretch and shrinkage. Fabrics may be stretched or ironed back into shape.
Moisture regain:	11%.
Specific gravity:	1.25.
Chemical Properties	
Effects of bleaches:	Damaged by strong oxidizing bleaches such as sodium hypochlorite. Mild concentration of hydrogen peroxide or sodium perborate may be used.
Acids and alkalies:	Concentrated mineral acids will destroy silk; nitric acid will cause silk to yellow. Damaged by strong alkalies; will dissolve in hot caustic soda.
Organic solvents:	Is not damaged by organic solvents.
Sunlight and heat:	Considerably weakened by sunlight, which accelerates decomposition. Silk will begin to decompose at 150°C.
Resistance to stains:	Easily stained by perspiration; fair resistance to oil and waterborne stains. Requires hand laundering or dry cleaning.
Dyeability:	Can be dyed in very deep shades and will absorb dyestuffs at low temperatures. Direct, acid, base, and vat dyes may be used.
Biological Properties	
Effects of fungi and molds:	Highly resistant to fungi and mold and will not be damaged except under extreme conditions.
Effects of insects:	Not attacked by insects.
Flammability Behavior	Burns slowly with sputtering. Usually is self-extinguishing.
Electrical and Thermal Conductivity	Poor conductor of electricity and heat.

Fiber Properties

The important physical and chemical properties of silk are listed in Table 5.5.

APPEARANCE The smooth, translucent surface of silk gives it a high luster, while the triangular shape of the fiber provides highlights that cause silk fabrics to sparkle.

COMFORT The hand of silk is usually considered to be the most pleasant of all of the fibers. It is often described as smooth, crisp, soft, and dry. The pleasant hand comes about through a combination of smooth surface,

fineness of fiber, and ability to absorb moisture. The smooth, fine yarns do not trap air well and the protein structure of silk allows a high level of moisture absorption and good wicking. Thus, silk garments are comfortable on all but the most hot and humid days.

MAINTENANCE The smooth surface of silk fibers prevents dirt from attaching itself readily, so silk fabrics do not soil easily. Fibroin is destroyed by strong acids and alkalies, and even weak alkalies in long contact with the fiber will cause some damage. For this reason, silk may be laundered in mild detergents with peroxide or perborate bleaches, but should never be exposed to chlorine bleach. Many manufacturers recommend that silk garments be dry-cleaned.

Silk fabrics have good dimensional stability and usually will not shrink or stretch when laundered or dry-cleaned. The resiliency of the fiber assures that it will not wrinkle readily, and that creases will hang out well. Silk is damaged by high temperatures and will yellow if pressed with a hot iron. In addition, in the presence of moisture, silk becomes plastic; it also distorts under pressure. Careless pressing with a steam iron or pressing of damp cloth may cause an unwanted gloss on the surface of the cloth.

DURABILITY Silk is a moderately strong fiber with good resistance to abrasion. It decomposes in strong sunlight and when exposed to atmospheric fumes. Storage is most effective in sealed containers away from sunlight or fluorescent lamps. Silk is highly resistant to molds and fungi and is not attacked by insects.

The sensitivity of silk to perspiration and body oils is of greater concern. Human perspiration contains dissolved salts and, depending on individual body chemistry, may be acid or alkaline. As silk garments absorb body moisture, they also absorb the dissolved salts. Within the fiber, the salts attack the fibroin, eventually destroying the polymer, and with it the fiber. Human body oil, *sebum*, is partially soluble in water and is absorbed along with perspiration. When the cloth dries, the soil is retained by the fiber. A sufficient buildup of sebum will cause a permanent stain. Silk is best protected by the use of antiperspirants that do not contain high levels of metal salts. Garment shields and regular laundering or dry-cleaning also offer protection.

Uses

Silk is so versatile that it may be woven or knitted into the sheerest, most revealing lingerie or the heaviest of velvets. It is cool and comfortable for summer wear yet, because it is a good insulator, appropriate for cool weather. For apparel, silk offers high strength, excellent drape, a comfortable, luxurious hand, a pleasing luster, and beautiful colors. Sheer silks cannot be

equalled in the way they flatter the wearer. For daytime wear, silk provides comfort, durability, and wrinkle resistance to garments that proclaim the wearer's consciousness of quality. The esthetics of silk for formal wear are unsurpassed.

Silk is rarely used to make heavy fabrics because it is too expensive and too fine. However, to give fuller body to lightweight fabrics, silk is often *weighted* by steeping the yarn in a solution of tin salts (such as tin chloride or tin phosphate) followed by drying. This treatment loads the fibers with a dense substance. An addition of salts up to 15 percent of the weight of the fiber improves the body and drape without harming the cloth. Excessive weighting, however, will damage the fibers and greatly reduce the tear strength and abrasion resistance of the cloth. (*Tendering* is the term used to describe such weakening of a fabric by chemical or mechanical means.) Current regulations require that the level of added salts be indicated on the label of weighted silks.

In home furnishings, silk fabrics provide a richness of sense impressions. A dry, firm, yet yielding hand gives a pleasant tactile sensation; the brilliance of color and the natural luster of the fiber delights the eye, while the soft rustle, or "scroop," of the cloth as it is rubbed pleases the ear. No other fiber can delight so many of the senses. In addition to their esthetic qualities, silk furnishings are comfortable and durable. However, because of their cost and difficulty of maintenance, they should be treated more like art than commodities.

The silk from broken cocoons, torn filaments, or cutting waste is made into spun yarns. Spun silk is less elastic, duller, and stiffer than thrown silk. It is also less expensive. Spun silk is used for lower grades of cloth for apparel, and to provide interesting esthetic effects in upholstery and drapery fabrics.

REVIEW QUESTIONS

1. Sketch the cross-section of the wool fiber and label its parts.
2. Which microstructural differences make silk stronger than wool?
3. Which macrostructural features make wool more abrasion-resistant than silk?
4. Why do protein fibers have such a high moisture regain?
5. Compare the comfort properties of silk and wool. Which is better for summer wear? Which is better for winter wear? Explain why.
6. Which macrostructural features of wool fiber influence its ease of maintenance?
7. Silk garments are normally hand-washed or dry-cleaned. Why?
8. Wool garments are normally hand-washed or dry-cleaned. Why?
9. Wool will stretch much more than silk. Explain why.
10. What factors work against using wool for drapery fabrics?

MINERAL FIBERS

ASBESTOS

The only naturally occuring mineral fiber of any importance is asbestos. The name is taken from the Greek *asbestos*, meaning inconsumable. The ability of asbestos yarns and cloth to withstand fire and flame was a source of amazement for generations. The early Greeks spoke of the lamp in the temple of Minerva which had a wick that was never consumed by the fire. The Romans looked upon asbestos cloth as the "cloth of kings," for both its rarity and its ability to pass through fire unscathed. In 1684 a handkerchief that would not burn was shown to the Royal Society. In 1724 Benjamin Franklin brought to London the earliest known example of an American asbestos textile product in the form of a small bag which he had acquired from Canadian Indians.

Despite the wonderous nature of asbestos cloth, it did not become an important commercial product until the late 1800s. Asbestos is more difficult to acquire and less easily spun into yarn than the other natural fibers. Before the Industrial Revolution, there was not an appreciable demand for a fiber that could withstand very high temperatures. Potholders, tinkers' gloves, blacksmiths' bellows, and other items that came in contact with hot items could be made from cotton or leather, since the time of contact was relatively short, and the material did not get very hot. But the steam engine made greater demands on materials.

Mechanized factories required shaft seals, pump packing, boiler insulation, acid- and friction-resistant cloths for wiping and polishing, and inert filter materials. Asbestos rope, cloth, and mats satisfied many of these requirements. As industry progressed, many new uses were found for asbestos such as reinforcing fibers for brake shoes, protective clothing for firefighters, and insulation for electric generators and motors.

Fiber Production and Yarn Manufacture

Asbestos is found in *serpentine* and *amphibole* rock as thick veins held within the mineral (Fig. 5.14). The rock is mined much like coal, by either strip-mining or shaft-mining techniques. The ore is crushed and dried, and the asbestos fibers are removed from the crushed rock by a high-velocity air stream. The fibers are classified by length and bagged. The longer fibers, measuring 1 cm ($^3/_8$ in) or more are suitable for spinning. The shorter fibers are used for such products as roofing tile, floor tile, filter paper, and insulation. Asbestos is spun rather like cotton, and is often blended with from 5 to 20 percent cotton to improve the yarn properties.

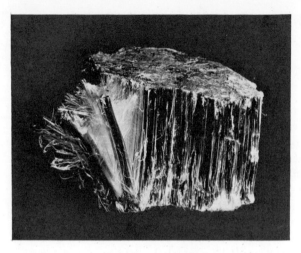

Figure 5.14 The mineral crystals of serpentine asbestos are flexible and fine enough to be used in textiles. (*Johns-Manville Corporation*)

Fiber Composition

MACROSTRUCTURE Asbestos fibers are fine, tubular rods of mineral crystals (Fig. 5.15) measuring from ½ to 30 cm (0.2 to 12 in) in length. The fibers are actually bundles of even finer crystalline fibrils that may be as small as 0.02 μ. The surface is usually smooth, but may contain very fine striations. The cross-section is generally round or polygonal.

MICROSTRUCTURE The two most important types of asbestos are *chrysotile*, a green or brown crystalline mineral made up of silicon dioxide, magnesium oxide, and water; and *crocidolite* (known as *blue asbestos*), a blue crystalline mineral composed of silicon dioxide, iron oxide, and sodium oxide.

Chrysotile, mined from serpentine rock, is the most important asbestos fiber for textile purposes. It is more readily spun into yarn and is more heat-resistant than blue asbestos because of the water that is bound in the mineral.

Figure 5.15 Asbestos fibers highly magnified (× 25,000) showing the smooth, rod-like structure. (*AATCC and ASTM*)

TABLE 5.6 Properties of Asbestos

Molecular Structure	Crystalline mineral.
Macroscopic Features	
Length:	½ to 30 cm.
Cross-section:	Round and tubular.
Color:	White, green, yellow, grey, or blue.
Light reflection:	Bright to dull.
Physical Properties	
Tenacity (g/den):	Low.
Stretch and elasticity:	Low.
Resiliency:	Poor.
Abrasion resistance:	Very high.
Dimensional stability:	Very high.
Moisture regain:	Very low.
Specific gravity:	2.2.
Chemical Properties	
Effects of bleaches:	Not affected.
Acids and alkalies:	Excellent resistance to boiling concentrated acids and alkalies.
Organic solvents:	Not affected.
Sunlight and heat:	Not affected.
Resistance to stains:	Excellent stain resistance.
Dyeability	May be dyed with disperse dyes.
Biological Properties	Not affected by molds, fungi, or insects.
Flammability Behavior	Loses water when heated to incandescence. Essentially unaffected by fire.
Electrical and Thermal Conductivity	Poor.

Fiber Properties

The important physical and chemical properties of asbestos are listed in Table 5.6.

Asbestos has excellent resistance to heat and flame. It is a relatively weak fiber but has good abrasion resistance. Because the fibers have such a smooth surface, asbestos yarns are weak. For this reason the fiber is often blended with cotton for improved strength. Asbestos products have good resistance to acids, alkalies, and organic solvents. The fiber is not affected by sunlight, molds and mildew, or bacteria. Pests do not eat it.

Asbestos has one major drawback: it is a carcinogenic or cancer-causing agent. The effects of exposure to asbestos may show up as cancer of the liver, which becomes evident as many as forty years after exposure. It is not known what level of exposure is dangerous. For this reason, industry and government are attempting to reduce the exposure of the public to asbestos fibers in the air and water by more rigorous antipollution measures, and substitution of other materials for asbestos where possible. Asbestos is prohibited in consumer apparel.

Uses

Asbestos is an industrial fiber. It is used whenever a temperature-resistant, inert, durable material is required. Insulation, filters, packing and

gaskets, brake linings, electrical insulation, and protective clothing are some of its end uses. Asbestos is also a component of theater curtains and scenery, because it helps to reduce the hazard of fire.

SUMMARY

The natural fibers may be cellulosic, protein, or mineral. The major cellulosic fibers are cotton, a seed-hair fiber; linen, a bast fiber; and jute, also a bast fiber. In general, cellulosic fibers are comfortable, durable, and easily dyed. The stiffness of jute generally precludes its use in apparel. The high cost of linen limits its use to luxury items. Cotton's moderate cost makes it a favorite throughout the world.

The major protein fibers are wool and silk, although certain animal hairs and furs may be used in specialty products. Since wool fibers were once living things, their structure is quite complex; asymmetry in the wool fiber makes it highly crimped. Silk, secreted by a silkworm, is not a living material and has a very simple structure. It is homogeneous, straight, and smooth. Silk and wool have a similar chemistry, and differ mainly in their physical properties. Wool fibers have a high level of moisture absorption, are very abrasion-resistant, but relatively weak. Silk fibers are also absorbent, have low abrasion resistance and high strength. The particular esthetic and tactile properties of silk have earned it the title "queen of the fibers."

The only mineral fiber of importance is asbestos. Its fibers consist of fine crystals of silicon dioxide, magnesium oxide, and water. Since asbestos is a carcinogen and can also cause respiratory diseases, its uses are limited to high-temperature applications where no substitutes yet exist.

6

man-made cellulosic fibers

RAYON

The first man-made fiber, and one that is still commercially important, is rayon. It is defined under the Textile Fiber Products Identification Act (TFPIA) as follows:

> A manufactured fiber composed of regenerated cellulose, as well as manufactured fibers composed of regenerated cellulose in which substitutents have replaced not more than 15 percent of the hydrogens of the hydroxyl groups.

Known since 1891, regenerated cellulose was called "artificial silk" until 1924. In the early 1920s the National Retail Dry Goods Association, predecessor to the National Retail Merchants Association, realized that the public did not consider "artificial" products the equivalent of the real thing and recommended the word "rayon" in place of "artificial silk." The Federal Trade Commission adopted the term in 1937. However, "rayon," as it was then defined, included other fibers that were not strictly regenerated cellulose. In 1952 the definition cited above was made law.

Fiber Production and Yarn Manufacture

A detailed discussion of rayon manufacture is given in Chapter 18. In the VISCOSE process, rayon is produced from cellulose obtained from wood pulp. The raw material is treated with sodium hydroxide (caustic soda) to form

Cell—OH $\xrightarrow{\text{NaOH}}$ Cell—O$^-$ $^+$Na

Cellulose
(staple fiber)

Soda cellulose

Cell—O$^-$ $^+$Na $\xrightarrow{\text{CS}_2}$ Cell—O$^-$ $^+$Na
$\underset{S \quad S}{\underset{\diagup \backslash}{C}}$

Sodium cellulose xanthate
(soluble in NaOH)

Cell—O$^-$ $^+$Na
$\underset{S \quad S}{\underset{\diagup \backslash}{C}}$ $\xrightarrow{\text{H}^+}$ Cell—OH + CS$_2$ + Na$^+$

(Filament rayon)

Figure 6.1 In the viscose process, cellulose in the form of staple is converted to cellulose in the form of filaments.

sodium cellulose. The sodium cellulose is then reacted with carbon disulfide. The resulting material, sodium cellulose xanthate, is dissolved in caustic soda to form a syrupy, viscous solution. This liquid is aged, filtered, and pumped through spinnerets into a bath of dilute sulfuric acid. The acid decomposes the xanthate to regenerate the original cellulose. In effect, the cellulose is converted from the staple fiber in which it is found in nature to a filament fiber. After spinning, the filaments are washed, stretched, and wound on bobbins or chopped into staple length. The process is illustrated in Fig. 6.1.

Another less common process is used to make CUPRAMMONIUM RAYON. In this technique, discovered in 1857, cotton linters are added to a solution of copper sulfate and aqueous ammonium hydroxide, which dissolves the cellulose. After filtration, the cellulose solution is pumped through spinnerets into an acid bath, which regenerates the cellulose. Then the ammonia and copper sulfate are removed in a water bath, and the filaments are stretched and wound on bobbins. Until given their final stretch, the fibers must be carefully handled, because they are rather soft and weak.

Almost all cuprammonium rayon is produced by the J. P. Bemberg Company, so it is widely known as Bemberg rayon. It is more expensive to produce than viscose, but the fibers are finer, softer, stronger, and more elastic. Cuprammonium rayon is found in higher-quality women's undergarments and garment linings.

Rayon may be used to make filament yarns or cut into staple lengths to be converted into spun yarns. (Spun yarns have properties different from filament yarns.) Rayon cut to staple length may also be blended with other fibers before spinning.

Fiber Composition

MACROSTRUCTURE Rayon fibers are long, solid rods of cellulose without significant internal structure. Under the microscope the cross-section (Fig. 6.2a) is seen to be irregular. The irregular surface causes light to be

reflected at different angles, so that under the microscope the valleys show up as dark lines against the light background of the peaks. These variations in reflectance give the fiber a striated appearance. Although it is possible to produce nearly round fibers by the cuprammonium process (Fig. 6.2b), the manufacturing method makes this difficult.

If delustrants have been added during the spinning of the fiber, they appear as tiny dark flecks under the microscope. Bright fibers are almost transparent.

MICROSTRUCTURE Since rayon is regenerated cellulose, its chemical structure is identical to that of cotton. In the early days of fiber production, engineers and scientists were disappointed that rayon fibers were much weaker than cotton. Early rayon had a tenacity of about 0.4 g/denier, while cotton has a tenacity of about 4.0 g/denier. It was not until the early 1950s that scientists were able to explain the phenomena that caused the difference, and develop methods to correct the problem.

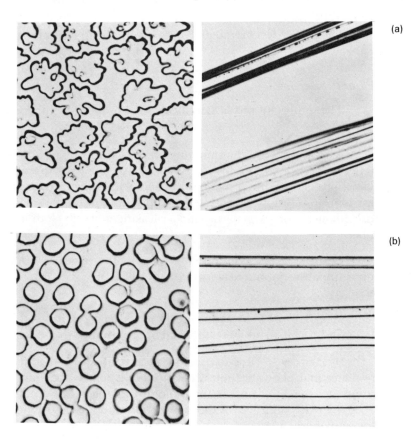

(a)

(b)

Figure 6.2 Photomicrographs of (a) viscose rayon and (b) cuprammonium rayon. Note the differences in cross-section and surface. (*AATCC and ASTM*)

It was found that the strength of the cellulosic fibers was related to the length of the molecule, the degree of crystallinity, and the orientation of the crystals within the fiber. The degree of polymerization (DP) of cotton is very high, ranging from 3,000 to 10,000, while that of early rayon was rather low, about 250. The low DP of rayon meant that the molecules were less ordered, and not as likely to form crystals.

In addition, cotton fibers are highly oriented. They are composed of fibrils and microfibrils arranged in neatly ordered layers, more or less aligned with the axis of the fiber. The rayon fibers were found to be much less oriented; the molecules and crystals within them did not align themselves with the fiber axis. The low level of orientation meant that the molecules did not act in concert to resist tensile forces, and could not bear the loads that cotton could.

In 1951, in Japan, S. Tachikawa patented a process for the manufacture of the improved rayon fiber. The ripening stage was modified to achieve a higher DP, the acid bath and the extruding technique were changed so that the fiber coagulated more slowly, and the fibers were stretched. The first and second changes result in a higher level of crystallinity, and the third change yields a higher level of orientation. These improved rayon fibers, also called *polynosics*, have higher tenacity and better wet strength than regular rayon.

The properties of regular rayon, polynosics, and cotton are compared in Table 6.1.

Fiber Properties

The important physical and chemical properties of rayon are listed in Table 6.2.

APPEARANCE The smooth surface of rayon fibers allows light to be reflected well, but the highly irregular cross-section tends to scatter light in all directions. The result of these two phenomena is that rayon is brighter than the natural cellulosic fiber, but not as bright as most man-made fibers. The fine filaments of rayon yarns lend a pleasing drape to cloth made from this fiber.

COMFORT Rayon provides a smooth, pleasing hand and good moisture absorption and wicking to cloth. It has good stretch and stretch recovery.

MAINTENANCE Rayon absorbs water-borne stains readily. Because it is a cellulosic, it wrinkles readily and needs ironing.

DURABILITY Regular rayon is a relatively weak fiber with low resilence and poor abrasion resistance. This means that rayon fabrics are subject to stretching and tearing if roughly handled. The durability of rayon goods is greatly improved by the substitution of the higher-strength polynosics for regular rayon. As the cost of these improved fibers has dropped, the use of regular rayon has declined.

High-strength and high-wet-modulus rayon filaments are better suited to home furnishings and industrial uses. In drapery, curtain, and upholstery,

TABLE 6.1 Comparison of the Properties of Rayon, Polynosics, and Cotton

	DP	Percent Crystallinity	Tenacity (g/denier)		Elongation at Break (%)		Recovery at 2% Stretch
			Dry	Wet	Dry	Wet	Dry
Cotton	6000	85	4.0	4.5	5	7	75
Regular viscose	250	40	1.9	0.9	20	25	80
High-strength polynosic	500	50	3.8	2.5	13	17	85
High-wet-modulus polynosic	900	55	4.9	3.7	8	11	95

TABLE 6.2 Properties of Rayon

Molecular Structure	Cellulose.
Macroscopic Features	
Length:	Produced in both filament and staple length.
Cross-section:	Highly irregular; serrated edges to almost round.
Color:	White.
Light reflection:	Can be produced in dull, semi-dull, and bright.
Physical Properties	
Tenacity (g/den):	Depends on type of rayon and degree of polymerization. Regular: 2. High-wet-modulus (HWM): 4.5.
Stretch and elasticity:	Varies with production method. Regular: 20% extension at break, 80% recovery at 2% elongation. High modulus: 13% extension at break, 85% recovery at 2% elongation. HWM: 12% extension at break, 95% recovery at 20% elongation.
Resiliency:	Low.
Abrasion resistance:	Low.
Dimensional stability:	Fabrics will relax during laundering, stretch easily during yarn and fabric manufacturing. Regular poor, HWM and polynosic good.
Moisture regain:	12 to 13%.
Specific gravity:	1.52.
Chemical Properties	
Effects of bleaches:	Can withstand both oxidizing and reducing bleaches. Attacked by strong oxidizing bleaches.
Acids and alkalies:	Easily damaged by strong acids. Hot dilute mineral acids will disintegrate fibers. Concentrated alkali will cause swelling and reduced strength.
Organic solvents:	Good resistance to organic solvents.
Sunlight and heat:	Will undergo deterioration when exposed to ultraviolet light. Loses strength above 300° F. Ironing temperature 275° F.
Resistance to stains:	Poor resistance to water-borne stains.
Dyeability:	Better affinity for dyes than cotton. Direct, vat, and sulfur dyes are used.
Biological Properties	
Effects of fungi and molds:	Will resist mildew if dry and clean.
Effects of insects:	May be attacked by insects eating stains. Silverfish will attack viscose.
Flammability Behavior	Burns rapidly.
Electrical and Thermal Conductivity	The electrical conductivity of rayon is sufficient to prevent static electric charge. Good heat conductor.

rayon combines excellent esthetics with satisfactory durability. However, rayon upholstery should be tightly constructed and of a heavy weight to counteract the low abrasion resistance of the fiber. High-wet-modulus rayon is widely used as tire cord because it bonds well to rubber, withstands heat well, and does not stretch readily.

The chemical properties of rayon are very similar to those of cotton. Rayon is resistant to most organic solvents, and is not readily decomposed by dilute acids. Resistance to alkalies ranges from poor to good, so chlorine bleaches should be used according to directions. Rayon fiber is destroyed by concentrated mineral acids.

Sunlight and most insects do not readily harm rayon. It will, however, degrade if exposed to strong sunlight for extended periods of time. Mildew will grow on rayon, especially if the material is allowed to remain soiled or damp.

The flammability of untreated rayon precludes its use in children's sleepwear under the Flammable Fabrics Act. However, rayon fabrics may be treated with flame-retardant chemicals. Specially prepared flame-retardant rayon fibers are now being produced. The application of these chemicals may, however, reduce the comfort and durability of apparel made from the treated fibers.

Uses

Rayon is widely used in apparel, home furnishings, and automobile tires. For apparel use, rayon fibers may be used for lightweight summer blouses as readily as for heavy, bottom-weight fabrics for trousers. The intended application determines the fiber and yarn denier, yarn construction, and fabric construction. In home furnishings, filament and spun yarns of rayon provide fashion appeal with bright, long-lasting colors and pleasing light reflectance. Tightly constructed, heavy rayon fabrics give satisfactory durability and ease of care. Rayon tire cord, though not as strong as other materials, bonds well to rubber and gives good service at low cost.

Today, rayon is one of the least expensive fibers. Blending rayon with other, less hydrophilic fibers such as polyester and nylon, yields fabrics that are softer, more comfortable, and inexpensive. Rayon filament, used in combination with spun yarns of other fibers, gives strength to the fabric without sacrificing comfort.

ACETATE AND TRIACETATE

The TFPIA provides the following definition of the acetate fibers:

> A manufactured fiber in which the fiber-forming substance is cellulose acetate. Where not less than 92 percent of the hydroxyl groups are acetylated, the term *triacetate* may be used as a generic description of the fiber.

Cellulose acetate was discovered in 1869, but it was 35 years later that Henri and Camille Dreyfus developed an economical process for its com-

mercial manufacture. During World War I, the Dreyfus brothers sold acetate lacquer—less flammable, safer, and more durable than the cellulose nitrate products up till then used for painting airplane wings and fuselages. After the war the firm developed a technique for spinning cellulose acetate into "artificial silk." Production of this fiber began in England in 1921, and in the U.S. in 1924.

For many years the public thought of both cellulose acetate and regenerated cellulose fibers as essentially the same material, "artificial silk." When the term "rayon" was adopted in 1924, little effort was made to enlighten consumers. In 1951, however, the Federal Trade Commission ruled that *rayon* meant regenerated cellulose, and that *acetate* meant cellulose acetate. Almost immediately, the Celanese Corporation of America (now Celanese Fibers Marketing Co.) introduced cellulose *triacetate*. In 1960 the present definitions of rayon, acetate, and triacetate were adopted.

The concern for legal definitions extends beyond mere hair splitting. The fibers differ in their strength, durability, comfort, ease of care, dyeability, and appearance, so that it is important for consumers to know what they are buying.

Fiber Production and Yarn Manufacture

The production of acetates is discussed in detail in Chapter 18. In the production of triacetate, wood pulp, or cotton linters, is treated with glacial acetic acid and acetic anhydride to form cellulose triacetate (Fig. 6.3). Addition of water slowly converts some of the ester groups back to hydroxyl groups. This process is called *saponification*. The extent of the reaction is controlled so that the proper number of ester groups are saponified, and the secondary acetate is obtained. The product is precipitated in the form of small flakes by the addition of a large excess of water. If triacetate is desired, the saponification step is omitted. The triacetate ester is precipitated in excess water and dried. The dried acetate flake is dissolved in acetone, and the triacetate flake is dissolved in methylene chloride/ethanol solution to produce a thick, syrupy liquid known as the spinning *dope*.

Acetate and triacetate are DRY-SPUN. After filtration, the spinning dope is pumped through spinnerets into a stream of warm, dry air. The acetone or

Figure 6.3 Cellulose triacetate if formed from the reaction of cellulose with acetic acid and acetic anhydride; the acetate is formed when triacetate reacts with water. (Figure continued on p. 114)

Step 2

(cellulose triacetate)

H_2O →

(cellulose acetate)

Figure 6.3 (continued)

the methylene chloride/ethanol solution evaporates, leaving thin filaments of acetate or triacetate, respectively. The solvent is recovered to be used again. Solvent recovery not only reduces air and water pollution, it makes the manufacturing process more economical.

Fiber Composition

MACROSTRUCTURE Both acetate and triacetate are solid filaments with little significant internal structure. Under the microscope (Fig. 6.4) they show an irregular, lobed cross-section. A longitudinal view reveals striations similar to those in rayon, although fewer in number. It is possible to prepare the fibers with any shape cross-section and any diameter, so that microscopic examination of a fiber is not sufficient for positive identification.

MICROSTRUCTURE Both cellulose acetate and cellulose triacetate are esters of acetic acid and cellulose. In acetate, between 4.5 and 5 of the six

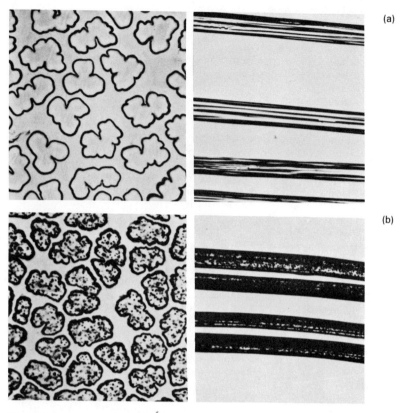

Figure 6.4 Acetate fibers (a) and triacetate fibers (b) have an irregular cross-section and a striated surface. *(AATCC and ASTM)*

hydroxyl groups on each cellobiose unit are reacted to form acetyl groups ($CH_3-\overset{\displaystyle O}{\overset{\|}{C}}-$). In triacetate, almost all the hydroxyl groups have been replaced. The chemical structures of both materials are illustrated in Fig. 6.3.

Examination of Fig. 6.3 indicates that the neat, ordered arrangement of atoms found in cellulose is not possible in the acetates. The small hydroxyl groups that fit between the cellulose chains in cotton and rayon have been replaced by bulky acetyl groups. The presence of the acetyl groups forces the polymer chains apart and reduces the chances that the chains will form crystals. Furthermore, even though the average number of acetyl groups per glucose unit may be 2.5 or 2.6 or 2.9, any particular glucose residue unit may have none, one, two, or three of its hydroxyl groups replaced by the acetyl groups. The nonuniform distribution of the acetyl groups makes the formation of ordered regions more difficult. Finally, the acetate and triacetate molecules are less oriented than those in the cellulosic fibers. All these factors serve to weaken the fibers.

Another consequence of the replacement of hydroxyl groups by acetyl groups is a reduction in hydrogen bonding. One result of the decreased number of hydrogen bonds is weakening of the fiber; a second is a decrease in moisture

115

TABLE 6.3 Properties of Acetate and Triacetate

Molecular Structure	Esterified cellulose.
Macroscopic Features	
Length:	Varied; can be produced in any length depending on use.
Cross-section:	Lobed in outline, irregular.
Color:	White.
Light reflection:	Available in bright, semi-bright, and dull.
Physical Properties	
Tenacity (g/den):	1.2 to 1.5.
Stretch and elasticity:	Acetate—35% elongation at break, 80% recovery at 2% elongation. Triacetate—35% elongation at break, 90% recovery at 2% elongation.
Resiliency:	Acetate poor, triacetate good.
Abrasion resistance:	Poor to moderate; triacetate better than acetate.
Dimensional stability:	Both are resistant to stretch and shrinkage.
Moisture regain:	Acetate 6.0%; triacetate 3.5%.
Specific gravity:	1.32.
Chemical Properties	
Effects of bleaches:	Resistant to weak oxidizing and reducing bleaches.
Acids and alkalies:	Concentrated strong acids decompose the fibers. Strong concentrations of alkalies cause saponification.
Organic solvents:	Not harmed by dry-cleaning solvents; however, fibers destroyed by acetone and acetic acid.
Sunlight and heat:	Lose strength and develop splits after prolonged exposure. May use iron up to 135°C (275°F) for acetate and 215°C (400°F) for triacetate.
Resistance to stains:	Fibers tend to shed dirt. More resistant to waterborne stains than rayon and cotton.
Dyeability:	Require use of special acetate dyes. May also be solution-dyed. Fabrics have good washfastness and lightfastness.
Biological Properties	
Effects of fungi and molds:	High resistance to deterioration by mildew.
Effects of insects:	Silverfish may attack heavily sized fabrics.
Flammability Behavior	Moderately high flammability, but does not produce melt drip.
Electrical and Thermal Conductivity	Poor electrical conductivity. Low heat conductivity.

absorption. One may expect that both acetate and triacetate will be much less hydrophilic than cotton or rayon, and the triacetate will be even less receptive to penetration by water than acetate.

Fiber Properties

The important physical and chemical properties of acetate and triacetate are listed in Table 6.3.

APPEARANCE Light reflection from both acetate and triacetate is good, giving relatively bright fibers. These fibers contribute good drape and a lustrous, pleasing appearance to fabrics.

COMFORT The ability to absorb moisture is greatly reduced because few hydroxyl groups are available in the fibers, so the comfort properties are not as satisfactory as in natural cellulosics or rayon.

MAINTENANCE Both acetate and triacetate resist wrinkling better than cotton. Wrinkles hang out if the garments are properly stored after wearing. Triacetate holds pressed creases and pleats very well.

Acetate and triacetate are thermoplastic materials. That is, they will melt upon heating. Under carefully controlled conditions, this property may be used to advantage in embossing patterns and setting pleats and creases into cloth made from these fibers. However, this also means that too hot an iron will melt the cloth. Acetate may be safely ironed at temperatures up to 135° C (275° F), while triacetate may be ironed at temperatures up to 215° C (400° F).

Both fibers may be laundered or dry-cleaned, but, because of their low wet strength, they should be treated with care. Detergents and bleaches, if properly used, will not harm the fibers. It should be noted that acetate dissolves readily in acetone, denatured alcohol, and acetic acid, while triacetate is damaged by these materials. Most nail-polish removers contain acetone, and should not be used near acetate fabrics. By the same token, nail polish spilled on acetate or triacetate garments is very difficult to remove.

DURABILITY Both acetate and triacetate are weaker than cotton owing to lower crystallinity and reduced hydrogen bonding. The abrasion resistance is poor for the same reasons. However, both fibers resist degradation by sunlight and are suitable for use in curtains. Drapes are likely to stretch because they are usually too heavy to allow acetate fibers to maintain their stability. Triacetate is more resistant to stretching, but drapes do tend to lengthen during use.

Both acetate and triacetate may be dyed with special dyes to give bright, long-lasting colors. However, some of the dyes are not resistant to atmospheric gases, and fume fading may result. This problem is particularly acute with blue colors. Solution-dyed fibers—those in which pigment is added to the fiber before spinning—have excellent fastness. However, the cost of providing solution-dyed fibers has become prohibitive because of the broad range of colors the manufacturer must be willing to provide. Customers don't want just red; they want strawberry red, Mandarin red, scarlet, etc. It is cheaper to prepare a dye bath and dye the finished cloth than it is to reformulate the spinning dope each time a color change is made, even though more expensive dyes must be used. Most manufacturers have discontinued production of solution-dyed acetate and triacetate.

Uses

Both acetate and triacetate are widely used in apparel and home furnishings. However, it should be noted that both are relatively weak and have low abrasion resistance. Acetate or acetate/rayon blends and combinations often found in low-priced upholstery have good esthetics, but poor durability. In curtains, both fibers give good wear as well as a wide range of fashion accents. Acetate, triacetate, and blends or combinations of these fibers with rayon are useful in bedspreads, particularly those with intricate colored patterns. Again, durability is not a strong point.

In apparel, both fibers are suitable for a wide range of fabrics, the weight and construction being determined by the end use. These fibers have good drape, fair wrinkle resistance, and a pleasing luster. In blends with rayon, they provide improved wrinkle resistance and a pleasing luster, and resist absorbing water-borne stains. When blended with wool, they reduce the tendency to shrink and felt. However, decreased durability may result.

SUMMARY

The man-made cellulosic fibers are rayon, acetate, and triacetate. Rayon is a filament fiber spun from an alkaline solution of modified cellulose into an acid bath. Although, like natural fibers, it is pure cellulose, rayon has a lower molecular weight and less crystallinity. For these reasons, rayon is not as durable as cotton or linen. The esthetics of rayon are superior to the natural cellulosic fibers. It can have a high luster and a smooth, silky hand. Rayon's major advantages are good appearance, comfort, and low cost. Its major disadvantages are poor durability, low shrink resistance, and a tendency to absorb waterborne stains.

Acetate and triacetate fibers are made by chemically modifying cellulose to replace the hydroxyl groups with acetyl groups. If about 2.5 of the 3 —OH groups on each glucose ring are replaced by $—OOCCH_3$ groups, the product is acetate. If more than 92 percent of the —OH groups are replaced, the product is triacetate. The fibers are similar in their properties. Major differences lie in triacetate's more thermoplastic nature, which allows it to be permanently heat-set. Both acetate and triacetate are less absorbent, have greater wrinkle resistance, and are more stain-resistant than the natural cellulosics or rayon. They are also less durable and less comfortable.

REVIEW QUESTIONS

1. Rank rayon, acetate, and triacetate in order of increasing moisture regain. Explain the causes of the differences.
2. Acetate is much weaker than rayon, although both are man-made cellulosic fibers. Explain the causes of the difference.
3. Compare the maintenance properties of rayon to those of acetate. Which would make a better necktie?
4. Compare the comfort and durability properties of rayon with those of acetate. Explain the differences. Which is better suited for use in home furnishings? Explain.
5. Compare the durability properties of rayon with those of triacetate. Which would make a better upholstery fabric? Which would make a better pair of slacks or trousers?
6. Both rayon and cotton are made of cellulose. Compare their performance properties and explain the differences.

7

man-made petroleum-based fibers

NYLONS

The Textile Fiber Products Identification Act provides the following definition for nylon:

> A manufactured fiber in which the fiber-forming substance is a long-chain synthetic polyamide in which less than 85 percent of the amide linkages are attached directly to two aromatic rings.

Implicit in this definition is the suggestion that nylon, unlike the cellulosic synthetic fibers, can be prepared from more than one chemical compound. Current technology is capable of producing a variety of polyamides, all of which fit the definition cited above. These materials are used for mechanical and structural components and adhesives as well as for fibers. At this writing there are about 29 U.S. manufacturers producing nylon fibers under 60 different trademarks. In this section we shall discuss the three nylons of major importance as textile fibers: NYLON 6,6; NYLON 6; and CYCLIC NYLONS.

The invention and development of nylon fibers is one of the more interesting chapters in the history of modern industry. It illustrates how well scientific inquiry, technological innovation, and marketing can be meshed to create goods to satisfy consumer needs. In 1927, the DuPont Company created a research group, under the direction of Wallace Hume Carothers, to study high-molecular-weight materials. What made this group different from

almost all other such groups in industrial laboratories was that it was not required to produce anything. Carothers was allowed to pursue pure science.

By 1930, Carothers and his associates had performed a feat that had eluded researchers for centuries. They had created a textile fiber! Over the next nine years, scientists, engineers, and managers developed the processes, techniques, and equipment for manufacturing a synthetic polyamide in commercial quantities. The marketing organization provided information on the physical and chemical properties that would make the new fiber acceptable to consumers. They also gave it the name *nylon*. Accompanied by a well-planned marketing and advertising campaign, knitted nylon hosiery for women was introduced to the public in early 1940. It was an immediate success.

The choice of women's stockings as the vehicle for the introduction of nylon was not accidental. At that time women could choose among silk stockings that were comfortable, flattering, reasonably durable, and expensive; rayon stockings that were not so comfortable and durable, but were less expensive; and cotton or wool stockings that were inexpensive and durable, but by no means flattering. Nylon stockings had the esthetics of silk, were far more durable, and were lower in price.

The early nylons sold for about $5 a pair—less than silk, but more than cotton. They were so popular that demand outstripped supply. However, before significantly greater amounts of the fiber could be produced, the U.S. entered World War II, and fiber production was diverted to military use. Nylon was first used as a replacement for silk in parachutes and later used for belts, webbing, camouflage, truck tires, and other items of military importance. It was not until after the war that nylon reappeared in consumer use.

The DuPont Company was justifiably proud of its achievement. Its early literature claimed that the major importance of nylon lay in the fact that man had stopped trying to imitate the silkworm, and had instead created a molecule specifically intended for use as a textile fiber. Yet nylon and silk share a similar chemical structure. Silk is a biological polymer in which many different amino acids are joined by amide linkages; nylon is an organic polymer in which many hydrocarbon units are joined by amide linkages. Interestingly enough, the first uses for nylon were as a replacement for silk.

Fiber Production and Yarn Manufacture

The production of nylon is discussed in greater detail in Chapter 18. The usual procedure is to extrude the melted polymer into a stream of cold air by a process called MELT SPINNING.

Nylon 6,6 The original and still the most important polyamide is nylon 6,6. It is formed from hexamethylene diamine and adipic acid by a stepwise polycondensation reaction (Fig. 7.1). In the usual procedure, hexamethylene diamine and adipic acid are reacted to form *nylon salt*. The salt is then heated under pressure to form long-chain molecules of nylon. The nylon is extruded from the reactor, cooled, and broken into flakes. In the

H_2N—$(CH_2)_6$—NH_2 + $HOOC$—$(CH_2)_4$—$COOH$ ⟶

hexamethylene diamine adipic acid

H_2N—$(CH_2)_6$—$NH_3^+\ ^-OOC$—$(CH_2)_4$—$COOH$ $\xrightarrow{\text{Heat}}$

nylon salt

H_2O +

nylon 6,6

Figure 7.1 The formation of nylon 6,6 from hexamethylene diamine and adipic acid.

water

process known as melt spinning, the flakes from many batches are blended and remelted. The molten material is extruded through spinnerets into a stream of cold air. The hot nylon cools to form filaments, which are stretched to orient the molecules and increase crystallinity, and wound on bobbins. The filament may also be cut to staple length and spun into yarn.

The general structure of the polymer is that of a chain of methylene ($-CH_2-$) groups joined by amide linkages. These nylons are designated by the number of carbon atoms in the diamine and the number of carbon atoms in the acid, respectively. The polyamide prepared from hexamethylene diamine (6 carbon atoms) and adipic acid (6 carbon atoms) is called nylon 6,6. The product of hexamethylene diamine (6 carbon atoms) and dodecanedioic acid (12 carbon atoms) would be nylon 6,12. Nylon 4,12 is prepared from tetramethylene diamine (4 carbon atoms) and dodecanedioic acid (12 carbon atoms).

Nylon 6 Another commercially important nylon is nylon 6. More widely used in Europe than in the United States, nylon 6 has properties similar to those of nylon 6,6. It is manufactured by polymerizing *caprolactam*, extruding the polymer to form a flake, blending and remelting the flake, and extruding the hot melt into a cold air stream. Since only one chemical compound is involved, this polyamide has only one number. The preparation of nylon 6 is shown in Fig. 7.2.

caprolactam nylon 6

Figure 7.2 The preparation of nylon 6. The 7-membered ring of caprolactam opens to form a linear polymer.

Another type of polyamide incorporates cyclic molecules within the polymer. These ring structures increase tensile strength, melting temperature, and elastic recovery. The cyclic nylons are prepared in a manner similar to

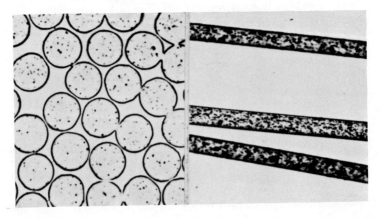

Figure 7.3 The structure of Qiana nylon.

nylon 6, but the fibers are dry-spun. Qiana is a cyclic nylon prepared from *bis*(p-aminocyclohexylmethane) and dodecandioic acid. Its structure is shown in Fig. 7.3.

Fiber Composition

MACROSTRUCTURE Commercial nylons are usually solid filaments with little or no internal structure. Under the microscope (Fig. 7.4), the fibers appear translucent with some visible specks of delustrant. The cross-section is usually round, although some brands may have lobed, triangular, or square cross-sections. Antron II is particularly interesting in that it is square in cross-section with holes running longitudinally through the fiber.

MICROSTRUCTURE Nylon 6,6 and nylon 6 are composed of linear hydrocarbons held together by amide links. The hydrocarbon portions are HYDROPHOBIC; that is, they reject water. The amide groups are HYDROPHILIC— "water loving." The hydrophobic portion of the molecule predominates, so that nylons have a rather low moisture regain. This is a liability as far as comfort is concerned, but is an advantage in that nylons are not readily stained by water-borne materials such as fruit juices or coffee.

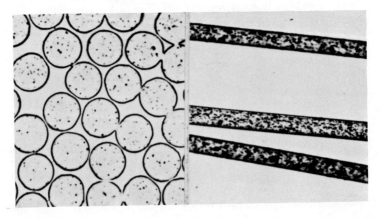

Figure 7.4 Photomicrographs of nylon fibers showing the smooth surface and round cross-section. (*AATCC and ASTM*)

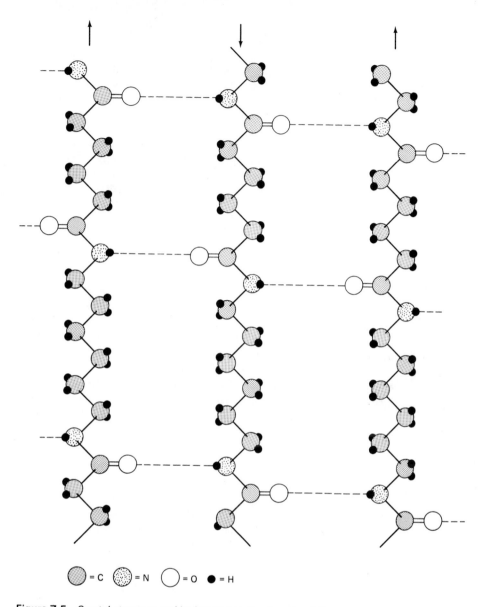

\bigcirc = C \bigcirc = N \bigcirc = O \bullet = H

Figure 7.5 Crystal structure and hydrogen bonding in nylon 6,6.

The regular chain structure, Fig. 7.5, allows the formation of crystals within the fiber, and the amide links provide hydrogen bonding to help hold the crystals together. Thus, nylons with their high level of crystallinity, rank among the strongest of the fibers and possess good resilience and elasticity. The highly ordered crystal structure also helps make the fiber resistant to penetration by oil-borne stains. In addition, the hydrocarbon portion of the molecule provides some lubricity, so the fibers are very smooth and do not hold soil particles well.

Note that the atoms of the molecule do not lie in a straight line, but have a

sawtooth structure. This structure allows the polymer to stretch slightly under tension and to yield slightly under compression. This makes the fibers very tough, so that they resist destruction by flexing and abrasion.

The cyclic nylons, such as Qiana, have less ability to absorb moisture than do the linear polymers. This is because there is a greater proportion of hydrophobic components in the molecule. In addition, the cyclic polymers are not as easily packed into neat crystal structures. This reduces the tenacity of the fiber and also lowers the resistance to staining by oil-borne dirt. The rings do not provide the lubrication that the straight-chain hydrocarbons do, so the fibers do not feel as slick, and the hand is improved. Finally, the cyclic portion of the polymer raises the melting temperature, so that textured fibers maintain their crimp longer. This means that the air and moisture permeability, elasticity, and hand of cloth made from the cyclic nylons is better maintained throughout the life of the garment.

Fiber Properties

The important physical and chemical properties of nylon 6,6 and nylon 6 are given in Table 7.1. Qiana differs from the other two fibers in its lower tenacity 3.3 g/den; specific gravity 1.03; and moisture regain 3.5%.

APPEARANCE Because nylon fibers are melt-spun, it is relatively easy to vary their cross-sections. Thus, the manner in which light is reflected from the surface of the fiber can be changed. The fiber surface is very smooth and highly reflective; however, finely ground powder, called *delustrant*, may be added to the polymer before the fiber is spun to scatter the light and reduce brightness. Because of the many ways in which the brightness of the fiber may be affected, nylon fibers may be dull, lustrous, or bright and sparkling.

COMFORT Since nylon fibers have a low moisture regain and a very smooth surface, the hand tends to feel slick and cool. For this reason, nylon fibers are often textured. Texturing provides a drier, more full-bodied hand and a more comfortable fabric. Because of their high strength, nylons are well suited to lightweight fabrics and have good draping qualities.

MAINTENANCE Nylon apparel is easily maintained, because the cloth resists staining, dries quickly, and needs little or no ironing. However, white or pastel nylon fabrics are subject to graying and discoloring with extended use. This problem can be alleviated, to some extent, through the use of peroxide or perborate bleaches.

Nylon 6,6 may be ironed at temperatures between 150 and 175 C° (300 to 350° F). Nylon 6 requires a lower temperature—no higher than 150° C (300° F). Qiana may be ironed at temperatures as high as 200° C (400° F). The high melting temperature of these materials means that creases and pleats will stay in the garment. In addition, incorrect ironing will be less likely to cause the cloth to glaze than if the melting temperature were lower.

The excellent resilience of textured nylon fibers means that cloth made from them will not be easily crushed and will resist wrinkling.

TABLE 7.1 Properties of Nylon

Molecular Structure	Polyamide.
Macroscopic Features	
Length:	Produced as filament and staple.
Cross-section:	Generally round, but may be any shape.
Color:	White.
Light reflection:	High natural luster. May be delustered.
Physical Properties	
Tenacity (g/den):	Very high—4.6 to 5.8; high-tenacity nylon may be as high as 9. Qiana 3.3.
Stretch and elasticity:	High elasticity and good elongation. 30% elongation at break, 100% recovery at 2% elongation.
Resiliency:	Good; good wrinkle-resistant properties.
Abrasion resistance:	Excellent; good resistance to flexing.
Dimensional stability:	Can be heat-set to maintain shape. Will maintain shape if heat-set temperature is not exceeded.
Moisture regain:	4.2 to 5% at standard conditions. Nylon 6 slightly higher than nylon 6.6 Qiana 3.5%.
Specific gravity:	1.14. Qiana 1.03.
Chemical Properties	
Effects of bleaches:	Not affected by oxidizing and reducing bleach but may be harmed by chlorine and strong oxidizing bleaches.
Acids and alkalies:	Weakened by strong acids; not affected by alkalies.
Acids and alkalies:	Resists dry-cleaning solvents and reagents used in spot and stain removers.
Sunlight and heat:	Loses strength on prolonged exposure to sunlight. Good resistance to heat.
Resistance to stains:	Excellent resistance to water-borne stains, fair resistance to oil-borne stains.
Dyeability:	Acid, direct, vat, disperse, basic, and metalized dyes are used.
Biological Properties	
Effects of fungi and molds:	Resistant to mold and fungi.
Effects of insects:	Not attacked by insects.
Flammability Behavior	Burns slowly, self-extinguishing. Melts and drips.
Electrical and Thermal Conductivity	Fibers have low electrical and thermal conductivity. May develop a static charge, particularly under conditions of low humidity.

The low moisture regain of nylon permits the buildup of static electricity on nylon fabrics. This becomes a problem in slips, hosiery, and carpeting. The static charge can cause intimate lingerie to cling to the body and prevent trouser legs from hanging properly. In addition to ruining the drape of clothing, this can be quite uncomfortable. Charge buildup from walking across carpeting can give an uncomfortable shock. To prevent static buildup, nylon fibers have been developed with antistatic agents added prior to spinning. Finishes also exist that will prevent static buildup in untreated fibers.

DURABILITY Nylon fibers have high strength, good elasticity, and a high level of abrasion resistance. These properties make them suited to end uses, such as home furnishings, in which resistance to high levels of wear and

abuse are important. Their chemical resistance, and good performance at elevated temperature recommend them for industrial applications. Since nylons do not support the growth of micro-organisms and do not provide food for insects and other pests, they do not require elaborate precautions during storage. Nylons are sensitive to destruction by prolonged, intense sunlight. For this reason they are not often found in unlined curtains and drapes.

Apparel Uses

Nylon is one of the most widely used fibers. Its high strength and excellent resistance to soils and stains allow it to be used in sheer cloth for lingerie and hosiery. Its low moisture absorption means that nylon swimwear will dry quickly. Its high abrasion resistance makes it well suited to work clothes. One of the major drawbacks in apparel use is the clammy feeling that untextured filament nylon can cause. This can be decreased through the use of spun yarns or textured filaments. Knit apparel made from these yarns is sufficiently comfortable to be used as underwear.

Non-Apparel Uses

Nylon is widely used in upholstery because of its high strength, abrasion resistance, elasticity, and dyeability. Nylon upholstery fabrics resist tearing and wear in hard use. Because the fibers are elastic, cushions maintain their neat appearance without wrinkling and chair arms covered with nylon fabric resist abrasion. Materials are readily cleaned with home methods. If kept out of direct sunlight, colors will be long-lasting.

Today, tufted nylon is used for about 75 percent of the carpets in residential use. The fibers are strong, resilient, abrasion- and stain-resistant, and readily dyed. Recent advances in spinning technology have yielded very fine nylon fibers that make carpets as soft as those made from fine wools. Low-loop nylon carpeting is particularly suited for kitchens and playrooms because it is easily maintained and nonallergenic.

Outside the home, nylon is found in many automotive, recreational, and industrial uses. Nylon tire cord is widely used in replacement tires. Nylon cloth in sails and camping equipment has almost totally replaced cotton canvas. High-strength nylon ropes and reinforced belts and hoses help to hold and move everything from automotive coolant to iron ore.

A major drawback to the use of nylon tire cord is the tendency to flat-spot. Nylon yarn will stretch if held under tension for long periods of time. When an automobile is left standing for many days, the bottoms of the tires are under a high tensile load; this load causes the yarns to stretch slightly. When the car is eventually driven, the stretched region, appearing as a flat spot on the tire, causes the tire to bump. After a few miles, however, the tire heats up, the yarns return to their original shape, and the flat spot disappears. Flat-spotting is particularly noticeable on large, heavy cars. For this reason polyester is generally used for original-equipment tires, but nylon is very popular for replacement tires.

Uses of Qiana

This fiber is gaining increasing popularity in apparel and home furnishings because it competes well with silk in its luster, drape, and hand. Even though Qiana has a low moisture regain, it is comfortable because of its good *wicking* ability. Moisture is transferred from the body to the atmosphere by adsorption onto the surface of the fibers in the region near the skin. Subsequent transport along the fiber surface to the outer surface of the cloth allows the moisture to evaporate into the atmosphere. In addition, this fiber takes dyes well, is wrinkle-resistant, stronger than silk, and is not subject to perspiration stains.

POLYESTERS

The Textile Fiber Products Identification Act defines polyester as follows:

> A manufactured fiber in which the fiber-forming substance is any long-chain synthetic polymer composed of at least 85 percent by weight of a substituted aromatic carboxylic acid, including but not restricted to substituted terephthalate units and parasubstituted hydroxybenzoate units.

As with the nylons, this definition allows a number of molecular structures to be termed "polyester." At present, the three most important polyester fibers are poly(ethylene terephthalate) [PET], poly(1,4-cyclohexane dimethyl terephthalate) [PCDT], and poly(ethylene oxybenzoate) [PEB].

Polyester fibers were originally created by the DuPont research group under Carothers. However, they decided that the polyamides would be more likely to yield a useable textile fiber, and abandoned further work in this area. The investigations were continued in England by J. R. Whinfield and associates of Calico Printers Association, Ltd. Work was impeded by World War II, but sufficient progress has been made so that in 1944 DuPont purchased the U.S. rights to polyester. Commercial production of PET fiber began in the United States in 1953.

Fiber Production and Yarn Manufacture

PET Poly(ethylene terephthalate), commonly known as PET, is the most widely used polyester fiber. It may be produced by a stepwise polycondensation reaction between ethylene glycol and terephthalic acid, as shown in Fig. 7.6. However, a purer product is achieved by reacting the

Figure 7.6 Preparation of PET from a diacid and a diol. (Figure continued on p. 128)

Step 2 $HO-(CH_2)_2-O-\overset{\overset{O}{\parallel}}{C}-\langle\bigcirc\rangle-\overset{\overset{O}{\parallel}}{C}-O-(CH_2)_2-OH$ + H_2O $\xrightarrow[\text{Heat}]{\text{Catalyst}}$

di(2-hydroxyethyl) terephthalate

$\left[\overset{\overset{O}{\parallel}}{C}-\langle\bigcirc\rangle-\overset{\overset{O}{\parallel}}{C}-O-(CH_2)_2-O\right]_n$ + $HO-(CH_2)_2-OH$

poly(ethyleneterephthalate)

Figure 7.6 (continued)

dimethyl ester of terephthalic acid with ethylene glycol. After polymerization, the fiber is produced by melt spinning.

The polymer is extruded, flaked, blended, remelted, and pumped through spinnerets into a cold air stream to form filaments. The filaments are stretched to increase crystallinity, and wound on bobbins.

PCDT Poly(1,4-cyclohexane dimethyl terephthalate), illustrated in Fig. 7.7, is marketed as the Kodel 200 series of polyester. This molecule contains two rings, so that its properties are different in many respects from PET. PCDT is manufactured much as is PET, and is spun by the melt-spinning process.

PEB Poly(ethylene oxybenzoate), manufactured under the trade name A-Tell by Unitika, Ltd. of Japan, is the most recent of the polyester fibers. Until the introduction of A-Tell, the TFPIA required polyester to be a product of terephthalic acid alone. In order to avoid having to develop a new generic classification for this fiber, the FTC broadened the definition of polyester. The structure of PEB is given in Fig. 7.8. Its fibers are produced much as are the other polyesters.

Figure 7.7 The structure of PCDT, a cyclic polyester.

Figure 7.8 The structure of PEB, an ester of benzoic acid.

Fiber Composition

MACROSTRUCTURE Polyester fibers are smooth solid rods with little or no significant internal structure. Under the microscope (Fig. 7.9), the fibers appear translucent. Some delustrant may be visible. The cross-section of the fiber is usually round, although trilobal and pentalobal cross-sections are available.

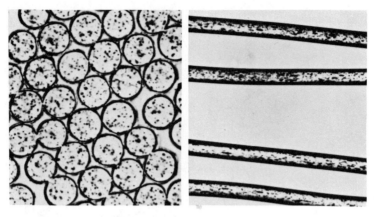

Figure 7.9 Photomicrographs of polyester showing the smooth surface and round cross-section. Note the similarity to nylon, Fig. 7.4. (*AATCC and ASTM*)

MICROSTRUCTURE The polyester fibers consist of organic molecular units linked through ester ($-\overset{\overset{\text{O}}{\|}}{\text{C}}-\text{O}-$) groups. The properties of the polyesters are determined, to a great extent, by the aromatic rings and ester groups that make up the molecule. The ring structures are much more hydrophobic than are the linear hydrocarbons in the polyamides. In addition, the ester groups are not as polar as amide groups. Both of these factors indicate that polyesters should have a very low affinity for water; in fact, the standard moisture regain for polyesters is less than 1 percent. In addition, the smooth surface of the fibers reduces the wicking action of water over the surface. Thus, polyester fabrics, particularly those made from untextured filament yarns, are somewhat uncomfortable as garments. The aromatic groups in the molecule have a high affinity for oily materials—that is, polyesters are *oleophilic*. This means that polyester fabrics will be easily stained by oily materials that can penetrate the fiber. These stains will not wash out readily, since it is difficult for water and detergents to penetrate the fiber. For this reason 100 percent polyester fabrics may sometimes have to be dry-cleaned. Another effect of the oleophilic nature of polyester is the tendency to pick up dirt from other clothes in the wash. This redeposition of soil from the washwater onto the polyester can produce a grey tinge to white polyester.

Examination of the molecular structure of the polyesters reveals that these molecules are bulkier than the nylons, so that it is more difficult for polyester to form crystals (Fig. 7.10). In addition, the polyesters do not have the same level of hydrogen bonding; thus, they do not have quite as high a tensile strength as nylon. Furthermore, PCDT with its two ring structures, should be the least crystalline of the three materials. This reduced crystallinity leads to reduced tenacity. Since the less ordered regions of the fiber have less resistance to motion, the weaker fibers are also the ones with higher elongation. However, the stretch recovery is not as great.

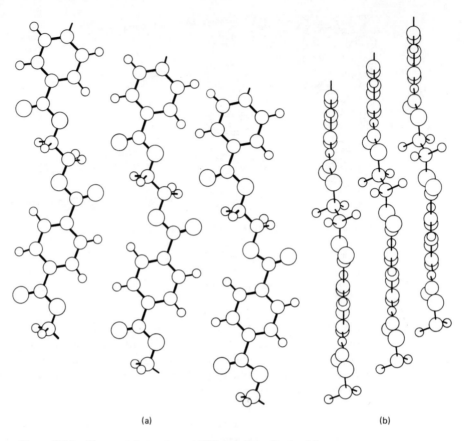

(a) (b)

Figure 7.10 The crystal structure of PET seen from the top (a)
and side (b). PET does not pack as closely as nylon 6,6.

Fiber Properties

The important physical and chemical properties of PET are listed in
Table 7.2.

The properties of PCDT and PET are similar to PEB; those which differ
are compared in Table 7.3. It should be noted that all the polyesters have
satisfactory properties.

Polyesters have good strength, good to excellent abrasion resistance,
high resiliency, and good dimensional stability. Polyester fabrics, particularly
those made from textured yarns, exhibit excellent wrinkle recovery. Yarns are
smooth and lustrous, with a good hand. Textured yarns yield lightweight,
full-bodied, opaque fabrics that drape well. Polyester is particularly suited to
knits.

APPEARANCE Like the nylons, polyester fibers may be spun with
different cross-sections, and delustrants may be added to affect the level of
light reflection and light scattering. Thus, polyesters may be dull or bright.

130

TABLE 7.2 Properties of Polyester

Molecular Structure	PET poly(ethylene terephthalate).
Macroscopic Features	
Length:	Is produced in filament and staple form.
Cross-section:	Generally round; may be trilobal, oval, or pentalobal.
Color:	White.
Light reflection:	Bright or dull.
Physical Properties	
Tenacity (g/den):	4.5 to 5.0. As high as 8 for high-tenacity fibers.
Stretch and elasticity:	20 to 30% elongation at break; 97 to 100% recovery at 2% elongation.
Resiliency:	Excellent to good wrinkle recovery.
Abrasion resistance:	Exceptionally good.
Dimensional stability:	If properly heat-set will not shrink or stretch.
Moisture regain:	0.4 to 0% at standard conditions.
Specific gravity:	1.38.
Chemical Properties	
Effects of bleaches:	Not affected by oxidizing or reducing bleaches.
Acids and alkalies:	Good resistance to almost all common acids. Hot concentrated sulfuric acid will cause deterioration. Resists most alkalies.
Organic solvents:	Not affected by organic solvents.
Sunlight and heat:	Good resistance to sunlight, if behind glass. Prolonged exposure weakens and causes deterioration. Low temperatures should be used for ironing.
Resistance to stains:	Good resistance to water-borne stains. Oil-borne stains may be difficult to remove.
Dyeability:	Wide range of shades can be produced which have good to excellent colorfastness in water and fair to good fastness in light. Disperse and azoic dyes, and some pigments are used.
Biological Properties	
Effects of fungi and molds:	Resists mildew.
Effects of insects:	Do not damage.
Flammability Behavior	Burns slowly; will shrink away from flame, yet will exhibit melt drip.
Electrical and Thermal Conductivity	Will not conduct electricity.

TABLE 7.3 Comparison of PET, PCDT, and PEB

	PET (Dacron)	PCDT (Kodel)	PEB (A-Tell)
Tenacity (g/d)	4.5–5.0	2.5–3.0	4.0–5.3
Elongation (%)	20–30%	25–40%	15–25%
Elastic recovery at 2% elongation	97–100%	85–95%	100%
Standard moisture regain	0.6%	0.2%	0.4%
Specific gravity	1.38	1.22	1.34
Melting temperature (C)	240°	290°	220°

COMFORT The major factor affecting the comfort of garments made from polyester fibers is the low moisture regain. Low moisture absorption means that the fibers will build up static charges that can be uncomfortable

and cause garments to drape improperly. In addition, low moisture absorbance will make it difficult to transfer body moisture to the atmosphere. This leads to discomfort in the summer, when polyester garments feel hot, and to a cold, clammy feeling in the winter. Texturing the fibers helps improve comfort by increasing the amount of air trapped in the yarns and increasing the surface available for moisture transport. Increased air improves the warmth of the material, while improved wicking reduces the clammy feeling.

MAINTENANCE The oleophilic nature of the fibers means that oil-borne dirt can penetrate the fibers. One of the major consumer complaints is the difficulty of removing oily stains from polyester. In addition, polyesters will adsorb body oils. Bacterial action on these natural oils can lead to unpleasant odors.

DURABILITY The high strength and abrasion resistance of polyester fibers sometimes leads to *pilling* of the surface of the cloth. Pills are small balls that are produced as the fibers are rolled about and entangled by abrasive forces. Because the fibers are strong, the pills do not break away from the surface of the cloth. Pilling is particularly evident in goods made from spun polyester yarns, which are hairier than filament yarns.

Polyesters have good resistance to most acids and alkalies. However, concentrated alkalies will destroy the fiber. Dry-cleaning fluids and most other organic solvents have little effect on the material. Insects and micro-organisms are not attracted to polyesters. Extended exposure to direct sunlight will weaken and destroy polyester. However, glass absorbs the wavelengths of sunlight that damage polyester, which means that polyester behind glass is very resistant to sunlight. This property makes polyester particularly well suited for use in curtains and drapes.

Apparel Uses

Polyester is among the most widely used fibers for apparel. Its strength, abrasion resistance, and resiliency makes it exceptionally good for use in knitwear. The major drawback of 100 percent polyester fabrics is the discomfort caused by low affinity for moisture.

Non-Apparel Uses

Polyester has also been used to great advantage in home furnishings. Polyester drapery and curtains resist stretching, will not yellow or fade in sunlight if kept behind glass, and may be laundered. Polyester carpets compete well with nylon, giving a softer, more luxurious hand and better resistance to sunlight than nylon. However, intense competition among fiber manufacturers causes constant reversals in the relative advantages of the fibers. For example, the introduction of finer-denier nylon yarns has led to the introduction of nylon carpets that are not only as soft as those made from polyester but also are more-stain resistant.

Polyester has taken much of the original-equipment tire cord market away from nylon and rayon. Since new cars often sit for a long time before being sold, auto manufacturers are unwilling to use nylon, which flat-spots, on new cars. Polyester tires are stronger and safer than rayon tires with the same number of plies.

Polyester/Cotton Blends

In an attempt to improve the consumer acceptance of polyester in apparel, the DuPont Company developed techniques for blending polyester and cotton in the same yarn; 65 percent polyester and 35 percent cotton give improved comfort and better dyeability while maintaining the wrinkle resistance and dimensional stability of 100 percent polyester. The cotton contributes a high level of moisture absorption to the blend as well as a better hand. The major disadvantage of the blend is that the cotton absorbs water-borne stains, while the polyester absorbs oil-borne stains. The blended fabrics are more difficult to clean than either 100 percent polyester or 100 percent cotton.

Under competitive pressure from the polyester manufacturers, cotton producers found that suitable fabrics may be produced from a wide range of polyester/cotton blend ratios. Today the most popular ratios for apparel are 65/35, 50/50, and 35/65 blends, although blends as high as 80/20 or as low as 20/80 have proved useful.

Increasing the polyester content gives greater wrinkle resistance, higher elasticity and dimensional stability, faster drying times, and better abrasion resistance. These advantages are accompanied by decreased comfort, a slicker, more synthetic hand, less brilliant colors, and a tendency to grey. Higher levels of cotton promote a drier, more natural hand, increased comfort, more brilliant colors, and a reduced tendency to absorb oil-borne dirt. The disadvantages are increased need for ironing, a tendency to shrink upon laundering, and absorption of water-borne stains. Stain removal is a problem with all polyester/cotton blends.

Polyester/Wool Blends

Increased consumer demand for the look and feel of natural fibers has led to a more widespread use of polyester/wool blends for both men's and women's wear. The polyester contributes better abrasion resistance and crease retention to the blend at lower cost. The wool provides resilience and excellent draping characteristics, coupled with warmth and good moisture absorption and wicking. The most popular ratios for apparel are 65/35, 60/40, 55/45, and 50/50. The 55/45 polyester/wool blend is most popular for lightweight, year-round apparel. The 50/50 blend is better for winter weights, because it gives greater warmth; while the 65/35 and 60/40 blends give better shape retention to lighter-weight suiting with a wool-like hand and appearance.

Increasing the polyester content gives greater crease retention, improved dimensional stability, and better abrasion resistance. These advantages are

accompanied by a slicker, more synthetic hand, less brilliant colors, and a tendency to pill. Higher levels of wool promote a drier, softer, more natural hand, improved comfort through greater insulating qualities, and improved moisture absorption, brighter colors, and a reduced tendency to absorb oil-borne dirt. The disadvantages are an increased need for ironing, lowered resistance to felting when laundered, and higher cost. Manufacturers' care instructions should be closely followed because wool and wool blend fabrics may shrink if improperly cleaned.

ACRYLIC

The Textile Fiber Products Identification Act defines acrylic as follows:

> A manufactured fiber in which the fiber-forming substance is any long-chain synthetic polymer composed of at least 85 percent by weight of acrylonitrile units.

Acrylonitrile was synthesized in the late 1890s, and its ability to polymerize to poly(acrylonitrile) was discovered not long after. However, polyacrylonitrile remained a laboratory curiosity until the latter part of the 1930s because it could not be melted without degradation, and could not be dissolved in any solvents then used. Just before World War II, German chemists discovered that acrylonitrile could be used in compounding a synthetic rubber; this became very important in both Europe and the United States as supplies of natural rubber were reduced by the war.

Following the war, acrylonitrile was available in large quantities, and its uses in rubber, paints, plastics, and synthetic fibers was investigated. The major problem, that of finding a suitable solvent for the polymer, was overcome by 1948, and the fiber was introduced commercially in 1950 by the DuPont Company under the name Orlon. Monsanto Textiles Co. followed with Acrilan in 1952, and other producers entered the market in the late 1950s.

Fiber Production and Yarn Manufacture

Poly(acrylonitrile) (PAN) is produced from the ADDITION polymerization of acrylonitrile (as illustrated in Fig. 7.11). One hundred percent poly-(acrylonitrile) is strong and highly resistant to chemicals, but is rather stiff, and presents problems in dyeing. For these reasons, the acrylic fiber is prepared from a copolymer of acrylonitrile and another material, known as a *comonomer*. Proper choice of the comonomer produces acrylic fibers that retain their resistance to sunlight and chemicals, but will accept dyes well and have a soft, resilient hand. (Addition polymerization and copolymerization are discussed in Chapter 3.)

Following polymerization, the copolymer is dissolved in dimethyl-formamide (DMF), extruded through spinnerets, stretched, wound on bobbins, or cut into staple. In the dry-spinning process, the solution of polymer in DMF is extruded into a hot air stream, in which the solvent is evaporated. In the wet-spinning process, the polymer solution is spun into a proprietary

Step 1

$$\underset{\text{acrylonitrile}}{\overset{\overset{\displaystyle H}{|}\quad\overset{\displaystyle H}{|}}{\underset{\underset{\displaystyle H}{|}\quad\underset{\displaystyle CN}{|}}{C=C}}} \quad + \quad \underset{\text{comonomer}}{\overset{\overset{\displaystyle H}{|}\quad\overset{\displaystyle H}{|}}{\underset{\underset{\displaystyle H}{|}\quad\underset{\displaystyle X}{|}}{C=C}}} \quad + \quad \underset{\text{initiator}}{R} \quad \longrightarrow$$

Step 2

$$\underset{\text{initiating radical}}{R-\overset{\overset{\displaystyle H}{|}}{\underset{\underset{\displaystyle H}{|}}{C}}-\overset{\overset{\displaystyle H}{|}}{\underset{\underset{\displaystyle CN}{|}}{C}}\cdot} \quad \xrightarrow[\text{comonomer}]{\text{monomer}} \quad \underset{\text{growing chain}}{R-\overset{\overset{\displaystyle H}{|}}{\underset{\underset{\displaystyle H}{|}}{C}}-\overset{\overset{\displaystyle H}{|}}{\underset{\underset{\displaystyle CN}{|}}{C}}-\overset{\overset{\displaystyle H}{|}}{\underset{\underset{\displaystyle H}{|}}{C}}-\overset{\overset{\displaystyle H}{|}}{\underset{\underset{\displaystyle X}{|}}{C}}\cdot} \quad \longrightarrow$$

$$\underset{\text{copolymer}}{\left[\overset{\overset{\displaystyle H}{|}\quad\overset{\displaystyle H}{|}}{\underset{\underset{\displaystyle H}{|}\quad\underset{\displaystyle CN}{|}}{-C-C-}}\right]_m \left[\overset{\overset{\displaystyle H}{|}\quad\overset{\displaystyle H}{|}}{\underset{\underset{\displaystyle H}{|}\quad\underset{\displaystyle X}{|}}{C-C-}}\right]_n}$$

Figure 7.11 Preparation of acrylic by a free radical polymerization; m is greater than n.

solution which removes the DMF. Both wet-spun and dry-spun acrylics are suitable for use as textile fibers. The choice of spinning process leads to minor differences in dyeability, tensile properties, and elongation.

Fiber Composition

MACROSTRUCTURE Acrylic fibers may be spun in any desired cross-section. The most popular are round, bean-shaped, or dog-bone (Fig. 7.12).

(a)

(b)

Figure 7.12 Photomicrographs of acrylic fibers: (a) wet spun with a bean-shaped cross-section; (b) dog-bone shaped dry spun fiber. (*AATCC and ASTM*)

High-bulk bicomponent fibers are often lobed. Wet-spun fibers may exhibit a thick skin surrounding a central core. Dull fibers will show small specks of delustrant. A longitudinal view shows a smooth rodlike structure with some fine striations. Electron microscopes using ultra-high magnification reveal that the fiber surface is much more porous than the other artificial fibers. This improves the hand and increases the moisture absorption of the fiber.

MICROSTRUCTURE The molecular structure of poly(acrylonitrile) is illustrated in Fig. 7.13. The molecule may be thought of as a long, twisted strand of carbon atoms from which nitrile (—CN) groups project at regular intervals. The spacing of the nitrile groups is described by a helix surrounding the carbon chain. The molecular forces generated by the nitrile groups surrounds the chain with a field that prevents penetration by other PAN chains. Thus, the molecule acts somewhat like a solid rod, the diameter of which is that of the "envelope" formed by the nitrile groups. Because of the rodlike behavior, the PAN molecules do not form crystals as the nylons and polyesters do. The crystallinity of acrylic fibers is less than half that of nylon.

Ordered regions within PAN are formed by stacking of the polymer chains in a manner similar to the packing of peppermint sticks. There is little intermolecular cohesion in the ordered regions. The ordering of the chains without formation of crystals means that PAN will behave like a GLASS rather than a crystal. The glassy nature of PAN manifests itself in the thermomechanical properties.

Poly(acrylonitrile) does not have a defined melting point, since the fiber is destroyed by heat before it melts. However, it does exhibit a GLASS TRANSITION TEMPERATURE (T_g), defined as that temperature *below* which a material becomes rigid and glassy. The T_g of PAN is 100°C (212°F). Thus, at temperatures well below 100°C, the fiber will be stiff and inflexible. As the fiber is heated from room temperature, it becomes less rigid. Above 100°C, the fiber is soft and pliable.

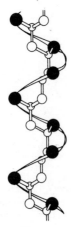

Figure 7.13 The helical configuration of PAN is caused by the mutual repulsion of the nitrile (—CM) groups. (G. Natta and P. Corradini, *Journal of Polymer Science*)

Stretching a PAN fiber while it is hot causes the molecules to slide past each other and assume an extended configuration. When cooled, the fiber remains in the stretched state. Reheating the fiber allows the molecules to contract. The contraction of the extended chains causes the fiber to shrink. Shrinkage of fabrics made from acrylic fibers may occur if they are laundered or ironed at too high a temperature. In the summer, acrylic draperies may reach temperatures high enough to cause shrinkage.

Acrylic fibers, because of their glassy structure, will also stretch when cold. Stretching of drapery fabrics under tension is one of the drawbacks of acrylics. The cycling resulting from stretch under tension and contraction by heating will fatigue the fiber and lead to breakage. However, the glassy structure of the acrylic fibers makes them very resilient. At room temperature, the fiber resists crushing, and will spring back to shape after the compressive force is released. This property makes acrylics well-suited to use in carpets and other end uses, such as sweaters, for which a high level of bulkiness and resistance to crushing is desired.

Preparing copolymers of acrylonitrile with other materials can cause a change in the properties of the resulting fiber. The glass transition temperature is lowered so that the fiber is not so stiff at room temperature. The comonomer may also be more receptive to dyes, so that the brilliance and fastness of colors is improved. In some cases the tenacity may be increased, but usually fiber strength is reduced by addition of a comonomer.

Fiber Properties

The important physical and chemical properties of acrylic fibers are listed in Table 7.4.

APPEARANCE In the same manner as nylon and polyester, acrylic fibers can be made dull or bright by varying the cross-section and by adding delustrants.

COMFORT Although the fibers are hydrophobic (water-hating), the porous surface allows some adsorption of moisture. This adsorbed moisture serves two purposes: (1) it reduces the static charge that would normally build up on the fiber and (2) it allows transfer of moisture from the inside surface of the fabric to the outside surface, where it can evaporate (wicking). Both of these processes increase the comfort of acrylic fabrics beyond what it would be if the surface were smooth.

Because glassy materials are more easily textured than crystalline materials, acrylics are often used where a bulky, hairy yarn is wanted. Very high bulk may be obtained by spinning *bicomponent* fibers. This type of fiber is prepared from two types of acrylic polymer spun through the same spinneret. The components respond differently to temperature and humidity changes, causing the fiber to twist and curl, as shown in Fig. 7.14b (see p. 139). High-bulk acrylics imitate wool well in their texture, hand, and dyeability.

TABLE 7.4 Properties of Acrylic

Molecular Structure	Poly(acrylonitrile).
Macroscopic Features	
Length:	Produced in both staple and filament lengths.
Cross-section:	Orlon is dumbell-shaped; bicomponent is mushroom- or acorn-shaped; acrilan is round.
Color:	White or off-white.
Light reflection:	Depending on type of pigments added, may be bright, semi-dull, or dull.
Physical Properties	
Tenacity (g/den):	2.5.
Stretch and elasticity:	Elongation at break 20 to 55%; 95% recovery at 2% elongation. Drops off rapidly at higher elongation.
Resiliency:	Good resiliency, resists wrinkles well.
Abrasion resistance:	Abrasion resistance is good, comparable to wool.
Dimensional stability:	Excellent dimensional stability if not overheated.
Moisture regain:	1.5 to 3.0%.
Specific gravity:	1.14 to 1.19.
Chemical Properties	
Effects of bleaches:	May be safely bleached by all household bleaches.
Acids and alkalies:	Damaged only by strong concentrated acids; good resistance to mineral acids and acids used in spot and stain removal. Fair to good resistance to weak alkalies; concentrated ones will cause rapid degradation.
Organic solvents:	Resistant to all dry-cleaning solvents.
Sunlight and heat:	Excellent resistance to sunlight; yellowing may occur at temperatures above 150° C (300° F).
Resistance to stains:	Good for water-borne stains, poor to fair for oil-borne stains.
Dyeability:	Can be dyed in a wide range of colors that will have satisfactory fastness to washing and light. Acid, base, chrome, permetallized, and cationic are used.
Biological Properties	
Effects of fungi and molds:	Not affected by micro-organisms.
Effects of insects:	Unaffected by all insects.
Flammability Behavior	Burns rapidly with bright, yellow flame. Produces a hot residue.
Electrical and Thermal Conductivity	Fair to good electrical conductivity. Does not conduct heat rapidly.

MAINTENANCE Unfortunately, the porous surface permits adsorption of oily materials onto the fiber. Thus, acrylics are susceptible to oily stains. It is important that acrylic fabrics be laundered at moderate temperatures and dried at low settings in order to prevent excessive shrinking. Ironing temperatures should be kept below 150° C (300° F).

DURABILITY Acrylic fibers are moderately strong, very resilient, and have good abrasion resistance. In normal apparel use, the dimensional stability of acrylic fabrics is satisfactory. The fibers have good elongation and elasticity at low levels of elongation. In knit fabrics, stretch recovery is quite good, but in wovens, in which the construction prohibits the fabric from stretching, acrylic yarns may be extended beyond their ability to recover.

(a) (b)

Figure 7.14 Photomicrographs of high-bulk acrylic fibers: (a) Cross-section of bicomponent fiber (*AATCC and ASTM*). (b) A Type 57 Acrilan bicomponent fiber after crimp development. Note the helix direction reversal. Reversals of this type add greatly to fabric esthetics. (*Monsanto Textiles Company*)

Uses

Acrylics are found in a variety of apparel uses, particularly those in which a soft, bulky yarn is important. Sweaters, winter sportswear, and robes, in particular, benefit from the warmth, light weight, and ease of maintenance of acrylic. Imitation fleece linings and furs for winter wear are often acrylic. Acrylic blankets are as warm as those made from wool, but are lighter and require less care. Although quite satisfactory for carpets, acrylics seem to have lost the market to nylon and polyester.

Acrylic and Wool Blends

The ease with which acrylics are textured and the resultant bulkiness of the fibers give them characteristics similar to wool. Acrylic/wool blends are lightweight and warm. They are also less expensive than 100 percent wool. A 60/40 blend of acrylic and wool will yield fabrics with good crease retention and wrinkle resistance. In addition, the fabrics exhibit greatly diminished felting, so that they may be laundered on a delicate-fabric cycle in washing machines. The blend will be stronger than wool alone, but has a tendency to pill. Acrylic/wool blends are used in sweaters, suits, slacks, and socks.

Acrylic and Nylon

Blends and combinations of acrylics with nylon have higher wicking and moisture adsorption than nylon alone. Furthermore, these materials are bulkier and softer than equivalent 100 percent nylon fabrics. The nylon contributes high strength and abrasion resistance. The durability is greater than a 100 percent acrylic fabric. Nylon/acrylic combinations are found in

socks and stockings, because of the soft, bulky, wool-like hand and the high abrasion resistance.

MODACRYLICS

Modacrylic is defined under the Textile Fiber Products Identification Act as follows:

> A manufactured fiber in which the fiber-forming substance is any long-chain synthetic polymer composed of less than 85 percent but at least 35 percent by weight of acrylonitrile units . . . except fibers qualifying . . . as rubber.

From its definition, it is apparent that modacrylics are *modified acrylic* fibers. Whereas in acrylic fibers up to 15 percent of a comonomer or other materials may be added to acrylonitrile, in modacrylics the comonomer may be the major constituent.

Fiber Production and Yarn Manufacture

The usual comonomer used in the production of modacrylics is vinyl chloride, a gaseous, vinyl monomer similar in its chemical structure to acrylonitrile. The properties of the fiber are dependent upon the ratio of vinyl chloride to acrylonitrile used in the preparation of the polymer. (The formation of modacrylic polymer may be seen in Fig. 7.11.) After polymerization, the copolymer is dissolved in acetone or other solvents and either wet-spun or dry-spun to form filaments.

Fiber Composition

MACROSTRUCTURE As shown in Fig. 7.15, modacrylic fibers are translucent solid rods with little internal structure. The longitudinal view

Figure 7.15 The shape of modacrylic fibers is similar to acrylic. The specks are delustrant. (*AATCC and ASTM*)

shows striations. The cross-section may be round, bean-shaped, or peanut-shaped, as illustrated for acrylic fibers.

MICROSTRUCTURE The modacrylic fibers have a microstructure similar to the acrylics; that is, they form glassy fibers with low crystallinity.

Fiber Properties

The important physical and chemical properties of modacrylic fibers are listed in Table 7.5.

Modacrylic fibers are weaker than acrylics, although stronger than acetates. Abrasion resistance is very low. They have good resistance to organic solvents, although they do dissolve in acetone. Weak alkalies and acids do not affect the fiber. Sunlight resistance is poor.

The modacrylics are less resistant to heat than the acrylics, and must be laundered in warm water and dried on a low setting. A gentle cycle is

TABLE 7.5 Properties of Modacrylic

Molecular Structure	Copolymer of acrylonitrile.
Macroscopic Features	
Length:	Produced in both staple and filament lengths.
Cross-section:	Varies according to end use.
Color:	White or off-white.
Light reflection:	Depending upon type of pigments added, may be bright, semi-dull, or dull.
Physical Properties	
Tenacity (g/den):	1.7 to 2.8.
Stretch and elasticity:	Varies with end use. Generally, stretch recovery is less than that of acrylic.
Resiliency:	Fair to good.
Abrasion resistance:	Poor.
Dimensional stability:	Good to excellent if not overheated.
Moisture regain:	0.5 to 3.0%.
Specific gravity:	1.3 to 1.4.
Chemical Properties	
Effects of bleaches:	Some fibers may be harmed by chlorine bleach. Observe care label instructions.
Acids and alkalies:	Good resistance to both acids and alkalies.
Organic solvents:	Resistant to all dry-cleaning solvents. Damaged by acetone.
Sunlight and heat:	Excellent resistance to sunlight; yellowing may occur at temperatures above 150° C (300° F).
Resistance to stains:	Good for water-borne stains, fair for oil-borne stains.
Dyeability:	Can be dyed in a wide range of colors that are fast to washing and light.
Biological Properties	
Effects of fungi and molds:	Not affected by micro-organisms.
Effects of insects:	Unaffected by all insects.
Flammability Behavior	Difficult to ignite. Self-extinguishing.
Electrical and Thermal Conductivity	Fair to good electrical conductivity. Does not conduct heat readily.

recommended because the cloth may develop a harsh hand or pill if agitation is too rough. Ironing temperature should be below 120°C (250°F).

Modacrylic fibers will not support combustion. They will burn in direct contact with a flame, but self-extinguish when the source is removed.

Uses

Modacrylics may be spun into fine flexible fibers that have a hand very much like human hair or animal fur. For this reason they are widely used in wigs and deep pile fabrics. The low glass transition temperature of the fiber allows modacrylic wigs to be heat-set and styled with the same equipment and techniques used for human hair wigs.

The fibers may also be tailored to provide the relatively stiff, harsh hand of the guard hairs of fur. Thus, imitation fur of modacrylic is very similar in its hand to that of real fur. Air trapped between the fibers gives a high degree of thermal insulation. Modacrylic pile fabric may be cleaned by conventional techniques, making them more easily maintained than fur.

Under the Flammable Fabrics Act, carpets and rugs must satisfy certain flammability regulations. Many types of acrylic carpets were found to fail this test. However, the addition of about 25 percent of modacrylic fiber reduced the flammability of the carpets to within the requirements of the Act. It was also found that modacrylic brushed and pile fabric for children's sleepwear would pass the flammability regulations, while acrylic, cotton and some rayons could not. The flammability regulations have increased the use of this fiber.

OLEFIN

The Textile Fiber Products Identification Act defines olefin as follows:

> A manufactured fiber in which the fiber-forming substance is any long-chain synthetic polymer composed of at least 85 percent by weight of ethylene, propylene, or other olefin units, except amorphous (non-crystalline) polyolefins qualifying . . . as rubber.

Olefins are a class of chemical compounds similar in their structure to the acrylic and modacrylic fibers. The polymer consists of a long chain of carbon atoms of the general formula $-\overset{\displaystyle H}{\underset{\displaystyle H}{\overset{|}{\underset{|}{C}}}}-\overset{\displaystyle H}{\underset{\displaystyle X}{\overset{|}{\underset{|}{C}}}}-$. The pendant group, symbolized by X, may be a hydrogen atom, in which case the material is *poly(ethylene)*; or a methyl group ($-CH_3$), in which case the material is called *poly(propylene)*. Other olefins may be made into fibers, but they are not available in commercial quantities.

In the 1930s, research in the relatively new field of polymer chemistry led to the creation of polyethylene, a soft, flexible thermoplastic material that enjoys widespread use in a variety of packaging applications. Further investigations into the chemistry of polyolefins led to the development of

Figure 7.16 Olefin fibers are round, smooth rods. The dark specks are delustrant. (*AATCC and ASTM*)

polypropylene. In 1951 the Montecatini Company of Italy developed a process for producing polypropylene fibers. Although these early fibers were deficient in many of their properties, continued development led to olefin fibers with sufficiently high melting temperature, tenacity, and abrasion resistance to make them an important factor in the modern textile industry. Since the early 1960s, production of polypropylene fibers has expanded dramatically.

Fiber Production and Yarn Manufacture

Poly(propylene) is formed from the high-pressure-addition polymerization of propylene gas. After polymerization, the polyolefin is converted to filament form by the melt-spun process. Filaments may be textured and cut to staple length, or packaged as textured or untextured filament.

Fiber Composition

MACROSTRUCTURE Poly(propylene) is a solid, transparent, rodlike fiber with little internal structure (Fig. 7.16). The cross-section may be any shape, but is usually round. Delustered fibers may show dark specks.

MICROSTRUCTURE Poly(propylene) may take one of three structures. In the *isotactic* form all the methyl ($-CH_3$) groups lie on the same side of the carbon chain. In the *syndiotactic* form the methyl groups lie alternately on each side of the carbon chain. In the *atactic* form the methyl groups are randomly arranged on either side of the carbon chain. These forms are shown in Fig. 7.17.

The atactic form has very low crystallinity, a low melting point, and poor stretch recovery. This is because the random arrangement of pendant groups impedes the formation of ordered regions within the fiber. The syndiotactic form can be arranged in ordered regions more easily, but the molecules are forced to maintain a relatively large distance between chains.

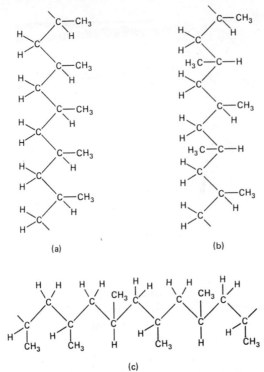

(a)

(b)

(c)

Figure 7.17 Polypropylene can exist in (a) isotactic, (b) syndiotactic and (c) atactic forms.

Although the properties of the material are improved over atactic polypropylene, they are still less than satisfactory.

The isotactic polymer is well ordered and can easily form crystals (Fig. 7.18). This ability gives it a satisfactorily high melting temperature, good strength and elasticity, yet still permits sufficient elongation to allow the fiber to be useful in textiles. In addition, the fiber's resiliency is improved by the formation of crystals.

Fiber Properties

The important chemical and physical properties of polypropylene are listed in Table 7.6.

APPEARANCE Poly(propylene) is essentially a highly crystalline wax. Thus it is hydrophobic and very difficult to dye. For this reason the fibers are

Figure 7.18 Adjacent chains of polypropylene can easily intermesh to form crystals.

TABLE 7.6 Properties of Olefin

Molecular Structure	Poly(propylene).
Macroscopic Features	
Length:	Produced in filament and staple lengths.
Cross-section:	Usually round or elliptical.
Color:	Translucent.
Light reflection:	Dull, semi-dull, and bright.
Physical Properties	
Tenacity (g/den):	3.5 to 8.0.
Stretch and elasticity:	Very good—40% elongation at break, 100% recovery at 2% elongation.
Resiliency:	Good to excellent resiliency.
Abrasion resistance:	Excellent.
Dimensional stability:	Unaffected by water and will not shrink unless exposed to temperatures above 150° C (300° F).
Moisture regain:	0.1%.
Specific gravity:	0.90 to 0.91.
Chemical Properties	
Effects of bleaches:	Good resistance to all bleaches at temperatures below 150° F. Strength loss will occur if fabrics are bleached in wash water higher than 150° F.
Acids and alkalies:	Highly resistant to all alkalies. Good resistance to most acids; strong oxidizing acids will cause deterioration.
Organic solvents:	Resistant to petroleum and fluorocarbon dry-cleaning solvents. Perchloroethylene causes swelling that may result in shrinkage.
Sunlight and heat:	Suffers loss of strength and eventual degradation after prolonged exposure. Relatively heat-sensitive.
Resistance to stains:	Most soil will stay on surface and is easy to remove.
Dyeability:	Difficult to dye owing to low moisture regain. Usually pigmented.
Biological Properties	
Effects of fungi and molds:	Not harmed.
Effects of insects:	Not attacked.
Flammability Behavior	Slow-burning, melts.
Electrical and Thermal Conductivity	Excellent electrical conductivity. Good insulation properties owing to light weight.

usually colored by the manufacturer. Dope, or solution, dyeing is expensive and limits the variety of available colors. The pigments used tend to scatter light and reduce the brightness of the fiber. In addition, delustrants may be added to further reduce light reflection.

COMFORT The major factors affecting the comfort of the olefins are their waxy nature and low level of moisture regain. Both make olefins too uncomfortable for use in apparel.

MAINTENANCE Because poly(propylene) is hydrophobic, it has excellent resistance to penetration by water-borne stains. In addition, the high level of crystallinity enables the fiber to resist penetration by oil-borne materials. The ability to resist both oily and aqueous stains helps make polypropylene one of the most easily maintained fibers. It also possesses excellent resilience, so that fabrics made from these fibers have a high degree of wrinkle resistance.

Poly(propylene) has a very low melting temperature and must be dried and ironed at low temperatures.

DURABILITY Poly(propylene) is a relatively strong fiber with outstanding abrasion resistance. It is not attacked by biological organisms and has good resistance to sunlight.

Uses

The hydrophobic nature of the fiber limits the acceptable end uses. Olefins have not been readily accepted in apparel; consumers complain of a waxy or oily feel to the fabric. In addition, the very low level of moisture absorption and low level of wicking makes olefin garments somewhat uncomfortable.

Poly(propylene) has, however, found ready acceptance in home furnishings. Textured filament yarns, although possessing a less satisfactory hand than many other fibers, are acceptably comfortable. It may be used in upholstery fabrics, since it is strong, durable, and easily maintained; it also has high abrasion resistance and low susceptibility to staining. Because of the difficulty of dyeing and printing olefins, fabrics are usually found in stripes, checks, and solid colors.

Poly(propylene) has also made deep inroads into the market of primary carpet backing. Because of its relatively low cost, stable market price, high strength, and resistance to molds and fungus, this fiber has been able to replace jute in many applications. Poly(propylene) has also been used as the face fiber for carpets. Kitchen carpeting and indoor-outdoor carpets are the major uses. High abrasion resistance and relative freedom from stains are the major advantages of poly(propylene) carpet fibers. The major disadvantages are the hand, difficulty of dyeing, and low melting temperature.

SPANDEX

The Textile Fiber Products Identification Act defines spandex as follows:

A manufactured fiber in which the fiber-forming substance is a long-chain synthetic polymer composed of at least 85 percent of a segmented polyurethane.

Fibers that may be stretched at least 200 percent before they break, and rapidly recover when tensile forces are released, are called ELASTOMERS. Elastic fibers, in the form of rubber, have been used for many years to provide stretch in garments. Elastic waistbands, girdles, and straps for intimate apparel are among the most important uses. Since the stretched fibers exert a restraining force upon the wearer, *power-stretch* fabrics, in which the high retractive force of the elastomeric cloth can shape and control body contours, have been widely used in support and foundation garments.

The natural look in apparel requires garments that define the contours of the body and lend support and shaping without forcing everyone into the same mold. Such fabrics stretch for comfort, and provide a more gentle

restraining force for shaping. Those fabrics, in which the restraining forces are somewhat less than in power-stretch fabrics, provide *comfort stretch*. Modern elastomeric fibers can be tailored to provide the proper amount of stretch and the required degree of restraint to meet the requirements of the fashion market.

Fiber Production and Yarn Manufacture

Spandex is produced by wet-spinning a solution of a segmented polyurethane in an appropriate solution—e.g., dimethylformamide. The filaments coagulate upon contact with the spinning bath. Following spinning, the fibers are washed, dried, and wound on bobbins. The details of the manufacturing processes are proprietary.

The secret of spandex lies in its structure. Most of the other manmade fibers, such as nylon and polyester, are composed of long chains in which the repeating units are identical to one another. The strength of these fibers comes from the crystals formed by the molecules, and the stretch is a consequence of the disordered regions in the fiber. Spandex fibers are prepared from block copolymers that contain at least two types of repeating units: one forms crystals easily and is called the *hard segment*; the other, which does not form crystals easily, is the *soft segment*.

The segmented polyurethane is produced by a moderately complicated but elegant procedure illustrated in Fig. 7.19. The soft segments may be polyesters or polyethers. These polymers have a lower degree of polymerization than the materials used to produce polyester fibers; thus, they do not form crystals easily. In our example, terephthalic acid is reacted with an excess of ethylene glycol to yield a low-molecular-weight polyester with hydroxyl groups at each end. The polyester is then reacted with a *diisocyanate*

Step 1

HO—POLYESTER—OH + OCN—R—NCO ⟶

 soft segment diisocyanate

Step 2

OCN—R—N—C—O—POLYESTER—O—C—N—R—NCO + HO—R'—OH ⟶

prepolymer glycol

～～POLYESTER～～O—C—N—R—N—C—O—R'—O—C—N—R—N—C—O～POLYESTER～～

 soft segment hard segment soft segment

Figure 7.19 Preparation of spandex. A polyester is reacted with a diisocyanate (step 1) to form a prepolymer which is also a diisocyanate. This is reacted with a glycol (step 2) to form a polymer in which long, soft polyester segments alternate with short, hard segments.

Figure 7.20 Photomicrographs of spandex in cross-section and longitudinal views. (*AATCC and ASTM*)

to form a *prepolymer*. The prepolymer is formed into a long-chain polymer consisting of long, soft segments of polyester connected by short, hard segments containing urethane groups, $-\mathrm{O-\overset{\overset{O}{\|}}{C}-\overset{\overset{H}{|}}{N}-}$, by addition of a glycol (HO—R—OH).

Fiber Composition

MACROSTRUCTURE Spandex is a soft, flexible rod with little internal structure. Specks of delustrant are visible under the microscope (Fig. 7.20). The cross-section varies; some manufacturers favor round fibers, others prefer dog-bone or peanut shapes. Fibers may be produced as monofilaments, or more usually, as multifilament yarn.

MICROSTRUCTURE In the relaxed state, the polyurethane molecules assume a relatively disordered arrangement within the fiber. The soft segments are coiled and curled; the hard sections tend to group together. These "knots" are formed by the attraction of the urethane groups for one another and are maintained by hydrogen bonds between adjacent molecules. The relaxed state is illustrated in Fig. 7.21a.

When the fiber is stretched, the soft segments uncoil and assume an extended configuration. The hard segments are forced into closer proximity and hydrogen bonding causes the hard segments to form crystalline regions. These crystals resist slippage of the molecules and make further extension of the fiber more difficult. Eventually, the fiber becomes highly oriented, crystalline, and hard rather than elastomeric. Thus, spandex yarns will stretch easily at relatively low elongation, but will resist stretching at higher elongation. This means that garments can be tailored to be form-fitting without being confining, yet will provide support and figure control. The extended configuration is shown in Fig. 7.21b.

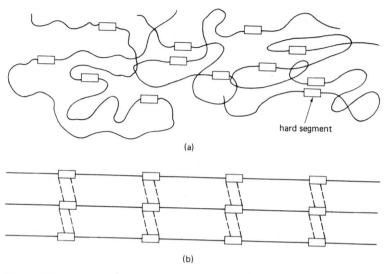

(a)

(b)

Figure 7.21 In the relaxed state (a) spandex molecules are coiled. In the stretched state (b) the soft segments are extended and crystals are formed by hydrogen bonds between hard segments.

When the tension is released, the soft segments return to their original, coiled arrangement. The hard sections move apart, and the crystallinity is reduced. The fiber is once again soft and elastic. By the proper selection of chemical constituents, the resistance to stretch and the elongation of the fiber may be tailored to fit the end-use requirements.

Fiber Properties

The important physical and chemical properties of spandex are listed in Table 7.7.

Spandex is a weak fiber, capable of extreme elongation without breaking; it is very elastic, and is capable of complete recovery from the stretched state. Its major advantages over rubber are higher resistance to sunlight, heat, and aging; superior dyeability; improved resistance to seawater and chlorine in swimming pools; lower sensitivity to body oils and lotions; and superior retention of elastic properties. Furthermore, although rubber is difficult to produce in filaments of less than 140 denier, spandex is easily spun as fine as 40 denier. The finer fibers may be utilized in support stockings, for example, without sacrificing esthetic appeal.

Uses

Spandex may be used as bare filament, core yarn with a cotton wrapper, or in core-spun yarns. Core and core-spun yarns provide increased comfort by raising the moisture absorption of the yarn. Spandex yarns are used alone or in combination with other yarns to provide increased recovery in knit

149

TABLE 7.7 Properties of Spandex

Molecular Structure	Segmented polyurethane.
Macroscopic Features	
Length:	Can be produced in any length.
Cross-section:	Peanut or dog-bone shaped.
Color:	White, nearly white.
Light reflection:	Generally dull.
Physical Properties	
Tenacity (g/den):	Low strength—0.7.
Stretch and elasticity:	Excellent elastic properties; 500% elongation at break, 100% recovery at 2% elongation.
Resiliency:	Very good, highly flexible.
Abrasion resistance:	Very good abrasion resistance, superior break strength and flex life.
Dimensional stability:	Will not shrink from exposure to water; however, some types shrink upon exposure to high temperatures.
Moisture regain:	0.6%.
Specific gravity:	1.21 to 1.35.
Chemical Properties	
Effects of bleaches:	Good resistance to bleach at temperatures below 150° F. Some manufacturers recommend perborate bleaches.
Acids and alkalies:	Good resistance to most acids; some discoloration may occur. Will be damaged by hot alkalies, which cause rapid deterioration.
Organic solvents:	Resistant to all dry-cleaning solvents.
Sunlight and heat:	Resistant to light. High temperatures will reduce elasticity.
Resistance to stains:	Good resistance to oil and water stains.
Dyeability:	Colorfastness to washing and light ranges from fair to poor. Acid, disperse, and chrome dyes are used.
Biological Properties	
Effects of fungi and molds:	Unaffected.
Effects of insects:	Unaffected.
Flammability Behavior	Burns slowly, forms gummy residue.
Electrical and Thermal Conductivity	Low electrical conductivity. Poor heat conductor.

garments, increase the stretch of woven garments, and provide figure control in foundation garments and support in hosiery.

For foundation garments, heavy-denier spandex gives greater durability, longer life, and a higher degree of comfort than rubber yarns. The very good abrasion resistance and dyeability of the fiber makes it suited for use, along with cotton, polyester, or other fibers, in outerwear. Tricot-knit lingerie utilizes spandex fibers to shape and define the body without binding.

HIGH-TEMPERATURE-RESISTANT FIBERS

This section deals with *aramid* and *novoloid*, two of the high-performance, temperature-resistant petroleum-based textile fibers that have recently been introduced. Many of these fibers are limited to special industrial processes, while others are enjoying more widespread use. The Flammable Fabrics Act, as amended in 1967, aroused intense interest in the production of inherently

flame- and temperature-resistant fibers. The advantage of such fibers is that they do not require extra finishes to impart flame resistance. Thus, they will retain their flame-resistant properties through innumerable launderings or dry-cleanings.

ARAMID

In the late 1950s, researchers at the DuPont Company discovered that polyamides formed from aromatic (ring) compounds were significantly different from the nylons formed from linear molecules. In the early 1970s, after many years of intensive development, the company began commercial production of an aromatic polyamide under the trade name Nomex, and in 1975, introduced Kevlar. The physical and chemical properties of these new fibers were sufficiently different from the linear nylons to warrant the adaptation of a new generic category. Under the Textile Fiber Products Identification Act, the Federal Trade Commission introduced the new classification aramid, defined as follows:

> A manufactured fiber in which the fiber-forming substance is a long-chain synthetic polyamide in which at least 85 percent of the amide linkages
> $$(-\overset{\text{O}}{\overset{\|}{\text{C}}}-\text{NH}-)$$ are attached directly to two aromatic rings.

Fiber Production and Yarn Manufacture

Both Kevlar and Nomex are produced by the dry-spun process. The details of the manufacturing process are proprietary. The fibers are sold as filament yarns. Nomex is also produced in staple length.

Fiber Composition

MACROSTRUCTURE Aramid fibers are solid rods with little significant internal structure. The fibers are produced with smooth, round cross-sections. Nomex may also be found with a rectangular cross-section.

MICROSTRUCTURE The chemical structure of Nomex is shown in Fig. 7.22a. That of Kevlar is illustrated in Fig. 7.22b. Nomex is poly(m-phenylene isophthalamide), and Kevlar is poly(p-phenylene terephthalamide). The fibers are highly crystalline, and very strong. The regular structure of the molecule allows the development of a high degree of crystallinity, while the manufacturing process results in a high degree of orientation. In addition, hydrogen bonding promotes intermolecular attraction and higher strength. Hydrogen bonding in Nomex is illustrated in Fig. 7.23.

In addition to providing high strength, the aromatic rings are more stable than linear arrangements of atoms, allowing these fibers to resist destruction by heat. At temperatures as high as 265° C (500° F), Nomex will merely shrink slightly. When exposed to direct flame, the fiber will char

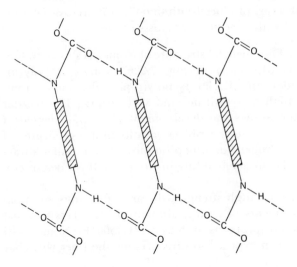

Figure 7.22 The structures of (a) Nomex and (b) Kevlar. Both are aromatic polyamides (aramid).

without burning or melting. It is inherently flame-resistant. The flame-resistant properties of Kevlar are similar.

Fiber Properties

The important physical and chemical properties of Nomex are listed in Table 7.8. The properties of Kevlar are similar to those of Nomex.

Uses

In apparel and home furnishings, the major advantage of the aramid fibers is their flame resistance. Thus, they find application in draperies and upholstery for institutional use, where fire codes require a high degree of flame resistance. The high temperature performance of the aramids makes them suitable for industrial applications, such as filters for industrial boilers, where the fiber is in constant contact with high-temperature gases and other materials. In addition to high resistance to elevated temperatures, the aramids are very strong. Their tenacity is about five times that of steel. Nomex has found wide application in turnout coats for firefighters, crash suits for auto racers, and flight suits for military pilots. Kevlar is now being used in tire cord.

Figure 7.23 Hydrogen bonding between amide groups of adjacent chains leads to strong, dense crystals. The shaded rectangles are the benzene rings seen on edge.

TABLE 7.8 Properties of Nomex

Molecular Structure	Aromatic polyamide.
Macroscopic Features	
Length:	Produced in filament, staple, and tow.
Cross-section:	Round or rectangular.
Color:	Off-white.
Light reflection:	Luster varies depending on the fiber.
Physical Properties	
Tenacity (g/den):	5–6.
Stretch and elasticity:	20% elongation at break, 100% recovery at 2% elongation.
Resiliency:	Good.
Abrasion Resistance:	Fair to good.
Dimensional stability:	Excellent.
Moisture regain:	2–3%.
Specific gravity:	1.38.
Chemical Properties	
Effects of bleaches:	Resistant to chlorine and oxygen bleaches.
Acids and alkalies:	Excellent resistance to acids. Good resistance to alkalies at room temperatures.
Organic solvents:	Fully resistant to organic solvents.
Sunlight and heat:	May lose up to 50% of its strength when exposed to intense sunlight. Resistant to dry heat.
Resistance to stains:	Most dirt and stains can be easily removed; however, garments heavily soiled with grease may present problems.
Dyeability:	Only cationic dyes may be used.
Biological Properties	
Effects of fungi and molds:	Unaffected.
Effects of insects:	Unaffected.
Flammability Behavior	Excellent flame-retardant properties; will not melt or drip when exposed to flames. Degrades about 375° C (700° F).
Electrical and Thermal Conductivity	Poor electrical conductivity; will not conduct heat.

NOVOLOID

Novoloid is defined by the Textile Fiber Products Identification Act as follows:

A manufactured fiber containing at least 85 percent by weight of a crosslinked novolac.

At present, the only commercial novoloid fiber is Kynol, a golden-brown fiber exhibiting a higher moisture regain than the aramids. Noted for its flame resistance and high-temperature performance, Kynol's abrasion resistance is low. It has found acceptance in fabrics for aircraft interiors, institutional furnishings, and as protective clothing for firefighters, race drivers, and astronauts. The molecular structure is given in Fig. 7.24. The important chemical and physical properties are listed in Table 7.9.

Figure 7.24 The structure of Kynol, a crosslinked novolac.

TABLE 7.9 Properties of Kynol

Molecular Structure	Crosslinked novolac.
Macroscopic Features	
Length:	Produced in both staple and filament lengths.
Cross-section:	Round or oval.
Color:	Golden-hued.
Light reflection:	Semi-dull.
Physical Properties	
Tenacity (g/den):	2.
Stretch and elasticity:	35% elongation at break, 100% recovery at 2% elongation.
Resiliency:	Good.
Abrasion resistance:	Poor.
Dimensional stability:	Excellent.
Moisture regain:	6%.
Specific gravity:	1.25.
Chemical Properties	
Effects of bleaches:	Is damaged by high concentrations of chlorine and oxidizing bleach.
Acids and alkalies:	Resists all acids. Is damaged by concentrated alkalies at high temperatures.
Organic solvents:	Resists organic solvents.
Sunlight and heat:	High heat and light resistance.
Resistance to stains:	Good.
Dyeability:	Can be dyed only in a small variety of colors owing to natural golden color.
Biological Properties	
Effects of fungi and molds:	Unaffected.
Effects of insects:	Unaffected.
Flammability Behavior	Exceptional flame-retardant properties. Will char without burning or melting.
Electrical and Thermal Conductivity	Excellent insulating properties.

REVIEW QUESTIONS

1. Nylon is one of the most durable fibers. Explain why.

2. List the major advantages and disadvantages of polyester/cotton blend fabrics for apparel use. Explain your answers.

3. Compare the performance of 50/50 wool/nylon blend fabric to that of a 100 percent wool fabric of the same weight and construction. Explain the differences. Which would be better for use in upholstery? Explain why.

4. Acrylic is often used as a substitute for wool. Compare the performance properties of these two fibers and discuss in which end uses acrylic would be suitable and in which it would not.

5. One of the major disadvantages of polyester is its affinity for oil-borne stains. Which structural features make polyester so easily stained?

6. The major advantage of olefin fiber for furnishings is its durability. What are its major disadvantages? Considering that olefin fibers are very inexpensive, do the advantages outweight the disadvantages? Explain your answer.

7. Relatively small amounts of spandex yarns included with yarns made from other fibers allow woven cloths to stretch. Give three examples of apparel in which stretch woven cloth would be useful. Discuss why.

8. Compare the micro- and macrostructures of wool and nylon. Compare their performance properties. Explain how the structural differences relate to the performance properties.

9. Following the enactment of the children's sleepwear standard, modacrylic fibers were widely used because of their flame-retardant properties. Consider the properties of modacrylic fibers and state their advantages and disadvantages for children's sleepwear. Would modacrylic be your first choice? Explain.

10. Wool is often considered to be the original bicomponent fiber. How does the bicomponent nature of wool affect its performance properties? How could man-made fibers be made to imitate wool?

ACTIVITIES

1. The wicking of yarns and fibers may be investigated in the following experiment. Obtain some yarns made of different fibers but with approximately the same level of twist. Cut the yarns to a 15 cm (6 in) length and make an ink mark 10 cm (4 in) from one end. Tie the yarns at the short end around a pencil and place this over the mouth of a beaker so that the bottom of the yarn just touches the bottom of the beaker. (If an appropriate beaker is not available, revise the dimensions of the yarn to fit the beaker.) Pour enough water, to which has been added a few drops of vegetable dye, to cover the bottom centimeter of the beaker. Measure the time required for the water to rise to the mark on each thread. Report on the ease of wicking of the different fibers.

2. The hydrophilic and hydrophobic properties of fibers may be estimated in the following manner. Pour a small amount of water or a small amount of oil into each of two petri dishes or other shallow containers. Place small tufts of different

fibers on the surface of each liquid. Measure the time required for the tufts to absorb enough liquid to cause them to sink.

Group the fibers as to whether they absorb oil or water. Explain your results on the basis of the micro- and macrostructural properties of the fibers.

3. The stain-resistant properties of fibers may be illustrated by the following experiment. Prepare 5×5 cm (2×2 in) swatches of plain woven cloth made from different fibers. On each sample place one or two drops of mustard, catsup, household oil, coffee, and fruit juice. Mark the position of each stain.

Allow the stained samples to stand overnight. Place each swatch into a quart jar filled with lukewarm soapy water. Shake vigorously, allow to stand for 5 minutes, repeat. Remove the samples and rinse them in cold water.

Record which fibers retain which stains. Explain the results on the basis of microstructural features of the fibers.

8

other man-made fibers

GLASS

The Textile Fiber Products Identification Act defines glass as follows:

> A manufactured fiber in which the fiber-forming substance is glass.

Glass ranks as the oldest of the man-made fibers, although its use in textiles is a recent innovation. The ancient Egyptians developed techniques for forming glass into thick rods and drawing fine filaments from the rods. These glass fibers are used to ornament glassware. Although the art of glassmaking was continually improved throughout the ages, glass fibers were not considered as textile materials until the late 1800s, when E. D. Libbey exhibited a dress made entirely of glass fibers. However, the cloth was too stiff, heavy, and expensive to be practical. In addition, the hand methods of manufacturing were slow and required a great deal of skill on the part of the worker.

In the early 1930s the Owens-Corning Fiberglas Corporation was formed to develop glass filaments suitable for textile use. By 1939 the company had commercialized several processes for producing glass filaments suited to industrial, home-furnishings, and commercial uses. Other companies entered the field following World War II. Since that time, the glass fiber industry has expanded fourfold.

Fiber Production and Yarn Manufacture

Glass is prepared by heating sand, limestone, and other minerals in an electric furnace until they fuse together and liquefy. The molten glass is usually formed into marbles. After inspection and testing, the marbles are remelted and the molten glass is passed through spinneretlike devices called *bushings*. As it passes from the bushing, the molten glass cools quickly and hardens. The solid glass is pulled from the liquid at the exit of the bushing by a high-speed winding device. The hot glass filament is attenuated and formed into fine filaments measuring from 2 to 10 μ in diameter. Glass staple is prepared in a similar manner, except that the solid fibers are exposed to high-velocity jets of air which break them into staple of from 20 to 40 cm (8 to 16 in) in length.

The filaments are coated with a lubricant and wound into packages for use as filament yarns. The staple fibers are coated and sprayed onto a revolving drum to form a mat on the surface of the drum. The mat may be further processed into spun yarn, or packaged for use.

Fiber Composition

MACROSTRUCTURE Glass fibers, shown in Fig. 8.1, are solid, smooth transparent rods with no internal structure. The cross-section is usually round.

MICROSTRUCTURE Glass is an amorphous composition in which one or more oxides of silicon, boron, or phosphorous are fused with oxides of sodium, potassium, magnesium, or calcium. The material exhibits an almost complete absence of crystallinity. The exact structure of glass is not known. However, the atoms appear to be arranged in a pseudopolymeric structure. Unlike the natural fibers and the other man-made fibers, glass is not a polymer but is actually a frozen liquid composed of small molecules. Because this liquid has a very high melting point, glass is a useful solid at normal temperatures.

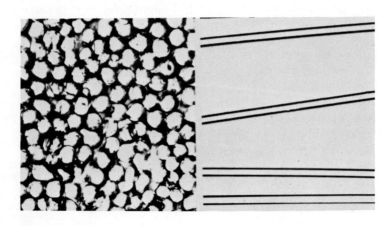

Figure 8.1 Glass fibers are straight, smooth, and transparent. (*AATCC and ASTM*)

TABLE 8.1 Properties of Glass

Molecular Structure	Silica (SiO_2) and metal oxides.
Macroscopic Features	
Length:	Filament or staple.
Cross-section:	Circular.
Color:	Colorless or white.
Light reflection:	Good luster.
Physical Properties	
Tenacity (g/den):	6.3 to 6.9.
Stretch and elasticity:	Very low stretch, completely elastic; 3% elongation at break, 100% recovery at 2% elongation.
Resiliency:	Excellent resilience, good wrinkle-resistant properties.
Abrasion resistance:	Poor.
Dimensional stability:	Excellent, unaffected by water.
Moisture regain:	0.
Specific gravity:	2.5.
Chemical Properties	
Effects of bleaches:	Not harmed by oxidizing or reducing bleaches.
Acids and alkalies:	Not damaged by most common acids and alkalies. Dissolved by hydrofluoric acid.
Organic solvents:	No effect.
Sunlight and heat:	No strength loss from light; colors may be affected. Highly resistant to heat. Will not burn. Loses strength above 315°C (600°F).
Resistance to stains:	Does not stain.
Dyeability:	Usually dyed with resin-bonded pigments. Solution dyeing is sometimes used, but it has a limited color range.
Biological Properties	
Effects of fungi and molds:	Unaffected.
Effects of insects:	Unaffected.
Flammability Behavior	Nonflammable; will melt and decompose at high temperatures.
Electrical and Thermal Conductivity	Poor electrical conductivity. Poor heat conductivity. Provides good insulation.

Fiber Properties

The important physical and chemical properties of glass are listed in Table 8.1.

The outstanding properties of glass fibers are their high strength, dimensional stability, and chemical inertness. The major disadvantage is very low abrasion resistance. The rubbing of glass filaments against each other produces cracks on the surface which lead to the breaking of individual fibers. Abrasion resistance may be improved by application of lubricating coatings, but these finishes do not provide permanent protection.

Glass is impervious to penetration by most materials, and the smooth surface does not permit soil particles to cling. Thus, glass does not soil readily or stain. However, these same factors contribute to a dry, harsh hand which precludes the use of regular glass fibers in apparel. Furthermore, these fibers will not accept dyes and must be pigmented to obtain colored fabrics.

Beta Fiberglas is a very fine fiber, about 2 μ in diameter, which is softer

and more flexible than regular glass fibers. Textured Beta Fiberglas has a soft hand similar to mohair. It has been used in apparel for astronauts, where the requirement for flameproof garments precluded the use of other fibers. However, the abrasion resistance of this material is quite inferior to that of other fibers (e.g., nylon or polyester).

> *Coronizing* is a patented process for treating fabrics made from glass fibers; it softens the hand and allows the material to be colored. In this process, the cloth is treated with a colloidal dispersion of silica. The extremely fine particles of silica are bonded to the glass by being heated at 650°C (1200°F). During the heat treatment the fibers relax so that crimp is developed and the yarns are softened. The last two factors improve the hand and drape of glass cloth. The cloth is then coated with a mixture of pigment and a resin binder and cured at 160°C (320°F). The silica provides a rough surface to which the resin and pigment adhere. Coronizing improves the abrasion resistance of the treated cloth, but the resin can be removed from the surface with a loss of color and eventual cracking of the fabric.

Uses

The bulk of the consumption of glass fiber goes to industrial uses. Glass fiber mats and filament yarns are used to reinforce plastics for boat hulls, automobile bodies, and rockets. Mats are used for filters and insulation in processes in which chemical inertness and temperature resistance are of major importance.

For residential use, glass fibers are found in draperies and curtains, and insulation. In window coverings, glass provides soil resistance, dimensional stability, and sunlight resistance. The finer fibers, such as Beta Fiberglas, provide a natural look and feel that is often lacking in regular glass fibers. There have been attempts to introduce glass into upholstery, carpeting, and apparel, but these attempts have not proved successful owing to the poor abrasion resistance and low moisture regain of the fiber.

The insulating properties of fiberglass mats are excellent. The material will not rot or settle. Adequate fiberglass insulation will keep a home cool in the summer and warm in the winter with a minimum of energy consumption. It has been shown that, for most regions of the U.S., fiberglass insulation will pay for itself within three years in reduced heating and cooling bills.

Outside the home, glass yarns have become increasingly important in automobile tires. The very high strength and flex resistance of glass tire cords, particularly at high temperatures, have made them very popular for belted tires.

Glass fabrics may be laundered. Dry-cleaning should be avoided for colored fabrics, because the resin binder may dissolve in dry-cleaning fluids. Glass fabrics should be washed by hand, separately. Because of their low abrasion resistance, glass fibers will break if subjected to the mechanical action of a washing machine and the short, broken fibrils will be dispersed among the other items in the wash. Even if laundered alone, the glass particles will remain in the machine and may be picked up by clothing in the next load.

Because these fibrils are strong and stiff, they can penetrate the skin and cause an unpleasant irritation.

METALLIC FIBERS

The use of metallic fibers to decorate fabrics predates recorded history. Cloth containing gold or silver threads has symbolized the wealth and power of many kings and queens. Today metallic fibers serve useful as well as decorative purposes. The ease with which a metal can be formed into a textile fiber depends upon its DUCTILITY. Ductile metals, such as gold and silver, are those which can easily be beaten very thin or drawn into fine wires. Less ductile metals—e.g., steel—require modern fiber-forming techniques.

Metal fibers are formed by the drawing of a rod through successively finer holes until the diameter has been reduced to the desired dimensions. During the process the rod becomes longer. For example, a gold rod initially 15 cm (6 in) long by 3 mm ($\frac{1}{8}$ in) in diameter will lengthen to 13.5 km ($8\frac{1}{2}$ mi) if drawn down to 10 μ (0.0004 in). The manufacture of very fine metallic fibers, with diameters of about 5 μ, requires somewhat more sophisticated techniques: A bundle of metal rods must be encased in a metal alloy and attenuated. The alloy is then dissolved, leaving the fine fibers.

Gold is the most highly prized metallic fiber. Because it is among the most ductile of metals, gold filaments may be drawn to extremely fine diameters. In addition, gold fibers will not tarnish, so the material maintains its luster and beauty. Silver is also capable of being drawn into very fine filaments. However, silver fibers can tarnish and lose their beauty. Both of these metals, particularly gold, are very expensive. To reduce the cost, base metals such as copper may be drawn into filaments and then given a gold or silver coating. This technique provides the esthetic qualities of the precious metals at lower cost. However, the coating may eventually wear away.

Modern technology has allowed the development of techniques for forming metals such as steel, tantalum, and zirconium into fibers. These metal filaments find uses in such specialized applications as antenna systems for space satellites, screening for paper-making machines, and industrial filters. Cloth made from aluminum filaments is widely used in screening for windows and doors.

The electrical properties of metallic textile fibers are put to good use for static control. For example, stainless steel staple may be blended with nylon or polyester to produce yarns for carpets and rugs. The blended yarns, unlike the polymers, will conduct electricity readily (i.e., a static charge will be dissipated over the surface of a carpet by the conductive yarns). The charge will not build up to a level sufficient to cause an unpleasant shock. Conductive fabrics are also used in operating rooms and other facilities where a spark could cause an explosion.

Electric blankets can now be made with heating units made of very fine metal yarns. As electricity flows through the metal it generates heat. This is

known as *resistive heating*. The use of fine metal yarns instead of wires preseves the drape and reduces the weight of electric blankets. In addition, the blankets can be made washable.

Finally, the high strength and puncture resistance of metal monofilaments makes them excellent candidates for tire cords. Steel-belted tires rank among the longest-wearing and most durable automobile tires.

OTHER MAN-MADE FIBERS

Since the end of World War II, scientific imagination and technological expertise have combined to produce dozens of new fibers. However, keen economic competition in the marketplace and consumers' demands for performance have relegated most of these to low-volume, specialty markets. In this section we will introduce some of the less significant fibers the consumer may occasionally encounter. In alphabetical order, they are anidex, azlon, nytril, rubber, saran, vinal, and vinyon.

ANIDEX

The Textile Fiber Products Identification Act defines anidex as follows:

> A manufactured fiber in which the fiber-forming substance is any long-chain synthetic polymer composed of at least 50 percent by weight of an ester of a monohydric alcohol and acrylic acid ($CH_2 = CH—COOH$).

This fiber was introduced by the Rohm & Haas Company under the trade name ANIM/8. The specific chemical composition was not revealed, but the fiber was described as an acrylate. It had good elastomeric properties, and was claimed to exhibit superior recovery from stretch. However, the fiber has not been produced in large volume.

AZLON

The Textile Fiber Products Identification Act defines azlon as follows:

> A manufactured fiber in which the fiber-forming substance is composed of any regenerated naturally occurring protein.

Azlon fibers may be prepared by dissolving zein (from corn), casein (from milk), or other proteins in concentrated alkali and wet-spinning the resultant solution to form protein fibers. The azlons have a soft wool-like hand, do not felt, and are more shrink-resistant than wool. Their major use was in wool blends for suiting and felts. However, the fibers have low tenacity and poor wet strength. In addition, the raw materials for azlon fibers are also food sources. The competition for proteins as food, as well as the limited performance of the fiber, led to the replacement of azlons by other fibers, notably acrylic.

NYTRIL

The Textile Fiber Products Identification Act defines nytril as follows:

> A manufactured fiber containing at least 85 percent of a long-chain polymer of vinylidene dinitrile ($-CH_2-C(CN)_2-$), where the vinylidene dinitrile content is no less than every other unit in the polymer chain.

Nytril fibers were developed by the B. F. Goodrich Company and were marketed under the name Darvan by Celanese and Hoechst. The fiber is wool-like in its hand and resiliency.

RUBBER

The Textile Fiber Products Identification Act defines rubber as follows:

> A manufactured fiber in which the fiber-forming substance is comprised of a natural or synthetic rubber. . . .

The definition goes on to specify a number of compounds which may be termed *rubber*.

When the bark of the *hevea* tree is cut, it exudes a thick, milky-white liquid which hardens upon contact with the air. Natives of the Amazon River valley in Brazil, where the tree originated, fashioned this gum into small, elastic balls which they used in sports. Europeans and Americans knew of the material, but for centuries it remained little more than a curiosity. Thomas Jefferson, upon receiving a sample from a friend along with the information that it could be used to erase ink from paper, named it "rubber" since it was used to rub out errors. The gum has been known by that name ever since.

Natural rubber is polyisoprene. Its structure is shown in Fig. 8.2. The unsaturated bonds ($-C=C-$) permit the stretch and elasticity characteristic of rubber. However, natural rubber is weak and has a low melting temperature. The VULCANIZING process, discovered by Charles Goodyear in 1839, crosslinks the molecules by opening the double bonds in adjacent polymer molecules and rejoining them through sulfur atoms. A crosslinked rubber is illustrated in Fig. 8.3. Vulcanizing increases the strength, raises the melting temperature, and improves the dimensional stability of rubber while maintaining the high stretch and elasticity.

In the 1920s the U.S. Rubber Company developed the technology for preparing rubber fibers. The process consists of extruding the natural rubber latex into a coagulating bath to form filaments; then the material is crosslinked to obtain fibers that exhibit high stretch and excellent elasticity.

The rubber filaments are wrapped in cotton or rayon to form core yarns. They are used to provide support and figure control in foundation garments,

Figure 8.2 The structure of polyisoprene. The double bond can react to form crosslinks.

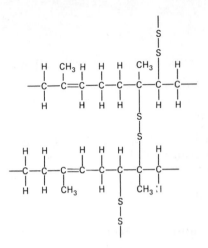

Figure 8.3 Vulcanizing cross-links rubber molecules with sulfur atoms.

hosiery, and waistbands. Natural rubber has generally been displaced by synthetic rubber and spandex, which have greater durability to laundering, retain their elasticity longer, are not as readily stained by perspiration and body oils, and are less expensive. Table 8.2 shows the properties of rubber.

TABLE 8.2 Properties of Rubber

Molecular Structure	Polyisoprene.
Macroscopic Features	
Length:	Produced in filament.
Cross-section:	Round or rectangular.
Color:	Usually white, but may be colored.
Light reflection:	Dull.
Physical Properties	
Tenacity (g/den):	0.5.
Stretch and elasticity:	700 to 900% elongation; 100% recovery.
Resiliency:	Not applicable.
Abrasion resistance:	Poor; however, core yarns have the abrasion resistance of the outer fiber.
Dimensional stability:	Good; however, fibers will stretch permanently if held under tension for long periods at elevated temperature.
Moisture regain:	Negligible.
Specific gravity:	1.0.
Chemical Properties	
Effects of bleaches:	Chlorine bleaches will attack rubber if improperly used. Peroxide and perborate bleaches are safe.
Acids and alkalies:	Resistant to most acids except concentrated sulfuric acid. Good resistance to alkalies.
Organic solvents:	Dry-cleaning solvents will cause swelling and softening of the fibers.
Sunlight and heat:	Will discolor and harden under prolonged exposure to sunlight. Heat will cause the fibers to become brittle.
Resistance to stains:	Rubber will absorb oil-borne stains; resistant to water-borne stains.
Dyeability:	Difficult to dye because of low moisture regain. May be pigmented.
Biological Properties	
Effects of fungi and molds:	Good resistance.
Effects of insects:	Unaffected.
Flammability Behavior	Will burn slowly with a smoky flame.
Electrical and Thermal Conductivity	Good insulator.

SARAN

The Textile Fiber Products Identification Act defines saran as follows:

> A manufactured fiber in which the fiber-forming substance is any long-chain synthetic polymer composed of at least 80 percent by weight of vinylidene chloride units ($-CH_2-CCl_2-$).

Originally introduced as a packaging film under the name Saran Wrap by the Dow Chemical Company, the copolymer of vinylidene chloride and vinyl chloride was later formed into fibers. Saran fibers are lustrous, abrasion-resistant, and resilient, with good stretch recovery. Cloth made from saran is easily cleaned and stain-resistant. However, the fibers are stiff, darken upon extended exposure to sunlight, and have a relatively low melting temperature and little affinity for water. These properties limit the fiber's usefulness in apparel, but can allow its use in furnishings. Because saran fibers do not support combustion, they can be used in automotive upholstery, carpets, and other products that must meet flammability standards. Saran is not widely used because of competition from olefins, which have similar properties at lower cost. The properties of saran are given in Table 8.3.

TABLE 8.3 Properties of Saran

Molecular Structure	Poly(vinylidene chloride).
Macroscopic Features	
Length:	Produced in both filament and staple lengths.
Cross-section:	Circular.
Color:	Varies with differing pigmentations.
Light reflection:	Has high luster unless dulled by pigments.
Physical Properties	
Tenacity (g/den):	1.4 to 2.4.
Stretch and elasticity:	15 to 30% elongation at break; 98% recovery at 3% elongation.
Resiliency:	Stiffer fibers will resist crushing. Heavy compression may cause permanent deformation.
Abrasion resistance:	Excellent.
Dimensional stability:	Excellent.
Moisture regain:	Less than 0.1%.
Specific gravity:	1.7.
Chemical Properties	
Effects of bleaches:	Good resistance to bleaches.
Acids and alkalies:	Excellent acid resistance. Colored by hot solutions of sodium hydroxide and ammonium hydroxide.
Organic solvents:	Synthetic solvents cause swelling and softening of fibers.
Sunlight and heat:	Fabrics darken after prolonged exposure to sun without appreciable strength loss. Heat-sensitive; low ironing temperatures must be used.
Resistance to stains:	Good.
Dyeability:	Difficult to dye owing to low moisture regain. Acetate and pigment dyes are used.
Biological Properties	
Effects of fungi and molds:	Unaffected.
Effects of insects:	Unaffected.
Flammability Behavior	Self-extinguishing.
Electrical and Thermal Conductivity	Good electrical conductivity. Poor heat conductor.

The Textile Fiber Products Identification Act defines vinal as follows:

> A manufactured fiber in which the fiber-forming substance is any long-chain synthetic polymer composed of at least 50 percent by weight of vinyl alcohol units ($-CH_2-CHOH-$), and in which the total of the vinyl alcohol units and any one or more of the various acetal units is at least 85 percent by weight of the fiber.

Poly(vinyl alcohol) fibers, first produced in 1931, were water-soluble and of limited use. In 1939 Japanese scientists developed methods for insolubilizing the fibers, and after World War II commercial production began in Japan. Fiber is usually produced by wet-spinning, followed by heat treatment and exposure to formaldehyde to crosslink the molecules and make the fiber insoluble in water.

Vinal fibers are strong and abrasion-resistant. However, the fiber has low resiliency, poor wrinkle resistance, shrinks upon exposure to heat, and is weakened by exposure to sunlight. Uses within the U.S. are limited, due to competition from other fibers; they are sometimes used in surgical applica-

TABLE 8.4 Properties of Vinal

Molecular Structure	Poly(vinyl alcohol).
Macroscopic Features	
Length:	Available in both filament and staple lengths.
Cross-section:	Bean-shaped.
Color:	White.
Light reflection:	Can be bright, semi-dull, or dull.
Physical Properties	
Tenacity (g/den):	4 to 5, regular; 6 to 9, high tenacity.
Stretch and elasticity:	Good elasticity; high degrees of molecular orientation result in lower elasticity.
Resiliency:	Low; poor wrinkle resistance.
Abrasion resistance:	Good abrasion resistance.
Dimensional stability:	Fair.
Moisture regain:	4 to 5%.
Specific gravity:	1.30.
Chemical Properties	
Effects of bleaches:	Is dissolved by oxygen bleaches.
Acids and alkalies:	Strong acids cause deterioration. Resistant to all alkalies.
Organic solvents:	Resists most organic solvents; attacked by phenols.
Sunlight and heat:	Shrinkage occurs upon exposure to heat. Prolonged exposure to sunlight weakens fibers.
Resistance to stains:	Fair.
Dyeability:	Acid, base, and disperse dyes are used.
Biological Properties	
Effects of fungi and molds:	Unaffected.
Effects of insects:	Unaffected.
Flammability Behavior	Exhibits good flame-resistance properties.
Electrical and Thermal Conductivity	Moderate conductivity.

tions. Interesting design effects can be created by weaving or knitting fabrics containing vinal fibers and subsequently dissolving them. The properties of vinal fibers are given in Table 8.4.

VINYON

The Textile Fiber Products Identification Act defines vinyon as follows:

> A manufactured fiber in which the fiber-forming substance is any long-chain synthetic polymer composed of at least 85 percent by weight of vinyl chloride units ($-CH_2-CHCl-$).

Poly(vinyl chloride) (PVC) was invented in 1838, but its commercial exploitation had to await the discovery of suitable solvents and spinning techniques. The fiber was commercially introduced in the U.S. in 1937. Because the fibers may be prepared from 100 percent PVC, copolymers of vinyl chloride and compounds such as vinyl acetate, or from chlorinated PVC, they have a wide range of physical and chemical properties. Vinyon has had limited success in apparel and furnishings owing to its low melting

TABLE 8.5 Properties of Vinyon

Molecular Structure	Poly(vinyl chloride).
Macroscopic Features	
Length:	Produced in staple and filament lengths.
Cross-section:	Dogbone-shaped.
Color:	White.
Light reflection:	Translucent.
Physical Properties	
Tenacity (g/den):	Strength may vary from low to high.
Stretch and elasticity:	Strong fibers have low elasticity; weaker fibers have high elasticity.
Resiliency:	Low to moderate.
Abrasion resistance:	High.
Dimensional stability:	Good.
Moisture regain:	Low.
Specific gravity:	1.3 to 1.5.
Chemical Properties	
Effects of bleaches:	Resistant to all bleaches.
Acids and alkalies:	Resistant to most acids. Fully resistant to all alkalies.
Organic solvents:	Softened by commercial dry-cleaning solvents.
Sunlight and heat:	Very heat-sensitive; softens and shrinks at 65° C (150° F) and melts at 125° C (260° F). Resistant to light.
Resistance to stains:	Moderate to good.
Dyeability:	Dyed with dispersed dyes with swelling agents added; acetate dyes, and napthol dyes.
Biological Properties	
Effects of fungi and molds:	Unaffected.
Effects of insects:	Unaffected.
Flammability Behavior	Will not support combustion.
Electrical and Thermal Conductivity	Poor conductor.

temperature and poor resistance to dry-cleaning solvents. It is used industrially for filters and other applications in which resistance to strong acids and alkalies and insensitivity to moisture are important. In addition, vinyon is flame-resistant and will not support combustion; therefore it is useful for theater seats and in autos and other vehicles in which fabrics must conform to flammability standards. The properties of vinyon are given in Table 8.5.

HETEROGENEOUS FIBERS

All the fibers discussed thus far have been HOMOGENEOUS—that is, except for minor amounts of additives, they are composed of a single chemical substance. This substance might be a pure polymer such as nylon, or a copolymer, as in modacrylic, but the chemical constituents of the fiber are not separable. HETEROGENEOUS fibers are prepared from two or more chemical entities which retain their identities after the fiber has been formed.

To date, only fibers containing two constituents have been commercialized. These are known as BICOMPONENT or BICONSTITUENT fibers.

The three types of heterogeneous fibers, illustrated in Fig. 8.4, are the side-by-side (SS), sheath-core (SC), and matrix (M). In the SS and SC fibers, the two materials are in direct contact with each other, but are distinct and separate. They may be likened to the components of a stereo system, in which the speakers, amplifier, and turntable are separate but connected. The matrix fiber may be likened to a chocolate chip cookie in which the chocolate is dispersed within the matrix of the batter so that all portions of the cookie contain some chocolate, yet the chocolate chips retain their identity.

SIDE-BY-SIDE (SS) FIBERS

SS fibers are produced by extruding two polymeric liquids through specially constructed spinnerets so that the liquid polymers emerge in contact with

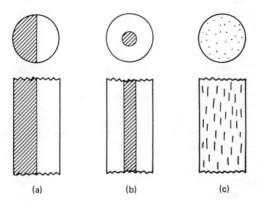

(a) (b) (c)

Figure 8.4 Heterogeneous fibers may be (a) side-by-side, (b) sheath-core, and (c) matrix types.

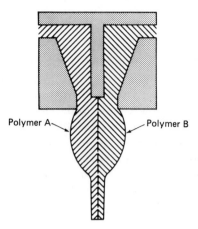

Polymer A — — Polymer B

Figure 8.5 Side-by-side heterogeneous fibers are spun from spinnerets which allow the polymers to touch without mixing.

each other. Upon solidification, the materials remain joined in one fiber. One type of spinneret used to extrude these fibers is illustrated in Fig. 8.5. These fibers are engineered to produce a wool-like crimp.

One of the factors responsible for the high level of crimp in wool fibers is the presence of *ortho-* and *para-*cortical cells of which the fiber is formed. It is the differential response of these cells to changes in temperature and humidity that cause the crimp. In SS man-made fibers, the molecules of one side of the fiber are extended to a greater degree than those of the other. This difference, combined with differences in temperature sensitivity and moisture absorption, gives rise to an internal tension within the fiber, which causes it to curl. By proper control of the types of polymers, the ratio of the components, and the processing conditions, the manufacturer can produce fibers with differing degrees of bulk. The effect is similar to a texturing process, but is more permanent. Typical SS bicomponent fibers are shown in Fig. 8.6.

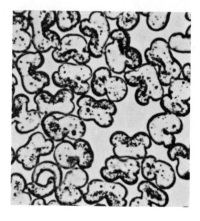

Figure 8.6 Cross-section of a typical side-by-side bicomponent fiber made of two types of acrylic. (*AATCC and ASTM*)

SHEATH-CORE (SC) FIBERS

The SC fibers were developed with the intent of giving fibers with satisfactory physical properties improved surface properties. For example, polyamide fibers are strong, wrinkle-resistant, and elastic, but they have low moisture absorption. By sheathing a nylon fiber with a polymer of "high absorptive power for water," one manufacturer was able to develop a nylon fiber of superior strength and comfort. The acceptability of sheath-core bicomponent fibers depends to a great extent upon the costs of manufacture as well as upon the physical properties of the fiber. One of the disadvantages of such fibers is that if the sheath is too thin, it may be abraded away, causing the fiber to lose its desirable surface characteristics.

Recently the Monsanto Textiles Company introduced Ultron nylon carpet yarn. This yarn incorporates a conductive fiber in which the core, a nylon/carbon black matrix fiber, is eccentrically located on the outer edge of the sheath. The fiber behaves essentially as a nylon fiber with the additional advantage of low static electricity buildup. The fiber is shown in Fig. 8.7.

MATRIX FIBERS

The matrix fibers are formed from a physical mixture. They may be composed of fibrils of one material distributed in a matrix of another material, or they may be mixtures of equal parts. In either case, the materials form distinct and separate phases. One of the major advantages of matrix fibers is that one component will reinforce and strengthen the other component. Source, a 30/70 mixture of polyester fibrils in nylon, was developed to alleviate the

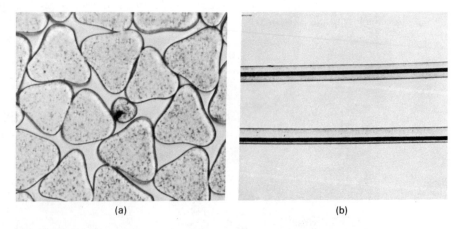

(a) (b)

Figure 8.7 Photomicrographs of Ultron. (a) The cross-sectional view shows the round conductive fiber (with conductive stripe) in the center. The conductive fiber is easily distinguished from the 15-denier trilobal staple which features a rounded triangular cross-section. (b) The longitudinal view shows the conductive carbon-bearing stripe which is virtually invisible. (*Monsanto Textiles Company*)

problem of "flat-spotting" in nylon tire cord. In addition, the fiber had an interesting luster, which combined with its high strength and other properties associated with nylon, made it a good candidate for use in carpets. Due to marketing problems, Source is no longer manufactured.

Cordelan, a 50/50 mixture of vinyon and vinal, was found to be well suited to children's sleepwear when the flammability regulations made a flame-retardant fiber necessary. The vinyon contributed flame resistance and tenacity, while the vinal made the fiber more flexible and lent comfort with its higher moisture absorption. Cordelan is no longer marketed in the U.S.

The development of bicomponent and biconstituent fibers provides fiber manufacturers and consumers with an important class of materials that can be engineered to improve the performance of textile products. Improved comfort through high bulk, elasticity and static control, improved ease of maintenance through soil release, increased durability, and safety may be achieved by the proper combination of existing materials.

FIBER MODIFICATIONS

Commercial man-made textile fibers are not pure polymers. They contain a number of additives designed to improve their performance properties. Most fibers contain a DELUSTRANT—titanium dioxide or other pigment—which reduces light reflection and gives the fiber a more pleasing, subdued luster. Many fibers contain chemicals (U. V. STABILIZERS) which absorb the ultraviolet rays of the sun and retard the degradation of the fiber. Some materials, such as acrylic and vinyon, need PLASTICIZERS to make them more flexible and less likely to crack when flexed. ANTISTATIC agents may be included to enhance moisture absorption and reduce the buildup of static charge. These materials are of particular importance in improving the performance properties of the nylons and polyesters.

Physical modification of fibers may include modification of cross-section to change light reflectance, to alter mechanical properties such as stiffness, or to hide soil. The capacity of the man-made fibers to be tailored to meet specific end-use requirements through chemical and physical modification is an important characteristic that provides consumers with a wide variety of new and better products.

fiber identification methods

Although it is a relatively simple matter for consumers to determine fabric type and, in most cases, yarn construction, the fiber content of a cloth is often not easily ascertained. The variety of modern fibers and the techniques of texturing, blending, and finishing available to manufacturers make it difficult for even the most experienced purchaser to recognize the fiber or fibers in a given piece of goods. Since no two textile fibers, whether natural or man-made, have the same properties and performance characteristics, fiber content is one of the major determinants of fabric performance.

For centuries reputable merchants and manufacturers, as well as consumers, have tried to prevent the unscrupulous from misrepresenting their products. If a consumer purchases a cloth alleged to be made of wool, it is with the understanding that it will have certain properties related to its comfort, appearance, maintenance, and durability that warrant its higher price. He or she will not be happy with acrylic, even if it is the finest acrylic available. The Wool Labeling Act and the Textile Fiber Products Identification Act require that the fiber content of most textile products be clearly stated by means of a label or hang tag.

However, tags or labels can be lost, or goods accidentally mislabeled. The manufacturer or retailer may even have misrepresented the product. In cases where doubt may arise—e.g., a "polyester" cloth that wrinkles too readily and might be rayon—there are some nontechnical tests the consumer may perform. These include testing by touch, burning, microscopic observa-

tion, staining, and solubility. The first two may be conducted without special apparatus, while the others require some preparation. More sophisticated testing is usually undertaken at testing laboratories when the cost of the product warrants the expense. Often the Cooperative Extension Service, the state or county Consumer Protection Agency, or the state university may be of help.

IDENTIFICATION BY TOUCH

The hand of a cloth can usually provide a good clue to its fiber content. However, finishing, texturing, and differences between grades of a given fiber can alter the feel. Rubbing a cloth between the thumb and first finger allows you to judge its warmth, elasticity, smoothness, and dryness. In general, the major fibers compare as follows:

> *Acrylic* feels cool, elastic, smooth, and dry.
> *Cotton* feels cool, inelastic, soft, and dry.
> *Glass* feels warm, stiff, smooth, and dry.
> *Linen* feels cool, leathery, stiff, and dry.
> *Nylon* feels cool, elastic, smooth, and slick.
> *Olefin* feels warm, elastic, smooth, and waxy.
> *Polyester* feels cool, elastic, smooth, and slick.
> *Silk* feels warm, crisp, smooth, and dry.
> *Wool* feels warm, springy, rough, and dry.

BURNING TEST

A more accurate test, easily performed at home, is to burn a few threads of the fabric and observe their behavior. This method, along with the results of the touch test, is sometimes sufficient to identify the fiber content. For example, if a "woolly" fabric is suspected of being acrylic, the burning test can provide ample evidence as to the fiber type. On the other hand, the burning test would not be able to distinguish among cotton, linen, and rayon. At times the method is useful for determining what a fiber is *not*. For example, the burning test can determine whether a smooth, lustrous filament is silk or not, but does not provide enough information to identify the filament as acetate or triacetate if it is not silk.

The procedure is quite simple, but it is important to exercise caution to avoid the risk of burns or fire.

1. Remove several yarns from the warp or filling, and untwist them to form a loose mass.
2. While holding the yarn with tweezers, slowly bring the fiber mass to the edge of a flame such as a candle, match, or cigarette lighter. *Observe the behavior as the fibers approach the flame.*
3. Ignite the fiber mass with the flame and *observe the ignition.*

TABLE 9.1 Burning Behavior of Selected Fibers

	Approaching Flame	In Flame	Out of Flame	Odor	Residue
NATURAL FIBERS					
Cellulose					
Cotton Linen	Ignites readily. Scorches.	Burns rapidly with yellow flame.	Continued rapid burning; red afterglow upon extinguishing.	Burning paper.	Light feathery ash, gray to charcoal color.
Protein					
Wool	Chars; curls from flame.	Burns slowly and unevenly.	Self-extinguishing.	Burning hair.	Brittle, irregular black ash.
Silk	Curls away from flame.	Burns slowly and sputters. Weighted silk glows red.	Self-extinguishing or may burn very slowly.	Like singed hair.	Round, shiny black beads, easily crushed. Weighted silk—skeleton of original fiber.
Mineral					
Asbestos	Unaffected.	Glows red if flame is hot enough.	Does not burn.	None.	None—unaffected.
MAN-MADE FIBERS					
Acetate	Melts and shrinks from flame; scorches.	Burns rapidly.	Continues to burn; melts and drips.	Vinegar.	Hard, irregular black bead.
Acrylic	Melts and shrinks from flame; ignites quickly.	Burns rapidly with bright, sputtering flame; smoky.	Continues to burn; melts and drips.	Acrid.	Hard, irregular black bead.
Anidex	Shrinks from flame.	Melts and burns.	Continues to burn.	Pungent.	Brittle black bead.
Aramid	Puckers near flame.	Scorches and glows red.	Self-extinguishing.	None.	Skeleton of fiber.
Azlon	Shrinks from flame.	Burns slowly and sputters.	Self-extinguishing.	Burning hair.	Brittle black bead.
Glass	Melts and shrinks from flame.	Melts; glows orange.	Does not burn.	None.	Hard white bead.
Metal					
Pure	May melt and shrink from flame.	Glows red; may melt.	Does not burn.	None.	Skeleton of fiber.
Coated	Behaves according to its coating.				Hard black bead.

Fiber	Reaction approaching flame	Reaction in flame	Reaction removed from flame	Odor	Residue
Modacrylic	Shrinks from flame.	Burns slowly and irregularly.	Self-extinguishing.	Acrid.	Hard, irregular black bead.
Novoloid	Shrinks from flame.	Glows red; finishes may char.	Does not burn.	Sharp.	Skeleton of fiber.
Nylon	Melts and shrinks from flame.	Melts and burns slowly; smoky.	Burns slowly; tends to self-extinguish.	Celery.	Hard, shiny brown or gray bead.
Nytril	Melts and shrinks from flame.	Melts and burns slowly; smoky.	Continues to burn.	Acrid.	Hard, irregular black bead.
Olefin	Melts and shrinks from flame.	Melts and burns.	Continues to burn.	Candle wax.	Tough, tan bead.
Polyester	Melts and shrinks from flame.	Melts and burns slowly.	Burns slowly, melts and drips.	Slight sweet.	Hard, shiny black or brown bead.
Rayon	Scorches; ignites readily.	Burns rapidly with blue flame.	Continued rapid burning; red afterglow upon extinguishing.	Burning paper.	Light feathery ash, gray to charcoal color.
Rubber	Shrinks from flame.	Melts and burns; smoky.	Continues to melt and burn.	Sulfurous.	Soft, tacky black ash that hardens upon cooling.
Saran	Melts and shrinks from flame.	Melts and burns slowly; smoky.	Self-extinguishing.	Acrid.	Brittle, irregular black bead.
Spandex	Melts without shrinking from flame.	Melts and burns.	Continues to melt and burn.	Pungent chemical odor.	Fluffy, easily crushed black ash.
Triacetate	Melts and shrinks from flame; scorches.	Melts and burns irregularly.	Continues to burn; melts and drips.	Vinegar.	Hard, irregular black bead.
Vinal	Melts and shrinks from flame.	Melts and burns.	Continues to melt and burn.	Penetrating chemical odor.	Tough, tan bead.
Vinyon	Melts and shrinks from flame.	Melts and burns slowly.	Self-extinguishing.	Penetrating acrid odor.	Hard, irregular black bead.

4. Remove the mass from the flame and *observe the burning behavior.*
5. Inhale and note the odor by wafting the smoke or gases toward your nose with your hand. *Do not hold the burning material up to your nose.* Often the odor is most intense immediately after the burning stops.
6. When the material has cooled, *observe the ash or residue.*

The burning behavior of selected fibers is given in Table 9.1. The burning test readily classifies fibers as to their generic type: cellulosic, protein, mineral, or petroleum. With some experience it is possible to identify many fibers. However, various finishes, dyes, or additives may alter the burning characteristics enough to make conclusive identification impossible. Many flame-retardant synthetic fibers cannot be identified by this method.

MICROSCOPIC OBSERVATION

Although a microscope is not a common household item, many high schools and colleges are equipped with low-power (less than 100X) instruments. These are quite adequate for rapid determination of fiber type. The major natural fibers—cotton, linen, wool, and silk—may be readily identified by their characteristic cross-section or longitudinal appearance. Man-made fibers, however, may not possess a unique geometry, so that observation under the microscope is rarely sufficient to identify them unequivocally. For example, a nylon fiber may possess a round, lobed, Y-shaped, or square cross-section. Its longitudinal appearance will probably be that of a smooth, translucent rod containing tiny flecks of delustrant. Since the same description could as readily be applied to a polyester fiber as to a nylon fiber, the microscope is not capable of making a positive identification in this case.

The photomicrographs accompanying the descriptions of the fibers in Chapters 5 to 8 show how microscopic observation can be useful in identifying textile fibers.

STAINING METHOD

Differences in the chemical and physical structure of fibers have a dramatic effect upon the types of dyes that will combine with them, and upon the ease of penetration of a particular dye. For these reasons stain tests may be used to identify fibers. Several identification stains are available which consist of specially prepared mixtures of dyestuffs. Fabric treated with such dyestuffs will be stained a color characteristic of the fiber type. In some cases the depth of shade can be used to distinguish between different brands of a given fiber. This method of identification is limited by the finishes applied to the cloth and the type of processing the fiber has undergone in its manufacture. There are times when dye penetration or shade may give ambiguous results. This technique cannot be used to identify fibers that have already been dyed unless the dye can be stripped from the fiber.

SOLUBILITY

Differences in the chemical nature of the various fibers cause them to be sensitive to different organic solvents, acids, and bases. These differences in solubility provide one of the most widely used test methods for the determination of fiber content. Solvents can be dangerous if misused, so solubility testing must be conducted in a properly equipped laboratory. In order to insure accurate results, the fibers should be thoroughly cleaned before testing. Yarns should be untwisted, and the fibers teased out to provide a large surface area for solvent penetration. A tightly twisted yarn will take a very long time to dissolve, and the tester may misinterpret the results.

The procedure is to place a small amount of solvent, about 10 cc, in a glass petri dish or small beaker, and add to it a few fibers. The sample should be just large enough to be visible; too large a sample will extend the time required to complete the test. Usually the test may be conducted at room temperature (20 to 25°C). In some cases, however, the solvent may have to be warmed or heated to the boil. Warming is best accomplished by putting the fiber sample and solvent in a test tube which is then placed in a beaker of water heated on an electric hot plate. When it is necessary to heat the solvent to the boiling point, the test should be conducted in a fume hood. Heating with a gas flame is not recommended for organic solvents, because many are flammable.

TABLE 9.2 Solubility of Common Fibers in Selected Solvents

	Acetone	Sulfuric Acid (H_2SO_4)	Bleach (NaOCl)	Hydrochloric Acid (HCl)	Dimethyl-Formamide	Meta-xylene	Meta-cresol	Hydrofluoric Acid
Concentration (%)	100	70	5	28	100	100	100	50
Temperature (°C)	20	20	20	20	25	boiling	95	20
Fiber								
Acetate	S	S	I	I	S	I	S	I
Acrylic	I	I	I	I	S	I	P	I
Cotton	I	S	I	I	I	I	I	I
Glass	I	I	I	I	I	I	I	S
Linen	I	S	I	I	I	I	I	I
Modacrylic	S	I	I	I	S	I	P	I
Nylon	I	S	I	S	I	I	S	I
Olefin	I	I	I	I	I	S	I	I
Polyester	I	I	I	I	I	I	S	I
Rayon	I	S	I	I	I	I	I	I
Silk	I	S	S	I	S	I	I	I
Spandex	I	P	I	I	S*	I	P	I
Triacetate	S	S	I	I	S	I	I	I
Wool	I	I	S	I	I	I	I	I

*At the boil

S = Soluble P = Partially soluble I = Insoluble

It should be noted that the separation of fibers in blends is not always easily accomplished, and that ambiguous results may be obtained.

The solubilities of the common fibers in eight different solvents are given in Table 9.2. These are sufficient to identify the fibers usually found in consumer products.

REVIEW QUESTIONS

1. Explain how you could determine, without any laboratory apparatus, whether a fabric made of filament yarn was actually silk.

2. Is a burning test alone sufficient to determine if a yarn is made of either cotton or rayon? Explain.

3. Will using only a microscope be enough to determine if a fiber is either nylon or polyester? Explain.

4. How would you determine whether a fabric that was reported to be 100 percent wool was not really a blend of wool with another fiber? Describe your procedure in detail.

5. Explain the utility of the burning test, the microscope, and the solubility test in identifying fibers. Devise a scheme showing how these tests could be used to unequivocally identify the various natural and man-made fibers (refer to Table 9.2).

III

10 Simple Yarns

11 Complex Yarns

YARNS:
Construction and
Performance

IN PART III we will examine the structure of yarns, consider how their physical structure relates to their properties, and observe how yarn properties can affect the performance of the cloths into which they are made. In Chapter 10 we discuss the simple yarns, both those spun from staple fibers and those made of filament fibers. In Chapter 11 we look at complex yarns, in particular, some of the more common novelty yarns which can be used to enhance the esthetics of cloth. We then consider the properties of the textured filament yarns in comparison with the untextured filament yarns and spun yarns. Finally, we will discuss some of the newer methods of yarn formation.

10

simple yarns

INTRODUCTION

The technique of spinning fibers into yarns freed early peoples from their dependence on animals for skins, sinew, and rawhide, and provided a greater variety of materials for domestic and commercial use. Yarns make up the basic material for clothing, straps, ropes, nets, rugs, blankets, tents, sacks, and numerous other household and industrial products.

The American Society for Testing and Materials (ASTM) defines YARN as "a generic term for a continuous strand of textile fiber, filaments or [other] material. . . ." Originally, yarns were formed by pulling out and twisting together a number of fibers from a bundle of wool, linen, or cotton. Pulling the fibers from the bundle helped to align them and make twisting easier. Twisting the fibers together formed them into a unified strand in which all of the fibers worked together. Through the ages, although the technique has been modified and production speeds have increased, the principle is still in use. Today we make yarns from fibers, filaments, and ribbons. The yarns may be simple or fancy, single strands or multiple plies, smooth or fuzzy, glossy or dull. The variety of yarns is almost endless.

An understanding of yarn performance begins with classification. We may catalog yarns according to whether they are *spun* or *filament*. They may be *single* or *plied* strands. They may be divided into *simple* or *novelty* categories. Thus, we may have a simple, single spun yarn or a novelty, plied

filament yarn. SPUN YARNS are those made by twisting together staple-length fibers into a strand. FILAMENT YARNS are made directly from filament fibers, usually without twist. SINGLE YARNS consist of just one strand of fiber. PLIED YARNS are formed by twisting (plying) together two or more singles. Cords are formed by twisting plied yarns together. Cables are made by plying cords, ropes by plying cables, and hawsers by plying ropes. SIMPLE YARNS are smooth, even, and homogeneous. NOVELTY, or complex yarns, are those in which different yarns are wrapped, looped, or twisted about each other to achieve various esthetic effects.

Combed or worsted Carded

Figure 10.1 Carded yarns are coarser and hairier than combed or worsted yarns.

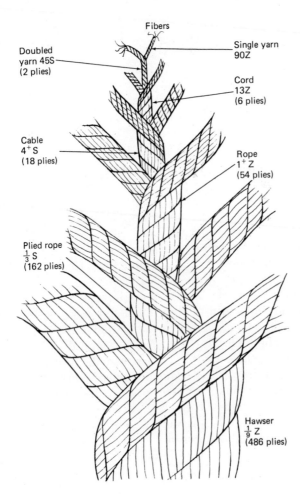

Figure 10.2 The plying of yarn results in larger and stronger cords, cables, ropes, and hawsers.

Spinning is the oldest method of manufacturing yarn. The process requires aligning a bundle of staple fibers, pulling them out into a rope, known as a ROVING, and further pulling out and twisting the roving to form the yarn. (A detailed discussion of the spinning process is given in Chapter 18.) The product of the spinning operation is a twisted assembly of fibers that is strong and flexible. The yarn is stronger than the individual fibers since the fibers act in concert to support a load. Two types of simple spun yarns are shown in Fig. 10.1. Single yarns may be twisted together to form an even stronger yarn. These plied yarns may be plied again and again to make thicker and stronger cords, cables, ropes, and hawsers. Figure 10.2 illustrates the formation of a 162-ply hawser from single yarns.

Twist Direction

Yarns, cords, and cables may be twisted in either the S or Z direction (Fig. 10.3). An S-twist yarn is one in which the fibers follow a spiral pattern parallel to the center bar of the letter S. In a Z-twist yarn the fibers are parallel to the center bar of the letter Z. Often yarns are too fine to allow the unaided eye to discern the twist direction. However, if you hold a short length of yarn vertically in your left hand and rotate it between the thumb and forefinger of your right hand while pulling upward, you can determine the twist direction. When it is rolled *clockwise*, toward the left shoulder, an S-twist yarn will become tighter and a Z-twist yarn will untwist and pull apart. The direction of twist does not affect the yarn's performance. However, it is customary to produce cotton and linen yarns with a Z-twist and woolen and worsted yarns with an S-twist. This custom has its roots in Medieval consumer protection laws; consumers could easily find out whether a cloth was really wool by simply untwisting one of the yarns and checking the direction of twist.

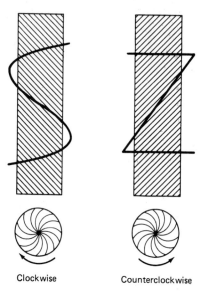

Clockwise Counterclockwise

Figure 10.3 Yarns may be twisted clockwise (S-twist) or counterclockwise (Z-twist). Their properties are the same.

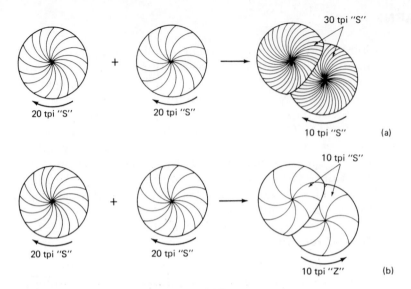

Figure 10.4 If two yarns are plied in the direction of their twist (a), the internal torque exceeds the external torque and the resultant plied yarn is unbalanced. In (b) the yarns have been plied in the direction opposite their twist and the torques are equal. This yarn is balanced.

As the yarn is twisted, internal forces are built up in the direction of the twist. These forces are known as TORQUE. In general, each turn adds the same amount of torque to the yarn, so yarns with the same number of turns per inch (tpi) have about the same amount of torque. Since the torque is approximately proportional to the tpi, we may illustrate the formation of BALANCED and UNBALANCED yarns in Fig. 10.4 by counting the turns per inch. Start with a pair of single yarns having 20 tpi in the S direction. Twist them together with another 10 tpi in the S direction. The internal torque on each of the singles will be about 30 tpi, while the torque on the two-ply yarn will be 10 in the S direction. This yarn will be unbalanced, and will curl, as shown in Fig. 10.5a. If the same two singles yarns are plied into a doubles by twisting 10 tpi in the Z direction, the counterclockwise twist will tend to unwrap the singles yarns and the internal torque of the singles yarns will be reduced to 10 in the S direction. The external torque will be 10 in the Z direction. The internal and external torques balance each other and the yarn will be balanced. The yarn will loop, as shown in Fig. 10.5b. It is important to the manufacturer that the yarns be balanced during cloth construction because the kinks and curls that may be formed by unbalanced yarns will become entangled in the machinery (possibly causing jamming) and cause imperfections in the product. This simple analysis holds only for two-ply yarns. More complicated structures, such as cords and cables, require a more sophisticated approach. Examination of Fig. 10.2 reveals that each of the levels of the multi-ply hawser has been twisted in the direction opposite to that of the preceding level.

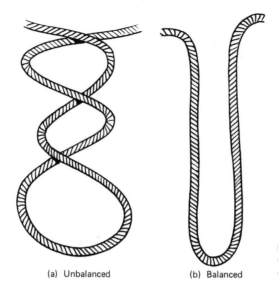

(a) Unbalanced (b) Balanced

Figure 10.5 Unbalanced yarn (a) tends to coil and kink. Balanced yarn (b) hangs straight.

Nomenclature

Most of the yarns used in household and apparel end uses are cords or smaller. We shall, therefore, concentrate on these types.

From the beginning, weavers and other users of yarn needed a standard way to designate the various yarn types accurately, so that buyers and sellers could reach mutual understanding. During the early Middle Ages, a system of yarn numbering was devised. This system, still in use today, is known as the YARN NUMBER or yarn count (ct). (Note that "yarn count" also designates the number of ends and picks in a woven cloth. Be aware of this overlap in nomenclature and don't confuse the two applications.) *Yarn number is defined as the number of standard hanks per pound of yarn.* What is the standard hank? It varies with the fiber. Cotton and spun-silk yarns are measured by an 840 yd (756 m) hank; worsted (a fine wool yarn) is measured by the 560 yd (504 m) hank; linen and standard wool yarns are measured by the 300 yd (270 m) hank. The lengths of the standard hanks were chosen as convenient values for the yarn sizes in use at the time the system was devised.

By this system, a no. 50 cotton (50 ct) is a fine yarn in which 50 hanks, each 840 yards long, weigh one pound. Note that each hank weighs only $1/50$ lb (9 g). A no. 10 cotton requires 10 hanks to make up one pound, and is much coarser. A no. 1 cotton is a very coarse yarn. *Note that the higher the yarn number, the finer the yarn.*

What about plied yarns? If a spinster (yarn manufacturer) were to combine a pair of no. 60 cotton yarns into a no. 30 doubles, how would the yarn be labeled? In some mills it would be marked 2/60s (2 plies of no. 60 singles yarn), while in others it would be marked 30/2 (a no. 30, 2-ply yarn). In either case, the number of plies and the yarn count are both given. In this discussion we shall use the latter nomenclature. Thus, a plied yarn is labeled as *yarn number of the yarn/number of plies in the yarn.* If the spinster wants

185

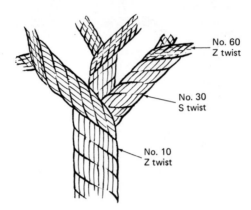

No. 60
Z twist

No. 30
S twist

No. 10
Z twist

Figure 10.6 A 30/2/3S cord.

to produce a cord, the same numbering system is followed. Suppose three of the 30/2 yarns are plied into a cord with an S-twist. This yarn would be labeled 30/2/3S, which means, reading from right to left: *an S-twist, 3-ply cord made up of 2-ply no. 30 yarns.* The cord is illustrated in Fig. 10.6. Note that from the nomenclature it is possible to specify the yarn number and twist direction for each of the plies.

FILAMENT YARNS

When, as legend has it, the Chinese Empress Hsi Ling-Shi discovered that the cocoon of the silkworm could be unraveled to yield a fine, white filament, a new fiber was introduced to the world. The extraordinary length of the silk filament is one of the reasons why silk is superior to other natural fibers. Filament yarns are stronger than spun yarns because the fibers are so long. If you cut off a short section of a spun yarn and separate it into fibers, you will find that the fibers are of different lengths. Many are much shorter than the full length of the section, and only a few are long enough to span the entire length of the section. The short fibers may be pulled from the yarn, lose contact with the other fibers in the yarn, or become disentangled from the other fibers. Any of these processes will cause the spun yarn to lose its integrity.

In a short section of a filament yarn, however, all the fibers are of the same length. Thus, each fiber supports its share of the stresses upon the yarn, and the entire assembly is better able to maintain its performance level. Unlike staple yarns, filament yarns need not be twisted. This is because each of the fibers spans the full length of the yarn and bears its portion of the load whether or not it is entangled with the others. (If the end use requires it, however, these yarns may be twisted.)

From the discovery of silk in about 2600 B.C. until the invention of rayon in the 1890s, silk was the only usable filament fiber. Because of its light weight and luxurious qualities, silks were given a different nomenclature than other fibers. Filament yarns are numbered not by the yarn number system, but by

the DENIER system. *Denier is defined as the weight, in grams, of 9,000 meters of filament or yarn.* Thus, a filament yarn is characterized by its denier and the number of fibers in the yarn. For example an untwisted 300-denier yarn containing 50 filaments is labeled as a 300/50/0. With a 10 tpi twist in the S direction, it would be labeled as 300/50/10S. Note that this nomenclature allows one to calculate the size of each filament in the yarn. In the example mentioned, each of the filaments is $300 \div 50 = 6$ denier.

Not only are there two numbering systems for yarns; the yarn number system in different countries is also based on a different standard hank for each fiber. Although it is possible to convert from one system to the other, as shown in Table 10.1, the use of the various numbering systems is still a problem recognized the world over. For the last two decades, the nations of the world have been trying to achieve a standardized yarn system. The result, currently being adopted, is the TEX system. *Tex is defined as the weight in grams of 1,000 meters of yarn, whether spun or filament.* It is expected that the tex system will replace other methods of defining yarns by the end of the 1980s.

PROPERTIES OF SIMPLE YARNS

Yarn construction can alter the properties of the fabrics that are made from them. The cloth properties that are most dependent upon yarn construction are those affecting comfort, soil resistance and soil removal, strength, abrasion resistance, and texture. In this section we discuss how yarn properties can affect fabric performance.

Appearance

The amount of light reflected from the surface of the cloth, and the way in which it is reflected, defines the property we call LUSTER. Although cloth construction can affect the way light is reflected, it is the yarns and fibers

TABLE 10.1 Comparison of Tex, Denier, and Yarn Number

Tex	Filament Yarn Denier	Yarn Number	
		Cotton System (840 yd/hank)	Worsted System (560 yd/hank)
1	9	—	—
5	45	—	—
7	63	84	—
10	90	59	89
15	135	39	59
20	180	30	44
40	360	15	22
80	720	7.5	11
100	900	6	9
200	1,800	3	4.4
500	4,500	1.2	1.8

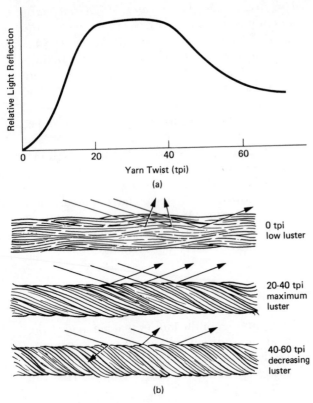

Relative Light Reflection

0 20 40 60

Yarn Twist (tpi)

(a)

0 tpi
low luster

20-40 tpi
maximum
luster

40-60 tpi
decreasing
luster

(b)

Figure 10.7 (a) Light reflection from a spun yarn increases as the twist is increased, reaching a broad maximum between 20 and 40 tpi before decreasing. (b) At low twist, light is scattered from individual fibers; between 20 and 40 tpi, light is reflected from a relatively smooth surface; at higher twists, light is absorbed in the valleys between ridges.

that have the greatest effect. A highly reflecting fiber, such as silk or nylon, appears very shiny. A highly crimped fiber, like wool, has a duller appearance. The amount of twist in the yarn also modifies the way light is reflected.

Consider a spun yarn made from a fiber with a moderately good degree of light reflectance—e.g., combed cotton. Figure 10.7 shows how the luster is affected by the amount of twist in the yarn. With no twist at all, the light is scattered from each individual fiber and the yarn appears dull. With a small amount of twist, the fibers are aligned and light is scattered from their sides; this increases the amount of light reflected to the eye of the observer. With increasing twist, the yarn becomes smoother. It acts more like a mirror, and the amount of reflected light increases. In the region of 20 to 40 tpi, the yarn is not sensitive to the degree of twist. However, as the yarns are overtwisted, ridges appear on the surface of the yarn. These ridges tend to scatter the light away from the observer, with a concomitant loss of luster. In the case of filament yarns, the filaments are already aligned and the yarn acts as a smooth relecting surface. Filament yarns need not be twisted to give a lustrous look.

Comfort

INSULATION The warmth of a garment is determined by the insulating capacity of the cloth from which it is made. The insulating properties of cloth are derived from the trapped air retained between the fibers

of the yarns. Thus, the ability of a cloth to retain body heat depends upon the tightness of the *construction* and the *bulk* of the yarns. A loose, open construction allows air to pass between the yarns. This flow of air enhances thermal interchange between the outside air and the air held between the garment and the body. Such a material will feel cool. A tight, compact construction prevents air from passing between the yarns, and feels warmer. The yarn properties, however, can reverse the behavior. Consider a tweed jacket made of a low yarn count cloth woven from bulky wool yarn. Compare it to a cotton blouse or shirt of a higher yarn count made from fine yarns. The wool sweater will be much warmer because the bulky yarns trap air between the fibers. The trapped air warms up and, in the absence of a wind, acts as an insulating layer between the body and the atmosphere. The cotton yarns are less bulky. They cannot trap as much as the wool yarns, and do not maintain an effective barrier against heat transfer.

From this example we can see that fine, highly twisted yarns provide less insulation than coarse, bulky yarns of low twist.

MOISTURE PERMEABILITY The moisture permeability of a garment is affected in much the same way as are the insulating properties. We all have a thin film of water covering our skin. It is the evaporation of this surface water that allows us to regulate our body temperature. As the water evaporates into the atmosphere, heat is removed from the body. If the surrounding air is dry, or if there is a breeze, the moisture evaporates readily and we feel cool. If the atmosphere is humid and the air is still, our body moisture is not readily removed, and we feel warm. On very sultry days we feel clammy and uncomfortable.

Filament yarns are very smooth. Cloth made from them tends to lie flat on the body. If the cloth is compact and in close contact with the skin, it is difficult for moisture to penetrate the cloth. The moisture permeability will be low. Spun yarns, however, have stray fibers projecting from their surface. These stray fibers help to support the cloth and reduce its contact with the skin. This helps to improve moisture permeability and make the garment feel more comfortable. Today's filament yarns are often textured in an attempt to approximate the hairiness of the spun yarns and make fabrics more comfortable.

TEXTURE The texture of a fabric can affect our feeling of comfort. If it feels smooth and silky, it's good; if it feels slick and waxy, it's bad. "Fuzzy and warm" is fine for winter pajamas, but "hairy and coarse" is suited to penitents. *The texture of the yarn must be chosen to match the end use of the cloth.* The fuzzy, comfortable feel of wool or textured acrylic is well suited to fall- or winter-weight clothing. The fine, highly twisted yarns of combed cotton or linen yield a smooth pleasant surface that is desirable for summer wear. The same effect is produced by smooth filaments of rayon or acetate. It would be foolish to use hairy yarns in a satin construction, since satins are intended to provide a smooth surface that highlights the luster of the yarns. In uses such as linings, it is meant to ease dressing or disrobing. If the yarns are

hairy, the surface fibers will diffuse the reflection of light and the fabric will lose its luster. In the second example, the increased friction caused by the protruding fibers will counteract the purpose of the satin weave.

STRETCH AND ELASTICITY In earlier discussions, we pointed out how construction could define the degree of stretch and elasticity of a cloth. Woven cloth had much less stretch than knit cloth. Tightly constructed fabrics were less likely to give than loosely constructed ones. Yarns can affect the degree of stretch. All yarns have some degree of resilience. The fact that the fibers in the yarns are able to move, even though the movement may be small, is what provides a cloth with its flexibility. If the fibers were rigidly held in place, cloth would be as stiff as a board.

When a spun yarn is held at its ends and pulled, the fibers within the yarn are stretched from their normally crimped state to an extended one. Upon release of tension, the fibers return to their original positions. This act of retraction from the extended position provides the elasticity of the yarn. If the tension on the yarn is too great, the fibers will not only extend, they will slip. If tension is released after the fibers have slipped past each other, the yarn cannot return to its original length; it will have been permanently stretched. The amount of tension a yarn can withstand before losing its elasticity is determined by the fiber from which it is made and the amount of twist. A high level of twist provides a great deal of fiber-to-fiber friction. This means that the fibers will not be easily extended and the yarn will not be readily stretched. As the amount of twist is decreased, the amount of stretch is increased, but the stretch recovery is lessened.

Untextured filament yarns have a low level of stretch. This is because the fibers in the yarn are not normally curled, but are extended. Thus, tension on the yarn stretches not the fibers but their molecules as well. One can appreciate that the force required to stretch the molecules of a straight fiber is greater than that required to pull out the kinks in a curled fiber. Such a filament yarn will provide a high degree of dimensional stability, but very little stretch. The stretch and elasticity of filament yarns, particularly those from man-made fibers, is greatly enhanced by texturing.

Maintenance

The ease of maintenance of a cloth can be modified by the types of yarns used in its construction. Loosely twisted, bulky yarns are not able to resist penetration by soil or staining agents. Tight yarns with a high level of twist readily shed soil. In addition, the more open yarns are more easily compacted by the mechanical action of laundering. This increases the propensity of the fabric to shrink. In general, smooth, highly twisted yarns give better maintenance characteristics to a material.

Durability

The durability of a cloth is strongly dependent upon the yarns used in its construction. Filament yarns usually provide very high strength and abrasion resistance. Their strength derives from the fact that all the fibers are the same

length, thus sharing equally in the load placed upon the yarn. The abrasion resistance of the filament yarns is often due to the high strength of the fibers. However, filament yarns of weak material, if given a moderate amount of twist, can withstand the cutting motion of abrasive forces acting across the fibers.

A major drawback of the filament yarns is their tendency to snag and pill. If one of the fibers of a filament yarn is broken, the loose end remains attached to the yarn. It cannot be pulled out because it is too long. Often it is too strong to simply break away. This fiber curls itself up into a little ball, called a pill, which remains on the surface of the cloth. If enough pills form, the material becomes unsightly. Modification of the fibers has made current filament yarns much less likely to pill than the early man-made products.

The strength of a spun yarn (Fig. 10.8) follows a curve similar to that for the luster of a spun yarn, but for different reasons. A yarn with no twist can, of course, have no strength; there are no forces to hold the fibers together. As the yarn is twisted, fiber-to-fiber friction is increased and the yarn becomes stronger. In the region beyond 40 tpi, however, the strength of the yarn decreases because of internal stresses created in the yarns. The fibers are actually crushing one another, so that most of their strength is expended in resisting the forces of their neighbors instead of bearing a load. *Crepe* yarns, those which have a twist in the region of 70 tpi, have a slightly higher strength. This is because they are allowed to develop kinks and loops. Thus, when a load is applied, crepe yarns can stretch and accommodate themselves to the new stress more easily than those which have slightly less twist.

The abrasion resistance of spun yarns follows a pattern similar to that for strength. As the level of twist increases, the yarn becomes more compact. Abrasive stress is distributed over a number of fibers rather than a few, and it is more difficult to break or tear individual fibers. If the yarns are overtwisted, the fibers are subject to large internal stresses and will be easily broken by the application of outside forces.

In sum, the durability of spun yarns is greatest for a moderate amount of twist. If the twist is too low, the yarn easily falls apart; when the twist is too high, internal forces cause the yarn to be weakened.

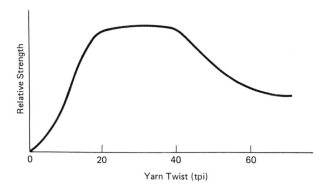

Relative Strength

0 20 40 60

Yarn Twist (tpi)

Figure 10.8 The strength of a yarn increases with increasing twist as friction between fibers holds them together. Beyond 20 to 40 tpi, increased torque weakens the fibers and yarn strength decreases.

PLIED YARNS

Two or more simple yarns may be twisted together to produce a plied yarn. In our earlier example, we showed how plied yarns could be plied again to make cords. The cords could be used to make cable, and so forth. Obviously, one of the purposes in making plied yarns is to gain greater strength. If one yarn can support a given weight, then two yarns should support twice that weight. Three yarns would allow the load to be tripled.

In addition to increasing the strength, plying creates more regular, better balanced, smoother yarns. A twenty count singles (20s) yarn could be replaced by a two-ply yarn of equivalent size (20/2). The plied yarn would be more evenly balanced and less likely to curl and kink. In addition, the 20/2 yarn would be more regular, because any weak spots in one of the plies would be supported by the other strand. Finally, plied yarn, because of more thorough processing, is smoother and less hairy than the singles yarn. (It should be noted that the plied yarn will also be more expensive.)

SUMMARY

Yarns may be classified as *simple* or *novelty*. They may also be categorized as *spun* or *filament*. The simple yarns may be further grouped as *single* or *plied*.

Spun yarns made from staple fibers may be given a twist in the S or Z direction. The direction of twist does not affect the performance of a single yarn, but is important in the manufacture of plied yarns. To produce a balanced yarn, the torque in the Z direction should balance the torque in the S direction.

The level of twist affects the performance properties of spun yarns; the optimum twist lies in the region of 20 to 40 tpi. Overtwisting may cause weakening of the yarn.

The size of spun yarns is determined by the *yarn number*, defined as the number of standard hanks of yarn per pound.

Filament yarns may be produced without twist. They are usually stronger than spun yarns, but are not as comfortable.

The size of filament yarns is determined by the *denier*, which is defined as the weight, in grams, of 9,000 meters of yarn. The *tex* system, meant to apply to all yarns, defines the size of a yarn as the weight, in grams, of 1,000 meters of yarn.

REVIEW QUESTIONS

1. How would the properties of a Z-twist yarn differ from those of an S-twist yarn with the same degree of twist made of the same fibers?
2. Show how the tensile strength of a spun yarn is affected by the degree of twist. Explain.

3. Sketch the following yarns and label each part in terms of yarn number and direction of twist:

 a. 15/2S **b.** 12/3/2Z **c.** 10/4/5S

4. Why might a fabric made of loosely twisted yarns be more comfortable for winter wear than one made of tightly twisted yarns?

5. Show how the appearance of a spun yarn is affected by the amount of twist. Explain.

6. How is the ease of maintenance of a spun yarn affected by its twist level? Sketch a curve like that of Figs. 10.7 and 10.8.

7. Why are plied yarns stronger than simple yarns of the same number or denier?

11

complex yarns

NOVELTY YARNS

As we have pointed out, textiles are an art form as well as a utilitarian commodity. The artists among us could not long accept plain, flat fabrics made of simple yarns. One of the outlets for artistic expression is the use of fancy yarns. These yarns can provide a level of surface texture and eye appeal that is lacking in the simple yarns. It would not be fruitful to conduct the reader through a catalog of all the novelty yarns; there are as many types as there are designers. We shall, instead, discuss a few of the basic types to indicate the ways in which the use of novelty yarns can affect fabric performance. The yarns we will examine are illustrated in Fig. 11.1.

Slub Yarns

Slub yarns contain partially twisted, bulky, fluffy regions called *slubs*, which are spaced at irregular intervals throughout their length. These bulky portions of the yarn break up the smooth surface. An ornamental shading provides eye appeal, and the fluffy yarns produce a pleasant tactile sensation. The slubs are weaker than the rest of the strand, so these yarns should be used in tightly woven cloths. Since slub yarns are rather open, the slubbed regions do not resist soiling as well as the rest of the material does; also, the fluffy areas are more readily abraded than is the rest of the cloth.

A slub effect is achieved in *flake* yarns by the trapping of tufts of fibers

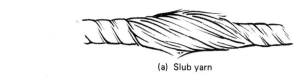

(a) Slub yarn

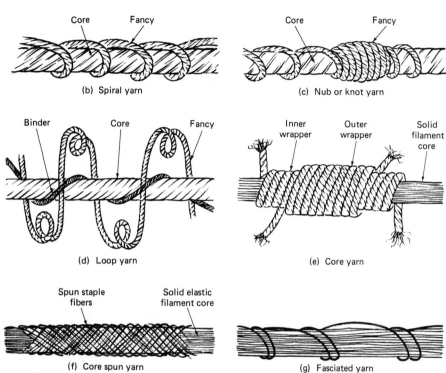

(b) Spiral yarn

(c) Nub or knot yarn

(d) Loop yarn

(e) Core yarn

(f) Core spun yarn

(g) Fasciated yarn

Figure 11.1 Basic novelty yarns. (a) *Slub yarn* has loosely twisted bulky areas. (b) In *spiral yarn* the fancy is usually different in color and texture from the core. (c) In *nub yarn* the fancy is allowed to build a raised knot. (d) In *loop yarn* the fancy is held to the core by a binder and stands out from the surface of the cloth. (e) In a *core yarn* the wrapper provides the feel of a spun yarn while the filament core provides strength or stretch. (f) In *core-spun yarn* a filament core is surrounded by spun fibers, combining the advantages of both. (g) *Fasciated yarns* (discussed on p. 201) are formed by wrapping a single filament around a bundle of aligned fibers.

within plied yarns as they are being twisted together. Flake yarns, though stronger than the slub yarns, have similar drawbacks.

The popularity of slub yarns is a triumph of salesmanship over tradition. Technically, a slub is a mistake. A properly spun yarn should not have partially twisted, bulky regions. One can visualize a manufacturer calling in his top salesperson and saying, "Sam, I have a warehouse full of off-grade slub yarns. Can you help me unload them?" Sam has a few yards of cloth made up from the irregular yarns and takes it around to his customers. "Look at the shading, feel the hand. Think what these yarns can do for your product line! Since we're friends, I'll let you have them for the same price as regular."

Because the esthetic appeal outweighed the disadvantages, Sam's customers bought his yarn.

Spiral Yarns

It is possible to ply together two yarns of different diameter, color, fiber type, or luster. This will yield a yarn in which one strand is seen to spiral around the other, much like the stripes on a barber's pole. Usually spiral yarns consist of a heavy, spun yarn, called a *fancy*, wrapped around a fine, highly twisted *core*. Relaxation of the yarn after twisting can enhance the spiral effect, making the yarn appear somewhat like a corkscrew. These yarns are rather elastic and can provide bulk to the material if the proper tension is used in weaving.

Nub (Knot) Yarns

These yarns may be another example of a mistake becoming a saleable product. If, during the production of a spiral yarn, the machinery were to go awry, the outside yarn could be wrapped around and around a single spot on the core. This would build up a knot, or nub, on the yarn. Nub yarns are prepared by winding a fine yarn many times around the same position of a heavier core. The core yarn is then moved forward and another knot is formed. The effect may be varied by using more than one yarn, usually of different color and texture, to form alternating spots of color along the yarn.

The nubs are usually quite secure in these yarns, so snagging is not a great problem. Soiling is moderately greater than with single yarns. Yarn strength is that of the core yarn; however, because the spots stand out from the surface of the cloth, they are subject to a high degree of abrasion. The abrasion resistance of the yarns, then, is strongly dependent upon the fibers used.

Loop Yarns

The loop yarns have a more complex structure than the preceding yarns. They require a *base* or *core* yarn around which the *fancy* or *effect* yarn is wrapped. The fancy yarn is secured to the core by a *binder*. The base yarn is generally the strongest yarn in the assembly; its major purpose is to lend strength to the system. It is often dyed a neutral color so as not to compete with the fancy. The fancy may be a single or plied yarn, usually moderately twisted, and dyed a bright color. The fancy is allowed to curl about the core, forming loops that stand out from the axis of the yarn. The binder is generally a fine yarn, dyed a neutral color so that it is not readily visible. The overall effect of the yarn is to produce loops on the surface of the fabric which give a wool-like hand to the cloth. Variations of loop yarns are bouclé, ratiné, and gimp.

The loops trap air and increase the insulating value of the cloth. These yarns are readily snagged and pulled, so fabrics made with them should be treated with some care in wearing and laundering.

Core Yarns

A core yarn is produced by wrapping one yarn around another so that the outer yarn completely covers the central strand. This construction can be used to increase the strength of yarns prepared from weak fibers by using a strong filament as the core. It may be used to produce comfortable stretch yarns. An example is a rubber filament wrapped in cotton. Here the wearer feels the cotton wrapper, which is comfortable, while the rubber filament provides a high degree of elasticity.

Core-Spun Yarns

In core-spun yarns a solid elastic core, usually spandex, is completely encased in spun staple fibers. The yarn is prepared by feeding a spandex filament into the spinning frame with the roving. The resulting product has the appearance of a normal spun yarn, but is highly elastic and stretchable. Besides its high elongation, this yarn has the properties of a spun yarn, due to the encasing fibers.

TEXTURED YARNS

The production of man-made fibers results in filament yarns that are very smooth and strong. However, these yarns have a limited amount of stretch, very low bulk, and practically no hairiness; all these factors are important in defining the comfort of garments. For these reasons, manufacturers developed techniques for improving the comfort potential of their yarns. These methods TEXTURE the yarns in an attempt to approximate the surface character of spun yarns produced from the natural fibers. (Texturing processes are discussed in Chapter 18.)

Texturing increases the potential elongation of yarns by converting the straight filaments into various crimped or curled configurations (Fig. 11.2). Thus, cloth made from these yarns stretches more and allows greater freedom of motion to the wearer. Texturing also increases the bulkiness of yarns; the bulkier yarns yield fabrics that have an improved ability to trap air, so cloth made from these yarns is warmer.

The air and moisture permeability of the cloth is increased. In the absence of wind, air is trapped within the yarns and provides warmth. However, because the filaments of the yarns are separated by the texturing process, a breeze can penetrate the cloth. This means that thermal exchange is enhanced and the rate of moisture evaporation is increased. Both these processes aid in cooling. The overall effect of texturing is to make the cloth feel warmer in winter and cooler in summer.

By crimping or curling the filaments, texturing allows the filament yarns to feel more like spun yarns. The hairiness of the spun yarn is approximated by the projections of the loops and the curves of the crimps.

Untextured filament yarn

Entangled yarn

Knit-de-knit crinkle yarn

Multifilament coil yarn

Monofilament coil yarn

Stuffer box crinkle yarn

Core-bulked yarn

Figure 11.2 Textured filament yarns are bulkier and more like spun yarns than untextured yarns.

The cloth does not lie flat against the skin, but is supported by these projections. Thus, the garment provides a more pleasant tactile sensation to the wearer.

In addition to its effect on comfort, texturing also provides subjective improvement to the finished cloth. The bulkier yarns give the cloth a firmer body. Thus, garments do not hang limply, but fall in pleasing folds. The hand is improved. Consumers report a more pleasant, warmer, less synthetic feel to cloth after the yarns have been textured. The appearance of the goods is improved. Light reflection is more diffuse, giving the cloth a muted luster and a more attractive appearance.

Ease of maintenance is affected in two ways. The textured yarns, being more elastic than the untreated filament yarns, provide improved wrinkle resistance. However, since the filaments are generally produced from wrinkle-resistant fibers—e.g., nylon—anyway, this effect is small. Of greater importance is the tendency of textured yarns to soil more readily because they are more open and provide a coarser surface than untextured yarns. The former property allows soil to penetrate the yarns more easily; the latter helps to hold the soil within the yarn, making laundering more difficult.

The abrasion resistance of textured yarns is slightly decreased, because the filaments are separated from each other. The individual filaments cannot aid each other as readily in resisting abrasive forces, so individual fibers are more easily broken. However, it is the fiber properties that usually play the major role in determining abrasion resistance for filament yarns, so the decrease in yarn performance has a minimal effect upon fabric performance. The yarn strength is usually not affected by the texturing process.

In sum, textured yarns improve the comfort and appearance of cloth prepared from them. This improvement is, however, purchased at the cost of decreased resistance to soiling. Durability of the fabric is hardly affected by the texturing processes.

BLENDS AND COMBINATIONS

Since the perfect textile fiber has not yet been found, it is often advantageous to make cloth from more than one fiber. The concept is an old one. The Old Testament mentions the use of garments made from more than one kind of fiber. Linsey-woolsey, a cheap cloth made from linen and wool fibers, was the mainstay of the working classes throughout the nineteenth century. Single yarns composed of an intimate mixture of two or more fibers are called BLENDS. Blends are usually spun yarns, although it is possible to intimately mix separate filament yarns to create a filament blend. Cloths produced from blended yarns are also called blends.

Yarns are prepared from fiber blends in order to improve their properties by drawing upon the best qualities of both fibers or to reduce the cost of the product. A blend of polyester and cotton, for example, obtains high strength and wrinkle resistance from the polyester and comfort from the cotton. An acrylic/wool blend can provide a comfortable, bulky cloth at lower cost than 100 percent wool. A BLEND FABRIC is one in which all the yarns are an intimate mixture of two or more fibers, e.g., polyester/cotton or acrylic/wool.

It is possible to make a woven cloth in which the warp yarns are different from the fill yarns. This fabric is not a blend. It is properly known as a COMBINATION FABRIC. An example of this construction is an upholstery cloth in which the warp yarns are 100 percent filament nylon and the fill yarns are a spun, 50-50 nylon/wool blend. The nylon filament, stronger and more dimensionally stable than the spun yarns, provides high strength in the warp direction where it is most needed to resist abrasion and tearing. The spun yarns are more comfortable than the filament yarns, and provide a better hand and surface texture to the cloth. In this case, the combination fabric would perform better than a nylon, a nylon/wool blend, or an all-wool fabric.

One of the points overlooked in the Textile Fiber Products Identification Act is the fact that blends and combinations do not behave alike. The law requires that manufacturers state the fiber content of their fabrics. Thus, a label reading "50% cotton, 50% polyester" could apply to a woven cloth prepared from a 50-50 polyester/cotton blend or to a woven cloth consisting of a polyester warp and a cotton filling. It is intuitively obvious that these two materials are not equivalent. The consumer should be aware of this oversight and inspect goods containing more than one fiber to ascertain whether they are blends or combinations. Reference to fiber properties in Chapters 5 to 8 may aid the reader in understanding the importance of blends and combinations.

OTHER METHODS OF YARN FORMATION

Modern textile technology is a dynamic field. New methods of manufacture as well as new products are continually being introduced to the market. This section describes some of the newer yarns.

Open-End Spun Yarns

Open-end (OE) spinning is a new technique for preparing yarns directly from fibers without the intermediate steps of normal spinning. (The manufacturing process is described in Chapter 18.) To the manufacturer, the major advantage of open-end spinning is its high speed and subsequent low cost per pound of yarn produced. These yarns can be produced for about two-thirds of the cost of the usual ring-spun yarns—a difference that has led to very rapid growth in the amount of yarn produced by this technique.

The overall performance of fabrics made from open-end yarns compares favorably with those made from ring-spun yarns. The major criticism has been that OE yarns are 40 percent weaker than standard yarns, according to some tests. This disadvantage, however, is more than made up for by changing the yarn count or the cloth construction. Thus, the performance of the finished product has been acceptable, even though the yarns may have been weaker.

The major advantage that proponents of OE spinning have claimed for yarns made with this technique is greater abrasion resistance. This has been shown to be dependent upon fabric construction. Abrasion resistance of both OE and ring-spun yarns is also a function of the degree of twist imparted to the yarns. Thus, it is likely that future developments will show that the two products are essentially equivalent in their resistance to abrasive forces.

Another advantage both to the manufacturer and the consumer is the greater regularity of OE yarns. The more regular the yarn, the less likely it is to produce weak spots or uneven dyeing in the final cloth. In addition, a more regular yarn will produce a better overall appearance in the finished goods.

Open-end spun yarns are hairier and bulkier than ring-spun yarns; thus cloths produced from them are better able to trap air and are more efficient thermal insulators. The fuzzier yarns yield a more pleasing hand in many end uses, while the increased bulk provides a higher degree of opacity and allows for lighter-weight fabrics. Hairiness and bulk, however, are not always useful yarn properties. For example, hairy yarns in a satin construction would detract from the esthetics of the cloth. A sheer raschel knit nightgown would not profit from the use of bulky yarns.

In sum, the development of open-end yarn spinning technology promises to provide the consumer with a greater choice in textile products, and the expanded choice will be accompanied by a decrease in cost.

Self-Twist Yarns

In this method, plied yarns are formed directly from fibers. An untwisted strand of fiber is passed through two sets of rollers. The first set is fixed; the

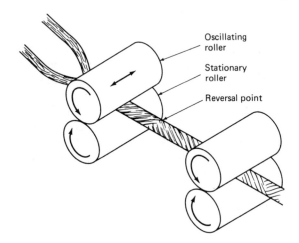

Oscillating roller

Stationary roller

Reversal point

Figure 11.3 Self-twist spinning allows untwisted fiber strands to be converted directly to yarn.

second set oscillates side to side as it rotates. The motion of the oscillating rollers causes the fibers to twist around each other to form a yarn. As the rollers reverse direction, the twist direction of the yarn also reverses. In the zone in which the direction of twist direction changes, the yarn is weak. To overcome this problem, pairs of self-twist yarns are twisted again. In the second twisting, the yarns are fed to the rollers with the weak regions out of phase with each other. This assures that the weak points in one yarn are supported by the strong sections of the other yarn. Self-twist spinning is illustrated in Fig. 11.3.

The major advantages of self-twist spinning are (a) reduced space requirements, (b) labor savings up to 50 percent over standard spinning methods, and (c) higher speed of production. All these factors help to reduce the cost to the consumer. It has been reported that self-twist yarns, although different in their performance properties from standard spun yarns, perform satisfactorily when made into fabrics for trousers and slacks. As experience with these new yarns grows, it is expected that a larger share of all fabrics will be produced from them.

Fasciated Yarns

Fasciated yarns (see Fig. 11.1g) consist of a bundle of aligned fibers held together by yarns wrapped around the surface. The assembly is produced by the projection of an untwisted strand of fibers through the nozzle of a jet. Under the action of a high-velocity air stream, the surface fibers are formed into a yarn, which is wrapped about the untwisted, central core. The manufacturing process is much faster than conventional spinning. Fasciated yarns incorporate qualities of both spun and filament yarns; they are claimed to have a higher luster, to be stronger and more regular, and to be less hairy than spun yarns. In addition, fasciated yarns can provide spun-yarn esthetics to fine-gauge fabrics that are usually knit from filament yarns.

Twistless Yarns

These yarns are produced by bonding untwisted strands of fiber with a removable adhesive, or by bonding the fibers to a molten thermoplastic resin. In the former process, the adhesive serves only to hold the fibers together during cloth formation. In the latter, the polymer becomes an integral part of the yarn. Where the nonpermanent adhesive is used, the yarns are prepared by impregnating an untwisted strand of fibers with an uncooked starch, imparting a slight twist to the assembly. The yarn is then wound on packages which are steamed so that the starch, known as *sizing*, will cook. This holds the yarns together as they are being woven. After the cloth is made, it is washed to remove the sizing. The yarns are then held together by the friction between the warp and fill at the intersections.

Although these yarns are weaker than conventionally spun yarns, the woven fabrics have acceptable strength. Furthermore, fabric hand and appearance is improved. These yarns are more open than spun yarns, giving a softer hand to the finished goods and yielding a more opaque, fuller-bodied cloth.

Bobtex yarns are prepared by the bonding of an outer sheath of staple fibers either to a core of filament yarns coated with a bonding agent or directly to a semi-molten monofilament or filament yarn as it is being spun. The final product is comparable to core-spun yarns in its appearance. *Bobtex* yarns gain their strength from the filament core and their esthetic quality from the sheath of staple fibers. The process is claimed to greatly reduce costs, increase production speed, and allow for the tailoring of yarns to meet specific performance requirements.

Yarns from Film

Man-made filament yarns are generally produced by the extrusion of a polymer or polymer solution through a spinneret containing many holes. Each hole produces one filament, and the bundle of filaments forms a yarn. Filament yarns may also be prepared by the extrusion of a thin film which is slit or fibrillated.

Slit films are formed when a polymer film is passed through a line of rotary knives, usually spaced 2 to 4 mm (0.08 to 0.16 in) apart. They yield a relatively wide strip that is rectangular in cross-section. Slit-film, or ribbon, yarns are generally produced from polyolefins (see Chapter 7), and enjoy widespread use in industrial bindings and belts, as well as primary backings for tufted carpets and in the manufacture of artificial turf. These yarns are stiffer than those made from fiber, so are not often found in apparel. Their strength and durability is of major importance and is strongly dependent upon the polymer from which they are made.

Fibrillated yarns (Fig. 11.4) are made by stretching a narrow sheet of film longitudinally until it is highly oriented and then cracking it into thousands of fine filaments, called fibrils, by stretching laterally. An alternate process embosses a pattern onto the surface of a stretched film and then fibrillates the film by lateral stretching. This method produces a netlike material which

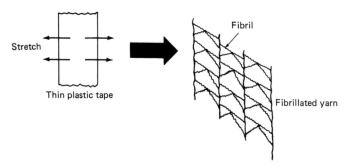

Stretch

Thin plastic tape

Fibril

Fibrillated yarn

Figure 11.4 Lateral stretching of an oriented tape causes it to crack into a network of fine fibers (fibrillae) which can be used as a yarn.

forms yarns that are bulkier and thicker than those made by the former technique.

Fibrillated yarns have properties close to yarns made from fibers, and are sometimes found in apparel and household goods. They are not as stiff as ribbon yarns, can be stronger than spun yarns, but lack the esthetic qualities necessary for most consumer uses. They are generally found in industrial products such as belts, binding twine and cordage, and sacks.

Laminated Yarns

Laminated yarns (Fig. 11.5) are a variant of slit-film yarns. They are often used to provide high-gloss, metallic-looking yarns. In home furnishings, particularly carpeting, they are used to reduce the buildup of static. The yarns are prepared by sandwiching a layer of aluminum foil between two layers of plastic film. The assembly may be bonded by heat or adhesives. The sandwich is slit into yarns. Alternatively, aluminum or another metal may be deposited on the surface of a plastic film by a technique known as *vapor deposition*. The metallized film is then sandwiched to another film so that the metal layer is protected, after which it is slit into a ribbon yarn.

These yarns retain the brightness of the metal, so that they can lend interesting optical properties to a cloth. Care in maintenance is very important; such yarns can melt during ironing or dissolve in dry-cleaning solvents.

Because they have a central core of metal, laminated yarns conduct electricity; their inclusion in carpeting can allow a static charge to be dissipated. Since they can be formed from plastics, such as nylon, that are identical to the rest of the fibers of the carpet yarn, laminated yarns perform in the same manner as the rest of the carpet and do not require special care.

Foil

Plastic film

Figure 11.5 Laminated yarns are made by sandwiching metal foils between plastic films and slitting the assembly.

SUMMARY

The novelty yarns are intended for decorative purposes. In general, they are not as durable nor as easily maintained as the simple yarns. Novelty yarns lend increased esthetic appeal to cloth, and may improve the comfort properties.

The comfort of the filament yarns may be improved by *texturing*.

REVIEW QUESTIONS

1. Sketch and describe the following yarns:
 a. Spiral yarn b. Knot yarn c. Slub yarn
2. Explain how the comfort properties of a filament yarn are affected by texturing.
3. Why is it not necessary to texture silk yarns?
4. What are the major advantages of a 50/50 polyester/cotton yarn? What are its major disadvantages?
5. Sketch and describe the following yarns:
 a. bouclé b. ratiné c. gimp
6. What are the major disadvantages of textured man-made filament yarns when compared to the same untextured yarns?

ACTIVITIES

1. Visit your local department stores and shops. Survey the types of yarns (simple spun, textured and untextured filament, complex) used in the following end-use categories:
 Men's and women's daytime wear, men's and women's evening wear, children's playclothes, children's sleepwear
 Explain why certain types of yarns might be used only in certain categories of apparel.
2. Repeat the above exercise for upholstery, window coverings, carpets, and rugs.
3. Collect samples of fabrics made from simple filament, simple spun, and novelty yarns. Try to keep the fiber content and cloth construction the same. Subject the fabrics to stains from fruit juice, mustard, machine oil, and coffee. Launder and observe the extent of staining. Does the yarn type affect the stain resistance? Note that yarns made from very stain-resistant fibers—such as nylon, olefin, and glass—are not sensitive to yarn type.
4. It is possible to estimate the abrasion resistance of fabrics by lightly rubbing their surface with fine sandpaper. Do this for the fabrics described in Activity 3. Does yarn construction affect abrasion resistance?

IV

12 Woven Cloths

13 Knit Cloths

14 Pile, Nonwoven, and Specialty Fabrics

FABRICS: Construction and Properties

IN PART IV we examine the construction and properties of fabrics. In Chapter 12, after a brief introduction defining some of the terms essential to understanding the construction and properties of different types of fabric, we discuss the basic weaves—plane, rib, basket, twill, and satin—and how their construction affects performance and choice of end use. Chapter 13 describes and evaluates the various types of basic knit constructions—jersey, rib, and purl—as well as briefly comparing their performance with that of woven cloths. Also, in this chapter we examine the interactions between cloth construction and type of yarn. In Chapter 14 we look at the performance of pile fabrics, and discuss the structure and properties of nonwoven textiles and specialty fabrics such as Jacquard weaves. We also consider the interactions between yarns and cloth and the ways in which fabric properties can be altered when these parameters are changed.

12

woven cloths

Before we discuss the construction and properties of different types of fabrics, a few definitions will help clarify our use of terms. Some years ago the terms *cloth* and *fabric* were interchangeable. They were usually defined as materials made by weaving, knitting, or felting fibers. Today this definition is no longer satisfactory. Fabrics can be made without the use of fibers, as in vinyl upholstery; or they can be made by other processes, as in nonwoven disposables or liners.

In this text we define a FABRIC as any thin, flexible material prepared from cloth, polymeric film, foam, directly from fibers, or any combination of these methods. A CLOTH is any thin, flexible material prepared from yarns. By these definitions, such materials as wallpaper, plastic upholstery products, carpets, and nonwoven materials are fabrics; woven, knit, tufted, or knotted materials made from yarns are cloth. *Note that cloth is a fabric, but all fabrics need not be cloth.*

FABRICS WOVEN ON SIMPLE LOOMS

Weaving is the oldest method of producing cloth. A simple loom is sketched in Fig. 12.1. Although the machinery for weaving cloth has changed over the millennia, the basic operation has remained the same. WEAVING, which is the interlacing of two or more sets of yarns (usually at right angles to each other), requires holding one set of yarns in parallel rows and passing another set over

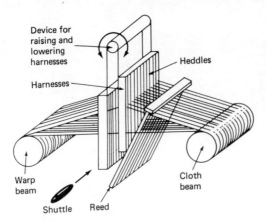

Figure 12.1 A simple two-harness loom.

and under the first set. The set of lengthwise yarns is called the WARP, and the individual warp yarns are known as ENDS. The set of crosswise yarns is the FILL or FILLING. The individual fill yarns are called PICKS. (Other names for the filling are *woof* and *weft*.) To keep the cloth from unraveling, a narrow width at each edge is closely woven. This strip is called the SELVAGE. The closeness of the weave is determined by the YARN COUNT (also called the thread count), which is defined as the number of ends and the number of picks per square inch of cloth. Yarn count may be given as the sum of the warp and fill yarns, or as the number of warp yarns by the number of fill yarns. For example, a sheeting material may be described as 140 count, or as 77 × 63 muslin. The higher the yarn count, the closer the cloth construction.

The simple cloths may all be woven on a simple two-harness loom like that shown in Fig. 12.1. Cloths may be woven by passing one fill yarn over and under single ends (plain weave), passing one pick over and under groups of ends or passing groups of fill yarns over and under single ends (rib weave), or by interlacing sets of fill yarns with sets of warp yarns (basket weave).

Plain (Tabby) Weave

In plain-weave fabrics, a single warp yarn passes over and under single fill yarns. Thus, the surface of the fabric shows a warp yarn passing over a fill and then under the next fill in both the vertical and horizontal directions. Figure 12.2 shows a plain-weave fabric.

Figure 12.2 A plain weave cloth.

```
X O X O X O X O X O
O X O X O X O X O X
X O X O X O X O X O
O X O X O X O X O X
X O X O X O X O X O
O X O X O X O X O X
X O X O X O X O X O
O X O X O X O X O X
X O X O X O X O X O
```

Figure 12.3 Three ways of representing the point diagram of a plain weave.

POINT DIAGRAMS are a simplified way of communicating the structure of a cloth. We may use light and dark squares, dotted and empty squares, or Xs and Os to represent the respective warp and fill yarns that appear on the surface of a cloth. In this text the dark square indicates a warp yarn, or end, on the surface and a light square indicates a fill yarn, or pick. The different ways of showing the point diagram of a plain-weave cloth are shown in Fig. 12.3.

Rib Weaves

The artistic talents of the weaver could not long stay confined to the simple plain weave. A logical step is to interlace the filling with more than one warp yarn. This is the RIB WEAVE. While the plain weave yields a fabric without a defined surface pattern, the rib weave can be used to create the effect of vertical or horizontal stripes, or ribs, on the surface. Figure 12.4a shows a WARP-RIB pattern which creates the impression of crosswise stripes. Figure 12.4b shows a FILLING-RIB pattern which appears as lengthwise stripes. Dimity, a lightweight cloth used for curtains and dresses, is an example of a rib weave. The rib-weave patterns repeat on either two ends for warp rib, or two picks for filling rib. Other rib weaves are shown in Fig. 12.8.

(a) (b)

Figure 12.4 Rib constructions: (a) warp rib, (b) filling rib.

209

Figure 12.5 Ribbed plain weave. Faille has a definite crosswise rib.

Ribbed Cloth

Another variation of the plain weave is found in RIBBED CLOTH. In this construction a bulky yarn is used to provide surface texture. The weaver can place a larger yarn at, say, every fourth end to achieve a lengthwise striped pattern; or a bulky filling yarn could be used to provide a crosswise ribbed effect, as in Fig. 12.5. The point diagram of these fabrics is the same as the plain weave, but the surface appearance is similar to a rib weave. Oxford cloth (Fig. 12.6), a popular shirting fabric, is a ribbed 2/2 filling rib in which the fill yarns are twice the size of the warp yarns. This combination of rib weave and bulky yarn suppresses the striped appearance and provides a surface similar to that of the plain weave.

Basket Weaves

The BASKET WEAVE allows a greater amount of freedom to the designer. Here, groups of warp and fill yarns are arranged to repeat over a greater number of yarns. The simplest pattern is the 2/2 basket, shown in Figs. 12.7 and 12.8d. In this design, two warp and two fill yarns are grouped in squares

Figure 12.6 Ribbed filling rib weave. In Oxford the rib effect is suppressed.

Figure 12.7 Basket weave. Here the pattern repeats in squares.

which alternate as warp on the surface followed by filling on the surface. The fabric appears to have a checkerboard pattern.

More complex basket patterns may be created by alternating squares of different size (see Figs. 12.8e and f). The numbers, called COUNTERS, indicate the respective number of warp yarns and fill yarns on the surface. When more than two counters are used, the pattern is developed as warp/fill/warp, etc.

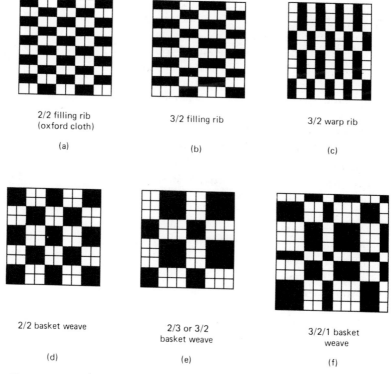

2/2 filling rib
(oxford cloth)

(a)

3/2 filling rib

(b)

3/2 warp rib

(c)

2/2 basket weave

(d)

2/3 or 3/2
basket weave

(e)

3/2/1 basket
weave

(f)

Figure 12.8 Point diagrams of some simple weaves.

(Note that in the case of an odd number of counters, such as the 3/2/1 pattern, the pattern repeat is on twice the number of ends and picks.)

Since all basket weaves may be made on a simple loom, the complexity of the pattern is limited only by the designer's imagination. However, it should be noted that the more complicated the design, the more expensive will be the fabric because of the additional weaving time required.

YARN COUNT

Not only the appearance, but the performance of a cloth is affected by its construction. A basket weave and a plain weave do not have the same resistance to abrasion, the same qualities of drape, the same wrinkle resistance, and so forth. The way the individual yarns are interlaced within a cloth determines, to a great extent, the way the cloth will behave. The other factor that affects the performance of a fabric is the number of yarns in the fabric. We earlier defined *yarn count* as the number of ends and picks making up a square inch of cloth.

If the yarn is not changed, a cloth with a high yarn count will be heavier than one with a low yarn count. In general, its performance will be superior. The yarn count of a cloth is usually measured with the aid of a small magnifying glass, known as a LINEN TESTER or PICK GLASS, and a TEASING NEEDLE. Yarn count may also be determined by marking off a one-inch square of cloth and unraveling it to count the individual warp and fill yarns.

If a cloth has the same number of ends and picks per inch, it is called a BALANCED CLOTH. Thus, a cloth of 80 × 80 (ends × picks) count is balanced, while a cloth of 80 × 40 is grossly unbalanced. A balanced cloth has essentially the same properties in both warp and fill directions; an unbalanced cloth usually does not. Consider a cotton cloth with 80 ends and 40 picks. The strength in the warp direction will be much higher than in the fill direction, since the stresses are distributed among 80 yarns instead of 40. Since there are fewer fill yarns, each is subject to greater wear than are the warp yarns, so abrasion of the cloth, and subsequent tearing, will come about by weakening and breaking of the fill yarns.

Garment performance is also affected by fabric differences. A garment made from an 80 × 40 fabric will shrink more in the warp direction than in the fill. This differential shrinkage, in which one direction of the garment is affected more than the other, will lead to altered shape as well as altered size. Another problem that can arise with unbalanced fabrics is in the area of garment construction. Seams may pucker or open when the stitches are not properly held by the portion of fabric with too low a yarn count for the number of stitches.

Performance of Simple Weaves

For millennia the plain weave has been the workhorse of textiles—not only because the plain weave is easy to produce but also because it performs well in almost all areas. Table 12.1 details the performance characteristics of

TABLE 12.1 Performance Properties of Simple Weave Cloths*

| | Plain Weave (Tabby) | | Rib Weaves | | | | Basket Weaves | |
| | | | Filling Face | | Warp Face | | | |
	40 × 40	100 × 100	2/2	8/8	2/2	8/8	4/4	8/8
APPEARANCE								
Light transmission	moderate	↓	=	↑	=	↑	=	↑
Light reflection	fair	↑	=	→	=	→	→	→
Drape	soft	firmer	softer	softer	softer	softer	softer	softer
Pattern	none	none	vertical stripes		horizontal stripes		squares	
COMFORT								
Stretch	moderate	→	=	→	=	→	→	→
Stretch recovery	good	→	= to ↓	→	= to ↓	→	→	→
Moisture permeability	moderate	→	=	→	=	→	→	→
Wind resistance	low	↑	= to ↓	→	= to ↓	→	→	→
Shrink resistance	moderate	→	= to ↓	→	= to ↓	→	→	→
Hand	coarse	smoother	=	coarser	=	coarser	coarser	coarser
MAINTENANCE								
Soil resistance	fair	↑	= to ↓	→	= to ↓	→	→	→
Soil removal	good	→	= to ↑	→	= to ↑	→	→	→
Wrinkle resistance	moderate	→	= to ↑	→	= to ↑	→	→	→
Wrinkle recovery & removal	moderate	→	= to ↑	→	= to ↑	→	→	→
Dimensional stability	fair	↑	= to ↑	→	= to ↑	→	→	→
DURABILITY								
Tear strength	good	→	= to ↑	→	= to ↑	→	→	→
Tensile strength	fair	↑	→	↓	→	↓	→	→
Abrasion resistance	fair	↑	= to ↓	→	= to ↓	→	→	→
COST	low	↑	=	=	=	=	=	=

*The 40 × 40 plain weave is the reference for comparison. ↑—higher, ↓—lower, =—equal.

213

the simple weaves. For now, it is sufficient to note that the plain weave is found in adhesive bandages and gauze pads; shirts, dresses, trousers, and outerwear; carpet backing; furniture upholstery; canvas and burlap bags; sheets and pillowcases. Wherever a reasonably comfortable, strong, plain cloth will do the job, the plain weave can be used. But plain, hardworking fabrics don't fit into the fashion world. We often want performance and artistry that the plain weave can't provide. Here is where the more complex patterns become important.

APPEARANCE The basket and rib variations provide an interesting patterned effect that is not found in the plain weave. By proper choice of colored warp and fill yarns, basket weaves can be used to produce checked patterns that provide a more sprightly appearance. In addition basket weaves have improved performance in some areas of use.

COMFORT AND MAINTENANCE The more open structure of the basket weave increases MOISTURE PERMEABILITY. A higher value of permeability means that water trapped between the fabric and the body can be more readily exchanged with outside air. This helps keep the wearer cool in hot weather. Also, since the yarns are free to move, they can more readily absorb the stresses caused by their crushing and bending. For this reason the basked weave is more WRINKLE-RESISTANT than the plain weave. Furthermore, because the yarns are held less tightly in the basket weave, they have greater mobility. This allows the garment to stretch more as the wearer moves about.

DURABILITY Unfortunately the improved esthetics, superior wrinkle resistance, and increased comfort of basket weaves are achieved at the cost of decreased durability and soil resistance. In the basket weave the warp and fill yarns FLOAT over their fellows to form the pattern. These extended lengths of yarn are subject to snagging, tearing, and other abrasive action. In addition, dirt particles can be trapped beneath the floats. As a general rule, *the longer the floats, the less durable and more difficult to maintain the fabric will be.*

The statements also hold for rib weaves. One of the most popular fabric constructions for shirting is the 2/2 filling rib known as Oxford cloth, in which the fill yarns are made twice the diameter of the warp yarns. Thus, when the fabric is woven, the rib pattern is suppressed and the cloth has the overall appearance of a plain weave. However, because the yarns are not held as tightly as in the plain weave, the cloth is more wrinkle-resistant and more comfortable.

Ribbed fabrics can be produced by placing heavier warp or fill yarns at regular intervals across the cloth. Ribs can enhance the body by stiffening the cloth and giving it the feel of a heavier fabric. But, because the ribs stand out from the surface, they are subject to greater abrasion than the rest of the fabric. A second problem is that as the fabric is used, the stronger yarns rub against the weaker ones, causing flex abrasion.

NAMES OF SIMPLE CLOTHS

These cloths may be made from any natural or man-made fibers or blends. Here they are listed under the fibers traditionally used.

Plain-Weave Cloths

COTTON
 batiste, buckram, bunting, calico, cambric, canvas, casement, chambray, cheesecloth, chintz, crash, cretonne, crinoline, duck, flannelette, gingham, grosgrain, lawn, mull, muslin, nainsook, organdy, osnaburg, percale, poplin, sailcloth, voile

LINEN
 art linen, cambric, crash toweling, dress linen, handkerchief linen, ottoman, sailcloth

WOOL
 batiste, Bedford cord, bengaline, challis, crepe, homespun, ottoman, rep, shoddy, tweed, voile

SILK
 chiffon, China silk, crepe de chine, eponge, organza, pongee, rep, shantung, taffeta, voile

RAYON and ACETATE
 georgette, ninon, seersucker

Rib-Weave Cloths

The most common are *Oxford*, used for shirting, and *dimity*, used for curtains, both traditionally made from cotton.

Basket-Weave Cloths

The most common are *hopsacking* and *monk's cloth*, both traditionally made from cotton.

TWILL WEAVES

The family of TWILL weaves is the most durable of the cloth constructions. Twills are formed by interlacing the ends and picks so that a diagonal pattern is formed. This construction requires a more complex loom, with a minimum of three harnesses. Twills may have the diagonal running from the lower left to the upper right (a *right-hand twill*), or from the lower right to the upper left (a *left-hand twill*). There is no rule that determines which way the

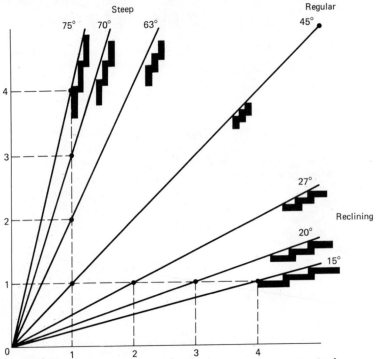

Figure 12.9 The twill angle of a balanced cloth is set by the length of the floats. Changing the yarn count or yarn size can affect the twill angle of the finished cloth.

diagonal should run; the properties of the cloth are the same in either case. However, custom and tradition have ordained that wool fabrics be right-hand and cotton fabrics be left-hand twills.

The angle of the diagonal is determined by the positioning of the floats. Figure 12.9 shows *reclining twills*, in which the filling is held over two or more warp yarns; a *regular twill*, in which adjacent warp yarns go up one fill and successive fill yarns go over one warp; and *steep twills*, in which the warps go up two or more fill yarns. The angle of the twill is normally varied between 15 and 27 degrees for the reclining twills and between 63 and 75 degrees for the steep twills. The regular twill is set at 45 degrees.

The angle of the diagonal is often a good indication of the quality of the cloth. Since warp yarns are usually stronger and more abrasion-resistant than fill yarns, a steep twill can be more durable than a regular or reclining twill. However, the performance of a twill fabric also depends upon the pattern. In order to produce the diagonal pattern, the yarns must float. In *warp-faced twills* there are more warp yarns than fill yarns on the face of the cloth. Adjacent floats start above each other, in contrast to the rib and basket weaves, in which floats begin on the same row. In *filling-faced twills* more fill yarns appear on the surface. Where there are equal numbers of ends and picks on the

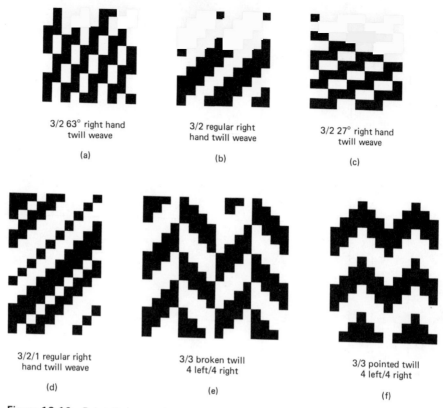

3/2 63° right hand twill weave	3/2 regular right hand twill weave	3/2 27° right hand twill weave
(a)	(b)	(c)

3/2/1 regular right hand twill weave	3/3 broken twill 4 left/4 right	3/3 pointed twill 4 left/4 right
(d)	(e)	(f)

Figure 12.10 Point diagrams of some simple twill patterns.

surface, the fabric is known as an *even twill*. This last group produces reversible fabrics.

It is possible to design twills in any combination of warp and fill floats. As shown in Fig. 12.10, we can have 3/1, 3/2, 3/3, or 3/4 designs, in which the pattern shifts from a warp-faced to an even to a filling-faced motif. Furthermore, the patterns may be reproduced with reclining, regular, or steep diagonals. More complicated designs, such as the 3/2/1 pattern, can also be produced.

Performance of Twill Weaves

The performance of the twill weaves is detailed in Table 12.2.

APPEARANCE The interaction between structure and yarn count is more complex in twill weaves than in plain weaves; various combinations of pattern and angle allow many more designs to be created in twill weaves. Furthermore, differences in the warp and fill yarn counts, as well as differences in the size of the yarns, can cause design variations that would not be apparent in the plain weave.

217

TABLE 12.2 Performance Properties of Twill Weave and Satin Weave Cloths*

| | Plain Weave (Tabby) | | Twill Weaves | | | | Satin Weaves | | | |
| | | | Regular | | Steep | Reclining | Warp Face | | Filling Face | |
	40 × 40	100 × 100	2/1	8/8	5/3	3/5	5/2	9/2	5/2	9/2
APPEARANCE										
Light transmission	moderate	↓	↓	↑	↑	=	=	↑	=	↑
Light reflection	fair	↑	= to ↑	↓	↑	↑	↑	↑	= to ↑	= to ↑
Drape	limp	firmer	firmer	softer	firmer	softer	softer		softer	softer
Pattern	none	none	diagonal line	diagonal line	diagonal line	diagonal line	none		none	none
COMFORT										
Stretch	moderate	↓	= to ↑	= to ↑	↓	↓	↓	↓	↓	↓
Stretch recovery	good	↑	↑	↓	↓	=	↑	↑	↑	↑
Moisture permeability	moderate	↓	= to ↑	= to ↑	↓	= to ↓	↑	↑	↑	↑
Wind resistance	low	↑	= to ↓	= to ↓	↑	= to ↓	= to ↑	↓	= to ↓	↓
Shrink resistance	moderate	↑	↓	↓	↑	= to ↓	= to ↑		= to ↓	
Hand	coarse	smoother	coarser			coarser	smoother		smoother	
MAINTENANCE										
Soil resistance	fair	↑	↑	↑	↑	↑	= to ↑	↑	↑	↑
Soil removal	good	↓	↓	↓	↓	↓	↓	↓	↓	↓
Wrinkle resistance	moderate	↓	= to ↓	↑	= to ↑	= to ↑	↑	↑	↑	↑
Wrinkle recovery and removal	moderate	↑	= to ↑	↑	= to ↑	= to ↑	↑	↑	↑	↑
Dimensional stability	fair	↑	↑	↑	↑	↑	↑	↑	↑	↑
DURABILITY										
Tear strength	good	↓	↑	↑	↑	↑	= to ↓	↓	= to ↓	↓
Tensile strength	fair	↑	↑	= to ↓	↑	↑	= to ↓	↓	= to ↓	↓
Abrasion resistance	fair	↑	↑	↑	↑	↑	↑	↑	↑	↑
COST	low	↑	↑		↑	↑	↑		↑	

*The 40 × 40 plain weave is the reference for comparison. ↑—higher, ↓—lower, =—equal.

COMFORT Twill weaves usually have low permeability because the arrangement of the warp and fill yarns allows for a more compact structure. Thus, the space between yarns is reduced. At the same time, the wind resistance of the cloth is increased. These properties make the twill construction very useful for outerwear such as jackets and raincoats.

MAINTENANCE Another advantage of twill construction is the improved pliability and wrinkle resistance as compared to the plain weave. However, wrinkle resistance cannot be made as great as in the rib or basket weaves without decreasing the durability. The compactness of twill structure makes the soil resistance of warp-faced twills greater than that of the other constructions, while soil removal is equivalent to the plain weave.

DURABILITY We have noted that floats cause a decrease in fabric durability. However, the *warp-faced twills* are more durable than the plain weave, provided that the floats are not too long. For example, a 2/1 or 3/2 regular twill has greater strength and higher abrasion resistance than does a comparable rib or basket weave or plain weave. The 3/2 twill with a steep diagonal is even more durable. This is true for two reasons. First, more of the surface of the cloth is covered by the stronger warp yarns. Second, the yarns are not held as tightly in the twill as in the plain weave (although they are held more tightly than in the basket weave). The slight motion allowed the yarns in the twill weave means that stress is distributed over a greater surface. When the angle of the diagonal is increased, the cloth becomes more compact and the stresses are distributed over more yarns. In addition, the length of the filling floats is reduced in the steep twill as compared to the regular twill. This provides greater resistance to abrasion, which is more likely to destroy the filling yarns.

If the cloth is made as an even twill, more of the fill yarns are exposed on the surface and abrasion resistance is lowered. For filling-faced constructions, this effect is even more pronounced and abrasion is lowered even further. If a reclining twill is used, the abrasion resistance is reduced still more. In the extreme case of a reclining, filling-faced twill with long floats, as for example a 3/5 reclining twill with a 15° angle, the pattern overcomes the advantages of the twill construction and the fabric durability is no better than a plain weave.

The strength of a properly designed twill is higher than that of a plain weave of the same thread count and weight because of the reduced number of INTERSECTIONS in the cloth. The intersections are the spots where the warp and fill yarns are interlaced. When one attempts to tear or pull a fabric apart, the warp and fill yarns dig into each other at the intersections and the yarns are weakened. However, it is at the same points that stresses are transferred from warp to fill or from fill to warp yarns. If the intersections are too widely spaced, the transfer of stress is reduced, with subsequent breaking of the yarns under stress. The plain weave has too many intersections for maximum strength, while the basket weave has too few. The twill weave can be made with the proper number of crossover points to achieve the optimal strength properties.

The most popular variation of the twill weave is the *herringbone* (so named because it resembles the backbone of a herring). It is formed by alternating right- and left-hand twills at regular intervals. Its major advantage is the striking pattern formed on the surface of the cloth.

Herringbone Twills

The herringbone pattern may be produced by either a BROKEN-TWILL or a POINTED-TWILL design. In the broken twill the pattern reverses on a line that falls between two ends. As shown in Fig. 12.11, the right warp diagonal meets the left-hand fill diagonal at this line. In the pointed twill, the pattern is symmetric about one end. The warp diagonal meets its opposite and the fill diagonal meets its opposite. In either case, the pattern may be made to repeat on as wide or as narrow a width as is desired.

The performance properties of the herringbone twills are essentially the same as those of the basic twills, except that in the pointed twill the filling floats are longer. The longer filling floats cause a reduction in soiling resistance and abrasion resistance as well as a slight decrease in tensile strength. For these reasons, one does not often find pointed-twill patterns in the marketplace.

Twills are generally used in heavier fabrics in which strength and durability are the most important requirements. Other uses are in suits, trousers, and slacks; windbreakers and raincoats; and work clothes.

NAMES OF TWILL-WEAVE CLOTHS

These cloths may be made from any of the natural or man-made fibers or blends. Here they are listed under the fibers traditionally used.

COTTON
chino, covert, cretonne, denim, drill, duvetyn, gabardine, grosgrain, jean, khaki, ticking

LINEN
drill, ticking (for tablecloths)

SILK
foulard, serge, surah

WOOL
barathea, broadcloth, cassimere, cheviot, covert, flannel, kersey, melton, serge, sharkskin, tweed, whipcord

RAYON and ACETATE
foulard, gabardine, surah

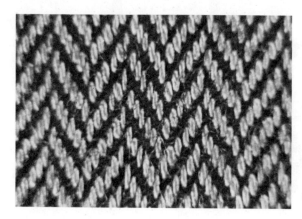

Figure 12.11 Herringbone twill weave.

SATIN WEAVES

The last of the basic weaves are the SATINS. These are formed by the creation of long floats which may cover from four to twelve fill yarns. In a *warp-faced* satin the warp threads are caught under a single pick before floating over the next set of filling yarns. The points at which the fill yarns appear on the surface are widely spaced so that *adjacent picks do not touch each other*. In a *filling-faced* satin, the filling yarns float. The overall effect achieved by this construction is that of a flat, smooth surface with no discernible pattern. Satin weave, particularly the warp-faced, shows off the sleek luster of silk or man-made filament yarns.

Note that the term "satin" refers to a type of weave and not to a fiber. Many people refer to all silk fabrics as satin. Silk may be used in a variety of fabric constructions, and satins may be made from a number of fibers.

In a true satin, the yarns are made from filaments, and the warp yarns float on the surface of the fabric. Before the development of man-made fibers, satins were made from silk only. This meant that they were very expensive. SATEEN was developed to provide people of more modest means with a fabric that imitated the luster, drape, and smooth appearance of satin fabrics. The pattern of sateen is usually the same as filling-faced satin; that is, it is the filling, instead of the warp, which floats. Sateen is made from spun yarns.

The pattern of a satin or sateen fabric is a bit more complicated than the other weaves. To understand how the pattern is derived, refer to Fig. 12.12. Start at the lower left-hand corner with a fill yarn, or pick, on the surface. Continue across a row the required number of warp yarns. For the seven-shaft satin in our example we have a fill followed by six warps, for a total of seven yarns. Starting at the fill, count off the required number of warps to the next fill and *place it one row up*. In the example we have counted over three warps to the next fill and placed it on the second row. Fill in the warp yarns of the second row. Starting from the second fill, count over three warps and place the third fill in the third row. We have now run out of space.

Start the count with the first warp on the third row, and count off the first

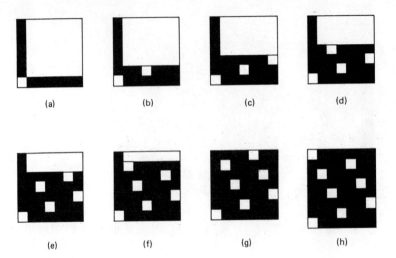

Figure 12.12 The steps in constructing a 7/3 satin weave. The dark squares are warp yarns floating on the surface.

three warps. Place the fourth fill on the fourth row. Fill in the warp yarns. Count three spaces from the fourth fill and place the fifth fill on the fifth row. Fill in the warp yarns. At this point we have only one space to count to the right. Count the one end and, just as you would with a typewritter carriage, move all the way to the left. Count the next two warps from the left, and place the next fill in the sixth row. Continue the procedure to the seventh fill. Note that the eighth fill is a repeat of the first. The pattern may now be duplicated in all directions.

We have derived the point diagram for a *seven-shaft, three-count* satin. It is a "seven-shaft" because it requires seven operations of the harnesses of the loom to form the pattern. It is a "three-count" because the picks are placed at every third warp yarn. A seven-shaft satin may also be woven with a two, four, or five count. These patterns are shown in Fig. 12.13.

The formula for determining how to prepare the point diagram of a regular satin is as follows:

1. Choose the shaft number. We shall choose 7.
2. Determine the pairs of numbers that will add up to the shaft number, $7 = 6 + 1; 5 + 2; 4 + 3$.
3. Eliminate those pairs in which the numbers are divisible by each other, or which have a common factor: $6 \div 1 = 6$.
4. The remaining numbers may be used as counters: 7S,5C; 7S,2C; 7S,4C; 7S,3C.

As is evident from the illustrations, this formula produces a pattern in which the fill yarns are evenly spaced over the surface of the cloth. Another

Figure 12.13 Seven-shaft satin weaves. The 7/3 satin is shown in Figure 12.12.

7/2 7/4 7/5

Figure 12.14 The irregular eight-shaft satin weave suggests a corkscrew effect.

pattern can be produced from even-numbered shafts to produce an IRREGULAR SATIN. If we number the warp yarns consecutively from left to right as 1, 2, 3, 4, etc., we can produce a four-shaft satin in which the picks appear on the surface in the first column of row 1, the third column of row 2, the second column of row 3, and the fourth column of row 4. The pattern is then repeated in all directions. Following this method, we can produce other irregular patterns as follows:

> Six-shaft crosses at 1, 3, 5, 2, 6, 4
> Eight-shaft crosses at 1, 3, 5, 7, 2, 8, 6, 4
> Twelve-shaft crosses at 1, 3, 5, 7, 9, 11, 2, 12, 10, 8, 6, 4

The eight-shaft irregular satin is shown in Fig. 12.14. Note that unlike the regular pattern, this weave has the suggestion of a corkscrew effect on the surface.

Performance of Satins

The performance of the satin weaves is detailed in Table 12.2.

APPEARANCE AND COMFORT The satin weave is the pattern of choice when a lustrous, sleek appearance and full-bodied drape is required. By proper selection of yarn, yarn count, and shaft number, the esthetic qualities of the fabric can be maintained without a great sacrifice in durability and comfort. High yarn count and short floats yield a compact fabric that will feel warm in the winter, while a lower yarn count and long floats increase the air permeability for lighter-weight summer wear. Because the long vertical floats give the cloth a smooth surface, satin fabrics are often employed as linings for coats and jackets; they make it easy to slip a garment on and off. Satins are also found in draperies and furniture upholstery, to which they lend an appearance of formality.

MAINTENANCE Satin weaves do not resist soil as well as plain or twill weaves. The exposed yarns on the surface of the cloth invite the penetration of dirt particles. Since soil is generally ground in by vertical rubbing action against the fabric, sateens and filling-faced satins soil more readily than warp-faced satins.

DURABILITY As we might expect from the discussion of plain and twill weaves, the long surface floats in a satin pattern cause a reduction in durability. However, the compact structure of satin weaves tends to make up for this deficiency. The strength of this weave is not as great as the plain weave or twill, because there are fewer intersections by which stress can be distributed throughout the cloth. However, this problem is overcome because satins are usually made with high thread counts. A more important deficiency is the lowered abrasion resistance caused by the long floats.

In warp-faced satin weaves, abrasion in the lengthwise direction is minimized by the use of filament yarns. Because these yarns are very smooth, friction in the warp direction is reduced. However, rubbing across the warp yarns produces a high level of friction. In addition, the tendency to snag and pull is high. Both of these actions can cause tearing of the fibers and a subsequent fuzzy surface which destroys the appearance of the cloth.

Sateen and filling-faced satins are less durable than warp-faced satins. Because the floats are crosswise rather than lengthwise, the major portion of abrasive action is across the floating yarns rather than with them. This results in a greater degree of yarn breakage and faster destruction of the fabric. Furthermore, the sateens are made from spun instead of filament yarns. These yarns have a lower resistance to tearing. Thus, the combination of crosswise floats and spun yarn makes sateen far less durable than satin weave.

With reasonable care on the part of the user, satin fabrics can be protected from heavy abrasion and soiling so that these deficiencies will be minimized. Under these conditions the comfortable feel and the outstanding esthetics of the fabric far outweigh the disadvantages in maintenance and durability.

NAMES OF SATIN WEAVE CLOTHS

Almost all cloths made in the satin or sateen construction are called *satin* (*antique satin*, *bridal satin*, etc.). Other common satin weave cloths are *charmeuse, cretonne, messaline, peau de soie.*

SUMMARY

The performance properties of the basic weaves are given in Tables 12.1 and 12.2.

The basic weaves are made by interlacing yarns at right angles to each other. The yarns that lie parallel to the long direction of the cloth are called the *warp*. The individual warp yarns are called *ends*. The crosswise set of yarns is called the *fill* or *filling*. The individual fill yarns are called *picks*. The closeness of the weave is determined by the *yarn count*. Cloths with a high yarn

count are denser than those with a low yarn count. A *balanced* yarn count generally yields better performance.

Plain weave (tabby) is the simplest woven cloth. The yarns are interlaced as warp over fill, warp under fill. Plain weaves are satisfactory for almost all end uses. They are found in fabrics ranging from the flimsiest gauze bandages to the heaviest canvases.

Rib weaves are formed by interlacing sets of fill yarns over and under single warp yarns or by interlacing single fill yarns over and under sets of warp yarns, producing vertical or horizontal stripes, respectively.

In *basket weaves* sets of warp yarns are interlaced with sets of fill yarns to provide a pattern based on squares. The comfort properties, wrinkle resistance, and tear strength are greater in the rib and basket weaves than in the plain weave; however, long floats decrease durability and make maintenance more difficult.

A *ribbed cloth* is one in which thicker warp or fill yarns are used to create a raised surface effect. The abrasion resistance of the ribbed fabrics is not as great as those with smooth surfaces, since the raised yarns are subject to increased wear.

The *twill weaves* are recognized by the diagonal surface design, which may be left-handed, right-handed, or herringbone. Twill fabrics are classed according to the interlacings of the warp and fill floats—e.g., 3/2, 2/2, 1/2 as *warp-faced, even,* or *filling-faced,* respectively. The cloth may have a steep, regular, or reclining twill line, depending upon the construction and the yarn count. Twill fabrics are among the most durable constructions and have good wrinkle resistance, launder easily, do not soil readily, and have low permeability and high wind resistance.

Satin weaves require that one set of yarns floats over at least four other yarns before being interlaced. The long floats on the surface of the fabric produce the major esthetic advantages of this weave. However, they also reduce the durability, and increase the maintenance requirements. High thread counts and a compact structure help to minimize the disadvantages of this pattern. Satin weaves produce fabrics with a firm body and flowing drape. They have little surface pattern and set off the luster and the smoothness of the filament yarns from which they are made.

Sateens are satin weaves made of spun yarns. Usually the filling floats over the warp yarns. They imitate the properties of the satins in a cloth that is produced more cheaply, but is less durable and does not have the esthetic properties of the satins.

REVIEW QUESTIONS

1. Show the point diagram of the following cloths:
 a. 3/3 basket weave d. Plain weave
 b. 2/1/4 filling-faced rib e. 2/1/2 basket weave
 c. 2/2 filling-faced rib f. 1/3/1 warp-faced rib

2. Compare the comfort properties of the 2/2 filling-faced rib with those of the plain weave with the same yarn count made from the same yarns and fibers.

3. Compare the durability properties of the 4/4 basket weave with those of the plain weave with the same yarn count made of the same yarns and fibers.

4. Show the point diagram of the 2/1 basket weave and the 2/1 filling-faced rib. Compare the ease of maintenance of the two cloths. Assume the yarn count, yarns, and fibers to be the same.

5. Explain how changing the yarn count of a 2/2 basket weave from 80 × 80 to 40 × 40 will affect its performance. Consider all the selection criteria.

6. Show the point diagram of the 2/2 filling-faced rib weave and sketch the appearance of the cloth (a) for a balanced yarn count, (b) when the number of ends is twice the number of picks, (c) when the number of ends is twice the number of picks, but the fill yarns are twice the size of the warp yarns. Does the point diagram change if the yarn count is changed?

7. Show the point diagrams of the 4/4 basket weave and the plain weave. Compare the comfort properties of the two cloths. Repeat for a basket weave with twice the yarn count of the plain weave. Is the comfort of the basket weave improved by having its yarn count increased? Explain.

8. Compare the ease of maintenance of the 2/2 filling-faced rib weave with that of the plain weave of the same yarn count. What would be the effect on the rib weave of doubling the number of ends? The effect of doubling the number of picks?

9. Show the point diagrams of the following cloths:
 a. 3/2 L.H., reg. twill
 b. 3/3 pointed twill 6L/6R
 c. 3/2 L.H. 63° twill
 d. 3/2 R.H. reg. twill
 e. 5/2 R.H. 70° twill
 f. 3/3 broken twill 6L/6R
 g. 1/2/3 R.H. reg. twill
 h. 4/2 L.H. 20° twill

10. Which of the constructions in Question 9 would be the most durable? Explain.

11. Compare the durability of the 3/2 regular twill weave with that of the plain weave. Explain your answer.

12. Compare the ease of maintenance of the 3/3 broken twill 5L/5R to that of the 3/3 pointed twill 5L/5R. Explain the differences.

13. What would be the effect on the angle of the twill line if the number of ends in a balanced 3/2 R.H. regular twill were doubled? Would this affect the durability properties? Explain.

14. Compare the ease of maintenance of a 4/2 L.H. regular twill to that of a plain weave. Explain the differences. Repeat for a 4/2 L.H. 63° twill.

15. The comfort of a twill weave can be improved by reducing the yarn count. What will be the effect on durability and ease of maintenance? Explain.

16. How many regular eight-shaft satins can be made? Show your calculations. Show the point diagrams of the cloths.

17. Repeat Question 16 for the five-, seven-, nine-, and ten-shaft satins.

18. Compare the performance properties of the 5/2 satin to those of the plain weave made with the same yarn count of the same yarns and fibers. Repeat for the 9/2 satin. How does increasing the length of the floats affect the performance?

19. Compare the durability of the 5/2 satin to the 5/2 sateen made with the same yarn count of the same yarns and fibers. Explain the differences.

ACTIVITIES

1. Visit your local department stores and apparel shops. Make an inventory of the plain, rib, basket, twill, and satin-weave constructions in the following end-use categories:
 a. Junior sportswear
 b. Men's suits
 c. Women's daytime wear

 Can you account for the preponderance of one construction over the others in each of the categories? Explain.

2. Compare the performance properties of a plain weave made of simple spun cotton yarns to that of a 4/4 basket weave made of 50/50 polyester/cotton simple spun yarns. The yarn count of the two cloths is the same. Which would be better suited for use as a summer-weight shirt or blouse? Explain why.

3. Compare the performance properties of a 2/2 regular twill made of simple spun wool yarns to that of a plain weave made of 65/35 polyester/wool simple spun yarns. Which would be better suited for use as winter-weight trousers or slacks? Explain why.

4. Visit your local department stores and dry goods shops. Make an inventory of the fabric constructions and fiber types in the following end-use categories:
 a. Upholstery fabric
 b. Drapes and curtains

 Can you account for the preponderance of one type of construction and/or one fiber over the others? Are there different choices in different price ranges?

5. Choose among the plain, rib, basket, twill, and satin constructions for the following end uses. Explain why you made your choices. (Note that there is more than one correct answer.)
 a. Men's dress shirts
 b. Women's blouses
 c. Raincoats
 d. Windbreakers
 e. Trousers or slacks
 f. Athletic shorts

6. Visit your local department stores and shops. Make an inventory of fabric constructions and fiber types used in men's and women's wear. Does one fabric construction or fiber type dominate? Are there differences between men's and women's wear? Can you account for the differences?

13

knit cloths

The dramatic increase in the popularity of knit fabrics during the 1970s and 1980s provides a vivid example of the interrelationships between lifestyle, technology, and fashion. The contemporary consumer pursues a lifestyle that puts a premium on mobility and the conservation of time. Business men and women may be in Boston on Tuesday, San Diego on Thursday, and Miami on Friday. The clothing they wear while traveling must look fresh and feel comfortable. Their garments must be wrinkle-resistant, maintain their shape, and require a minimum of maintenance. These travelers cannot waste important and expensive time waiting for their clothes to come back from the cleaners.

Leisure wear must also be suited to a lifestyle that demands comfort and neat appearance during strenuous exercise with a minimum of maintenance. Who would prefer ironing a tennis outfit to being out on the courts? The high degree of stretch and comfort that knit cloth brings to close-fitting garments, coupled with excellent wrinkle resistance, makes them eminently suitable to the modern consumer's demands.

Furthermore, modern knitting machines allow the manufacturer to produce cloth at rates much higher than many looms can achieve. A pair of panty hose, for example, can be knitted in only $2\frac{1}{2}$ minutes by a modern knitting machine. In a time of high labor costs, saving time means saving money; and this means lower prices for the consumer. Thus, knit fabrics have performance characteristics that readily satisfy the selection criteria of appearance, comfort, maintenance, and cost.

Terminology

KNITTING is the interlocking of one or more yarns through a series of loops. The lengthwise columns of stitches, corresponding to the warp in woven cloth, are called WALES; the crosswise rows of stitches, corresponding to the filling in woven cloth, are known as COURSES. FILLING KNITS (WEFT KNITS) are those fabrics in which the courses are composed of a single strand of yarn, while WARP KNITS are those in which the wales are composed of single strands of yarn. GAUGE corresponds to the yarn count in a woven fabric, and is defined as the number of needles, or yarns, in $1\frac{1}{2}$ inches of cloth. The higher the gauge, the more compact and finer the cloth.

FILLING (WEFT) KNITS

Filling knits are composed of combinations of four basic stitches: in KNIT the loop is pulled from the back of the fabric toward the front; in PURL the loop is pulled from the front of the fabric toward the back; in TUCK two courses are interlooped with a third; and in MISS a loop is not formed. These stitches are shown in Fig. 13.1. Accompanying the drawings are the symbols that are used in the point diagrams of knit fabrics.

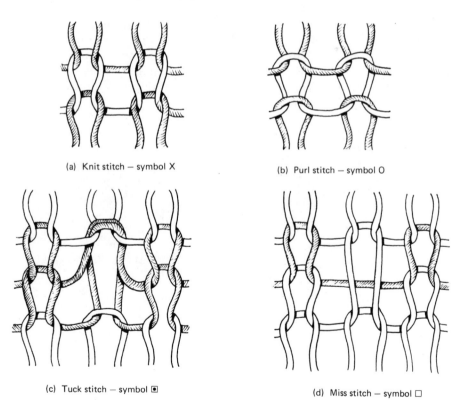

(a) Knit stitch — symbol X

(b) Purl stitch — symbol O

(c) Tuck stitch — symbol ◉

(d) Miss stitch — symbol □

Figure 13.1 The basic filling knit stitches.

SINGLE-KNIT CONSTRUCTION

In this section we will examine the structure and properties of the three basic weft-knit constructions: jersey, rib, and purl. In addition, one type of run-resistant filling knit will be introduced.

Jersey Knits

The simplest of the knit cloths is the jersey or plain knit. In this pattern all the stitches are brought toward the face of the fabric—that is, all the stitches are *knit* stitches. The same fabric is formed if all the stitches are purl stitches. Figure 13.2 shows a jersey knit fabric. The face of this cloth is characterized by lengthwise columns of Vs. The back of the cloth appears as rows of short dashes or half-circles.

The jersey is to knitting what the plain weave is to weaving; it is the basic pattern for knit goods. The reasons for this are that the cloth (1) has relatively good stretch in both lengthwise (walewise) and widthwise (coursewise) directions; (2) recovers most of the stretch so that it is not easily pulled out of shape; and (3) can be sewn without great difficulty. In addition, it is easy to make on relatively inexpensive machinery.

The disadvantages of jersey include a tendency to unravel when snagged or pulled, little run resistance when the yarns are torn or cut, a propensity to shrink when laundered, and a tendency to curl when patterns are cut out.

Jersey knits are used for sweaters, underwear, hosiery, dresses, and sport shirts. They can also be made into pile fabrics for other end uses. (Pile fabrics are discussed in Chapter 14.)

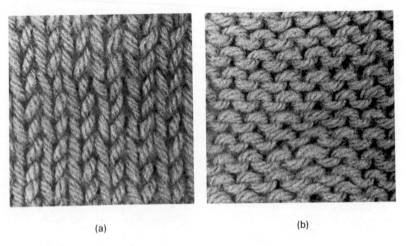

(a) (b)

Figure 13.2 The jersey knit from the front (a) shows columns of Vs; the back (b) has rows of dashes.

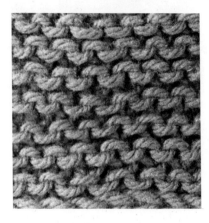

Figure 13.3 Purl knit cloth has the same appearance front and back.

Purl Knits

Purl-knit cloth, which has a rather nondescript appearance, is made by alternating courses of knit and purl stitches. Both its face and back are composed of short dashes or half-circles lying in the direction of the courses. A purl-knit fabric is shown in Fig. 13.3. Note the similarity to the back of a jersey knit.

Purl knits provide fabrics of the same bulk as jersey knits. However, wind resistance can be less than in jerseys of the same weight. Since wind can penetrate the fabric more easily, its use in outerwear is limited. Furthermore, this cloth provides fair stretch recovery in the walewise direction, but can be stretched out of shape in the coursewise direction. This makes it best suited to stoles, scarfs, quilts, and other items that are not subject to crosswise stretching; its utility for many garments is limited because of its poor shape retention.

Rib Knits

Rib knits are made by alternating wales of knit and purl stitches. A 1/1 rib construction is shown in Fig. 13.4. The rib stitch appears as a series of hills and valleys running lengthwise across the surface of the cloth. In the simplest construction the wales alternate as knit-purl. However, more complex combinations may be formed, as in a 2/1 or a 1/2/3 rib. Rib knits with an even repeat, such as 1/1 or 2/2, are reversible.

Rib-knit cloth provides greater bulk than jersey of the same weight. Its opacity, therefore, limits its usefulness in hosiery. However, this pattern provides excellent elasticity in the coursewise direction. For this reason, the rib is used for cuffs and collars to provide a body-fitting closure for neatness and protection against the wind. With the recent acceptance of form-fitting garments, rib knits have become popular in sweaters and sport shirts, especially in lighter-weight cloth.

Rib knits do not curl as jersey knits do, so cutting and sewing is not as difficult. However, because of the ease with which the cloth stretches, care

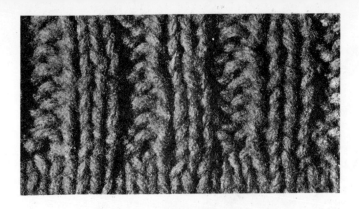

Figure 13.4 Rib knit cloth shows alternating hills and valleys. It has the same appearance front and back. (Isabel B. Wingate, *Textile Fabrics and Their Selection*, 7th ed. © 1976, p. 112. Reprinted by permission of Prentice-Hall, Inc., Englewood Cliffs, N.J.)

must be taken in construction. Since one of the desirable properties of rib-knit garments is the close fit they provide, some shrinkage is tolerable. Because of this, such garments may be laundered. This easy-care feature has helped enhance the popularity of rib-knit fabrics.

Run-Resistant Filling Knits

By alternating knit and miss stitches in alternate courses, it is possible to make a filling-knit fabric that is more run-resistant than jersey or purl-knit fabrics. This construction is shown in Fig. 13.5. Cloth knit from this combination of stitches gives the appearance of jersey, and has similar properties. However, it is more resistant to raveling and running.

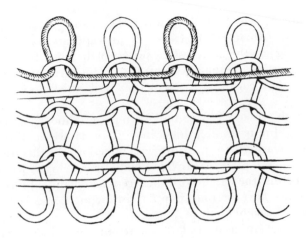

Figure 13.5 The miss stitches in this hosiery construction keep runs in check.

DOUBLE-KNIT CONSTRUCTIONS

As useful as the weft knits are, they lack the dimensional stability, ease of handling, and durability of woven cloth. Many of these drawbacks are overcome through the use of DOUBLE-KNIT techniques. In double knits, two fabrics are interlooped at the same time they are being knitted; this is a great improvement over single-knit cloths. Because machinery used for manufacturing double knits is more costly than that used for producing single knits, and twice the yarn is needed, the fabric is more expensive. However, the performance of the double knits generally makes up for the higher price.

As compared to single-weft knits, double knits have better dimensional stability, greater resistance to running and raveling, higher strength, and a fuller body. They are also easier to cut and sew. However, double knits are less elastic than single knits. The double-knit constructions discussed below are interlock and double jersey.

Interlock Knits

By using a knitting machine equipped with two sets of needles, it is possible to make a fabric that resembles a jersey knit on both front and back. The interlock knit, shown in Fig. 13.6, is produced by alternating knit and purl stitches in both the walewise and coursewise directions. Figure 13.7 shows how the stitches are arranged. Note that each course alternately knits to the front and then to the back of the fabric. The knit cloth is essentially two rib knits knitted together.

Figure 13.6 The interlock knit is similar to the front of the jersey knit (see Fig. 13.2a).

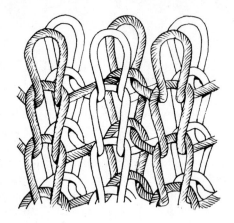

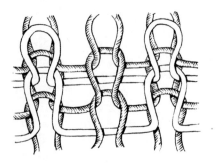

Figure 13.7 Stitch structure of an interlock double knit: two 1/1 rib knits are knitted together.

Figure 13.8 Stitch structure of double jersey knit.

Double Jersey or Rib Double Knit

This fabric has an appearance similar to jersey on one face and to a rib knit on the other. The stitch structure is shown in Fig. 13.8. In this weft knit, one course is composed of alternating knit and purl stitches while the next course is made up of alternating knit and miss stitches. The cloth is held together as the knit stitches of one course interloop with the miss stitches of the next. Note that whereas the interlock is reversible, the double jersey has two different faces.

DOUBLE- AND SINGLE-KNIT FABRICS COMPARED

APPEARANCE The properties of double-knit fabrics may be illustrated by a discussion of the interlock knit. This fabric has the same appearance as the jersey knit, and its esthetic properties are essentially the same; interlock knits, however, are heavier and more full-bodied than jerseys of the same gauge, made from the same yarns, because they are actually two knit cloths combined into one fabric.

COMFORT Interlock knits can provide good resistance to penetration by wind while allowing transfer of moisture from the body to the outside air. The former property helps to maintain warmth and the latter provides a comfortably dry feel. These two important properties are achieved by the placing of stitches so that penetration through one layer of loops is blocked by the other layer. Thus, wind is prevented from directly penetrating the fabric. Moisture transmission, however, is a slower process and the water vapor can follow a zig-zag pattern through the fabric to the outside. In addition, interlock knits do not stretch as readily as single knits. The reduced stretch

provides greater dimensional stability and shape retention, but at the cost of decreased ease of motion.

MAINTENANCE The maintenance properties of double knits are essentially those of jersey knits, except that interlocks do not require as much care in laundering.

DURABILITY As expected, double knits have higher strength than single knits, and better dimensional stability. Abrasion resistance is the same as in single knits. Resistance to running and raveling is greater in double knits. Finally, interlock knits are more easily made into garments, since they cut easily and do not curl as readily as jerseys.

Double jerseys provide much the same properties as interlocks. However, since either side of the fabric may be used as the face, double jerseys provide an extra degree of esthetic freedom and a greater variety of patterns.

Uses

Double-knit fabrics are used for shirts, sleepwear, slacks and pants, and jackets. The menswear market has been greatly affected by the introduction of double knits for men's suits. These fabrics, with their greater wrinkle resistance and higher elasticity, have provided consumers with clothing better suited to a mobile lifestyle. Knit cloth, however, is not readily suited to all aspects of menswear. It is difficult to maintain a proper crease and a tailored look with knit fabrics. In addition, woven cloth is more easily hand-sewn than knit cloth. These two factors have retarded the acceptance of knits in higher-priced men's suits, in which a great amount of hand-sewing and the requirements of an impeccably tailored appearance still give woven cloth the edge.

THE EFFECT OF GAUGE

The properties of a knit fabric are affected by the kind and number of yarns used in its preparation. The durability, esthetics, and comfort of a garment are determined by the knitting gauge and the size of the yarns used. For example, a cloth knit of heavy yarns on a 6 gauge traps a lot of air within the fabric; this makes it warm. The bulk of the yarns provides an opaque fabric. The loose construction of the cloth assures that it will stretch well. These characteristics make the cloth suitable for use in a bulky sweater that will be warm, cover the body well, and provide freedom of movement. However, the sweater will not have good abrasion properties, will be pulled out of shape easily, and will require careful handling in cleaning.

Stockings made from heavy yarn on a 6 gauge, however, though they would be warm, would not satisfy the consumer's esthetic requirements. Hosiery is intended to flatter the wearer. For this end use, a much higher

gauge, say 60, with finer yarns, would be used. This combination provides a sheer fabric with a lustrous appearance and a smooth hand. It will also be more elastic and hug the leg. Unfortunately, the fine yarns do not withstand stress or abrasion as well as heavy yarns, so although the fabric is more compact, its strength and abrasion resistance are low.

Between these extremes might lie a fabric to be used in underwear. It would be made of a medium gauge, say 30, from medium-size yarns. This cloth would not have the warmth of the sweater, but would be warmer than the hosiery. It would have high abrasion resistance and tear strength because of its compact construction. Freedom of motion would be retained because of the nature of the pattern. The combination of compact structure and medium-size yarns would make the durability better than in either of the other cloths. Laundering of the garment could be accomplished with less care.

For these examples we can see that proper choice of gauge and yarn size in knit cloth can satisfy a wide range of end-use requirements. *In general, higher gauge means more compact cloth; thicker yarns yield a bulkier cloth.*

WARP KNITS

In warp knitting, many yarns running in the walewise direction are looped to form a material in which the courses are interlocked in a zig-zag pattern instead of straight across as in weft knits. A comparison of the warp knit shown in Fig. 13.9 with the simple filling knit shown in Fig. 13.2 makes the difference readily apparent. Warp-knit fabrics are tighter, have less stretch, and are not as bulky as weft knits. Furthermore, warp knitting can produce decorative effects that are beyond the capabilities of filling-knit methods.

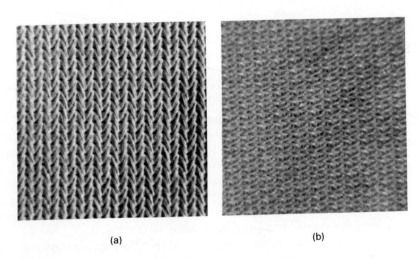

(a) (b)

Figure 13.9 The tricot knit has vertical columns on its face (a) and horizontal rows on its back (b).

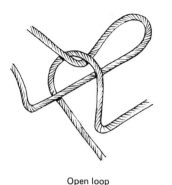

Open loop Closed loop **Figure 13.10** Warp knit stitches.

Warp-knit fabrics have better dimensional stability, greater resistance to snagging, raveling, running, and abrasion, as well as higher strength than weft knits. Warp knits are also prized for their soft hand, smoothness, sheerness, and good draping qualities. The warp-knit cloths of major importance are TRICOT and RASCHEL.

TRICOT KNITS

Just as filling-knit patterns can be produced from four basic stitches, all tricot cloth can be produced by three basic motions of the knitting needles. The yarn may be formed into (1) a *closed loop*, (2) an *open loop*, or (3) *no loop* is formed. Figure 13.10 shows the formation of open and closed loops.

In the simplest tricot constructions, a single layer of cloth characterized by walewise ribs on the face and coursewise ribs on the back is produced. A photograph of a single-warp-knit tricot cloth is shown in Fig. 13.9. The loop pattern is illustrated in Fig. 13.11. Single-warp tricot cloth has good permeability to air and moisture, acceptable elasticity, a soft hand, and good drape. Its dimensional stability and run resistance are also better than those of most weft knits.

Tricot knitting lends itself readily to light, sheer constructions. For this reason the cloth is usually made of fine-filament yarns. The spacing of the yarns may be measured by the gauge, as in weft knitting, but is more often measured by the NEEDLE COUNT or CUT. These terms are defined as *the number of needles, or stitches, in one inch*. The standard tricot machine operates with a cut of 28, the equivalent of 42 gauge.

Properties of Tricot Knits

APPEARANCE Tricot-knit fabrics have a very fine walewise stripe in the face and a coursewise stripe on the back. Except under close inspection the pattern is not readily seen, so either the technical face or back of the fabric may

237

Figure 13.11 The construction of a tricot knit.

be used as the face when the material is being made up into garments. This ability to use either side of the cloth is useful to the manufacturer because it gives some flexibility in printing or other finishing processes such as napping. The drape of tricot-knit fabrics is usually very soft.

COMFORT Single-warp tricot cloth has good permeability to air and moisture. Wind resistance, as with filling knits, is dependent upon the gauge or cut. The hand is usually soft and smooth, although the fabric may be napped to give a fuzzy texture well suited to sleepwear. Stretch, although less than that of filling knits, is greater than that of wovens. Elasticity is good.

MAINTENANCE Tricot knits, because they are usually made from filament yarns, tend to have good soil and stain resistance. Their structure, with the yarns running in the walewise direction, also improves the soil resistance and ease of soil removal. Wrinkle resistance is excellent, as would be expected from a knit fabric. Dimensional stability is better than that of most weft knits, so that tricot knits may be machine-laundered.

DURABILITY Run resistance, resistance to snagging, and burst strength of tricot knits is greater than that of weft knits. This is because, as inspection of the fabric construction illustrated in Fig. 13.11 shows, the loops

are better able to maintain their structure under stress than are the loops in a weft knit. Thus, the tricot knit is more abrasion-resistant.

Because more handling of the material is involved, and because knitting looms for tricot operate more slowly than a circular weft-knit machine, tricot fabrics are usually more expensive than weft-knit fabrics.

DOUBLE TRICOT

Fabric properties and patterning capability are improved by the use of more complex techniques. It is possible to produce double and even triple layers of cloth interknitted to form a single fabric. Double-warp tricot fabrics provide a higher degree of dimensional stability, greatly improved run resistance, more opportunity for imaginative pattern design, and increased bulk. The bulkier fabric has increased resistance to penetration by wind. In addition, the fabric is more opaque.

Tricot knits are put to good use in lingerie and intimate apparel, loungewear and nightwear, blouses, and shirts. Double-warp tricot is useful for outerwear, such as men's suits, and bonded or laminated fabrics.

In menswear, double-tricot fabrics compare favorably with weft double knits; they are easier to sew, provide a better hand, and reduce the garment weight without reduction in body. Furthermore, by using tricot fabrics, manufacturers can produce small lots more economically than with other fabrics. This allows them to provide goods at lower cost to the consumer.

RASCHEL KNITS

Raschel knitting can be used to produce a much wider range of products than can weft or tricot knitting. However, this technique is somewhat more complicated than tricot knitting. Raschels are produced by having one or more sets of needles make columns of loops in the walewise direction, while other sets of needles connect the columns by inserting yarns in the coursewise direction. Figure 13.12 illustrates a typical raschel construction.

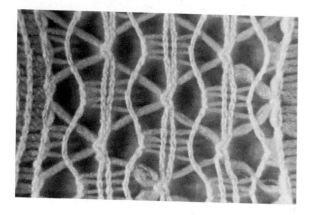

Figure 13.12 A typical raschel knit cloth.

Raschel-knit fabrics can be found in both apparel and nonapparel uses. They may be as fine as the lightest veils and laces, as dramatic as multicolored patterned hosiery, or as soft and sensuous as imitation fur jackets. Around the home, raschel knits are finding increasing acceptance in crochetlike curtains and draperies, as well as in upholstery and slipcovers. Industrial materials, such as fish nets, are also produced on raschel machines. The variety of patterns and design effects is almost endless.

The properties of raschel-knit goods are not as easily described as those of tricot knits. Because of the wide range of constructions possible, raschels may be light and airy with low strength and abrasion resistance, or heavy and strong with a thick, warm pile. The former might be a bridal veil, while the latter might be used as cold-weather outerwear. Each raschel construction must be considered on its own. However, the principles described in earlier sections on weft and warp knitting and woven materials should provide adequate guidance to the consumer.

KNITS AND FASHION

The knitting operation is more flexible than weaving in that it can produce not only fabrics but also garments. When stitches are missed in a programmed manner, the shape of the cloth can be altered. By this method a pair of pantyhose, a stocking, or the parts of a sweater may be knit directly without laborious cutting and sewing. The manufacturer is able to adjust the pattern of the garments directly on the knitting machine to respond to fashion change rapidly and with minimum cost.

Another advantage of knitting is that patterns in the form of surface texture or color can be introduced into the cloth as it is being made. The knit and miss stitches provide the means for hiding a yarn in the back of the cloth. Proper choice of colored yarns makes colored patterns possible on the surface of the cloth. Such patterns can be formed directly, making the cost to the consumer less than if the fabric were woven and the pattern subsequently added.

FABRIC COMPONENTS AND PERFORMANCE

Throughout our discussion of the properties and performance of the three fabric components—fiber, yarn, and cloth construction—we have assessed performance in terms of the five selection criteria of importance to consumers: appearance, comfort, maintenance, durability, and cost. By now it is obvious that changing any of the fabric components can make a marked change in performance.

The use of different fibers will affect all the selection criteria, although to different extents. The bright, shiny appearance of some nylons contrasts sharply with the relatively dull surface of wool. The comfort of cotton is

TABLE 13.1 Performance Properties of Knit Cloths*

	Jersey		Rib		Purl	Interlock	Tricot	Double Tricot
	6-gauge	20-gauge	1/1	20/5				
APPEARANCE								
Light transmission	high	↓	= to ↓	=	=	↓	↑	↑
Light reflection	low	↑	= to ↑	=	=	↑	↑	↑
Drape	firm	firmer	firmer	=	softer	firmer	softer	softer
Pattern	Vertical stripes on face; dashes on back	Fainter stripes on face	Vertical ribs		Faint vertical & horizontal stripes, same on both sides	Vertical stripes, same on both sides	Faint vertical stripes on face, horizontal stripes on back	softer
COMFORT								
Stretch	good	=	↑	= to ↓	↑	↓	↓	↓
Stretch recovery	good	↑	= to ↑	=	↓	↑	↑	↑
Permeability	high	↓	↓	=	= to ↑	↓	=	↓ to =
Wind resistance	low	↑	↑	=	= to ↓	↑	=	↑ to =
Shrink resistance	poor	↑	= to ↑	=	↓	↑	↑	↑
Hand	coarse	smoother	coarser	coarser	=	=	smoother	smoother
MAINTENANCE								
Soil resistance	low	↑	↓	= to ↓	↓	=	↑	↑
Soil removal	high	=	↑ to =	= to ↑	= to ↑	=	= to ↑	= to ↑
Wrinkle resistance	high	=	↓ to =	= to ↑	=	=	=	=
Wrinkle recovery & removal	high	=	↑ to =	=	=	=	=	=
Dimensional stability	low	↑	↑ to =	= to ↑	↓	↑	↑	↑
DURABILITY								
Burst strength	fair	↑	↑	=	↑	↑	↑	↑
Abrasion resistance	low	↑	↑	↑	↑	=	↑	↑
Snagging resistance	low	↑	=	=	=	=	↑	↑
Run resistance	low	↑	↑	= to ↓	=	↑	↑	↑
COST	low	=	= to =	=	=	↑	↑ to =	↑

*The 6-gauge jersey-knit cloth is the reference for comparison. ↑—higher, ↓—lower, =—equal.

241

superior to that of polyester, while the maintenance requirements of polyester make it more desirable in many end uses. In both durability and cost, the fibers extend across the spectrum from the relatively fragile yet expensive silk to the tough and relatively inexpensive nylon.

Changing the yarn type can effect dramatic changes in cloth properties. Fine, plied yarns with a high level of twist may yield durable, soil-resistant cloths that are excellent for work clothes but lack the esthetic and comfort properties that other types of garments may require. Lowering the degree of twist of simple yarns may give a cloth with a more pleasant hand and drape, and superior comfort. Filament yarns can, depending upon fiber type and whether or not they are textured, affect the appearance, comfort properties, maintenance requirements, and durability of cloth. Finally, novelty yarns, with their many variations of texture and color, may totally alter the appearance and performance of a cloth even though its construction and fiber remain the same.

Fabric construction is a very important factor, affecting not only how a fabric performs but also how it is rated by the consumer. The notable difference in stretch between woven and knit goods illustrates how fabric construction can affect comfort. Open constructions, which offer little resistance to soil penetration, may require more maintenance than tight constructions, which shed dirt. The compact structure of twill weaves makes them score high in durability; the sheen and soft drape of the satins gives them superior esthetics; and the wrinkle resistance of double knits makes them excellent fabrics for men's and women's daytime wear.

We must always keep in mind that superior performance in one area may be achieved at the cost of decreased performance in another area. We cannot expect a single fabric to give us everything, so we must be prepared to make decisions in which we trade off between selection criteria. Superior durability may be accompanied by reduced comfort, or we may trade ease of maintenance for superior appearance.

The following example illustrates how changes in two of the fabric components, cloth construction and yarn type, can affect fabric performance.

INTERACTION BETWEEN CLOTH CONSTRUCTION AND YARN TYPE

Up to this point, the effects of weave or knit structure on the performance properties of cloths have been considered separately from those of the yarns. To illustrate how yarn and construction can combine to change the properties of a fabric, we will compare the following four cloths suitable for blouses, shirts, or T-shirts:

> Cloth A: 90 g/m² (2.7 oz/yd²) plain weave of untextured rayon filament
> Cloth B: 135 g/m² (4 oz/yd²) plain weave of spun rayon yarn
> Cloth C: 125 g/m² (3.7 oz/yd²) jersey knit of untextured rayon filament
> Cloth D: 120 g/m² (3.5 oz/yd²) jersey knit of textured rayon filament

The comparative performance of the four cloths is shown in Table 13.2.

TABLE 13.2 Interaction between Cloth Construction and Yarn Type

	PLAIN WEAVE		JERSEY KNIT	
	CLOTH A (untextured filament)	CLOTH B (spun yarn)	CLOTH C (untextured filament)	CLOTH D (textured filament)
APPEARANCE	Fair Flat, smooth, shiny surface, little eye appeal	Fair + Flat, grainy surface reduced shine	Fair + Flat, shiny surface, faint vertical rib pattern	Good Grainy surface Reduced shine highlighted by pinpoints of light Suggestion of surface depth
COMFORT	Fair Poor body Limp drape Low moisture permeability and wicking Slick hand Tendency to cling and feel clammy in warm weather Feels cold in cool weather Low stretch	Good + Fuller body Firmer drape Improved moisture permeability and wicking Pleasant hand Reduced clinging Less clammy in warm weather Warmer in cool weather Improved stretch and elasticity	Fair + Poor body Very limp drape Low moisture permeability and wicking Slick hand Tendency to cling and feel clammy in warm weather Feels cold in cool weather Good stretch and elasticity	Good Full-bodied Firm drape Improved moisture permeability and wicking Improved hand Reduced clinging Less clammy in warm weather Warmer in cool weather Best stretch and elasticity
MAINTENANCE	Good Good soil resistance; easily laundered; may require ironing	Good Slightly increased tendency to soil; easily laundered; may require ironing	Good Reduced soiling resistance; easily laundered; no ironing	Good Most readily soiled; may require frequent laundering; easily laundered; no ironing
DURABILITY	Good + High strength Very good abrasion resistance Excellent dimensional stability	Good Good strength Good abrasion resistance Good dimensional stability; some shrinkage upon laundering	Good − Good strength Good abrasion resistance, but tends to snag, causing runs and raveling Fair dimensional stability	Fair Good strength Fair + abrasion resistance, tends to snag, causing runs and raveling; may pill as filaments are torn Good dimensional stability due to resiliency of yarns
COST	Low	Low	Low	Low

APPEARANCE The appearance is affected by both the yarn and fabric construction. The spun yarn and the textured filament yarn give a less shiny surface than the untextured filament yarn, while the knit construction yields more depth to the surface than the woven cloth can achieve. In addition, the spun and textured yarns provide a firmer body and drape. Thus, the knit cloth made from textured yarn (cloth D) has the most pleasing combination of light reflection, drape, and surface texture.

COMFORT Comfort is greatest when the cloths have some stretch, good elasticity, a high level of moisture permeability, good wicking properties, and an ability to trap air for insulation. The spun and textured yarns yield cloths with good comfort characteristics independent of the cloth construction. The knit constructions provide greater stretch than the wovens and good elasticity. Thus, cloths B and D will be the most comfortable, with cloth D, the jersey knit, being best for close-fitting garments.

MAINTENANCE The maintenance levels of the four cloths are about equal, but for different reasons. The filament yarns and the woven constructions yield the best soil resistance, but may require ironing. The knit constructions and the spun and textured filament yarns have the greatest wrinkle resistance, but require laundering more often.

DURABILITY The woven cloths have higher abrasion resistance than the knit cloths. The filament yarns are also superior to the spun and textured filament yarns in this regard. In addition, the knit constructions are subject to snagging, raveling, and running, and the dimensional stability of the woven cloths is greater than that of the knit cloths. For these reasons the durability of cloth A > cloth B > cloth C > cloth D.

This example has been used to illustrate how a knowledge of the performance properties of the components of fabric—fibers, yarns, and cloth construction—can be used in assessing the performance of different cloths, as well as to show how changes in the components can affect fabric performance. Keep in mind that different fibers will modify the results of this example. For instance, if cloth D were made of nylon rather than rayon yarn, its durability would be raised to the point where it would be the most durable cloth. On the other hand, its comfort properties would be inferior to those of the other cloths.

SUMMARY

The performance properties of knit cloths are summarized in Table 13.1. Knit fabrics compare quite favorably with woven cloths, and in some respects provide much better performance. Knit cloth *stretches* more than woven cloth to provide greater freedom of motion, particularly in close-fitting garments. Moisture *permeability* is higher in knits than in woven cloth of the

same weight, increasing comfort. Knit goods are very *wrinkle-resistant*, making them suited to carefree travel.

Filling-knit cloth is made by interlooping yarns by any one or a combination of the knit, purl, miss, or tuck stitches. The basic fabrics produced by these processes are the jersey, purl, and rib. Run-resistant, patterned, and double-knit cloths are more complex variations of the basic constructions. The *warp-knit* constructions most popular in the United States are *tricot* and *raschel*. Tricot knits are best suited to light, sheer fabrics. Double-warp tricot is a heavier, more opaque fabric. Raschel knits may be produced in many patterns and find a wide variety of uses in apparel, home furnishings, and industrial products.

Single-filling knits are susceptible to snagging and running, have lower dimensional stability and abrasion resistance than woven cloth, and, depending upon the fiber from which they are made, may require more care in cleaning. Double-knit fabrics are superior to the single-filling knits in the areas of dimensional stability, strength, and body. Warp-knit cloth may also be superior to single-filling knits in these properties.

REVIEW QUESTIONS

1. How do weft knits differ from warp knits?
2. What are the advantages of raschel knitting over tricot knitting?
3. Show the point diagrams of the jersey knit and of the 2/2 rib knit. Compare the durability of the two cloths. Explain the differences.
4. What are the major disadvantages of using purl-knit cloths in apparel? In home furnishings?
5. Why are weft-knit cloths not used for curtains and drapes? Consider all the performance factors.
6. Compare the comfort properties of the interlock knit to those of the jersey knit. Which would be better suited for use as a T-shirt? Explain.
7. Compare the performance properties of a tricot-knit cloth to those of a 2/2 rib-knit cloth made of the same yarns and fibers with the same gauge. Which would be better suited for use in intimate apparel? Which would be better for tops? Explain.

ACTIVITIES

1. How would the performance of a jersey-knit cloth made from textured acrylic yarns differ from that of an interlock knit made from textured polyester bouclé yarns? Which would you choose for a sweater suitable for school or office wear? Why?
2. Because knit fabrics stretch more than woven fabrics, they may be made into garments that fit more closely to the body. Discuss the differences in attitudes between societies that accept and societies that reject widespread use of knit apparel.
3. Compare the performance of a 100 percent nylon tricot knit and a 100 percent cotton plain weave of the same weight for use in men's shirts. Which would you prefer? Why?

4. Repeat Activity 3 for women's blouses.

5. Visit your local department stores and dry goods shops. Make an inventory of knit fabric constructions and fiber types in the following end-use categories:

 a. Upholstery fabric

 b. Drapes and curtains

 Can you account for the preponderance of one type of construction and/or one fiber over the others? Are there different choices in different price ranges?

14

pile, nonwoven, and specialty fabrics

PILE FABRICS

The fabric constructions discussed in the preceding chapter were all flat; the cloths were no more than two or three yarns thick. Surface texture was achieved by allowing some yarns to lie upon others and stand out from the surface. Pile fabrics are noticeably thicker. These constructions require a ground cloth which provides a base for an assembly of fibers to stand upon. Extra warp or fill yarns may be incorporated during weaving, or an extra yarn may be interlooped in knitting. The pile may also be stitched through an existing cloth by the tufting process. Finally, fibers can be cemented to the surface of a cloth by flocking. This section examines the properties of pile fabrics made by weaving, knitting, tufting, and flocking.

VELVET AND VELVETEEN

Velvet is a fabric woven from *filament* yarns, in which the pile is formed by the addition of extra *warp* yarns. Velveteen is a fabric, usually woven from *spun* yarns, in which the pile if formed by the addition of extra *fill* yarns. The ground cloth for either fabric may be woven with a plain or twill pattern. The pile may be produced with a V or W interlacing. Figure 14.1 illustrates the pile constructions. A W-interlaced velvet on a 2/2 twill ground cloth is shown in

247

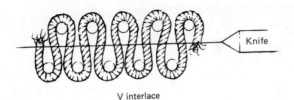

V interlace

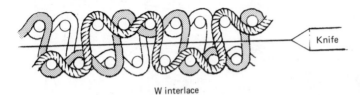

W interlace

Figure 14.1 In the double cloth method, two pile fabrics are woven together and then slit by a knife.

Fig. 14.2. After the loops have all been cut and properly brushed, the pile covers the entire surface.

Velvet and velveteen constructions provide a warm, soft hand; an interesting, shaded surface appearance; and a firm, full-bodied drape.

APPEARANCE The light and dark shading of the surface, typical of velvet and velveteen fabrics, is produced by the differences in light reflected from the ends and sides of the fibers. The light that strikes the ends of the fibers is scattered and absorbed, while the light that strikes the sides of the fibers is reflected to the viewer's eye. Thus, areas in which the pile is standing up appear darker than those in which the pile is lying down. Finally, the extra yarns used to produce the pile add weight, stiffen the fabric, and give a fuller body and more pleasing drape characteristics.

COMFORT The pleasant hand is due to the fact that in these fabrics it is the ends of the fibers, rather than their sides, that touch the skin. The fiber ends produce a mild, pleasurable, prickling sensation. In addition, the

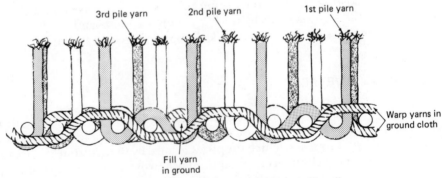

Figure 14.2 W-interlaced velvet on a 2/2 twill ground cloth. The pile follows the diagonal of the interlacing in the ground cloth so that the entire surface is covered.

multitude of fibers that form the pile trap a large amount of air, which acts as an insulator to give the cloth its warmth.

MAINTENANCE The good performance in appearance and comfort are achieved at the expense of other performance properties. Velvet and velveteen are more likely to stain than are flat cloths made from the same fibers because the pile yarns have a very large exposed surface area. When a foreign material is spilled on the fabric, it comes in contact with a great many fibers which rapidly *ad* sorb the spill. (*Adsorption* is the coating of a surface by a foreign material.) The adsorbed matter may then be *ab* sorbed by the fibers to cause a stain. (*Absorption* is the penetration of a surface by a foreign material.) A flat cloth does not adsorb foreign matter as readily as a pile fabric, so absorption and staining are less likely to occur.

In addition to the staining problem, velvets and velveteens also require more care in cleaning. Dry-cleaning is preferred to laundering because rough handling in the laundering process may remove the pile yarns. Furthermore, these materials must be ironed carefully since too much pressure or too high a temperature may crush the pile and produce a permanent shine on the surface. It is necessary to brush velvets and velveteens regularly to preserve their appearance and performance properties.

DURABILITY The durability of velvet and velveteen fabrics is dependent upon the fibers from which they are made, the construction of the ground cloth, and the interlacing of the pile. Naturally, the most durable fibers will produce the most durable pile. Filament yarns, such as silk or man-made fibers, provide greater durability than do spun yarns made from staple fibers. This is because every fiber in a filament yarn is held by the yarns of the ground cloth, while some of the spun-yarn fibers are not bound by the ground cloth and can be pulled out easily. A compact, tightly woven ground cloth holds the pile more firmly, and is itself more durable than a loosely woven ground cloth. Generally, other factors being equal, a twill construction is more durable than a plain weave. Finally, the W interlacing, because it holds the pile yarns under three fill yarns instead of only one, yields a more durable material. A W-interlaced velvet based on a tightly woven twill ground cloth will be far more durable than a V-interlaced velveteen based on a loose plain weave.

For a given fiber, a pile construction can be far more durable than a flat construction. Since the strength of the fabric is that of the ground cloth, a velvet based on a plain weave will be just as strong as the plain-weave cloth. In the pile fabric, abrasion occurs almost entirely on the tips of the fibers. In order to remove the pile, the fibers must be worn away. In the flat cloth, abrasion takes place on the sides of the fibers and yarns, where they are most susceptible to being broken and torn. Thus, the abrasion resistance of the pile fabric may be greater than that of the flat cloth, while the strengths are equivalent.

Velveteen is an imitation velvet. Its major advantage is that it costs less to

produce. In weaving, it is easier to insert extra fill yarns than it is to provide extra warp yarns. Also, spun yarns are usually less expensive than filament yarns. Finally, the loops in a velveteen can be cut with less effort than can the loops in a velvet. However, velveteen has neither the durability nor the esthetic appeal of velvet.

Uses

Velvet and velveteen fabrics provide a warm, luxurious material for such end uses as full-length gowns and jackets for formal attire. They are also popular for home furnishings, particularly in drapery and upholstery fabric, where their sensuous feel and appearance provide an atmosphere of warmth in formal arrangements. In addition, because of their durability, velvets are recommended for higher-quality applications.

CORDUROY

The pile in corduroy is produced by the addition of extra fill yarns which float over one or more warp yarns. This fabric differs from velveteen in that the pile tufts are aligned so as to give a warpwise stripe on the surface. Corduroy may be produced with a V or W interlacing. The ground cloth may be of a twill or plain construction. A W-interlaced corduroy is shown in Fig. 14.3. The raised portions of the pile are called WALES; the spacing between them may be changed by varying the length of the floats when the pile yarns are inserted. Pinwale corduroy may have as many as 23 wales per inch, wide-wale corduroy as few as 5. No-wale corduroy is a pinwale construction in which the pile has been sheared very short and pressed down. This process hides the wales and yields a fuzzy fabric without noticeable stripes.

Corduroy is expected to be a hardier fabric than velvet or velveteen. It is usually made with heavier yarns and coarser fibers. This combination yields a fabric that has a stiffer drape and rougher hand than velveteen. The factors that affect its performance are similar to those that determine the properties of velvet and velveteen. Corduroy, however, is easily laundered and may be ironed.

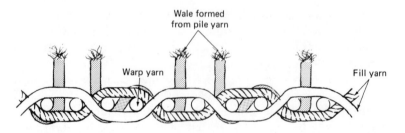

Figure 14.3 W-interlaced corduroy on a 2/2 filling face rib ground cloth. The tufts of the pile yarn form the wales of the cloth.

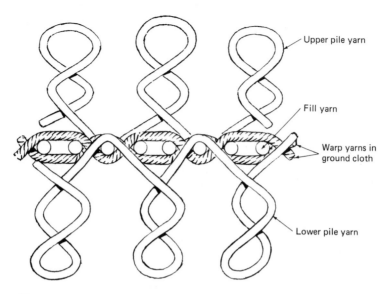

Figure 14.4 A terrycloth on a 2/1 warp face rib ground cloth.
The highly twisted pile yarns kink to form the characteristic terry pile.

Labels in figure:
- Upper pile yarn
- Fill yarn
- Warp yarns in ground cloth
- Lower pile yarn

TERRYCLOTH

Terrycloth, shown in Fig. 14.4, is manufactured with extra highly twisted warp yarns that are held slack during part of the weaving process. When the tension on the cloth is released, the slack yarns form loops on the upper and lower surfaces. The pile is not cut. Terrycloth is used for toweling and beachwear; its relatively rough pile stimulates the skin while removing moisture. In addition, the pile traps air and maintains body temperature. Since its purpose is to keep the body dry, terrycloth is made of fibers, such as cotton, that absorb moisture readily.

The durability of terrycloth is dependent upon the yarn count of the ground cloth, the strength of the pile yarns, and the density of the pile. A thick, closely spaced pile woven into a tightly constructed ground cloth gives the longest wear. In addition, it absorbs more moisture and provides more warmth than a more loosely constructed cloth. Terrycloth is more susceptible to snagging and pulling than are the velvets and corduroys because the loops of the pile remain uncut.

Velour

Velour, a variation of terrycloth, has achieved some popularity in toweling and apparel. Shearing the ends of the loops in a terrycloth pile fabric allows the yarns to untwist and yields a surface similar to that of a velvet, although usually less dense and with a longer pile. Velours are characterized by a soft, springy texture, and are similar to velvets in their performance properties. Velours may also be made by shearing a knitted pile fabric, in

251

which case the performance would be similiar to a knit pile fabric. Velour is often combined with terrycloth in toweling and sportwear to provide a cloth that shares the good properties of both fabrics.

KNIT PILE FABRICS

When an extra yarn is brought along as the loops are being formed on weft knitting machines, knit pile fabrics are produced. The extra yarn is pulled out of the base cloth by a hook which forms it into a loop perpendicular to the ground cloth. Weft-knit pile fabrics usually have a long pile similar to fleece or fur.

Warp-knit pile fabrics are produced by a process known as *weft insertion*. In this process, an extra weft yarn is inserted as the base cloth is knit. The extra yarn is held by the knit loops much as extra filling yarns are held in a woven fabric. Warp knitting may be used to produce pile fabrics in which the pile height can be varied from very short to very long. In addition, unlike weft pile fabrics, the pile may be patterned. Thus, corduroy, terrycloth, or furlike fabrics can be produced on a single knitting machine.

Knit pile fabrics have greater stretch than do woven pile fabrics. This makes them more comfortable when used in outerwear and gives a better fit with fewer construction problems in upholstery. Furthermore, it is claimed that these fabrics provide better coverage than woven fabrics while still maintaining durability and comfort. Perhaps the greatest advantage of knit pile fabrics over woven pile fabrics is the reduced manufacturing cost.

TUFTED FABRICS

Tufting is a process used to produce pile fabrics by the insertion of yarns into a finished cloth much as is done in sewing. A number of needles are used to stitch the pile yarn into the ground cloth in parallel rows. Production speeds may be as high as 100 stitches per minute. A tufted fabric is shown in Fig. 14.5. The pile may be left uncut or it may be cut during the tufting operation. Patterns may be formed by producing high- and low-level loops on the surface. In addition, a textured surface of loops and tufts may be produced by shearing.

In tufting, the pile yarns are not held as tightly as in the other pile-forming processes. This means that in goods subject to moderate or heavy wear, the pile yarns must be bonded to the ground cloth by application of an adhesive to the back of the fabric. Bonding sometimes produces a rather stiff fabric that may not be suitable for apparel.

The spacing between the needles is called the *gauge*. It is the reciprocal of the number of needles per inch. Thus, a 1/8 gauge has eight needles per inch. The spacing between stitches is determined by the number of stitches per inch (SPI). The tuft density of the pile is determined by dividing the SPI by the

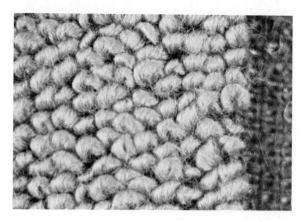

Figure 14.5 A tufted carpet fabric showing the open weave of the ground cloth.

gauge; this yields the number of tufts per square inch. Thus a fabric tufted on a 1/10 gauge with 8 SPI has 80 tufts per square inch. The performance of a tufted fabric is heavily dependent upon the tuft density.

Fine-gauge tufting, with a gauge of about 5/64 to 1/25, is used to produce fabrics suitable for outerwear or upholstery. These fabrics have a dense, durable surface that is easily patterned by means of colored yarns or by printing techniques. Coarser-gauge fabrics are used in bedspreads and blankets. Because of its high speed and pattern flexibility, tufting is now the major method for producing carpeting in the United States. Typical carpet fabric is produced on a 3/16 gauge with 7 SPI.

FLOCKED FABRICS

Pile fabrics may be produced by cementing very short fibers to the surface of a finished cloth so that they stand upright. This procedure is called *flocking*. Flocked fabrics are produced by spreading a thin layer of adhesive onto the surface of a cloth and then dusting the surface with fibers. An electric field may be used to orient the fibers perpendicularly to the cloth so that they penetrate the adhesive surface like little arrows. They will be bonded to the surface when the adhesive dries. Those which do not penetrate the surface can be removed by vacuuming.

This process produces a fabric with a short, relatively rough pile surface. Flocking may be applied over the entire surface of the cloth or it may be used to provide a surface pattern. Flocked fabrics are found on lamp bases, bookends, and similar objects to provide protection against scratching and scarring of table tops. They are also used as wallcoverings to provide a luxury appearance as well as noise control. Flocked fabrics have been used with some success in apparel; however, the durability of the pile surface is dependent upon the adhesive used. It is important to determine whether the adhesive will withstand the stresses of laundering and the action of dry-cleaning solvents.

Summing up, pile fabrics give an extra dimension to textiles. Velvet and velveteen constructions have a soft, luxurious hand and enhanced esthetic appeal when used in apparel or home furnishings. Heavier corduroy fabrics offer greater durability and warmth. Terrycloth gives the extra absorbency and surface texture needed in towels. Knit pile fabrics can reproduce the beauty, comfort, and warmth of natural furs. Tufted and flocked fabrics provide inexpensive, durable materials for a variety of end uses.

NONWOVEN FABRICS

All the fabrics discussed so far have been made from yarns, whether by weaving or knitting. The term *nonwoven* is applied to fabrics that are made directly from fiber, without the intermediate step of yarn preparation. We will discuss *felt* and *bonded* fabrics in this section.

FELT

Felting, one of the oldest methods of fabric manufacture, originated among the wandering tribes of Central Asia. It is based on an interesting property peculiar to wool. Wet wool fibers, when subjected to mechanical agitation, form a compact mass that is not easily pulled apart. This ability to form a cohesive mat is a result of wool's unique scaly structure.

In the felting process, wool fibers, sometimes mixed with other fibers, are arranged in mats similar to rolls of absorbent cotton. These mats are then pounded in warm soapy water until they have been thoroughly compacted and the fibers are entangled in a three-dimensional structure. The entangled fibers are held together by friction and the interlocking of the wool surface scales (Fig. 14.6).

Figure 14.6 A felt fabric; the fibers are randomly entangled.

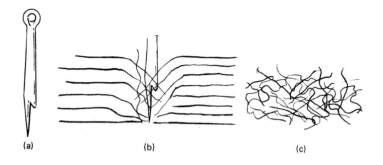

Figure 14.7 Needle punching is accomplished by inserting a barbed needle (a) into a mat of fibers (b). The entangled fibers form a felt-like fabric (c).

Felt may be finished to give a smooth, dense surface that is impervious to water, or it may be left porous. The dense felts are rather stiff and hard. They have little stretch, excellent abrasion resistance, and high tear strength. In addition, they provide a high degree of insulating ability. These felts are used for hats, coats, insulation around doors and windows, sound-absorbing materials, and padding.

Less compact felts have a higher degree of air and moisture permeability and a softer hand. These cloths may be used in apparel, especially for winter wear, because of their warmth and smooth drape.

NEEDLED FELTS

True felts are composed almost entirely of wool. A feltlike material can be made from any fiber by a process called *needle punching*. A set of barbed needles (Fig. 14.7) is repeatedly punched through a layered assembly of fibers, causing them to entangle in a three-dimensional network. This mat is similar to wool felt; however, needled materials are not as strong nor as compact as felt. Quite often, a loosely woven cloth, called a *scrim*, is placed between layers of fiber to provide extra strength. When they are punched, the fibers become entangled within the scrim as well as with each other. This improves the tear strength and durability of the material.

Needled felts are used for carpets and rugs (particularly indoor–outdoor types), towels and washcloths, and as a substitute for wool felt.

BONDED NONWOVEN FABRICS

Wet Bonding Many fibers are not suitable for felting operations. They may be too short or have too low a surface friction to resist tearing or coming apart in use. These fibers may be formed into textile materials by WET BONDING. In this process, an adhesive is sprayed from either a water solution or

255

an organic solvent onto a web or mat of fibers. The adhesive is preferentially adsorbed at the intersection of two or more fibers. After heat curing at temperatures of from 100 to 200°C (312 to 392°F), the adhesive permanently bonds the fibers together.

Dry Bonding The same result may be achieved by DRY BONDING. A powdered thermoplastic resin or thermoplastic fiber is mixed with the material to be formed into a mat. The mat is then pressed at high temperature to melt the thermoplastic. Upon cooling, the melted material forms a bond between fibers.

Spun Bonding Thermoplastic fibers may also be fused to each other by the application of heat and pressure to yield a nonwoven material that does not contain any additives. This last process has certain advantages over the adhesive bonding methods. Since the entire material is made of a single fiber, the effects of high temperature, laundering, and dry-cleaning can be predicted from the properties of the single fiber. There need be no concern that the adhesive will be dissolved in dry-cleaning fluids, crumble during laundering, or melt upon ironing. When the cloth is produced directly as the fiber is extruded from the spinneret, the material is called SPUNBONDED.

Properties of Nonwoven Fabrics

The properties of nonwoven materials are determined by the fibers used, the bonding agents, and the bond density. Bond density is defined as the number of fiber-to-fiber bonds per unit area. Fabrics with a high bond density are strong. However, the high number of bonds prevents the fibers from moving as the material is flexed, causing it to be stiff. A low bond density yields a more supple fabric with a lower strength.

The bonding agents can also affect the hand, drape, and strength of a fabric. In general, strong adhesives are also rigid. This means that higher strength will be accompanied by a coarser hand and stiffer drape. Adhesives that are more elastic and yield a better drape are also weaker. Thus, for nonwoven fabrics, high strength is accompanied by a stiff hand, while a soft hand and good drape imply a weak cloth.

Bonded nonwoven materials have high air and moisture permeability, and can have a good hand and drape, or can be stiff and strong. These fabrics are often used as interfacings in apparel to provide shape and body to garments. They may also be found in disposable items such as diapers, bibs, washcloths, and medical supplies. A major use of nonwoven materials in home furnishings is in backing for tufted carpet. Industrial uses are manifold, ranging from air filters to electrical insulation.

LAYERED (LAMINATED) FABRICS

This class of textiles comprises materials that are formed in a sandwich-like composition. They may be cloth bonded to cloth, cloth bonded to film, or cloth bonded to foam.

Cloth Bonded to Cloth

These layered fabrics are formed by cementing a face cloth to a backing cloth. The adhesive may be applied from solution, or it may be a resin that is cured by application of heat. Its purpose is to provide a fabric that has better performance properties than either the face or backing cloths used separately. For example, a wool jersey knit could be bonded to a nylon tricot knit. Apparel made from this fabric would retain the warmth of the wool, while the tricot would provide a smooth inner surface that would make the garment less scratchy to the touch. In addition, the tricot would reduce shrinking and minimize fabric stretching. Better-quality tufted carpets also use this layering process; the tufted cloth is backed by an extra layer of heavy jute cloth, which increases the strength of the carpet, gives better dimensional stability, and increases wear life.

Cloth Bonded to Film

This layered combination takes excellent advantage of the properties of polymers while retaining many of the properties of textile products. If the polymeric material is less than 0.5 mm (0.020 m) thick, it is called a *film*. If it is thicker than 0.5 mm, it is known as a *sheet*. Films are used for wearing apparel, sheets for upholstery. Polymer film or sheet is usually impervious to water, has excellent soil and stain resistance, and is highly elastic. Polymeric material may be colored or left transparent. Of particular importance is the fact that these materials may be textured to resemble leather, or given other interesting surface patterns. The films or sheets alone are usually not strong enough to withstand the stresses encountered in use; for this reason they are bonded to a woven or knitted cloth backing. The cloth provides the dimensional stability and strength which the polymer alone lacks.

For apparel use, and to some extent for upholstery, the lack of air and moisture permeability of film or sheet is a great disadvantage. The films and sheets may be made porous by having thousands of tiny pinholes punched in them. The holes are sufficient to permit passage of air and water vapor, but too small to let water through. Thus, a raincoat composed of a vinyl film bonded to a cotton flannel prevents penetration by rain, while the cotton absorbs body moisture. Moisture is then transmitted through the pores of the film to the atmosphere. In this way the wearer stays dry without feeling clammy.

Cloth Bonded to Foam

These constructions are of great importance in upholstery and carpeting; to a lesser extent they are popular in apparel. In this process, a cloth is bonded to a thin polymer foam much like a cloth is bonded to film or sheet. For apparel and upholstery use, such a fabric has properties similar to bonded film or sheet; however, in carpets and rugs this combination provides other advantages. The tufted fabric that makes up the face of a carpet may be bonded directly to a foam layer ½ to 1 cm (¼ to ½ in) thick. This foam backing provides a resilient layer that makes the carpet feel more comfortable, muffles

sound transmission, provides thermal insulation, and absorbs impacts from falling objects. The foam backing gives these advantages at a lower cost than other types of carpet padding.

Properties of Layered Fabrics

Layered fabrics can only be as good as the poorest element in their construction. This means that if the adhesive is not of high quality, or if the film, sheet, foam, or cloth is not up to par, the entire assembly will perform poorly. In choosing layered fabrics for apparel wear, it is very important to make sure that the adhesive does not dissolve in dry-cleaning solvents or crack during laundering. It is also necessary to be sure the adhesive will retain its suppleness over time, so that the hand, drape, and comfort of the garment is not destroyed.

The layers of cloth, film, sheet, or foam must be compatible. Consider a fabric formed from a woven wool layer bonded to a leatherlike textured polymer layer. How can it be cleaned? Wool should be dry-cleaned, since it is likely to shrink during laundering; however, polymer may dissolve in dry-cleaning fluids. The consumer may have a material that is not cleanable! Even when all the layers of the composite can be cleaned in the same manner, it is still necessary to confirm that they are compatible. A fabric composed of two cloths that have different levels of shrinkage will warp and wrinkle upon laundering.

QUILTED FABRICS

Quilted fabrics are formed by the mechanical encasement of a layer of foam or a fabric mat between two cloths. The three layers of fabric are held together by being stitched in a diamond pattern.

For thermoplastic materials bonding may be accomplished by means of ultrasonic welding techniques. The layers are heated by contact with a special device which supplies high-frequency energy to the material. The increased temperature causes a tiny region of the materials to melt and flow together, forming a bond through all the layers.

In apparel and home furnishings, quilted fabrics are used in robes, jackets, bedspreads, comforters, etc. They provide lightweight, warm materials that are somewhat firmer and stiffer than single layers of cloth. Durability is determined by the outer cloth layers. However, the bonding method can be important. Sewn fabrics may have their wear life shortened if the threads used to quilt the fabric break. The durability of welded materials is dependent upon the properties of the thermoplastics from which they are prepared. Breakage of the thread or fused regions will allow the filling to shift, causing lumps and thin spots. Naturally, this impairs the insulating properties and the appearance of the goods. As is true of bonded fabrics, maintenance depends upon the properties of all the components. In particular, the composition of the filling should be noted. A highly absorbent material, such

as cotton, may take an unreasonable long time to dry after laundering. This may make the product susceptible to mold and mildew.

SPECIAL DECORATIVE EFFECTS

In earlier sections we considered how colored patterns and surface texture could be introduced into woven and knit goods. These methods are used to heighten the esthetic value of otherwise plain constructions. Quite often, the pattern or design is of major importance. For example, the elaborate designs of brocade and damask upholstery make furniture visually interesting as well as practical. Embroidered patterns can turn a plain piece of fabric into a work of art. Lace making raised the embellishment of clothing and household goods into the sphere of the arts. In this section we will discuss some of the special techniques of cloth manufacture used to obtain decorative effects.

DOBBY WEAVES

Simple geometric designs may be produced on a standard loom by the addition of a DOBBY attachment. This device increases the number of harnesses that may be incorporated in the weaving of a fabric. The extra harnesses allow the weaver to reproduce a small surface figure (Fig. 14.8) or a multicolored check or plaid. Colored yarns are used to produce the pattern.

JACQUARD WEAVING

One of the most important developments in the textile industry was Joseph Marie Jacquard's invention of a loom in which each of the many warp yarns is individually controlled. The Jacquard loom (described in Chapter 18), first exhibited in 1801 after almost fifty years of development, brought all the flexibility of hand weaving to mass production. Any pattern a designer can imagine can be reproduced in Jacquard-woven cloth. The techniques of

Figure 14.8 The extra harnesses of a Dobby loom allow simple geometric figures to be woven into a cloth.

Figure 14.9 Jacquard woven pattern.

Jacquard weaving have been adopted to produce Jacquard knitting machines, so that the full range of the designer's art can be reproduced in both knit and woven cloth. Figures 14.9 and 14.10 are examples of Jacquard-woven and Jacquard-knit materials.

Figure 14.10 Jacquard knit cloth.
(*AFF Encyclopedia of Textiles*)

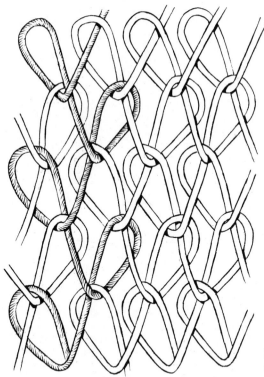

Figure 13.11 The construction of a tricot knit.

be used as the face when the material is being made up into garments. This ability to use either side of the cloth is useful to the manufacturer because it gives some flexibility in printing or other finishing processes such as napping. The drape of tricot-knit fabrics is usually very soft.

COMFORT Single-warp tricot cloth has good permeability to air and moisture. Wind resistance, as with filling knits, is dependent upon the gauge or cut. The hand is usually soft and smooth, although the fabric may be napped to give a fuzzy texture well suited to sleepwear. Stretch, although less than that of filling knits, is greater than that of wovens. Elasticity is good.

MAINTENANCE Tricot knits, because they are usually made from filament yarns, tend to have good soil and stain resistance. Their structure, with the yarns running in the walewise direction, also improves the soil resistance and ease of soil removal. Wrinkle resistance is excellent, as would be expected from a knit fabric. Dimensional stability is better than that of most weft knits, so that tricot knits may be machine-laundered.

DURABILITY Run resistance, resistance to snagging, and burst strength of tricot knits is greater than that of weft knits. This is because, as inspection of the fabric construction illustrated in Fig. 13.11 shows, the loops

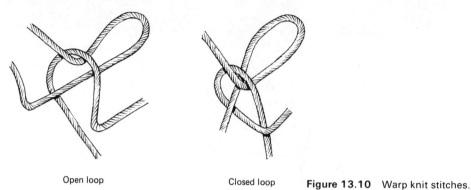

Open loop Closed loop **Figure 13.10** Warp knit stitches.

Warp-knit fabrics have better dimensional stability, greater resistance to snagging, raveling, running, and abrasion, as well as higher strength than weft knits. Warp knits are also prized for their soft hand, smoothness, sheerness, and good draping qualities. The warp-knit cloths of major importance are TRICOT and RASCHEL.

TRICOT KNITS

Just as filling-knit patterns can be produced from four basic stitches, all tricot cloth can be produced by three basic motions of the knitting needles. The yarn may be formed into (1) a *closed loop*, (2) an *open loop*, or (3) *no loop* is formed. Figure 13.10 shows the formation of open and closed loops.

In the simplest tricot constructions, a single layer of cloth characterized by walewise ribs on the face and coursewise ribs on the back is produced. A photograph of a single-warp-knit tricot cloth is shown in Fig. 13.9. The loop pattern is illustrated in Fig. 13.11. Single-warp tricot cloth has good permeability to air and moisture, acceptable elasticity, a soft hand, and good drape. Its dimensional stability and run resistance are also better than those of most weft knits.

Tricot knitting lends itself readily to light, sheer constructions. For this reason the cloth is usually made of fine-filament yarns. The spacing of the yarns may be measured by the gauge, as in weft knitting, but is more often measured by the NEEDLE COUNT or CUT. These terms are defined as *the number of needles, or stitches, in one inch*. The standard tricot machine operates with a cut of 28, the equivalent of 42 gauge.

Properties of Tricot Knits

APPEARANCE Tricot-knit fabrics have a very fine walewise stripe in the face and a coursewise stripe on the back. Except under close inspection the pattern is not readily seen, so either the technical face or back of the fabric may

The properties of Jacquard-woven or -knit fabrics are dependent, to a great extent, on the fibers and yarns used in their construction. The cloth is generally closely woven or knit, so that constructional effects are minimized. Since the pattern in Jacquard-woven cloth is often raised, it is important that the yarns be tightly twisted, and that the fibers be durable.

EMBROIDERY AND OTHER DECORATIVE TECHNIQUES

Embroidery is the technique of using a needle and thread to form a raised, ornamental pattern on the surface of a cloth (Fig. 14.11). Originally a hand operation used to decorate the borders of ecclesiastical robes, embroidery is now produced on special machines such as the one shown in Fig. 14.12.

Mass-produced embroidered effects in which the pattern is part of the fabric may also be achieved by using extra warp or extra filling yarns during the manufacture of the cloth. The three major processes are referred to as the LAPPET, SWIVEL, and SPOT weaves. In addition, the SCHIFFLI machine is used to create more intricate designs after the cloth has been woven.

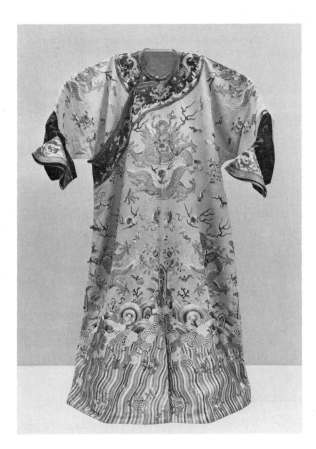

Figure 14.11 Embroidered silk Chinese robe, 18th century imperial court. (*The Metropolitan Museum of Art*)

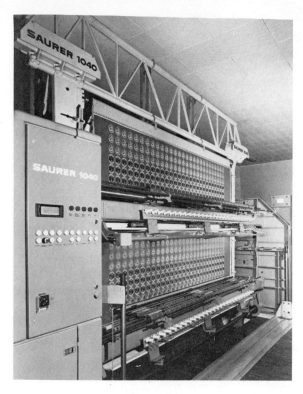

Figure 14.12 A modern high-speed embroidery machine. (*Saurer Corporation Textile Machinery*)

Lappet Weave

In this process, extra warp yarns are passed through a needle bar attached to the reed of the loom without passing through the reed itself. The needle bar is capable of side-to-side as well as up-and-down motion. When the needles are down, the filling yarn catches the extra warp yarns; when the needles are up, the extra warps float on the back of the cloth. Spots are woven into the cloth in a zig-zag pattern (Fig. 14.13). They may be clipped or left on the back of the cloth. The process produces a patterned effect that is both durable and pleasing to the eye. However, lappet weaves have faded in popularity because they are rather expensive, and the patterns can be produced more cheaply by other means.

Figure 14.13 Lappet weave, with unclipped floats (*left*) and clipped spots (*right*). (*AFF Encyclopedia of Textiles*)

Swivel Weave

To produce a swivel weave, extra filling yarn is bound several times around a set of warp yarns after the normal filling yarn has been laid in place. The extra filling yarns are carried by small shuttles, called *swivels*, placed across the width of the loom; these operate in a circular motion. Since each swivel carries its own yarn, multicolored patterns may be formed. In addition, the pattern design may be as small as a dot or may encompass the width of the cloth. Swivel patterns have a raised appearance and are very durable. The process is not widely used in the United States, since Jacquard looms can produce similar patterns.

Spot Weaves

In spot weaves, extra filling yarns, or sometimes extra warp yarns, are used to create a small pattern neatly woven into the body of the cloth. When extra warp yarns are used, they are brought in from a separate warp beam and extra harnesses are used to control the interlacing with the filling yarn.

Schiffli Embroidery

The patterns produced by lappet, swivel, and spot weaving are integrated with the cloth as it is being woven. The Schiffli machine, however, produces a raised pattern on the surface of an already finished cloth. It employs up to 1.020 extra threads passing through needles that operate very much like sewing machine needles. A control mechanism determines whether or not the needles penetrate the cloth. A small shuttle beneath the cloth ties each needle loop into the base material. This system is capable of producing very fine, intricate embroidered patterns. A lacelike fabric can be produced by embroidering a pattern onto a cloth that dissolves readily in a caustic reagent. Dissolution of the base cloth leaves Schiffli lace.

LACE

Lace illustrates the apex of textiles as art; in lace the pattern is not just applied to the cloth, the pattern *is* the cloth (Fig. 14.14). Lace is made by knotting, looping, braiding, or twisting yarns together to form a light, open cloth incorporating a pattern. Laces for the mass market are described by the type of machinery on which they are produced. The most important are leavers, bobbin, and raschel.

Leavers lace is produced by intertwisting thousands of yarns, each carried on its own separately controlled bobbin. This is the most expensive of the machine-made laces, and most closely approximates handwork in its intricacy of pattern and fineness of cloth.

Bobbin lace is produced by braiding yarns together. The material is heavier than Leavers lace and the patterns are less fluid. Bobbin lace tends to be more geometric in its pattern.

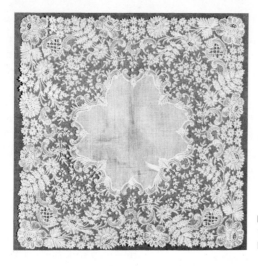

Figure 14.14 Belgian handkerchief, late 19th century, with Valenciennes bobbin lace. (*The Metropolitan Museum of Art*)

Raschel lace is knit, so that like Schiffli lace it is not a true lace. However, a fine cloth and intricate patterns can be produced, and the overall effect is almost as pleasing.

As might be expected with such a fine fabric, lace is mainly used for decorative purposes, such as borders or inserts in apparel, table linens, curtains, etc. With proper care, lace can retain its beauty for many years.

SPECIAL CONSTRUCTIONS

The fabric constructions discussed in the following section were developed largely for the novel esthetic properties thay they lend in some end uses.

Leno Weave

The *leno* weave, also known as *doup* or *gauze*, is particularly useful for open, loosely constructed fabrics such as curtains, thermal blankets, laundry and shopping bags, and mosquito netting. The leno construction (Fig. 14.15)

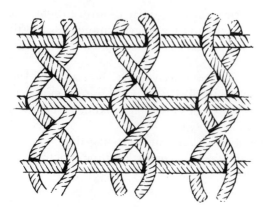

Figure 14.15 Leno weave. The filling yarn is inserted through the crossed warp yarns.

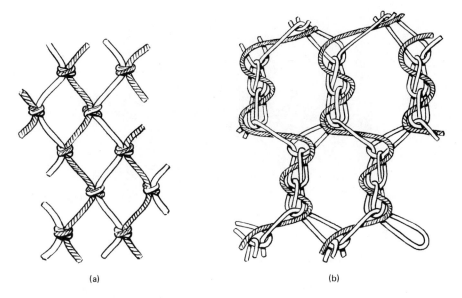

(a) (b)

Figure 14.16 Knotted net (a) and knitted net (b). Raschel knitted netting is better suited to apparel and home furnishings. The knotted construction is heavier and better suited to industrial use.

is unique in that the filling yarn passes through pairs of warp yarns which criss-cross each other as well as the filling yarn. The filling is held more tightly by the crossed warp yarns than it would be by a single end; thus, even though the fabric is of a loose construction, it will not easily pull apart.

Net

Netting is an open-mesh construction in which the yarns are held together by knots (Fig. 14.16). Netting provides a durable cloth that finds its major use in industrial end uses such as fishnets or bags. A netlike cloth may also be produced by raschel or tricot knitting. However, since the yarns are looped together rather than knotted, the material is not as durable. Finer mesh netting may be found in lightweight summer apparel, where it provides visual interest.

Braid

Braided materials are produced by interlacing three or more yarns together so that each passes diagonally over the other. Braided cloth may be produced as a flat ribbon or in tubular form. It is characterized by a diagonal surface pattern (Fig. 14.17). Braided yarns may be used to lend interest to novelty fabrics. It is found in shoelaces, trim, hoses, wire insulation, rugs and carpets, ribbons, and cords.

Figure 14.17 Braided cloth.

Stitch-Through Constructions

One of the more important of the recent innovations in fabric production was the invention of MALI technology by Heinrich Mauersberger of Limbac, Germany. The term *mali* comes from the first two letters of the inventor's name and the first two letters of the city. Mauersberger's technique allows layers of yarns or fibers to be formed into a textile material by means of a separate yarn that is sewn through the layers. This method may be used to produce (a) flat fabrics from layers of yarn (malimo); (b) pile fabrics made in a manner similar to tufting (malipol); and (c) a layered fabric by using mats or webs of fibers (maliwatt). Figure 14.18 is a schematic of a *mali* machine.

Malimo fabrics are produced by laying warp and fill yarns in separate layers at right angles to each other. The yarn assembly is then joined by a third yarn, which is sewn through the layers in a chain stitch. When the chain stitches predominate on the surface of the fabric, it has the appearance of a knit. When the warp or fill yarns predominate, the fabric has the appearance of a woven construction. In either case, the fabric performs much like a woven material. It has a high tear strength, does not ravel, and is not easily snagged.

Malipol fabrics use a base material, either woven or nonwoven, through which a pile yarn is inserted. This technique is similar to the tufting process, but uses finer yarns on a much smaller gauge. The fabric is similar to corduroy or, if sheared, velveteen. However, the durability of the pile is not as great as in the woven materials. By use of a special attachment a terrylike cloth can be produced.

Maliwatt fabrics are produced by stitching through a loose fiber mat to produce a strong, compact material that has many of the properties of felt. It is suitable as an insulating material or interlining to provide warmth and body to garments.

The major advantage of stitch-through techniques is the high produc-

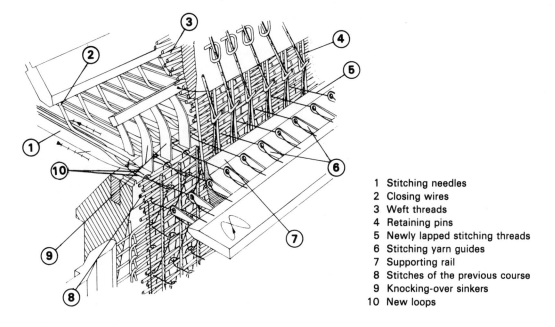

1 Stitching needles
2 Closing wires
3 Weft threads
4 Retaining pins
5 Newly lapped stitching threads
6 Stitching yarn guides
7 Supporting rail
8 Stitches of the previous course
9 Knocking-over sinkers
10 New loops

Figure 14.18 Mali sewing-knitting machines use special stitching needles in conjunction with other stitch-bonding elements. The stitching needles pierce the sheets of yarn, backing fabrics or, fiber webs fed to the needles; guide needles transfer the stitching threads to the hooks of the stitching needles. For loop formation, the hooks are temporarily covered by closing wires. The kinds of stitches applied are interlocking chain stitch or plain chain stitch, known from warp knitting. (*Chima, Inc.*)

tion speed. A *mali* machine can produce as much fabric as twenty standard looms. However, because of the cost of the machinery and competition from other types of high-speed knitting machines and looms, these machines are not in use in the U.S. today.

The *arachne* machine, produced in Czechoslovakia, and the *kraftmatic* machine from Great Britain, produce materials very similar to maliwatt and malipol, respectively.

REVIEW QUESTIONS

1. Compare the durability of a W-interlaced velvet on a plain-weave ground cloth to that of a W-interlaced corduroy on the same ground cloth. Which is better suited for work pants? Why?
2. Terrycloth is widely used for towels and beach wear. Explain why.

3. Compare the performance of a nylon flocked fabric to that of a no-wale corduroy made of the same fibers. Which is better suited for an autumn-weight jacket? Why?

4. Knit pile fabrics are often used as a substitute for fur. How are they superior to woven pile fabrics in this end use?

ACTIVITIES

1. Visit your local shops and make an inventory of laminated fabrics as they are used for apparel and home furnishings. Where and how are they used? What advantages do they offer?

2. Visit your local fabric shops and compare the prices of the fancy fabrics such as dobby- and Jacquard-woven cloths to those of similar cloths without the special esthetics. Is the improved appearance worth the extra cost? Discuss.

3. Survey one or more of the departments in your local stores. Compare the use of pile fabrics to flat fabrics. Does the use of pile fabrics follow the whims of fashion to a greater extent than the use of flat fabrics?

V

15 General Finishes

16 Functional Finishes

17 Design: Color and Pattern

FINISHING AND COLORING OF FABRICS

IN PART V we examine the finishing and coloring techniques applied to fabrics. Chapter 15 begins with an introduction to the various types of finishes and their purpose, and also discusses the role of the converter in the preparation of products. It then discusses the general finishes that are used to prepare cloth for sale or for further processing. In Chapter 16, we examine functional finishes used to modify cloth for special purposes. Finally, in Chapter 17, we look at color and pattern—the composition and performance of dyes and pigments and their methods of application.

15

general finishes

THE PURPOSE OF FINISHES

Consumers would not readily accept most cloth in the state in which it emerges from the weaving, knitting, or other manufacturing processes. Unfinished fabrics, referred to as GREIGE or grey goods, contain many impurities and imperfections, have a harsh hand and little esthetic appeal. They may be white, grey, or colored if dyed yarns or fibers have been used in their manufacture.

Before reaching the consumer market, cloth must undergo at least one and usually several finishing processes. The purpose of these finishes is to impart specific properties to the cloth to make it more appealing to the consumer. The end result may be improved esthetics; better performance; increased durability; resistance to insects, molds, and fungi; improved safety or protection for the user; the addition of color and design; or simply the preparation of the cloth for further finishing processes.

Most consumers are not aware that finishes have been applied to the goods they buy, because finishing is generally not mentioned on the label or hang tag, although special finishes, such as durable press, are often identified in order to influence sales. Since special finishing generally adds to the cost of an item, it is important for consumers to be familiar with the many types of finishes that may be applied to cloth, in order to make rational decisions regarding price and performance properties. The consumer should keep the following considerations in mind:

1. Does the finish provide the specific improvement in properties that is claimed? Some finishes can be quickly and easily evaluated. For example, a finish intended to impart improved crease resistance can be readily checked. Compress the cloth in your hand and let it go. Observe how it responds. Compare it with a similar cloth without the finish. Is the apparent improvement worth the increased cost? (Unfortunately, the efficacy of all finishes is not so easily evaluated.)

2. How durable is the finish? This is often hard to determine. Good finishes should perform well over the "normal" or "expected" life of the garment. The consumer is not getting full value if this is not the case.

3. Will the finished cloth require special care in order to preserve its properties? If finishes do require special care, clear instructions should be given on the label.

4. How safe is the finish? Is it likely to cause skin irritations? Could it be harmful to a child who chewed the garment? (It is usually a good practice, for children or for adults with skin problems, to launder garments once or twice before wearing to remove irritating surface chemicals.)

TYPES OF FINISHES

Finishes may be applied to cloth by mechanical or chemical means. Although many of these techniques have been in use for thousands of years, improvements in machinery design, advances in chemical technology, and the discovery of new types of finishes have greatly improved the performance of textile products while reducing the cost to the consumer. The major advances have been in the field of chemical finishes. Since 1950, developments such as durable-press polyester/cotton blends, shrink-resistant wool, and flame-retardant treatments have decreased maintenance requirements, improved performance, and enhanced the safety of textile materials. Significant new chemical finishes, particularly for polyester/cotton blends, are likely to be developed in the next decade.

The finishing processes performed on cloth from the point of manufacture until it is ready for sale may be divided into three broad categories: general finishes, functional finishes, and the application of color. In this chapter we discuss general finishes—those which are used to clean the cloth, give it shape, improve the hand and texture, or give it a special surface characteristic. Functional finishes and the application of colors will be examined in Chapters 16 and 17.

THE ROLE OF THE CONVERTER

The individual responsible for giving greige goods the desired finishes (including general finishes, appropriate functional finishes, and the final color and pattern) is called the CONVERTER. Converters may act as agents for textile producers or apparel manufacturers who send their cloth to be processed according to their specifications; or they may purchase the cloth and

process it for sale to apparel manufacturers. Sometimes large mills do their own converting.

Converters play a vital role in the textile manufacturing process. They must know how to create customer appeal and, thus, salable products by imparting the right esthetic properties. They must know and understand how to finish individual fibers as well as fiber blends. They must be able to modify, develop, and apply the many basic finishes, the large number of functional finishes, and the broad range of colors and surface prints to the wide variety of fibers and blends available in the market today. A converter's job is complex and challenging because the finishes that are just right for today's cloth and consumers will probably not be suited to the expectations of those of tomorrow. The textile industry is very innovative, and converters must be prepared to operate in a dynamic rather than a static system if they are to be successful.

GENERAL FINISHING PROCEDURES

Most cloth after it emerges from the manufacturing process is routinely subjected to one or more general finishing processes. General finishes are applied by mechanical or chemical means; they may or may not affect fabric performance, care, and use. Some finishes are permanent while others are nonpermanent. Some are suitable for only a special type of fiber or blend.

The order of application of the general finishes will vary with fiber type, manufacturing process, and economic considerations. For this discussion, however, we will follow the sequence typically used in the industry, and describe in turn the various procedures for:

1. Cleaning the cloth prior to subsequent finishing
2. Shaping, sizing, or preparing cloth for further finishing
3. Improving texture and hand
4. Improving appearance
5. Inspection and quality control

CLEANING PROCEDURES

Greige goods must undergo a series of preliminary cleaning treatments before shaping, application of functional finishes, or dyeing and printing. These preliminary treatments are approximately the same for all cloth, but they vary to some extent with fiber type.

Desizing

Sizing materials are applied to yarns, particularly warp yarns, before they are woven into cloth. These form a protective coating over the yarns and keep them from chafing or breaking during weaving. It is usually not necessary to apply sizing to yarns that are used in knitting.

Chemicals used as sizing agents may be divided into two general types: (1) water-soluble, such as gelatin; and (2) water-insoluble, such as starch. Oils and waxes are also often used with sizing agents to increase the softness and pliability of the yarns.

Water-soluble sizes are generally used on man-made fibers. They are easily removed by a hot-water wash or in the scouring process. Cotton and rayon yarns are most often sized with water-insoluble starches. Enzymes or sodium bromite are used to break the starch into smaller, water-soluble molecules; these degradation products are then easily removed by washing before the cloth is scoured. This is a necessary step because some of the starch degradation products in the presence of the sodium hydroxide (alkali) used in scouring form strong reducing agents that can cause color changes in dyed materials.

Scouring

Scouring is a cleaning process used to remove impurities from fibers, yarns, or cloth. It is easiest to perform at the cloth stage. The specific scouring procedures, chemicals, temperature, and time vary with the type of fiber, yarn, and cloth construction. Impurities such as lubricants, dirt and other natural materials, water-soluble sizes, antistatic agents, and fugitive tints used for yarn identification are removed in scouring.

Cloth may be scoured in large kettles called KIERS. The kier is loaded with cloth in rope form (Fig. 15.1) and the scouring chemicals are pumped through the cloth. This is an aqueous process, and is sometimes done under pressure at the boil. The need to keep cloth, particularly heavyweight cloth, from creasing during scouring led to the development of open-width kiers. Kier boiling is essentially a batch process.

Figure 15.1 Cloth in rope form being loaded into a high pressure kier. (*Gaston County Dyeing Machine Company, Stanley, N.C.*)

In the United States the preferred method is continuous scouring in open-width washing machines that are called J-BOXES because of their shape (Fig. 15.2). The cloth is fed into the box at the top, folded to fill the longer arm, and removed through the shorter arm. This process is also aqueous, but often requires the addition of a wetting agent to obtain good penetration of the chemicals.

Cotton cloth is generally scoured with a dilute solution of sodium hydroxide (1 to 3 percent, based on the weight of the cloth). The process must be carefully controlled or the cloth may be damaged during scouring, with a resultant loss of strength. Synthetic detergents or soaps containing alkaline builders are used to scour wool. Man-made fibers such as nylon and polyester are scoured with synthetic detergents containing alkali. Acrylics are scoured with nonionic detergents, and care is taken to avoid alkaline conditions, since these fibers turn yellow in hot alkali. Acetates are scoured with detergents under very mild alkaline conditions. Rayons are also scoured under alkaline conditions, but the process is varied depending on the type of rayon. Desizing, scouring, and bleaching of man-made fibers may be combined in some finishing operations.

A special scouring process used to remove the natural gum, sericin, from silk, is called degumming (see Chapter 5). The silk is washed in hot soapy water, usually under alkaline conditions. Sericin functions as a size in the manufacturing process and is generally removed after the yarn is woven or knitted.

Figure 15.2 The J-box is used for continuous scouring and bleaching (*Morrison Machine Company*)

Solvent Scouring

Solvent scouring is a new cleaning process used to remove wax, grease, and oil from cloth before dyeing and printing. It has been used sucessfully for polyester/cotton blends. The most common solvents used in solvent scouring are perchloroethylene, trichloroethylene, or 1,1,1-trichloroethane. The solvents may be used singly or in emulsions with water. Tumbler-type dry-cleaning machines are used, and the solvent is removed from the cloth by centrifuging followed by hot-air drying. The tumbling motion provides considerable mechanical action and thus promotes relaxation and development of bulk in knits. This is a batch process but there is some interest in developing continuous solvent-scouring processes.

In solvent scouring, the cloth is treated with an aqueous emulsion of a solvent-detergent mixture containing an enzyme. This is followed by an alkaline wash and a peroxide bleach. The cloth is rapidly wet by the solvent, which increases desizing efficiency.

The advantages of solvent scouring are said to be elimination of water and water treatment costs, easier effluent disposal, lower consumption of energy, more uniform treatment because of rapid and uniform wetting, and the possibility of greater automation, resulting in lower labor costs. The future of solvent scouring is not entirely clear at this time. The cost and availability of solvents and processing problems such as complete removal of solvent from fibers and recovery of solvents after processing may restrict the use of this process to a few limited applications.

Bleaching

Bleaching is a chemical process used to eliminate unwanted coloring matter from fibers, yarns, or cloth. The main purpose of bleaching in the manufacturing process is to obtain white cloth or to prepare the cloth for further finishing processes such as dyeing or printing. Bleaching is carried out in the yarn as well as the cloth stage of manufacturing. Finished products are bleached by the consumer to maintain the whiteness or brightness of items during use and care.

Several different kinds of chemicals are used in bleaching agents; the particular one selected depends on the type of fiber present in the yarn, cloth, or finished product. Common bleaching agents are hydrogen peroxide, sodium hypochlorite, sodium chlorite, sulfur dioxide gas, and sodium perborate. The perborate bleaches are not used commercially but are available for use by the consumer. Their bleaching action is similar to that of hydrogen peroxide. In manufacturing processes, bleaching may be carried out in a continuous or batch process. The choice of the particular process used is generally based on cost considerations. Hydrogen peroxide is the most widely used commercial bleaching agent.

Cellulosic fibers such as cotton, linen, and high-wet-modulus rayons may be bleached with sodium hypochlorite or sodium chlorite as well as with hydrogen peroxide. Greater care must be used in bleaching regular rayon and for blends of cellulose or wool with man-made fibers.

Wool may be bleached with sulfur dioxide gas or with hydrogen peroxide. The process utilizing sulfur dioxide gas, referred to as STOVING, may be used to bleach yarns or cloth. Wool bleached by this technique may be oxidized in air during use and revert to its natural color. Hydrogen peroxide, the preferred bleaching agent for wool, is less expensive. Moreover, the colored impurities are destroyed in bleaching with hydrogen peroxide so the white color obtained is permanent. Silk is bleached either with sulfur dioxide or hydrogen peroxide, the latter being preferred.

Man-made fibers are generally white and usually require little or no bleaching before the dyeing and finishing processes. If necessary, nylon, acrylic, and polyester fibers may be bleached with sodium chlorite under acidic conditions. Polyester fibers may also be bleached with hydrogen peroxide or sodium hypochlorite. Acetate generally does not require bleaching, but if it is necessary, alkaline conditions must be avoided or the fiber will be destroyed.

Several steps are involved in the bleaching process: (1) the cloth is saturated with the bleaching agent; (2) the temperature is raised to that recommended for the particular fiber or blend and held for the time needed to complete the bleaching action; and (3) the cloth is thoroughly washed and dried. The bleaching agent, temperature, and time must be carefully controlled to avoid damage to the fiber, or severe losses in strength may occur.

Carbonizing

Cellulosic impurities such as burrs and vegetable fibers that were not removed during carding must be removed from wool cloth by chemical treatment before it can be further processed. In the carbonizing process, the wool cloth is treated with dilute sulfuric acid, dried, and then heated until the impurities are converted to carbon. Next, the cloth is fed through corrugated rollers which crush the charred particles and shake them free. Finally, the cloth is washed and neutralized to remove residual acid. Sometimes it is necessary to carbonize wool fibers or yarn before they are made into cloth. The strength of the wool is not appreciably affected by carbonizing if the process conditions are carefully controlled.

Singeing

When cotton cloth comes from the loom, the fiber ends or "fuzz" must be removed, because a smooth surface is necessary, particularly if the cloth is to be printed. This is especially important for fabrics known for their smooth surface (popline, percale, or gingham). SINGEING is the name given to the finishing process used to remove these fiber ends or short hairs by burning without causing damage to the cloth. Since burning entails oxidation, this process may be thought of as a chemical process.

Before singeing, the cloth is thoroughly dried and brushed so the short fiber ends will be brought to the surface. There are two singeing techniques. In the *plate technique*, the cloth is passed rapidly (140 to 180 meters [150 to 200 yards] per minute to avoid scorching) over a curved copper plate heated to

a bright red. In the *gas technique*, two gas burners are placed so that both the front and back of the cloth is singed in a single pass through the equipment. The hot cloth is then passed through water or steam to extinguish any sparks that may be present.

Singeing is traditionally the first finishing process for woven cotton cloth. But sometimes starches and waxes may be more firmly fixed during singeing, making desizing more difficult. So, even though it is more economical to singe first, in some cases it is advantageous to modify or reverse the sequence of these finishing operations.

The use of polyester staple in blends with cotton, with the resultant pilling problem during wear, has increased the importance of singeing for these cloths. It is also important to singe knitted cloth to obtain a smooth surface. Improved machines have been introduced which insure clean singeing across the entire width of the cloth with less tension in the lengthwise direction.

SHAPING AND SIZING PROCEDURES

After it has been cleaned and scoured, most cloth is in a relaxed condition. The warp and fill yarns are neither straight nor parallel. Furthermore, the warp and fill yarns are not perpendicular. Knit goods are stretched out of shape, and the yarns are under varying degrees of tension. Thus, the cloth must be straightened and brought to its proper shape and size before it is subjected to further finishing steps. This is particularly important for those finishes which are meant to impart surface design or color. In addition, it is often advantageous to treat cloth to make it more chemically reactive, so that subsequent chemical finishes will be more permanent. These processes are discussed in this section.

Tentering

Tentering is a mechanical process used to stretch cloth to specific dimensions in the warp and fill directions. It is also used to straighten cloth so that the warp and fill yarns are perpendicular to each other. The process is carried out in a *tenter frame* (Fig. 15.3), which encloses a pair of endless parallel chains. The distance between the chains is adjustable so that the cloth can be given the desired width. In addition, the chains are independently adjustable so that they may move at the same speed, or one chain may move more rapidly than the other. Attached to the chains are pins (*tenterhooks*) or clips to which the selvage of the wet cloth is attached.

Cloth is continuously fed into the device. Control of the forward speed of the chains and the tension on the cloth roll allows the cloth to be stretched to its desired length. Adjustment of the spacing of the chains allows the cloth to be stretched to the desired width. Control of the rate of rotation of each chain allows the cloth to be straightened.

Figure 15.3 The tenter frame is used to strengthen and set cloth. (*Marshall & Williams Co.*)

As the cloth travels through the tenter frame the operator, or automatic control system, closely monitors and continually adjusts the forward movement of the chains. These adjustments are necessary to insure that the grain of the cloth is straight. If the cloth is improperly held in the tenter frame, it will dry with the warp and filling yarns not perpendicular and improperly aligned with the selvage. If this happens, the cloth will exhibit BOW or SKEW (Fig. 15.4), and subsequent finishing operations, such as heat setting, printing, or durable-press finishing will be adversely affected.

The tentering process may be adapted to include steaming, drying, and shrinking of cloth. Therefore, it may be used at various stages of finishing.

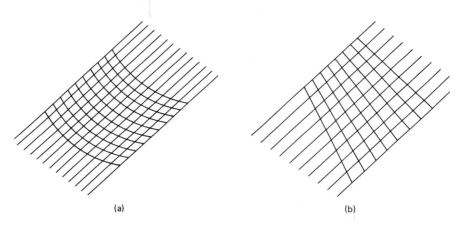

(a) (b)

Figure 15.4 Cloth exhibiting (a) bow and (b) skew in the filling yarns.

Sometimes tentering is combined with heat-setting of man-made fibers. If the cloth is stretched in tentering, particularly when it is combined with heat-setting, the cloth is likely to shrink when it is laundered, tumble-dried, or ironed at temperatures higher than those used in the heat-setting process.

Heat Setting

Heat setting is an essential step in the finishing process for man-made fibers. The major reason for heat setting is to give dimensional stability and shape to cloth made from these fibers. When man-made fibers in cloth are properly heat-set, the cloth will maintain its shape and size in subsequent finishing operations as well as in consumer use, as long as it does not encounter temperatures higher than the setting temperature.

Fibers are usually heat-set at a temperature at least 30° C (54° F) higher than the highest temperature expected in use. Home ironing temperatures are about 165° C (329° F) if the iron is set at the low or synthetic-fiber setting. This means that the cloth should be heat-set at a temperature of at least 195° C (383° F) to stabilize the cloth for normal home ironing. If done properly, heat setting does not interfere with other finishing process such as dyeing, nor does it prevent the formation of permanent pleats or creases in garments. Properly heat-set cloth will revert to its original set position if the temperature at which it was heat-set is not exceeded.

Heat setting is done on tenter frames that are used to adjust the fabric to the desired width and length before maximum heat is applied to give the cloth dimensional stability. Either wet or dry heat may be used depending on the fiber. Heat-setting conditions must be very accurately controlled. The cloth will be stabilized, or set, in the form it is held—smooth, creased, uneven, etc. When maximum stability is required, heat setting should be carried out at as high a temperature as possible using a minimum amount of tension.

Heat setting can be used to impart a variety of other properties to man-made fibers used alone or in blends. These include interesting and durable surface effects such as pleating, creasing, puckering, and embossing. Heat setting gives cloth resistance to wrinkling during wear and the ease-of-care properties that may be attributed to improvements in resiliency and in elasticity.

Mercerization

Mercerization is a chemical finish for cotton goods which increases luster, moisture absorbency, and strength. The process was discovered by John Mercer in 1850 when he noticed that cotton undergoes a general swelling and shrinking when it is treated with caustic soda solution (sodium hydroxide). Horace Lowe, in about 1890, noted that treatment of cotton under tension gives a high luster.

In the mercerizing process, yarn or cloth is treated under tension at room temperature with a sodium hydroxide solution that may vary in strength from 15 to 30 percent. The concentration of sodium hydroxide and the length of

treatment vary depending on the particular properties to be achieved and whether it is yarn or cloth that is being processed. All properties are not improved equally at one level of caustic treatment. For example, if improved moisture absorption is sought, the sodium hydroxide concentration is kept low. If improved luster is the goal, the sodium hydroxide concentration is kept at a high level.

After treatment of yarns or cloth, the sodium hydroxide is removed by several washes under tension. Remaining alkali may be neutralized with a cold acid treatment followed by several more rinses to remove the acid.

The mercerization process causes the cotton fibers to swell laterally and shrink longitudinally. This produces a round cross-section which reflects light to give the improvement in luster. Mercerized cotton also undergoes a change in crystal structure as well as a reduction in the amount of crystalline material present. This relieves some of the stresses and increases the strength of the weak points in the fiber. The greater uniformity along the fiber length is largely responsible for the increase in strength. The decrease in crystallinity and the change in the crystalline structure are responsible for the improved absorption properties. The fiber structure is simply "opened up" and becomes more accessible to chemical reagents.

Slack Mercerizing

Slack mercerization is simply an extension or a variation of the classical mercerizing technique. It is used to impart stretch properties to cotton. The process is a simple one in that cotton yarn or cloth is allowed to shrink without tension in 25 to 30 percent sodium hydroxide solution at temperatures of 30°C or lower. The sodium hydroxide is removed by washing and the cloth is dried.

The process may be varied to provide stretch properties in either the warp or filling direction of the cloth. For example, stretch in the filling direction may be obtained when the cloth is held under tension in the warp direction during the treatment with sodium hydroxide, after which it is washed with hot water and dried. The filling yarns not held under tension shrink during the treatment and have 15 to 20 percent stretch after drying. Stretch recovery during wear is about 80 percent, but complete recovery occurs after laundering. Both stretch and stretch recovery are dependent upon yarn and fabric construction.

The conditions under which mercerization is carried out must be carefully controlled, since overtreatment can result in a decrease in strength and ultimate destruction of the fiber.

Crabbing

Crabbing is a mechanical process used particularly for worsted wool to set the cloth in a smooth, flat state. It prevents creasing or uneven shrinkage in subsequent wet-finishing processes. During crabbing, the cloth is passed over rollers while being treated with hot water or steam. It is then bathed in cold water and pressed.

IMPROVING TEXTURE AND HAND

The texture and hand of a cloth are two of the most important factors in its merchandising. General finishes that may be used to make the cloth smooth or fuzzy, give it a soft or stiff hand, highlight or suppress the construction, or add weight are discussed in this section.

Calendering (Pressing)

Calendering, often called *pressing*, is a mechanical process that gives cloth a smooth, lustrous surface. It is essentially an ironing process and the effect is not permanent. Calendering is used in the finishing of almost all natural and man-made fibers.

The cloth is given a smooth, flat finish by being passed through the rolls of a calender under heat and pressure. A calender (Fig. 15.5) has at least two, and may have as many as seven rollers, or "bowls," made from polished steel or from compressible materials such as cotton or wool paper. Plastic rollers without seams have been introduced recently. The polished rollers are heated and pressed upon the compressible rollers with great force. As the cloth passes between the rollers, the yarns are flattened by the pressure and set by the heat.

Shearing

The shearing process mechanically cuts away undesirable surface yarns to give a clear view of the weave or to level (even) any pile or nap that has been raised on the cloth. It is used on cloth made from most natural fibers and from

Figure 15.5 A modern five-roll calender. Note the high polish on the rollers. (*B. F. Perkins*)

staple artificial fibers. Shearing is also used to cut designs into pile fabrics to give a sculptured effect.

The machine used to shear cloth has rotating spiral blades and resembles a lawn mower. The cloth is passed over brushes to raise the fiber ends, or nap, before it is sheared. After shearing, the cloth is brushed to remove the sheared ends of the yarn.

Beetling

The texture and appearance of linen or cotton can be modified by a process called beetling. The cloth is wrapped on a large roller which rotates slowly as it is struck 300 to 400 times a minute by large wooden hammers (*fallers*). The force of the blows is adjusted so that the material is not damaged but the yarns are flattened and the weave is closed. The flattened yarns reflect more light and increase the luster of the fabric. The beetling of heavy cotton cloth gives it the appearance of linen. Careful laundering and pressure ironing give a permanent finish. Beetling is often used to finish table linens and give them a smooth, flat, lustrous appearance.

Sizing

The application of various chemicals to yarn or cloth to form a more or less continuous film around the yarn or individual fibers is referred to as sizing. Sizes are used to increase strength, stiffness, smoothness, or weight. Sizes applied to yarns before weaving for protection during the weaving process are removed afterwards.

Sizing agents may be applied to cloth by a padding technique, in which the cloth is passed through the sizing solution and then through rollers which squeeze the solution into the cloth and remove excess size. A second technique uses revolving rollers containing the size solution. The cloth is passed between the rollers, and the size is deposited and padded into the cloth.

The most common sizing agent is starch. It improves the stiffness and luster of the cloth, adds weight, and may retard soiling; however, it must be replaced each time the material is laundered. Other sizing agents commonly used are natural gums (tragacanth, acacia, locust bean, etc.), proteins (glue, gelatin, casein), and water-soluble resins (polyvinyl alcohol, polyacrylates).

Decating

Decating is a mechanical process, developed initially for finishing wool to set the nap and develop luster, and now used for cotton, rayon, silk, wool, and blends containing these fibers. Decating enhances the luster, softens and improves the hand, and sets the cloth to give dimensional stability. It is said to delay the appearance of breaks and cracks, reduce shine, and help overcome uneven or blotchy dyeing.

In the decating process, the cloth is wound around a perforated drum between layers of a blanket. Steam is first forced through the cloth from the inside to the outside layers and then the process is reversed. When the treatment is completed, the steam is removed.

Fulling (Felting or Milling)

By means of fulling (sometimes called *felting* or *milling*,) moisture, heat, friction, and pressure are applied to wool and sometimes worsteds to cause them to become fuller and more dense. The pattern or weave structure may disappear, depending on the severity of the process.

The wet cloth is lightly extended and then compressed as it is fed through rollers in a continuous band. Pressure may be applied after it passes through the rollers. The alternate extension and compression of the wet cloth brings about the felting or fulling.

Softening

Softening agents are chemical finishes—sulfonated oils, glycerine, waxes, or silicones—applied to the surface of fabrics to improve the hand. These lubricants allow yarns to slide over each other easily for a softer drape and a smoother feel.

Softeners are generally applied to the cloth along with other types of finishes. For example, they are used with flame-retardant finishes to decrease stiffness and give a softer hand. The two finishes must be compatible, so that one does not diminish the effect of the other. Softening agents that are effective on some fibers may have little or no effect when applied to others. It is difficult to evaluate the effectiveness of softeners, since the only method available relies on subjective assessment. Some softening agents may be durable to washing and dry-cleaning; others may not.

Weighting

When silk is degummed it becomes very soft and lustrous, but loses 20 to 30 percent of its weight due to the removal of the sericin. To replace some of the weight that has been lost, the silk is treated with metallic salts. Normally, this process does not appreciably affect the silk's hand or durability; however, weighting greater than 15 percent can destroy the hand, luster, and strength.

The metallic salts used to weight silk are stannous chloride and sodium phosphate; these form insoluble tin phosphate which is deposited within the fibers. Sericin and other organic gums are sometimes used to stiffen fabrics made from silk and to give them body. Such treatments are satisfactory as long as the items are dry-cleaned.

Weighting may also refer to the addition of a substance to a yarn or cloth made from fibers other than silk. In either case, the finishing process is considered to be a chemical one.

FINISHES THAT IMPROVE APPEARANCE

The appearance of cloth may be modified in several ways to improve esthetic qualities. These modifications may be achieved by compressing the cloth, as in calendering; by raising the surface fibers, as in napping; or through various

chemical treatments. In this section we discuss some of the more common techniques.

Special Calendering Techniques

Calendering, as discussed earlier, is generally used in textile finishing to press cloth to make it smooth. Modifications of this process may be used to give cloth a special appearance. By varying roller speeds; temperature; pressure; moisture content; and the number, type, and arrangement of rollers, several types of finishes may be obtained. These special effects may be achieved mechanically, or by a combination of mechanical and chemical treatments. Such treatments may or may not be permanent.

Glazing

Cloth can be given a highly polished or glazed surface if it is passed through a calender in which the rollers are geared to run at different speeds, thus causing a high level of friction and subsequent temperature rise on one surface of the cloth. This finish is generally applied to cotton goods. Materials such as *chintz* or *polished chino* are prepared by this process. Durability is improved by application of a small amount of thermoplastic resin to the cloth before finishing.

Ciré is a process in which the cloth is heavily loaded with wax or a thermoplastic resin *before* friction calendering. The melted wax or resin covers the surface of the cloth and yields a very shiny surface. This process has been used in recent years to obtain the "wet look."

Embossing

Embossing is a finishing process used to produce raised surface designs on cloth. The material is passed between heated rollers, one of which has a pattern engraved on it. Cloth made from thermoplastic fibers can be shaped by heat and pressure to make a permanent design. Relatively durable surface effects can now be obtained on cloth made from cellulosic fibers if it is impregnated with a synthetic resin before it is embossed. The resin reacts with the cellulose to form crosslinks that permanently hold the cloth in the shape of the design.

A calender with at least two rollers is used to emboss cloth. The roller with the engraved design or pattern is made from highly polished steel. The second roller is covered with a soft material such as cotton or wool paper. The engraved design is transferred to the cloth as it is passed between the heated rollers under pressure.

Schreinering produces a highly lustrous surface on cotton or rayon fabrics. To achieve this surface effect, the cloth is passed between special calender bowls. The upper roller, which is heated to a high temperature, is a hollow, highly polished steel roller. It is engraved with very fine, closely spaced, parallel lines that spiral at an angle parallel to the twist in the yarns on the surface of the cloth. The lower roller is much larger in diameter and is

Figure 15.6 This wavy pattern is characteristic of a moiré finish. (*AFF Encyclopedia of Textiles*)

covered with compressed cotton or wool paper. A very high pressure is maintained between the two rollers as the moist cloth is passed between them. This flattens and smooths the fabric, as the impression of the parallel lines on the surface also increases the surface light reflection. Fabrics finished by this process are often used as lining. The effect is not permanent unless resins are applied before the process.

In recent years Schreinering has been used to make the tricot-knit cloth used for lingerie more opaque. Adjustment of the temperature and pressure allows the thermoplastic yarns to be flattened to fill the space between the stitches and reduce luster.

Moiré is a wavy or watered surface appearance (Fig. 15.6) generally applied to ribbed cloth such as taffetas, failles, and bengalines made from silk or man-made fibers. Two layers of the cloth are fed between rollers in a calender using heat, moisture, and pressure to give a bar effect. The pattern emerges as the ribs of one thickness impress an image on the other layer by flattening the ribs. The pattern may be varied by use of an engraved metal roller rather than a smooth one. The moiré effect is achieved because light is reflected from the surface differently by the crushed and uncrushed parts of the cloth.

Cotton and rayon cloth can be given a moiré finish if they are impregnated with a resin before being passed through the calender. The finish is reasonably durable even if it is washed.

Raised Surfaces

Another way of affecting the appearance of cloth is by raising the surface fibers. Light is scattered among the fibers and gives a more diffuse luster to the cloth. There are various techniques of raising surface fibers, three of which we describe below.

Napping is a mechanical process used to raise fibers to the surface of either woven or knitted cloth. The fibers are teased up when the cloth is passed over long, revolving cylinders covered with very fine wire hooks. (In the past, teasel burrs, the dried flower heads of the thistle plant, were used.) Either one or both sides of the cloth may be napped.

Cloth of low-twist, spun yarns made from cotton, rayon, wool, and man-made fibers may be napped. If the nap is left upright, the cloth has a soft, fuzzy appearance; if the nap is pressed flat, the cloth takes on a lustrous appearance. The woven or knitted structure in napped fabrics is generally

(a) (b)

Figure 15.7 A smooth-surfaced worsted wool (a) and a highly napped woolen (b). The napped cloth is warmer since it can trap more air within the raised fibers. (*AFF Encyclopedia of Textiles*)

obscured. This process gives more warmth to the wearer because napped fabrics trap air and provide better insulation. Napped and untreated cloths are compared in Fig. 15.7.

Napped cloths include flannel, flannelette, wool broadcloth, suede cloth, blankets, and a variety of other materials used in apparel and outerwear.

In *gigging*, wool fabrics are saturated with water and the surface is gently napped. Upon drying, the fibers tend to shrink and curl; a lustrous appearance is then achieved when the material is brushed.

Sanding is a process used to produce a fine, suedelike, textured surface on cloth. The material is passed through a set of rollers similar to a friction calender; one of the rollers is covered by a very fine-grit sandpaper. In fabrics made with spun yarns, the sandpaper gently raises short fiber ends. In cloth made of filament yarns, the sandpaper abrades and raises some of the surface filaments. This technique is particularly suited to producing napped surfaces on goods made from filament yarns.

Fluorescent Brighteners

Fluorescent brighteners are chemical compounds applied to cloth to increase its apparent whiteness or brightness. They work by absorbing invisible ultraviolet radiation and emitting it as visible light. Thus, more light is reflected from the surface of the cloth than would normally be the case, and the cloth looks brighter. These compounds are often referred to as "optical bleaches" or "optical whiteners," but *fluorescent* more precisely describes their action, and *fluorescent brightener* is the preferred terminology used in the Colour Index.

Fluorescent brighteners may be added during bleaching or other steps in the finishing process, as well as before or during the application of color. When they are added depends upon the particular fiber or blend of fibers. Very pleasing effects can be obtained by the careful uses of fluorescent brighteners and dyes.

Some detergents and home-laundry aids that are formulated with fluorescent brighteners can significantly alter pastel colors of cellulose or nylon fabrics laundered with these products.

INSPECTION AND QUALITY CONTROL

Imperfections in finished goods must be detected at appropriate steps in the finishing process. Once detected, they must be corrected as a part of quality control. If the imperfection cannot be satisfactorily corrected, the cloth must be removed from the production line. The following three inspection steps are utilized in the manufacturing process.

The examination of cloth to record defects or for quality classification is called *perching*. A highly skilled operator observes the cloth as it moves rapidly over a light box. As defects are noted, he or she stops the movement of the cloth and marks the defect. The cloth may be returned to the production line for corrective action or it may be moved. In some larger mills, highly sophisticated, computer-controlled laser detection systems are being used in place of human operators.

Burling is the removal of knots, burrs, and surplus hanging threads from the surface of cloth. This inspection process is carried out by hand by inspectors who clip and pick out the defects. Initially, the term was applied to wool, but it is now used for other fibers as well.

Actual repairs made in cloth following inspection are referred to as *mending*. If the defect is still visible after the correction process, the cloth may be classed as a "second."

SUMMARY

Griege goods, as they come from the knitter or weaver, are not suited for consumer use. They are treated by the converter to improve esthetics, comfort, and durability, and to provide enhanced performance characteristics. General finishes are intended to clean the cloth, give it shape, improve the hand or texture, and impart special surface characteristics. Many general finishes have been devised to enhance the properties of different fabrics made from different fibers. In general, though, all cloth must be cleaned, shaped, ironed, and inspected before sale.

REVIEW QUESTIONS

1. What would be the effect of a sodium hydroxide scour on cloths made of wool? Cotton? Nylon?
2. Wool is often carbonized and cotton is often singed. Why do we not carbonize cotton or singe wool?

3. In what ways does mercerization improve the properties of cloth made from cotton?

4. How do tentering and heat setting affect cloths made of cotton? Silk? Polyester? Acrylic?

5. Desizing is often one of the first finishing steps, yet many cloths are sized in later finishing steps. Explain why a manufacturer might first de-size and then size a cloth.

6. What is the mechanism by which softeners affect the hand of fabrics?

7. Which of the following plain-weave cloths would be improved by shearing: 100 percent cotton, 100 percent wool, 100 percent acrylic?

8. Flannelette is a cotton cloth with a napped surface. How does napping change the properties of the cloth? Where is flannelette likely to be used?

9. How would glazing affect the performance of a 100 percent cotton chino cloth?

10. How would fulling affect the performance of a 100 percent wool jersey-knit cloth?

ACTIVITIES

The effect of mercerization on cotton fabrics can be studied by soaking a cotton cloth in a 12 percent solution of cold sodium hydroxide. (*Caution: Sodium hydroxide can cause chemical burns. Use eye protection and gloves.*)

Cut a sample of 100 percent cotton plain weave measuring 20×20 cm (8×8 in). Mark the boundaries of a 15×15 cm (6×6 in) square and sew X marks at the boundaries with sewing thread. Place the cloth in a tray or beaker containing the solution and soak it for 30 minutes. The temperature of the solution should be kept constant—within $2°$C ($36°$F) at some value between 5 and $15°$C (40 to $60°$F). Rinse for 10 minutes under running water.

Measure the dimensions of the marked square. Is it the same as at the start? Is the luster of the cloth the same?

Remove a yarn from the filling of the cloth. Separate it into fibers and observe them under a microscope. Compare to untreated fibers. How do they differ?

16

functional finishes

Functional finishes are chemical and mechanical processes which impart to fabrics specific performance properties they normally do not have. These finishes may, for example, make cloth water-repellent, flame-resistant, or immune to bacteria and fungi. The functional finishes are usually more durable than the general finishes, since consumers expect the additional performance properties for which they have paid to be retained by the material or garment throughout its life.

In this chapter we will consider the following types of functional finishes:

1. Finishes that improve comfort
2. Finishes that improve ease of maintenance
3. Finishes that improve durability
4. Finishes that provide environmental protection or improved safety
5. Finishes that provide biological resistance

FINISHES THAT IMPROVE COMFORT

Softeners

The term *softener* is difficult to define because it represents a chemical finish that may function in several ways. The primary function of a softener is

to improve or enhance the hand or feel of cloth and make it more appealing to to the consumer. In addition, softeners may improve the abrasion resistance of cloth is serving as a lubricant, and may affect the absorbency and the antistatic properties of cloth. Softeners are also used to increase the extensibility and recovery properties of finished items such as hosiery (half-hose and pantyhose), stretch covers, and "skinny-rib" constructions by improving the surface lubrication and pliability of individual fibers. Softeners are applied to sewing thread as lubricant to reduce friction between cloth and needle in high-speed sewing operations, thus preventing the needle from becoming too hot and melting the fibers (a problem which results in poor seam strength).

Softeners are of particular importance in improving the hand of cotton, rayon, acetate, and most man-made fibers. Since cloth made from wool and silk usually has a pleasing hand, softeners may not be needed for these materials. Generally, softeners are used to "upgrade" cloth, and in this role are probably as important in textile finishing as detergents or dyeing assistants.

To be effective as a finish, softeners must have certain properties. They must not cause a change in the shade of the dyed cloth or cause the cloth to look dull; they must not impart hygroscopic properties to the cloth—that is, make it tend to pick up moisture and feel wet or damp; they must not develop odors during storage and use; they must be heat-stable; they must be durable throughout laundering; they must not cause skin irritation or dermatitis when in contact with the human skin; they must be compatible with other finishes applied to the cloth; and they must not have a corrosive effect on the equipment used to apply them to the cloth.

Softeners may be divided into five main classes: (1) anionic, (2) cationic, (3) nonionic, (4) emulsions, and (5) solvent-soluble.

Anionic softeners, used for cotton and rayon cloth, are usually sulfated oils and fatty acid esters. Their softening effect is due to the negatively charged anion that is formed when the oils and fats are sulfated. Their major problem is that they tend to develop an odor, particularly if the cloth is stored, because oils and fats are easily oxidized and become rancid. To counteract this problem, anti-oxidants are added to the finishing agent. Sulfated fatty alcohols are superior to sulfated oils and fatty esters because they do not develop an odor upon storage.

Cationic softeners, used on both natural and man-made fibers, are chemical compounds with a positive charge. They consist of materials such as long-chain amides, imidazolidines, and quaternary nitrogen compounds. As well as being softeners, cationics also give good antistatic properties to cloth. Because of their lubricating properties, they also improve tear strength and abrasion resistance. Cationic softeners are not compatible with anionic agents such as detergents or wetting agents that may be used in processing cloth. Such agents must be thoroughly rinsed from the cloth before cationic softeners can be applied. Cationic softeners may cause a change of shade on dyed fabrics. Home-laundry softeners are generally of the quaternary nitrogen type, which provide a high degree of softness for general use.

The most widely used *nonionic* softeners are fatty esters of palmatic or

stearic acid with alcohols or polyglycols. These softeners do not have a charge; their softening effect is due to the long-chain fatty acid. Nonionic softeners not only give a soft hand; they are also good lubricants and impart antistatic properties. There is no problem with odor development or discoloration of cloth. They are generally water-soluble or water-dispersable and most of them are highly compatible with other finishing agents.

Emulsion-type softeners may be anionic, cationic, or nonionic, but the most commonly used are nonionic. These materials are not water-soluble and must be suspended in a finely dispersed form in some solvent. The emulsion must be stable at all dilutions and temperatures encountered in the finishing process. Waxes, polyethylene, and silicones are the major softeners in this class. They serve to improve tear strength, abrasion resistance, and sewing properties of the cloth. Emulsion-type softeners are often used with cross-linking resins in the treatment to make durable-press cloth. Silicones are outstanding as softeners and lubricating agents.

Finally, there is the class of *solvent-soluble* softeners that must be soluble in organic solvents. Although solvent finishing is still in the early stages of development, it is used to a limited extent in the finishing of knit goods. Quaternary nitrogen compounds that are soluble in chlorinated solvents are used. Higher concentrations are required to impart a soft hand.

Softeners may be applied in conjunction with other finishing agents or processes. In durable-press resin formulations, they are applied by the pad-dry-cure process. They may be applied during dyeing or in the final rinse after dyeing or printing. They may be added to the solvent-cleaning process in solvent finishing after scouring. The add-on of softener is usually less than 1 percent; however, the amount is dependent upon the application process, the particular softener selected, and the desired softening effect.

Antistatic Finishes

You can understand *electrostatic charges* by means of a very simple experiment. Place a small piece of tissue paper, about ½ cm (¼ in) square on a table top. Brush your hair a few times and bring the brush close to the paper. Usually, the paper will jump up to the brush, attracted by the electrostatic charges formed by the friction between your hair and the brush. This phenomenon was discovered by Thales of Greece in the sixth century B.C. It has since been shown that when unlike materials are rubbed together, electrons are transferred from one to the other. The material that gains electrons becomes negatively charged, while the material that gives up electrons becomes positively charged.

Negatively charged objects try to give up their excess electrons to neutral (uncharged) bodies, while positively charged materials try to extract electrons from neutral bodies. In either case, if the amount of transferred charge is high, the neutralization of the charged body is accompanied by a spark and a discernible snapping sound. When yours is the charged body, either from wind friction creating charges on your clothes or from walking across a large area of carpet, the transfer of electrons can result in an unpleasant shock.

Static electricity is not a problem with materials that are good conductors, since charges do not accumulate on the surface of such materials. Metals and impure water are examples of good conductors. Static electricity only becomes a problem on materials that are poor conductors or insulators. Most man-made fibers fall into this class. The problem is intensified under conditions of low humidity, when moisture in the surrounding air is not sufficient to dissipate the charges built up on the fibers.

The natural fibers, such as cotton, linen, wool, and silk, have *hydrophilic* surfaces and therefore absorb enough water to prevent noticeable static buildup, except when the humidity is very low. Man-made fibers, such as nylon, polyester, acrylic, and olefin, with *hydrophobic* surfaces, have a greater tendency to retain high electric charges.

In consumer use, static electricity causes the clinging of slips to dresses and sweaters, the spark and shock experienced after walking across a nylon carpet, the attraction of lint and fibers to shoes and pants legs, and the attraction of dirt and soil to cloth. The problem can be hazardous in the operating room of a hospital, where a static electric spark may ignite combustible or explosive vapors. Since it is impossible to prevent the generation of electrostatic charges on the surface of fibers, it is necessary to improve the charge dissipation process so that the charge is conducted away from the fiber. This is done by using chemical finishes called antistatic agents or *antistats*, or by copolymerizing hydrophilic monomers with the fibers.

These finishes make the surface of the material more conductive so that electrostatic charges will be dissipated. During processing, they function as a lubricant to prevent or reduce the generation of charges by rubbing or friction. Since the major difference between the antistatic properties of natural and man-made fibers is due to their difference in moisture regain, antistatic finishes are used to increase the moisture content of man-made fibers. It has also been shown that electrolytes (positively or negatively charged ions) will increase the conductivity and the efficiency of antistatic agents in preventing and/or dissipating electrostatic charges. Thus, many commercially available antistat finishes not only make the cloth hydrophilic, but contain electrolytes as well.

Antistatic finishes may be either durable or nondurable. If the finish is to function solely as a processing aid which will be removed in scouring, nondurable antistats are used. Durable antistats should be able to withstand laundering and dry-cleaning and are generally expected to function for the life of the garment.

Nondurable antistats are organic compounds that are surface-active agents. They are similar to those chemicals used as softeners and lubricants. In fact, these chemicals may have dual functions. Nondurable antistats are *nonionic, anionic, cationic,* and *amphoteric.* Nonionic antistats function by absorbing moisture and increasing the conductance of the material. Anionic, cationic, and amphoteric antistats have nonpolar (hydrophobic) groups on one end of the molecule and strongly polar (hydrophilic) groups at the other. The nonpolar end is thought to be adsorbed on the surface of the fiber so that

the polar groups form an outer layer around the fiber. The polar surface layer gives the material a conductive surface.

Nondurable *anionic antistats* dissociate in water to give a positive and negative ion. The active portion of the molecule is the negative ion or *anion*. Four major classes of compounds are included in this group: (1) fatty acid salts; (2) sulfates of fatty acids, fatty acid esters, triglycerides, fatty alcohols, fatty alcohol ethoxylates, and fatty amides; (3) phosphate esters of alcohols, polyoxyethylenated aliphatic alcohols, and polyoxyethylenated alkylphenols; and (4) aliphatic sulfonate salts.

Nondurable *cationic antistats* dissociate in water to give a positive and a negative ion. The active portion of the molecule is the positive ion or *cation*. These chemical agents often function in a dual role as antistat and as softener. These materials are easily adsorbed onto textile fibers because they are positively charged and most fibers have a negative charge. Two classes of chemical compounds are found in this group: organic acid salts of alkylamines, alkylamides, and alkylimidazoles; and quaternary ammonium compounds.

Nondurable *amphoteric antistats* contain both an acidic and a basic group in the molecule and can dissociate into a positively charged or negatively charged active ion depending on the pH of the solution. At a specific pH called the isoelectric point, the compound is neutral because the positive and negative charges are identical. Chemical compounds included in this group are aminocarboxylic acids and betanes.

Nondurable *nonionic antistats* do not dissociate into ions in water. These compounds increase the hydrophilic surface properties of fibers and cloth. The major classes of chemical compounds in this group are ethylene oxide adducts of fatty acids, fatty alcohols, alkylphenols, alkylamines and alkylamides, alkanolamides; polyols or polyglycols such as sorbital and polyethylene glycol; and polyalkylene glycol monoethers. The nonionic antistats are compatible with many fiber finishes and some of them are good lubricants.

Durable antistats are able to survive laundering and dry-cleaning. These finishing agents are usually polymeric electrolytes which self-crosslink to form a network polymer on the surface of the cloth. Combinations of polyamines and polyepoxides have been applied to cloth by a pad-dry or pad-cure process using an appropriate catalyst. The durability of these antistats is dependent upon add-on levels that range from 0.5 to 5.0 percent, based on the weight of the cloth, which will withstand the abrasive action in the washing process. Cloth treated in these antistats may have undesirable properties such as reduction in tenacity and elongation, increased stiffness, harsh hand, and sensitivity to yellowing when heat-set.

Nondurable antistats are generally used to control static electricity encountered in fiber processing and conversion of the fibers into cloth. They are applied to the filaments after extrusion. The incorporation of *internal antistats* in the polymer mix before extrusion is a new approach to solving the problems of static electricity. These will not affect the properties of the polymer other than to provide polar groups that are oriented toward the surface of the fiber, making it more polar or hydrophilic and thus more conductive. Antistats of this type must be effective at low concentrations to

avoid changing polymer properties; they must be thermally stable; they must be compatible with the polymer; and they must be evenly distributed to minimize variations in physical and optical properties following dyeing. Internal antistats must be able to survive processes and chemicals encountered in the manufacturing process; they must also be able to survive laundering and dry-cleaning as well. A variety of internal antistats have been used, but ethylene oxide adducts predominate because they are readily available and may be easily modified for desired characteristics. Internal antistats have been developed for polyamide, polyester, polypropylene, and acrylic fibers. These types of antistats appear to be promising for man-made fibers.

Recently, a new conductive "epitropic" fiber has been introduced. It is said that as little as 0.1 percent, blended with other fibers, can provide adequate static protection. It is made via the incorporation of a carbon dispersion. Fibers of this type are said to have permanent static protection without the loss of desirable mechanical properties. Epitropic fibers are black, but small quantities can be blended with dyed natural or synthetic fibers.

FINISHES THAT IMPROVE EASE OF MAINTENANCE

In this section we will discuss the three most important finishes used to improve the ease of maintenance of fabrics: durable-press, soil-resistant, and water-resistant finishes.

Durable-Press Finishes

The first progress in developing a no-iron fabric was made in England by researchers at the Tootal Broadhurst Lee Company, Ltd., in 1928. Having been assigned to find a process that would prevent cotton from creasing, the scientists succeeded in causing a reaction between phenol and formaldehyde or urea and formaldehyde to form small molecules. They treated cotton with a solution of these chemicals and a catalyst, dried the cloth, and then baked it. The chemicals reacted inside the cotton fibers and formed larger molecules that were not lost upon subsequent washing. The first "no-iron" cotton was the result of this research.

However, no attempt was made to market this product in England. In 1948 American textile manufacturers publicized and marketed the first no-iron garments, which were made from nylon rather than chemically treated cotton. The Americans discovered that by heating nylon cloth to levels at which the fibers became plastic and holding the cloth smooth and flat until it cooled, garments made from this cloth would remain smooth and flat after laundering. These heat-set fabrics with the remarkable no-iron property were enthusiastically accepted. But faults soon became apparent. The early fabrics greyed even though carefully laundered, formed pills which could not be removed without difficulty, and were not very comfortable. These problems stimulated researchers throughout the world to seek methods for imparting durable-press properties to cotton cloth.

Today's accepted method of imparting crease resistance and wrinkle recovery to cotton is essentially that which was discovered in England in 1928. The cloth is treated with chemicals containing at least two groups that are capable of reacting with cellulose in the presence of an appropriate catalyst. In the trade, these chemicals are called *resins*, although the term "pre-condensate" is more suitable. These resins react with the cellulose to form crosslinks in the less crystalline areas of the cellulose.

In the regions of the cellulose that are highly ordered and crystalline, the cellulose molecules are bound firmly together and cannot be penetrated by the resins. However, they are believed to be substantially crease-resistant, because the forces holding the molecules together will pull them back in place if they are deformed or creased. The crosslinks formed by the textile resins in the less crystalline areas of the cellulose act in the same manner, causing the cellulose to "snap back" to its original position. Thus, if the cellulose is crosslinked in the smooth, flat position, it will return to this position after creasing when the wrinkling forces are released. If the cellulose is crosslinked in the creased or deformed position, it will return to the creased position after deformation.

Since cellulose fibers swell when they are wet and collapse when they are dry, it is important that the crosslinks be introduced so that they will allow the cellulose to snap back to its original position under *normal service conditions*. If the cellulose is crosslinked in the highly swollen wet state, it will have good crease recovery in the wet state but little or no crease recovery properties in the dry or collapsed condition, because the crosslinks are not taut in this condition. Therefore, cellulose is crosslinked when it is dry so that it will have crease recovery or crease retention properties under normal use.

Many textile resins have been used to crosslink cellulose. Urea-formaldehyde resins were first used to treat cloth to give it good performance properties. Formaldehyde and urea first were reacted to produce dimethylolurea, the textile resin which was then used to crosslink the cellulose. The crosslinking reaction is similar to that of DMDHEU, discussed below.

Although cloth treated with dimethylolurea has good durable-press properties, this resin causes the cloth to absorb chlorine during hypochlorite bleaching in laundering. The chlorine reacts with free NH groups present in the resin to form chloroamines. These readily decompose under the hot, moist conditions used in ironing to form hydrochloric acid on the cloth and, thus, tender it and cause it to lose strength and to yellow. Thus dimethylolurea resins are only suitable for use on colored cloth that is not meant to be bleached.

A variety of textile resins have been developed to crosslink cellulose and impart durable-press properties. These are all polymethylol compounds formed by the reaction of aldehydes with amines. They include melamine-formaldehyde, dimethylolethyleneurea, urons, and triazones, to name only a few. Over the years, much research has been directed to learning more about how these textile resins work, how to overcome loss of performance properties such as strength and abrasion, and how to improve the treatment conditions so that better cloth with better performance properties can be obtained. Better and more efficient catalysts were developed, softeners to improve the hand of

the products were introduced, and methods to improve strength and abrasion properties of the treated cloth were created.

Today, one of the most widely used textile resin systems is dimethyloldihydroxyethyleneurea (DMDHEU). Since 1963, it has been used in the production of durable-press garments. However, the DMDHEU system will retain chlorine and will cause yellowing and some tendering of the cloth; therefore it is not suitable for use with white cloth, but it is widely used for colored cloth. The DMDHEU system is illustrated in Fig. 16.1.

A textile resin system that can be used satisfactorily with white cloth has been developed at the Southern Regional Research Laboratories in New Orleans. It is generally called a *carbamate*, since its resins are esters of carbamic acid. This system gives excellent wash-and-wear properties and is not chlorine-retentive.

Just as there has been an evolution of textile resins used to treat cellulose to give it durable-press properties, there has been an evolution in two other important areas: design of cloth and application techniques.

Cloth Design It was soon learned that 100 percent cotton cloth was not satisfactory for production of wash-and-wear clothes. Although good wrinkle-resistant properties could be obtained, the loss of strength and abrasion properties was so severe that 100 percent cloth garments often developed holes after the first wearing. Consequently, blends of polyester and cotton or rayon were developed for wash-and-wear clothes. Polyester was blended with the cellulose fiber for its strength and abrasion properties; cellulose provided comfort because of its moisture-absorption properties. Other improvements in both yarn and cloth construction were introduced, and today the major cloth used in durable-press garments is a polyester/cotton blend. Blend levels ranging from 80/20 polyester/cotton to 20/80 polyester cotton can be used.

Figure 16.1 DMDHEU Reacts with an —OH group on each of two cellulosic chains to join them into one large molecule.

The pre-cure process

Figure 16.2 In the precure process, cloth is cured and then made into garments.

The post-cure process

Figure 16.3 In the post-cure process cloth is first made into garments and then cured.

Application Techniques The evolution in application techniques for treating cloth with the resin system to give wash-and-wear properties is equally important. The textile resin systems and catalyst were usually applied to the cloth by a pad-dry-cure technique. In this process (schematically shown in Fig. 16.2) the cloth was dried at a temperature of approximately 30° C (85° F) and then cured for a few minutes at 175 to 180° C (350 to 360° F). This process produced a cloth with good performance properties. The seams of the first wash-and-wear garments puckered when the garments were washed because of cloth distortion during sewing and because of differential shrinkage of sewing thread and cloth. This led to the development of new polyester-core sewing thread and improved techniques in the pad-dry-cure process.

The real breakthrough was made by Koret of California; this company treated cloth made from blends of cotton or rayon and polyester with a textile resin and catalyst using a pad-dry technique that caused little crosslinking of the textile resin. The sensitized cloth was then made into garments which were pressed and cured for 10 to 20 minutes at a high temperature to bring about crosslinking and to permanently fix the resin in the cloth. This post-cure method, now known as the *Koratron process*, is widely used to make durable-press garments.

A second post-cure process (schematially shown in Fig. 16.3) consists of a pad-dry-partial cure of the textile resin in the polyester/cotton cloth in which some crosslinking and permanent fixing of the resin occurs. The partially cured cloth is made into garments that are pressed and then cured in large ovens at high temperatures for a shorter period of time. Changes of shade and yellowing are minimized in this process.

Soil/Stain-Resistant and Soil-Release Finishes

The removal of soils and stains from cloth has always been a problem for consumers. With the growing use of polyester knits, polyester/cotton blends, and durable-press cloth, the problems of staining and soiling have increased, and stain and soil removal has become more difficult. This is particularly true for oily soils and stains. STAINING or SOILING is the wetting and/or adsorption onto the surface of a fabric of a fluid stain or soil to form a film over the surface

of the cloth. STAIN and/or SOIL RELEASE is the removal of the stain or soil from the surface of the fabric by a desorption process. This usually occurs in an aqueous detergent solution. An ideal finish would repel the soil or stain as it comes in contact with the cloth during use, to prevent soiling. If the soil or dirt were to be ground into the cloth during use, the finish would function to make the surface of the cloth more hydrophilic (water-loving) and thus make the soil easy to remove during laundering in an aqueous detergent system.

Cloth may be soiled by three types of materials: (1) fluids, (2) dry particulate matter, and (3) a combination of fluid and particulates. Fluid stains may be borne by oil, water, or a combination of both, and may contain colored dyes or pigments (e.g., lipstick, grape soda, mustard) which may be very difficult to remove from the fabric. Dry particulate matter may consist of clay, carbon black, or other solid particles. Sometimes these particles are held to the material by electrical charges. The combination of fluid and particulate matter is particularly difficult to remove. Dirty motor oil is such a soil. The fluid (oil) contains particulate matter (carbon black formed in the engine) that may be "ground into" the cloth as the oil spreads over the surface.

Stain or soil release usually occurs in an aqueous detergent solution. The major function of the detergent is to lower the surface tension of the water, which is 72 erg/cm^2, so that it is more nearly like the critical surface energy of the cloth, and thereby promote the desorption of the stain or soil. The more hydrophilic (water-loving) the surface of the cloth, the easier to remove stains and soils. Hydrophilic fibers such as cotton or wool have critical surface energies very near the surface tension of water. This means that relatively little soap or detergent is needed to remove soil and stains from cloth made of these fibers. Hydrophobic (water-hating) materials such as polyester and nylon have critical surface energies of about 45 erg/cm^2, so somewhat more detergent is required to reduce the surface tension of the water to enable it to remove the soil or stain.

Why are oily soils and stains so difficult to remove from durable-press cloth? To answer this question, we must look at its surface characteristics. Before the introduction of durable-press, wearing apparel and household items were generally made from cotton, linen, or rayon cloth—these were easy to clean because they were hydrophilic; soil was easily removed in water with a soap or detergent. Cloth made from synthetic fibers or from resin-treated synthetic/cotton blends is used in durable-press garments. The surface of cloth made from synthetic fibers is hydrophobic or oleophilic (oil-loving) rather than hydrophilic. The surface of the resin-treated synthetic/cotton blends is made less hydrophilic and more hydrophobic by the resin treatment. Since the surface of the cloth is more like oil than water, oily stains and/or soils can easily spread over the surface of the cloth and wet the surface. Once the stain penetrates the surface of the fibers, it is very difficult to remove by washing it in water with a detergent. The water/detergent system cannot get in to remove the soil from the surface of a cloth that is hydrophobic.

Soil/stain-resistant finishes function by making the surface of the cloth difficult to wet. This prevents the foreign matter from spreading on the

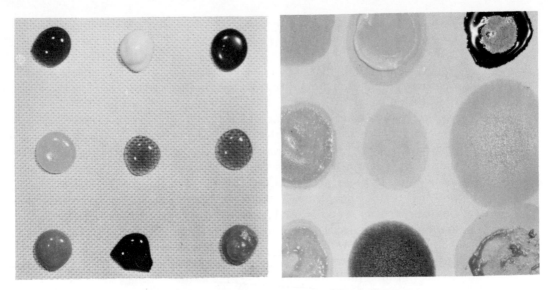

Figure 16.4 (*Left*) Drops of various substances do not penetrate fabric treated with a stain-resistant finish. (*Right*) The same substances soak into an untreated cloth. (*3-M Company*)

surface of the cloth. A thin layer of a chemical finish is applied to the surface of the cloth; this lowers the critical surface energy of the material. Consequently, any fluid will remain as a drop on the surface and will not spread (Fig. 16.4). Fluorochemical finishing agents are the most effective materials known for making durable-press fabrics soil- and stain-resistant. Silicone polymers, hydrocarbons (waxlike compounds), and pyridinium compounds are also effective in preventing the wetting of the cloth surface by fluid, particularly water-borne stains. (These materials are also used as water-repellents.)

The fluorocarbons are the most effective soil- and stain-resistant materials; when properly applied, they also have the greatest resistance to removal by laundering and dry-cleaning. Silicone finishes have excellent resistance to water-borne soils, but are not as effective as the fluorocarbons in resisting oil-borne stains. They are also more susceptible to dry-cleaning fluids. Hydrocarbon finishes have the lowest resistance to oil-borne stains, but provide satisfactory protection against water-borne stains. They generally do not survive dry-cleaning, but may last through several washings. (The consumer should also note that the most effective finishes are the most costly.)

Soil-release finishes make the critical surface energy of the cloth higher. This is particularly true for the polyester component in polyester/cotton blends used in permanent press. If the surface of the cloth is more hydrophilic, the stain or soil is easier to remove. Chemicals used to encourage the release of soils and stains are fluorocarbons, acrylate emulsions, and other hydrophilic polymers. These materials may also improve the softness and hand of the cloth, promote wicking, and decrease the static electricity problem by functioning as *antistats*.

The ideal finish would be one that would function both as a stain- or

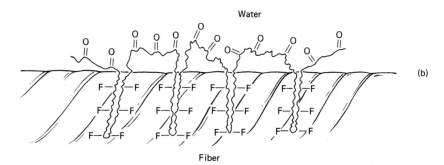

Figure 16.5 The structure of a fluorocarbon finish (a) at the fiber-air interface and (b) at the fiber-water interface. Note that the finish flip-flops.

soil-resistant finish and as a soil-release finish. A finish of this type was developed by the 3M Co. several years ago. It is a block copolymer which contains two distinctly different segments that make up the polymer molecule. The fluorochemical segment (F) gives the cloth soil- and stain-resistant properties during use in the air environment. The second segment of the polymer (H) is hydrophilic. In water, it gives the cloth a more hydrophilic surface and functions as a soil-release agent during laundering.

The surface orientations of the two segments of the copolymer in air and aqueous environments are illustrated in Fig. 16.5. In effect, the surface orientation of the finish does a "flip-flop" as it changes from a soil/stain-resistant finish to a soil-release finish. After the cloth has been laundered and dried, the molecules flip back to their original orientation. This finish may be applied to cloth made from polyester/cotton blends that have been treated with a resin and a catalyst. It is also useful for other artificial fibers and fiber blends.

Waterproof and Water-Repellent Finishes

There are two types of cloth that will provide protection against exposure to rain. These cloths are referred to as WATERPROOF or WATER-REPELLENT. A waterproof cloth is one in which the open spaces (pores) between

TABLE 16.1 Comparison of Waterproof and Water-Repellent Cloth

Property	Waterproof	Water Repellent
Pores	Filled	Unfilled
Permeability:		
Water vapor	Very low	Low to high
Air	Low	Usually high
Resistance to water	Extremely resistant to wetting and to passage of water through the cloth	Resistant to wetting by a drop of water and to the spreading of the water over the surface of the cloth
Wearer comfort	Very uncomfortable due to excessive perspiration trapped between the wearer and cloth	Comfortable because the cloth is permeable to air and water vapor
Uses	Tents, shower curtains, umbrellas	Raincoats, rain jackets, shower curtains

the warp and filling yarns and between the fibers is filled with substances which give the cloth a continuous water-resistant surface. Early barrier materials used were rubber and oxidized oils. Today, thin films of synthetic polymers are used. Such a cloth has little if any vapor or air permeability. A water-repellent cloth is one in which the yarns are coated with a hydrophobic (water-hating) compound, but the pores are not filled. The cloth is permeable to water vapor and air. These two types are contrasted in Table 16.1.

The ability of a surface, whether waterproof or water-repellent, to resist wetting is a function of the chemical nature of the surface, the surface roughness, the porosity of the surface, and the presence of other water molecules on the surface. When a drop of water comes into contact with a solid surface, it may wet the surface (completely spread over the surface), partially wet the surface, or not wet the surface. The drop of water may assume any of the orientations illustrated in Fig. 16.6 or any intermediate orientation from complete wetting to complete nonwetting. The angle of contact, θ, formed by

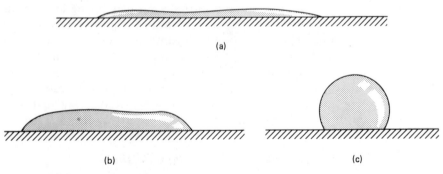

Figure 16.6 Wetting of a surface by a liquid drop: (a) wetting, (b) partial wetting, (c) not wetting.

the tangent to the drop at the point of contact with the surface is related to the repellency of the surface. If the contact angle, θ, is less than 90°, the surface is wettable. If the contact angle is larger than 90°, the surface is nonwettable or repellent.

The droplet in Fig. 16.6c is one in which the attraction between water molecules is greater than the attraction between the water molecules and the surface upon which the drop is resting. SURFACE TENSION, the force that results from the attraction of like molecules, causes the water to form itself into a sphere. The droplet in Fig. 16.6a is one in which the attraction of the water molecules for each other is less than their attraction for the surface. In this case, surface tension cannot hold the droplet together and the liquid spreads over the surface on which it is resting.

Cloth is different from the flat, smooth, continuous surface shown in Fig. 16.6. Because of its structure, cloth usually has a very porous, screenlike surface. If the angle of contact of a drop of water on the surface of cloth is much larger than 90°, it will assume the orientation shown in Fig. 16.7a and will not wet or spread on the surface. If the angle of contact of the drop of water on the cloth is much smaller than 90°, the water will wet the surface and spread. This is illustrated in Fig. 16.7b. It will also penetrate between the yarns.

Water-repellent cloth, unlike waterproof cloth, will not provide protection indefinitely. The finish will lose some of its ability to prevent wetting because it may be abraded by wear and/or removed in cleaning; or new untreated surfaces of the fibers may be exposed under use conditions that will not repel water; or the surface geometry of the cloth may change, opening the pores of the cloth and allowing water to penetrate. Closely woven cloth made from tightly twisted yarns is easier to make water-repellent than cloths with looser structures.

In early attempts to make water-repellent cloth, waxes or a combination of waxes and metallic soaps were used to treat the cloth. But these materials were removed whenever the cloth was laundered. In the 1930s, pyridinium-type treatments were used for cotton cloth; even though they had greater durability, they were still lost after several launderings.

Stearamidomethylpyridinium chloride is used commercially as a water-repellent chemical finish for cotton. It is applied to the cloth from an aqueous emulsion by a pad-dry-cure technique. The reaction with cellulose gives a stearamidomethylether of cellulose. The water repellency of the cellulose is due to chemically bound stearamidomethyl groups as well as to deposited stearamidomethyl compounds that are not reacted with the cellulose.

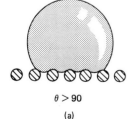

$\theta > 90$

(a)

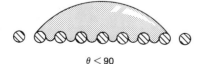

$\theta < 90$

(b)

Figure 16.7 Drop of water on cloth: (a) not wetting (b) wetting.

The long-chain hydrocarbons are hydrophobic and change the surface of the cotton to make it less attractive to water. However, since they do not fill the pores of the cloth, comfort is not greatly affected. On the other hand, a heavy rain will eventually wet the fabric. In addition, repeated laundering and dry-cleaning will remove the water-repellents.

Other systems such as methylolstearmide and methylenedistearamide were used alone or in conjunction with resins such as urea formaldehyde or melamineformaldehyde to make durable, water-repellent cloth. However, these types of treatments are subject to the same shortcomings as the pyridinium-type treatments.

The next major development in water-repellents was the introduction of the silicone water-repellents. These polymeric compounds impart durable water repellency and a unique, soft hand to cloth. They are supplied as emulsions of copolymers or mixtures of two different silicone polymers, poly(methylsiloxane) and poly(dimethylsiloxane), whose repeat units are shown in Fig. 16.8. They are applied to the cloth by a pad-dry-cure process to give a 1 to 1.5 percent silicone pickup. The silicone water-repellents are not chemically bonded to the fibers, but form a thin film around each fiber and give the entire cloth resistance to wetting by water. They are durable because the cured film is insoluble in both solvents and water. However, the temperature and agitation encountered in laundering may cause the film to "break up" due to fiber swelling and abrasion and seriously impair its resistance to wetting.

This problem with silicone finishes was minimized by developing a method for covalently bonding the film to the cotton. This method involved the design of a bifunctional coupling agent which contains silanol groups ($-SiOH$) for condensation with siloxane polymers and the amidomethylpyridinium salt to react with cellulose and covalently bond the water-repellent to the cellulose. This bifunctionality permits the coupling agent to join the siloxane water-repellent permanently to the cotton. Figure 16.9 shows the structure after reaction or coupling has taken place. Silicone water-repellent finishes of this type have good laundry durability. This silicone system may be applied simultaneously with crease-resistant resins for improved tear strength, abrasion resistance, and wrinkle recovery.

Figure 16.8 Typical silicones: (a) poly-(methylsiloxane); (b) poly(dimethylsiloxane).

(a)

(b)

Figure 16.9 Improved silicone water-repellent finish. The poly(methylsiloxane) is coupled to the cellulose.

The late 1950s introduction of fluorochemical textile finishes that imparted both oil- and water-repellent properties to cloth was an important development in durable water-repellent finishes. These finishes are used at add-ons of 1 percent or less to impart oil- and water-repellent properties to cotton and cotton/blend cloth. The durability of these finishes to laundry and dry-cleaning improves directly with add-ons up to 2 percent or more, but the added cost usually cannot be justified. Fluorochemical polymers such as the one shown in Fig. 16.5 will give water and oil repellency when properly applied to cloth. These materials are adsorbed on the surface of the cloth to form a thin film. They may be applied with resins that improve the wrinkle-recovery properties of the cloth, but in this case softeners must also be used to improve the hand of the fabric. Silicone softeners and water-repellents cannot be used with these fluorochemical finishes because they are extremely effective in reducing the oil-repellency properties of the fluorochemical finishes even when present in trace amounts.

Fluorochemical oil- and water-repellent finishes can be combined with pyridinium- or stearamide-type water-repellents. Finishes of this type, developed by the U.S. Army, combined fluorochemical and pyridinium water repellents and were called *Quarpel*. Cloth treated with this type of finish retains both its oil- and water-repellency properties after laundering. The physical properties of the treated cloth are good. The use of fluorochemicals in conjunction with water-repellents of the pyridinium or stearamide type appears to be standard practice today.

The major problem of water-repellent finishes is still one of durability to laundering and dry-cleaning. Current washing and dry-cleaning practices do not completely remove detergents from cloth, so the retention of durable water-repellent properties in the presence of detergents is difficult. Initially, the water-repellent properties of raincoats are very good but after several renovation procedures, they no longer resist wetting and must be retreated.

FINISHES THAT IMPROVE DURABILITY

Three of the more important finishes intended to improve the durability of fabrics are (1) stabilization finishes that improve resistance to both shrinking and stretching, (2) abrasion-resistant finishes that protect the fabric from being rubbed away, and (3) anti-pilling finishes that help prevent the appearance of little balls of fuzz and fiber on the surface of fabrics. These finishes are discussed below.

Stabilization Finishes

The ability of a garment to maintain its shape and size during normal use is an important performance characteristic. Shape and size retention insures that the garment will continue to fit (assuming no change in the size of the wearer) and that the comfort and esthetic properties based on fit will be retained. Consumers often ask, "Will it shrink?" They should also ask, "Will

TABLE 16.2 Reduction in Size of Jeans at Different Shrinkages

Original Size	Percent Shrinkage				
	1	2	3	4	5
Waist (26 inches)	$1/4''$	$1/4''$	$3/4''$	$1''$	$1^1/4''$
Outside leg (50 inches)	$1/2''$	$1''$	$1^1/2''$	$2''$	$2^1/2''$
Hip (36 inches)	$1/3''$	$3/4''$	$1''$	$1^1/2''$	$1^3/4''$

it stretch?" Either process—shrinking or stretching—will result in loss of shape and size and will lead to consumer dissatisfaction. Even if the garment still looks new, if it doesn't fit, it won't be worn and its wear life will have come to an end. Stabilization finishes control both shrinkage and stretching.

The shape and size retention of garments is related directly to the dimensional stability of the original cloth. In turn, the stability of the cloth is dependent upon the physical and chemical properties and surface characteristics of the fiber, the friction between fibers and yarns, and the geometry of the cloth. All cloth must be dimensionally stabilized by mechanical means, by chemical or resin treatments to maintain stretching and shrinkage within acceptable limits, or by both mechanical and chemical modification of the fibers. The importance of dimensional stability is illustrated in Table 16.2 for a pair of jeans. Note that a shrinkage of 2 to 5 percent will shorten the length by as much as 1 to 2½ inches, and will reduce the hip and waist measurements appreciably. Such changes noticeably affect the fit, comfort, and appearance of the jeans.

There are three distinct types of shrinkage: relaxation shrinkage, progressive shrinkage, and felting shrinkage. RELAXATION SHRINKAGE is that which occurs during the first wet-cleaning of cloth. It is generally associated with cloth made from cellulosic fibers, but may be a problem with cloth made from other fibers, especially wool. This type of shrinkage is usually encountered in laundering, but it can occur in dry-cleaning if a wet process is used.

Relaxation shrinkage results from two processes: (1) the release of temporary set resulting from stretching the wet cloth and drying it in the stretched or extended state during manufacturing, and (2) the swelling of fibers in warp and filling yarns upon wetting.

The major portion of relaxation shrinkage is due to the release of the temporary set given the cloth during manufacture and general finishing. The cloth becomes set because it is processed wet, generally under tension. This tension causes the cloth to be stretched in the wet state to a dimension larger than it would normally have. After drying in the stretched condition, the cloth maintains its size and shape until it is again wetted. When the cloth is moistened without tension, it relaxes and returns to its normal dimensions. It is not possible to wet, stretch, and iron garments made from this cloth back to the original size.

The second cause of relaxation shrinkage is a bit more complex. When the fibers that make up the warp and filling yarns are wetted, they take up water and swell. As they swell, the yarns become thicker and shorter. The cloth, in turn, shrinks as a result of the changes in the yarns. The shrinkage of the cloth allows the crimp in the yarns to increase. When the cloth dries without tension, the compressed yarns are unable to return to their original dimensions and the cloth has shrunk in size.

PROGRESSIVE SHRINKAGE is the kind that occurs upon repeated laundering or cleaning and drying of cloth. This type of shrinkage occurs in most types of cloth except those made from animal-hair fibers. As in relaxation shrinkage, progressive shrinkage is often associated with cloth made from cellulosic fibers and is most often encountered in laundering. Cloth made from viscose rayon is particularly subject to this type of shrinkage. Progressive shrinkage is due to the thickening and swelling of fibers and yarns in a cloth; this results in an increase in crimp of the warp and filling yarns. It is similar to the second mechanism of relaxation shrinkage, but does not cause as dramatic a reduction in length. After a cloth has been laundered or cleaned several times, progressive shrinkage usually ceases.

FELTING SHRINKAGE is characteristic of cloth made from animal-hair fibers and occurs as a result of the unique felting properties of these fibers. The mechanism of felting shrinkage is very different from that of relaxation shrinkage. The two types are contrasted in Table 16.3.

Felting shrinkage occurs because the rough, scaly surface of animal hair fibers causes them to become entangled when they are washed. The combination of heat, water, agitation, a soap or other cleaning agent, and pressure during wringing or spin drying forces the fibers together. As a result, cloth made from these fibers becomes thick and more compact as the fibers become more and more entangled, and shrinkage occurs. Wool cloth is particularly subject to this type of shrinkage.

TABLE 16.3 Classification of Shrinkage Types

	Relaxation Shrinkage	*Progressive and Felting Shrinkage*
Characteristics	Rapid Nonprogressive Sometimes restorable (in whole or in part) Little change in appearance	Relatively slow Progressive Nonrestorable Considerable change in appearance (usually adverse)
Caused by	Mechanical stress, resulting in strained fabric	Felting property of wool fibers or swelling of cellulosic fibers
Responsive to	Mechanical relaxation Setting process	Shrink-resist process (usually modification of the fiber by chemical reaction or by addition of polymer)

The methods used to stabilize fabrics vary with fiber content. In general, they consist of mechanical, chemical, or combined mechanical/chemical treatments. Sometimes stabilization is a byproduct of other types of functional finishes, such as durable-press, water-repellent, and flame-retardant finishes.

Mechanical Methods of Stabilization

The simplest method of stabilizing a cloth is to relax the yarn tension and reduce the spacing between yarns by a purely mechanical treatment. The compressed yarns will not tend to move closer during subsequent cleaning. Such treatments are designed to control or eliminate both relaxation and progressive shrinkage. At home, the consumer attempts to preshrink cloth by thoroughly wetting it and ironing it without stretching before cutting and sewing the material.

In a finishing plant, wet cloth may be stabilized by being fed without tension into a tenter frame and then dried. This technique is suited to nonthermoplastic fibers, but does not completely eliminate relaxation shrinkage because of the difficulty of keeping the cloth completely slack during processing. Cloth made from thermoplastic fibers is stabilized by heat-setting during finishing. The length and width dimensions are adjusted in a tenter frame and the cloth is heated. Heat-setting releases the strains imposed during processing and permanently sets the cloth at the pre-determined size. Since the tension has been removed, relaxation shrinkage is eliminated. Because these fibers do not swell to any appreciable extent in water, progressive shrinkage is not a problem. The dimensions of the cloth will be maintained as long as the cloth is not subjected to temperatures higher than the heat-setting temperature.

The most satisfactory mechanical finishing technique for cloth made from cellulosic fibers utilizes the concept of COMPRESSIVE SHRINKAGE. This concept of preshrinking cloth is the basis of the *Sanforizing* and *Sanforset* processes in the United States and the *Rigmel* process in England. Cloth preshrunk by either of these two finishing methods can be guaranteed to have a progressive shrinkage not to exceed 1 percent in either the warp or filling directions. The Sanforizing process was the first stabilization method for cloth that could meet the 1938 Federal Trade Commission ruling of a guaranteed progressive shrinkage of 1 percent or less.

Before cloth can be stabilized by the compressive shrinkage technique, a sample of the cloth must be washed by standard test methods designed to indicate the maximum shrinkage expected during the useful life of the cloth. The shrinkage of the cloth is measured and the result used to determine how much the cloth will be preshrunk or compressed. In the Sanforizing process, the cloth is straightened between rollers to remove wrinkles and then wet by water or steam to relax the yarns. The fabric is then passed through a tenter frame, where it is pulled from side to side in the presence of steam to release the tension on the warp yarns and to obtain a predetermined shrinkage in the warp, or lengthwise direction. The filling yarns are stretched in the process so that the fillwise direction of the cloth must be adjusted to the predetermined measurement.

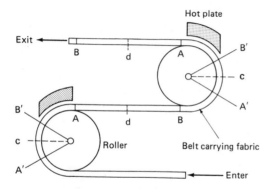

Hot plate

Exit ←

Figure 16.10 Schematic of the shrinking process. Note that the cloth is compressed on both sides.

The cloth is smoothed and passed into the compressive-shrinkage machine shown in Fig. 16.10. The machine consists of a roller covered with a thick blanket or a thick rubber belt. The outer surface of the blanket or belt is stretched as it passes around the roller. The damp cloth adheres to the blanket, which contracts as it moves to the flat position at *d*. Although the blanket or belt is stretched as it moves around the roller, the cloth is not. When the blanket relaxes, the cloth is compressed and crinkles such that the distance between points A and B at d is less than the distance between points A' and B' at *c*. These crinkles are pressed into the cloth by a hot metal plate. The result is that the cloth has been shrunk in both the warp and filling directions to a predetermined dimension so that it will not progressively shrink more than the amount given on the label, and relaxation shrinkage has been eliminated.

Chemical Methods of Stabilization

The cellulosic fibers—particularly cotton and rayon—and wool can be stabilized by chemical treatment alone. Such a treatment may consist of absorption of a crosslinking agent into the fiber, surface application of a resin, or modification of the fiber surface.

Rayon and cotton cloth, or fabrics made from blends of cellulosics and other fibers may be stabilized by a pad-dry-cure process. This procedure consists of immersing the cloth in a solution containing the crosslinking agent and squeezing out excess solution between rollers (*padding*), heating the cloth to remove the water (*drying*), and heating at high temperatures to activate the crosslinking agent (*curing*). The crosslinking agent may differ depending upon the fibers used and the performance properties required. Figure 16.1 (p. 297) shows a typical process in which dimethyloldihydroxy-ethyleneurea (DMDHEU) is used to crosslink rayon or cotton. Note that mechanical stabilization is not required.

Combined Mechanical and Chemical Methods of Stabilization

For materials that are difficult to stabilize by only a mechanical treatment, a combined chemical and mechanical finish may be used. This technique is particularly well suited to rayon, which is difficult to stabilize by mechanical means alone, although many fibers may be treated this way. In a typical process, stabilization is accomplished by treating rayon cloth with low levels of formaldehyde, drying and passing the cloth through a compressive

309

shrinkage machine, and then curing the mechanically stabilized cloth at elevated temperatures for a few minutes. The formaldehyde forms crosslinks within the cellulose, which permanently sets the cloth to the dimension achieved in the mechanical process.

The use of glyoxal instead of formaldehyde in the above treatment is the basis of the *Sanforset* process used for rayons. The cellulose is crosslinked by the glyoxal in a manner similar to that when formaldehyde is used. Either method may be used on any cellulosic material.

The stabilization of open-width knitted cloth containing substantial amounts of cellulosic fiber can be accomplished by the *Micrex process*, another form of combined mechanical/chemical treatment. The cloth is padded with a resin, dried, compressively shrunk and cured, usually by infrared radiation. The resin forms a coating on the surface of the fibers and yarns, which prevents the further relaxation or stretching of the cloth during use. Cloth treated by this process is said to shrink less than 1 percent when laundered.

The mechanical treatments cause the least reduction in strength, hand, and comfort properties, but cannot always stabilize the cloth. The chemical treatments generally provide the highest level of stabilization, but at the cost of reducing fabric strength and creating a harsh hand. The combined mechanical/chemical treatments tend to give the best combination of stabilization and durability, but at the highest price.

Chemical Stabilization of Wool

Several different chemical treatments have been used to stabilize wool cloth and prevent undesirable felting shrinkage. Most of these modify the surface of the wool fiber in one of three ways: (1) they soften the scale structure (or cuticle) of the fiber to eliminate the differential friction properties and prevent shrinkage; (2) they spot-weld the fibers and/or yarns to prevent their movement during washing; or (3) they deposit a thin surface coating of a polymer over the cloth to mask the scale structure and prevent felting during washing.

The early shrinkproofing treatments for wool were based on a wet chlorination process. The wool was treated with aqueous acid hypochlorite solutions, which made it shrink-resistant by softening the scale structure and modifying the differential frictional properties. Such treatments were difficult to control and often resulted in nonuniform treatment. In addition, the wool was often damaged by chlorination.

Many modifications of the chlorination process have been developed. These include dry chlorination with chlorine gas, which is known to be an effective way to obtain shrink-resistant wool. Probably the most important chlorinating agent for wool is dichloroisocyanuric acid (DCCA) and its salts. The treatment of wool with DCCA can be controlled such that only the fiber surface is chlorinated and better shrink resistance with less damage to the fiber is obtained.

Large amounts of wool are made shrink-resistant by oxidative treatments

which also modify the scale structure of the fiber. Chemicals such as hydrogen peroxide, peroxy acids, and potassium permanganate have also been used. Permonosulfuric acid, which is used in the *Dylan* process, is probably the most important peroxy acid used to modify the scale structure.

Treatment of wool cloth with resin finishes restricts the movement of the fibers and prevents felting shrinkage. The fibers are welded by the resin at the points where they interlace. Resins similar to those used to control the shrinkage of cloth made from other fibers can be used on wool. These include urea-formaldehyde and melamine-formaldehyde type resins. However, large amounts of resin are needed to control shrinkage, which makes the hand of the treated wool unacceptable.

One of the most interesting developments for preventing felting shrinkage in wool cloth is the deposition of a thin coating of a polymer on the surface of the cloth. The *Wurlan Process* for shrink-proofing wool, developed at the U.S. Department of Agriculture's Western Regional Research Laboratory in Albany, California, can be used to illustrate this process. A thin layer of nylon 6,10 is deposited on the surface of the cloth in the following manner. The cloth is passed through a dilute solution of hexamethylenediamine in water, the excess solution is removed, and the cloth is passed through a dilute solution of sebacoyl chloride in benzyl chloride. The nylon polymer is formed by interfacial polymerization of the hexamethylene diamine and sebacoyl chloride. This occurs on the surface of the cloth at the interface between the two solutions, and a thin layer of polymer is deposited on the surface of the wool cloth.

The Wurlan Process was used commercially in the United States to produce shrink-resistant wool, but its use is now decreasing and other polymer systems are being used. These include *Synthappret LKF*, Fig. 16.11

Figure 16.11 Synthappret LKF—a crosslinked polyurea.

Crosslinked polyurea

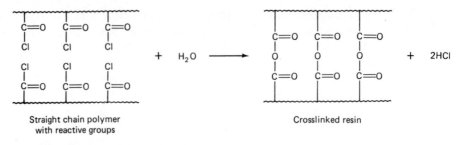

Straight chain polymer
with reactive groups

Crosslinked resin

Figure 16.12 Zeset TP—a crosslinked resin.

(Bayer), which is applied to the cloth from an organic solvent or from an emulsion, and Zeset TP (Du Pont), which is applied to wool cloth from an organic solvent. These two polymer systems illustrate the two types of prepolymers that are applied to wool cloth to make it shrink-resistant. *Synthappret LKF* is a polymer with a branched-chain structure. Each branch is terminated with reactive aliphatic isocyanate groups. *Zeset TP*, Fig. 16.12, is a straight-chain polymer with pendant reactive acid chloride groups along the polymer backbone. After application of the prepolymers to wool cloth, both types undergo self-crosslinking reactions to form a thin film of polymer on the surface of the cloth. These polymers are believed to impart shrink-resistance by covering the scales on the fibers and by spot-welding the fibers in the structure of the cloth. In this way the differential frictional effect is eliminated and the fibers in the cloth structure are held in place.

A combined chlorination-polymer process called the CSIRO-IWS process has been developed to be used on wool tops and knitted garments. The fiber or cloth is first chlorinated and then treated with a branched-chain prepolymer with pendant reactive groups.

The U.S. Department of Agriculture has recently introduced the *Wurnit Process*, which is a polymer process for knitted garments. In this method, the garments are treated in a modified laundry washer-extractor. After washing and scouring, they are treated with an aqueous solution of ethylenediamine (EDA), centrifuged, and immersed in a nonaqueous solution of 4,4'-diphenylmethyldiisocyanate (MDI), centrifuged, and dried. The reaction between EDA and MDI produces a thin film of a polyurea on the surface of the cloth. The treated garments are machine-washable and have a relatively good hand. This process is not suitable for white or pastel shades because the polymer yellows when exposed to sunlight. It is also unsuitable for compact structures, such as double knits, because a noticeable white resin is deposited on the tightly knitted cloth.

Several desirable properties of wool cloth are affected when it is treated with a polymer to obtain good shrink-resistance. These include hand, soiling properties, water-repellency, and the ability to shape wool (provided it is treated in the cloth rather than the garment stage). The improvement in shrink-resistance must, therefore, be balanced with the adverse effects on the above properties.

Abrasion-Resistant Finishes

Abrasion is the wearing away of any part of a material through rubbing against some other surface. In textiles, the major type of abrasion is caused by the rubbing of the fabric surface against another material. Known as FLAT ABRASION, this may come about when two parts of a garment rub against each other or when the garment is rubbed against another surface such as a chair. FLEX ABRASION occurs when the yarns within a fabric rub against each other as the fabric is flexed. This type of abrasion may occur in seams in garments, or in upholstery fabrics. EDGE ABRASION occurs when a creased edge or cuff is rubbed against another surface. This form of abrasion may be important in trousers or slacks, on the cuffs or collars of shirts and jackets, or in the hems of drapes where they touch the floor.

ABRASION RESISTANCE is the amount of surface wear, or friction, that a surface can withstand. The higher the abrasion resistance, the less likely that a cloth will be worn through. Some man-made fibers, such as nylon, polyester and olefin, have outstanding abrasion resistance. This is due to several properties, including inherent toughness, natural pliability, and high flex resistance. Most natural fibers, and some of the man-made fibers, have low abrasion resistance and are damaged by rubbing.

Several methods have been developed for improving the abrasion resistance of cloth. Fibers with high abrasion resistance may be blended with those which have low abrasion resistance to create cloth with improved performance. Examples of this are the blending of nylon with acrylic in the heels and toes of socks to improve durability, and the blending of polyester with cotton to achieve the same result, particularly in durable-press fabrics.

The decrease in abrasion resistance of durable-press cellulosic fabrics has been a major source of consumer disaffection. In order to overcome this problem, various techniques are used. The abrasion resistance of durable-press fabrics may be improved by coating the yarns with a thin layer of polymer, which provides a protective surface that resists abrasive forces and protects the yarns. Polymers also contribute to wrinkle recovery and smooth drying properties, so that a lower level of crosslinking agent can be used in the durable-press process. Reduction of the crosslinking agent helps to improve other properties of the material, so these polymers serve a dual purpose. Polymer additives used in conjunction with durable-press finishing include the polyacrylates, polyurethanes, and polysilicones.

Processes that result in a differential treatment of durable-press cloth may improve abrasion resistance. Preferential backcoating, in which the crosslinking agent is applied to only one side of the cloth and the cloth is dried before the agent can penetrate to the other side, has been used. The cloth is crosslinked on one side only, and this maintains abrasion resistance.

Another technique used to improve performance is to blend cotton fibers treated with a crosslinking agent with untreated cotton fibers. Thus, the cloth is made from yarn that contains treated and untreated fibers. The treated fibers provide wrinkle recovery, while the untreated fibers maintain comfort and durability properties.

Core crosslinking, which is a technique used for preventing cross-linking on the surface of a fiber, has also been suggested as a way to improve abrasion properties. Gaseous ammonia can be used to deactivate the catalyst used in durable-press treatment on the surface of the fibers to obtain core-crosslinked fibers. Substantial improvements in abrasion performance have been reported.

Treatments to improve abrasion resistance have been suggested for specific areas that are subject to excessive abrasive forces. These include pockets and cuffs on slacks, and lining materials. Some of the newer processes developed to improve the abrasion resistance of durable-press cloth may achieve commercial significance; however, the blending of polyester and cotton fibers to improve abrasion properties is still the dominant commercial position.

Anti-Pilling Finishes

Pilling is the formation of small balls of fiber and other contaminants, called pills, which are held to the surface of cloth by anchoring fibers. They are caused by abrasion as different parts of a garment rub against each other, or as a cloth is rubbed against another surface. Pilling is often the first sign of wear due to abrasion; it causes a cloth to have an unsightly and disheveled appearance. Often, otherwise satisfactory garments are discarded because the surface has become covered with pills.

It has been said that pilling did not exist before 1945. To some extent this statement is true, since knitted garments were first introduced on a large scale between 1945 and 1950, and they pill more readily than woven garments. Also, during this period synthetic fibers, which are more likely to pill than natural fibers, and lightweight fabrics, which are more easily abraded than heavy-weight fabrics, became more popular.

Pilling occurs in a stepwise manner. Fibers from spun yarns migrate progressively to the surface of the cloth. These loose fibers become entangled and may be contaminated with other materials to form balls of fiber. The pill may continue to grow until it reaches a maximum or limiting size. It may then become permanent on the surface or fall off as a result of abrasion. Pills formed from synthetic fibers of high breaking strength remain on the surface because they are too strong and tough to be abraded away.

Pills may be formed on fabrics made from filament yarns in a similar manner. Under abrasive stress, the filaments within the yarns are torn. The loose ends are brushed to the surface, where they form balls. Usually these pills are not easily removed because the anchoring fibers are strong filaments imbedded in the cloth.

Pilling may be reduced or controlled by mechanical finishing processes. Shearing, brushing, and singeing—either singly or in combination—may be used. Thermosetting of nylon or polyester cloth, or of materials made from these fibers blended with others, helps to reduce pilling by lowering the tendency of the fibers to migrate to the surface.

Resins used for easy-care finishes usually reduce pilling by improving the adhesion of fibers in yarns. Shrink-resistant treatments for wool or wool/synthetic blends usually reduce pilling by preventing fiber migration. Pilling in blankets made from acrylic fibers blended with cotton, wool, rayon, or other fibers may be reduced by the application of an aqueous solution of a cyclic aliphatic carbonate, followed by evaporation of the solution to bond the fibers at points at which they intersect.

The Wool Industries Research Association suggested using a flexible latex on the back of knitted cloth to reduce pilling. This reduced the pilling without appreciably changing the hand of the cloth, but extended exposure to light and air caused discoloration.

Fiber producers have reduced pilling by lowering the tenacity of their fibers so that pills may be more easily abraded from the surface of cloth. Fabric softeners may sometimes be effective in reducing pilling, since they lubricate the surface of the cloth and reduce the abrasive forces. On the other hand, they also promote the migration of fibers within spun yarns, especially synthetic fibers, so this technique is not always effective. Fabric manufacturers have also been able to hide pills within the fabric pattern by weaving or knitting cloth with novelty yarns that present a textured appearance when new. The pills that may be formed appear to be a part of the overall surface texture.

FINISHES THAT PROVIDE ENVIRONMENTAL PROTECTION OR IMPROVED SAFETY

One of our most useful servants, fire, can also be one of our most dangerous enemies. The protection of life and property from fire damage is a concern almost as old as civilization. With the maturation of society, the perceived risks associated with fire have changed. At first people were concerned with keeping their wooden homes from being destroyed. With the development of better buildings and better methods of fighting fires, the focus of safety shifted to public buildings where large gatherings of people might be endangered in case of fire. As building codes became stricter, and the risk of fire in public places lessened, the protection of individuals assumed greater importance.

Flame-Retardant Finishes

The use of flame retardants on textile materials dates back to 1638, when a treatment for the canvas used as curtains in Parisian theaters was patented. Later, Joseph Louis Gay-Lussac, one of the founders of the science of chemistry, was commissioned by King Louis XVIII of France to develop a better means of protecting the theater-going public from the hazards of fire. In 1821 Gay-Lussac disclosed the development of a flame-retardant finish for linen and jute; it was a mixture of ammonium phosphate, ammonium chloride, and borax. He also established that the most effective flame-retardant salts are either those with a low melting point, which are capable of

coating the cloth with a glassy layer, or those which decompose into nonflammable vapors on heating.

William Henry Perkin, a renowned chemist, was attracted to the problem of fabric flammability early in this century; he carried out a series of experiments that defined the requirements of the flameproofing process. He noted that

> "A process, to be successful, must, in the first place, not damage the feel or durability of the cloth or cause it to go damp as so many chemicals do, and it must not make it dusty. It must not affect the colors or the design woven into the cloth or dyed or printed upon it; nothing (such as arsenic, antimony, or lead) of a poisonous nature or in any way deleterious to the skin may be used and the fireproofing must be permanent, that is to say, it must not be removed even in the case of a garment which may possibly be washed 50 times or more. Furthermore, in order that it may have a wide application, the process must be cheap."

Perkin's work led to a commercial process known as *Non-Flam*, in which cotton flannelette was treated with sodium stannate and then ammonium sulfate, after which it was washed and dried. The flame retardant was thought to be stannic oxide and durable to washing with soap. However, this technique did not eliminate the smoldering combustion (afterglow) that is characteristic of the cellulosic fibers and could not prevent the cloth from being consumed.

The process was not popular and very little attention was focused on flameproofing until World War II. Flameproof and waterproof canvas for outdoor use by the military was developed in the late 1930s and early 1940s by treating the canvas with a chlorinated paraffin and a metal oxide such as antimony oxide (Sb_2O_3). The chemicals were applied to the canvas via an organic solvent containing a binder.

Concern for consumer protection in relation to textile products was stimulated when several deaths were caused by "torch sweaters" made from brushed rayon. This material was so flammable that it burned almost explosively when ignited. In order to remove such hazardous material from the marketplace, the Flammable Fabrics Act of 1954 incorporated a specified test method to determine whether or not a material could be sold for wearing apparel in the United States. Further amendments of the Act (1967) broadened its scope to include almost all textile materials and empowered the Secretary of Commerce to promulgate regulations that would protect the consumer from "unreasonable risk." Today carpets and rugs, mattresses, and children's sleepwear are regulated under the Flammable Fabrics Act, which is now administered by the Consumer Product Safety Commission.

Since almost all textile materials will burn when exposed to an ignition source, it is necessary to describe or define how these materials burn. A FLAMMABLE textile is one which ignites after exposure to a heat source and continues to burn under normal conditions until it is consumed. A FLAME-RESISTANT textile will retain its shape and will not ignite after exposure to temperatures as high as 600°C. A FLAME-RETARDANT textile may or may not ignite after exposure to a heat source. However, if it does ignite, it will burn or

smolder for only a short time after the heat source is removed and will self-extinguish.

The burning process is called PYROLYSIS or COMBUSTION. Since textile materials do not have appreciable vapor pressure, they must first undergo decomposition to form volatile combustibles before they will burn. This occurs when the textile material (substrate) is exposed to a sufficient source of heat. The decomposition temperature for textile materials is dependent upon the composition of the material and is different for different polymers. Volatile materials, called COMBUSTIBLES, are formed when the textile polymer decomposes. In the presence of oxygen these materials ignite to give FLAMING COMBUSTION, in which other volatile combustible materials are formed and heat is produced. The heat produced in the pyrolysis process may cause further decomposition of the textile material. The pyrolysis process is cyclic and may continue until the material is completely decomposed, leaving only a small amount of char or ash. The cyclic pyrolysis of a textile material, based on the work of K.-N. Yeh, is shown in Fig. 16.13.

To make textile materials safer, the cyclic decomposition process must be interrupted or the fabric will be completely destroyed. Flame retardants may interrupt or change the decomposition process in several ways: (1) they may melt at relatively low temperatures and resolidify in the form of a foam, which serves as a barrier to heat transfer from the flame to the substrate; (2) they may be converted upon heating into acids or bases, which catalyze the decomposition of the substrate at lower temperatures than are required for the formation of volatile combustibles; (3) they may decompose or sublime upon heating to release large amounts of nonflammable vapors which exclude oxygen from the flame; or (4) they may react with chemical species within the flame to stop the combustion reaction.

Most textile flame retardants change or interrupt the normal thermal decomposition process of the polymer. They may function in the solid substrate (cloth) to lower the decomposition temperature of the fiber and change the nature and amount of volatile combustibles formed, or they may

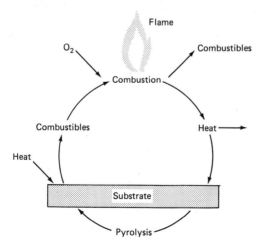

Figure 16.13 The pyrolysis cycle.
(K.-N. Yeh, University of Maryland)

function in the vapor phase. For example, compounds containing phosphorus are converted to acidic materials which catalyze the thermal decomposition of the polymer. The flame retardants containing bromine or chlorine (halogens) also decompose when the polymer decomposes to form volatile combustibles. The halogen escapes with the volatile combustibles and acts in the vapor phase to inhibit flaming combustion. For the flame-retardant chemical to be effective, it must be available at the point at which the polymer decomposes.

Three general methods are available for producing cloth with improved flammability properties: (1) flame-retardant chemical finishes may be applied to the surface of cloth, (2) they may be added to the polymer at some step in the synthesis process prior to extrusion of the polymer into fibers, or (3) inherently flame-resistant fibers may be developed and converted into cloth.

Flame-retardant chemical finishes may be classified as nondurable, semidurable and durable.

Nondurable Flame Retardants Nondurable flame retardants are generally water-soluble inorganic salts that are easily removed by water, rain, or perspiration. If the cloth is washed, the flame retardant is removed and the cloth must be re-treated to have its flame-retardant properties restored. The most widely used nondurable flame retardants are ammonium phosphate, diammonium phosphate, borax, boric acid, sulfamic acid, and various metallic salts, or combinations of some of these materials. For example, a highly effective nondurable flame retardant for cellulose is a mixture of borax, boric acid, and ammonium phosphate in a 7:3:5 ratio in 10 percent or higher concentration. It is applied to the cloth simply by wetting it in the solution and letting it dry.

Semidurable Flame Retardants Semidurable flame retardants will withstand leaching with water as well as a limited number of launderings. They are generally thermally unstable insoluble salts deposited within or on the surface of the cloth. This is generally done by padding the chemicals onto the cloth in a two-bath process. The cloth is first impregnated with one chemical, passed through a padder to remove excess chemical, and then impregnated with the second chemical by the same technique. Best results are usually obtained if the cloth is dried before treatment with the second chemical. Usually 25 to 30 percent add-on of chemical is necessary for good flame-retardant properties. These materials decompose when heated to release strong acids or alkalis which alter the process of decomposition of the polymer and reduce flame propagation. Examples of compounds used are insoluble phosphates or borates of tin, zinc, and aluminium, as well as stannic, ferric, zinc, and silicon oxides.

Durable Flame Retardants Durable flame retardants are chemical finishes which react with or are physically held on the surface of the cloth or within the fiber. These finishes must withstand laundering or other cleaning procedures throughout the expected life of the cloth while maintaining the improved flame-retardant properties of the cloth. Durable flame-retardant finishes are generally organic compounds which contain phosphorus, nitrogen and/or halogen (chlorine or bromine) atoms, or combinations of these in the chemical structure.

Durable flame-retardant finishes are applied to cloth by a pad-dry-cure process. The finish formulation usually contains the flame-retardant chemical, a softener or hand builder, a resin binder or crosslinking agent, and an appropriate catalyst. The finish may react with the fibers of the cloth and thus become permanently held to the cloth, or it may react with itself to form a polymer within and around the interstices of the cloth and thereby become permanently attached to the cloth without reacting with it. The amount of finish needed to give the desired flammability properties depends on the structure and weight of the cloth, the particular flame retardant that is being used, and the fiber content of the cloth. The add-on of finish may vary between 10 and 30 percent. Because of the large amount of finish required, treated fabrics often suffer from loss of physical (particularly strength and abrasion) and esthetic properties. Softeners are generally required to make the hand of the cloth acceptable.

Durable flame retardants may also be added to the fiber at some step in the synthesis before spinning. These are usually organic compounds (not polymers) which contain phosphorus, nitrogen, and/or halogen. Sometimes, inorganic flame-retardant materials are added to fibers. If the fibers are melt-spun, the additives must be stable at the temperature used in spinning. If added to fiber solutions before spinning, they must be stable in the solvent or spinning bath. In any case, the fiber producer must be concerned with maintaining the desirable physical properties of the fiber while adding the appropriate or desired flame-retardant property to the fiber. The flame-retardant chemical must not interfere appreciably with the normal processing of the fiber in spinning, yarn formation, or any other step in the manufacturing process. Flame-retardant additives are generally fiber-specific, and different chemicals are used for different fibers.

Many durable flame-retardant systems have been developed for cotton and rayon. Cloth made from these fibers ignites easily and burns readily, leaving only a small amount of ash. Most of the useful flame retardants are organic compounds which contain phosphorous and nitrogen. A few flame-retardant finish formulations for cellulosic materials contain phosphorous, nitrogen, and halogen. The structure and properties of a number of commercial flame-retardant formulations are listed in Table 16.4. These materials are usually combined with other chemicals to form polymers (resins) which either form within the fiber or coat the fiber's surface. In either

TABLE 16.4 Common Flame-Retardant Agents for Apparel Fabrics

FIBER	COMPOUND
Cellulosics	Tetrakis(hydroxymethylphosphonium) compounds:
Cotton	THPC $(CH_2OH)_4$—P^+· Cl chloride
Linen	THPOH $(CH_2OH)_4$—P^+· OH hydroxide
Rayon	THPS $[(CH_2OH)_4$—$P^+]_2$ $^{-2}SO_2$ sulfate

To improve their durability and efficiency, THP compounds are sometimes reacted with nitrogen-containing compounds such as urea, or with metal salts and oxides such as antimony chloride or antimony oxide. A condensate of bis(betachloroethyl vinyl phosphonate):

$$\left[-O-\overset{\overset{O}{\|}}{\underset{\underset{CH=CH_2}{|}}{P}}-O-CH_2-CH_2- \right]$$

is often used with methylol melamine to improve the efficiency of THP compounds.

Acetate and Triacetate	Halogenated phosphates. Tris(dichloropropyl)phosphate: $(Cl-CH_2-CHCl-CH_2-O)_3-P{=}O$ is usually added to spinning solution during fiber manufacture.
Wool and Silk	THP compounds and metal salts may be used, but these fibers are usually satisfactory without flame retardants.
Polyester	Tris(dichloropropyl)phosphate. Antimony oxide, Sb_4O_6.
Polyester/Cotton Blends	If polyester content is high, use polyester flame retardants. If cotton content is high, use cotton flame retardants.
Nylon	Usually satisfactory without flame retardants.
Acrylic	No satisfactory flame retardants.
Olefin	Not found in apparel products that must meet stringent flammability standards.

case, the flame-retardant action is obtained by changing the nature of the decomposition of the textile material.

A typical flame retardant is the condensation product of tetrakis (hydroxymethyl)phosphonium chloride (THPC) with trimethylol melamine (TMM), shown in Fig. 16.14. An add-on of 18 to 20 percent is required for satisfactory flame-retardant properties. The finish is durable to commercial and home laundering and to dry-cleaning. Note that during the condensation reaction, HCl, which may cause severe fiber damage and loss of strength, is released. Urea is included in the finish formulation to reduce fiber damage by acting as an acid acceptor and neutralizing the HCl.

Figure 16.14 The condensation product of THPC and TMM can react with the —OH groups of cellulose to crosslink the fiber and provide flame-retardant properties.

Comparative Flammability of Textile Fibers

Polyester/cotton blends, which at present rank among the most widely used apparel fabrics, are easy to ignite and burn readily. The most important compositions are the 50/50 and 65/35 polyester/cotton blends, yet only two flame-retardant finishes are available. Both suffer from a poor hand, and problems with causing frosting (a whitish deposit) on dark colors. It is safe to say that at this time, there is no commercially available flame-retardant finish for these two blend levels of polyester/cotton that is acceptable with regard to flammability properties, esthetics, comfort, and other performance properties. Cloth made from blends containing high levels of cotton to polyester (20/80 blends) may be finished with the flame retardants recommended for cotton and rayon. The commercially available durable flame retardants for polyester/cotton blends are listed in Table 16.4.

Pure wool cloth is considered to be relatively safe from the point of view of flammability. If a sufficient heat source is applied, it will ignite, but usually does not support the flame, and will burn or smolder for only a short time after the ignition source is removed. The natural flame-resistant properties of wool are related to its high moisture and nitrogen content, its high ignition temperature, its low heat of combustion, and its low flame temperature. It does not melt or drip when it burns as do synthetic fibers. Because of its good flame-retardant properties, relatively little attention has been directed to developing flame retardants for wool cloth used in apparel. The com-

mercially available durable flame-retardant treatments recommended for wool are summarized in Table 16.4.

Cloth made from 100 percent polyester is widely used in the consumer textile market. Such cloth is hard to ignite, but will burn with melting and dripping. Cloth made from 100 percent polyester treated with tris(2,3-dibromopropyl)-phosphate (TDBPP or "tris") by a pad-dry-cure process to impart flame-retardant properties was the principal material used in children's sleepwear until the Consumer Product Safety Commission (CPSC) issued an order in May 1977 banning its use. Until TDBPP was banned it was practically the only treatment for polyester. A limited number of other finishes for polyester are available (see Table 16.4).

Cloth made from 100 percent nylon is somewhat difficult to ignite but once ignited, will burn. During burning it melts and drips. A limited number of flame-retardant finishes for 100 percent nylon cloth used in draperies and upholstered furniture have been developed. These are all based on a thiourea-formaldehyde derivative. (These finishes are summarized in Table 16.4).

There are no commercially available flame-retardant finishes for 100 percent nylon cloth used for wearing apparel at this time.

Cloth made from 100 percent flame-retardant acetate and triacetate was available until recently. The flame-retardant used for these fibers was TDBPP. The chemical was added to the fiber before spinning. This cloth is no longer available since the use of TDBPP as a flame-retardant was banned by CPSC.

It is also possible to make fabrics from fibers that are *inherently flame-resistant*. For apparel use, modacrylic fibers and matrix fibers of vinal/vinyon are available. These both contain chlorine as part of the basic polymer. Other materials such as glass, aramids, Kynol (a phenolic), and PBI (polybenzimidazole) are also inherently flame-resistant. These materials, however, are generally deficient in many of the performance properties required of apparel fibers, and are not found in this end use. They are satisfactory for upholstery in aircraft and other vehicles, flame-resistant protective clothing, and institutional furnishings, where the consequences of fire may be of greater concern than other performance properties.

FINISHES THAT PROVIDE BIOLOGICAL RESISTANCE

Of the various finishes that provide protection against animals, insects, and micro-organisms, we will consider only those that protect against moths and microbes.

Moth-Resistant Finishes

The clothes moth, the carpet beetle, the tapestry moth, and the case-bearing clothes moth find that the protein in an attractive wool sweater or skirt makes a very appetizing diet for their young. The moths themselves are not the culprits, since their sole function is to procreate and ensure survival of the species. The female moth lays her eggs and dies in one to two weeks. In a

little more than a week the eggs hatch into little white grubs (larvae). These grubs settle down and chew their way through the wool where they have been deposited. They may remain as grubs for from three months to three years before they turn into pupae and then moths and start the life cycle all over again.

Although these moth larvae and beetles live on wool keratin, they often chew their way through other types of cloth to get to the wool. They seem to be particularly fond of soiled cloth, so that woolen clothes that have been worn and are soiled should never be stored without proper cleaning.

Considerable effort has gone into the development of methods of preventing moth damage to wool. Three general types of mothproofing processes, which vary in effectiveness, are commonly used. These are as follows:

1. The common "moth ball," containing naphthalene, is placed among stored wool items. Moths do not like the naphthalene and generally seek a more pleasant place to raise their families. Under ordinary conditions, the vapors from naphthalene will not kill the moths. Therefore, it is a moth-*repellent*.

2. Substances which actually kill the moth or grub on contact are more effective in controlling attacks. Such materials are known as *contact insecticides* and are sprayed onto clothes or applied to cloth in other ways. Many organochlorine compounds are used as general insecticides. Dieldrin is an example of an outstanding mothproofing agent. However, a surface application of Dieldrin applied from solvent crystallizes on the surface of the cloth; it is easily removed by washing in aqueous detergent solutions and dry-cleaning solvents. It must be reapplied prior to storage.

3. The most effective mothproofing agents are chemicals that are toxic to moths and are permanently anchored in the wool. These cannot be easily removed by washing or by dry-cleaning. In addition to the organochlorine compounds, such as Dieldrin, which are used as general insecticides as well as for mothproofing, other chlorinated compounds such as Eulan U33, Eulan WA, and Mitin FF are used only for mothproofing. These industrially important mothproofing compounds are "colorless dyes" which can be applied to wool from acidified aqueous solutions at the boil. They are absorbed by wool in much the same way as acid dyes. These compounds are almost ideal mothproofing agents. They have acceptable resistance to washing, dry-cleaning, pressing, and light; they are odorless and colorless and cause no undesirable changes in the properties of the wool; they can be applied during wet processing; and they are toxic to the moths and beetles that like to eat wool. However, the relatively high cost of these compounds has limited their use and the low cost of Dieldrin has led to its much wider use for general mothproofing.

One of the prime requirements of a mothproofing agent is that it be toxic to moths and beetles that attack wool, but it must not be toxic to human beings at the concentration levels used for mothproofing. Biologists are now searching for still other methods that will effectively control moths and beetles.

Restrictions on the use of chlorinated hydrocarbon insecticides in the United States have left the homeowner and the textile industry with only a few compounds suitable for mothproofing. Resmethrin, a broad-spectrum synthetic pyrethroid, is one of the many organophosphate and synthetic pyrethroid insecticides with low mammalian toxicity being investigated as a replacement for the chlorinated hydrocarbon mothproofing agents. Resmethrin, applied as an oil aerosol or as an aqueous pressurized spray, is effective in protecting woolen cloth from damage from the black carpet beetle. Further investigations have shown that Resmethrin may be applied to wool cloth in a variety of ways, which suggests that it has promise as a mothproofing agent.

Until recently, it was generally thought that the sulfide linkage in wool is the most attractive part of the wool to moths and beetles. Recent evidence, however, suggests that amino and carboxyl groups are also attractive to moths and beetles. Chemists are seeking ways to permanently mothproof wool by chemically modifying the fiber to make it less desirable as food for these insect pests. Chemical modification of the disulfide links can be achieved easily by reducing the link and introducing a chemical group between the two sulfur atoms (Fig. 16.15).

The new linkage is not easily broken by the enzymes in the digestive tract of the moths and beetles; thus the treated wool is less attractive to them as food. Other types of chemical modification of wool could also interfere with the digestive process of the grubs and result in the permanent mothproofing of wool. Work on the chemical modification of wool continues, but without commercial success thus far.

In addition to the chemical modifications of wool as a method of mothproofing, other studies are underway to protect wool from moths and beetles. These include the development of antimetabolites, which interfere with the digestion of wool by the grubs; the control of insect behavior with chemicals; insect sterilization; and various methods of biological control using parasites or microbial pathogens.

Figure 16.15 Modification of the disulfide links in wool.

Cystine crosslink in wool Sulfhydryl groups 1,5-difluoro-2,4-dinitrobenzene

Reformed crosslink in wool

Antimicrobial Finishes

There are many who believe that a return to nature and natural ways would solve all our problems and give us an environment that is pure and benign. The fact is that even if we ignored natural disasters and extremes of climate, we would still be faced with an invisible, omnipresent population of tiny life forms called micro-organisms. Some of these organisms, such as those which sour milk to make cheese, are useful. Others, such as those which destroy textiles or cause disease, are destructive. These micro-organisms are usually classified as BACTERIA and FUNGI. In general, they are either *parasitic* or *saprophytic*. Parasites live on or in the organs of other species and may be beneficial or harmful to the host. Saprophytes live on dead matter. They are dependent upon foodstuffs already available or which they can make from available substrates for their energy, reproduction, and growth. The soil is the main source of these tiny forms of life which are readily airborne (in dust) and are found everywhere.

Antimicrobial finishes are applied to textiles for three major reasons: (1) to control the spread of disease and reduce the danger of infection following injury, (2) to control the development of odor from perspiration and other soil on textile materials, and (3) to control the deterioration of textiles, particularly cellulosic textiles, caused by mildew and rot. Mildew and rot present special problems for textile materials used out-of-doors—e.g., tents, awnings, tarpaulins, outdoor furniture, upholstery, and carpets.

The treatment of textiles to protect them from the effects of micro-organisms is not new. Over 4,000 years ago the Egyptians preserved the cloth used for wrapping mummies by treating it with spices and herbs. In World War II, German Army uniforms were treated with quaternary ammonium compounds to protect wounded soldiers from infection caused by microbe action. The attempt to inhibit odor development and reduce the incidence of skin rashes and infections that may be related to micro-organisms in wearing apparel has become a concern in recent times, largely as a result of the increasing use of man-made fibers and man-made/natural fiber blends. Because these materials have low moisture regain, stale perspiration is more likely to be held in the interstices of cloth and/or garments. This provides an ideal setting for metabolism of the perspiration by micro-organisms, and hence, the formation of odors.

There are many textile items for which it is desirable to have antimicrobial treatment. These include wearing apparel such as diapers, undergarments, foundation garments, socks, shoe linings, and outerwear; bedding such as sheets, pillowcases, blankets, bed spreads, mattress pads and covers; other household items such as upholstery fabrics, carpets, rugs, towels, wash cloths, and table linens; and miscellaneous items such as bandages, handkerchiefs, and personal items.

The performance requirements of antimicrobial finishes are diverse. They range from preventing odor to preventing deterioration to providing self-sterilizing capabilities for textile materials. Because of the diverse end-use requirements, some finishes must be durable or semidurable to washing and

dry-cleaning while others do not have durability requirements beyond the initial use of the item.

Antimicrobial finishes can be divided into two general types: (1) impervious finishes and (2) active finishes. *Impervious finishes* function by forming a thin skin of resin on the surface of the textile. The resin forms a barrier that cannot be penetrated by fungi or bacteria. *Active finishes* are chemicals that are lethal to the fungi or bacteria. Some textile materials can be protected from microbial attack by fiber modification. Cellulose diacetate and cellulose triacetate, for example, are not attacked by micro-organisms because most of the hydroxyl groups have been converted to acetate groups. The modified fiber cannot be metabolized by fungi or bacteria that attack cotton, rayon, and other cellulose fibers.

A wide variety of compounds are known to have antifungal or antibacterial activity. These include copper and copper-organo compounds; mercury and tin organic compounds; compounds of zinc, zirconium, and cadmium; organo lead compounds; phenols and related compounds; and surface active agents such as quaternary ammonium compounds and cationic softeners. Some of these compounds stop or prevent the growth and activity of bacteria or fungi. Others may be lethal to bacteria or fungi.

Some conventional textile finishes or finishing agents—such as dye-fixing agents, softeners, and water-repellent finishes—impart antibacterial properties to cloth.

Chemicals used as antimicrobial finishes must not be harmful to people who come into contact with or use the treated items. In the development of new antimicrobial finishes, the proof of safety is one of the most expensive and difficult parts of the development process.

A variety of terms are used to describe the processes and antimicrobial finishes applied to cloth. These include *sterilization*, *disinfectant*, *antiseptic*, *sanitizer*, *bactericide*, *bacteriostat*, *fungicide*, *fungistat*, *mildew-resistant finish*, and *rotproof finish*.

SUMMARY

Functional finishes improve performance properties and usually impart extra characteristics that cloth does not normally possess. These improved performance properties are achieved by chemical and mechanical finishing processes. The most important of the functional finishes in today's market are those that improve comfort, ease of maintenance, durability, and safety or protection. Those that improve ease of maintenance are durable-press and soil-resistant finishes. Finishes that improve safety or protection include water-repellent, flame-resistant, and biological resistance finishes. Those that improve comfort are fabric softeners and antistats. Functional finishes are usually more durable than general finishes, since consumers expect the added performance properties for which they have paid to be retained by the material or garment throughout its life.

REVIEW QUESTIONS

1. How do ionic fabric softeners differ from nonionic fabric softeners both chemically and in terms of performance?

2. Name three end uses in which antistatic finishes are very important to consumers. Explain why.

3. Durable-press finishes are very important for cotton and cotton-blend apparel. Explain why. Why are they not used on nylon fabrics?

4. Why are soil-release finishes not generally used on fabrics made from natural fibers?

5. Which would be preferable: a raincoat made of cotton with a water-repellent finish or a raincoat made of sheet vinyl with a cotton flannelette liner? Explain, considering all the performance criteria.

6. Which fabrics would need a stabilization finish? Why?
 a. 100 percent cotton twill weave
 b. 65/35 polyester-cotton plain weave
 c. 100 percent nylon tricot knit
 d. 100 percent polyester jersey knit

7. Which cloths would be most likely to benefit from an anti-pilling finish? Why?
 a. 100 percent wool rib knit
 b. 100 percent acrylic jersey knit
 c. 100 percent polyester double knit
 d. 100 percent nylon satin weave

8. Discuss why cotton, which once accounted for about 98 percent of the children's sleepwear market, is no longer found in this end use.

9. Discuss why natural fibers are more in need of protection from insects and micro-organisms than are man-made fibers. Which man-made fibers do need biological protection?

10. Why might moth repellents be preferred to insecticides in the home environment?

ACTIVITIES

1. The desizing of cotton denim can be achieved by multiple launderings. Before laundering it, estimate the stiffness, tensile strength, and tear strength of a sample cloth. If equipment is available, use the standard test methods. Next, launder the fabric along with a regular wash load. What changes occur after ten launderings? After twenty launderings?

2. The effect of fabric softeners can be examined by comparing a "softened" fabric with one that has not been treated. Launder and machine-dry a piece of cotton toweling in a regular wash load. Pink the edges to prevent fraying. Repeat the laundering with a second peice of toweling, but add a fabric softener to the wash according to the manufacturer's directions. Repeat with a third piece of toweling, but add the softener, in the form of a treated sheet, to the dryer. (Spray softeners are not recommended for this experiment.)

3. Soil- and stain-resistant finishes are available in spray cans for consumer use. Their effect on fabrics may be studied as follows:

Place a folded paper towel over half of a piece of cotton cloth. Spray with a commercial finish according to the manufacturer's directions. After drying, place drops of machine oil, coffee, mustard, ketchup, and fruit juice on both the treated and untreated sides of the cloth. Observe the behavior of the liquids.

After five minutes, use a blotter to remove the liquids. Is the cloth stained?

Repeat the staining procedure on the treated side of the cloth. Allow to stand overnight. Blot up remaining liquid. Wash in soapy water, rinse, squeeze out excess water, and dry by ironing the cloth between layers of cotton cloth. How effective was the finish? Did it work better on some liquids than on others?

17

design:
color and pattern

From the very beginning of civilization, people in all cultures have used color to ornament their homes, their clothing, and their bodies. Paints, dyes, and pigments have been used to produce pleasing patterns, create moods, and declare rank or status.

The application of color to textile materials is an ancient art. Colored designs can transform a utilitarian cloth into a work of art. People select the colors and patterns of their furniture and clothing to set moods and influence others' perceptions of their taste and sensitivity. Except for certain symbolic colors, such as black for mourning, combinations of color and design are generally chosen to create a feeling of pleasure.

Color is a complex subject that has intrigued scientists, philosophers, and artists for centuries. In this chapter, we discuss the perception of color, the physical processes that bring color into being, the interpretation of color and pattern, and the methods by which color may be applied to textile materials.

PHYSIOLOGY OF COLOR PERCEPTION

An analysis of how we perceive color involves the study of the anatomy of the eye, the nervous system, and the brain. The eye is sensitive to light. The sensations that stimulate the eye are passed through nerves to the brain. The brain interprets the image that the eye transmits. Because no two people have

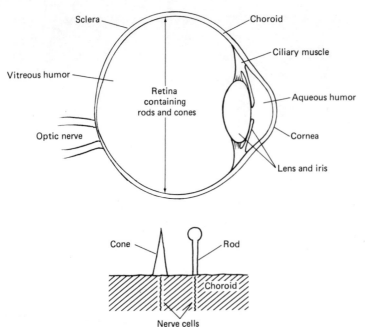

Figure 17.1 Anatomy of the eye, and structure of the rod and cone light receptors.

the same eyes, nervous system, or brain, no two people "see" precisely the same color.

The human eye is shown in Fig. 17.1. The eyeball is an almost spherical shell of white tissue, with a transparent section at the front. At the rear, the eyeball is pierced by the optic nerve. The lens allows the eye to focus on near or distant objects. The iris is a pigmented tissue that can close around the lens to control the amount of light entering the eye and prevent damage to the retina, the inner lining of the eye which contains light-sensitive cells. The surface of the retina is covered with two types of light receptors: *cones*, which are used for perception of color and determination of detail in daylight or with artificial light; and *rods*, which are sensitive to low levels of light but cannot distinguish color. Nerve impulses produced in these receptor cells are transmitted through nerve cells to the optic nerve, and on to the brain. In the brain the image is formed and interpreted.

PHYSICS OF LIGHT AND COLOR

In 1672 Sir Isaac Newton passed a beam of sunlight through a glass prism and separated the white light into the colors of the spectrum (Fig. 17.2). He showed that each of the colors of the spectrum was homogeneous and could not be divided into other colors either by reflection from colored bodies or by further refraction. In addition, he showed that recombining the spectrum would generate the original white light. Thus began the modern scientific study of light and color.

330

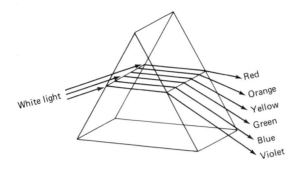

Figure 17.2 The refraction of light by a prism.

Modern physical theory holds that light is a form of *energy*. This energy, known as *electromagnetic radiation*, is emitted in discrete packets, or QUANTA (singular: quantum), which travel through spaces in WAVES much as ripples in a pond travel through water. These waves all travel at the same speed, 3×10^{10} cm sec^{-1} (186,000 mph), irrespective of their energy. The electromagnetic spectrum comprising all forms of energy from the very energetic gamma rays to the weak radio waves, is illustrated in Fig. 17.3. Max Planck showed that the energy of these quanta is related to the WAVELENGTH, with the less energetic quanta having the longer wavelengths.

Visible light is that portion of the electromagnetic spectrum which is capable of exciting the light receptors of the eye. Higher-energy radiation is too strong to activate these receptors, while lower-energy radiation is too weak. The quanta of visible light are known as *photons*. The nerve cells that are sensitive to light are capable of discriminating between photons of different energy. Because of this ability, we are able to see the VISIBLE SPECTRUM, which Newton produced in his early experiments. The visible spectrum extends over the range 400 to 700 nm (nanometer = 10^{-9} meter), and has been arbitrarily divided into the colors red, orange, yellow, green, blue, and violet.

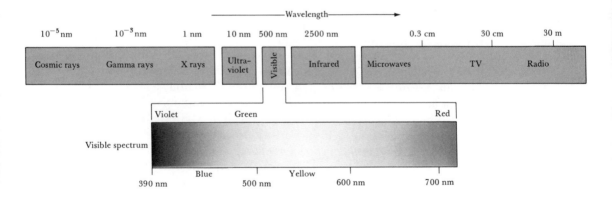

Figure 17.3 The electromagnetic spectrum. The visible region is the narrow section between 390 and 700 nm. (T. L. Brown and H. E. LeMay, Jr., *Chemistry, The Central Science*, 2nd ed. © 1981, p. 125. Reprinted by permission of Prentice-Hall, Inc., Englewood Cliffs, N.J.)

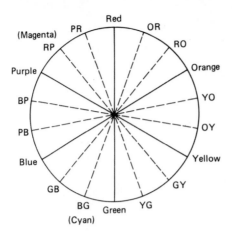

Figure 17.4 Munsell color circle.

Almost all the colors of the spectrum may be generated by the combination of three colored lights, as long as these lights are not combinations of other colors. This is known as ADDITIVE color mixing. It has been found that the combination of red, green, and blue yields the widest range of colors; these three are known as the primary additive colors. It is also possible to reproduce colors from white light by passing it through a combination of three colored filters. The colored filters selectively absorb light of different wavelengths so that the residual colors are revealed. This is known as SUBTRACTIVE color mixing. The primary subtractive colors are yellow, cyan, and magenta.

Colors that absorb each other are known as COMPLEMENTARY colors. Yellow is complementary to blue and violet; cyan is the complement of red and orange; and magenta is the complement of yellow and green. A system of color description that illustrates this was devised by A. H. Munsell, who arranged the families of colors in a circle and labeled them according to HUE as red, yellow, green, blue, and purple. Note that *purple,* the color formed by mixing red and blue, is not the same as *violet*, the color of the spectrum with a wavelength below 450 nm. These are *simple hues.* The colors lying between the simple hues, red-yellow, green-yellow, blue-green, purple-blue, and red-purple, are *intermediate hues.* The Munsell Hue Circle is shown in Fig. 17.4. It can be seen that the complementary colors are diametrically opposed.

Why are objects colored? When white light is reflected from the surface of an object, some of the light rays are absorbed to a greater extent than others. *The object takes on the complement of the color that is absorbed to the greatest extent.* Thus, a tomato is red because it absorbs the blue and green light that falls upon it. Grass is green because it absorbs the reds and blues. The exact hue of the tomato, grass, or other object is dependent upon the precise wavelengths of light absorbed and the degree of which this light is absorbed or reflected. If, for example, the tomato is not completely ripe, it will absorb strongly in the blue, but less strongly in the green, portion of the spectrum. This will give the tomato a greenish cast.

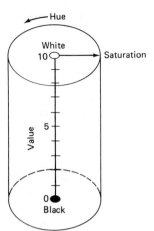

Figure 17.5 Color cylinder showing the relationship among hue, saturation, and value.

Not all tomatoes are the same color red, grass has many shades of green, and the blue of the sky can change from day to day. Hue does not completely describe the color of an object. Two other characteristics of color are SATURATION, also called *chroma* or *intensity*, and VALUE, also called brightness or lightness. Figure 17.5 illustrates the three components of color.

Saturation is a measure of the degree to which a color is removed from the central gray scale. It may be thought of as the degree of purity of the hue. The less of its complementary color that is reflected from an object, the greater is its saturation. For example, pure red has no cyan. Addition of light of a blue-green color decreases the saturation and causes the red to become grayer. Saturated colors are generally bright and intense, while less saturated colors appear dull.

The value of a color is a measure of the degree to which light is reflected from the object to the eye. Munsell arranged the neutral grays on a scale of 1 to 10 so that white, which reflects the greatest amount of light, would be 10, while black, which reflects no light, would be 0. If an object of a given hue and saturation reflects nearly all of the light striking it, its color will be pale, but well defined. As the total light reflected decreases, the color will become darker and less vivid. When very little light is reflected, the object will appear almost black, and its color will be difficult to distinguish.

PSYCHOLOGY OF COLOR

The meanings of colors, whether or not particular patterns or color combinations are pleasing or displeasing, and the mood that may be evoked by particular colors, are culturally defined. Some cultures are color-oriented and care little for the patterns that may be formed. Other peoples may be oriented toward pattern with little regard for the colors within the pattern. Still other cultures may be sensitive to both patterns and color. Within a culture, acceptable color and pattern combinations may change. In the 1950s the

combination of charcoal gray and shocking pink seemed to dominate the campus scene, while faded indigo blue and yellow was very popular in the 1970s. Furthermore, the 1950s were dominated by solid colors; the combination of stripes, paisleys, and plaids that were popular in the 1970s would have seemed garish and irritating then.

Sometimes particular colors can take on specific significance. In the Western world, black symbolizes mourning, while in Japan it is blue. Certain colors may be reserved for males, and others for females—e.g., pink for girls and blue for boys. We "roll out the red carpet" for visiting dignitaries. Colors may also be used to evoke moods. Red is exciting, yellow is cheerful, blue is cool—at least in today's Western society. All the attitudes toward pattern and color are culturally defined, and are subject to the same factors that affect any fashion or style. Perhaps one day, all babies will wear yellow and visiting dignitaries will get the moss-green carpet treatment from officials dressed in cool magenta suits.

> Our perceptions of color, and our responses to them, are greatly influenced by pattern and color combinations. When two colors are placed together they may change in hue, value, or saturation. A color may appear light against a dark background, and dark against a light background. This is an apparent change in value. A change in apparent saturation may occur when a color is moved from a gray background to one of the same hue but greater saturation. A green, for example, will appear grayer upon a background of another, stronger green. A neutral gray may acquire hue and chroma and change its value if seen against a background other than white. Usually the grays acquire the hue of the color complementary to the background, so that a gray against a blue-green background may acquire a red tint and appear more intense and lighter.

Our perception of color is also influenced by the color of the light that is used to illuminate an object. Common light bulbs (incandescent lamps) emit strongly in the yellow region of the spectrum, while fluorescent lamps have a greater blue component. The northern afternoon sky appears very blue, while the evening sun may cause it to shift toward red. These various light sources will change the perceived hue, saturation, and value of an object.

Contrasts in value and hue are important factors in design. Maximum contrast and maximum visibility are obtained when colors differ in value. Black on white makes a marked contrast, but pale orange on pale yellow is almost invisible. Complementary colors have the effect of enhancing each other's brilliance, while colors of similar hue tend to weaken each other. The pattern may also influence our color perception. A small geometric pattern of complementary colors appears vivid and vibrant when seen close up; however, at a distance the colors merge to produce a pale gray. A large print, on the other hand, maintains its intended effect.

CHEMISTRY OF PIGMENTS AND DYES

Over thirty thousand years ago painters of Southern Europe drew pictures on the walls of their caves and colored them with black, red, and yellow pigments.

These colors were not necessarily related to the colors of the animals and objects portrayed; they were the only colors available. The progression from drawings on cave walls to the vast array of colored objects of the modern world has been a long, slow process, fueled by an innate desire for beauty and variety and powered by a growing knowledge of why some materials have the capacity to lend color to other materials.

PIGMENTS (insoluble colorants) were extracted from ores and clays or produced by grinding semi-precious stones until, through trial and error, techniques of chemical compounding were discovered. DYES (soluble colorants) were prepared from plants and animals until 1856, when W. H. Perkin discovered the synthetic dye, mauve. The application of the scientific principles of chemistry and physics has provided, over the last 125 years, a greater number of colorants, of a greater range of shades, than ever before existed. The available dyes and pigments are numbered in the thousands. In this section, we discuss the chemical basis of these materials, the types of colorants available, and their uses.

Pigments are insoluble in water and most organic materials, while dyes are usually water-soluble. When mixed in a vehicle that will harden upon drying, pigments form an opaque coating. Thus, paint spread upon a wood surface forms an opaque, colored coating on the wood. There is little penetration of the colorant into the substrate. Dyes, on the other hand, are meant to be absorbed into the substrate. Thus, a dye does not hide the surface of the material it colors. Since pigments are rarely used in the coloring of textiles, and since the mechanisms by which dyes and pigments act to produce color are essentially the same, this discussion concentrates primarily on dyes.

Both dyes and pigments are able to color their substrates through the presence of a CHROMOPHORE, a chemical entity that is able to absorb light of specific wavelengths while reflecting the rest of the spectrum. To understand the action of a chromophore, visualize a tennis player practicing against a wall that has a large hole in it one meter (39 inches) above the ground. Our tennis player is quite good, and always strikes the ball from the same point, at the same speed. By tilting the racket, he can make the ball strike the wall at any height.

The tennis ball simulates a photon of visible light traveling at 300 million meters per second. The angle at which it is struck simulates the energy of the photon, high angles being energetic photons (blue light) and low angles being weak photons (red light). If the ball is struck at too high or too low an angle it will hit the wall and bounce back to the server. However, if the ball is struck at just the right angle to hit the wall at one meter, it will pass through the hole in the wall. In an analogous manner, chromophores *absorb* light of just the right wavelength or energy, while *reflecting* light of other wavelengths.

Typical chromophores are shown in Table 17.1. Almost all chromophores contain a double bond, since unsaturated groups readily absorb photons in the visible region.

In addition to the chromophore, dyes also contain AUXOCHROMES, which heighten color and make the dye more brilliant. They may also be used to

TABLE 17.1 Typical Chromophores

Name	Structure
Azo	$-N{=}N-$
Azoxy	$-N{=}N-$ with \mid O \mid
Nitroso	$-N{=}O$
Quinoid	(quinoid ring structure)

increase the solubility of the dye in water and to bond the dye to the fibers with which they are used. Auxochromes can also change the hue of the dye. For example, anthraquinone is a pale yellow dye. The addition of two —OH groups yields alizarin, a dark reddish-orange dye, while the further addition of two —NHCH₃ groups and a rearrangement of the auxochromes produces disperse blue, a dark blue dye. Typical auxochromes are given in Table 17.2.

Finally, the overall chemical structure of the dye affects the color. Indigo Blue A and Direct Red are both azo dyes containing three $-N{=}N-$ chromophores (Fig. 17.6). The color difference is due to the other atoms that are attached to the azo groups.

TABLE 17.2 Typical Auxochromes

Name	Structure
Amines:	
primary	$-NH_2$
secondary	$-NHCH_3$
tertiary	$-N(CH_3)_2$
Akloxy:	$-O-C_2H_5$
ethoxy	$-O-CH_3$
methoxy	
Hydroxyl	$-OH$
Sulfonates:	
acid form	$-SO_3H$
salt form	$-SO_3^-\,{}^+Na$

Indigo Blue A

Direct Red

Figure 17.6 Indigo Blue A and Direct Red have azo group chromophores. The difference in color is due to the other atoms.

PERFORMANCE REQUIREMENTS OF DYES AND PIGMENTS

The purpose of dyes (and pigments, when they are used) is to provide color to the material. If all dyes were permanent and easy to apply, neither the manufacturer nor the consumer would be concerned about their performance. However, dyes do vary in their properties, so a knowledge of the factors affecting their performance is important to both producer and consumer.

The major performance characteristic of a dye is its ability to maintain its color in normal use. This is known as COLORFASTNESS. The major factors affecting colorfastness are light, perspiration, cleaning methods, friction, and atmospheric fumes.

Fastness to Light

LIGHTFAST colors are those that do not change under exposure to sunlight or artificial light sources. Light, as we have noted, is a form of energy. As dyes absorb this energy, they may be altered in their chemical makeup; an auxochrome may be removed, or chemical bonds within the dye may be broken. These chemical changes affect the hue, value, and saturation of the dye. Eventually the colorant may entirely lose its ability to produce color.

Fastness to Perspiration

Human perspiration is a complex solution of organic acids and bases. The perspiration of some people is acidic; that of others may be basic. Perspiration may chemically react with some dyestuffs and alter them so that they no longer absorb light. In less extreme cases, the action of perspiration may change the color of the dye, or cause it to fade. Antiperspirants and deodorants may also affect dyes.

Fastness to Laundering and Dry-Cleaning

Some dyestuffs may be chemically bonded to the fibers with which they are used. However, these dyes are generally expensive, and cannot be used with all fibers. The dyes that are not chemically bonded may be leached from the fiber by soaps or detergents during laundering, or by dry-cleaning solvents. Removal of any dye causes the color to fade. Strong bleaches may also cause chemical changes that affect dyes, and cause them to lose their color. In BLEEDING, one of the major causes of consumer dissatisfaction, the dye is removed from one fabric and absorbed by another during laundering. A common example is the pair of red socks that are accidentally laundered with white goods and turn the entire washload pink.

Sometimes fashion dictates the use of dyes that are not WASHFAST. The faded denim look, popular in the 1970s, was obtained by using dyes that have low resistance to chlorine bleach and are easily removed during laundering. Bleeding madras, a cloth that was popular during the 1960s, was a plaid cotton material colored with dyes that were not washfast. Bleeding of the dyes during laundering led to continually varying colors in the cloth. Unfortunately, the colors also washed out, so that garment life was shortened.

Ironing may cause color changes if the dyes are volatile at the ironing temperature. The dye will evaporate from the hot region covered by the iron and condense upon a cooler portion of the cloth. The result is splotches of light and dark over the surface of the material.

Fastness to Friction

Friction during use can cause the dye to rub off when it does not properly penetrate the fiber but remains on the surface. This is known as CROCKING, and it results in the fading or removal of color.

Fastness to Fumes

Air is never completely pure, but the air surrounding cities and industrial centers is even less pure. Automobile exhaust, heating systems, power plants, and industrial stack gases emit nitrogen and sulfur oxides as well as other vapors into the atmosphere. These gases can react with dyes to cause FUME FADING.

TYPES OF DYES

The consumer wishes to pay the lowest price commensurate with the best performance, while the producer wishes to provide the best performance commensurate with the lowest cost. The attempt to satisfy consumer desires while maintaining manufacturers' needs for reasonable profits has led to the large number of available dyes. In the textile industry, dyes are classified by both chemical type and method of utilization. This methodology, the result of

historical development, is not satisfactory to the chemist, who classifies them according to chemical type.

The major classes of dyes are disperse, direct, vat, reactive, basic, acid, and sulfur.

Disperse Dyes

The disperse dyes were originally developed to dye acetate, but are now used for almost all fibers. These dyes are not soluble in water, but are very finely ground powders that are dispersed throughout the dye bath. The particles are absorbed into the fiber at the point at which they happen to touch. They are insensitive to fiber chemistry, and only slightly affected by surface properties. These dyes are usually used for the home market as well as for commercial production.

Multicolor effects may be achieved by dyeing a knit fabric in a bath of mixed disperse dyes. Since the dyes are not affected by fiber chemistry and surface properties, they will leave little spots wherever they happen to touch the cloth. When the knit fabric is unraveled, a multicolored yarn is obtained which may be used in weaving, knitting, or tufting.

Disperse dyes have good fastness to light, perspiration, laundering, and dry-cleaning. Crocking resistance is good. However, fume fading may be a problem.

Direct Dyes

These may be classified as substantive, developed, and naphthol. They are called direct dyes because they can be directly applied to cellulosics to give bright, deep colors. The dyestuffs are soluble in water and are absorbed into hydrophilic fibers as the fiber swells in the water solution. Upon drying, the dye is physically trapped within the fiber.

Substantive direct dyes are used on cellulosics, wool, and silk. They have good lightfastness, resist perspiration, are fast to dry-cleaning solvents, do not crock readily, and exhibit good resistance to atmospheric fumes. However, since they are water-soluble, they are not washfast, and may bleed.

Developed direct dyes are formed by the application of a dye to the fiber, followed by treatment with a developing compound. The developer forms a chemical compound with the dye within the fiber and renders it insoluble in water by increasing the size of the dye molecule and trapping it within the fiber. The developed dyes exhibit superior washfastness as compared to the substantive direct dyes. However, developing changes the color of the dye, since the developer acts as an auxochrome. The action of a developer on a direct dye is shown in Fig. 17.7.

Naphthol or (azoic) direct dyes are similar to the developed dyes. The fiber is treated in a cold caustic solution of a *beta*-naphthol derivative, which is absorbed by the fiber, and then immersed in a dye bath. Reaction between the dye and the naphthol produces the color and forms a compound that is insoluble in water. An after-treatment in boiling soap solution permanently

Figure 17.7 A developed direct dye is made more colorfast by coupling to phenol.

fixes the dye within the fibers. The azoic direct dyes are used for cellulosics, and to some extent for man-made fibers. They have excellent fastness to laundering but may crock, and can bleed when dry-cleaned.

Vat Dyes

The vat dyes are the oldest of the dyestuffs. They are insoluble in water but are readily soluble in alkaline solution. These dyes contain $\diagdown C=O$ groups, which are readily reduced to $\diagdown C-OH$ groups. In sodium hydroxide solution, the reduced dye is changed to its sodium salt form, which is colorless, but soluble and readily absorbed into the fiber. After application, the dye is converted back to its original, insoluble colored form. The vat dyes are noted for their excellent colorfastness and range of colors. They may be used on all fibers except those which are sensitive to alkalies. A typical vat dye is shown in Fig. 17.8.

Reactive Dyes

Although most dye types depend upon physical absorption of the dye to hold it within the fiber, reactive dyes form chemical bonds with the fiber. The chemical bonds are much stronger than physical attraction, so these dyes are essentially permanent. In practice, the reactive group is attached to the dye as

Salt form
(colorless and soluble)

Leuco form
(colorless and insoluble)

Dye form
(colored and insoluble)

Figure 17.8 Vat dyes in their oxidized form are colored and insoluble.

Figure 17.9 The formation of a reactive dye and its reaction to cellulose. The dye portion of the molecule is much larger than shown.

an auxochrome. (The reaction of a typical reactive dye with cotton is illustrated in Fig. 17.9.) After dyeing, the fabric is boiled in a soap solution to remove unreacted dye, and the color is fixed. The reactive dyes were originally developed for use with the cellulosic fibers, but modern developments are extending the use of this class of dyes to wool, silk, and some man-made fibers.

Reactive dyes exhibit good to excellent colorfastness; however, they may be damaged by chlorine bleaches and alkaline perspiration.

Basic (Cationic) Dyes

The basic dyes were the earliest of the synthetic dyes. They are salts of organic acids, and are called cationic dyes because the dye molecule is positively charged. The cationic dyes find their most important use in the dyeing of acrylics. Acrylic polymer contains negatively charged ($-SO_3^-$) groups added to the polymer molecule during the polymerization process. These negatively charged groups react with the positively charged dye to form a permanent chemical bond. The cationic dyes may also be used on modified nylons and polyesters. The reaction of a typical basic dye with acrylic fiber is shown in Fig. 17.10.

Basic dyes have excellent colorfastness on acrylics, modacrylics, nylons, and polyesters, where they give bright colors. Deeper shades may be formed on acrylics. They are no longer used on natural fibers because of poor light and washfastness.

Acid Dyes

Acid dyes were developed as modifications of basic dyes. Their molecules carry a negative charge. Developed primarily for wool and silk, they are now used on a variety of fibers. These dyes are not suitable for cellulosics and other fibers sensitive to acid solutions.

Figure 17.10 The coupling of a cationic dye with a reactive group in an acrylic polymer.

Many acid dyes exhibit poor washfastness and poor resistance to perspiration unless they are treated with a *mordant*, a metal that binds two or more dye molecules to each other and whose resultant complex is too large to wash out of the fiber. The usual mordants are salts of chromium, tin, copper, or aluminum. Acid-dyed fabrics that have been treated with a mordant are duller but have much better colorfastness than those which have not been mordanted. Figure 17.11 shows an acid dye mordanted with chromium.

Sulfur Dyes

These dyes contain sulfur or sulfur compounds in an alkali-soluble form. They are applied from an alkaline solution and form insoluble compounds when they are rinsed. The structure of sulfur dyes is not well determined, but they appear to be complex polymers in which the repeat units are joined by sulfide links. They are used almost exclusively for dark shades, since the lighter colors exhibit poor resistance to light and laundering.

Figure 17.11 Three Solway Blue acid dye molecules mordanted with chromium.

CoO·Al$_2$O$_3$ blue cobaltous aluminate

4CoO·Al$_2$O$_3$ green cobaltous aluminate

pigment orange

(a) (b)

Figure 17.12 (a) Inorganic and (b) organic pigments.

PIGMENTS

The structures of typical inorganic and organic pigments are shown in Fig. 17.12. Unlike dyes, pigments do not dissolve in water or in the fibers to which they are applied; however, they may be added to the fiber-forming material before spinning. This technique is particularly useful for olefins and other fibers that are not readily dyed. Finely ground pigments formed from inorganic salts or organic substances may be added to molten polymer or to spinning solutions before extrusion. The pigments remain dispersed within the fiber. Fibers colored in this manner are referred to as *solution-dyed* or *dope-dyed* fibers. The color is permanent and is unaffected as long as the fiber is intact. The major disadvantage of this method is the high cost associated with stocking inventories of colored fibers. In addition, it is too expensive for a manufacturer to produce a broad range of colors, so colors are limited.

Pigments may also be applied to fibers through the use of a binder. In this method, a resin binder and pigment are applied to the material and the resin is cured. The pigment is retained on the material as long as the binder is intact. Fabrics pigmented in this manner often exhibit poor crocking resistance. In addition, sunlight may darken the binder and cause color changes. Sometimes the binders are soluble in dry-cleaning solvents, in which case the color is not fast to dry-cleaning.

METHODS OF APPLICATION

Cloth may be colored and patterned by DYEING or PRINTING techniques. In general, dyeing yields deeper shades and more colorfast materials, while printing provides a greater variation of patterns. Cloth may be dyed while in the fiber form, as yarns, or after the material has been woven or knit. Printing is generally done on the finished cloth, although some techniques allow for the printing of yarn before cloth manufacture.

DYEING TECHNIQUES

Depending upon the desired results, cost, and materials available, textile products can be colored by dyeing the fiber, the yarn, or the finished cloth.

343

Fiber Dyeing

In *stock dyeing*, raw fiber is dyed in large kettles. In general, this technique produces complete penetration of the dye into the fiber and yields deep brilliant shades. Irregularities in color are removed as the fibers are blended when they are made into yarn. In *top dyeing*, fibers may be converted into lightly twisted roving, or tops, before they are dyed. In both methods, very uniform colors are achieved.

Staple fibers dyed in this manner must be treated one batch at a time, and there may be color variations from batch to batch. Filament yarns, which are continuously spun, however, are more uniform in color after dyeing. Solution dyeing is not flexible enough to provide the wide array of colors possible when the batch process is used.

Yarn Dyeing

To weave or knit a pattern into cloth while it is being formed, yarns dyed before cloth manufacture are used. Yarn dyeing may be accomplished by skein-dyeing, package-dyeing, or beam-dyeing methods.

In skein dyeing, the yarn is formed into loose coils (hanks or skeins) and immersed in a large, open dye bath. Since the yarn is loosely hung in the bath, dye penetration is good. However, the process is slow.

Package dyeing is quicker. Yarns are wound on spools, stacked on perforated rods, and placed in a pressurized tank. The dye liquid is pumped through the perforated rods and through the package of yarn; the liquid is recirculated until the proper color is achieved. Because the operation occurs under pressure, the dye is forced into the yarn more quickly than in skein dyeing. However, uniformity of color is not as good as in the skein dyeing method, in which the yarn is visible during processing.

In beam dyeing, the yarns are wound onto a perforated warp beam and dyed under pressure in the same manner as package dyeing. The advantage of this method is that the yarns are all wound on the warp beam from which they will be taken during the weaving process. Variations in color from the inside of the beam to the outside is similar for all the yarns, so irregularities are less obvious in the finished product.

Space-dyed yarns are produced by dyeing a knit cloth rapidly, so that the dye penetrates the outer surfaces of the yarn but is not taken up at the points where the yarns cross each other. When disperse dyes are used, the yarns may be multi-hued in addition to exhibiting shading.

Cloth Dyeing

The dyeing of woven or knit cloth is known as *piece dyeing*. Piece-dyed goods may be colored by batch or continuous processes. The batch methods are usually slower, but produce more uniform colors. The continuous processes are much less costly. Except for small lots of less than 100 meters (110 yards), woven cloth is dyed by the continuous processes. Because knit cloth must be carefully handled during dyeing to prevent stretching, most are dyed by batch methods.

All fabrics may be piece-dyed. However, if the cloth contains two or more different fibers, special care must be taken to achieve the same color in both fibers. Sometimes the cloth must be dyed in two different dye baths, one for each color. Occasionally, two different dyes may be used in one bath. The process of dyeing two or more fibers the same color is called *union dyeing*.

It is also possible to weave or knit cloth using two or more fibers, or variations of a fiber, to achieve patterned effects upon dyeing. This may be done by using different yarns in the warp and fill to achieve checked patterns, or by mixing warp or fill yarns to produce stripes. The fabric may be dyed in separate baths to yield different colors, or different dyes may be used in the same bath, one dye being compatible with one fiber and the other dye having an affinity for the other fiber. This process is called *cross-dyeing*.

Whether the cloth is made from a single fiber or is meant to be union dyed or cross dyed, the batch process consists of immersing the cloth in a large vat, called a *kier*, and treating it until the proper color is achieved. The cloth is removed, the dye bath is replaced, and a new batch of fabric is treated. In the continuous processes, much greater yardages of cloth can be accommodated, dyeing is faster, and variations from batch to batch are eliminated.

The two major procedures are *beck dyeing* and *jig dyeing*. In beck dyeing the cloth is twisted to form a rope (much as movie characters form their bedsheets into escape ropes). The rope is passed over sets of reels, through the dye bath, and out again in a continuous loop. A number of these loops are formed across the face of the beck, so thousands of meters of cloth may be treated at one time. Jig dyeing is used when the cloth is easily wrinkled or creased. The process is similar to beck dyeing except that the cloth is dyed in its open width. Figure 17.13 shows a modern high-temperature piece-dyeing machine.

Figure 17.13 An "Aqualuft" dyeing machine. (*Gaston County Dyeing Machine Company, Stanley, N.C.*)

PRINTING TECHNIQUES

Except for Jacquard woven or knit fabrics, for which elaborate looms or knitting machines utilizing colored yarns can produce intricate patterns, dyeing procedures are limited to solids or simple geometric patterns. Printing, however, allows the artist to achieve complete flexibility in color and pattern. The major printing processes are (1) direct printing, (2) resist printing, and (3) transfer printing. In addition there are a number of handicraft techniques that are of interest.

Traditionally, direct printing was considered to provide the finest detail, greatest range of colors, and best colorfastness, although at greatest cost. However, recent developments in all the techniques have led to an intense controversy over which methods produce the best results, and at what costs. The manufacturers of screen-printing and transfer-printing machinery are claiming improvements in detail and color that rival direct printing, while the producers of direct-printing machines are claiming reductions in cost. The following is a discussion of the types of commercial printing methods currently in use.

DIRECT-PRINTING METHODS

The earliest method of printing fabrics was by carving a design on a wooden block, inking the block, and transferring the design to the fabric. This hand process was followed by flatbed printing, which operated much the same as early printing presses. The modern technique of *roller printing* was invented by Thomas Bell in 1783.

Roller Printing

In roller printing, seamless metal cylinders (usually copper) are carefully engraved, each with a portion of the pattern to be printed in each color. The portion of the rollers that will not apply color are covered with a chemically resistant coating (the resist), and the uncovered portions are etched away. The resist is then removed. The rollers are made more durable by the application of a chrome coating.

The color rolls are arranged around the circumference of the central cylinder of the printing machine. This may be as large as 2½ meters (8¼ ft) in diameter, and have sixteen color rolls. Each color roll is partly immersed in a trough of dye paste; each has a metal blade which scapes the paste from the surface of the roll.

The cloth passes around the padded central cylinder and is pressed against each of the engraved rollers in turn. The dye paste is transferred from the etched regions of the roll onto the cloth and successive additions of color form the pattern. Fig. 17.14 shows the operation of a roller printing machine.

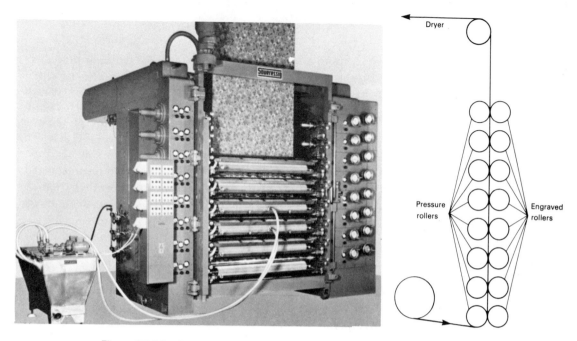

Figure 17.14 A roller printing machine and a schematic of its operation.
From one to eight colors may be applied. (*Ciba-Geigy Corp.*)

Photo Printing (Daguerrotype)

Photographic techniques may be employed to etch the pattern onto the
surface of the roller. A photo negative is placed over a screen plate that breaks
the image into tiny dots. From this image a contact print is made. The contact
print is placed over a roller covered with a light-sensitive chemical. Where
light passes through the print the chemical is cured to form a resist coating.
An etching solution removes the metal from the region not covered by the
resist. Color film may be used to make engraved rollers for each of the primary
colors. In this manner any photograph may be roller-printed.

Discharge Printing

In the discharge-printing process, the pattern is created by removing
color. To a cloth dyed a solid shade, a bleaching agent is applied in the same
manner in which a dye paste is applied in roller printing. The bleach removes
the color from the fabric, leaving a light pattern on a dark background.
Discharge printing may be combined with other direct printing methods to
produce shading and other pattern variations. Its major drawback is that the
bleaching agents may tender (weaken) the fabric.

In resist printing, some portions of the fabric are covered by a protective material, called a RESIST, which impedes penetration of the dye. The fabric that is not covered by the resist material becomes colored, while the covered portion remains white. Many hand methods such as tie dyeing and batiking (see Handcraft Methods, following) are based on the resist principle. In one variation of this method, roller-printing techniques may be employed; here a dye-resistant paste is printed onto a fabric and the cloth is subsequently dyed. The cloth remains white in the covered areas, and is colored in the uncovered areas. Subsequent removal and reapplication of the resist allows the printer to apply a number of colors to the fabric. The major resist methods in use today are FLATBED and ROTARY-SCREEN methods.

Flatbed Screen Printing

In this method the cloth to be printed, supported by a resilient pad, is laid out on a table, often as long as 30 to 50 meters (99 to 165 ft). A screen, composed of a very fine fabric—nylon, silk, polyester, or metal filaments—stretched over a rectangular frame, is placed in guides above the cloth. A resist material, usually a plastic film into which a design has been cut, is placed over the screen. Alternatively, a pattern may be painted directly on the screen material to fill the holes in the fabric and prevent the dye from penetrating to the cloth.

Printing paste is spread across the screen and forced through the resist by a rubber wiper blade. The frame is then lifted from the cloth and moved to its next position. The process is repeated until the full length of the cloth has been printed with one color. The cloth is long enough so that the first impression has dried by the time the last impression is done. A new screen, with a new resist, is placed in the starting position and a second color is applied. The process is repeated for as many colors as is necessary to complete the pattern (see Fig. 17.15).

Flatbed printing may be accomplished by manual or automatic devices. By hand, the production rate is about 1 meter (3 ft) per minute; automatic systems operate at about seven times that rate. However, hand operation generally yields better pattern definition and can accommodate more colors. Flatbed printing, although rather slow, is well-suited to short production runs of many colors or large repeats.

Rotary-Screen Printing

Production rates are much higher if the cloth moves through the machine rather than having the machine move over the cloth. This is the major advantage of rotary-screen printing. Such machines can operate at about 75 meters (250 ft) per minute. In this process, the cloth is carried on a moving belt through a series of rotating cylinders. Dye paste is fed into the upper cylinders and forced through a resist-covered screen on the circum-

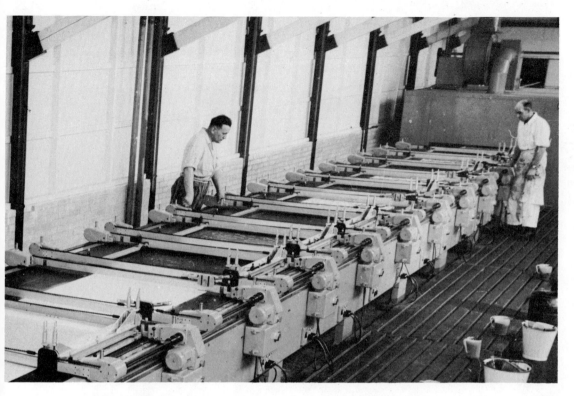

Figure 17.15 A modern automatic flat screen printing machine. Each screen is used to apply a different color. (*AFF Encyclopedia of Textiles*)

ference of the rollers. Each roller applies one color. Following dye application, the fabric is passed through an oven to set the dye, a rinse bath to remove unfixed colorant, and a drying oven. The printing process is illustrated in Fig. 17.16.

The higher speed of the process requires very accurate alignment of the rotating screens and rapid-drying dyes. If the machinery is not carefully controlled, pattern definition will be poor and colors will overlap. Rotary-screen printing is particularly well suited to large production runs of a few colors and small pattern repeats. However, some of the larger machines can handle up to twelve colors, and skillful use of these devices can make them as versatile as the flatbed screen printing technique.

TRANSFER PRINTING

The newest and fastest-growing printing method, TRANSFER PRINTING, is based on the proclivity of some disperse dyes to SUBLIME when heated. That is, the solid dye evaporates when heated and deposits itself, as a solid, upon another surface. In practice, a pattern is printed with disperse dyes on a special paper. As many colors as desired may be used, and any pattern may be reproduced.

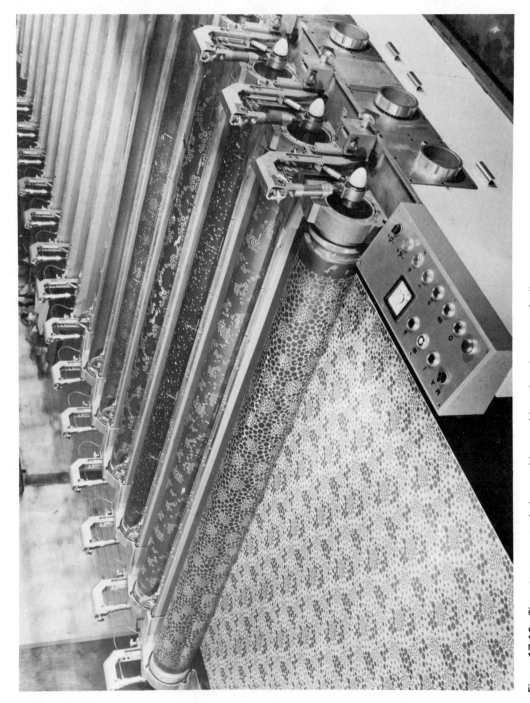

Figure 17.16 The rotary screen printing machine combines the advantages of roller and screen printing. (*B. F. Perkins*)

The printed paper and the cloth to be printed are passed between a pair of hot rollers. The solid dyes vaporize and, since they have a greater affinity for the cloth than for the paper, deposit themselves on the cloth in the exact pattern that was printed on the paper.

The disperse dye is absorbed into the cloth almost instantaneously so that transfer printing may be accomplished at speeds as high as 60 meters per minute (200 fpm), although 15 mpm (50 fpm) is more usual. The major advantages of the process are rapid setting of dyes with no need for drying or rinsing, very good dye penetration, and low capital investment. In addition, if the pattern fails to sell well, the converter is stuck with only the investment in printed paper rather than an inventory of printed cloth. The process may be used on short production runs with great economy. On larger runs, over 1,500 meters (1,650 yards), rotary-screen printing is often more economical.

Transfer printing is suitable for applying designs on cloth, cut panels, or finished garments. At present, this technique is best suited for man-made fibers such as polyester, nylon, and some acrylics. Blends, such as 65/35 polyester/cotton, can be accommodated, but deep, brilliant colors are difficult to achieve. Current research on improved dyes and advanced transfer methods holds promise for extending the transfer-printing process to natural fibers.

HANDCRAFT METHODS

Three handcraft techniques of interest are the direct application of dyestuffs to cloth with a brush or other device, tie dyeing, and batiking. Each of these methods was once a major commercial procedure for printing cloth. However, hand methods are extremely slow and require a great deal of skill on the part of the artisan. For these reasons, hand printing is almost exclusively reserved for high-fashion, high-cost fabrics which warrant the expense. All the handcraft methods can be duplicated by commercial techniques with reasonably good results.

Stencil Printing

Painting a picture or other pattern on a fabric is rather slow. In addition, artists with the requisite skill to produce complex designs are usually not temperamentally suited to repeating the same pattern over and over again, as is required of textiles. Thus, direct-painting techniques are limited to display items such as wall coverings and screens.

Stencil printing is a method whereby less skilled artisans can apply a complex design to a large area of fabric at greater speed. It is a resist method, similar in principle to flatbed screen printing. A stencil made of thin, stiff paper or plastic is cut with a pattern, for each color. The stencil is laid directly on the cloth and dye is applied with a brush. After each color has dried, a new stencil is placed on the cloth and a new color is applied. Stencil printing is costly, and best suited to short runs of high-fashion fabrics.

Tie Dyeing

Although not strictly a printing method, tie dyeing is based on the resist principle, and produces patterns that are similar to prints. Portions of fabric are tightly wrapped with thread or string, and the whole cloth is dyed. The tied portions are not dyed because the wrapping material resists dye penetration. After rinsing, the fabric is retied and redyed. The process may be repeated as often as desired. Colors may be mixed by repeated application of different dyes to give a multicolored material, usually characterized by large blotches of color which fade into each other. However, very complex patterns may be achieved by careful application of this method.

Batik

A resist method indigenous to Southeast Asia, batiking has become very popular in the West. The cloth is covered by a wax coating in the regions that are meant to remain uncolored. The wax may be applied in very fine detail or in large coarse patterns. The cloth is then dyed. After rinsing, coated areas may be freed of resist material by being boiled in water or by absorption of the hot wax into another cloth. Then the wax is reapplied, and the cloth is dyed another color. The process is repeated until the design is complete. Batik is characterized by very complex and detailed patterns, often intertwined by very fine colored lines. The fine lines appear where the wax resist has cracked and the dye has penetrated to the yarns. The method is slow and expensive, making it suitable mainly for high-cost fabrics and display items rather than the mass market.

SUMMARY

The perception of color is brought about by photons of a particular wavelength striking the cones of the eye, and stimulating impulses in the retina. These impulses are transmitted to the brain and interpreted as color sensations. The color stimulus comes about as light is reflected from the surface of an object.

The object absorbs some of the wavelengths of light to a greater degree than others and the color that is transmitted to the eye is the complement of the color that is absorbed. Colored objects may be described by their hue, saturation, and value. The perception of color is also affected by adjacent or background colors, the color of the light source, and the pattern used.

Dyes and pigments are used to give color to objects. Dyes are soluble; pigments are not. Both types of materials contain chromophores, which are the active sites that give the impression of color. Dyes may also contain auxochromes which affect the brilliance of the color. Most dyes are physically trapped within the fibers to which they are applied, although some may chemically react with their substrates. The reactive dyes have greater fastness to laundering and dry-cleaning. The important factors that affect the per-

formance of dyes are fastness to light, perspiration, cleaning methods, friction, and fumes.

Color and design are applied to textiles by dyeing and printing techniques. Dyeing is generally used for application of solid colors, and is suited to fiber, yarn, and cloth. Printing methods (direct, resist, or transfer techniques) are used when complex patterns are desired.

There are many types of dyestuffs; the proper ones are chosen for their affinity to the fibers being dyed, their color, and their cost.

REVIEW QUESTIONS

1. Often, colored materials are viewed under different types of light. Northern daylight is strong in the blue region of the spectrum, while southern sunlight is more yellow. Fluorescent lamps are bluer than incandescent lamps, which are somewhat yellow. The apparent change in color of a dyed fabric when viewed under lights of different colors is called *metamerism*. How would you expect the color of an apple-green fabric to change when it is seen under the different light sources mentioned above? How does metamerism affect the choice of fabrics in both apparel and home furnishings?

2. Rank the following fibers in descending order of dyeability (explain your answers): nylon, acrylic, wool, cotton, polyester, olefin, glass, acetate.

3. Which dyes would be used on the following fibers (explain): wool, nylon, polyester, acrylic, cotton, acetate.

4. How could you tell if a pattern on a colored fabric had been achieved by a printing technique or by dyeing of the yarns before manufacture? Which method yields the more durable colors?

5. Dyes are expected to be fast to light, perspiration, dry-cleaning and laundering, friction, and fumes. No dye can be superior in all categories and no product requires superior performance in all categories. Which of the above fastness requirements would be of most importance in the following end uses (explain your answers): curtains and drapes, automobile upholstery, living-room carpets, dining-room chairs, bed linens, towels.

ACTIVITIES

The colorfastness of fabrics is of some importance to the consumer. The following experiments, based on AATCC (American Association of Textile Chemists and Colorists) test methods, are intended only as teaching aids. The standard tests for colorfastness may be found in the AATCC manual.

A. *Colorfastness to Bleaches*

 1. Chlorine bleach

 Prepare a solution of chlorine bleach in the following manner:

 Dissolve one gram of sodium bicarbonate ($NaHCO_3$) in 100 ml of water. This is solution I. Dissolve 15 grams of sodium carbonate (Na_2CO_3) in 300 ml of water. This is solution II. Mix 15 ml of solution I with 285 ml of solution II. Take 225 ml of the

mixture and add to it 25 ml of household bleach (any brand) to make up 250 ml of bleach solution.

Cut a 10 × 10 cm (4 × 4 in) cloth sample and immerse it in a ½ percent soap solution until it is thoroughly wet. Remove from the soap solution and place in a 500 ml capped jar containing 250 ml of the chlorine bleach solution. Shake well and set in a warm-water bath at approximately 27° C (80° F) for one hour. Remove the cloth and thoroughly rinse under cold running water for 5 minutes. Squeeze to remove excess water and iron between two layers of white cotton cloth to dry.

Mount the treated specimen on white posterboard next to an unbleached specimen cut from the original sample of cloth. Repeat the experiment using samples of cloth made from different fibers and dyed different colors. Are some colors more resistant to chlorine bleach than others? Are the dyes for some fibers more colorfast than others? Tabulate and explain your findings.

2. Peroxide bleach

Prepare a solution of peroxide bleach in the following manner:

Mix 4 ml of sodium silicate ($NaSiO_3$) with 10 ml of 35 percent hydrogen peroxide (H_2O_2). Dissolve 0.5 gram of sodium hydroxide in the liquid. Pour this solution into a test tube large enough to accommodate the fabric sample.

Prepare the specimen by cutting a 10 × 4 cm (4 × 1½ in) strip of sample fabric and a similar strip of white cotton cloth. Lay one cloth over the other and roll them together in the long direction to form a short, fat cylinder. Place the prepared specimen in the test tube with the bleach solution, making sure that the fabric is covered by the liquid.

Place the test tube in a bath of boiling water for one hour. Remove and cool with running tap water. Remove the cloths from the test tube with a tweezers and rinse under cold running water for 5 minutes. Squeeze to remove excess water and dry by ironing between layers of white cotton cloth.

Observe the strip of white cotton cloth. Did it absorb any dye from the test specimen? Mount the treated specimen on white posterboard next to an unbleached specimen cut from the original sample of cloth. Repeat the experiment using (a) sample fabrics made from different fibers but dyed similar colors and (b) sample fabrics made from the same fibers dyed different colors. Are some colors more resistant to peroxide bleach than others? Are the dyes for some fibers more colorfast than others? Tabulate and explain your findings.

B. *Colorfastness to Chemicals*

Cut six 10 × 4 cm (4 × 1½ in) fabric specimens. Roll them up to form short, fat cylinders. Place the rolled specimens in test tubes and push to the bottom with a glass rod.

Prepare six test solutions as follows:

1. Dilute 10 ml of 35 percent hydrochloric acid (HCl) to 100 ml. This is a strong acid.

2. Dilute 10 ml of concentrated acetic acid (CH_3COOH) to 30 ml. This is a weak acid.

3. Dissolve 10 grams of sodium carbonate (Na_2CO_3) in 100 ml of water. This is a weak base.

4. Concentrated ammonium hydroxide (NH_4OH). This is a moderately strong base.

5. Undiluted perchloroethylene (commercial dry-cleaning fluid).

6. Undiluted acetone (oil-free nail-polish remover).

Add a sufficient amount of solution to each test tube to cover the fabric specimen.

Remove the samples after 2 minutes. Allow to dry overnight at room temperature. Rinse thoroughly under cold running water for 5 minutes. Squeeze out excess moisture and dry by ironing between layers of white cotton cloth.

Mount the treated specimens on white posterboard next to an untreated specimen cut from the original sample of cloth. Repeat the experiment with (a) sample fabrics made from different fibers but dyed similar colors and (b) sample fabrics made from the same fibers dyed different colors. Are some colors more resistant to chemical attack than others? Are the dyes for some fibers more colorfast than others? Tabulate and explain your findings.

C. *Colorfastness to perspiration*

Since human perspiration may be either acid or alkaline, two solutions are needed.

1. Acid solution: In a large beaker, place 10 grams sodium chloride (table salt), 1 gram lactic acid, 1 gram disodium hydrogen phosphate, and ¼ gram histidine monohydrochloride. Dilute to 1 liter.

2. Alkaline solution: In a large beaker, place 10 grams sodium chloride (table salt), 4 grams ammonium carbonate, 1 gram disodium hydrogen phosphate, and ¼ gram histidine monohydrochloride. Dilute to 1 liter.

Cut specimens from the test sample and from a strip of white cotton cloth to the dimensions of glass microscope slides, or to the dimensions of any available glass plates. Immerse one specimen and one strip of cotton cloth in the acid solution and one specimen and one strip of cotton cloth in the alkaline solution for at least 15 minutes. Remove the fabrics and sandwich between layers of glass. The acid specimen should not contact the alkaline specimen. Bake overnight in a warm oven, approximately $38°C$ ($100°F$). If the samples are not completely dry, allow to dry in air at room temperature. Observe the samples for color change.

Mount the treated specimens on white posterboard next to an untreated specimen cut from the original sample of cloth. Repeat the experiment with (a) sample fabrics made from different fibers but dyed similar colors and (b) sample fabrics made from the same fibers dyed different colors. Are some colors more resistant to perspiration than others? Are the dyes for some fibers more colorfast than others? Tabulate and explain your findings.

D. *Colorfastness to Light*

This experiment is easily conducted during the summer or in sunny climates. Cut four specimens from a fabric sample to any convenient size. Cover half of each of the specimens with a strip of posterboard so that only half of the cloth is exposed. Tape the specimens to a window that receives direct sunlight during an appreciable fraction

of the day. Remove one specimen after two days, the next after five days, the third after ten days, and the last after twenty days. Observe the color change.

Mount the specimens on white posterboard. Repeat the experiment with (a) sample fabrics made from different fibers but dyed similar colors and (b) sample fabrics made from the same fibers dyed different colors. Are some colors more resistant to light than others? Are the dyes for some fibers more colorfast than others? Explain.

VI

18 Manufacturing Methods

19 Standards and Testing

MANUFACTURING METHODS, STANDARDS AND TESTING

PART VI DEALS WITH the manufacture and testing of fibers, yarns, and fabrics in a general way. Since the details of machinery and the precise techniques employed in various processing and inspection steps vary from producer to producer, a detailed account of all processes and techniques is beyond the scope of an introductory textbook.

18

manufacturing methods

It is natural for consumers to be more interested in the performance properties of the goods they buy than in the methods employed in the manufacture of those goods. However, a general understanding of the techniques and procedures employed in manufacture enables consumers to understand why products have the properties they do, why there are differences in the quality of goods of different brands, and why products are priced as they are. Provided with such an understanding, consumers are better able to deal with retailers and manufacturers in the marketplace as well as to be better judges of the tradeoffs involved in governmental regulation of the market.

FIBER MANUFACTURE

The preparation of the various textile fibers has been discussed in earlier chapters. This section describes in greater detail the manufacturing processes and equipment used in the production of man-made fibers. In general, the processes are based on the same principle used by the silkworm in spinning silk. A liquid is forced under pressure through a small opening and congeals into a solid when exposed to the atmosphere. Since the chemical constitution of the man-made fibers varies so widely, the details of the manufacturing processes must be altered to conform to the requirements of the fiber. The process of fiber formation is called SPINNING, and should not be confused with the twisting of staple fiber into yarn, also called spinning.

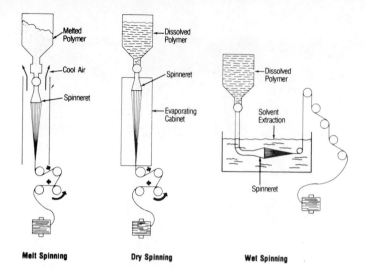

Melt Spinning Dry Spinning Wet Spinning

Figure 18.1 The three methods of spinning man-made fibers. (*Celanese Fibers Marketing Company*)

Man-made fibers are produced by (1) wet spinning, (2) dry spinning, and (3) melt spinning (Fig. 18.1). In *wet spinning* the fiber-forming polymer is dissolved to produce a solution which is forced through an opening under pressure (EXTRUDED) into a liquid bath in which the fiber is insoluble. As the solvent is dispersed in the bath, the fiber is formed. Often, a chemical reaction occurs between the solvent and the bath which liberates the polymer. Wet spinning is generally used when the fiber-forming polymer is insoluble in low-boiling solvents and cannot be easily melted. It is usually the most costly of the three manufacturing methods.

In *dry spinning*, a polymer is dissolved in a solvent that can be easily evaporated. The liquid is extruded into heated air, the solvent evaporates, and the fiber is obtained. Dry spinning is less complicated than wet spinning, but, solvent recovery is an important economic and health consideration.

Melt spinning is the cheapest and most straightforward of the spinning processes. The fiber-forming polymer is melted, extruded, and cooled by a flow of air to form a fiber. This method is limited to thermoplastic materials such as nylon, polyester, olefin, and glass.

Wet Spinning

The production of viscose rayon is an example of the wet-spinning process. Rayon is obtained by converting the cellulose found in wood pulp, cotton, or other plant materials to a soluble cellulose derivative which is regenerated in filament form. Since cellulosic materials do not melt, but are destroyed by heat, they cannot be converted to fibers by the melt-spinning process. In addition, cellulose is not soluble in the common, low-boiling solvents, so that dry spinning is not feasible.

The wet-spinning process is illustrated in Fig. 18.2. Timber is broken into chips which are treated with calcium bisulfite and steam. This treatment removes the impurities and leaves pure cellulose (Cell—OH) in fiber form known as wood pulp. The pulp is washed, bleached, and converted to sheets of

VISCOSE PROCESS

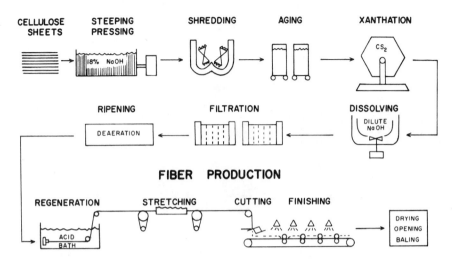

Figure 18.2 The rayon manufacturing process, an example of wet spinning. (*ITT Rayonier Inc.*)

paperboard, which are conditioned at standard temperature and humidity and then stacked in long presses. The paper is steeped in 17.5 percent sodium hydroxide (caustic) solution to form the soda cellulose (Cell—O⁻Na⁺). Excess liquid is squeezed from the paper by the press, and the moist mass of cellulose is passed to the shredder. Excess caustic solution is purified and reused.

The shredders consist of cylindrical drums containing revolving, toothed knives which break up the compacted paperboard into fine crumbs that can be further treated. The shredded crumb may be aged from a half to one-and-a-half days, in order to reduce the length of the polymer molecules and to insure complete conversion to soda cellulose. Aging must be carefully controlled; too little makes further processing difficult, while overtreatment leads to an inferior product.

After shredding and aging, the crumb is placed in air-tight vessels with about 10 percent of its weight of carbon disulfide (CS_2). As the materials are churned, an orange gelatinous mass of sodium cellulose xanthate

$$\text{(Cell—O—}\overset{\displaystyle S}{\overset{\displaystyle \|}{C}}\text{—S}^-\text{Na}^+)$$

is formed. Excess carbon disulfide is removed by vacuum and recovered for further use. Following xanthation, the orange material is mixed with caustic solution. The material dissolves to form a honey-colored, viscous liquid which contains about 7.5 percent cellulose.

The xanthate from a number of mixers is charged to a blending tank, where the material is allowed to ripen. Over a period of about four days the material becomes thinner and then regains it viscosity. Ripening is an important and carefully controlled part of the process. A solution that is too "young" cannot be properly spun. Material that is even a few hours too "old"

361

Figure 18.3 Spinnerets for the wet spinning of rayon. (*Fi-Tech, Inc.*)

will produce an inferior fiber. When the viscose solution has properly ripened, delustrants and other additives are charged to the blender. Air bubbles are removed by vacuum, and the liquid is pumped through filters to the spinning machine.

At the spinning machine, a row of small pumps meter a precise volume of solution through spinnerets into a long, lead-lined trough containing the spinning bath. (A typical spinneret is illustrated in Fig. 18.3.) The spinnerets are made from acid- and alkali-resistant materials. They may contain as many as 500 tiny holes ranging from 0.05 to 0.1 mm (0.002 to 0.004 in) in diameter. The spinning bath is a dilute sulfuric acid solution (about 10 percent by weight) containing sodium sulfate, zinc sulfate, and glucose and is maintained at 40 to 55°C (105 to 130°F). As the viscose solution of sodium cellulose xanthate in sodium hydroxide enters the spinning bath, the alkali is neutralized by the sulfuric acid and the xanthate is precipitated as a solid. The xanthate is converted to cellulose by reaction with the sulfuric acid. The zinc in the spinning bath modifies the reaction rate so that the fiber has a higher strength. In addition, the zinc causes the irregular cross-section characteristic of viscose rayon. The glucose increases the pliability of the fiber. The sodium sulfate slows the reaction rate so that the cellulose (Cell—OH) is not precipated in tiny flakes.

The composition of the spinning bath is empirically determined by the manufacturer, because it is still not clear precisely how the various components affect the fiber properties. Decreasing the acid concentration, lowering the spinning speed, and decreasing the bath temperature help to raise the strength of the fiber. However, such fibers may be too brittle. Reduction of the zinc content leads to fibers with better stretch and more rounded cross-sections, but wet strength is reduced.

The newly formed filaments emerging from the spinning bath are passed over pairs of rollers (Fig. 18.4). The second roller spins at two to three times the rate of the first roller so that the filaments are stretched between

Figure 18.4 Rayon tow being drawn from the spin bath. (*Fi-Tech, Inc.*)

them. This drawing step (not to be confused with drawing of staple to form yarn) raises the strength of the filaments by orienting and aligning the molecules of the fiber.

At this point the drawn yarns still contain small amounts of cellulose xanthate, caustic soda from the viscose solution, and acid from the spinning bath. They are rinsed with dilute acid to complete the conversion of the xanthate to cellulose and then with water to remove the acid. The yarns may now be wound on packages, textured, or converted to staple. The details of the machinery vary from manufacturer to manufacturer. Other fibers produced by wet spinning are acrylic and modacrylic.

Dry Spinning

The manufacture of acrylic fibers is an example of dry spinning. Poly(acrylonitrile), from which acrylic fibers are made, is destroyed upon heating, so that melt spinning is not feasible. However, since the fiber will dissolve in a relatively inexpensive low-boiling solvent (dimethyl formamide), the tedious procedure necessary to wet-spin rayon may be avoided. Wet spinning of acrylic fibers is also carried out, and these fibers have physical properties somewhat different from those prepared by dry spinning. It is likely that the wet-spun processes were developed as means of circumventing the Du Pont patents on the dry spinning of Orlon, since costs of wet spinning are higher but the fibers are not appreciably improved.

The manufacturing process is illustrated in Fig. 18.5. Acrylonitrile and other vinyl monomers, if used, are polymerized in water solution. The resultant polymer precipitates from the solution and is then washed, dried, and dissolved in dimethyl formamide (DMF). A 20 percent solution of polymer in DMF is filtered and extruded through a spinneret into a heated spinning chamber. A stream of hot gas (nitrogen, carbon dioxide, air, or steam) flowing countercurrent to the direction of the filaments carries off the solvent. The resultant filaments are stretched while they are hot and may be packaged, textured, or converted to staple. The solvent is recovered for reuse. Other fibers normally prepared by the dry-spinning process are acetate, triacetate, spandex, and aramid.

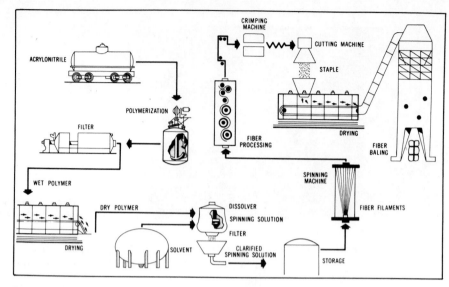

Figure 18.5 The manufacture of Acrilan, an example of the dry spinning process. (*Monsanto Textiles Company*)

Melt Spinning

By far the easiest method of spinning fibers, the melt-spinning process requires only that the polymer be melted, extruded, and cooled. The manufacture of nylon is an example of this process. The procedure is illustrated in Fig. 18.6 and a manufacturing unit is pictured in Fig. 18.7.

Figure 18.6 In melt spinning, solid polymer is loaded into the extruder, melted and forced through spinnerets, coated, drawn and in this illustration, cut into staple. (*Fi-Tech, Inc.*)

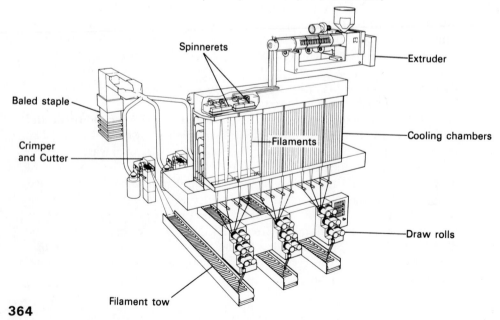

Figure 18.7 Drawing, texturing, and winding onto a package are accomplished in this integrated unit. (*Fi-Tech, Inc.*)

Nylon salt is polymerized and the resultant material is extruded as a ribbon onto a chilled drum. The frozen polymer is broken into chips and stored. Batches of chips are blended and fed to a MELT-EXTRUDER, a long, heated cylinder containing an internal rotating screw. The chips enter the barrel and are carried by the rotating screw into the heated zone, where they are melted. The resultant liquid is pumped, under an inert atmosphere, to the spinnerets and extruded into a cold air stream. The liquid freezes to form a fiber. The filaments are drawn before packaging, texturing, or conversion to staple. Melt spinning requires no chemical reactions beyond polymer manufacture, and no solvent recovery systems.

In addition to nylon, other fibers produced by melt spinning are polyester, olefin, and glass.

Texturing Methods

The improvements in bulk and elongation which enhance the comfort properties of man-made fibers are achieved through TEXTURING. Textured man-made yarns are generally prepared from thermoplastic fibers. The fibers are heated, mechanically deformed, cooled in the deformed state, and released. The molecules of the heated fibers are partially rearranged during processing, so that fibers do not return to their original straight, smooth configuration, but retain a crimp that simulates that of the natural fibers. Thermoplastic yarns, notably polyester and nylon, may be textured by processes that twist, crush, loop, or coil the filaments to achieve the desired properties. Nonthermoplastic fibers—those which do not melt upon heating—are not normally textured.

Twisting The earliest method of texturing man-made yarns, called the twist-heat set-untwist method, was developed by the Heberlein Company of Switzerland. It consisted of twisting a yarn, heating it for a short period in the twisted condition, allowing the yarn to cool, and then untwisting it. *Helanca* yarns were originally prepared in this way. However, the operation is rather slow and has been replaced by the false-twist processes.

In FALSE-TWIST texturing, the yarn is passed continuously through the false-twist apparatus. Thus, production speeds are much higher than in the twist-heat set-untwist method. Production rates of 175 to 225 meters per minute (190 to 250 ypm) are common, with rates of 400 mpm (440 ypm) attainable on low-denier yarns. A typical false-twist texturing machine with 200 spindles can produce 8 tons per month of 45-denier yarn.

The false-twist process is illustrated in Fig. 18.8. Untwisted yarn is fed through the delivery rolls to the twister, which may be of the spindle type or the friction type. In the spindle twister, the yarn is looped over a pin within a hollow cylinder. Rotation of the cylinder inserts twist in the yarn. In the friction twister, the yarn is caught between rotating disks which insert the twist. In either device, the section of yarn between the delivery rolls and the twister is given a high degree of twist, from 70 to 100 turns per inch. While twisted, the yarn is heated near its glass transition temperature by the heater and then allowed to cool as it passes the twister. Beyond the twister, the torque on the yarn is released and the filaments partially untwist. The filaments of the yarn now have been given a permanent crimp. The textured yarn is passed through the takeup rolls and wound on packages. False-twist textured yarns retain a residual twist, either S or Z, so they tend to kink in processing. To overcome this, manufacturers often ply S- and Z-twist yarn together to produce a balanced double yarn.

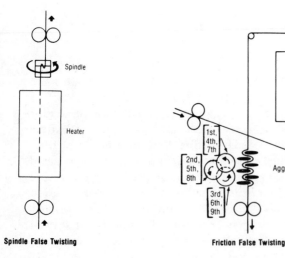

Spindle False Twisting

(a)

Friction False Twisting

(b)

Figure 18.8 False-twist process: (a) spindle type, (b) friction type. (*Celanese Fibers Marketing Company*)

Stuffer Box Joseph Bancroft and Sons Company, of Delaware, developed this method, and marketed textured yarns under the Ban-Lon trademark. The process is illustrated in Fig. 18.9. The feed yarn is forced by the delivery rolls into a narrow, heated box. The heated filaments are crushed into an accordionlike configuration, and removed by the takeup rolls. The treated fibers retain a sawtooth shape. Stuffer-box texturing is slower than false-twist texturing, but is better suited to heavier deniers such as carpet yarns and tow.

Gear Crimp Another texturing process based on crushing the heated filaments, gear crimping, simply passes the yarn through a set of heated, toothed gears. The filaments are deformed into a sawtooth shape much as in the stuffer-box method. Gear crimping (Fig. 18.10) is not as popular as other methods because critical control of the temperature and pressure are required to prevent breakage of the filaments.

Air Jet Developed by Du Pont and marketed under the Taslan trademark, yarns undergoing this method are textured by a high-velocity jet of hot air or steam (Fig. 18.11). The yarn is fed to a bulking chamber where it is blown about by a turbulent jet of air or steam so that individual filaments are looped and curled about each other. The process does not require that the filaments be heat-set, so it may be used on nonthermoplastic fibers such as rayon. It has also been used to texture glass yarns for use in drapery. Air-jet methods generally increase the apparent volume of the yarn without greatly increasing the stretch.

Edge Crimp Agilon, a trademark of the Milliken Company of South Carolina, is produced by the drawing of a thermoplastic yarn over a hot knife edge, as shown in Fig. 18.12. As the yarns are passed over the heated edge, the

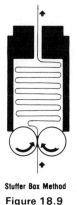

Stuffer Box Method
Figure 18.9

Gear Crimping
Figure 18.10

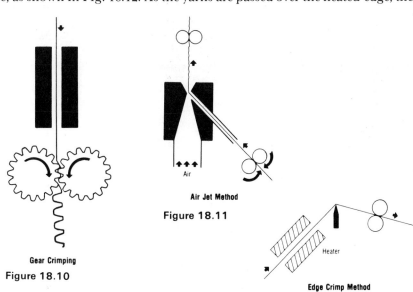

Air Jet Method
Figure 18.11

Edge Crimp Method
Figure 18.12 (*Celanese*)

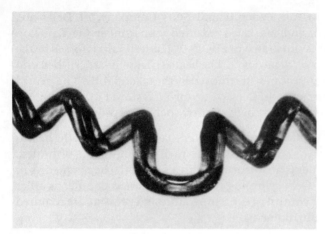

Figure 18.13 Bicomponent structure and the developed crimp in Acrilan. (*Monsanto Textiles Company*)

lower portion of the filaments in contact with the metal is heated, and the molecules in this region lose their orientation. This produces a fiber in which one portion has characteristics different from the other. The dissimilarities in physical properties cause the filaments to coil much like wool fibers. Edge-crimped yarns have a high degree of stretch with little tendency to twist. It is possible to simulate a knife-edge textured yarn by drawing a strip of paper or a ribbon across the edge of a scissors and causing the strip to curl. Note that the resulting "yarn" is quite bulky and has a high degree of stretch.

Self-Crimp Fibers Bulked or stretch yarns may be produced by fiber modification as well as by mechanical methods. Bicomponent or biconstituent fibers such as Acrilan, Monvelle, and Source develop crimp because of the differences in physical properties of the portions of the fibers. However, it may often be more expensive to texture yarns in this manner, and the market for such fibers is limited by economic factors. The bicomponent structure and the developed crimp in Acrilan are shown in Fig. 18.13.

YARN MANUFACTURE

Yarns may be prepared from staple fibers, filaments, or polymeric films. The conversion of filament fibers into yarn is a relatively simple procedure. Because of their length, filaments need only be twisted together to form strong, stable yarns. Furthermore, filament fibers, whether silk or man-made, are readily supplied in neat, untangled, easily handled packages. The short length of the staple fibers, and the fact that they are supplied in randomly packed bales, makes the job of converting them into smooth, stable yarns more difficult. Yet the oldest and most widely used method of yarn manufacture is the spinning of yarn from staple. This has come about for

historical reasons, since staple fibers such as cotton and wool were more readily available than silk filaments, and because many of the properties of spun yarns cannot be duplicated by filament yarns. In fact, in order to duplicate some of these properties, filaments of man-made fibers may be cut into staple lengths and processed into spun yarn. Blends of man-made and natural fibers, such as polyester-cotton and acrylic-nylon, are achieved by spinning.

Alternatively, the man-made filament yarns may be given spunlike properties by texturing methods. Texturing converts the smooth, rodlike filaments into crimped, curled, or tangled strands that closely resemble the structure of the natural fibers.

In this section we discuss the spinning of staple fiber into yarn by the cotton system and open-end spinning, and throwing of filament yarn. Some of the newer, less widely used methods of yarn manufacture are described in Chapter 11.

Spun Yarns

All staple fibers must be subjected to certain processing steps during yarn manufacture. The processing of the fibers may be by the COTTON SYSTEM or by the WOOLEN SYSTEM. The two systems differ in that their machinery has been designed to operate with different fiber types. The cotton-system machines are made to process short, strong, relatively smooth fibers. The woolen-system machines are designed to operate on long, weak, highly crimped fibers; however, the processing steps are essentially the same. The processing of staple fiber into yarn requires the following steps, each of which we will examine in detail:

1. *Opening/blending*—sorting, cleaning, and blending of fibers
2. *Carding and combing*—separating and aligning of fibers
3. *Drawing*—reblending of aligned fibers
4. *Drafting*—attenuating drawn fibers
5. *Spinning*—twisting drafted fibers into a yarn

Opening/Blending Natural fibers that have been compressed into large bales are delivered to the spinning plant from a number of suppliers. These fibers differ in quality and performance properties. In order to insure uniformity and the quality of the product, the spinster must sort the fibers as to grade, remove attached bits of dirt, twigs, leaves, and other trash, and blend the fibers from different bales. This is done by feeding fibers from different bales into the chute of the OPENER (Fig. 18.14), an enclosed chamber containing a rotating cylinder equipped with spiked teeth or a set of oscillating toothed bars. The tufts are pulled apart so that the fibers are loosened from each other. At the same time, impurities and trash are separated from the fibers. Since the feed to the opener comes from different bales, the fibers are blended as they are cleaned and opened.

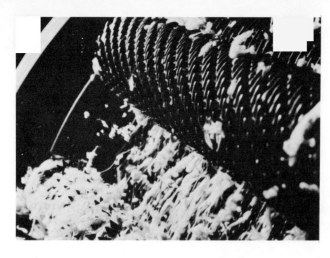

Figure 18.14 Raw fibers feeding into an opener/blender. Revolving toothed wheels open the fiber tufts. (*The Wool Bureau, Inc.*)

Carding and Combing The loosened tufts of fiber are conveyed by an air stream to be carded and combed. In carding (Fig. 18.15), the fiber tufts are caught between a set of rotating brushes and a belt covered with wire needles. The belt and brushes rotate at different speeds so that the needles tease the fibers out into a thin sheet. The fibers in this sheet are partially aligned with its axis, and many of the shortest ones are removed. Alignment aids in twisting the fibers into yarn more easily. Removal of the shorter fibers makes the yarn stronger, since there are thus fewer ends that can separate.

The sheet of carded fibers is drawn through a funnel into a soft, bulky untwisted strand called a SLIVER. Higher-quality yarns, containing fewer short fibers and having a smoother, less hairy texture, are made from sliver that has been combed. Combing is similar to carding except that the brushes and needles are finer and more closely spaced. Usually a number of card slivers are fed to the combing machine, where they are reformed into a web, blended, combed, and formed into sliver. Combed sliver is better aligned, smoother, and contains less foreign material than card sliver.

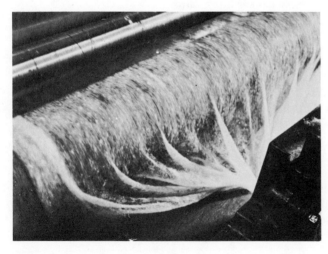

Figure 18.15 A fiber web being drawn from a carding machine. The fibers have been separated and aligned. (*The Wool Bureau, Inc.*)

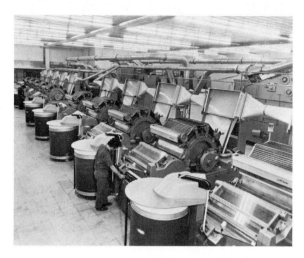

Figure 18.16 A line of integrated high production cards in which raw fiber is delivered to the input chutes and sliver is taken from the cans. (*Platt Saco Lowell*)

Yarns prepared by the woolen system may also be made in two grades. *Woolen* yarns are the equivalent of carded yarns, and *worsted* yarns are the equivalent of combed yarns. Carded and woolen yarns are coarser and hairier than combed or worsted yarns.

The above steps can be accomplished in an integrated device which accepts tufts of raw fiber into its hopper, opens, cleans, blends, separates, and aligns them, and delivers carded sliver. Such a device is shown in Fig. 18.16.

Drawing Five or six slivers are fed to the DRAWING FRAME, where they are combined into a single sliver. The drawing frame contains three or four pairs of smooth rollers rotating at different speeds. The first pair of rollers is the slowest; the last pair spins at five or six times the rate of the first pair. The slivers are flattened, pulled out (drawn), and recombined as they pass through the rollers. The final thin web is pulled through a funnel and reformed into a soft, bulky yarn similar to the original sliver. However, the drawn sliver is now five or six times as long as the original slivers (Fig. 18.17).

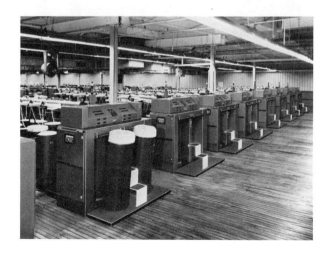

Figure 18.17 These drawing frames blend the fibers from six to eight card slivers and draw them out into one long strand ready for spinning. (*Platt Saco Lowell*)

Different fibers, such as polyester and cotton, may be blended in the drawing process. For example, a 50/50 polyester-cotton blend results if half of the sliver fed to the drawing frame is polyester and the other half is cotton. It is important that the fibers be of approximately the same length in order to achieve a proper blend. If, for example, long staple fibers of high-grade wool were drawn with short staple cotton, the wool sliver would not be attenuated to the same extent as the cotton, and the resultant drawn sliver would be uneven. Man-made fibers, which are produced as filaments, may be cut to staple length suitable for blending with natural fibers such as cotton or wool.

Drafting The drawn sliver, which is now better aligned than the original carded or combed sliver, is delivered to the ROVING FRAME. Here the sliver is passed through another set of drafting rolls which produce roving by reducing the diameter and increasing the length of the yarn. A small amount of twist is inserted in the yarn as it is being wound onto a rotating spindle. The roving is about one-eighth the diameter and eight times the length of the sliver.

Spinning The roving is mounted on the SPINNING FRAME (Fig. 18.18) and fed through another set of drafting rolls. The final pair of rollers spins at about thirty times the speed of the first pair. The highly attenuated yarn is fed onto a high-speed spindle by a guide which rotates on a ring surrounding the spindle. The guide, or traveler, rotates at a speed slightly slower than the spindle and is capable of an up-and-down motion. The difference in speed between the traveler and spindle determines the degree of twist of the yarn. The oscillating motion of the traveler winds the yarn into a neat package.

A more rapid method of preparing spun yarns uses an integrated

(a)

(b)

Figure 18.18 Drawn sliver is fed to the roving frame (a), and is drawn and spun onto bobbins (b). (*Platt Saco Lowell*)

spinning frame which converts sliver to yarn without the necessity for drawing and drafting. The steps in processing the fibers are essentially the same as in the standard process, but they take place on one machine. Yarns made in this manner are not as fine as those made in the standard way, but processing costs are greatly reduced.

It is obvious that with so many steps involved in the spinning of fiber to yarn manufacturers are constantly searching for more rapid and less expensive methods. The integrated carding device and the integrated spinning frame mentioned above are two of the means for reducing cost and increasing productivity. They are currently used for making coarser yarns, but in the future they may be used more and more for finer yarns.

Open-End Spinning

The most important new development in spinning technology is open-end (OE) spinning, a process for converting strands of untwisted fiber (sliver) directly into yarn. The card sliver is fed through a set of fluted rollers and beaters which open and draft the sliver so that the fibers are more or less separated from one another. The loose strand is then fed onto the inner surface of a rotating funnel, and is removed through the center of the funnel. Centrifugal force maintains the fibers on the surface of the cone, while the drawing action of the takeoff rolls pulls the yarn out. The change in direction of motion, from the circular path around the funnel to the lateral path through its center, inserts twist into the yarn, as illustrated in Fig. 18.19.

Figure 18.19 (a) An open-end spinning machine. (b) Cutaway view of an open-end spinning position, showing the sliver entering at top left, the trash chute, rotor, and exiting yarn. (*Platt Saco Lowell*)

(a) (b)

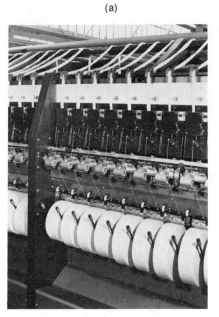
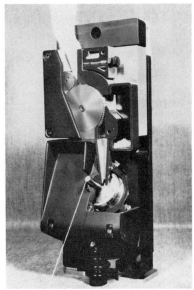

The major advantages of OE spinning are high production speed (over 10,000 m/min), reduced power consumption, improved evenness of yarn, and the ability to produce larger packages. This latter is important to the fabric manufacturer, since it means fewer knots in the final product and greater uniformity of supply yarn. The major disadvantages of OE spinning are the limited range of production capability (from yarn size no. 6 to no. 24) and the requirements for careful cleaning of the fibers before spinning. Small amounts of foreign material have a more deleterious effect on the production speed and yarn properties in OE spinning than in ring spinning. The performance properties of OE spun yarns are compared to those of ring spun yarns in Chapter 11.

Plied Yarns

The spinning methods discussed above are used to create singles yarns—that is, single strands of fibers, all twisted in the same direction. Singles yarns are often twisted together, or plied, in order to improve strength and uniformity and to balance the yarns. Plying is done on a machine similar to a spinning frame. Two or more yarns are fed through a pair of rollers and onto a rotating spindle. A yarn guide, similar to the traveler on a spinning frame, positions the yarn on the spindle and aids in twist insertion. A twisting machine is shown in Fig. 18.20. Plied yarns may be plied again to form heavier, stronger cords, as described in Chapter 10.

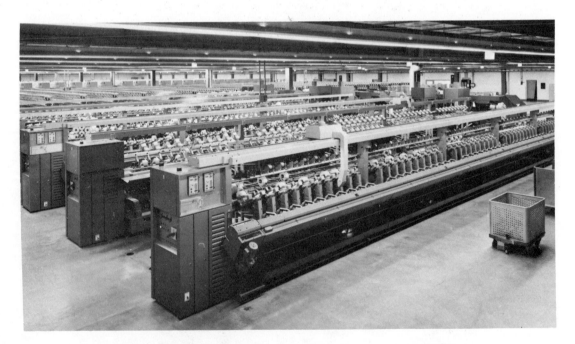

Figure 18.20 A bank of twisting machines. The yarn on the cylindrical packages is automatically plied and rewound on bobbins. (*Schlafhorst*)

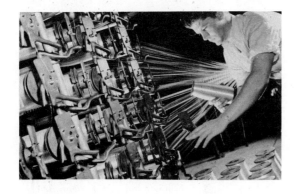

Figure 18.21 Hundreds of filaments are stretched on this drawing machine before being wound for shipment. (*Dow Badische*)

Filament Yarns

The preparation of yarn from filament is called THROWING. It is a much simpler operation than the spinning of staple fiber into yarn. The filaments are wound on bobbins and placed on a twisting machine much like that used for making plied yarns. For silk and some man-made fibers, the twister needs only to twist the filaments together to form a yarn. However, most man-made filaments need to be stretched before twisting. The stretching process known as DRAWING aligns and orders the molecules of the filaments and improves the yarn properties. Because of the need for drawing, most filament yarns are made on draw-twisters (Fig. 18.21) which stretch and twist the filaments in a combined operation.

For most man-made fibers the discontinuous process of producing filaments and later drawing and twisting them into yarn has been displaced by an integrated, continuous process in which the filament is spun, drawn, textured if necessary, and twisted (see Fig. 18.7). These integrated devices are quite complex, and usually are the result of a great deal of research and a high capital investment by the fiber producer.

Staple from Filament

In order to realize some of the advantages that spun yarns have over filament yarns, fiber producers reduce their filaments to staple lengths suitable for spinning. Thousands of filaments are spun and, if necessary, drawn as in the usual method of filament-yarn production. However, instead of being wrapped on individual packages, all the ends are collected into one large, untwisted rope called TOW. The tow is textured and passed between spiral revolving blades that cut the fibers. A set of fluted rollers, moving at different speeds, breaks the cut tow into tufts of fibers. Cutting and breaking are illustrated in Fig. 18.22. The crimped staple is now suitable for further processing. Man-made staple may be produced in lengths appropriate for use on wool- or cotton-system machinery.

FABRIC MANUFACTURE

The major methods for producing cloth from yarns are (1) weaving, (2) knitting, and (3) tufting. Knotting, plaiting, crocheting, braiding, and lacemaking are other techniques applied to specialty fabrics of commercial or esthetic importance. Nonwoven fabrics, produced directly from fibers, may be formed by felting or bonding. The major manufacturing techniques are discussed in this section.

WEAVING

The development of the loom from a hand-operated to an automatic device has been outlined earlier. This discussion will center on the three major types of modern looms: the standard shuttle-type loom, the rapier loom, and the fluid-jet loom.

The Modern Loom

The basic components of the loom include the WARP BEAM, a device for holding the warp yarns and feeding them into the cloth; HEDDLES, providing a means for separating and guiding the warp yarns so that some may be raised while others are kept lowered; HARNESSES, providing a way to raise and lower the heddles; SHUTTLE, a means for inserting the fill yarns; REED, a device to pack the filling yarns into the cloth so that they do not slip; and the TAKEUP ROLL, a device to hold the woven material. A typical loom is shown in Fig. 18.23.

The *warp beam* is a metal cylinder, capped by disks of much larger diameter, upon which the warp yarns are laid. In a process called BEAMING (illustrated in Fig. 18.24), the warp yarns are taken from packages mounted on CREELS and passed through a COMB onto the beam. The creel is simply a rack upon which the yarn packages are mounted. The comb keeps the yarns separated and insures that each yarn stays in its proper place.

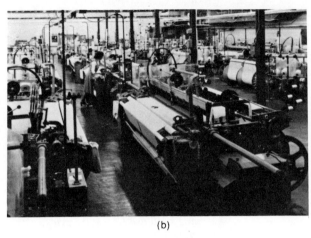

(b)

(a)

Figure 18.23 (a) Modern rapier loom seen from left front and above. The warp beam is on the left, the cloth beam on the right. (b) The same loom in a typical weave room installation. (*American Dornier Machinery Corp.*)

The beam is rotated and the yarns are wound on it in the form of a cylinder. Each end of the final cloth must be wrapped on the beam. A cloth 150 cm (59 in) wide containing 30 ends/cm (79 ends/in) requires 4,500 yarns to be wrapped on the beam. Usually the yarns are passed through a SIZING solution of starch or other viscous material on their path from creel to beam. The application of sizing is known as SLASHING. The sizing is used to protect the yarns against snagging and abrasion during manufacture of the cloth.

The completed warp beam is mounted on the back of the loom. Each of the ends of yarn is passed through the *heddles*, flat, thin rods of metal pierced

Figure 18.24 In this set up, yarns are taken from the creel directly onto the warp beam of a loom. (*American Dornier Machinery Corp.*)

Figure 18.25 In this close-up the heddles are the long, thin metal strips held in the frames of the harnesses. The reed is the comblike structure through which yarns pass. Note that the shed is open to allow the filling to be inserted. (*American Dornier Machinery Corp.*)

by a small hole, or eye, which hang vertically from a rectangular frame called a *harness*. The heddles and harness are illustrated in Fig. 18.25. *A loom must have at least two harnesses*, although as many as twenty may be used on modern looms. The positioning of yarns in the heddles is determined by the weave pattern. For example, in a plain weave all the odd-numbered yarns would be passed through the odd-numbered heddles in harness one, while the even-numbered yarns would pass through the even-numbered heddles in harness number two. In a 2/1 twill, the first end would pass through the first heddle of harness number one, the second end through the first heddle of harness two, and the third end through the first heddle of harness three. The fourth end is strung through the next heddle of harness one, and the pattern is repeated. In general, one harness is needed for each of the weft yarns in the repeat pattern.

A typical shuttle is shown in Fig. 18.26. The ends are pointed to allow easy passage through the shed. The brass caps on the ends are needed to absorb the impact of the hammers which propel it across the loom. The QUILL upon which the filling yarn is wound is placed in the hollow center of the shuttle. A wool covering inside the shuttle prevents the yarn from becoming tangled.

The REED is a rectangular, comblike frame enclosing many fine wires, which is placed immediately in front of the harnesses with the wires mounted vertically. The warp yarns are passed between the wires before being wound

Figure 18.26 A modern shuttle with the quill inserted.

TABLE 18.1 Harness Motion in a 2/1 Twill

Pick Number	Harness Number		
	1	2	3
1	UP	DOWN	UP
2	UP	UP	DOWN
3	DOWN	UP	UP
4	UP	DOWN	UP

on the takeup roll. The reed is used to press, or BEAT, the filling yarn into the cloth as it is being woven.

The weaving process involves four functions:

1. *Shedding*, in which the proper harness is raised to produce a space between the warp yarns for insertion of the filling yarn. This space has the appearance of the roof of a shed, hence its name.
2. *Picking*, in which the fill yarn is inserted across the width of the loom.
3. *Beating*, in which the reed moves forward to pack the fill yarns into the cloth, and then returns to position.
4. *Taking up*, in which the takeup roll advance to wind up the cloth and maintain tension on the warp yarns. The warp beam also rotates at this point to feed more yarn to the loom.

In weaving a tabby construction, the first harness is raised to form the shed. The shuttle is propelled across the loom, laying the fill yarn atop the even-numbered ends. The reed beats the yarn into the previously woven cloth and returns to position. The takeup roll advances. The first harness is lowered and the second harness is raised. The shuttle is returned to its original position and lays a fill yarn across the odd-numbered ends. Beating and taking up proceed as before, and the cycle is repeated. More complicated patterns are produced in a similar manner, except that the raising and lowering of more than two harnesses is a bit more complex. Table 18.1 illustrates the motion of the harnesses in making a 2/1 twill. The point diagram of the cloth is shown in Fig. 18.27.

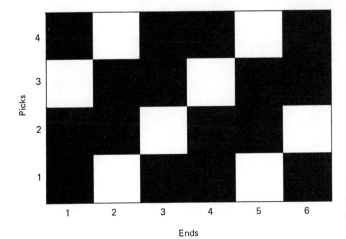

Figure 18.27 The 2/1 twill illustrated in Table 18.1. Ends 1 and 4, 2 and 5, 3 and 6 are operated by the first, second, and third harnesses, respectively.

Shuttle Looms

Shuttle looms operate at the rate of about 150 to 160 picks per minute (ppm). They are limited in their speed by the number of mechanical motions required to pass the shuttle across the loom. In addition, higher shuttle speeds impart greater stresses to the shuttle material, which may cause it to break. The filling yarn must be wound on a quill before insertion in the shuttle. Each color of yarn in the filling must have a different quill, so color changes are relatively slow. It is also possible for the shuttle to go awry and destroy the warp sheet (the warp yarns passing through the heddles), making it necessary to rewarp the loom. Finally, high speeds generate a high level of noise, which can be detrimental to the workers. For these reasons, high-speed looms, such as the rapier loom and the fluid-jet loom, operate without a shuttle.

Rapier Looms

In the rapier loom, the fill yarn is carried through the shed by a thin rod. The action of the rod is similar to the thrusting motion of a rapier in fencing; hence, the name of the loom. In one version, a single telescoping rod carries the yarn across the full width of the loom and returns to catch the next pick. In another, more widely used version, a pair of rapiers are employed. Yarn is fed to one rapier from a package mounted beside the loom. This arm carries the yarn halfway across the loom on the extending motion, where it is transferred to the other arm and carried the rest of the way on the return motion. Transfer of a filling yarn across a pair of rapiers is shown in Fig. 18.28. These looms can operate at speeds of 200 ppm, do not require the winding of a quill, and are quieter than shuttle looms.

Figure 18.28 Transfer of the filling yarn from left to right rapier. Both rapiers will return to the selvage side of the loom, and the left rapier will pick up another length of yarn. (*American Dornier Machinery Corp.*)

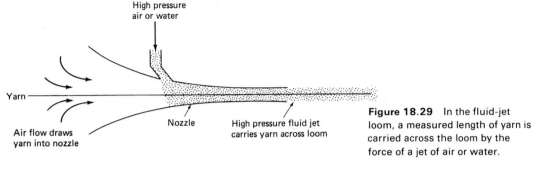

High pressure
air or water

Yarn

Air flow draws
yarn into nozzle

Nozzle

High pressure fluid jet
carries yarn across loom

Figure 18.29 In the fluid-jet loom, a measured length of yarn is carried across the loom by the force of a jet of air or water.

Fluid-Jet Looms

Rapier looms are also limited in their performance by the mechanical motion employed to carry the fill yarn across the warp sheet. Fluid-jet looms require almost no mechanical motion during the picking stage. A length of yarn is mechanically measured and cut and inserted into the nozzle of a high-speed jet of air or water. The force of the fluid carries the yarn through the shed. The selvage is formed separately. Fluid-jet looms can operate at speeds as high as 400 ppm. The action of a fluid jet is illustrated in Fig. 18.29.

Selvage Formation

In the common shuttle loom, the filling yarn is a continuous length of material limited only by the amount of yarn that can be wrapped on the quill. In this case, the selvage is formed as the shuttle reverses its direction. The fill yarn is wrapped around the last warp yarn on each side of the cloth. This type of selvage is illustrated in Fig. 18.30a. In shuttleless looms, each pick is made up of a single length of yarn, so the selvage is not automatically formed as each pick is laid in. On these looms, the selvage is formed by one of three methods: (1) tucking in the end of the filling yarn, (2) binding the fill yarn in a leno weave woven by an extra attachment, or (3) heating the cloth edge to fuse the yarns. The last method is satisfactory only if the yarns contain a high

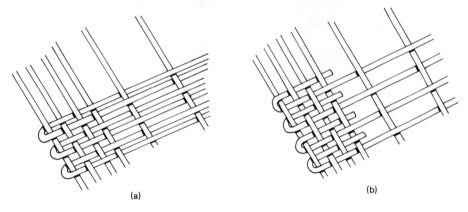

(a)

(b)

Figure 18.30 The four standard selvages: (a) plain woven, (b) tucked in, (c) leno woven, and (d) fused (see p. 382). Note that the yarn count in the selvage is higher than in the body of the cloth.

381

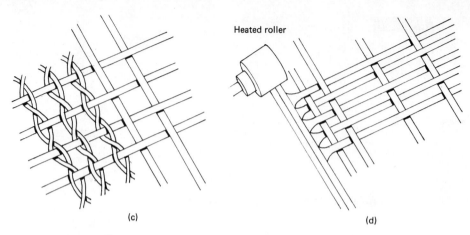

(c) Heated roller (d)

percentage of thermoplastic fibers. The formation of these selvages is illustrated in Fig. 18.30 b, c, and d, respectively.

Jacquard Looms

In the preceding weaving machines the heddles are operated in units rather then individually. In the Jacquard loom (Fig. 18.31) the heddles are arrayed in a frame that contains ten to twelve rows of heddles. Each heddle is connected by a cord or wire to a needle mounted at the top of the loom. When the needle rises or falls, the heddle rises or falls with it. The position of each needle is determined by whether or not it is aligned with a hole punched in a card mounted above the needle array.

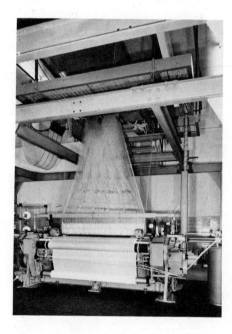

Figure 18.31 A Jacquard loom showing the control wires and cards. (*American Dornier Machinery Corp.*)

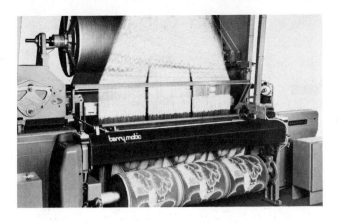

Figure 18.32 A Jacquard terry weaving machine. Note the pattern detail in the pile fabric. (*Saurer Corporation Textile Machinery*)

The pattern of the cloth to be woven is reproduced by means of holes puched in a set of cards to form a pattern. The cards are joined to form a long loop, which passes over a cylinder at the top of the loom. At each pick the cards are advanced one position and the needles are released. Those that are aligned with the holes in the cards rise, pulling the heddles with them to form the shed. Those that are blocked by unpunched areas remain in the "down" position, and the heddles attached to them do not rise. After the shuttle traverses the loom and the filling yarn is beaten in, the needles are returned to their original positions, the cards are indexed, and a new shed is formed. This process is repeated until the entire pattern has been woven. A typical pattern is illustrated in Fig. 18.32.

Triaxial Weaving

In a novel departure from standard weaving methods, triaxial weaving interlaces three yarns at 60° angles instead of two yarns at a 90° angle. The warp yarns are supplied from eight beams mounted on a circular track at the top of the machine. The yarns pass through guide tubes which form them into two parallel sheets running vertically from the top to the bottom of the device. In a typical machine (Fig. 18.33), there are 2,553 ends so arranged. The warp

Figure 18.33 The triaxial weaving machine is a radical departure from the loom. (*Barber-Coleman Company*)

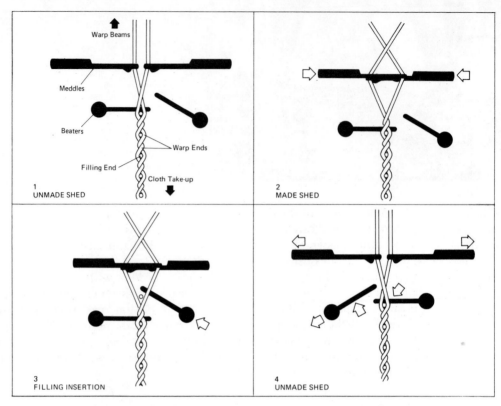

Figure 18.34 Shed formation in triaxial weaving.
Filling yarns are inserted perpendicular to the plane of
the paper. (*Modern Textiles*)

yarns pass through special heddles which move horizontally to form the shed.
The filling yarn is inserted by means of rigid rapier, and the yarn is beaten in
by a special set of beater bars. After each pick, the heddles are indexed in the
weftwise direction (horizontally) before a new shed is made. The process is
shown in Fig. 18.34.

Triaxial weaving is a relatively new technique, and triaxially woven
fabrics are not yet widely accepted. The process is claimed to be 50 percent
faster than standard weaving. The cloth is claimed to have excellent
dimensional stability. At present, triaxially woven cloth is used almost
exclusively for industrial products, but garment and upholstery manufacturers
are investigating its potential for apparel and residential use. The basic weave
is shown in Fig. 18.35.

Woven Pile Fabrics

Woven pile fabrics include velvets, made with extra warp yarns, and
velveteens and corduroy, made with extra weft yarns. The production of velvet
was originally a very slow and expensive process. The characteristic tufts

Figure 18.35 Triaxial woven cloth. In triaxial weaving, two warp yarns and one filling yarn are interlaced at 60 degree angles. (*Barber-Coleman Company*)

covering the surface of the fabric used to be made by holding the extra warp yarns in the heddles of another set of harnesses. As the cloth was woven, loops were formed in the extra warp yarns by the insertion of wires in place of filling yarns; these wires were removed after the beating step. This process left a cloth with a loop pile. After weaving, the tufts were formed by the insertion of thin wires sharpened to a knife edge through the loops and cutting them.

Today, velvets are made by the DOUBLE-CLOTH method (see Fig. 14.1). The ground warp yarns (those which form the ground cloth) are divided so that half are used to weave the upper cloth and half are used to weave the lower cloth. A third set of warp yarns is passed through another set of harnesses to form the pile. The pile yarns are interlaced with the yarns of the lower ground cloth during one cycle of shedding and picking. Then the harnesses are shifted so that the pile warp is interlaced with the upper ground yarns on the next cycle. On the repeat cycle the pile yarns return to the lower cloth. As the pile yarns pass from the upper to the lower cloth, they form a set of links between the two materials. The composite fabric is slit by a horizontal knife that cuts the pile yarns. The slit cloth is then wound onto two takeup rolls. The pile is brushed and sheared after weaving.

Velveteens and corduroys are prepared by the incorporation of extra fill yarns during the weaving. These extra yarns are allowed to float on the surface of the cloth. A set of circular knives, vertically positioned ahead of the takeup roll, slits the floats. The cut fabric is then brushed, and the extra yarns are raised to form the pile. In corduroys, the spacing of the tufts is wider than the yarns, so a striped surface effect is produced. In velveteens, the tuft spacing is small, so the surface is covered by the pile.

KNITTING

Most weft-knit cloths are produced on CIRCULAR knitting machines, although the production of some types of cloth is still conducted on FLATBED machines. The fabric that is produced follows the contour of the machine; that is, flatbed

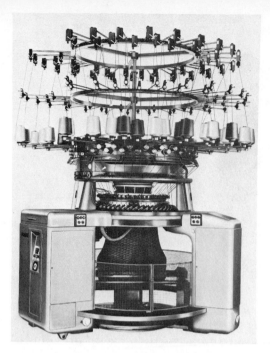

Figure 18.36 A circular weft knitting machine with Jacquard controls. This machine can knit intricate, multicolored patterns. (*Sulzer Bros., Inc.*)

machines produce flat fabrics, while circular machines produce tubes of cloth (Fig. 18.36).

Stitch formation is similar in both types of machines. The formation of the stitches in a single wale is illustrated in Fig. 18.37. In operation, each of the needles is controlled by a cam to rise and fall in synchronization with the other needles.

Figure 18.37 Stitch formation in knitting machines. (1) From its lowest position the needle rises through loop A; (2) yarn slips under the tip of the needle and onto the stem; (3) ascending hook catches the new yarn at the top of its rise and begins to descend; (4) the new yarn slips under the tip and into the hook; (5) needle moves down until the tip slides under loop A and the hook pulls the new loop through. Loop B is formed and the process is repeated.

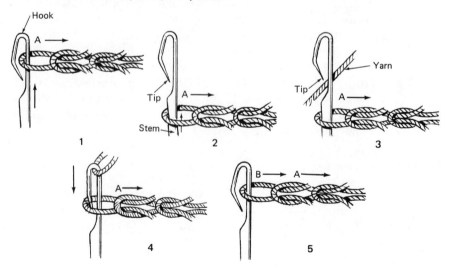

Rib knits and purl knits are produced in a similar manner, except that neighboring needles are arranged in a V shape so that one needle can draw the yarn forward while its neighbor draws the yarn back. In purl knits, one course is knit only on needles facing in the forward direction, skipping the needles facing in the backward direction. The next course is knit on the other set of needles.

Double-Knit Machines

Double-weft-knit cloth is usually made on knitting machines equipped with two sets of needles set at right angles to each other. The fabric is made by interknitting loops on both needles (Fig. 18.38). Note that except for the transfer of yarn from the cylinder to the dial needle, loop formation is the same as in single knitting.

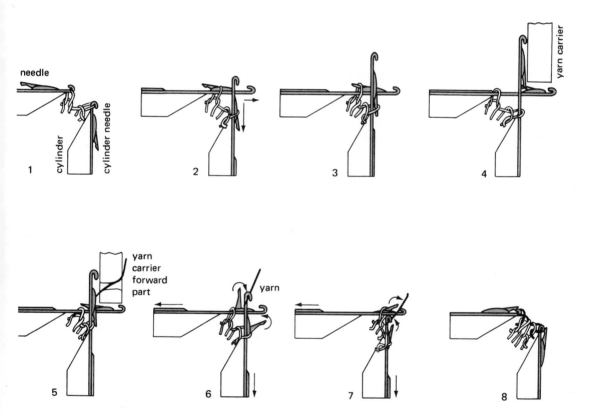

Figure 18.38 Stitch formation in a double weft knitting. (1) Needles in the rest position; (2) dial needle moves forward; (3) cylinder needle moves up; (4) stitches are held on needles as yarn carrier moves into position; (5) yarn is transferred to cylinder needle, which begins to retract; (6) latches on needles start to close as old loops slide along needle shafts; (7) cylinder needle closes and catches yarn, which is transferred to dial needle; (8) yarn is caught in dial needle, latches are closed and new loop is formed. (*Springs Mills, Inc.*)

Knit Pile Fabrics

Pile fabrics, similar to terrycloth, velvet, or fur, may be made on weft knitting machines; to do this, an extra yarn is drawn through the needles as the cloth is being knitted. In terry and velour constructions, two knitting yarns are brought through the yarn guides, just as in the manufacture of jersey knits. A hook set between adjoining needles holds one of the yarns as the loop is formed. At the completion of the stitch, the yarn that has been held back is stretched and under tension. When the stitch is dropped from the needle, this yarn relaxes and forms a twisted loop on the back of the fabric. The front of the cloth has the appearance of a jersey, while the back is covered by twisted loops. Velour is formed in the same manner, except that the loops are sheared and brushed to give a velvetlike texture.

Deep pile fabrics, such as simulated furs and fleece, may be made by drawing a sliver of staple fiber through the loops formed during knitting. The fibers are caught by the needles as the loops are formed, entangled with the ground yarn which forms the cloth, and held by the ground yarns as the loop closes. The pile is sheared and brushed after knitting. A faster technique, which provides better control over the pile length, is to prepare pile fabrics by a cut-loop method similar to that used in the manufacture of velours. A heavy, loosely twisted yarn, and a finer, higher-twist yarn are passed through the needles. The heavy yarn is pulled out into a loop on the back of the cloth and cut after the stitch is formed. The length of the loop can be controlled, so that the pile may be formed with both short and long fibers simulating the guard hairs and fur of a real pelt.

Warp Knitting

Warp knitting is done on machines similar to the one shown in Fig. 18.39. The operation differs from weft knitting in two important aspects: (1) each of the wales is formed from individual yarns similar to the warp in woven goods, and (2) stitches are formed by looping yarns around the needles. The major warp knitting machines are the tricot and raschel.

Figure 18.39 In tricot knitting the yarns are mounted on beams at the head of the machine. (*North American Rockwell*)

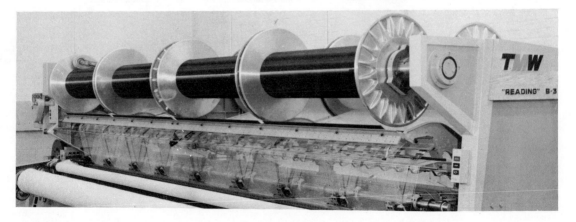

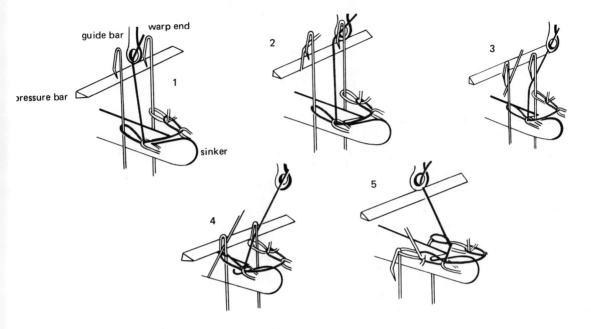

Figure 18.40 Stitch formation in warp knitting. (1) Needles are at rest in top position; (2) guide bar moves from left course around needle on right to form loop in right course; (3) needles descend and yarn slides into crook of needle; (4) pressure (presser) bar moves forward to close beard of needle and trap yarn; (5) needles descend through old loop to form new loop; old loop slips off needle. During the next motion, needles will rise and guide bar will wrap yarn onto left needle. (*Spring Mills, Inc.*)

The tricot knitting machines are usually fitted with beard-type needles and are suited to high-gauge constructions made from fine filament yarns. The formation of loops is shown in Fig. 18.40. In the simplest construction, loops are formed alternately on adjacent needles. That is, a loop is formed on the first course on needle number 1, on the second course on needle number 2, on the third on needle number 1, and so on. Tricot machines may be equipped with as many as four guide bars. Thus, four sets of yarns can be used to knit a cloth. This allows the knitter a wider latitude in pattern design and fabric construction.

Raschel knitting machines operate much like tricot machines, but are more versatile. They may have as many as 56 guide bars; in addition, their shogging motion is greater, so consecutive stitches may be placed a number of wales apart. Raschel knits usually have a more open construction than tricot knits, so latch-type needles may be used, eliminating the need for a presser bar.

Raschel knitting machines can also be used with weft insertion and warp insertion. These variations allow the knitter to "lay in" extra warp or filling yarns to make more intricate patterns. The extra weft yarns are carried across the width of the knitting machine by rapiers and are placed in position just before the needles catch the yarn to make the loop. If the weft yarn is laid in between the ground yarn and the needle, it will appear on the back of the

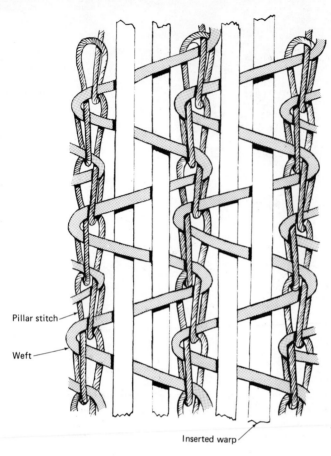

Pillar stitch

Weft

Inserted warp

Figure 18.41 Raschel crochet knit with warp insertion.

cloth; if it is laid in behind the ground yarn, it will appear on the face of the fabric. Extra warp yarns are passed through the yarn guides, just as the other warp yarns are, but the guide bar for these yarns does not shog. Therefore, the warp yarn appears as a vertical strand in one position. The extra yarns are held in place by the ground yarns as they form the stitches. Figure 18.41 shows a typical pattern in a warp and weft insertion effect.

Pile fabrics may be produced in a double-cloth method much like that used for velvet. A raschel knitting machine equipped with extra guide bars for the formation of the pile is used to produce a double cloth held together by the pile yarns. After knitting, the double fabric is slit. The pile yarns are held in place by the knit loops and extra laid in weft yarns.

TUFTING

The arrangement of the yarns and needles in a tufting machine is shown in Fig. 18.42. The tufting process is illustrated in Fig. 18.43. A row of hollow needles, fed with yarn from a creel, inserts the yarn through an already prepared ground cloth of either woven or nonwoven material. As each needle descends, a hook on the underside of the ground cloth forms a loop by catching and holding the yarn. The needles are withdrawn, and the cloth

Figure 18.42 A tufting machine forming a cut-loop fabric. The pile is on the underside. (D. T. Ward, *Tufting; an Introduction.* Published by Texpress, Stockport, England. Used by permission of D. T. Ward)

Figure 18.43 The tufting process in a level-loop fabric and a cut-loop fabric. In stage 1 the looper is retracted and the needle descends. In stage 2 the looper is inserted between the needle and yarn. In stage 3 the needle retracts and the loop is formed. Note that in the level-loop construction the pile moves away from the looper, while in the cut-loop construction it moves into the knife edge of the looper. (*Shirley Institute, Manchester, England*)

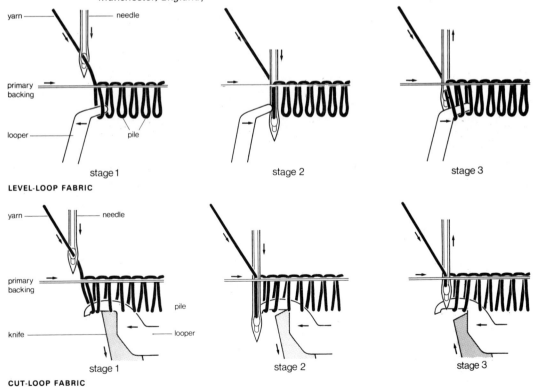

advances much like the movement of the cloth in a sewing machine. As the needle penetrates the cloth on the next stitch, the hook releases the previous loop and catches the yarn on the new stitch. The loops are held in place by friction between the pile yarn and the ground cloth. However, fabrics that will be subjected to a high level of wear, such as carpets or upholstery materials, are backed with a latex rubber coating to bond the pile to the ground cloth.

Tufting machines operate at speeds as high as 800 stitches per minute, and provide an economical way of producing pile fabrics. The length of the loops may be varied by adjustment of the depth of penetration of the needle and the tension on the yarn. The loops may be left as they are, or they may be cut to form tufts similar to velvet. In addition, the height of individual loops can be adjusted so that patterns of high and low loops can be formed on the cloth. After tufting, the surface may be sheared to yield a pattern composed of high loops, low loops, and cut tufts.

Today, almost all tufting machines are built for the production of carpet and heavyweight upholstery fabric. However, some manufacturers are developing machines with very fine needles for high-gauge (about 5/64 gauge) tufting of fabrics suitable for apparel use.

19

standards and testing

> "When I use a word, it means just what I choose it to mean—neither more nor less."
> Humpty Dumpty, in *Through the Looking Glass*

Imagine what the world would be like if we accepted Humpty Dumpty's philosophy. A yard of cloth would be as long as the seller wanted it to be. A pound could weigh anything. In fact, centuries ago in Europe, such was the state of affairs. There were no standards for length, weight, or volume, and each minor principality or city could define its own sizes. As cities and other small political entities became incorporated into nations, it became more and more important that buyers and sellers agree on precise definitions of weights and measures in order to insure a fair bargain. In 1120, Henry I of England established the "ell" as the length of his arm. This is one of the earliest examples of standardization.

National standards defining the basic units of length, weight, and volume were followed by other standards that were important to the various trades. In textiles, for example, standards were developed which governed yarn number, direction of twist, and weight of cloth. As time went on, informal agreements extended standardization beyond national boundaries so commodities produced in many nations would be uniform in size, weight, and quality. Cordage for shipping, for example, became standardized so that an English vessel could purchase rope of the proper size in an Italian port.

Eventually, the informal agreements between manufacturers and merchants were formalized in the International Conference on Weights and

Measures held in Paris in 1875. This convention established the meter and the kilogram as the basic units of measurement for the consenting nations. The United States, as a signatory to this agreement, officially became a metric nation even though it has continued to use the English system.

The value of standardization to manufacturers and merchants is obvious. Standards simplify commerce. If all lengths are measured in meters, then a purchasing agent needn't convert yards and feet into meters to order the proper amount of yarn. Furthermore, prices can be calculated easily without the necessity of making conversions from one system to another. In addition, merchants reduce the inventory that they must carry to supply their customers. It is complex enough to have to carry hundreds of different sizes of nuts, bolts, and screws that comply with the American Thread Standard; think of the problems involved in stocking Whitworth, square, and metric fasteners as well. Finally, standard parts are interchangeable. A manufacturer may purchase an item from company A, B, or C and know that it will be of the proper size.

The value to the consumer is less direct, but equally important. Standards protect the public interest in three ways:

1. By enforcing honesty and protecting the consumer with respect to the purchase of goods and services
2. By stimulating innovation and competition
3. By stimulating and facilitating trade

Overall, properly written and enforced standards improve quality and safety and lower the cost to the consumer.

Standards today are more complex than the simple rules that originally established length, weight, and volume. In addition to defining TERMS—e.g., "denier," modern standards may specify DESIGN or PERFORMANCE. A design standard specifies the shape and size of an object, and often, the materials from which it is made. Within limits, the exact details of a design standard are often less important than conformity to the standard. For example, it is not critical whether the base of a screw thread is cut to an angle of 50, 55, or 60 degrees; it *is* critical that all screw threads be cut to the *same* angle. Usually design standards, like definitions of terms, are intended to insure uniformity.

Performance standards set the allowable value of a particular characteristic. For example, the children's sleepwear flammability standard specified that the average char length may not exceed 7 inches. A performance standard must also specify a TEST METHOD. Thus, a manufacturer may require that a fabric have a breaking load of at least 9.8 kg/cm (55 lb/in) when tested in accordance with ASTM D1682-64.

VOLUNTARY AND MANDATORY STANDARDS

Standards are also classified as VOLUNTARY or MANDATORY. A voluntary standard is one adopted by a manufacturer, or a group of manufacturers, with the aim of promoting simplicity, interchangeability, or quality of perform-

TABLE 19.1 Performance Standard for Men's and Boys' Woven Sport Shirts

PROPERTY	REQUIREMENT	TEST METHOD
Breaking strength—kg	10	ASTM D 1682—Grab Method
Tear strength—g	900	ASTM D 1424—Elmendorf
Flex abrasion—cycles	200	ASTM D 1175—Flexing and Abrasion Method
Shrinkage—%		
Pressing/curing	1.5 × 1.5	
Laundering	3.0 × 3.0	AATCC 135-1973 IIB—3 cycles
Dry-cleaning	2.0 × 2.0	Coin-op dry-cleaning—3 cycles
Colorfastness—Gray Scale		
Laundering	Class 4 change	AATCC 61-1975 IIA
	Class 3 staining	
(If used with contrasting fabric)	Class 5 staining on contrast fiber	
Dry-cleaning	Class 4 change	Coin-op dry-cleaning—3 cycles
Crocking	Dry—Class 4 staining	AATCC 8-1974
	Wet—Class 3 staining	
Light	20 Hours—Class 4 change	AATCC 16A-1974
Ozone	Class 4 change	AATCC 109-1975—2 cycles
Gas	Class 4 change	AATCC 23-1975—2 cycles
Perspiration	Class 3 change	AATCC 15-1973
	Class 3 staining	
Dry Heat	Class 4 change	Use appropriate cure and/or press conditions
	Class 4 staining	
Abrasion	Class 3 change	AATCC 119-1974
Formaldehyde—ppm	1000	AATCC 112-1975
Smoothness retention	3.0 Durable Press	AATCC 124-1973
Random tumble pilling resistance	3–30 minutes	ASTM D 1375—after 3 washes
Seam slippage—kg/6 mm	10	ASTM D 434-42—after 3 washes

ance. A typical performance standard, devised by a leading garment manufacturer, is shown in Table 19.1. Note that it establishes minimum performance requirements and specifies the test methods to be used. Voluntary standards are adopted by agreement between seller and purchaser and have no legal standing unless they are included as part of a contract. Thus, voluntary standards may be modified in any way that the concerned parties may agree to.

Mandatory standards are those enacted by government. They are legally binding on all parties and may not be modified except by governmental action. Building codes, flammability standards, and garment labeling are examples of mandatory standards. Mandatory standards are generally enacted to prevent deception or fraud, or to insure the safety of goods in the marketplace.

MANDATORY STANDARDS

Under its constitutional mandate to regulate interstate commerce, Congress has legislated standards governing textile products. These laws attempt to prevent fraud and deception through labeling requirements, and set standards to minimize the hazard to the public from the sale of flammable fabrics.

Wool Products Labeling Act

The Wool Products Labeling Act was enacted in 1939 to insure that wool products were really made from wool. The Act requires that, with the exception of upholstery and floor coverings, all products containing wool must be labeled with the wool content and the kind of wool used. A typical label is shown in Fig. 19.1. The Act includes the following definitions:

> *Wool Product*—Any product or portion thereof which contains, purports to contain, or in any way is represented as containing wool, reprocessed wool, or reused wool.
>
> *Wool*—Fiber from the fleece of the sheep or lamb, or hair of the Angora or Cashmere goat, as well as specialty fibers, which has never been reclaimed from any woven or felted wool product. (Note that wool that has been made into yarn may be processed back into fiber.)
>
> *Reprocessed Wool*—Fiber reclaimed from scraps of fabrics, whether woven, knitted, or felted, that were never used by the ultimate consumer.
>
> *Reused Wool*—Fibers reclaimed from fabrics that have been used by the ultimate consumer.

Although not included in the Act, the term *virgin wool* has come to mean wool that has been made into yarn for the first time, and *lamb's wool* has come to be accepted as wool clipped from sheep less than 8 months old. These last two terms have acquired a quasilegal standing through customary usage.

In 1980 the Wool Products Labeling Act was amended to delete the terms "reprocessed wool" and "reused wool." Wool fiber reclaimed from any source must now be labeled as "recycled wool."

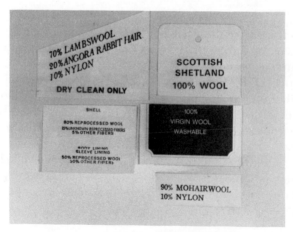

Figure 19.1 Wool products labels.

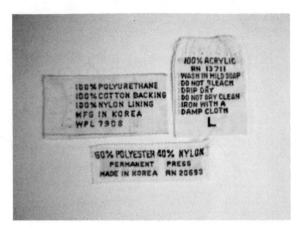

Figure 19.2 Fiber identification labels, with care instructions and the country of origin. The numbers are the manufacturer's identifying code.

Textile Fiber Products Identification Act

The Textile Fiber Products Identification Act (TFPIA) went into effect in 1960. Its purpose is to insure that the fiber content of textile products is not misrepresented. The Act does not include upholstery fabric already attached to the frame. It does require that the fiber content of textile products be shown on a label affixed to the product, and sets standard definitions for each recognized textile fiber. Some typical labels are shown in Fig. 19.2.

Care Labeling

In July 1972, the Federal Trade Commission's Trade Regulation Rule concerning care labeling went into effect. This rule requires that all apparel items bear a permanent label disclosing the procedures for regular care of the garment, and when necessary, specific instructions for washing, drying, ironing, bleaching, and dry-cleaning. The Rule also provides that care labels be made available for over-the counter sales of yard goods intended to be made into apparel. The purpose of the Rule is to provide the consumer with accurate information on the care of apparel with the aim of extending the useful life of garments. Under the Rule the manufacturer is, in essence, guaranteeing that the apparel item will not be damaged if it is maintained according to the instructions. Typical care labels are shown in Fig. 19.3.

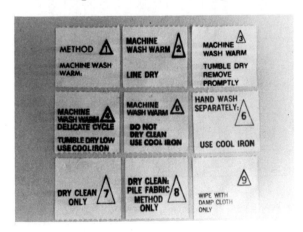

Figure 19.3 Apparel care labels.

TABLE 19.2 Guide for Apparel Care Label Instructions

	WHEN LABEL READS:	IT MEANS:
MACHINE WASHABLE	Washable / Machine washable / Machine wash	Wash, bleach, dry and press by any customary method including commercial laundering
	Home launder only	Same as above but do not use commercial laundering
	No bleach	Do not use bleach
	No starch	Do not use starch
	Cold wash / Cold setting / Cold rinse	Use cold water from tap or cold washing machine setting
	Warm wash / Warm setting / Warm rinse	Use warm water 90° to 110° Fahrenheit
	Hot wash / Hot setting	Use hot water (hot washing machine setting) 130° Fahrenheit or hotter
	No spin	Remove wash load before final machine spin cycle
	Delicate cycle / Gentle cycle	Use appropriate machine setting; otherwise wash by hand
	Durable press cycle / Permanent press cycle	Use appropriate machine setting; otherwise use medium wash, cold rinse and short spin cycle
	Wash separately	Wash alone or with like colors
NON-MACHINE WASHING	Hand washable / Hand wash	Launder only by hand in luke warm (hand comfortable) water. May be bleached. May be drycleaned
	Hand wash only	Same as above, but do not dryclean
	Hand wash separately	Hand wash alone or with like colors
	No bleach	Do not use bleach

	WHEN LABEL READS:	IT MEANS:
HOME DRYING	Tumble dry / Machine dry	Dry in tumble dryer at specified setting—high, medium, low or no heat
	Tumble dry / Remove promptly	Same as above, but in absence of cool-down cycle remove at once when tumbling stops
	Drip dry / Hang dry / Line dry	Hang wet and allow to dry with hand shaping only
	No squeeze / No wring / No twist	Hang dry, drip dry or dry flat only
	Dry flat	Lay garment on flat surface
	Block to dry	Maintain original size and shape while drying
IRONING OR PRESSING	Cool iron	Set iron at lowest setting
	Warm iron	Set iron at medium setting
	Hot iron	Set iron at hot setting
	No iron / No press	Do not iron or press with heat
	Steam iron / Steam press	Iron or press with steam
	Iron damp	Dampen garment before ironing
MISCELLANEOUS	Dryclean / Dryclean only	Garment should be drycleaned only, including self-service
	Professionally clean only / Commercially clean only	Do not use self-service drycleaning
	No dryclean	Use recommended care instructions No drycleaning materials to be used

Prepared by the Consumer Affairs Committee of the American Apparel Manufacturers Association (AAMA). Reproduced by permission of the AAMA.

The Care Labeling Rule has been quite controversial, and at this writing is still the subject of debate. Manufacturers and consumers are concerned by (1) the absence of defined terms and (2) the practice of *underlabeling*. The FTC elected not to impose its own definitions of terms applicable to garment care, but left it to the industry to develop the appropriate labels. Unfortunately, this led to the proliferation of various labels that were more confusing than helpful to the consumer. Recently the National Retail Merchants Association (NRMA), the American Apparel Manufacturers Association (AAMA), and the American Retail Federation (ARF) cooperated in the development of care labels intended to be standard for all manufacturers. The recommended guide is shown in Table 19.2.

Underlabeling is the practice of providing a care label that is more conservative than necessary. For instance, a garment manufacturer might label a pair of denim jeans *Dry Clean Only*. It is true that the garment would not be damaged by such a procedure, but the consumer would be paying for unneeded care. When manufacturers consistently underlabel, the consumer tends to disregard the care instructions so that the label becomes useless. The result is harmful to the consumer and to reputable manufacturers who invest in laboratory testing to make sure that their garments are properly labeled. At the present time there is no way to prevent underlabeling.

A third area of controversy involves the use of words vs. symbols. The FTC requires that care labels be written in words, in English. However, many consumer advocates argue that a set of symbols with properly defined, uniform meanings would be of greater use to persons who are less language-oriented or non–English-speaking. They cite the experience of the Europeans and Canadians, who have developed symbol systems because of their multilingual trade situation.

The controversy surrounding the care labeling rule since its promulgation points out the need for careful consideration of all the effects of a standard before it is put into force. It is reasonable to expect that in time, the care labeling rule will be modified to provide the consumer with maximum benefit at minimum cost, and that subsequent regulations will be more carefully drawn.

Flammable Fabrics Act

The Flammable Fabrics Act of 1953, which has been amended several times since its inception, provides authority and procedures for the development of standards to insure the public against unreasonable risk from burning apparel, upholstery, carpets and rugs, and other textile products. It should be noted that these regulations are in addition to local building codes or fire codes that regulate the flammability of textile products, such as theater curtains, that are used in places of public assembly. The Flammable Fabrics Act is currently administered by the Consumer Product Safety Commission. The six regulations that have been introduced under the Act are:

CS-191-53 General Apparel Fabrics Standard
FF1-70 Standard for the Flammability of Large Carpets and Rugs
FF2-70 Standard for the Flammability of Small Carpets and Rugs
FF3-71 Standard for the Flammability of Children's Sleepwear
 (sizes 0-6X)
FF4-72 Standard for the Flammability of Mattresses and Mattress Pads
FF5-74 Standard for the Flammability of Children's Sleepwear
 (sizes 7-14)

These standards are described below. (Printed copies are available from the Consumer Product Safety Commission, Washington, D.C. 20234.)

General Apparel Fabrics Standard (CS-191-53)

This standard was accepted and made into law by the Secretary of Commerce in 1953, after seven years of study and analysis. It was designed to eliminate from the marketplace extremely flammable materials, such as certain lightweight, brushed-rayon fabrics, that would burn rapidly and violently when ignited by very small ignition sources. The *standard* specifies a test method and the criteria under which a fabric under test is to be accepted or rejected. The *test method* describes the procedure by which a sample of specified dimensions is mounted within a test cabinet, ignited, and allowed to burn. The time required for the fabric to burn a set distance is recorded, and the burning rate is calculated. Fabrics that take less than 5 seconds to burn 7 inches are not permitted to be sold for apparel use. The test cabinet is illustrated in Fig. 19.4.

Flammability Standards for Carpet and Rug (FF1-70 and FF2-70)

Perhaps the major cause of death in building fires is the smoke and fumes emitted by burning interior furnishings. Whether in the form of furniture, rugs, curtains and drapes, wall hangings, or insulating materials, polymeric materials tend to produce large amounts of thick smoke as well as toxic gases. Following investigation of a number of fire incidents involving loss of life, the Department of Commerce determined that if the production of

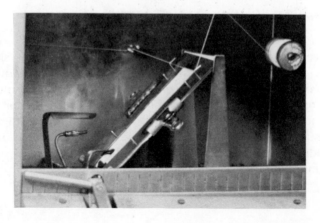

Figure 19.4 Flammability test cabinet, C.S. 191-53.

Figure 19.5 Pill test, FF-1 and FF-2.

smoke and fumes from carpets and rugs could be reduced, fewer lives would be lost. Subsequently, the FF-1 and FF-2 standards were introduced. They require that samples of carpet be subjected to the "pill test" in order to be certified for sale. In this test a metheneamine tablet, which has been manufactured according to very stringent controls, is placed on the surface of the sample and ignited. The amount of heat liberated by the pill is kept within close tolerance so that all samples are subjected to the same ignition source. The extent of burning of the carpet following ignition is measured. A carpet or rug may not exceed 6 feet in any direction or cover more than 24 square feet if it does not pass the pill test. The setup for this test is illustrated in Fig. 19.5.

Since the hazard is greatly reduced when the carpet or rug is small, FF2-70 permits the sale of carpets and rugs measuring less than 6 feet in any one dimension or covering less than 24 square feet, even though they may fail the pill test. However, these goods must be labeled *Flammable*.

At this time the "pill test" is being considered by the International Standards Organization. If adopted it will become a worldwide standard.

Flammability Standards for Children's Sleepwear (FF3-71 and FF5-74)

After some years of discussion and lobbying by consumer interests, the Congress determined that CS-191-53 was not adequate to protect children against fire accidents involving sleepwear. In a 1967 amendment to the Flammable Fabrics Act, it empowered the Secretary of Commerce to develop standards regulating the flammability of these garments. The Standards provide a test method, labeling requirements, and rules for recordkeeping. They require that the fabric, trim, and seams of a garment be tested before the garment can be sold as sleepwear. The Standards also provide that cloth sold over the counter which is intended to be made into children's sleepwear pass the test.

The two test methods are similar, but not identical. In both cases, a sample of specified dimensions is mounted in a test cabinet and ignited by a standard ignition source (Fig. 19.6). The char length (the length of material involved in burning) is measured. No specimen may have a char length

Figure 19.6 Flammability test cabinet, FF3-71.

exceeding 10 inches, nor may the average of a sample (five specimens) exceed 7 inches. For children's sizes 0–6X, the sample is tested under *bone-dry* conditions—that is, all moisture is removed by heating in an oven followed by cooling in a desiccator. In addition, molten drips that may fall from the test specimen are observed, and the length of time that they continue to burn is measured. This burning time is known as the Residual Flame Time (RFT) and may not exceed 13 seconds. The FF5-74 Standard allows samples to be tested at relative humidity up to 65 percent and does not require a measurement of the RFT. In both standards, the garments must still pass the test after fifty launderings.

The FF3-71 standard is the more stringent of the two, since it was felt that older children could take evasive action if their clothing became ignited, while younger children could not. Thus, FF5-74 provides a slightly reduced level of safety in response to less stringent safety requirements. At the time of this writing, however, it appears that manufacturers are providing fabrics and garments that comply with FF3-71 for sizes 7–14 as well as for sizes 0–6X. Such action reduces overall costs by eliminating the need for separate tests, standardizing manufacturing and finishing processes, and insures that all fabrics measure up to the highest safety standards.

It should be noted that the price of increased safety has been a 30 percent increase in cost to the consumer, a reduction in the variety of garments available, and the removal of cotton and cotton blends from this market, followed by their replacement by less comfortable and, in some cases, less durable man-made fibers.

Flammability Standard for Mattresses (FF4-72)

Smoking in bed has been recognized as a major hazard for so long that one wonders at the foolishness of people who do it. Yet this is the cause of

hundreds of deaths each year. The National Bureau of Standards, in its investigation of the problem, determined that uninvolved bystanders were put at great risk, since a smoldering mattress could generate enough fumes to kill other people in a house or apartment building. In addition, if a mattress actively burned, an entire building could be destroyed, with serious consequences to all its inhabitants. The FF4-72 Standard requires that all mattresses and mattress pads to be able to withstand the heat from nine lit cigarettes placed in specified positions on their surfaces without smoldering or flamming.

In addition to the above standards and local fire codes, other flammability standards are also in force. The Department of Transportation has set flammability standards for automobile upholstery in automobiles and trains, while the Federal Aviation Administration regulates the interior furnishings of aircraft. In addition, the FAA is preparing standards for the flammability of fight attendants' uniforms to insure that they will be able to aid passengers in the event of an accident rather than becoming victims of a fire.

The Consumer Product Safety Commission is considering the issuance of a standard for the flammability of upholstery and the advisability of a revised general apparel standard that would supersede CS-191-53. An improved test for measuring the flammability of carpets is currently being tested by the National Bureau of Standards and industry groups.

VOLUNTARY STANDARDS

Voluntary standards may be limited to a single manufacturer, in which case they become specifications that must be met by suppliers to that particular manufacturer only, or they may be adopted by agreement of all the manufacturers in a particular industry. Almost all industries have trade associations that are concerned with establishing industry standards. Standardization efforts by these groups attempt to simplify the conduct of business and to develop minimum levels of product quality. However, trade associations cannot remain aloof from the commercial interests of their members.

Consensus Standards Organizations

In contrast to the trade associations, which are organized for the benefit of their members, the consensus standards organizations attempt to bring producers and consumers together with the intent of promoting the general public interest. The American National Standards Institute acts as the national coordinating body for many U.S. standards organizations in the development of American National Standards, and as the U.S. representative to international standards setting bodies. The development of standards under ANSI auspices is safeguarded by procedures that prevent dominance by special-interest groups.

The procedures of the American Society for Testing and Materials, a member of ANSI, is illustrative of the VOLUNTARY CONSENSUS STANDARDS

process. ASTM is divided into many technical committees, each concerned with a particular subject. The ASTM Committee D-13 is concerned with textiles; consumer products are the responsibility of the ASTM Committee F-15. Within each committee are subcommittees composed of persons interested in particular facets of each subject area. For example, D-13.58 is the subcommittee on Yarn Test Methods. Committee members may represent producers, users, consumers, or the general public interest. ASTM makes a distinction between a user and a consumer: A *user* purchases a product with the intention of somehow utilizing it in the creation of another product for sale. A *consumer* purchases a product for his or her own private use. It should be noted that the line between producer and user is not always well defined. For example, a producer of fabric is also a user of yarn, while the producer of yarn is a user of fiber. Thus, it turns out that at times a yarn manufacturer may be aligned with user interests against the producer interests, and at other times may be on the side of the producers.

The subcommittees divide into task groups, chosen for their expertise and interest in the subject under study, which investigate special projects. A task group may report to a subcommittee that it wishes to propose a new ASTM standard or revise an old one. When the subcommittee meets to consider the proposal, *anyone interested in the topic may attend the meeting.* One need not be a member of ASTM, since meetings are open to the public and no fees are charged.

The discussions within the subcommittees are intended to foster a *competitive cooperation* among the various interest groups. The rules of procedure do not permit the producer interests to have more representatives on the subcommittee than the user and general-interest groups. In addition, the chairman of the subcommittee or the parent committee may not represent the producer interest. In this way the ASTM achieves a *balance of biases* for and against a particular standard, with the result being a compromise acceptable to the majority.

After all revisions, amendments, additions, and objections have been heard and voted upon, the subcommittee sends its report to the parent committee. Again, the proposal is debated, with the participation of all interested parties. The committee may then recommend to the ASTM board of directors that the proposed standard be sent out for approval of the entire membership of ASTM.

Under the direction of the board of directors, the ASTM professional staff reviews the proposal to make sure it complies with the standard format for standards, and submits it to the ASTM membership. Any members not satisfied with the proposal may submit a NO vote accompanied by a statement of their objections, and if they wish, suggestions for improvement. *A standard may not be adopted until all NO votes have been resolved.* Resolution of NO votes may be by amendment of the proposed standard to meet the objections or through the submission of data that refute the objections. By rigorously adhering to procedures that allow for a full and open debate by all interested parties, the voluntary standards organizations maintain their neutrality and

insure that the final standards do not promote the interests of one group over another.

ASTM and other organizations usually prepare standard test methods rather than performance standards. However, ANSI, in conjunction with other interested groups, has developed *The American National Standard Performance for Textile Fabrics, L22*. This performance standard provides minimum performance requirements and the methods of test for many items of apparel, upholstery, and industrial textiles. A typical L22 standard is shown in Table 19.3.

Certification Programs

One other type of standard is that used by a manufacturer to maintain the reputation of a product or trademark. If a company has invested a significant amount of its resources in the development of a new fiber, fabric, or finishing process that is an improvement over competitive products, it will seek to make the consumer aware of the advantages of purchasing this new product. At the same time, the company will try to maintain the quality of goods incorporating its development by requiring its customers to meet certain minimum standards of performance by means of *certification programs*. For example, a fiber manufacturer may mount an advertising campaign to inform consumers of the virtues of its new fiber. To insure that all garments that are made from this fiber will give the consumer good use, the producer prepares a set of performance specifications that must be met by fabric and garment manufacturers who wish to use the new fiber. The fiber company can then guarantee (certify) purchaser satisfaction and offer to reimburse dissatisfied customers. Certification programs such as Monsanto's *Wear Dated*, or DuPont's *501 Carpet* are examples of such programs.

In this now complex world of textiles, consumers are not always able to accumulate the knowledge and skills necessary to make informed decisions. For example, very few of us are able to ascertain whether or not a particular fabric is really virgin wool. Since the temptation to cut corners is always present, the police powers of the government have to be exercised to protect the public against fraud. This protection is provided through regulations such as the Textile Fiber Products Identification Act, intended to insure that manufacturers factually represent the fibers from which their goods are produced; the Care Labeling Rule, meant to provide consumers with the information necessary to properly maintain the garments that they have purchased; and the Wool Products Labeling Act, which provides rules for the use of wool in fabrics and garments.

However, governmental regulation can go beyond the mere provision of information and protection of the pocketbook. There are times when consumers can be endangered by the products they buy. Before the passage of the Pure Food, Drug and Cosmetics Act in 1932, manufacturers could produce goods for human consumption or medication without having to show that their products were not dangerous. With the passage of the Act, the Food and Drug Administration was empowered to monitor a large variety of products

TABLE 19.3 USA Standard Performance Requirements for Women's and Girls' Woven Blouse or Dress Fabrics (L22.10.3—1968)

PROPERTY	MINIMUM REQUIREMENTS					TEST METHOD See Part VII*
IDENTIFICATION:	L22.10.3-B Washable 160°F	L22.10.3-W Washable 160°F No Bleach	L22.10.3-C Washable 120°F No Bleach	L22.10.3-H Washable 105°F No Bleach	L22.10.3-D Dry-cleanable	
BREAKING STRENGTH Dry (See Note 1) Wet	20 lb 12 lb	20 lb 12 lb	20 lb 12 lb	20 lb 12 lb	20 lb 12 lb	USAS L14.184 Grab Test (ASTM D 1682)
RESISTANCE TO YARN SLIPPAGE	15 lb	15 lb	15 lb	15 lb	15 lb	USAS L14.102 (ASTM D 434)
TONGUE TEAR STRENGTH (see Note 2)	1 lb	1 lb	1 lb	1 lb	1 lb	USAS L14.207 (ASTM D 2261)
YARN SHIFTING Maximum Opening Satins Others	0.10 in. 0.05 in.	0.10 in. 0.05 in.	0.10 in. 0.05 in.	0.10 in. 0.05 in.	0.10 in. 0.05 in.	USAS L14.103 (ASTM D 1336) 1 lb load 1 lb load
MAXIMUM DIMENSIONAL CHANGE— EACH DIRECTION (See Note 3)	2.5%	2.5%	2.5%	2.5%		USAS L14.138 (AATCC 96) (ASTM D 1905) Table II Test No. III Test No. II Test No. I
ODOR	Class 3	Class 3	Class 3	Class 3	2% Class 3	AATCC 108 TDI No. 3

COLORFASTNESS TO

Property	Test IVA	Test IIIA	Test IIA	Test IA		Reference*
Atmospheric Fading after						
Washing (See Note 4)	Class 4	Class 4	Class 4	Class 4		USAS L14.54 (1 cycle) (AATCC 23)
Drycleaning (See Note 4)					Class 4	
Laundering	Test IVA	Test IIIA	Test IIA	Test IA		
Alteration in Shade	Class 4	Class 4	Class 4	Class 4		USAS L14.81 (AATCC 61)
Staining	Class 3	Class 3	Class 3	Class 4		Int'l Gray Scale
Drycleaning (See Note 5)	Class 4	Class 4	Class 4	Class 4		AATCC 85
Crocking						
Dry	Class 4	Class 4	Class 4	Class 4		USAS L14.72 (AATCC 8)
Wet	Class 3	Class 3	Class 3	Class 3		
Wet-Washed Crock Cloth (See Note 6)	Class 4	Class 4	Class 4	Class 4		Color Transference Chart
Perspiration						
Alteration in Shade	Class 4	Class 4	Class 4	Class 4		USAS L14.56 (AATCC 15)
Staining	Class 4	Class 4	Class 3	Class 3		Int'l Gray Scale
Light	L4-20 hr	L4-20 hr	L4-20 hr	L4-20 hr		USAS L14.53 (AATCC 16A)

Note 1: Fabrics known to exhibit a wet strength which is in excess of the dry strength requirement need not be subjected to a wet test.

Note 2: Use of USAS L14.203 (ASTM D 1424—Elmendorf) Test Method is permitted if preferred with existing requirements as given in this standard. However, in case of controversy, USAS L14.207 (ASTM D 2261) shall prevail.

Note 3: Use AATCC Test Method 99 when applicable. Use FLA Tests No. 1 and No. 2 for laminated (bonded) fabrics.

Note 4: Use corresponding test methods as provided in the columns under laundering and dry-cleaning.

Note 5: Under this standard, a washable fabric shall also be colorfast to dry-cleaning, unless specifically labeled: DO NOT DRY-CLEAN. Dry-cleanable goods are dry-cleanable only.

Note 6: For wet-washed crock cloth use CS 59-44. Part VIII. Colorfastness to Crocking, Para 31a.

*The references to the test numbers in this column give only the permanent part of the designation of the USA Standard. AATCC, ASTM, and other test methods. The particular edition for year of issue of each method used in testing the material for conformance to the requirements here specified shall be as stated in the current edition of Part VII of these L22 Standards.

and given the authority to prevent the sale of those it found to be harmful. In a similar fashion, the Consumer Product Safety Commission is empowered to provide for the public safety by setting standards for the performance of almost all consumer goods. Under the Flammable Fabrics Act, and related legislation, there now exist standards to control the flammability of mattresses, carpets and rugs, and children's sleepwear. Flammability standards for upholstered furniture and general wearing apparel are currently being considered by the Commission.

Product regulation, whether imposed by law or arrived at by consensus of the manufacturers, is a two-edged sword. On the one hand, it can protect the consumer from shoddily made or dangerous products. This is the case with the Textile Fibers Labeling Act or with the Flammable Fabrics Act. When consumers, no matter how knowledgeable, cannot be expected to be able to evaluate a product, it is necessary to employ professionals to do the job for them. Since we cannot expect consumers to be able to determine the fiber content of every fabric on the market, the Federal Trade Commission maintains laboratory facilities to assure that when a manufacturer claims that a product is made of a particular fiber, the product is actually made from that fiber. Likewise, standards controlling the flammability of mattresses can protect the general public from fires or asphyxiation from poisonous fumes that may be the result of someone else's careless behavior.

But consumers should be aware that protection has its costs, direct and indirect. For example, when the flammability standard was imposed, the price of children's sleepwear increased by about 30 percent. Indirect costs are paid from taxes which support the regulatory functions of government, from increased maintenance costs of products, and from reduced product durability that may result from the imposition of standards.

A further cost, which is difficult to quantify in terms of dollars and cents, is reduction in choice. Often, a regulated material that cannot meet the standards disappears from the marketplace. This was the case with children's sleepwear following the imposition of FF3-71, the flammability standard for children's sleepwear. Before the effective date of the standard, over 90 percent of children's sleepwear was made of cotton. This was the fiber of choice because of the comfort, durability, and low cost of cotton products. After all manufacturers were in compliance with the standard, children's sleepwear made from cotton virtually disappeared. It was so difficult to produce cotton sleepwear that would satisfy the standard at a competitive cost that manufacturers substituted other fibers for cotton. This substitution of man-made fibers for cotton caused a reduction in comfort, and in some cases the wear life of the garments.

Governmental regulation is not a recent factor in the textile industry. In the late thirteenth century in Europe, and hundreds of years earlier in the Orient, rules and regulations governed fabric weight, size of yarns, manufacturing methods and machinery, and training of workers. Many of these rules served the consumer. For example, at Bruges and Ypres, laws regulating the minimum weight of a fabric, the number of yarns per inch, and the size of

the yarns that could be used in making woolen cloth were meant to maintain the high quality of the fabrics produced in these cities. However, rules could also serve the manufacturer or the trade guilds. The spinning wheel was forbidden in Europe for almost ninety years after its invention because the spinners' guilds claimed that it produced a substandard yarn that was not worthy for use in quality fabrics. Of course, the spinning wheel produced yarns that were the equal of the usual hand-spun yarns, but the spinners were afraid that the introduction of new machinery might cost them their jobs.

The path to consumer protection is not always straight and clear. The foregoing examples show that consumer protection is a mixed blessing. Solutions to one consumer problem may serve only to create another. Consumers should be aware that even though the government may be looking out for their interests they must still exercise their own vigilance over the marketplace. Care labels may not always tell the truth. Government standards may not always provide what is best for each individual. Professionals, no matter how dedicated, cannot perform the functions of millions of consumers making their own purchase decisions.

TEST METHODS

Test methods specify the techniques and apparatus for assessing the performance of products and materials. In essence, they are the tools that make performance standards viable. The tables of contents of the AATCC Technical Manual and the Annual Book of ASTM Standards, Part 32 and Part 33, list over 275 tolerances, specifications, recommended practices, definitions of terms, and test methods devised to characterize the performance of textiles. Of course, one need not perform every test on each material; the user selects the important product characteristics and then applies the relevant tests.

To let you appreciate the attention to detail, the regard for precision, and the applicability of the accepted test methods, we have reproduced on pp. 410-14 the AATCC Test Method 93-1974—Abrasion Resistance of Fabrics: Accelerotor Method. Note that the standard begins with a statement of its purpose and scope, followed by a short summary of the method, its uses, and limitations. Sections 4 through 10 present a detailed description of the apparatus, samples, and preparation of specimens, and method of performing the test. Evaluation of the test results and mode of reporting are specified in section 11 and 12. Appropriate notes are contained in section 13. The procedures are painstakingly set down in order to insure that the test is run in the same way in every laboratory, every time. A misunderstanding of the procedures can lead to erroneous results that could result in sizable losses to either the producer or the user.

Abrasion Resistance of Fabrics:
Accelerotor Method

Developed in 1959 by AATCC Committee RA29; revised 1966; reaffirmed 1974, 1977; editorially revised 1978.

1. Purpose and Scope

1.1 This test is intended for evaluating the resistance of fabrics and other flexible materials to abrasion (see 13.1).

2. Principle

2.1 An unfettered fabric specimen is driven by an impeller (rotor) along a zigzag course in a generally circular orbit within a chamber, so that it repeatedly impinges the walls and abradant liner of the chamber, while at the same time it is being continually subjected to extremely rapid, high velocity impacts. The specimen is subjected to flexing, rubbing, shock, compression, stretching, and other mechanical forces during the test. Thus abrasion is produced throughout the body of the specimen by rubbing of yarn against yarn and fiber against fiber, as well as by rubbing of surface against surface and surface against abradant.

2.2 Evaluation is made on the basis of weight loss of the specimen, or grab strength loss of the specimen broken at the abraded edge, or on the basis of change in other characteristics such as air permeability, light transmission, visual appearance, hand, etc., depending on the type of fabric and its intended end use. Generally, flat woven fabrics should be tested by the grab breaking strength loss method, while tufted and other "3-dimensional" fabrics should be tested by the weight loss method.

3. Uses and Limitations

3.1 The results of the test are affected by its duration, the size, shape, and angular velocity of the rotor, and by the type of liner used. These effects are interrelated and may be varied to produce the desired degree of abrasion in the test specimen. For example, it may require only 2 or 3 minutes at 2000 rpm to produce a reasonable degree of abrasion in a delicate or fragile fabric, while a heavier or more durable fabric may require 10 minutes at 3000 rpm.

3.2 The results of this test should not be equated with service life.

4. Apparatus and Materials

4.1 Accelerotor (Fig. 1) (see 13.2).

Fig. 1—Accelerotor Fitted with Abrasive Liner over Foam Rubber Cushion and with 114.3 mm (4½ in.) S-Shape Rotor

4.1.1 Rotor, offset (elongated S-shape), 114.3 mm (4½ in.) (Fig. 2) (see 13.3).

Fig. 2—Elongated S-Shape Rotor.

4.1.2 Collar insert, plastic, lined with 3.175 mm (1/8 in.) polyurethane foam (see 13.4).

4.2 Liner, abrasive No. 250AO (see 13.2 and 13.5).

4.3 Neon Lamp or another stroboscopic device (see 13.2).

4.4 Timer, automatic, accurate to ±1 second.

4.5 Adhesive (see 13.6).

4.6 Brush, nylon (see 13.2).

4.7 Thread, size E, Type I, Class 1 or 2, Fed. Spec. V-T-295 (see 13.7).

5. Sampling

5.1 The specimens must be representative of the whole sample to be tested.

6. Specimens

6.1 Number.—A minimum of three replicates is required.

6.2 Size.

6.2.1 Method A (for evaluation by the weight loss method).—Specimens of heavier or bulkier fabrics should be cut smaller than those of lighter fabrics. Table I is a guide to the re-

Table 1—Selection of Specimen Size

Weight Range of Fabrics[a]	Size of Specimens[b]
300-400 (9-12)	95 (3¾)
200-300 (6-9)	115 (4½)
100-200 (3-6)	135 (5¼)
less than 100 (3)	150 (6)

[a] Grams per square meter (ounces per square yard)
[b] Millimeters (inches) square

lationship between fabric weight, in grams per sq cm (oz per sq yd), and specimen size.

6.2.2 Method B (for evaluation by the grab breaking—strength loss method). The specimen size is 100 x 150 mm (4 x 6 in.) with the greater length in the direction of the yarn to be broken (see 7.1.2).

7. Preparation

7.1 Specimens.

7.1.1 Method A—Cut a specimen with pinking shears (see 13.8). Place it on paper (to protect bench top) and apply a thin coating of adhesive to each pinked edge (Fig. 3) (see 13.6). Allow the adhesive to dry at room temperature.

7.1.2 Method B — Cut Specimens 100 x 300 mm (4 x 12 in.) (twice the length required for the grab breaking test). Number each specimen at both ends, and then cut in half, one half for determining the original grab breaking strength, and the other for determining grab breaking strength after abrading. The specimen to be abraded should then be prepared as in Method A. Then fold each specimen across the long dimension 50 mm (2 in.) from an end, making it into a 100 x 100 mm (4 x 4 in.) square. Attach the 50 x 100 mm (2 x 4 in.) flap with a seam 6.4 mm (¼ in.) from its edges including the folded edge to the body of the specimen (Fig. 4). Use 4 stitches to the cm (11 stitches per inch) (see 13.7).

7.2 Adjustment of Tachometer on Accelerotor.

7.2.1 Rotor—Select and install desired rotor.

7.2.2 Neon Lamp—To check the accuracy of the tachometer, the neon lamp is used as a simple stroboscope to view the spinning rotor. With the test chamber door *closed* and the neon bulb held close to the window of the door, the rotor gives distinct patterns at several useful speeds. With some practice, the following patterns will be recognized: 1800 rpm—the rotor appears as a stationary distinct two-bladed figure; 3600 rpm—the hub of the rotor appears as a stationary blur with two slight lobes apparent on the sides of the hub. If the tachometer does not read the appropriate speed, turn the small screw on the dial face to correct it.

7.2.3 Stroboscope—Set the stroboscope dial at 3000 rpm. *Close the*

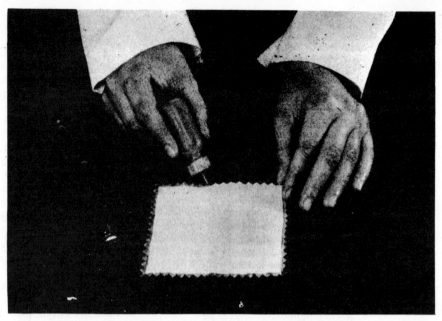

Fig. 3—Application of Ubabond Replacement Adhesive to Pinked Edges of Specimen from Plastic Squeeze Bottle.

door. Start the Accelerotor and bring the speed of the rotor to a point at which it appears as a stationary, two-bladed figure. If the tachometer does not read 3000 rpm turn the small screw on its dial face to correct it.

7.3 Liners (see 13.9).

7.3.1 Installation of Liners—Place liner into collar and with the fingers work liner around the collar wall until

Fig. 4—Specimen Prepared for Testing by Method B.

it fits snugly and smoothly in the collar without any crease.

7.3.2 Break-in of Fresh Liner—Insert the prepared collar into the Accelerotor equipped with the selected rotor. Break in the abrasive liner by running a 115 mm (4½ in.) square specimen of 80 x 80 finish-free cotton (preferably Airplane Cloth), edged with adhesive. *Close the door,* start the Accelerotor and maintain rotor speed at 3000 rpm for 12 minutes. If difficulties are encountered in running one specimen 12 minutes, two specimens may be run, one after the other, for 6 minutes each. Stop the Accelerotor and remove the specimen. Brush the abrasive liner to remove detritus.

7.3.3 Reversal of Liner—For greater reproducibility, it is recommended that after six test specimens have been run the collar assembly be removed from the Accelerotor and replaced in such a way that the rim which was next to the door goes to the back of the chamber.

7.3.4 Change of Liner—It is recommended that an abrasive liner be discarded after 12 specimens have been run (see 13.10).

8. Conditioning

8.1 Preconditioning. Let specimen reach moisture equilibrium in a standard atmosphere for preconditioning prior to conditioning it in the standard atmosphere for testing (see 13.11).

8.1.1 Moisture equilibrium for preconditioning is defined as having been attained when the change in weight does not exceed 0.5% of the weight of the specimen per 2 hr of exposure.

8.1.2 The standard atmosphere for preconditioning is an atmosphere of low relative humidity (5-25%) at a temperature not exceeding 49C (120F).

8.2 Testing. Let specimen reach moisture equilibrium in the standard atmosphere for testing 21 ± 1C (70 ± 2F) and 65 ± 2% RH.

8.2.1 Moisture equilibrium for conditioning at the standard atmosphere is defined as having been attained when progressive gain in weight does does exceed 0.1% of conditioned weight per 2 hr of exposure.

9. Safety Precaution

9.1 For safety, the door of the Accelerotor must be kept closed whenever the motor is running.

10. Testing Procedures

10.1 Method A—Weight Loss.

10.1.1 Weigh the conditioned specimen (see 8.1) on an analytical balance to ±0.001 gram.

10.1.2 Set up Accelerotor with the elongated, S-shaped, offset, 114.3 mm (4½ in.) long rotor, and No. 250 AO grit liner (see 13.3 and 13.9).

10.1.3 Crumple the test specimen and place it in the chamber.

10.1.4 *Close the door* (see 9), start the Accelerotor and maintain accurately at a selected speed for the desired time.

10.1.5 Stop the Accelerotor, and remove the test specimen.

10.1.6 Brush the liner to remove detritus.

10.1.7 Shake the specimen free of detritus.

10.1.8 Condition the tested specimen (see 8.2 and 8.2.1).

10.1.9 Reweigh the specimen on an analytical balance to ±0.001 gram.

10.2 Method B—Strength Loss.

10.2.1 Perform Steps 10.1.2 through 10.1.7.

10.2.2 Remove stitching thread to restore specimen to 100 x 150 mm (4 x 6 in.) dimension.

10.2.3 Condition specimen as in 8.2 and 8.2.1.

10.2.4 Determine breaking strength by the Grab Method ASTM D 1682, placing the worn edge of the test specimen between the jaws of the tensile tester (see 13.12). The specimen must break at the abraded edge for a valid test.

10.2.5 Determine breaking strength on conditioned (see 8.2) original (unabraded) (see 7.1.2) specimen.

11. Calculation and Evaluation

11.1 Method A.—Weight Loss. Calculate the percent loss in weight for each specimen to ±0.1%.

11.2 Method B.—Strength Loss. Calculate the percent strength loss for each pair (see 7.1.2) of specimens.

11.3 Additional tests. Additional evaluations may be made by determining abrasion-caused changes in air permeability, light transmission, thickness, visual appearance, hand, stiffness, etc.

12. Report

12.1 Method A—Report the average percent weight loss for the three replicate test specimens.

12.2 Method B—Report the average percent tensile strength loss for the three test specimens.

12.3 The report must state the exact conditions employed, *i.e.*, speed, time, size and type of rotor, and type of liner.

13. Notes

13.1 For additional information see: "Abrasion Testing with the Accelerotor-Reproducibility in Interlaboratory Tests." *Am. Dyestuff Reptr.* 47, No. 20, 679-83 (1958). "The Accelerotor for Abrasion Testing and Other Purposes." *Ibid.* 45, No. 19, 685-700 (1956).

13.2 For procurement write to Atlas Electric Devices Co., 4114 North Ravenswood Avenue, Chicago, Illinois 60613.

13.3 For special applications, pitched-blade rotors 107.95 mm (4¼ in.), 114.3 mm (4½ in.) and 120.65 mm (4 3/4 in.) and a shorter, 107.95 mm (4¼ in.) offset S-shaped rotor are available.

13.4 For special applications, a 6.4 mm (¼ in.) neoprene sponge liner, which can be used in place of the collar, is available.

13.5 For special applications, abrasive liner No. 180AO is available.

13.6 To prevent fraying, Ubabond Replacement Adhesive is applied to pinked edges of the specimen with a plastic squeeze bottle (see Fig. 3) to form a thin coating on edges. Penetration of adhesive into edges of specimen can be aided by use of small stiff brush. For unusual fabrics which cannot be pinked, specimens may be raveled 3.2 mm (1/8 in.) along each edge and adhesive applied as above.

13.7 For procurement information regarding a suitable thread, write to: AATCC Technical Center, P. O. Box 12215, Research Triangle Park, N. C. 27709.

13.8 It is convenient to mark specimens for cutting by means of square templates made of metal, plastic or cardboard. If available, cutting dies of appropriate dimensions may also be used; however, died specimens should be ravelled prior to the edge sealing (see 13.6).

13.9 The 250AO liner is a substitute liner for the No. 250 grit liner which is no longer available. The substitute is an aluminum oxide abrasive of 360 grit. The No. 250AO liner is used for most tests but for special applications, the No. 180AO substitute liner which is made with 240 grit aluminum oxide abrasive may be used. The No. 180AO liner is installed the same way as the No. 250AO liner. A no-grit (6.4 mm or ¼ in.) neoprene sponge liner may also be used. When the neoprene sponge liner is used, no collar insert is needed and the liner is secured in the chamber by placing a small piece of a double-face tape (e.g., Permacel No. P-50) between the butt joint of the liner and the chamber wall. No break-in of this type liner is necessary.

13.10 If the liner has not been subjected to severe duty, it may be used for more than 12 tests. The effective life of a liner may be checked by determining the weight loss of a control fabric, such as 80 x 80 cotton at the beginning of a series of tests and after intervals of 5 or 6 test specimen runs.

13.11 Preconditioning time, temperature and relative humidity are important for measurements in which regain is critical, as in weight change measurements.

13.12 Tensile strength tester as described in ASTM D 76.

glossary

absorption The penetration of a fiber by a foreign gas or liquid.

addition polymer A high-molecular-weight macromolecule prepared by the linking together of vinyl monomers. Acrylic, modacrylic, saran, and vinyon are examples.

adsorption The coating of the surface of a fiber by a foreign gas, liquid, or solid. The foreign matter does not penetrate the surface.

airplane cloth A lightweight plain-weave cloth, usually of cotton or linen, used for shirting.

alpaca A specialty hair fiber, softer than camel or wool. Usually used for coat fabrics in blends with wool or man-made fibers.

angora A fine, soft fiber from the pelt of the Angora rabbit. Often used to line gloves. See also *Mohair*.

antique satin A heavyweight, tightly woven satin weave with irregular filling yarns. Used for drapery and upholstery.

antiseptic Free from germs or other micro-organisms.

appliqué A decorative piece of cloth sewn or bonded to the surface of a fabric.

art linen A heavy plain-weave fabric, originally of linen, used for tablecloths. Also suited for embroidered home furnishings.

bactericide A chemical capable of destroying bacteria.

bacteriostat A chemical that inhibits the growth of bacteria.

balloon cloth A fine plain-weave cloth of high thread count made of very fine yarns. Usually made of filament fibers, it is used for dresses and shirts.

barathea A closely woven cloth in a variety of steep twill constructions having a grainy surface.

barré A pattern of bars of color running across the width of a fabric. Usually a defect.

bast Fibers obtained from the stems of plants, such as linen, jute, etc.

batik A dyeing technique in which parts of the cloth are covered with wax to resist dye penetration. A fine veining of the cloth occurs where the wax cracks to admit dye.

batiste A fine plain-weave cloth woven from mercerized combed cotton yarn. Used for blouses, shirts, lingerie, and handkerchiefs.

Bedford cord A heavy plain- or twill-weave cloth with a warpwise rib. Usually used for coats, suits, and trousers. Heavier weights are used for home furnishings.

beetling A process of pounding cloth with wooden hammers to produce a stiff, lustrous finish on cellulosic fabrics, usually linen.

bengaline A medium-weight plain-weave cloth with a fillwise rib. The warp yarns are usually filament, while the fill yarns are spun. Used for coats and dresses.

bicomponent fiber A man-made fiber in which two generically similar polymers are extruded in intimate contact throughout their length. Sheath core and side-by-side bicomponent fibers are most common.

biconstituent fiber A man-made fiber in which two generically different polymers are blended or mixed.

birdseye A figured knit or woven cloth in which the pattern is an open diamond with a dot in the center. Used for esthetic appeal in a variety of apparel and household items.

blend (1) A yarn made from an intimate mixture of two or more fibers. Usually a spun fiber. (2) A fabric made from such yarns. See also *Combination cloth.*

blister knit A double-knit cloth with a raised surface that appears as bubbles or blisters. Also called *popcorn knit.*

bouclé (1) A complex yarn having widely spaced tight loops projecting from its surface. (2) A cloth made from boucle yarns, or having a looped surface. Used for dresses, suits, curtains.

braiding The interlacing of three or more yarns in a diagonal formation.

breaking load The limiting force that will rupture a fiber, yarn, or fabric; expressed in grams or pounds.

broadcloth Originally a cloth woven on an extra wide (broad) loom. Any of a number of plain, rib, or twill, cotton, wool or man-made fiber cloths used for shirting or suiting. The term is now almost meaningless.

brocade A cloth with an intricate raised design made by Jacquard weaving. The background is usually of a satin or twill weave. The cloth is not reversible. Used for upholstery and drapes.

brocatelle An intricately patterned Jacquard-woven cloth in which the design is formed by raised warp yarns and the background is formed by the filling yarns. Used for upholstery.

buckram A low-yarn-count, plain-weave cloth heavily sized to give a very stiff hand. Used for linings.

bunting An open plain-weave cloth of cotton or wool, usually used for banners.

burlap A course, heavy plain-weave fabric of low yarn count, usually made of jute. Used for sacks, and occasionally for wall coverings and apparel as fashion interests change.

burling The removal of small imperfections in a woven or knit cloth.

calender A machine in which rollers rotating under pressure are used to finish fabrics.

calendering The finishing of a fabric under heat and pressure in a calender to effect a smooth embossed or glazed surface.

calico Originally, a printed, lightweight, coarse cotton cloth made of carded yarns. True calico is not suited to the demands of the modern market, and better-quality goods are often printed with the traditional calico pattern. Used for dresses.

cambric A medium-weight, high-count, plain-weave cotton or linen cloth, often calendered on one or both sides. Used for dresses and shirts.

canvas See *Duck.*

carbonizing The process of treating wool with sulfuric acid to remove vegetable matter.

carding In yarn spinning, a process by which staple fibers are separated and aligned into a sliver.

carrier A dyebath additive which promotes the penetration of dye into a hydrophobic fiber.

casement cloth A lightweight, high-count, plain-weave cloth. Used for curtains.

cashmere A soft, long, wool-like fiber taken from the hair of the Kashmir goat.

cassimere A tightly woven 2/2 regular twill cloth, fulled and sheared to provide a smooth surface. Used for men's suiting.

cavalry twill A steep twill cotton or wool cloth with a pronounced diagonal. Used for uniforms and riding habits.

challis A soft, lightweight, high-count plain- or twill-weave cloth. Used in a variety of apparel end uses. See also *Voile.*

chambray A moderate-weight, balanced plain-weave cloth with a colored warp and a white

filling. Usually of cotton. Used for lightweight clothing.

charmeuse A light- to medium-weight, soft satin fabric, usually of silk, with a high-luster finish on the face and a dull back.

cheesecloth A very open plain-weave cotton cloth. Used for cleaning cloths, cooking, costumes.

chenille (1) A yarn characterized by a short, fuzzy pile with an appearance much like a furry caterpillar. (2) A cloth made from chenille yarns.

Cheviot A heavy fulled and napped cloth with a shaggy, coarse surface.

chiffon A lightweight, sheer, plain-weave cloth made of highly twisted crepe yarns. Used in a variety of apparel end uses.

chino A strong twill-weave cloth made of combed two-ply yarns. Often used for uniforms.

chintz A light- to moderate-weight plain-weave cloth with a glazed surface. Usually printed in bright colors. Used for curtains.

cloqué A double cloth woven or knitted with a small, irregular, figured pattern. See *Matelassé*.

cloth A thin, flexible material produced from yarns by any of a number of processes—e.g., weaving, knitting, braiding, knotting.

combination cloth (fabric) A cloth containing two or more types of fibers in separate yarns— e.g., nylon warp yarn in combination with wool fill yarns. See also *Blend*.

combing In yarn spinning, the process of straightening and smoothing fibers by fine combs to produce a high-quality sliver. See *Carding*.

condensation polymer A high-molecular-weight macromolecule prepared from the combination of many small molecules accompanied by the formation (condensation) of water or alcohols.

copolymers Polymers composed of two monomers (see Chapter 3).

cord A yarn produced by plying yarns, usually in an S/Z/S or Z/S/Z configuration.

corduroy A heavy fabric with a raised cut pile made from extra filling yarns forming warpwise strips. Used for skirts, jumpers, trousers, jackets, suits, and upholstery.

core-spun yarn A yarn formed by spinning a sheath of staple fibers about a filament core.

core yarn A complex yarn formed by wrapping a sheath yarn about a core yarn.

courses In knitting, the horizontal rows of loops, similar to the filling in woven goods.

covert cloth A medium-weight warp-faced twill cloth with a flecked appearance obtained by using plied yarns composed of light- and dark-colored singles. Used for a variety of apparel and home-furnishing end uses.

crash A loosely woven, medium-weight plain-weave cloth made from irregularly twisted yarns of cotton, linen, or jute. Usually used for upholstery, although lightweight crash cloth may be used for apparel.

crepe (1) Highly twisted yarns that kink and curl upon relaxing. (2) Cloth made with crepe yarns having a crinkled, textured surface. (3) Any cloth possessing a textured surface like those made from crepe yarns.

cretonne A heavy cotton material (plain, twill, or satin weave) with a large printed design. Used for home furnishings.

crinoline A stiff, open, medium-weight plain-weave cloth.

crocking The loss of dye from a fabric by abrasion.

cut In warp knitting, the number of needles or stitches per inch.

damask A cloth with an intricate Jacquard-woven design on a satin background. The pattern is not raised and the cloth is reversible. Used for upholstery and drapes.

deluster To dull a man-made fiber by adding finely powdered solids before spinning.

delustrant A finely ground solid, such as titanium dioxide, added to man-made fibers before spinning to reduce the level of light reflection.

denier The linear density of a yarn or fiber expressed as the weight in grams of 9,000 meters of sample. See also *Tex, Yarn number*.

denim A strong, heavy twill-weave cloth made of coarse, well-twisted yarns. Traditionally denim was made from cotton with blue warp yarns and white fill yarns. Used for a variety of apparel, most often jeans.

dimity A lightweight filling-face rib weave with a pronounced warpwise stripe often accentuated by the use of heavy warp yarns. Used in a variety of apparel and home furnishings.

disinfectant A chemical agent used to destroy or inhibit the growth of micro-organisms and insects.

dobby (1) A cloth into which a small geometrical pattern has been woven. (2) A loom attachment for doing such weaving.

dotted swiss A lightweight, sheer, plain-weave cotton patterned with embroidered clipped spot- or swivel-weave dots. Used for curtains, blouses, and dresses.

double cloth (1) A woven fabric in which two sets of warp yarns are interwoven with a common filling to produce a fabric with two faces. (2) A knit fabric in which two sets of yarns are interknitted to form a fabric with two faces.

doupion A coarse, heavy, irregular silk yarn thrown from two entangled cocoons. Also *dupioni*.

drafting In yarn spinning, the attenuation of a sliver or roving.

drawing (1) In yarn spinning, the process of extending and blending sliver in making spun yarn. (2) The extension of man-made filament after extruding.

drill A moderate to heavyweight cotton fabric in a 2/1 left-hand regular twill construction. Used for a variety of apparel and home-furnishing end uses.

duck A heavy plain weave of high yarn count, usually made of plied cotton yarns. Used for awnings, belts, sails, and tents. Also called *canvas*.

duvetyn A soft downlike twill-weave cloth with a lustrous napped surface.

ends The individual warp yarns.

éponge A loosely woven plain-weave cloth made from loop yarns. Used in dresses, suits, and draperies.

fabric A thin, flexible material formed from cloth, polymeric film, fibers, or any combination of these.

faille A soft, lightweight, plain-weave cloth with a fillwise rib. Used for shirts and dresses.

fasciated yarn An untwisted filament yarn held together by an outer fiber or fibers wrapped around the core.

felt A nonwoven fabric in which the fibers are firmly entangled. True felts are made of wool, hair, or fur fibers. Felts made from other fibers often have a bonding agent. Used for hats, a variety of apparel, liners, and insulation.

fiber A fine, slender, rodlike material having a length at least 100 times its diameter. See *Staple* and *Filament*.

fibril A tiny, very fine fiber.

filament A long textile fiber, usually 100 or more meters (110 yards) in length. Silk and the man-made fibers are examples of filaments.

fill The crosswise yarns in a woven fabric. Also known as *weft*, *woof*, and *filling*.

filling knitting See *Weft knitting*.

flake yarn A fancy yarn with small lumps of fiber trapped along its length; similar in appearance to nub yarn.

flameproof Capable of withstanding a live flame for extended periods of time with little or no effect.

flame-resistant Capable of withstanding a live flame for a limited period of time with only minor effects.

flame-retardant (1) A material added to fibers or fabrics to reduce their flammability. (2) A fabric treated to have a reduced rate of burn.

flammable Easily set on fire.

flannel A woven wool fabric with a soft napped surface. Used for blankets, shirts, and sleepwear.

flannelette A soft, light- to medium-weight cotton plain- or twill-weave cloth with a napped surface. Used for sleepwear.

fleece (1) The coat of wool that covers a sheep. (2) A furlike knit pile fabric.

float In weaving, the yarn that passes over two or more yarns before being brought under another.

foulard A lightweight, firm, supple, twill-weave cloth with a lustrous face and dull back. Used for neckties and lightweight apparel.

frieze/frisé (1) A pile fabric in which the surface is composed of cut and uncut loops. (2) A heavy twill-weave cloth with a course, napped surface. (3) Any fabric with a coarse, fuzzy surface.

fulling The shrinking and compacting of woolen cloth by mechanical action in the presence of warm soapy water. Also known as *milling*.

fungicide A chemical agent used to destroy fungi.

fungistat A chemical that inhibits the growth of fungi.

fungus A plant such as a mushroom, mold, mildew, or rust which does not manufacture chlorophyll and lives on dead or living organic matter. Plural: *fungi*.

fustian Originally a cheap, heavy cloth of cotton and wool in which the yarn count in the weft was much higher than in the warp. Now, any heavy fabric with many more picks than ends.

gabardine A tightly woven twill construction in which the warp yarn count is much higher than the weft yarn count and the diagonal is pronounced on the face and suppressed on the back. Used for suits, coats, trousers, and dresses.

gauge In weft knitting, the number of needles or stitches in 1½ inches.

gauze A very open, lightweight plain-weave cotton fabric. Usually used for bandages and dressings.

gauze weave See *Leno*.

georgette A lightweight, sheer, loosely woven cloth with a crepelike texture. Used for evening wear.

gingham A light- to medium-weight plain-weave cotton cloth, yarn-dyed to create stripes, checks, or plaids. Used for a variety of apparel and home-furnishing end uses.

gray goods See *Greige*.

greige A cloth in its unfinished state. Also *gray goods*.

grenadine A lightweight, open, leno-weave cloth. Used for curtains.

gros-de-londres A light- to medium-weight plain-weave ribbed cloth with alternating thick and thin horizontal ribs. Used for dresses and hats.

grosgrain A stiff, lightweight, plain-weave cloth with a diagonal rib formed by heavier fill yarns. Used for dresses.

herringbone A broken or pointed twill weave resembling the skeleton of a herring. Has a variety of end uses.

homespun A coarse, plain-weave cloth made from irregular spun yarns. Has a variety of end uses.

hopsacking A medium- to lightweight open basket-weave usually of coarse cotton yarns. Has a variety of end uses.

huckaback/huck A towelling fabric with a figured surface formed by heavy fill yarns. Usually of cotton or linen.

hydrophilic Water-loving: having an attraction to water. Hydrophilic materials are usually oleophobic.

hydrophobic Water hating: having little or no attraction to water. Hydrophobic materials are usually oleophilic.

hygroscopic Capable of absorbing large amounts of moisture from the air; often to the extent of dissolving.

ingrain Yarn spun from a mixture of fibers that have been dyed different colors before blending. Also cloth made from such yarns.

interlock A double-knit cloth formed of two 1/1 rib knits interknitted together.

interstice The spaces between yarns in a cloth.

Jacquard (1) A cloth woven or knit in an intricate pattern. (2) A loom or knitting machine for making such a cloth.

jean A medium-weight cotton twill or herringbone woven cloth with a soft, smooth texture. Used for sportswear.

jersey A single-weft knit cloth made from all knit or all purl stitches.

kersey A heavyweight wool twill weave with a lustrous surface. Used for uniforms and outerwear.

knitting The formation of a cloth by the interlooping of yarn. See *Warp knitting* and *Weft knitting*.

knit stitch In weft knitting, a stitch in which the loop is formed by drawing the yarn from the back to the face of the cloth.

lace An openwork ornamental cloth made by looping, interlacing, or twisting threads together.

lamb's wool Wool sheared from a sheep less than eight months old. Softer and finer than regular wool.

lamé A fabric containing bright metallic yarns. Used for a variety of apparel.

lawn A lightweight sheer muslin with a high thread count, often calendered and sized to a soft, lustrous finish. Used for dresses and blouses.

leno A woven structure in which the filling yarn is inserted through pairs of warp yarns

twisted in a figure eight. This provides a stonger, more durable open cloth than the plain weave. Has a variety of end uses.

lingerie Feminine intimate apparel.

longcloth A fine, soft, cotton muslin woven of low-twist yarns. Heavier and duller than nainsook but lighter than cambric. Used for sheeting.

madras (1) A fine, soft, woven cloth with lengthwise stripes on a plain-weave, dobby, or Jacquard-woven background. (2) A hand-woven cotton fabric from India with a bold plaid pattern that bleeds upon laundering.

marquisette A lightweight open sheer cloth in a leno weave. Used for curtains.

matelassé A double cloth with a quilted appearance. Usually used in upholstery.

melton A thick, heavily fulled wool twill cloth with a lustrous napped surface. Used for coats and blankets.

mercerization The process of treating cotton yarn or fabric with caustic soda to improve luster and increase strength.

messaline A lightweight open-weave satin made with very fine filament yarns.

mildew-resistant Able to withstand or repel the growth of a fuzzy, whitish-gray fungus (mildew).

milling See *Fulling*.

miss stitch In weft knitting, a stitch in which a course is not looped through the preceding course. See *Welt stitch*.

mohair The long, fine hair of the Angora goat.

moiré A wavy or watered effect produced by pressing fabric between embossed calender rolls.

moisture regain The moisture absorbed by a fiber at standard temperature and relative humidity, expressed as a percentage of the weight of the dry specimen.

monk's cloth A loosely woven basket-weave cloth of heavy, coarse yarns. Usually used for draperies and upholstery.

monomer Small molecules from which polymers are formed.

mordant A metal salt used to improve the fastness of a dye.

mousseline French for muslin. Term applied to lightweight, moderately stiff fabrics. *Mousseline de laine* is a lightweight, plain-weave worsted wool cloth. *Mousseline de soie* is a lightweight, slightly stiff, plain-weave silk cloth.

mull A soft, thin, lightweight muslin, used for blouses and shirts.

muslin Any of a number of light- to heavy-weight plain-weave cloths, especially those used for sheets. Usually made of cotton. Muslins range, in increasing coarseness, from batiste through voile, lawn, mull, nainsook, longcloth, and percale to cambric.

nainsook A fine, soft, lightweight, plain-weave cotton cloth, often polished on one face. Used for lingerie, children's wear, and blouses.

napping The raising of fibers from the surface of a cloth by fine wire brushes. The napped surface is fuzzy.

ninon A fine, lightweight, smooth cloth in a 2/2 rib weave or a variant. Generally made of filament yarn. Used for sheer curtains and evening wear.

novelty yarn Any of a variety of irregular yarns purposely designed to produce variations in color or texture in a fabric.

oleophilic Oil-loving: having an attraction to oil. Oleophilic materials are usually hydrophobic.

oleophobic Oil-hating: having little or no attraction to oil. Oleophobic materials are usually hydrophilic.

organdy A thin, almost transparent plain-weave cotton fabric specially treated to give a stiff hand. Used for dresses and trims.

organza A cloth similar to organdy, but made with rayon, nylon, or silk filament yarns. Used for evening wear.

organzine A balanced two-ply yarn of medium twist.

osnaburg An open plain-weave cotton cloth made of uneven, coarse yarns.

ottoman A plain-weave fabric with a heavy fillwise rib.

Oxford cloth A 2/2 filling-faced rib in which the fill yarns are twice the size of the warp yarns. Used for shirting.

peau de soie A heavy, semi-dull, eight-shaft satin, traditionally of silk but may be made of any filament yarn.

percale A high-yarn-count, tightly woven, plain-weave cloth, traditionally of combed cotton or linen. Used for sheets.

permeability A measure of the ease with which gases or vapors, such as air or moisture, can pass through a fabric.

picks Individual fill yarns.

piece dyeing The dyeing of fabric (piece goods) after manufacture.

pilling The formation of little balls of fiber (pills) on the surface of a fabric.

pima A tough, strong, smooth American cotton grown in Arizona, Texas, and New Mexico.

piqué A woven or knit fabric with a textured surface formed by a raised rib. Waffled, diamond, or ribbed patterns may be formed.

plain weave A woven cloth in which the warp and fill yarns are interlaced in a 1/1 pattern.

plissé A cloth chemically treated to cause intermittent shrinkage and a crepe effect.

plush A pile cloth with a longer, less dense pile than velvet. May be woven or knitted.

plying The twisting of two or more yarns about each other to form a ply *yarn* or *cord*.

polymer A compound of very high molecular weight formed from the linking together of many smaller molecules. See *Addition polymer* and *Condensation polymer*.

pongee A lightweight plain-weave cloth using *tussah silk* yarns. Used for blouses and dresses.

popcorn knit See *Blister knit*.

poplin A closely woven plain-weave cotton cloth with a fillwise rib.

preshrunk A fabric that has been treated to have a residual shrinkage upon laundering of 1 percent or less.

purl knit A weft-knit cloth consisting of alternating courses of knit and purl stitches. See *Purl stitch.*

purl stitch A weft-knit stitch in which the loop is formed by drawing the yarn from the face to back of the cloth. See *Purl knit.*

ratiné A complex yarn having closely spaced, tight loops projecting from its surface.

raw silk Silk that has not been degummed.

regain See *Moisture regain.*

rep A light- to medium-weight, tightly woven, plain-weave with a pronounced fillwise rib.

rib A ridge formed on the surface of a cloth.

rib knit A weft-knit cloth composed of alternating wales of knit and purl stitches. Used in the cuffs, collar, and waistband of sweaters and for close-fitting tops.

rib weave A woven construction in which two or more warp yarns are interlaced with a single fill yarn or two or more fill yarns are interlaced with a single warp yarn. The former is called a *filling rib* and the latter is called a *warp rib.*

rotproof Able to withstand or repel the decaying action of bacteria, fungi, and other microorganisms.

roving In yarn spinning, the loosely twisted product of the drawing operation. Roving is spun into the final yarn.

sailcloth A heavyweight, plain-weave cloth usually of cotton, linen, or jute. Used for apparel and home furnishings subject to heavy wear.

sateen A woven fabric characterized by long fillwise floats on the face. May be made of spun or filament yarns. Often calendered for a high satinlike luster. Used for apparel and home furnishings.

satin A woven fabric characterized by long warpwise floats on the face. Traditionally, made from filament yarns. Used for apparel and home furnishings depending upon the weight.

scrim Any open, plain-weave fabric. Often used to reinforce nonwovens.

seersucker A lightweight, tightly woven, plain-weave cloth, traditionally of cotton, with a permanent pucker achieved by alternating sets of tight and slack warp yarns. Used for summer suits.

selvage The finished edge of a woven fabric; it is parallel to the warp yarns.

serge A twill-weave cloth with a well-defined diagonal formed by use of heavy warp yarns. Used for outer wear and suits, depending on the weight.

shantung Originally a plain-woven silk fabric from China made with slubby fill yarns. Any plain weave with heavy, irregular fill yarns.

sharkskin A lustrous, crisp, grainy fabric in a plain weave or small basket (2/1, 2/2) pattern made of highly twisted spun or filament yarns. Wool sharkskin is woven in a twill pattern with alternating light and dark yarns. The overall effect resembles the skin of a shark. Used for suits.

shed In weaving, the opening between sets of

warp yarns through which the filling yarn passes.

shoddy A plain woven cloth of loosely twisted yarns made from re-used wool fibers.

size A film-forming substance—e.g, starch, gelatin, poly(vinyl alcohol)—applied to yarn to form a protective surface.

sizing The application of a film-forming substance to the surface of yarns to strengthen and protect against abrasion. Also called *slashing*.

slashing See *Sizing*.

sliver In yarn spinning, a thick, ropelike assembly of aligned staple fibers produced by carding or combing.

slub A bulky, loosely twisted section of a spun yarn. Slub yarns are used to vary texture and light reflection in a fabric.

softener (1) A lubricating finish applied to fabrics to improve the hand. (2) A chemical added to soaps and detergents to prevent the formation of a soap scum.

solution-dyed Descriptive of a man-made fiber that has been colored before spinning. Also known as *spun-dyed* or *dope-dyed*.

space-dyed Descriptive of yarns that have been colored by application of different colorants at intervals along their length. Used to give a multicolored tweed or heather effect.

spinning (1) The process of drafting and twisting a roving to make a yarn. (2) The extruding of a polymer to form a filament fiber.

spun yarn A yarn made by twisting together staple fibers.

staple Short textile fibers, usually from 2 to 20 cm in length—e.g, cotton, wool.

stock dyeing The dyeing of staple fibers before spinning into yarn.

striation The fine lines extending longitudinally along the surface of some fibers, particularly pronounced in rayon.

suede cloth A fabric with a raised nap which resembles sueded leather.

surah A soft twill-weave cloth usually of plaid, stripe, or diamond pattern. Used for ties, blouses, and dresses.

tabby A plain-weave cloth.

taffeta A closely woven, stiff, plain-weave cloth with a characteristic rustle. Used for crinolines and dresses. *Faille taffeta* has a fine rib produced by use of a heavier fill yarn.

tapestry A heavy, Jacquard-woven cloth made with multiple warp and fill yarns in a pictorial pattern. Used for upholstery and drapery.

tenacity The strength of a fiber or yarn expressed as the breaking load (grams) divided by the linear density of the relaxed sample (denier).

tendering Reduction of the strength of a fabric by mechanical or chemical means.

terrycloth A warp-pile fabric, usually cotton, with characteristic loops on the surface. Used for toweling, sportswear, and bedspreads.

tex Linear density of a yarn or fiber expressed as the weight (grams) of 1,000 meters of sample.

texturing The process of crimping, curling, coiling, looping, or otherwise distorting a filament yarn to increase its apparent bulk in order to improve the hand and thermal properties. Often incorrectly called *texturizing*.

ticking Originally a heavy cotton twill cloth with a warpwise stripe used for mattress covers. May be any stiff twill or plain weave used for mattresses, upholstery, or slipcovers.

toile A French term designating any of a number of plain- or twill-weave cloths of cotton, linen, or hemp—e.g., *toile d'Alsace*, *toile de Frise*, *toile de Fouy*, etc.

tram silk A low-twist plied silk yarn.

tricot A lightweight, compact, warp-knit cloth, usually of filament yarns. Used for intimate apparel, dresses, blouses, and shirts.

tuck stitch In weft knitting, a stitch in which two courses are looped onto a third.

tussah silk Silk obtained from moths other than *Bombyx mori*. Also called *wild silk*.

tulle A fine lightweight net cloth used for veiling and evening wear.

tweed Any of a number of medium- to heavyweight coarse-textured twill or herringbone cloths with a heather effect. Used for suiting or upholstery.

velour Knit or woven cut-pile cloth with a soft, plush surface.

velvet A woven cut-pile fabric made by adding extra warp yarns to form the pile. Types include: *crushed velvet*—whose pile is crushed under pressure and heat; *Lyons velvet*—a heavy, closely woven velvet with a short, stiff pile; *moiré velvet*—which has a pattern embossed on the surface by heat and pressure; and *panne velvet*—in which the pile has been pressed down to give a satinlike appearance.

velveteen A woven pile fabric made by adding extra fill yarns to form the pile.

vicuña A soft, fine, luxurious specialty-hair fiber taken from the South American *Llama vicugna*.

voile A soft, sheer, lightweight, high-count plain-weave cloth made of fine, high-twist yarns. Sheerer than challis. Used for blouses, dresses, and curtains.

waffle cloth See *Piqué*.

wale (1) In knitting, the vertical column of loops. (2) In corduroy, the raised pile.

warp The yarns parallel to the selvage in a woven cloth.

warp knitting A method of making cloth by interlooping yarns along the length of the cloth. The wales are composed of single yarns.

waterproof Cannot be penetrated by water. Usually the pores of a waterproofed material are closed by a wax, clay, or resin treatment.

water-repellent Capable of resisting penetration by water. The pores of a water-repellent material are not sealed, as in a *waterproofed* material.

weaving A method of making cloth by interlacing yarns, usually at right angles. In *triaxial* weaving three yarns are interlaced at 60° angles.

weft (1) The filling yarns in a woven cloth. (2) The courses in a knit cloth.

weft knitting A method of making cloth by interlooping yarns across the width of the cloth. The courses are composed of a single strand of yarn. Also called *filling knitting*.

weighting The addition of a metallic salt to a fiber, usually silk, to improve the hand and drape. Excessive weighting causes deterioration of the fiber.

welt stitch See *Miss stitch*.

whipcord A cloth woven in a steep twill pattern with a pronounced diagonal rib formed by heavy warp yarns. Used for suits.

wicking The transfer of moisture along the surface of the yarns in a fabric by absorption on the fibers.

woof See *Fill*.

woolen Relatively coarse, hairy yarns spun on woolen (condenser)-system machinery. Also cloth produced from woolen yarns.

worsted Relatively smooth, tightly twisted yarns spun on woolen (condenser)-system machinery. Usually made from wool or wool blends. Also, cloth made from such yarns.

yarn An assembly of fibers held together in a single strand.

yarn count (1) The number of ends and picks per linear inch in a woven cloth. Also called *thread count*. (2) See *Yarn number*.

yarn number The linear density of a spun yarn expressed as the length per unit weight, usually as the number of hanks of specified length per pound. Also called *yarn count*.

bibliography

AATCC Technical Manual, Vol. 55. Research Triangle Park, N.C.: American Association of Textile Chemists and Colorists, 1980.

Adrosko, Rita J. *Natural Dyes and Home Dyeing*. New York: Dover Publications, 1971.

Alexander, Patsy R. *Textile Product Selection, Use and Care*. Boston: Houghton Mifflin Company, 1977.

ASTM Standards (published annually), Parts 32 and 33. *Textile Materials*. Philadelphia: American Society for Testing and Materials, 1981.

Billmeyer, Fred W. *Textbook of Polymer Science.*, 2nd ed. New York: Wiley-Interscience, 1971.

Booth, J. E. *Principles of Textile Testing*. New York: Chemical Publishing Company, 1969.

Buresh, Francis M. *Nonwoven Fabrics*. New York: Reinhold Publishing Corporation, 1962.

Carter, Mary E. *Essential Fiber Chemistry*. New York: Marcel Dekker, 1971.

Clarke, W. *An Introduction to Textile Printing*, 4th ed. New York: John Wiley & Sons, 1974.

Colour Index, 3rd ed., Vols. 1–6. Bradford, Yorkshire: Society of Dyers and Colourists and Research; and Triangle Park, N.C.: The American Association of Textile Chemists and Colorists, 1971 (Vols. 1–4) and 1975 (Vols. 5–6).

Cook, J. Gordon. *Handbook of Textile Fibres*, 2 vols. London: Merrow Publishing Company, 1968.

Corbman, Bernard P. *Textiles: Fiber to Fabrics*, 5th ed. New York: McGraw-Hill Book Company, 1975.

Cowan, M. L., and M. E. Jungerman. *Introduction to Textiles*, 2nd ed. Englewood Cliffs, N.J.: Prentice-Hall, 1969.

Dempsey, E. P., and C. E. Vellins. *Heat Transfer Printing*. Sale, Cheshire: Interprint, 1975.

Emery, Irene. *The Primary Structures of Fabrics*. Washington, D.C.: The Textile Museum, 1966.

Encyclopedia of Textiles, 3rd ed. Englewood Cliffs, N.J.: Prentice-Hall, 1979.

424

Farnfield, Carolyn A., ed. *Textile Terms and Definitions*, 7th ed. Manchester: The Textile Institute, 1975.

Fourt, Lyman, and Norman R. S. Hollies. *Clothing Comfort and Function*. New York: Marcel Dekker, 1970.

Giles, Charles Hugh. *A Laboratory Course in Dyeing*, 3rd ed. Bradford, Yorkshire: The Society of Dyers and Colourists, 1974.

Goswami, B. C., J. G. Martindale, and F. L. Scardino. *Textile Yarns: Technology, Structure and Applications*. New York: John Wiley & Sons, 1977.

Hall, A. J. *Standard Handbook of Textiles*, 8th ed. New York: Halstead Press, 1975.

Harries, Nancy G., and T. E. Harries. *Textiles*. New York: McGraw-Hill Book Company, 1974.

Hollen, Norma, Jane Saddler, and Ann Langford. *Textiles*, 5th ed. New York: Macmillan Company, and London: Collier Macmillan Publishing, 1979.

Hollies, Norman R. S., and Ralph F. Goldman. *Clothing Comfort*. Ann Arbor, Mich.: Ann Arbor Science Publishers, 1977.

Joseph, Marjory L. *Introductory Textile Science*, 4th ed. New York: Holt, Rinehart and Winston, 1981.

Lyle, Dorothy Siegart. *Modern Textiles*. New York: John Wiley & Sons, 1976.

Lyle, Dorothy Siegart. *Performance of Textiles*. New York: John Wiley & Sons, 1977.

Pankowski, Edith, and Dallas Pankowski. *Basic Textiles: A Programmed Manual*. New York: Macmillan Company, 1972.

Pizzuto, J. J., revised by Arthur Price and Allen C. Cohen. *Fabric Science*. New York: Fairchild Publications, 1974.

Reichman, Charles, ed. *Knitting Dictionary*. New York: National Knitted Outerwear Association, 1966.

Reichman, Charles, ed. *Knitted Fabric Technology*. New York: National Knitted Outerwear Association, 1974.

Reichman, Charles, ed. *Transfer Printing Manual*. New York: National Knitted Outerwear Association, 1976.

Reichman, Charles, J. B. Lancashire, and K. D. Darlington, *Knitted Fabric Primer*. New York: National Knitted Outerwear Association, 1967.

Reisfeld, A., C. Rotenstein, D. F. Paling, and J. B. Lancashire. *Fundamentals of Raschel Knitting*. New York: National Outerwear Association, 1958.

Renbourn, E. T. *Physiology and Hygiene of Materials and Clothing*. Watford, England: Merrow Publishing Company, 1971.

Robinson, A. T. C., and R. Marks. *Woven Cloth Construction*. Manchester: The Textile Institute, 1973.

Robinson, George. *Carpets*. 2nd ed. London: Textile Book Service, 1972.

Rotenstein, Charles. *Manufacture of Raschel Wool and Cotton Outerwear*. New York: National Knitted Outerwear Association, 1955.

Seagroatt, Margaret. *A Basic Textile Book*. New York: Van Nostrand Reinhold Co., 1975.

Selling, H. J. *Twistless Yarns*. Watford, England: Merrow Publishing Company, 1971.

Smirfitt, J. A. *An Introduction to Weft Knitting*. Watford, England: Merrow Publishing Company, 1975.

Storey, Joyce. *Textile Printing*. New York: Van Nostrand Reinhold, 1974.

Stout, Evelyn E. *Introduction to Textiles*, 3rd ed. New York: John Wiley & Sons, 1970.

Studies in Modern Fabrics. Manchester: The Textile Institute, 1970.

Studies in Modern Yarn Production. Manchester: The Textile Institute, 1968.

Szilard, Jules A. *Bleaching Agents and Techniques*. Park Ridge, N.J.: Noyes Data Corporation, 1973.

Taylor, Marjorie A. *Technology of Textile Properties*. London: Forbes Publishers, 1972.

Textile Fibers and Their Properties. Greensboro, N.C.: Burlington Industries, 1972.

Textile Handbook, 5th ed. Washington, D.C.: American Home Economics Association, 1975.

Tortora, Phyllis G. *Understanding Textiles*. New York: Macmillan Publishing Co., 1978.

Trotman, E. R. *Textile Scouring and Bleaching*. London: Charles Griffin & Company, 1968.

Trotman, E. R. *Dyeing and Chemical Technology of Textile Fibres*, 5th ed. London: Griffin & Company, 1975.

Ward, D. T. *Tufting: An Introduction*. London: Textile Business Press, 1969.

Weaver, J. W., ed. *Analytic Methods for a Textile Laboratory*. Research Triangle Park, N.C.: American Association of Textile Chemists and Colorists, 1968.

Wingate, Isabel B. *Dictionary of Textiles*, 6th ed. New York: Fairchild Publications, 1979.

Wingate, Isabel B. *Textile Fabrics and Their Selection*, 7th ed. Englewood Cliffs, N.J.: Prentice-Hall, 1976.

Recommended Periodicals

American Dyestuff Reporter
American Fabrics Magazine
America's Textile Reporter
Ciba Review (no longer published)
Journal of the Society of Dyers and Colourists
Journal of the Textile Institute
Knitting Times
Modern Textiles
Textile Chemist and Colorist
Textile Industries
Textile Month
Textile Organon
Textile Research Journal
Textile World
Textiles

index

Abaca, 83-84
Abrasion resistance: accelerotor test method, 409-13; and durability, 28; effect of texturing on, 198; finishes to enhance, 313-14
Absorption, 249
Acetate, 112-18; burning behavior, 174 *tab.*, 322; defined, 112; fiber composition, 114-16; fiber production and yarn manufacture, 113-14; fiber properties, 116-18, history, 63, 112-13; names of cloths, 215, 220; solubility, 117 *tab.*; tenacity, 65; uses, 117-18
Acetate/rayon blends, 117-18
Acid dyes, 341-42
Acrilan, 134, 368 *fig.*
Acrylic, 134-40; additives, 171; blends, 139-40, 199; burning behavior, 174 *tab.*; crystallinity, 57; defined, 134; dry spinning process, 363; dyeing techniques, 341; fiber composition, 135-37; fiber production and yarn manufacture, 134-35; fiber properties, 137-38; hand, 173; history, 63, 134; molecular weight and DP, 54 *tab.*; solubility, 177 *tab.*; uses, 139; world consumption, 14
Addition polymerization, 51-53
Additives, 171
Adsorption, 137, 249
Agilon, 367

Air-jet texturing method, 367
Alcohols, 44-45
Aldehydes, 45
Alkanes, 39-41, 48 *tab.*
Alkenes, 41, 42 *tab.*
Almy, William, 12
Alpaca, 96
American Apparel Manufacturers Association (AAMA), 399
American National Standard Performance for Textile Fabrics, 405
American National Standards Institute (ANSI), 403, 405
American Retail Federation (ARF), 399
American Society for Testing and Materials (ASTM), 181, 403-5
Amides, 46-47
Amines, 46-47
Amorphous regions, 56-58
Amphoteric antistats, 293, 294
Angora goat hair, 95
Angora rabbit fur, 86, 96
Anidex, 162, 174 *tab.*
Animal fibers. *See* Protein fibers
Anionic antistats, 293, 294
Anionic softeners, 291
Antimicrobial finishes, 325-26
Antipilling finishes, 314-15
Antistatic agents: fabric finishes, 292-95; fiber additives, 171

Antron II, 122
Appearance: evaluation of, 21–22; and fiber properties, 66; finishes to improve, 284–88; as selection criterion, 19. *See also* Performance characteristics
Arachne machine, 267
Aramid, 151–52; burning behavior, 174 *tab.*; fiber properties, 152, 153 *tab.*; history, 63, 151; tenacity, 65
Arkwright, Richard, 9
Aromatic hydrocarbons, 41, 43 *tab.*
Artificial silk, 107, 113
Asbestos, 103–6; burning behavior, 174 *tab.*; fiber composition, 56, 104; fiber properties, 105; production, 103; uses, 105–6
ASNIM/8, 162
A-Tell, 128, 131 *tab.*
Atomic number, 32
Atomic weight, 32
Atoms, structure of, 31–34
Automobile tires, 126, 133, 160, 162
Auxochromes, 335–36
Azlon, 162, 174 *tab.*

Bacteriostats, 325–26
Balanced cloth, 212
Balanced yarns, 184
Ban-Lon, 367
Base yarn, 196
Basic dyes, 341
Basket weaves: names of cloths, 215; patterns, 210–12; performance, 213 *tab.*, 214
Batik, 352
Bave, 99
Beam dyeing, 344
Beaming, 376–77
Beating, 379
Beck dyeing, 345
Beetling, 80, 283
Bell, Thomas, 346
Bemberg rayon, 108
Benzene, 41
Beta Fiberglas, 159–60
Bicomponent fibers, 168–71; acrylic, 137; comfort features, 137; matrix type, 170–71; self-crimping, 368; sheath-core type, 170; side-by-side type, 168–69
Biconstituent fibers. *See* Bicomponent fibers
Binders: in loop yarns, 196; for pigment application, 343
Biological resistance, finishes to enhance, 322–26
Bleaching, 276–77
Bleeding, 338
Blend fabrics, 199
Blending, of natural stable fibers, 369
Blend yarns, 199, 372
Bobbin lace, 263
Bobtex yarns, 202
Bohr, Niels, 32
Bonded fabrics, 255–58

Bonding, and molecular structure, 34–36
Bouclé, 196
Braid, 265
Brin, 99
Broken twill, 220
Brown, Moses, 12
Burling, 288
Burning test, fiber identification, 173–76
Burst strength, 28
Bushings, 158

Cables, 182
Calendering, 282, 285
Camel hair, 95–96
Caprolactam, 121
Carbamate, 297
Carbonizing, 277
Carboxylic acids, 46
Carding, 9–10, 370–71
Care Labeling Rule, 397–99, 405
Carothers, Wallace Hume, 119–20, 127
Cartwright, Edmund, 10
Cashmere, 95
Cationic antistats, 293, 294
Cationic dyes, 341
Cationic softeners, 291
Cellobiose, 73
Cellulose acetate, *See* Acetate; Triacetate
Cellulosic fibers, 70–85; abaca, 83–84; acetate and triacetate, 112–18; bleaching, 276; burning behavior, 174 *tab.*; cotton, 70–77; durable press finishes, 295–98; dyeing techniques, 339, 341; embossing, 285; and fiber classification, 68; hemp, 84; henequen, 84; jute, 81–83; kapok, 84; kenaf, 84; linen, 77–80; nettle, 85; ramie, 85; rayon, 107–12; sisal, 85
Certification programs, 405
Chardonnet, Count Hillaire de, 14
Chemical elements, 32, 33 *fig.*
Chemical reactions, writing, 41–44
Children's sleepwear, flammability standards, 401–2, 408
China grass. *See* Ramie
Chintz, 285
Chromophore, 335, 336 *tab.*
Ciré, 285
Cloth: bonded to film, 257; bonded to foam, 257–58; defined, 207; design of, and wrinkle resistance, 297; dyeing 344–45; interaction of construction and yarn type on performance, 242–44; knit, 228–40; woven 207–25. *See also* Fabrics.
Colorfastness, 337–38
Colors, 329–34; additive and subtractive mixing, 332; complementary, 332; hues, 332–33; perception of, 329–30; physics of, 330–33; psychology of, 333–34; saturation and value, 333. *See also* Dyes; Pigments
Comb, 376
Combination fabrics, 199

Combing, 370–71
Comfort: effect of texturing on, 197–98; evaluation of, 22–23; and fiber properties, 67; finishes to improve, 290–95; as selection criterion, 19; and yarn properties, 188–90. *See also* Performance characteristics
Comfort-stretch fabrics, 146–47
Comonomers, 134, 140
Complex yarns, 194–204; blends and combinations, 199; construction, 182; new methods of formation, 200–203; novelty type, 194–97; textured, 197–99
Compounds: atomic structure, 32, 33; bonding and molecular structure, 34–36; containing functional groups, 44–47
Compressive shrinkage, 308–9
Condensation polymerization, 49–51, 54
Conductive fabrics, 161
Consensus standard organizations, 403–5
Consumer Product Safety Commission, 316, 399–400, 403, 408
Consumer Protection Agencies, 173
Consumers: decision making by, 17–30; relationship to retailer, 15; vs. users (ASTM definition), 404; value of standards to, 394
Converters, 14, 272–73
Copolymers, 55, 56 *fig.*
Cordelan, 171
Cords, 182
Corduroy, 250, 384, 385
Core-spun yarns, 197
Core yarns, 197; in loop yarns, 196; in spiral yarns, 196
Coronizing, 160
Cortical layer, 89
Cost: evaluation of, 28; and fiber properties, 67–68; as selection criterion, 20
Cotton, 70–77; beetling, 283; burning behavior, 174 *tab.*; cost, 67–68; desizing, 274; durable press finishes, 55, 296; fiber composition, 72–74; fiber length, 64; fiber production and yarn manufacture, 71–72; fiber properties, 74–76, 110 *tab.*; glazing, 285; hand, 173; history, 63, 71; mercerization, 280–81; moiré finish, 286; molecular weight and DP, 54 *tab.*; morphology, 57, 58; names of cloths, 215, 220; removal from children's sleepwear market, 402, 408; scouring, 274; singeing, 277–78; solubility, 177 *tab.*; stabilization, 309; standard yarn hank, 185; twist direction of yarn, 183; uses, 76–77; world consumption, 14. *See also* Cellulosic fibers
Cotton gin, 12, 71
Cotton/polyester blends. *See* Polyester/cotton blends
Cotton system, 369
Counters, 211–12
Courses, 229
Covalent bonding, 34–35, 36–37
Crabbing, 281

Creel, 376
Crepe yarns, 191
Crocking, 338
Crompton, Samuel, 9, 10
Cross-dyeing, 345
Crosslinking, 55, 296
Crystalline region, 56–58
CSIRO-IWS process, 310
Cuban sisal. *See* Henequen
Cuprammonium rayon, 108
Cuticle: of cotton, 72; of wool, 88
Cyclic nylons: production, 121–22; properties, 119, 124

Dacron, 131 *tab.*
Dalton, John, 32
Darvan, 163
Decating, 283
Degree of polymerization (DP), 53–55, 110
Degumming, 98, 275
Delustrants, 124, 171
Democritus, 31
Denier system, 186–87
Density, fiber, 65
Design, 329–53; color, 329–34; dyes, 334–45; history, 7; pigments, 334–38; 343; specialty fabrics, 259–67
Design standards, 394
Desizing, 273–74
Dienes, 41
Dimity, 209, 215
Direct dyes, 339–40
Direct-printing methods, 346–47
Discharge printing, 347
Disperse dyes, 339
DMDHEU, 296, 297, 309
Dobby weaves, 259
Dope-dyeing, 343
Double cloth method, 385
Double knits, 233–35, 387
Double tricot knits, 239, 241 *tab.*
Doup weave, 264–65
Drafting, 372
Drawing, 371–72, 375
Drebbel, Cornelius, 11
Dreyfus, Camille and Henri, 112–13
Dry bonding, 256
Dry cleaning, 338
Dry spinning: of acetates, 113–14; of acrylics, 363; of cyclic nylons, 122; defined, 360
Ductility, 161
Durability: evaluation of, 28; and fiber properties, 67; finishes to improve, 305–15; as selection criterion, 20; of simple yarns, 190–91. *See also* Performance characteristics
Durable antistats, 293, 294
Durable press finishes, 55, 295–98; and abrasion resistance, 313; and soil/stain resistance, 299–300

Dyes: for acetates and triacetates, 117; application methods, 343–45; chemistry of, 334–36; history, 7, 11–12; performance requirements, 337–38; stain test, 176, types, 338–42

Dylan process, 311

Edge abrasion, 313
Edge crimp, 367–68
Effect yarn, 196
Elasticity, 65, 92, 190. *See also* Stretch
Elastomers, 65, 146–47
Electric blankets, 161–62
Electrons: and atomic structure, 32–33; in ionic and covalent bonding, 34–35; in organic compounds, 36–37
Elongation, 65
Embossing, 285–86
Embroidery, 261–63
Emulsion-type softeners, 292
Ends, 208
Epitropic fibers, 295
Esters, 39, 46
Even twill, 216, 219

Fabric manufacturers, 14
Fabrics: combination type, 199; construction and performance factors, 240–44; defined, 207; finishing, 271–88, 290–326 (*see also main entry*); knit, 228–40; nonwoven, 254–59; manufacture, 376–92; pile 247–54; specialty, 259–67; woven, 207–25
Factors, 16
False-twist texturing, 366
Fancy yarn, 196
Fasciated yarns, 201
Federal Aviation Administration (FAA), 403
Federal Trade Commission (FTC), 63, 107, 113, 151, 308, 397, 399, 408
Felt, 5, 254–55
Felting, 93, 254, 284
Felting shrinkage, 307, 310–12
Fiberglass. *See* Glass fibers
Fiber producers, 14
Fibers: classification, 64, 68; and cloth performance, 240–42; comparative flammability, 321–22; consumption of, 14; dyeing, 344; elasticity, 65; epitropic, 295; fineness, 64, 66; flexibility, 64, 66; history, 63–64; identification methods, 172–78; labeling, 64; modification, 171; natural, 70–106; petroleum-based, 119–54; physical and chemical properties, 55–59, 65–66; product performance, 66–67; requirements, 64–65; spinning quality, 64; tenacity, 67
Fibrillated yarns, 202–3
Fibrils: of cotton, 72; fringed, 58; of wool, 89, 91
Fibroin, 98, 99, 101
Filament fibers: defined, 14, 64; dyeing, 344; texturing, 365–68; throwing, 375. *See also* Man-made fibers; Silk
Filament yarns: blends, 199; construction, 182, 186; dernier system, 186–87; durability, 190–91; from film, 202–3; laminated, 203; luster, 188; moisture permeability, 189; sanding, 287; stretch and elasticity, 190; texturing, 197–99
Fill, filling, 208
Filling-faced satin, 218 *tab.*, 221, 224
Filling-faced twills, 216, 219
Filling knits, 229–36
Filling-rib patterns, 209, 211 *fig.*
Film: cloth bonded to, 257; yarns from, 202–3
Fineness, 64, 66
Finishing, 271–88, 290–326; cleaning procedures, 273–78; history, 6; to improve appearance, 284–88; to improve comfort, 290; to improve durability, 305–15; to improve ease of maintenance, 294–305; to improve texture and hand, 282–84; inspection and quality control procedures, 288; to provide biological resistance, 322–26; to provide improved safety, 315–22; purpose, 271–72; role of converter, 272–73; shaping and sizing procedures, 278–81; types, 272. *See also* General finishes; Functional finishes
Flake yarns, 194–95
Flame-retardant finishes, 55, 315–21
Flammable Fabrics Act, 112, 142, 150–51; 316, 399–403, 408
Flat abrasion, 313
Flatbed screen printing, 348
Flax, 77. *See also* Linen
Flex abrasion, 313
Flexibility, 64, 65
Float, 214
Flocked fabrics, 253
Fluid-jet looms, 381
Fluorescent brighteners, 287–88
Fluorochemical finishes: for soil resistance, 300–301; water repellant, 305
Flying shuttle, 9
Foam, cloth bonded to, 257–58
Food and Drug Administration, 405
Formaldehyde, 45
Franklin, Benjamin, 103
Friction, and colorfastness, 338. *See also* Abrasion resistance
Fulling, 8, 93, 284
Fume fading, 338
Functional finishes, 290–326; abrasion-resistant, 313–14; antimicrobial, 325–26; antipilling, 314–15; antistatic, 292–95; durable press, 295–98; flame-retardant, 315–21; moth-resistant, 322–24; softeners, 290–91; soil/stain-resistant, 298–301; stabilization, 305–12; waterproof and water-repellant, 301–5
Functional groups: compounds containing, 44–47; effect on chemical properties, 37–39

Fungi, finishes to control, 325–26
Fur fibers, 96; compared to hair fibers, 86;
 modacrylic substitutes, 142
Fur Products Labeling Act, 64

Gauge: for knit fabrics, 229, 235–36; for tufted
 pile fabrics, 252–53
Gauze, 264–65
Gay-Lussac, Joseph Louis, 315
Gear crimp, 367
General finishes, 271–88; beetling, 283;
 bleaching, 276–77; calendering, 282, 285;
 carbonizing, 277; crabbing, 281; decating,
 283; desizing, 273–74; embossing, 285–86;
 fluorescent brighteners, 287–88; fulling,
 284; glazing, 285; heat setting, 280;
 mercerization, 280–81; raised surfaces, 286–
 87; scouring, 274–76; shearing, 282–83;
 singeing, 277–78; sizing, 283; softening,
 284; tentering, 278–81; weighting, 284
Gigging, 287
Gimp, 196
Glass fibers, 157–61; burning behavior, 174
 tab.; composition, 158; hand, 159, 173;
 history, 63, 157; manufacture, 158;
 morphology, 56; properties, 159–60;
 solubility, 177 *tab.*; tenacity, 65; uses,
 160–61
Glass transition temperature, 59
Glazing, 285
Gold fibers, 161
Goodyear, Charles, 163
Greige goods, 271
Ground cloth, 247
Guinea hemp. *See* Kenaf

Hackling, 77
Hair fibers: compared to fur, 86; specialty
 types, 94–96; wool, 86–94
Hand: evaluation of, 23; and fiber
 identification, 173; finishes to improve, 282–
 84; of textured yarn, 198
Handcraft printing and dyeing methods,
 351–52
Hanks, standard, 185
Hargreaves, James, 9, 10
Harnesses, 376, 378
Hawsers, 182
Heat setting, 280
Heddles, 376, 377–78, 382–83, 384
Helenca yarns, 366
Hemp, 84
Henequen, 84
Herringbone twills, 220, 221, *fig.*
Heterogeneous fibers, 168–71
Howe, Elias, 13
Hydrocarbons, 37, 39–41
Hydrogen bonding, 35, 74
Hydrophilic fibers, 122, 293, 299
Hydrophobic fibers, 122, 293, 299

Industrial Revolution, 11, 95
Inspection procedures, 288
Insulation capacity: and product
 performance, 23; of simple yarns, 188–89;
 of wool, 93
Interlock knits, 233, 234–35, 241 *tab.*
Internal antistats, 294–95
International Conference on Weights and
 Measures, 393–94
International Union of Pure and Applied
 Chemistry (IUPAC), 39
Intersections, 219
Ionic bonding, 34
Irregular satin, 223

Jacquard, Joseph-Marie, 10, 259
Jacquard loom: decorative effects, 259–61,
 263; invention, 10; weaving process, 382
J-boxes, 275
Jefferson, Thomas, 163
Jersey knits: compared to plain weave, 242–
 44; construction and uses, 230; performance
 properties, 241 *tab.*
Jig dyeing, 345
Justinian, 97
Jute, 81–83

Kapok, 84
Kay, John, 9, 10
Kekulé, Friedrich A., 41
Kenaf, 84
Keratin, 90–91
Ketones, 45
Kevlar, 151–52
Kiers, 274, 345
Knit cloths, 228–40; compared to woven, 242–
 44; double-knit, 233–35; double tricot, 239;
 effect of gauge, 235–36; fashion advantages,
 240; Jacquard designs, 260–61; jersey knits,
 230, 234; manufacture, 385–90; performance
 properties, 234–35, 237–39, 241 *tab.*;
 popularity, 228; purl knits, 231; raschel
 knits, 239–40; rib knits, 231–32; run-
 resistant filling knits, 232; stabilization,
 310, 312; terminology, 229; tricot knits, 237–
 39. *See also* Knitting
Knit pile fabrics, 252
Knitting, 385–90; on circular vs. flatbed
 machines, 385–86; defined, 229; on double-
 knit machine, 387; four basic stitches, 229;
 history, 5, 9; of pile fabrics, 388, 390; warp
 type, 388–90. *See also* Knit cloths
Knot yarns, 196
Kodel, 131 *tab.*
Koratron process, 298
Kraftmatic machine, 267
Kynol, 153, 154 *fig.* and *tab.*

Lace, 263–64
Lamb's wool, 396

Laminated fabrics, 256-58
Laminated yarns, 203
Langmuir, Irving, 32-33
Lappet weave, 261, 262
Layered fabrics, 256-58
Leavers lace, 263
Lee, William, 9
Leno weave, 264-65
Lewis, Gilbert N., 32-33
Lewis structures, 37
Libbey, E. D., 157
Light: and colorfastness, 337; and physics of color, 330-33
Linen, 77-80; beetling, 283; burning behavior, 174 *tab.*; fiber composition, 78-79; fiber length, 64; fiber production and yarn manufacture, 77-78; fiber properties, 79-80; hand, 80, 173; history, 63, 77; names of cloths, 215, 220; solubility, 177 *tab.*; standard yarn hank, 185; twist direction of yarn, 183; uses, 80. *See also* Cellulosic fibers
Linen testor, 212
Linsey-woolsey, 199
Looms: fluid-jet, 381; history, 5-6; modern, 376-79; rapier, 380; shuttle, 380; simple, 207-8; triaxial, 383-84. *See also* Jacquard loom; Weaving
Loop yarns, 196
Lowe, Horace, 280
Lumen, 72
Luster, 187-88

Macromolecules, 48
Macrostructure, 65-66. *See also subentry for fiber composition under individual fibers*
Maintenance, ease of: effect of texturing on, 198; evaluation of, 23; and fiber properties, 67; finishes to improve, 295-305; as selection criterion, 19-20; and yarn properties, 190. *See also* Performance characteristics
Mali technology, 266-67
Man-made fibers: anidex, 162; annual consumption, 63; azlon, 162; bleaching, 277; burning behavior, 174-75 *tab.*; classification, 68 *tab.*; cellulosic, 107-18; cost factors, 67; heat setting, 280; glass, 156-61; heterogeneous, 168-71; history, 14, 63; macrostructure, 66; manufacture, 359-68; metallic, 161-62; nytril, 163; petroleum-based, 119-54; rubber, 163-64; saran, 164; scouring, 275; solution dyeing, 343; transfer printing, 351; vinal, 166-67; vinyon, 167-68; world consumption, 14, 63
Manufacturing methods, 359-92; fabrics, 376-92; fibers, 359-68; yarns, 368-75
Matrix fibers, 170-71
Mattresses, flammability standards, 402-3
Mauersberger, Heinrich, 266
Mechanical carder, 9-10

Medulla, 90
Melting temperature, 59
Melt spinning, 120, 360, 364-65
Mendeleev, Dmitri, 32
Mending, 288
Mercer, John, 280
Mercerization, 280-81
Merino sheep, 87
Metallic fibers, 161-62, 174-75 *tab.*
Micelles, fringed, 58
Micrex process, 310
Microscopic identification, 176
Microstructure, 55-59, 65, 66. *See also subentry for* fiber composition *under individual fibers*
Milling, 284
Mineral fibers, 68 *tab.*; asbestos, 103-6; glass, 157-61; metallic, 161-62
Miss stitch, 229
Modacrylics, 140-42; burning behavior, 175 *tab.*; fiber composition, 140-41; fiber properties, 141-42; introduction, 63; solubility, 177 *tab.*
Mohair, 95
Moiré, 286
Moisture absorption, 67, 249
Moisture permeability: of basket weave, 214; of simple yarns, 189
Molecular structure: and bonding, 34-36; and fiber properties, 66; of simple organic compounds, 36-41
Molecular weight: and crosslinking, 55; and degree of polymerization, 53-54; effect on physical properties, 47-48
Molecules: and fiber morphology, 55-59; polymers, 47-55
Monvelle, 368
Mordanting, 11, 342
Moth-resistant finishes, 322-24
Munsell, A. H., 332, 333
Munsell Hue Circle, 332

Napping, 286-87
National Bureau of Standards, 403
National Retail Dry Goods Association, 107
National Retail Merchants Association (NRMA), 107, 399
Natural fibers, 70-106; annual consumption, 63; cellulosic, 70-85; classification, 68 *tab.*; cost factors, 67-68; history, 63; mineral, 103-6; protein, 86-102
Needle count, for tricot knits, 237
Needled felts, 254
Net, 265
Nettle, 85
Neutrons, 32
Newton, Isaac, 330, 331
Nomex, 151-52, 153 *tab.*
Non-Flam, 316
Nonionic softeners, 291-92
Nonwoven fabrics, 254-56

Novelty yarns, 182, 194-97. *See also* Complex yarns
Novoloid, 63, 153-54, 175 *tab.*
Nub yarns, 196
Nucleus, atomic, 32
Nylons, 119-27; acrylic blends, 139-40; additives, 171; burning behavior, 175 *tab.*, 322; compared to silk, 120; cyclic, 119, 121-22, 124; defined, 119; dyeing techniques, 341; fiber composition, 57, 58, 122-24; fiber properties, 124-26; hand, 124, 173; history, 14, 63, 119-20; manufacture, 50-51, 120-22; melt-spinning process, 364-65; molecular weight and DP, 53, 54 *tab.*; solubility, 177 *tab.*; and Source, 170-71; uses, 126-27
Nytril, 163, 175 *tab.*

Olefin, 142-46; burning behavior, 175 *tab.*; compared to saran, 165; defined, 142; fiber composition, 143-44; fiber properties, 144-46; hand, 173; history, 63, 142-43; molecular weight and DP, 54 *tab.*; manufacture, 143; pigment application, 343; solubility, 177 *tab.*; uses, 146
Oleophilic fibers, 129, 132. *See also* Polyesters
Open-end (OE) spinning, 373-74; yarn characteristics, 200
Opening, 369
Optical whiteners, 287
Organic compounds: basic structure, 37-39; containing functional groups, 44-47; nomenclature, 39-41; polymers, 47-55
Orlon, 134, 363
Oxford cloth, 210, 211 *fig.*, 214, 215

Package dyeing, 344
PAN, 134, 135-36. *See also* Acrylic
Paul, John, 9
PCDT, 127, 128, 129, 130, 131 *tab. See also* Polyesters
PEB, 127, 128, 130, 131 *tab. See also* Polyesters
Perching, 288
Performance characteristics: effect of texturing on, 197-99; evaluating, 21-28; interaction of fabric construction and yarn type, 240-44; measurability, 28-29; of satin weaves, 223-24; as selection criteria, 19-20; of simple weaves, 212-14; of simple yarns, 187-91; of twill weaves, 217-19. *See also subentry for* fiber properties *under individual fibers*
Performance standards, 394
Periodic table of the elements, 32, 33 *fig.*
Perkin, William Henry, 12, 316, 335
Persian carpets, 7
Perspiration, 101, 337
PET, 127-28, 130, 131 *tab. See also* Polyesters
Petroleum-based fibers, 119-54; acrylic, 134-40; aramid, 151-53; and fiber classification,

68 *tab.*; modacrylics, 140-42; novoloid, 153-54; nylons, 119-27; olefin, 142-46; polyesters, 127-34; spandex, 146-50
Photo printing, 347
Pick glass, 212
Picking, 379
Picks, 208
Piece dyeing, 344-45
Pigments: application and fastness, 343; chemistry of, 334-36; performance requirements, 337-38
Pile fabrics, 247-54; corduroy, 250; flocked, 253; knit, 252, 388, 390; shearing, 283; terrycloth, 251-52; tufted, 252-53, 392; velvet and velveteen, 247-50; weaving, 384-85
Pilling, 232, 314-15
Plain weave: compared to jersey knit, 242-44; compared to twills and satin, 218 *tab.*; names of cloths, 215; performance, 212-14; structure, 208-9; weaving process, 378, 379
Plasticizers, 171
Plied yarns: construction, 182, plying, 374; properties, 192; yarn number, 185-86
Point diagrams, 209
Pointed twill, 220
Polished chino, 285
Polyesters, 127-34; additives, 171; blends, 133-34; burning behavior, 175 *tab.*, 322; defined, 127; dyeing techniques, 341; fiber composition, 128-29; fiber production and yarn manufacture, 49-50, 127-28; fiber properties, 130-32; hand, 173; history, 63, 127; molecular weight and DP, 54 *tab.*; solubility, 177 *tab.*; uses, 132-33; world consumption, 14
Polyester/cotton blends: abrasion resistance, 313, 314; advantages, 133, 199; drawing process, 372; for durable press finishes, 297; flammability, 321; singeing, 278; soil-release finish, 301
Polyester/wool blends, 133-34
Polymerization, 49-54
Polymers, 47-55
Polynosics, 110, 111 *tab.*
Polypeptides, 90
Polypropylene fibers. *See* Olefin
Power loom, 10
Power-stretch fabrics, 146
Pressing, 282
Printing, 346-52; advantages over dyeing, 343, 346; batik, 352; discharge method, 347; flatbed screen method, 348; photo method, 346; roller method, 346; rotary screen method, 348-49; stencil method, 351; tie dyeing, 352; transfer method, 349-51
Product manufacturers, 14-15
Progressive shrinkage, 307
Protein fibers, 86-102; alpaca, 96; azlon, 162; burning behavior, 174 *tab.*; camel hair, 95-96; cashmere, 95; fiber classification, 68 *tab.*;

Protein fibers (*cont'd*)
 fur, 86, 96; mohair, 95; silk, 97–102;
 vicuña, 96; wool, 86–94
Protons, 32
Pure Food, Drug and Cosmetics Act, 405
Purl knits, 231, 241 *tab.*
PVC, 167

Qiana, 122 *fig.*, 124, 127
Quality control, 288
Quarpel, 305
Quill, 378, 380
Quilted fabrics, 258–59

Raised surfaces, 286–87
Ramie, 85
Rapier looms, 380
Raschel knits, 237, 239–40, 389–90
Raschel lace, 264
Ratiné, 196
Rayon, 107–12; burning behavior, 175 *tab.*;
 crystallinity, 57; defined, 107; desizing, 274;
 fiber composition, 108–10; fiber production
 and yarn manufacture, 107–8; fiber
 properties, 110–12; history, 14, 63, 107;
 moiré finish, 286; molecular weight and
 DP, 54 *tab.*; names of cloths, 215, 220;
 scouring, 275; solubility, 177 *tab.*;
 stabilization, 309–10; uses, 112; wet-
 spinning process, 360–63. *See also*
 Cellulosic fibers
Rayon/acetate blends, 117–18
Reactive dyes, 340–41
Reclining twills, 216, 218 *tab.*
Reed, 376, 378
Reeling, 98
Regular twills, 216, 218 *tab.*
Relaxation shrinkage, 306–7
Resins, for durable press finishes, 296–97, 298
Resistive heating, 162
Resist-printing methods, 348–49
Resmethrin, 324
Retailers, 15
Retting, 77
Reversible reactions, 44
Ribbed cloth, 210
Rib knits, 231–32, 241 *tab.*
Rib weaves: names of cloths, 215; patterns,
 209, 211 *fig.*; performance, 213 *tab.*, 214
Rigmet process, 308
Ring-spun yarns, 200
Roller printing, 346
Ropes, 182
Rotary-screen printing, 348–49, 350 *fig.*
Roving, 183
Rubber, 163–64, 175 *tab.*
Rutherford, Ernest, 32

Safety: and fiber properties, 68; finishes to
 improve, 315–22

Sanding, 287
Sanforizing, 308
Sanforset process, 308, 310
Saponification, 113
Saran, 165, 175 *tab.*
Sateen, 221, 224
Satin weaves, 218 *tab.*, 221–24
Saturated hydrocarbons, 39–41
Schiffli embroidery, 261, 263
Schofield, John, 12
Schreinering, 285–86
Scouring, 274–76
Scrim, 255
Scutching, 77
Segmental motion, 59
Selection criteria, 19–20
Self-crimp fibers, 368
Self-twist yarns, 200–201
Selvage, 208, 381
Sericin, 98, 99, 275
Sericulture, 97–98
Sewing machine, 13
Shape: shaping procedures, 278–81;
 stabilization finishes, 305–12
Shearing, 282–83
Sheath-core (SC) fibers, 170
Shedding, 379
Shive, 77
Shrinkage: and ease of maintenance, 23; due
 to felting, 307, 311; finishes to prevent,
 305–12
Shuttle, 376, 378
Shuttle looms, 380
Side-by-side (SS) fibers, 168–69
Silicon finishes, 304
Silk, 97–102; bleaching, 277; burning
 behavior, 174 *tab.*; degumming, 274; dyeing
 techniques, 339, 341; fiber composition, 99;
 fiber production and yarn manufacture, 97–
 98; fiber properties, 100–101; hand, 100–
 101, 173; history, 7, 63, 97; names of cloths,
 215, 220; nylon compared to, 120; as
 protein fiber, 86; satin weaves, 221;
 solubility, 177 *tab.*; uses, 101–2; weighted,
 102, 284; yarn construction, 186
Silver fibers, 161
Simple yarns, 181–92; characteristics, 182;
 filament, 186–87; plied, 192; properties, 187–
 91; spun, 184–86
Singeing, 277–78
Singer, Isaac, 13
Single yarns, 182
Sisal, 85
Size, stabilization finishes, 305–12
Sizing: removing, 273; technique, 283; in
 twistless yarns, 202
Skein dyeing, 344
Slack mercerization, 281
Slater, Samuel, 12
Slit-film yarns, 202, 203
Slivers, 370–73
Slub yarns, 194–96

Softeners, 284, 290–91
Soil-release finishes, 298–301
Solubility tests, 177–78
Solution dyeing, 343
Solvent scouring, 276
Solvent-soluble softeners, 292
Source, 170–71, 368
Spandex, 146–50; burning behavior, 175 *tab.*;
 in core-spun yarns, 149, 197; defined, 146;
 fiber composition, 148–49; fiber properties,
 149, 150 *tab.*; introduction, 63;
 manufacture, 147–48; solubility, 177 *tab.*;
 uses, 149–50
Specialty fabrics, 259–67
Specialty hair fibers, 86, 94–96
Specific gravity, 65
Spinning: of man-made fibers, 359–65; open-
 end, 373–74; origins, 5; of staple fiber
 yarns, 372–73
Spinning dope, 113
Spinning frame, 372–73
Spinning jenny, 9, 10
Spinning mule, 9, 10
Spinning quality, 64
Spinning wheel, 8, 409
Spinsters, 14
Spiral yarns, 196
Spot weaves, 261, 263
Spun bonding, 256
Spun-silk yarns, 185
Spun yarns, 183–86: compared to filament
 yarns, 186; construction, 182; durability, 191;
 luster, 188; manufacture, 183; moisture
 permeability, 189; nomenclature, 185–86;
 open-end, 200; stretch and elasticity, 190;
 twist direction, 183–84
Stabilization finishes, 305–12
Stain removal guide, 24–27
Stain-resistant finishes, 298–301
Stain tests, 176
Standard hanks, 185, 187
Standards, 393–413; costs and limitations, 408–
 9; mandatory, 395–403, 405–7; test
 methods, 409–13; value of, 393–94;
 voluntary, 393–94, 403–5
Staple fibers: defined, 14, 64; dyeing, 344;
 from filaments, 375; spinning, 368–74
Static electricity: and comfort, 23; finishes to
 reduce, 292–95; with metallic fibers, 161,
 203
Steep twills, 216, 218 *tab.*, 219
Stencil printing, 351
Stepwise polycondensation reaction, 50
Stitch-through fabrics, 266–67
Stock dyeing, 344
Stocking frame, 9
Stoving, 276
Stretch: and comfort, 23, 67, 146–47; finishes
 to prevent, 305–12; measurement of, 65; of
 simple yarns, 190
Stuffer box, 367
S-twist yarn, 183

Sulfur dyes, 342
Surface friction, 67
Swivel weave, 261, 263
Synthappret LKF process, 311–12
Synthetic dyes, 12, 335–36
Synthetic fibers. *See* Man-made fibers

Tachikawa, S., 110
Takeup roll, 376
Taking up, 379
Taslan, 367
Tear strength, 28
Teasing needle, 212
Tenacity, 65, 67
Tendering, 102
Tensile strength, 28
Tentering, 278–80
Terrycloth, 251
Tex system, 186
Textile Fiber Products Identification Act
 (TFPIA), 64, 107, 112, 119, 127, 128, 134,
 140, 142, 146, 151, 153, 157, 162, 163, 165,
 166, 167, 172, 199, 397, 405
Textile industry: development of dyestuffs, 11–
 12; development of man-made fibers, 14;
 early origins, 3–7; four main branches, 3;
 in Industrial Revolution, 11; major inven-
 tions, 9–10; medieval Europe, 8–9;
 milestones, 4 *tab.*; modern, 14–16; New
 World contributions, 12–13
Textile mills, 12–13
Textile Products Labeling Act, 408
Texture: finishes to improve, 282–84; of
 simple yarns, 189–90
Textured yarns, 197–98
Texturing: effect on cloth characteristics, 197–
 99; methods, 365–68
Thermal properties, 23, 67, 197
Thread count, 200
Throwing, 375
Throwsters, 14
Tie dyeing, 352
Tie molecules, 58
Top dyeing, 344
Torque, 184
Transfer printing, 349–51
Triacetate, 112–18; burning behavior, 175
 tab.; defined, 112; fiber composition, 114–
 16; fiber properties, 116–18; manufacture,
 113; solubility, 177 *tab.*; uses, 117–18
Triaxial weaving, 383–84
Tricot knits, 237–39, 241 *tab.*, 389;
 Schreinering, 286; with spandex fibers, 150
Tuck stitch, 229
Tufted pile fabrics, 252–53
Tufting, 390–92
Turns per inch (tpi), 184, 188, 191
Tussah silk, 99
Twill weaves, 215–20, 221 *fig.*, 378, 379
Twisting, 366
Twistless yarns, 202

Ultron nylon carpet yarn, 170
Unbalanced yarns, 184
Union dyeing, 345
Unsaturated hydrocarbons, 41
U.S. Congress, 64, 68, 94, 396
U.S. Department of Agriculture, 311, 312
U.S. Department of Transportation, 403
U.V. stabilizers, 171

Van der Waals forces, 36
Vapor deposition, 203
Vat dyes, 340
Velour, 251–52
Velvet, 247–50, 384–85
Velveteen, 247–50, 384, 385
Vicuña, 96
Vinal, 166–67, 171, 175 *tab.*
Vinyl monomers, 51
Vinyon, 167–68, 171, 175 *tab.*
Viscose process, 107–8
Visible spectrum, 331
Vulcanization, 163

Wales, 229, 250
Warp, 208
Warp beam, 376–77
Warp-faced satin, 218 *tab.*, 221
Warp-faced twills, 216, 219
Warp knits: characteristics, 236–37; defined,
 229; machines for, 388–90; raschel, 239–40;
 tricot, 237–39
Warp-rib pattern, 209
Water frame, 9, 10
Waterproof and water-repellant finishes,
 301–5
Weaving, 376–85; on fluid-jet looms, 381; on
 Jacquard looms, 10, 259–61, 263, 382; and
 modern loom, 376–79; origins, 5–6; of pile
 fabrics, 384–85; on rapier looms, 380;
 selvage formation, 381; on simple looms,
 207–8; on shuttle looms, 380; triaxial,
 383–84
Weft, 208
Weft knits, 229–36
Weighted silks, 102
Weighting, 284
Wet bonding, 255–56
Wet spinning, 360–63
Whinefield, J. R., 127
Whitening agents, 171

Whitney, Eli, 12, 71
Wigs, 142
Wild silks, 99
Woof, 208
Wool, 86–94; acrylic blends, 139; bleaching,
 276; burning behavior, 174 *tab.*;
 carbonizing, 277; chemical stabilization,
 310–12; cost factors, 67–68; crabbing, 281;
 dyeing techniques, 339, 341; felting process,
 254–55; fiber composition, 88–91; fiber
 length, 64; flammability, 321; fulling, 93;
 fiber production and yarn manufacture, 88;
 fiber properties, 65, 91–94; grading, 88;
 hand, 173; history, 4–5, 63, 86–87; labeling
 terms, 396; macrostructure, 65–66; names of
 cloths, 215, 220; polyester blends, 133–34;
 scouring, 274; solubility, 177 *tab.*; standard
 yarn hank, 185; twist direction of yarn, 183;
 uses, 94
Woolen system, 369, 371
Wool Industries Research Association, 315
Wool Products Labeling Act, 64, 94, 172, 396,
 405
Worsted wool: crabbing, 281; durability, 93;
 source, 88; yarns, 183, 185, 371
Woven cloths, 207–25: basket weaves, 210–12;
 compared to knit, 242–44; decorative
 effects, 259–61; manufacture, 376–85; plain
 (tabby) weaves, 208–9; ribbed, 210; rib
 weaves, 209; satin weaves, 221–24; terms
 defined, 207–8; twill weaves, 215–20
Wrinkle resistance: of basket weave, 214; and
 ease of maintenance, 23; and cloth design,
 297. *See also* Durable press finishes
Wurlan process, 311
Wurnit process, 312

Yarn count, 185, 208, 212–14
Yarn manufacturers, 14
Yarn number, 185–86, 187
Yarns: classification, 181–82; complex, 194–
 204; defined, 181; dyeing, 344; interaction
 with construction and effect on
 performance characteristics, 240, 242–44;
 manufacture, 368–75; simple, 183–92
Yeh, K.-N., 317

Zeset TP process, 312
Z-twist yarn, 183